CULTURAL TREASURES
OF THE WORLD

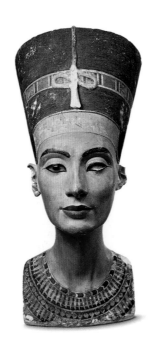

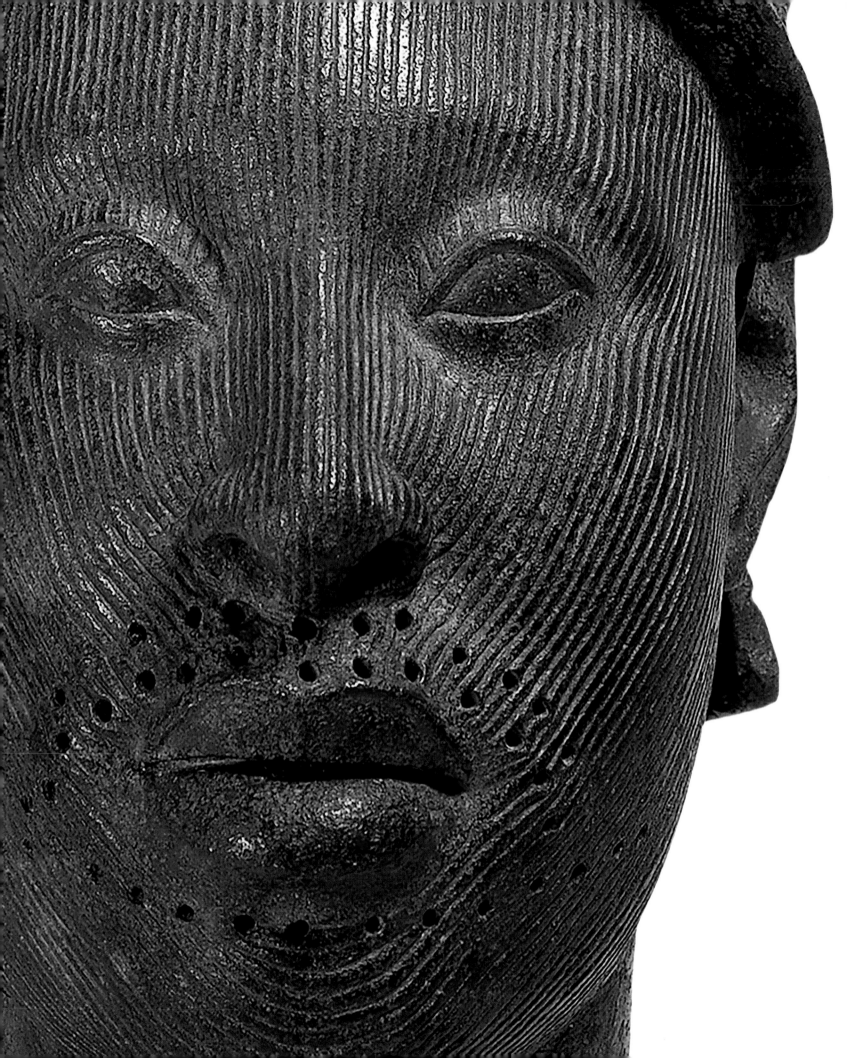

CULTURAL TREASURES
OF THE WORLD

From the relics of ancient empires
to modern-day icons

Produced for DK by
COBALT ID

Editors Diana Loxley, Kirsty Seymour-Ure,
Marek Walisiewicz
Designers Darren Bland, Paul Reid, Rebecca Johns
Picture Researcher Sarah Smithies
Illustrator Philip Gamble

DK LONDON

Senior Editor Chauney Dunford
Project Art Editor Katie Cavanagh
Managing Editor Gareth Jones
Managing Art Editor Lee Griffiths
Producer Rachel Ng
Production Editor Gillian Reid
Jacket Design Development Manager Sophia M.T.T
Jacket Designer Stephanie Cheng Hui Tan
Senior DTP Designer Harish Aggarwal
DTP Designer Nityanand Kumar
Senior Jackets Coordinator Priyanka Sharma-Saddi
Associate Publishing Director Liz Wheeler
Art Director Karen Self
Design Director Philip Ormerod
Publishing Director Jonathan Metcalf

CONTRIBUTORS

Tony Allan, Kay Celtel, Ian Chilvers,
Reg Grant, Philip Parker,
Marcus Weeks, Iain Zaczek

First published in Great Britain in 2022 by
Dorling Kindersley Limited
DK, One Embassy Gardens, 8 Viaduct Gardens,
London, SW11 7BW

A CIP catalogue record for this book
is available from the British Library.
ISBN: 978-0-2415-0892-3

Printed and bound in UAE

For the curious
www.dk.com

MIX
Paper | Supporting
responsible forestry
FSC™ C018179

This book was made with Forest Stewardship
Council™ certified paper – one small step
in DK's commitment to a sustainable future.
For more information go to
www.dk.com/our-green-pledge

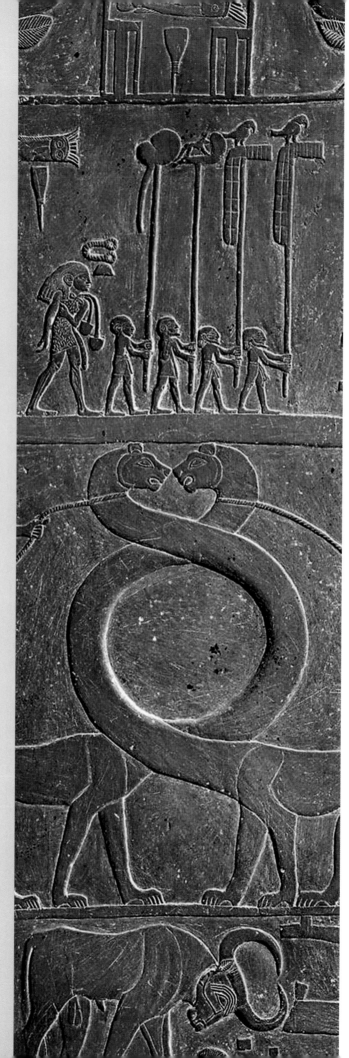

Contents

7

1900 – Present 300

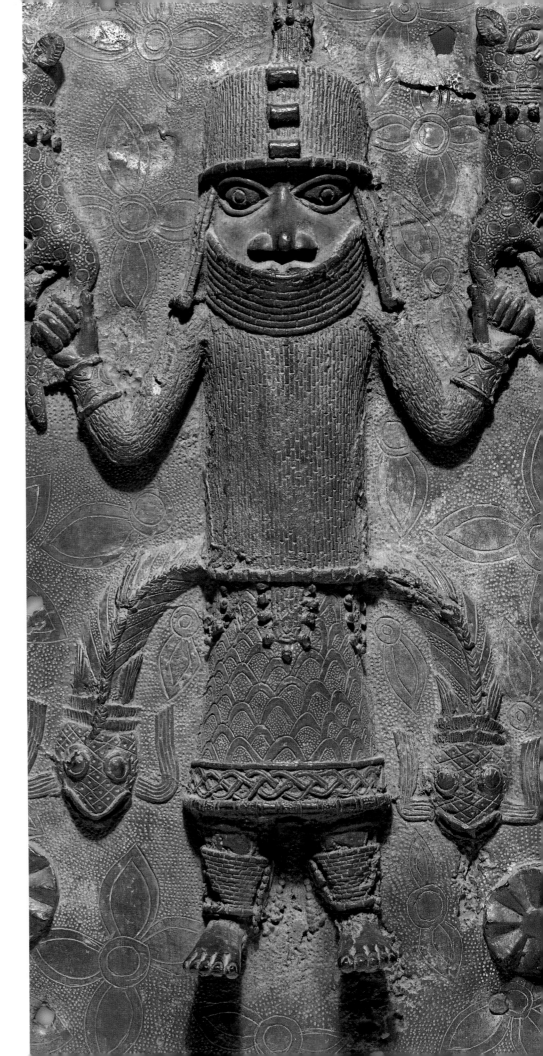

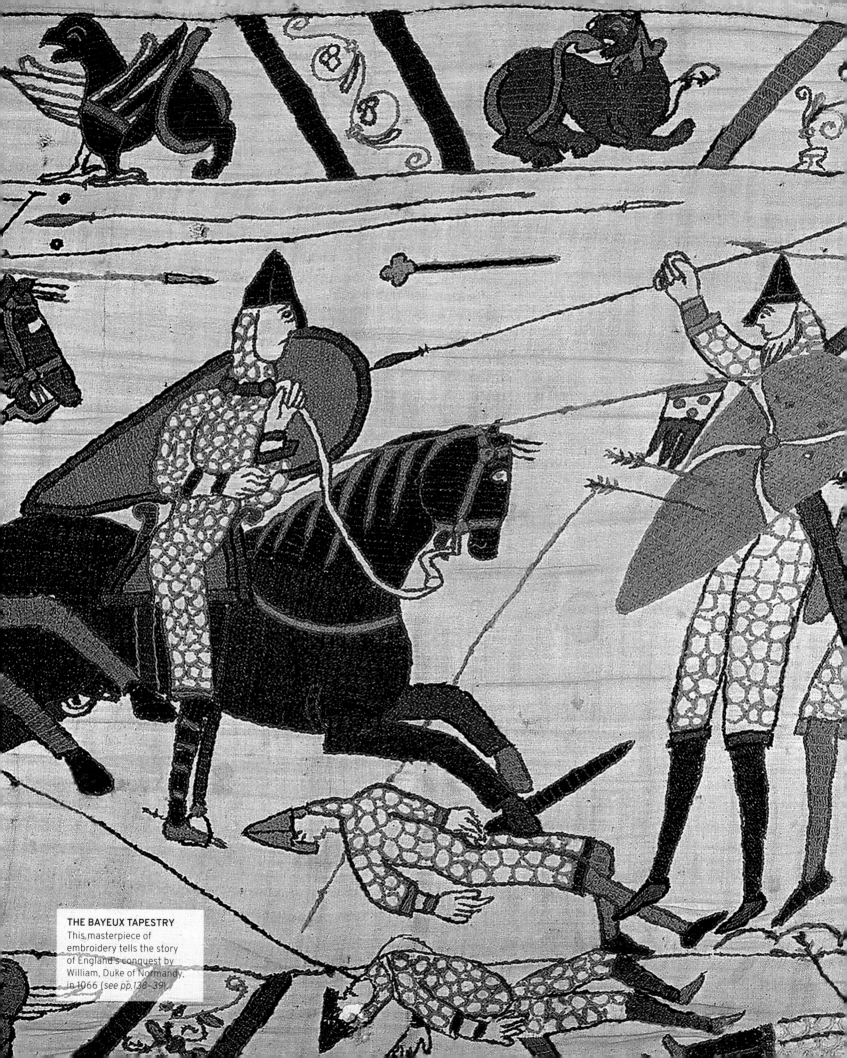

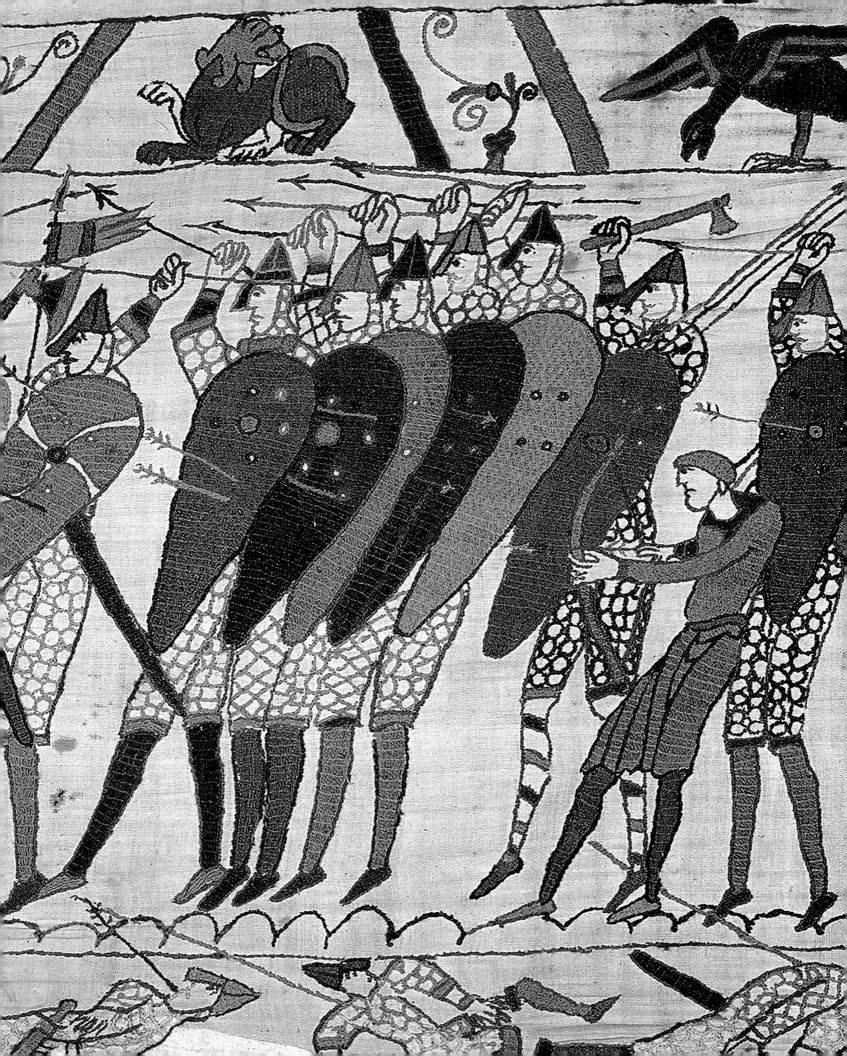

Introduction

The first objects deliberately crafted by our distant ancestors around three million years ago were stone tools – essentially pebbles given a sharp edge by striking them against other rocks. They proved so perfectly fit for their purpose that they remained in use for a million years. Over time, human ingenuity provided for other essentials, giving us the first weapons around 300,000 years ago, clothing 70,000 years ago, ceramic pots 20,000 years ago, and implements made of bronze 5,000 years ago and of iron 3,200 years ago. The same human impulse to improve everyday life has driven the technologies that shape our world today.

Woven deeply into human history is an even more remarkable desire to make things that are not strictly practical or necessary. The earliest remaining evidence of this creative drive goes back some 40,000 years, well before people had given up their nomadic lifestyles, to the Venus goddess sculpture found at Hohle Fels in Germany and the cave paintings of Altamira in Spain. Artistic endeavour is seemingly rooted in the human psyche, or – in the words of the 19th-century English designer and polymath William Morris – it is "no mere accident to human life, which people can take or leave as they choose, but a positive necessity of life." It is this fundamental human instinct, which has bequeathed us the most ornate, expressive, beautiful, and significant objects in the world, that is addressed in this book.

Extraordinary objects appear in every culture, and each one of them provides insights into how people of that culture lived. Studying and interpreting these artefacts reveals much about their creators' beliefs, customs, social structures, and – above all – the things they treasured the most. Despite their diversity of form, the objects shown on the following pages have much in common. Making each one required a significant investment of time, effort, and skill, and an appreciable level of craftsmanship or artistic sensibility. And most were produced with posterity in mind – evidence of yet another strong human urge, the desire to preserve ancestral heritage and create a cultural legacy.

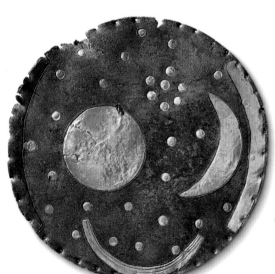

△ NEBRA SKY DISC, c.1600 BCE
This Bronze Age disc, discovered near Leipzig in Germany, carries a view of the heavens. It is an ancient calendrical device and perhaps one of the oldest star maps ever made (*see p.35*).

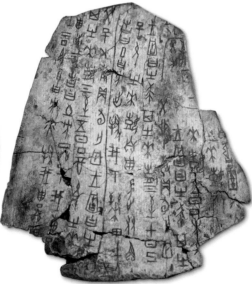

△ ORACLE BONES, c.300–1046 BCE
This ox scapula (shoulder blade) was inscribed in the Chinese Shang dynasty as part of a divination rite. Its pictographs provide first-hand accounts of the concerns of the Shang rulers (*see pp.42–43*).

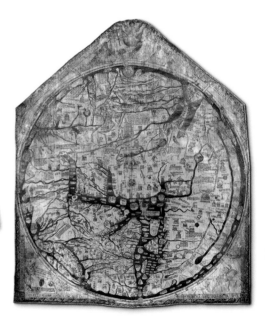

△ HEREFORD MAPPA MUNDI, c.1300
Occupying a single sheet of vellum (calf's skin), this map provides a unique insight into concepts of the world in Middle Ages Europe. It was drawn in ink by English monastic scholars (*see pp.166–67*).

"The aim of art is to **represent** not the **outward appearance** of things, but their **inward significance**."

ARISTOTLE, 384–322 BCE

Some were specifically designed with a religious purpose, for example, the paintings and sculptures of gods, mythological creatures, representations of ancestors, or beings in a spirit world; others, including masks, robes, and vessels, were crafted for use in ceremonies. Others still were made to honour the status of an important figure in society, or to commemorate a specific event. As civilizations became more sophisticated and able to support a class of professional artists and artisans, objects were increasingly made for purely decorative or artistic reasons, with the sole purpose of providing enjoyment. Creative people around the world continue this tradition, producing a dazzling array of "cultural treasures".

The objects pictured and analysed in this book are considered to be treasures not because of their intrinsic worth – some are indeed made from precious materials and are literally priceless, while others are formed from humble materials such as clay, stone, or wood – but because of the value bestowed on them by the society that inspired their creation. It is their cultural context

that provides the value – the broader system of beliefs and practices surrounding the object – rather than the object itself. That great value is recognized by anthropologists, historians, and ordinary people today; accordingly, most of the objects included are now housed in museums or galleries, or on sites that are protected and preserved for posterity (*see pp.342–43*).

Each object described in this book is a product of its time, of its place, and of its people. Reading this book as a collection reveals not only differences between cultures through the ages and around the world, but just as significantly, the values that we all share. Objects give us first-hand information – they are primary historical sources that speak to us viscerally as well as academically, making them an invaluable guide to world history and culture, an idea that echoes the words of US cultural critic Camille Paglia: "All objects, all phases of culture are alive. They have voices. They speak of their history and interrelatedness. And they are all talking at once!"

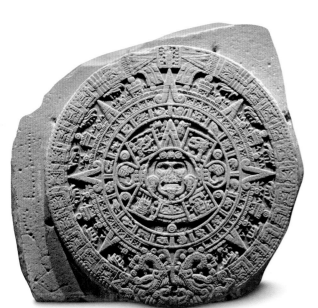

△ **AZTEC SUN STONE, 1502–21**
This huge stone was probably used as an altar in human sacrifice – a practice embedded in Aztec life. Regular offerings to the sun god Tonatiuh, depicted in the centre, were believed to ensure good harvests (*see p.222*).

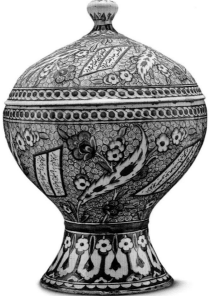

△ **IZNIK LIDDED BOWL, c.1580**
The town of Iznik in Turkey was home to the potteries of the Ottoman Empire that produced some of the world's most finely decorated tiles and vessels (*see pp.226–27*).

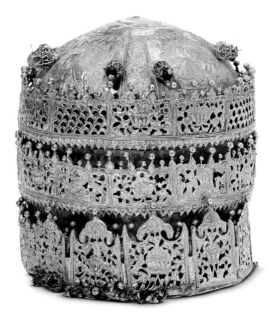

△ **MAQDALA CROWN, 1740s**
This exquisitely decorated gold crown, which carries images of the apostles, was commissioned by Empress Mentewab of Ethiopia and presented to the Orthodox church (*see p.249*).

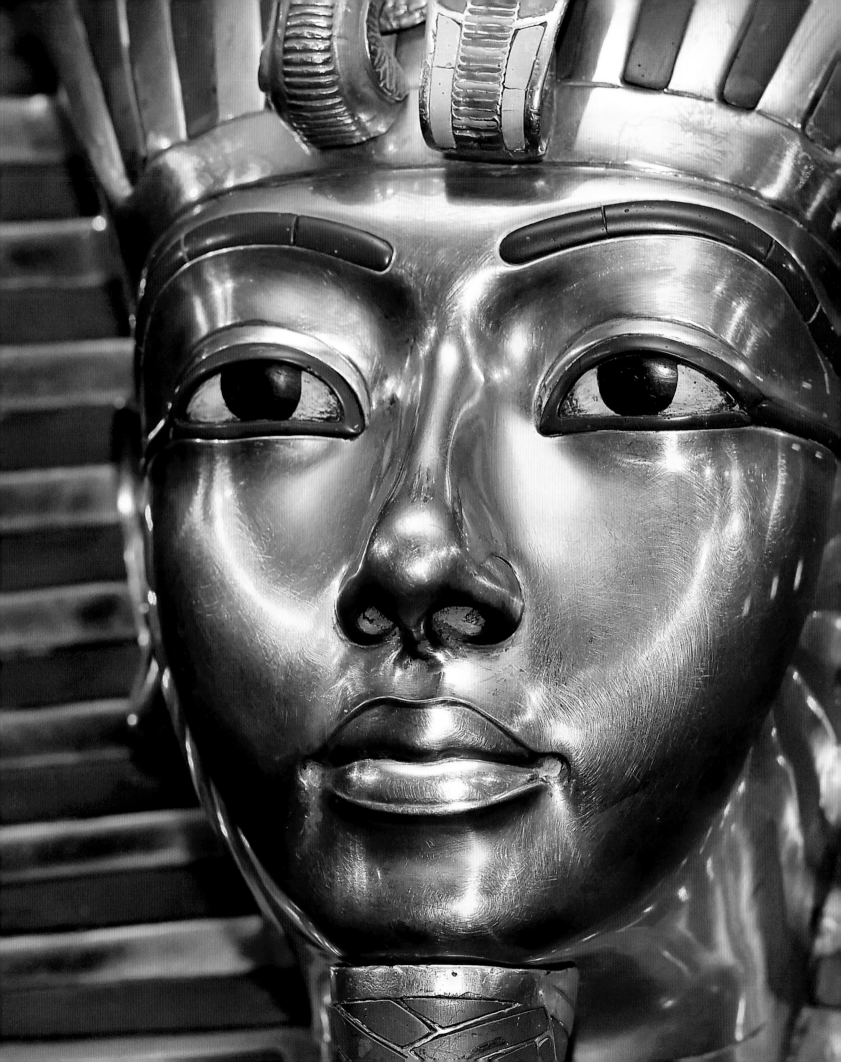

40,000 BCE – 501 BCE

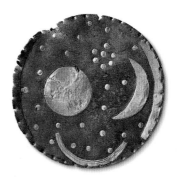

The period from 40,000 BCE to 500 BCE saw the spread of humans across the globe and the development of civilization from cave-dwelling and hunting and gathering, through settlement and migration, to the emergence of complex societies in the Middle East, Europe, Africa, Asia, and Central America. What unites these ancient cultures is the human drive to create objects of meaning and beauty that reflected nature, daily life, and the rituals and religions that helped people make sense of the world around them. From the earliest depictions of the human form to the sophisticated beauty of ancient Greek art, and from carvings and paintings to pottery and intricate metalwork, the period encompasses the early flowering of human creativity.

Hohle Fels, Germany

Venus of Hohle Fels

The oldest known depiction of a human being, sculpted from the tusk of a woolly mammoth, unearthed in a cave

An extraordinary figurine found in the Hohle Fels cave in the Swabian Jura of southern Germany shed new light on Palaeolithic culture, placing the beginnings of prehistoric art much earlier than previously assumed. The very obviously female figure was carved in mammoth ivory with flint tools between 40,000 and 35,000 years ago, making it the world's earliest known figurative carving.

The figure's prominent sexual characteristics have led scholars to assume it is a fertility symbol: it has been anachronistically dubbed a "Venus" (a reference to the Roman goddess of love), in common with later Stone Age statuettes of a similar nature. The Hohle Fels Venus – one of the earliest known examples of "mobiliary" art (*see box, below*) – is a voluptuous figure, apparently glorifying female reproductivity, and it is this that dictated the figurine's proportions: the short limbs are dwarfed by the body, with its slightly waisted midriff, large breasts, wide hips and thighs, and exaggerated genitalia; instead of a head there is a small perforated protuberance through which a cord might have been threaded.

MOBILIARY ART

The Palaeolithic hunter-gatherers were nomadic people, following herds of animals and taking shelter from the weather in caves. Their art therefore took two forms: paintings on the walls and ceilings of caves, known as parietal art; and mobiliary art – small and portable sculptures carved from wood, bone, ivory, or stone, or fashioned in clay, to accompany them on their travels.

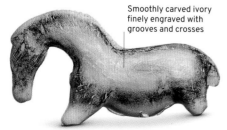

Smoothly carved ivory finely engraved with grooves and crosses

PREHISTORIC CARVED HORSE, VOGELHERD CAVE

REPAIR
Broken sections have been glued back together.

The **first** Venus figurines were **carved** at the same time as **early modern humans** appeared in Europe

◁ **VENUS OF DOLNI VESTONICE**
One of the world's earliest known ceramic artefacts, this figurine dates from 29,000–25,000 BCE; with its exaggerated breasts, hips and belly, it is typical of the "Venus" sculptures of the Upper Palaeolithic, or Late Stone Age, in Europe.

PERFORATION
In place of a head is a perforation in the carving, through which a cord was probably threaded

PROPORTIONS
The figure's small arms and short, footless legs are out of proportion with the body.

△ **SIDE VIEW**
In profile, the exaggeratedly swollen breasts and rounded abdomen are particularly conspicuous, emphasizing the figure's femininity and fertility.

CLOTHING
Grooves cut into the torso and arms possibly represent clothing.

ENLARGED BODY
The huge body, with its prominent belly and breasts, and wide hips, is indicative of fecundity.

GENITALIA
The exaggerated representation of genitalia suggests the figure was a fertility symbol.

△ **VENUS OF HOHLE FELS**
Six fragments from this ancient object have been discovered and pieced together to form an almost complete figurine – only the left arm is missing.
Height: 6cm (2½in). **Date:** c.38,000–33,000 BCE.

Scale

Lion-Man of Hohlenstein-Stadel

*An imposing lion-headed figurine, painstakingly reconstructed
from fragments of ivory found in the Hohlenstein-Stadel cave*

Hohlenstein-Stadel,
Germany

The caves of the Swabian Jura region in Germany have yielded a wealth of artefacts from the Upper Palaeolithic, including many skilfully carved figures and ornaments. Among the oldest of these is this carved mammoth-ivory sculpture depicting, in great detail, a lion-headed figure with a partly human body.

Discovered in tiny pieces in the dirt on the floor of the Hohlenstein-Stadel cave, the Löwenmensch, or Lion-Man, was pieced together over a period of more than 70 years as further fragments were found. Now almost complete, it reveals an astonishing degree of craftsmanship. Carved from a mammoth tusk using flint cutting tools, the hybrid figure has a clearly recognizable lion's head and paws, and the elongated back of a feline, but its arms and legs, and its confident upright stance are unmistakably human.

Considerable time and care went into the making of this figurine, suggesting it had immense cultural or religious significance, perhaps as a representation of a mythical anthropomorphic creature, or as an image of a shaman dressed in animal skin and wearing a lion's-head mask.

The Hohlenstein-Stadel **lion-man** has been assembled from more than **1,000** fragments of ivory

CARVING IVORY WITH FLINT TOOLS

The Upper Palaeolithic, or Late Stone Age, saw the replacement of simple flint-flake tools with more sophisticated blades made from a knapped flint core. A variety of specialized scrapers, knives, and pointed tools were produced, making intricate carving of ivory and bone possible; but sculpting tusks and bones, especially across the grain, was an arduous task requiring both strength and skill.

UPPER PALAEOLITHIC FLINT TOOL

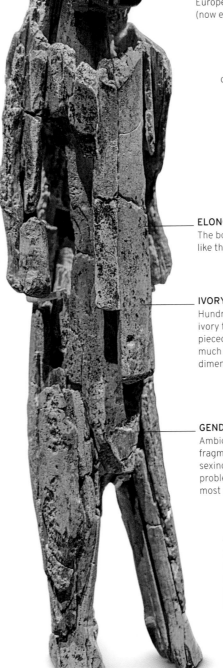

HEAD
The figure's head and neck are those of a European cave lion (now extinct).

GROOVES
Seven parallel grooves are deliberately gouged into the left arm.

PAWS
Lion's paws take the place of human hands.

ELONGATED BODY
The body is elongated, like that of a feline.

IVORY FRAGMENTS
Hundreds of tiny ivory fragments were pieced together, much like a three-dimensional jigsaw.

GENDER
Ambiguously shaped fragments made sexing the figure problematic, but it is most probably male.

△ **SIDE VIEW**
The variety of carving techniques of individual features suggests that several flint tools were used in the sculpting.

◁ **LION-MAN OF HOHLENSTEIN-STADEL**
The lion-man figurine is the earliest anthropomorphic animal sculpture yet discovered, and its combination of human and feline characteristics gives a tantalizing glimpse into a possibly shamanic Palaeolithic culture.
Height: 31.1cm (12¼in). **Date:** c.38,000–33,000 BCE.

Scale

▷ OCHRE
Reds, browns, and yellows were produced using different ochres (natural clay earth pigments).

BISON 43
The female bison identified as "Bison 43" is painted in a quite sophisticated, naturalistic style.

◁ MANGANESE
The body, mane, and horns are outlined with black manganese and charcoal.

IRREGULARITIES
The artists used cracks and other irregularities to add volume or emphasize and help capture various anatomical features, such as the bison's head.

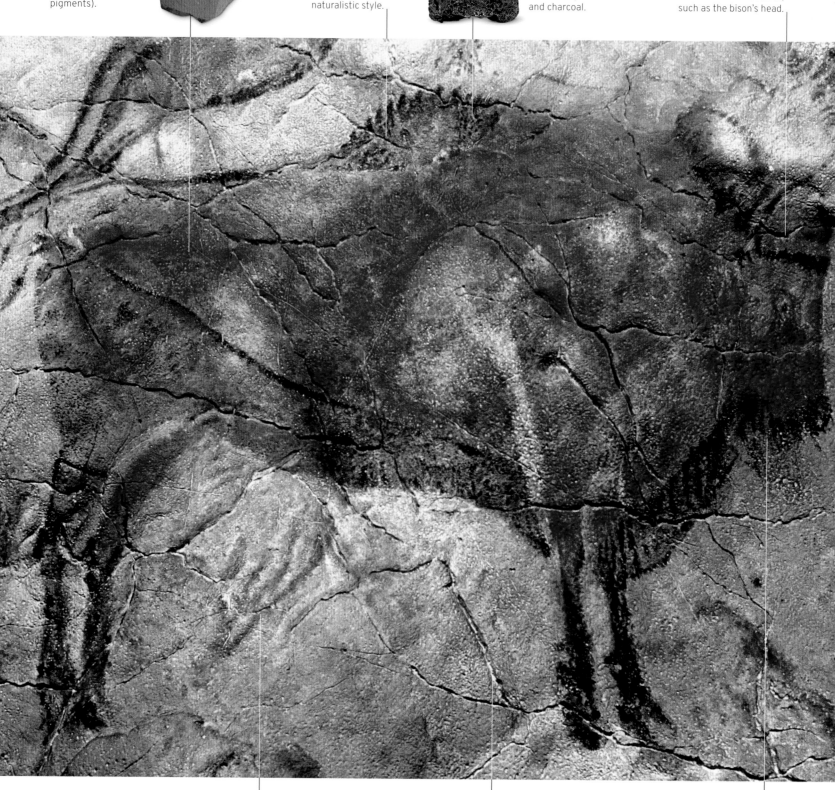

EARLIER DEPICTIONS
A previous red-figure layer has been painted over.

CEILING
The height of the ceiling in the Polychrome Chamber varies from about 1.2m to 2.7m (4ft to 9ft).

DETAILS
A charcoal stick was used to depict finer details, such as hair on the chin.

▽ **ALTAMIRA BISON**
This exceptional image of a
female bison is one of dozens
of depictions on the ceiling
vault of the Polychrome
Chamber at Altamira.
Height of bison: 150cm (59in).
Date: c.15,000–12,000 BCE.

Altamira Bison

*Remarkable treasures of European prehistoric art adorning
the walls of a Spanish cave*

Santillana del
Mar, Spain

Between 21,000 and 11,000 years ago, the cave complex
of Altamira near Santillana del Mar, northern Spain,
was home to Palaeolithic peoples of the Solutrean and
Magdalenian cultures. Artists from these cultures left
dozens of breathtaking paintings on the walls and
ceilings of the galleries and chambers into which
the 300m (984ft) long cave is divided.

Prehistoric cave art

Animals that could be hunted – bison, horses, wild
boar, goats, and deer – form the bulk of the paintings.
They were created on the walls and ceilings of the
caves; in some areas, the artists would have used
planks or a form of scaffolding to reach the ceilings.

The first paintings, in the Polychrome Chamber
(the cave's largest), were red-figure bison, made using
haematite or ochre pigment, diluted with juice or saliva
to create hues. Polychrome animals (*see left and below*)
were subsequently painted over many of them. For
these later animals, the artists used manganese to
produce black and often also exploited natural cracks
and contours in the surface to create dynamic effects.

Some artists used hollow bird bones to spray paint on
the rock and moss pads to smear it. The magnificent
150cm (59in) bison shown here, like most animals in
the cave, is just under life-size.

The caves were discovered in 1868, and investigated
properly from 1879, but at first the paintings were
dismissed as modern forgeries. Only in 1902 were they
recognized as among the finest examples of prehistoric
European cave art, so precious that now visitors can
only see replicas, to stop fungus (which grows on the
moisture from people's breath) from destroying them.

The **Polychrome** Chamber at Altamira has 27 **bison**, four **does**, one **stag**, and two **horses** painted on the walls

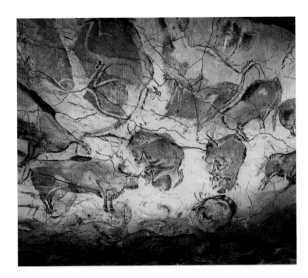

△ **RED BISON ON THE CEILING AT ALTAMIRA**
The artists who created these astonishing paintings on
the ceilings and walls of the dark caves would have worked
using the dim light from oil lamps (made from animal fat).

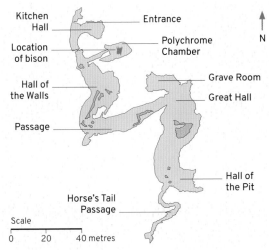

△ **ALTAMIRA'S GALLERIES**
There are several galleries in the Altamira cave complex,
including the Polychrome Chamber, the Great Hall, the
Hall of the Pit, and a passage known as the Horse's Tail.

Scale

Kakadu National Park, Australia

Scale

Kakadu Rock Art

Thousands of spiritually significant Aboriginal images forming one of the world's greatest concentrations of rock art

There are over 5,000 recorded rock art sites in Kakadu National Park in Australia's Northern Territory. Dating from around 20,000 years ago to the present day, the paintings comprise one of the longest continuous historical records of any culture in the world.

The main galleries of *gunbim* (Aboriginal rock art) are at Ubirr and Burrunguy (Nourlangie Rock), where paintings cover the walls, ceilings, and boulders of Aboriginal rock shelters. Images range from animals and plants to human figures and ancestral beings, along with hand prints and stencils. The rock art records the beliefs and history of the Bininj/Mungguy (the Indigenous traditional owners of the land in this area), testifying to their intimate relationship with the territory and to their spiritual heritage. Certain images are considered *andjamun* (sacred and dangerous) and may be seen by only a few senior Aboriginal men and women. Newer paintings are often layered over older ones, giving a glimpse into different time periods.

RED PIGMENT
Haematite, an iron oxide, was used to give a red colour, and is the pigment that has lasted longest over the millennia.

HAND OUTLINES
Pigment was blown from the artist's mouth over an outspread hand to create a stencil effect.

DIFFERENT HEIGHTS
Hand prints cover whole walls at different levels, according to the height of the artist and perhaps also his or her status.

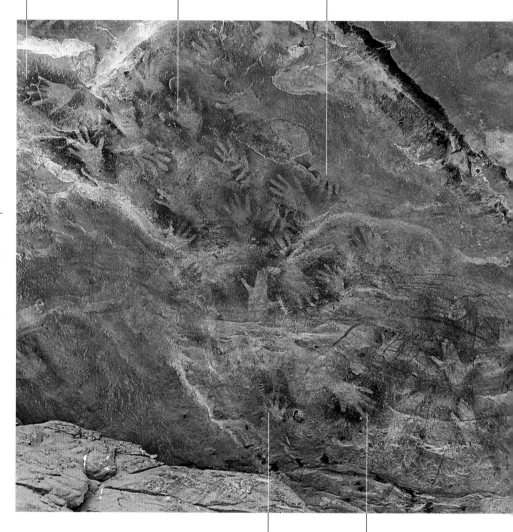

△ **KAKADU ROCK ART**
Aboriginal artists frequently employed stencils, including their hands, in their painting. Such prints are probably the oldest paintings made at Kakadu.
Dimensions: life-size. **Date:** c.20,000 BCE–2000 CE.

CHILD
Small, low-level prints such as this one were probably made by children.

BLACK PIGMENT
Black was derived from manganese oxide or charcoal, mixed with water to form a paste.

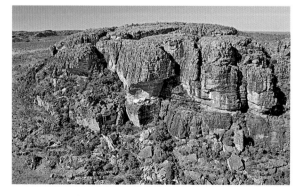

△ **KAKADU NATIONAL PARK**
Rocky outcrops such as this one near Ubirr served as shelters for Aboriginal people for thousands of years, and, like Ubirr, are frequently the site of rock art.

20TH-CENTURY ROCK ART

Traditional rock art continued to be painted at Kakadu until the 1980s. This image, at the Burrunguy site, was made by artists Nayombolmi (c.1895–1967) and Old Nym Djimongurr (c.1910–1969) in the 1960s. Nayombolmi is known to have created at least 650 works of rock art over the course of his life. Painting still forms part of Aboriginal culture, as a way of passing on cultural practices and laws, but is now more often created on bark or canvas.

ANCESTRAL FIGURES BY NAYOMBOLMI AND DJIMONGURR, 1963–64

Judaean Hills,
West Bank

Scale

Judaean Stone Mask

A mysterious 9,000-year-old carved limestone mask from a key moment in human history

This compelling and beautiful Neolithic stone mask was found near the settlement of Pnei Hever in the southern West Bank, and is one of sixteen similar masks from the area of the Judaean Desert and Hills. It dates to the Neolithic period around 9,000 years ago, a time when human cultures were moving away from hunting and gathering towards agriculture, and beginning to settle. This agricultural revolution was accompanied by an increase in activities relating to religious ritual, and it is thought that the mask played a ritual role, perhaps in death rites or ancestor worship.

Smoothly and expertly carved from a yellowish-pink limestone, the mask has an eerie quality, with its blank eyes and partly open mouth. The cheekbones are sculpted and a set of teeth is clearly defined, showing the high level of the carver's skill. Perforations along the edges of the mask, together with its hollowed-out back, suggest that it may have been worn over the face, or perhaps attached to a pole.

NEOLITHIC PLASTERED SKULLS

In another example of early ritualized behaviour from the same region, several plastered skulls dating from the Neolithic period have been found buried under house floors at sites in Israel, Palestine, Syria, and Jordan. Wet plaster was moulded around the skull to recreate facial features, and fragments show that shells and paint were used to denote the eyes and elements such as hair and moustaches.

PLASTERED SKULL
FROM JERICHO,
WEST BANK,
7000–6000 BCE

Nose remodelled
in plaster

Teeth ground back
to the roots

LIMESTONE
The mask is carved from limestone from the Judaean Hills, identified as a possible centre of mask production.

▽ **JUDAEAN STONE MASK**
Created using stone tools, the mask displays remarkable craftsmanship. **Height:** approx. 25cm (10in). **Date:** c.7000–6000 BCE.

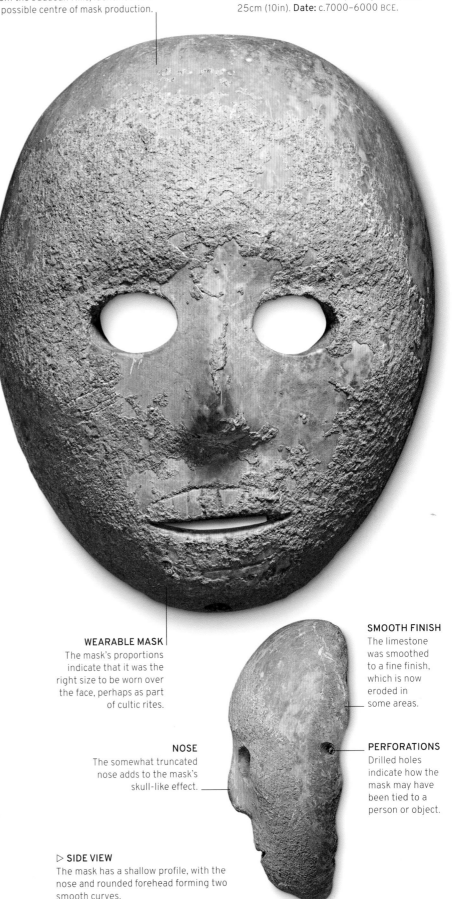

WEARABLE MASK
The mask's proportions indicate that it was the right size to be worn over the face, perhaps as part of cultic rites.

SMOOTH FINISH
The limestone was smoothed to a fine finish, which is now eroded in some areas.

NOSE
The somewhat truncated nose adds to the mask's skull-like effect.

PERFORATIONS
Drilled holes indicate how the mask may have been tied to a person or object.

▷ **SIDE VIEW**
The mask has a shallow profile, with the nose and rounded forehead forming two smooth curves.

PALETTE OF NARMER ▷
Discovered at Hierakonpolis, an ancient capital of Egypt, the palette is an important ritual object. Narmer himself is thought to have played a key role in the unification of his nation. **Height:** 63.5cm (25in). **Date:** c.3100 BCE.

Palette of Narmer

A unique artefact used in sacred rituals from the dawn of Egyptian history; its imagery symbolizes ancient cultural events

Hierakonpolis, Egypt

The Palette of Narmer is a 4th-century BCE grey siltstone tablet celebrating the achievements of King Narmer, who many historians have identified as Menes, the legendary founder of Egypt's First Dynasty (*see box, below*). Narmer's palette was found in 1898 by the British archaeologists Frederick Green and James Quibell in a temple complex at Hierakonpolis, one of the capitals of ancient Egypt.

Unique significance

Small, undecorated Egyptian palettes (commonly found as grave goods) were used for preparing cosmetics – the cosmetics were probably intended to adorn the statues of deities in the temples. Larger, decorated palettes served a ritual purpose and are much rarer. Most of the decorated palettes depict animals, but the iconography of the Narmer Palette is considerably more complex, indicating that this was an object of immense cultural significance.

The palette features low-relief engravings of exceptional quality and, even at this very early stage, displays traditional features of Egyptian art. The narrative is in registers (horizontal strips) and the figures are shown with their heads in profile, but with frontal torsos. The imagery is so unusual that scholars cannot agree on its meaning, but it is widely thought to relate to the unification of Egypt (*see box, below*): it is the earliest-known artefact showing the same king wearing the crowns of both Upper Egypt (the Nile Valley) and Lower Egypt (the Delta). On one side of the palette, Narmer raises his mace to crush an enemy's skull (a traditional image of royal authority), watched over by the falcon-god Horus (*see also below*). On the other side, he is shown leading a military procession to view the headless corpses of his defeated enemies. Below this, two intertwined beasts symbolize the unification that this victory has probably achieved.

In hieroglyphics, **Narmer's** name is represented by a **catfish** and a **chisel**

Two dogs define the sides of the palette

"Serpopards" (*see opposite, bottom*) encircle the pigment bowl

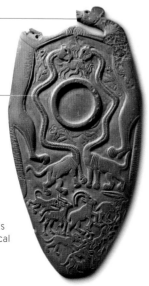

▷ **TWO-DOGS PALETTE**
This is more typical of the ceremonial palettes that were found at Hierakonpolis. With its mix of wild animals and mythical creatures, it embodies the earlier, predynastic concept of kingship (*see box, right*).

THE UNIFICATION OF EGYPT

The unification of Upper and Lower Egypt was the most significant event in the country's ancient history, marking its creation as a nation state and, around 3100 BCE, ushering in the dynastic era. At a social and political level, this process probably took place over the course of several reigns, although it may have been reinforced by a single, decisive battle. The scale of the change is reflected in Narmer's Palette. Earlier palettes showed hunting scenes, in which royal authority is linked to the controlling power of wild animals (*see left*), but with Narmer the emphasis shifted from hunting to warfare. The king is shown in human form crushing his enemies. He is also portrayed as a unifier, wearing the crowns of both Upper and Lower Egypt (*see opposite*). These were combined into the double-crown or *pschent*, representing unification, in the reign of Den (died c.2995 BCE) in the First Dynasty.

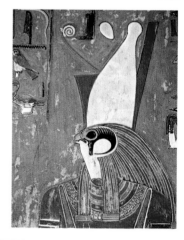

THE GOD HORUS WEARING THE *PSCHENT* CROWN

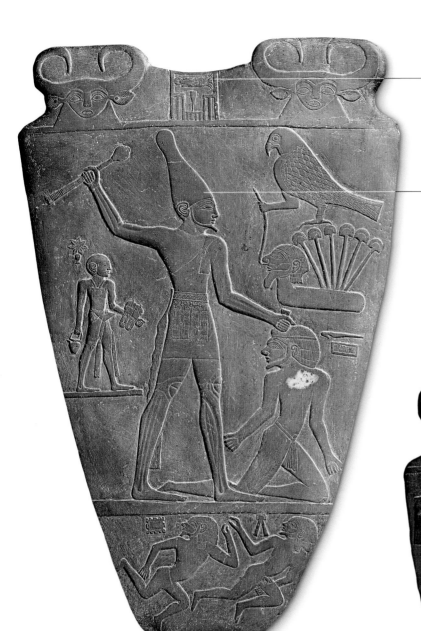

◁ NARMER'S NAME
Narmer's name is shown in hieroglyphics, alongside the gates of a royal palace.

WHITE CROWN
Narmer is shown here wearing the white crown, or *hedjet*, of Upper Egypt (*see box, opposite*).

RED CROWN
Narmer wearing the red crown, or *deshret*, of Lower Egypt (*see box, opposite*).

STANDARD-BEARERS
Four standard-bearers in procession.

THE GODDESS HATHOR
Hathor appears twice on both sides of the palette (*see also left*).

COSMETICS BOWL
The necks of two serpopards (*see below*), held with ropes by two attendants, form the bowl in which cosmetic ingredients were ground and mixed.

△ MYTHICAL CREATURES
The modern name for these mythical creatures is "serpopard" (a combination of "serpent" and "leopard"). The original Egyptian name is unknown.

Scale

▷ REVERSE VIEW
The other side of the Narmer Palette commemorates the victories of King Narmer, identified as King Menes, the unifier of Upper and Lower Egypt.

Ur, Iraq

Scale

Ram in the Thicket

One of the most remarkable survivals of the Sumerian civilization, which flourished in the 3rd millennium BCE

This is one of a pair of almost identical statuettes that were discovered in 1928–29 at Ur, a major religious, political, commercial, and artistic centre of Sumer (now in southern Iraq), a region that was home to one of the first great civilizations. Archaeologist Leonard Woolley gave the statuette its title in allusion to the biblical story of Abraham, who sacrificed a ram caught by its horns in a thicket. In fact, the figure represents a goat standing on its hind legs to reach leaves in a tree.

The statuette was found in a royal burial site, so it was likely a funerary offering for a person of rank, possibly a high priestess. Originally mounted on a wooden core, the piece displays the impressive artistic and technical skill of the Sumerians. Luxury materials were used, including gold, silver, and copper, with lapis lazuli and shell for the fleece; lapis lazuli for the goat's eyes and beard contributes to the face's lively expression. The figure's exact meaning is uncertain, but it may be connected with the fertility of the land.

Goats were associated with the shepherd god Dumuzid, consort of the goddess Inanna

LEONARD WOOLLEY

Sir Leonard Woolley (1880–1960) was one of the foremost archaeologists of the 20th century. He worked in various parts of the Mediterranean world and the Near East, but he is famous above all for his association with Ur, where he was director of excavations from 1922 to 1934. Renowned for his unflagging energy, he began work on site soon after sunrise and continued in his office well into the night. He spread knowledge of his work through popular books as well as scholarly publications.

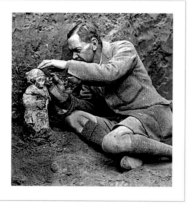

LEONARD WOOLLEY AT UR

LAPIS LAZULI
The goat's horns, eyes, beard, and shoulder fleece are made of the semi-precious stone lapis lazuli, imported from Afghanistan.

▷ **RAM IN THE THICKET**
The animal is thought to be a markhor, a wild species of goat noted for its large, corkscrew-shaped horns. **Height:** 46cm (18in). **Date:** c.2600 BCE.

DIVINE SYMBOL
The eight-pointed star or flower was associated with the goddess Inanna, later known as Ishtar.

GOLD LEAF
Gold leaf is used on the tree and the goat's face and legs.

SUPPORT
The tube that rises from the goat's shoulders suggests that the goat and its companion figure were used as supports for a small bowl or tray.

BASE
The wooden base is decorated with silver, lapis lazuli, shell, and limestone.

BODY FLEECE
The body fleece is made of intricately carved shell.

▷ **SIDE VIEW**
The figure and its near-identical companion piece were probably arranged facing one another.

Cyclades, Greece

Scale

Cycladic Figure

A type of radically pure ancient sculpture that has been much imitated and forged in the modern world

The term "Cycladic" refers to a civilization that flourished in the 3rd and 2nd millennia BCE on the Greek Cyclades islands in the Aegean Sea. These islands, particularly Naxos and Paros, were renowned for their high-quality marble, which was used to produce a distinctive type of figure in which the forms of the body and face are simplified to an almost abstract purity. The figures are mainly female and are generally depicted standing with arms crossed over their stomach, and their legs separated by a deep cleft. Shown here are a complete female figure (*far right*) and a head that has been broken off another figure (*right*), both slightly under life-size.

The purpose of the figures is uncertain, but many have been found in graves, so they may have had some ritual use. Since most are female, they were perhaps connected with a fertility or reproductive deity. In the 20th century, modern sculptors such as Brancusi and Modigliani were inspired by their elegant simplicity of form. Because of this very simplicity, they have been much imitated by forgers.

INFLUENCE OF CYCLADIC SCULPTURE

In the early 20th century many progressive painters and sculptors were inspired by non-Western art, finding in it a vigour and freshness lacking in mainstream European art. African, Oceanic, and Pre-Columbian art were all influential. Amedeo Modigliani (1884–1920) was particularly enthusiastic about Cycladic sculpture. Its impact is notable in the serenity and simplified forms of his sculpted stone heads (*see p.308*), which are strikingly close in spirit to Cycladic art, as can be seen in the pencil study shown here.

STUDY FOR A SCULPTED HEAD, AMEDEO MODIGLIANI, 1912

▷ **CYCLADIC FIGURE**
The complete figures vary from 8cm (3in) to almost life-size. The characteristic down-pointed feet of this figure meant that it could not stand upright. **Height:** 140cm (55in). **Date:** c.2800–c.2300 BCE.

LUSTROUS MARBLE
The most famous stone from the Cyclades comes from Paros (Parian marble); sculptors prized its regular grain and lustrous white colour.

SMOOTH SURFACE
The smooth surfaces were created by painstaking rubbing with abrasive powder made from emery (an extremely hard stone mined on Naxos).

CROSSED ARMS
The female figure has its arms crossed in typical fashion, with left arm above right.

SHALLOW DEPTH
The figures are usually made from slim rectangular blocks of marble, so the backs of heads are flattened.

◁ **SUBTLE DETAILING**
This profile view shows that the nose is carved as one with the forehead in a single smooth, shallow curve. An ear is visible in low relief on the side of the head. Although this 27cm (10½in) high head is now almost featureless, originally it may have been enlivened by coloured paint.

DAMAGE
This damage looks accidental, but sometimes Cycladic figures seem to have been deliberately broken, perhaps in some kind of ritual.

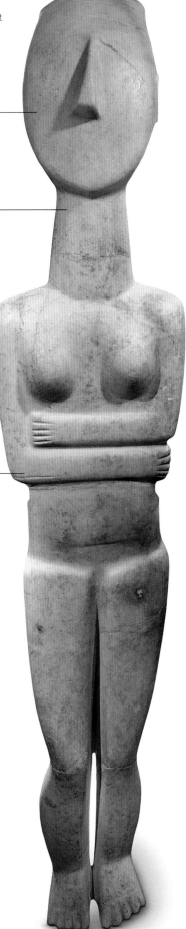

Tell Asmar, Iraq · Scale

Tell Asmar Hoard

A collection of distinctive statues of worshippers with the hallmark large staring eyes of Sumerian temple sculpture

Sumer was one of the first civilizations in the world, emerging in the region known as Mesopotamia, between the Tigris and Euphrates rivers, in what is now Iraq. Sumerian city-states developed a sophisticated culture centred around temples dedicated to their gods, in which art and crafts played a major role.

The excavation of one such temple, in Tell Asmar (ancient Eshnunna), revealed a hoard of twelve small stone statues of different sizes, carved from alabaster in a distinctive style. Apart from one who is kneeling, the ten men and two women are all portrayed in the same static, standing pose, with hands clasped and faces raised to heaven. Although the figures are highly abstracted, their dress and hair exhibit the styles of the time; the men are bare-chested and wearing long skirts, with crimped hair and beards, while the women wear dresses. The most striking feature, however, is the exaggeratedly large eyes, given prominence by an inlay of white shell and black limestone, fixed in place with bitumen. Each figure was believed to embody the essence of a worshipper, and some are inscribed with the name of who they represent. Placed in the shrine, they carried their dedicatee's prayers to the gods.

ALABASTER

As they are both relatively soft and easy to work, the two different types of alabaster, gypsum and calcite, were used for fine indoor sculpture in ancient Mesopotamia and the Middle East. The softer of the two, gypsum alabaster (as used for the votive statue on this page) is generally a translucent white and finely textured, while calcite alabaster (*right*), favoured by the ancient Egyptians, is more durable, and often banded, mottled, or marbled with different colours.

EGYPTIAN CANOPIC JAR, c.664–525 BCE

The **two largest statues** in the hoard may represent the **god Abu** and a **mother goddess** figure

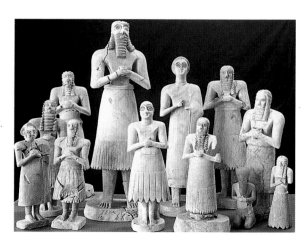

▷ **PRAYERFUL INDIVIDUALS**
The 12 figures of the Tell Asmar hoard are shown here. The varying sizes of the figures, and the type of stone they are made of, reflect the status of the worshipper they represent.

TILTED HEAD
The head is tilted back slightly to look towards heaven.

STARING EYES
The wide-open eyes may represent an attempt to communicate directly with the deity.

BLACK BEARD
The highly stylized beard and hair were originally blackened with bitumen.

CLASPED HANDS
Hands are clasped in a gesture of prayer or supplication.

SKIRT AND BODY
The pleated hem of the skirt forms a solid circular base to the cone-shaped body.

◁ **TELL ASMAR HOARD**
This gypsum alabaster figure was discovered in a temple dedicated to the god Abu in Eshnunna (now Tell Asmar), Iraq, and typifies the sculptural style of the Early Dynastic period of Sumer (c.2900–c.2350 BCE).
Height: 29.5 cm (11½in).
Date: c.2900–2550 BCE.

Great Sphinx of Giza

A colossal, majestic limestone sphinx honouring the pharaoh Khafre, carved from the bedrock beside the pyramid complex at Giza

Giza, Egypt

In ancient Egyptian culture, the sphinx, with the head of a human and the body of a lion, had iconic status as a powerful guardian, and many pharaohs had their likeness carved on the body of a sphinx to guard their tombs. Located next to the second pyramid at Giza, that of Khafre (ruled c.2558–c.2532 BCE), the Great Sphinx is believed to bear the face of Khafre, its likely creator.

This monolithic sculpture on the plateau of Giza is thought to have been carved from a rock formation, the lower body and legs formed by cutting a ditch around it. The head is adorned with a *nemes* (royal headdress); the face, though lacking its nose and ceremonial beard, gazes across the desert with a compelling power. Much mystery surrounds it, but during the New Kingdom (c.1550–c.1077 BCE) it is known to have been revered as the sun god. Wind and sand have eroded much of the detailed carving and worn away large parts of the body, yet despite this, its monumental scale ensures the Sphinx remains a breathtaking spectacle alongside the pyramids at Giza.

THE SPHINX IN OTHER CULTURES

Although usually associated with Egypt, the sphinx also figured in other ancient cultures, notably in the Asian and Greek traditions, whose sphinxes had wings and were often female. In Greek myth, Oedipus famously solved the riddle set by the Sphinx that guarded the city of Thebes, causing her to kill herself.

SPHINX, NAXOS, 570–560 BCE

ERODED BODY
The limestone of the body is softer than that of the head, and has suffered more erosion.

◁ **SIDE VIEW**
It is estimated that it took 100 workers three years to create the Sphinx, one of the largest sculptures in the world.

MISSING NOSE
The missing nose would have been about 1m (3ft 3in) wide.

▽ **GREAT SPHINX OF GIZA**
The Great Sphinx is by far the largest and most magnificent of all the Egyptian sphinxes, and has become a symbol of both ancient and modern Egypt. **Height:** 20m (66ft). **Date:** c.2550 BCE.

Scale

PRIMARY COLOURS
Traces of pigment on the face and body suggest it may originally have been painted in bold colours.

MISSING BEARD
It is likely that a ceremonial pharaonic beard was added to the monument at a later date, but this too is now missing.

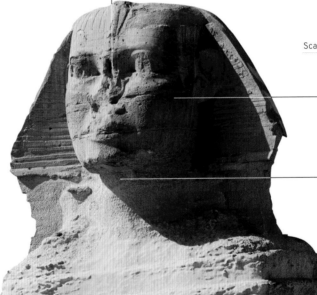

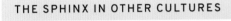

▽ **STANDARD OF UR**
The two long sides of the Standard have been dubbed "Peace" (see *below*) and "War" (see *opposite*). The end panels are also arranged in three bands; most bear images of animals, mainly goats. **Height** 21.6cm (8½in). **Date:** c.2600–2500 BCE.

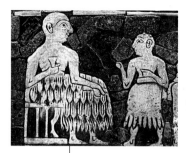

◁ **SOVEREIGN HOST**
Ur's ruler presides in state at a banquet. The Sumerian word for sovereign was *lugal*, literally "big man".

▷ **MUSICAL ACCOMPANIMENT**
A musician holds a lyre in one of the earliest representations of a stringed instrument.

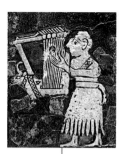

FRUITS OF THE LAND
Farm labourers line up, some with goats and asses, to pay a tax of food to the ruler.

Standard of Ur

A glorious mosaic box commemorating victory in war that is a symbol of one of the world's earliest centres of civilization

Southern Iraq

The Standard of Ur is a startling reminder of the great sophistication of the first urban civilizations. Its very existence in its current form is almost as extraordinary. The work consists of inlaid mosaic scenes made from shell, limestone, and lapis lazuli attached to a wooden frame with bitumen glue. When it was discovered in 1927 in a royal tomb at Ur (now in southern Iraq) during an archaeological excavation, the bitumen had decayed and the wood disintegrated. By registering the location of each piece taken from the soil and using plaster or wax to record the shapes of missing objects, the team was able to reconstruct it in its present form.

The Standard owes its present title to the Sumerian city-state where it was found. It lay beside the skeleton of a man who had gone to the grave with his ruler.

Leonard Woolley (*see p.22*), leading the excavation, identified this figure as a standard-bearer, and conjectured that in life he had carried the striking decorated box on a pole to advertise his master's achievements. His suggestion is a guess, but no more convincing alternative has yet been accepted.

What is certain is that the box's four panels illustrate one of the world's earliest city-states in peace and war. One side commemorates a military victory, the other a celebration banquet. On each, the city's ruler rises in the uppermost tier head-and-shoulders above those around him. The tomb was that of a king provisionally identified as Ur-Pabilsag (died c.2550 BCE). Otherwise nothing is known of him, but in the Standard he is enthroned for future ages in regal splendour.

▽ **REVERSE VIEW**
The War panel is an exercise in triumphalism, showing Ur's ruler (top centre) surveying naked, bound, and bleeding prisoners. Soldiers and war-chariots line up in the lower registers.

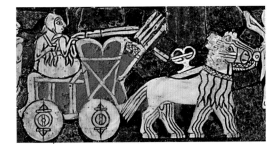

◁ **WHEELED WARFARE**
Wheeled vehicles were a Sumerian invention, and these war chariots are among the very first depictions of them.

Scale

PRISONERS OF WAR
Captured enemy soldiers are led naked before the ruler to await death or a life of servitude.

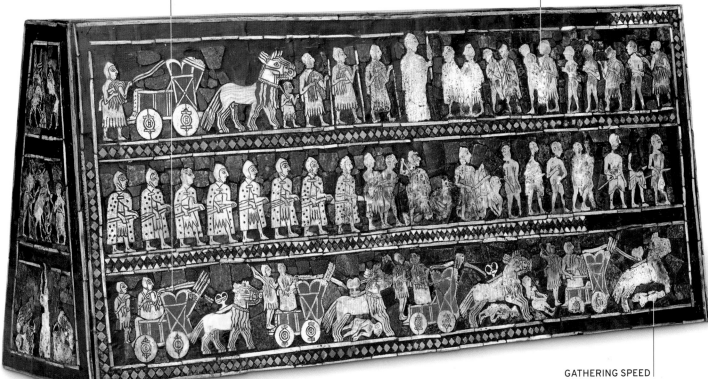

GATHERING SPEED
The four asses drawing the chariots gather speed as the strip progresses, from a sedate walk (*far left*) to a gallop.

The **lapis lazuli** in the Standard came from **Afghanistan**, indicating the vast extent of the **Sumerians'** trade links

◁ **END PANEL**
The enigmatic images on this end panel feature scenes of people and animals; the image in the top register closely resembles the statuette known as "Ram in the Thicket", which was also found at Ur (*see p.22*).

THE ROYAL CEMETERY AT UR

The magnificent Standard was one of many finds made in the cemetery at Ur excavated by Woolley's team from 1926 onwards (*see also p.22*). Among the 2,000 or more graves unearthed there, Woolley identified 16 as royal burials because of the richness of the goods found within them.

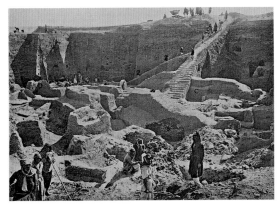

EXCAVATIONS AT THE CEMETERY

▷ **HEAD OF AN AKKADIAN KING**
Often referred to as the Head of Sargon, despite being officially unidentified, this life-size bronze portrait head of an Akkadian ruler remains remarkably evocative, even after being vandalized. **Height:** 31cm (12in). **Date:** c.2300 BCE.

EXPRESSIVE BROWS
The stylized eyebrows give the face an expression of benevolence and humanity.

EMPTY SOCKETS
The eyes may originally have been inset with an inlay of precious stone.

OVERSIZED NOSE
The size of the nose is exaggerated to emphasize Sargon's grandeur, but was flattened by whoever defaced the statue.

GEOMETRIC BEARD
While the face is portrayed with some naturalism, the beard and hair are more geometrically stylized.

DAMAGED EARS
Little remains of the ears, which were crudely torn off.

BROKEN BEARD
The beard, emblem of wisdom and maturity, was shortened by the vandals deliberately to humiliate the memory of the king.

△ **SIDE VIEW**
The braided hair and knotted bun were the typical hairstyle of Akkadian rulers.

Scale

Head of an Akkadian King

A striking bronze representation of an Akkadian ruler, possibly Sargon the Great, created in Mesopotamia around 2300 BCE

Nineveh, Iraq

In the early 24th century BCE, Mesopotamia (the region between the Tigris and Euphrates rivers in modern-day Iraq) consisted of a collection of small city-states. In one of these, Akkad, a ruler came to power who went on to conquer neighbouring states and establish the Akkadian Empire.

Damaged magnificence

This emperor, known as Sargon the Great, wielded unprecedented power and commanded godlike reverence, inspiring numerous images and inscriptions testifying to his achievements. This bronze head is believed to be a representation of Sargon, or possibly one of his successors, and may be all that remains of a full-body statue of the ruler.

The head, expertly cast in bronze, is portrayed with great artistic skill, as befits such a powerful emperor, with the features slightly idealized for emphasis. Its naturalistic style was new to Akkadian art, at a time when depictions of local gods, considered kings of specific regions, were giving way to portraits of exalted earthly rulers – of whom Sargon was the first.

What is immediately apparent is that the head has been mutilated: the eyes are crudely gouged out, the ears torn off, the nose flattened, and the beard broken. These are the very features that distinguished him as a strong and revered leader, so this literal defacing and beheading was likely deliberate – a symbolic gesture by a later conqueror to indicate that Sargon was not immortal, and the empire he had created had been brought to an end.

The **sculpture's beauty** signalled the king's **inner beauty** or **goodness**

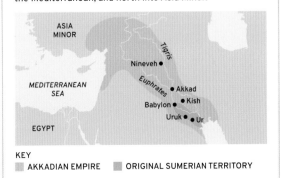

△ **SARGON'S VICTORY STELE, C.2300 BCE**
This fragment of a victory stele, or commemorative column, shows Sargon leading a triumphal procession. His hair is in a royal bun and he is shaded with a parasol by an attendant.

SARGON OF AKKAD

According to tradition, Sargon (ruled c.2334–2279 BCE) rose from humble origins to become cupbearer to the king of Kish. He went on to found the city of Akkad, proclaiming himself king. During his reign, he conquered all the city–states of Sumer (the southern region of Mesopotamia), establishing the Akkadian Empire – notable as the first empire in recorded history – which stretched as far as the Mediterranean, and north into Asia Minor.

ASIA MINOR

Tigris

Nineveh

MEDITERRANEAN SEA

Euphrates

Akkad
Kish
Babylon
Uruk
Ur

EGYPT

KEY
▪ AKKADIAN EMPIRE ▪ ORIGINAL SUMERIAN TERRITORY

△ **GODDESS INANNA**
Sargon claimed to derive his authority from the powerful goddess Inanna (or Ishtar), the queen of Heaven, whose cult became one of the most widespread in Sumer. She is seen here in a terracotta relief from Tell Asmar, Iraq, early 2nd millennium BCE.

Mohenjo-daro,
Pakistan

Scale

Mohenjo-daro Dancing Girl

Small enough to fit in the palm of a hand, a vivacious figurine that testifies to a civilization that flourished 4,500 years ago

This small, characterful statue of a slim young woman was discovered in 1926 at the archaeological site of Mohenjo-daro, in present-day Pakistan. Constructed around 2500 BCE, Mohenjo-daro was a major centre of the great Indus Valley Civilization, first excavated in the early 1920s. Made using the lost-wax method of bronze casting (*see p.164*), the statuette opened people's eyes to the technical achievements of one of the world's earliest urban civilizations. The use of metal was unusual, as most of the many figurines from Indus Valley sites were made of fired clay.

Naked apart from a stack of bangles on the left arm and four on the right, the girl is standing with her head slightly bent back, knees flexed, and one arm on a hip, a pose that has led to her being identified as "dancing". In fact, it is not known if the figure is dancing – it has been suggested it may depict a warrior, a labourer (the unencumbered right arm free for work), or even a goddess – but it has become established as the Dancing Girl. The arms and legs are disproportionately long, but the figure's natural look and the insouciant self-confidence of its pose have won it wide renown.

It has been **suggested** that the **Dancing Girl** may be a **portrait** of a **real woman**

FACIAL FEATURES
Some commentators see the facial features as African, although the hairstyle and body decorations are distinctively Indian.

BRAIDED BUN
The girl's long hair is braided into a bun that rests on her right shoulder.

NECKLACE
The torso is naked but for a necklace with three large pendants.

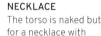

BANGLES
The girl has 25 bangles decorating her left arm, and only four on her right.

LOST ACCESSORY
In its left hand the figure apparently held an object, now lost.

▷ **MOHENJO-DARO DANCING GIRL**
The small figure's feisty vitality gives a human aspect to a civilization otherwise known at the time of its discovery mainly for its fired-brick ruins. **Height:** 10.8cm (4¹⁄₄in). **Date:** c.2500 BCE.

MISSING FEET
The figure was probably cast with feet, which have broken off.

Babylonian Jewellery

Gold ornaments dating back to the early days of Babylonian grandeur and still retaining their original glittering lustre

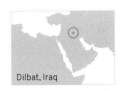

Dilbat, Iraq

Gold was treasured from the beginnings of history for its malleability and resistance to corrosion, as well as its beauty. In Mesopotamia (the fertile region between the Euphrates and Tigris rivers, home to successive ancient cultures, including the Babylonians) gold artefacts were being produced by early in the 4th millennium BCE. Thought to have been made in the 18th or 17th century BCE, the pendants and beads shown here demonstrate in exquisite detail the degree of sophistication the goldsmith's art had by then attained. Several employ the technique of granulation, originating with the Sumerians around 2500 BCE (*see box*).

The jewellery is thought to have come from Dilbat, a hill town in the Euphrates valley of what is now Iraq, which was conquered by Sumu-Abum, first king of Babylon's First Dynasty, shortly before the pieces were made. Besides their beauty, the pendants had a talismanic significance, with each depicting or symbolizing one of the many deities in the Babylonian pantheon.

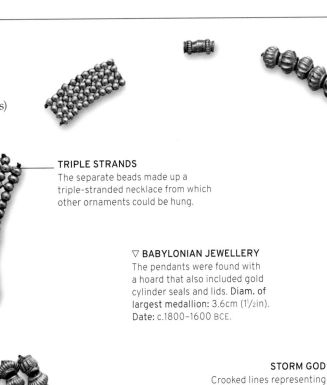

Scale

TRIPLE STRANDS
The separate beads made up a triple-stranded necklace from which other ornaments could be hung.

▽ **BABYLONIAN JEWELLERY**
The pendants were found with a hoard that also included gold cylinder seals and lids. **Diam. of largest medallion: 3.6cm (1½in). Date: c.1800–1600 BCE.**

STORM GOD
Crooked lines representing forked lightning symbolized Adad, god of storms and rain.

GODDESS LAMA
The two female figures wearing headdresses and long flounced robes are thought to represent the goddess Lama, a protective deity.

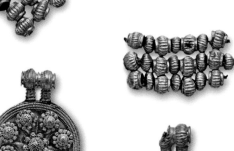

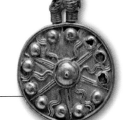

MOON GOD
The crescent shape was emblematic of the moon god, Sin.

GRANULATED JEWELLERY

The oldest known jewellery made using the decorative technique of granulation, in which tiny spheres of gold are fused to a surface in a pattern, date from the city-state of Ur around 4,500 years ago. By the 8th century BCE the method had reached Etruria in present-day Italy. Etruscan goldsmiths excelled in the technique, creating exquisite and intricate works (*see pp.54–5*).

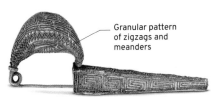

Granular pattern of zigzags and meanders

ETRUSCAN GOLD FIBULA, 700–600 BCE

SUN GOD
The solar image of rays emanating from a central circle was the symbol of Shamash, the sun god.

GODDESS ISHTAR
The eight rosettes on two pendants suggest they were sacred to Ishtar, goddess of love and war, whose symbol was an eight-pointed star.

The **pendants and beads** formed part of a **hoard** that may have been held by a **jeweller** for **raw materials**

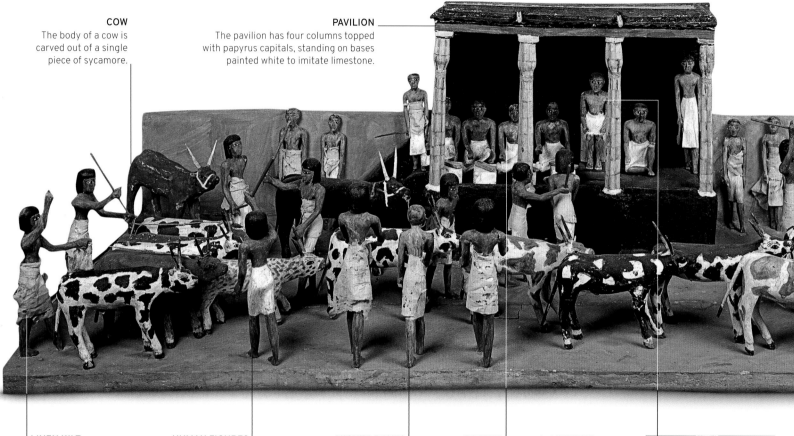

COW
The body of a cow is carved out of a single piece of sycamore.

PAVILION
The pavilion has four columns topped with papyrus capitals, standing on bases painted white to imitate limestone.

LINEN KILT
Fragments of linen are attached above a white-painted kilt.

HUMAN FIGURES
The people are made of conifer wood, with arms and legs slotted in separately.

HIGHER RANKS
A shaved head denotes higher-ranked estate workers.

SCRIBES
Four scribes take notes on papyrus scrolls and wooden writing boards.

▷ **MEKETRE**
Meketre is depicted seated on a throne, with his son Inyotef sitting to his left.

△ **MEKETRE TOMB FIGURES**
This model is the largest found in the tomb, and shows Meketre and Inyotef inspecting a parade of cattle, probably as part of an annual tax assessment. **Width:** 175cm (69in). **Date:** c.1981–1975 BCE.

Scale

Meketre Tomb Figures

Scores of beautifully carved and painted figurines concealed in the tomb of an Egyptian high official to serve him in the afterlife

Thebes, Egypt

Arrayed in scenes that mimic the life of a prosperous estate, these silent wooden figures comprise one of the most engaging testaments of ancient Egyptian life. They come from the rock-cut tomb of Meketre, chief steward to the 11th Dynasty pharaoh Mentuhotep II and his successors.

Servants in the afterlife
In his tomb were laid dozens of shabtis, or funerary figurines, depicting workers and servants to provide for Meketre in the next life. Mainly relating to food production, the remarkably well-preserved models

include a granary, a bakery, a brewery, a stable, a slaughterhouse, cattle, and even a garden. Made at a time during the Middle Kingdom when non-royal officials were gaining power and wealth, the figures were produced in carpentry workshops using adzes and bow-drills, then hand-carved to differentiate men, women, officials, and occupations. The figures of Meketre and his son are finer, probably made by a master-craftsman. Concealed in a bricked-up area near Meketre's burial chamber, the models were missed by looters, who left behind them some of the most vivid and haunting pieces of ancient Egyptian art.

SCALE
The human figures are at roughly one-seventh to one-eighth scale.

BREAD AND BEER
Conical loaves of bread and bottles of beer are carried in a basket.

LIBATIONS
This man bears a vessel for libations (drink offered to the gods) and an incense burner.

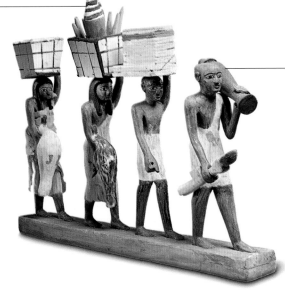

WOODEN BASE
The base and backboard are made of rough sycamore wood 2–3cm (¾–1¼in) thick.

◁ **PROCESSION OF OFFERING-BEARERS**
The two men and two women may be Meketre's children, and are shown carrying offerings for his burial ritual, including bread, beer, geese, and folded linen sheets. The yellow wood represents the desert floor on the way to the tomb.

◁ **CATTLE STABLE**
Oxen are being fattened for slaughter in this model stall, with the four on the right feeding from a manger.

HAND FED
The two oxen in the left-hand stall are being hand-fed with grain by two stablemen.

TOMB BOATS

For ancient Egyptians, models of boats interred in tombs were intended to help the soul navigate its way to the afterlife. In Meketre's case, they would also have represented the official inspection tours and leisure cruises he undertook along the Nile during his life. His tomb contained 13 boats (four travelling boats, two kitchen boats, four yachts, two canoes, and this hunting or sporting boat), all provided with models of the crew, including cooks, sailors, fishermen, and Meketre and his son.

Fishermen with harpoon

Fisherman carrying red *Mormyrus* fish

Helmsman controlling rudder

Shelter of woven reeds and decorative shields

Meketre, seated

Girl offering Meketre a mallard

HUNTING OR SPORTING BOAT

When the **archaeologists** cleaned the **tomb figures**, they found the **fingerprints** of those who had made them or placed them in **the tomb**

Knossos,
Crete

Minoan Snake Goddess

A figurine regarded as an icon of Minoan art, but whose cultural and religious significance remains a mystery

Little is known of the religion of the Minoan civilization, which flourished in Crete between about 2000 and 1100 BCE. So when two female figurines made of Egyptian faience (*see box*), with bare breasts and clutching what appeared to be writhing snakes, were discovered under the Royal Palace at Knossos, they were assumed to represent goddesses, or, at the least, priestesses. However, there is little other evidence of the existence of such a goddess in the Minoan pantheon. Whether or not it is accurate, the name "snake goddess" has persisted, and the smaller of the two statuettes in particular, shown here, has become a popular symbol of Minoan culture.

The statue's formal pose suggests some form of ritual: the arms are outstretched and the snakes held high. The very deliberately exposed breasts give the impression that she is a maternal goddess, or perhaps a priestess presiding over a fertility rite. Her colourful formal dress and ceremonial apron also point to the figurine's having some religious or ritual significance.

The **figure** may have been a **goddess of the household**, or a "**snake-wrangling**" priestess

EGYPTIAN FAIENCE

Known as Egyptian faience to distinguish it from true faience, the technique of moulding figures in a crushed quartz paste and then firing was developed in Mesopotamia and perfected by the ancient Egyptians, who passed the skill on to trading partners such as the Minoans. The fine, brightly coloured glaze was particularly suitable for items of jewellery and small figurines.

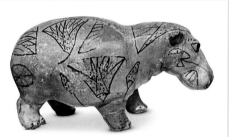

ANCIENT EGYPTIAN FAIENCE FIGURINE OF A HIPPOPOTAMUS, 2000–1900 BCE

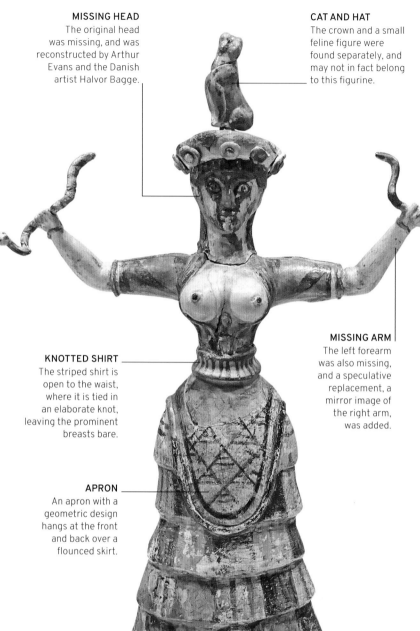

MISSING HEAD
The original head was missing, and was reconstructed by Arthur Evans and the Danish artist Halvor Bagge.

CAT AND HAT
The crown and a small feline figure were found separately, and may not in fact belong to this figurine.

KNOTTED SHIRT
The striped shirt is open to the waist, where it is tied in an elaborate knot, leaving the prominent breasts bare.

MISSING ARM
The left forearm was also missing, and a speculative replacement, a mirror image of the right arm, was added.

APRON
An apron with a geometric design hangs at the front and back over a flounced skirt.

△ **MINOAN SNAKE GODDESS**
The faience "snake goddess" was discovered among a collection of broken and discarded items in an underground chamber beneath the Royal Palace by the British archaeologist Arthur Evans, who controversially reconstructed the missing parts. **Height** 29.5cm (11½in). **Date:** c.1600 BCE.

Scale

Nebra Sky Disc

One of the most exciting archaeological discoveries of the 20th century, a Bronze Age depiction of the heavens that is the earliest known astronomical chart

Nebra, Germany

Believed to date from about 1600 BCE, the Nebra sky disc is a unique Bronze Age artefact, depicting astronomical features of particular importance to its creators. The bronze base has a striking blue-green patina to represent the sky, with heavenly bodies – sun, moon, and stars – picked out in gold leaf. It is not known whether the disc's function was as a practical astronomical instrument, or whether it had some religious significance, but either way it gives a unique insight into early humans' observations of the sky.

Analysis of the materials has shown that the disc as it was discovered is the result of several stages of development, with additions of astronomical detail at different times. The original design consisted of simply a gold disc and a crescent (most likely representing the sun and the moon), amid 32 small gold circles (representing the stars); the arcs on either edge, and at the bottom, and the punched indentations around the rim, were all added at later times.

The sky disc was uncovered in 1999 by looters, who sold it

BRONZE AGE ASTRONOMY

Bronze Age communities were primarily agricultural, and used astronomical phenomena to mark the passage of time, the changing of the seasons, and the best times for planting and harvesting their crops. The two solstices in summer and winter were one indicator, monitored by using astronomically aligned instruments. Another was the annual disappearance and reappearance of the Pleiades constellation.

THE PLEIADES

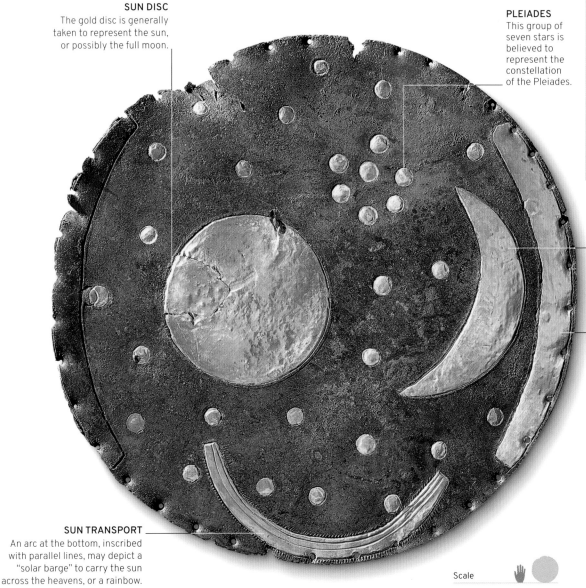

SUN DISC
The gold disc is generally taken to represent the sun, or possibly the full moon.

PLEIADES
This group of seven stars is believed to represent the constellation of the Pleiades.

CRESCENT
The crescent represents the crescent moon (or possibly the sun or moon in eclipse).

SOLSTICE MARKERS
Golden arcs on opposite edges show the angle between the positions of sunset at the summer and winter solstices (the gilding of the left-hand arc is missing).

SUN TRANSPORT
An arc at the bottom, inscribed with parallel lines, may depict a "solar barge" to carry the sun across the heavens, or a rainbow.

Scale

◁ **NEBRA SKY DISC**
The sky disc is a thick, solid-bronze plate, which has (probably deliberately) been allowed to develop a deep blue–green patina, with the design inscribed upon it and then gilded. **Diam.:** approx. 30cm (11¾in). **Date:** c.1600 BCE.

Erlitou, China

Scale

Erlitou Plaque

Dating far back into Chinese prehistory, a stunning bronze and turquoise plaque with a zoomorphic design

Bronze casting was known in China from around 3000 BCE, probably evolving as a byproduct of the use of high-temperature kilns for ceramic production. The earliest bronzes were utilitarian items, such as knives, but by around 2000 BCE objects with the grace and beauty of this small, turquoise-studded plaque were featuring as funerary goods in the graves of the elite.

The plaque is from the Erlitou culture, an important early Bronze Age urban society in China's Yellow River valley that existed from around 1900 to 1500 BCE. The remains of a bronze foundry and turquoise workshops have been found at the site, as well as other decorated objects including bells, cauldrons, and ritual vessels. The plaque shown here is inlaid with neatly trimmed turquoise tesserae forming a stylized animal mask. Its exact purpose is not known, but the fact that bronze bells were found buried with similar plaques suggests it was for ceremonial use by a figure such as a shaman. The loopholes at the corners together with its slightly curved shape indicate that it might have have been tied around a shaman's arm (or perhaps to his chest) during ritual offerings, accompanied by the sound of the bell.

THE *TAOTIE*

The stylized animal head on the Erlitou plaque represents an early form of the *taotie*, a mythical creature that was a staple of ancient Chinese art. Described in classical sources as "one of the four evil creatures of the world", it was viewed as a savage beast whose image could be used to scare away potential enemies.

Almond-shaped eye

C-shaped horn or eyebrow

Possibly a claw or fang

▷ TURQUOISE INLAYS
Rectangular pieces of turquoise were inlaid into the bronze.

▽ ERLITOU PLAQUE
The plaque's stylized animal-mask design may have been intended to ward off evil spirits, possibly as part of a shaman's paraphernalia. **Height:** 17cm (6in) long. **Date:** c.1900–1500 BCE.

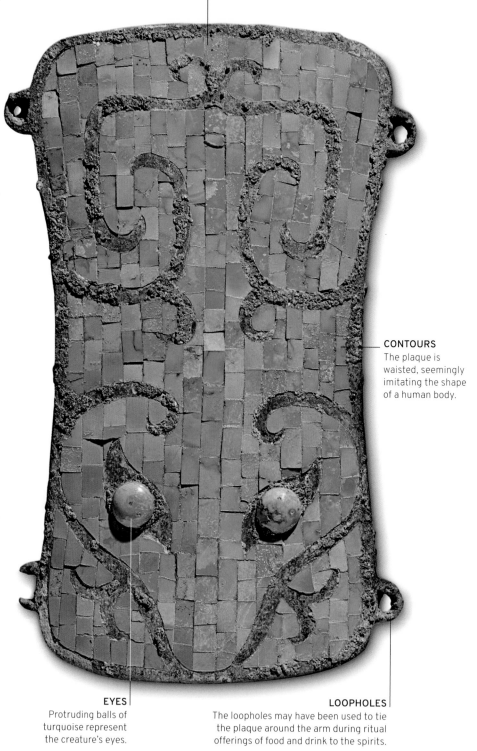

CONTOURS
The plaque is waisted, seemingly imitating the shape of a human body.

EYES
Protruding balls of turquoise represent the creature's eyes.

LOOPHOLES
The loopholes may have been used to tie the plaque around the arm during ritual offerings of food and drink to the spirits.

Three such **plaques** were found in **graves** at Erlitou, two of them placed on the **chest** of the **deceased**

Crete, Greece

Scale

Minoan Octopus Vase

A huge-eyed octopus spreading its tentacles in all directions, capturing the appeal and immediacy of mid-Bronze Age Minoan art

The art of few, if any, early cultures matches the freshness and vividness of that of Minoan Crete, which flourished in the 2nd millennium BCE, more than a thousand years before the classical Greek city-states rose to prominence. Excavations on the island have revealed wall paintings of stunning originality, as well as pottery of extraordinary charm and vitality.

Dating from around 1500 BCE, this vase represents the pinnacle of the Minoan potter's art. By the time it was made, vessels were fired at a higher temperature than in the early Bronze Age, producing ware of finer quality. The vase, designed to hold a liquid such as oil or wine, was wheel-made from two separate halves joined together, with the handles and base applied later. The design was painted on by hand, employing a dark slip (liquefied clay) made from shale. The curvilinear shape of the octopus and its writhing tentacles extend across the surface and echo the round-bellied form of the pot, generating a sense of liveliness and movement. Although there is little attempt at realism, the artist's attention to detail is seen in, for example, the rendering of the suckers.

The octopuses depicted on this and other similar vases typify the Marine Style of the 15th century BCE, when Minoan civilization was at its height. As a Mediterranean seafaring culture, the Minoans valued the sea and were inspired by its creatures.

MARINE LIFE
Sea-themed decorative images scattered among the tentacles include sea urchins, shells, corals, and seaweed.

The **pot** may be the work of an **artist dubbed** the **Marine Style Master**

LIGHT-ON-DARK AND DARK-ON-LIGHT

Minoan potters applied great creativity in their use of coloration as much as form. In the Kamares ware from the Middle Minoan period (c.2100–c.1600 BCE), white and red were used on a dark background to make vivid, dense spiral and geometric patterns. In the later New Palace period (c.1600–1425 BCE), the colour effect was reversed, with darker hues on a light ground exuberantly depicting plants and marine life.

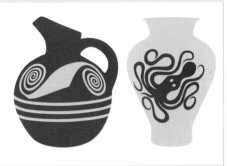

TENTACLE TIP
The coiled tip of the tentacle echoes the shape of the vase's handles above it.

HANDLES AND SPOUT
Along with the vase's base, the stirrup handles and spout were made separately and added later.

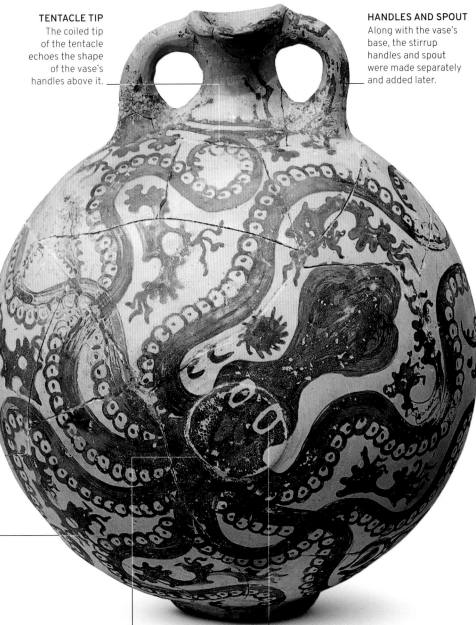

TWO HALVES
Raised discs, which appear on both sides, were the bases of each half of the vase before being joined together while the clay was still wet.

APPEALING EYES
The octopus's wide, almost cartoon-like eyes are a non-naturalistic feature that makes the image highly appealing to the viewer.

△ **MINOAN OCTOPUS VASE**
This round ceramic jar with engaging octopus is typical of the Minoan Marine Style.
Height: 27cm (10½in).
Date: c.1500 BCE.

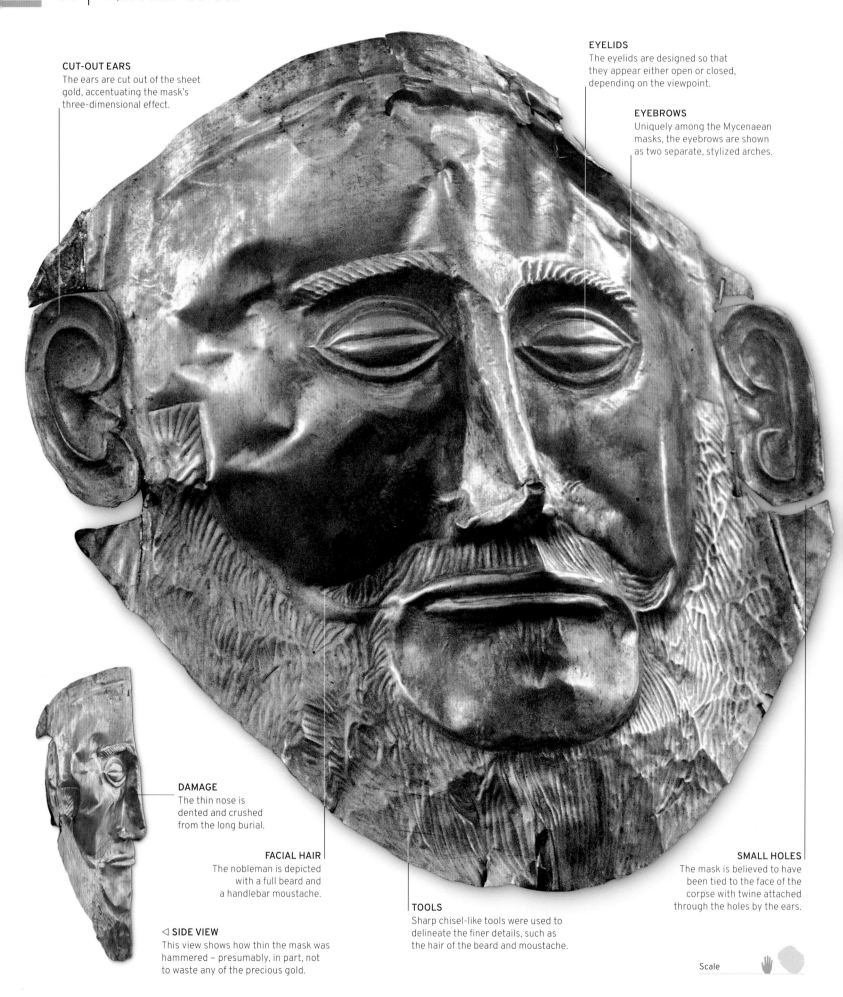

CUT-OUT EARS
The ears are cut out of the sheet gold, accentuating the mask's three-dimensional effect.

EYELIDS
The eyelids are designed so that they appear either open or closed, depending on the viewpoint.

EYEBROWS
Uniquely among the Mycenaean masks, the eyebrows are shown as two separate, stylized arches.

DAMAGE
The thin nose is dented and crushed from the long burial.

FACIAL HAIR
The nobleman is depicted with a full beard and a handlebar moustache.

◁ **SIDE VIEW**
This view shows how thin the mask was hammered – presumably, in part, not to waste any of the precious gold.

TOOLS
Sharp chisel-like tools were used to delineate the finer details, such as the hair of the beard and moustache.

SMALL HOLES
The mask is believed to have been tied to the face of the corpse with twine attached through the holes by the ears.

Scale

◁ **MASK OF AGAMEMNON**
The Mask of Agamemnon was crafted from a sheet of solid gold, skilfully hammered into relief to adorn the buried corpse of a Mycenaean nobleman. **Height:** 25cm (10in).
Date: c.1550–1500 BCE.

Mask of Agamemnon

A 16th-century BCE gold funerary mask thought to be the likeness of a ruler of the ancient Greek city-state of Mycenae

Mycenae, Greece

In 1876, just outside Mycenae, German amateur archaeologist Heinrich Schliemann discovered a necropolis of shaft graves containing the bodies of noble men, women, and children, along with golden funerary objects, including weapons, jewellery, and death masks. One piece in particular stood out as the finest, which Schliemann believed to be a likeness of Agamemnon, leader of the Achaeans in the Trojan War.

Exquisite craftsmanship
In fact, the mask, along with the other finds in the burial site known as Grave Circle A, was shown to date from the 16th century BCE, some 300 to 400 years before the reign of Agamemnon and presumed dates of the Trojan War, in the 12th century BCE. However, the title of Mask of Agamemnon has persisted to this day.

The craftsmanship of this gold mask is exceptional: others from the same vast cache of objects, although opulent, seem crude in comparison. To make the mask, a thin sheet of burnished gold was cut to shape and hammered into relief over a wooden former. Once the basic shape had been formed by the repoussé technique (*see p.81*), the mask was turned over and the features picked out. This was done by chasing the details into the face using chisel-like tools to make indentations and grooves, and a finer cutting of the outline. The life-sized mask had been intended for a powerful person of high standing to wear on his journey to the next world, accompanied by a rich array of funerary goods. The mask's striking features are what have earned this spectacular object pride of place among the other treasures found at Mycenae.

The mask's **striking features** have led to its description as **the *Mona Lisa* of prehistory**

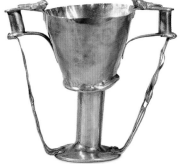

△ **NESTOR'S CUP**
Among the cache of treasures found by Schliemann at Mycenae was a gold goblet said to belong to the mythical hero Nestor. Two birds are perched at the top of its handles.

▷ **GRAVE CIRCLE A, MYCENAE**
The prehistoric city of Mycenae in the Peloponnese is one of Greece's most important archaeological sites. Agamemnon's funerary mask was unearthed in Grave Circle A (shown here in the centre of the picture) at the ancient site, along with other spectacular objects.

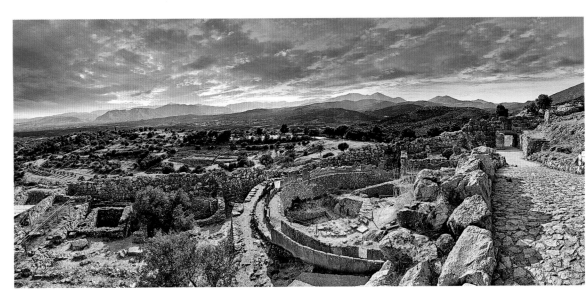

The **sun chariot** has become a **national symbol** of Denmark, appearing on its **1,000-krone banknote**

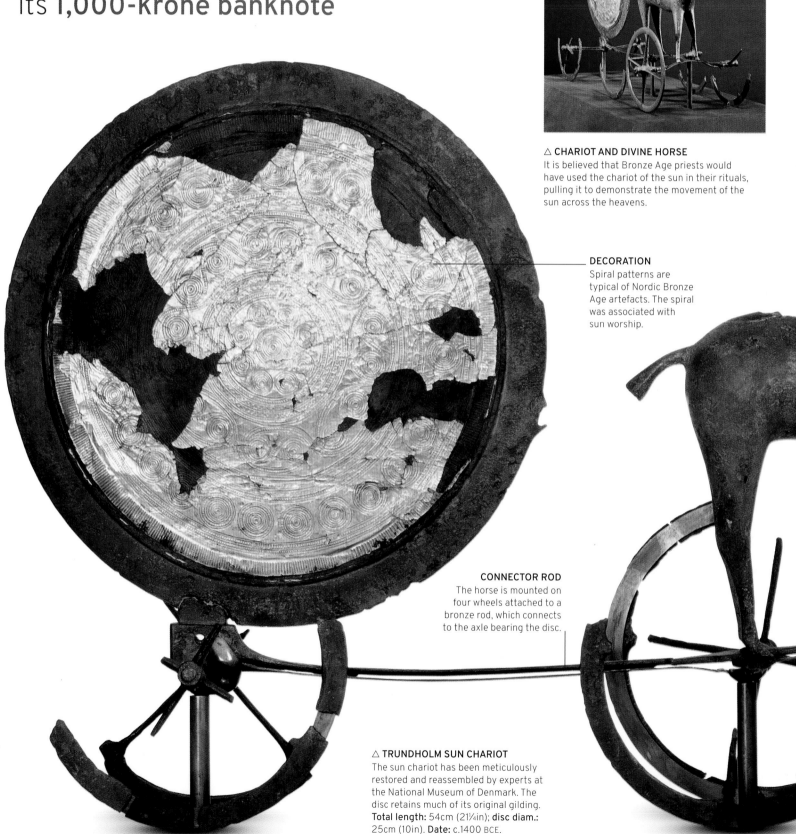

△ CHARIOT AND DIVINE HORSE
It is believed that Bronze Age priests would have used the chariot of the sun in their rituals, pulling it to demonstrate the movement of the sun across the heavens.

DECORATION
Spiral patterns are typical of Nordic Bronze Age artefacts. The spiral was associated with sun worship.

CONNECTOR ROD
The horse is mounted on four wheels attached to a bronze rod, which connects to the axle bearing the disc.

△ TRUNDHOLM SUN CHARIOT
The sun chariot has been meticulously restored and reassembled by experts at the National Museum of Denmark. The disc retains much of its original gilding.
Total length: 54cm (21¼in); **disc diam.:** 25cm (10in). **Date:** c.1400 BCE.

Scale

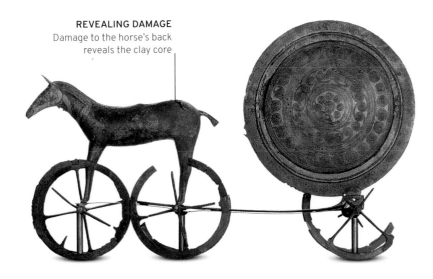

REVEALING DAMAGE
Damage to the horse's back reveals the clay core

◁ **LEFT SIDE**
No traces of gilding are found on the left side of the disc, corresponding to its correlation with the night sky.

CARVED DETAILS
Detailed features on the horse's head and neck were carved into wax before casting.

Odsherred, Denmark

Trundholm Sun Chariot

A unique representation of the sun chariot of Nordic mythology, dating from the Bronze Age

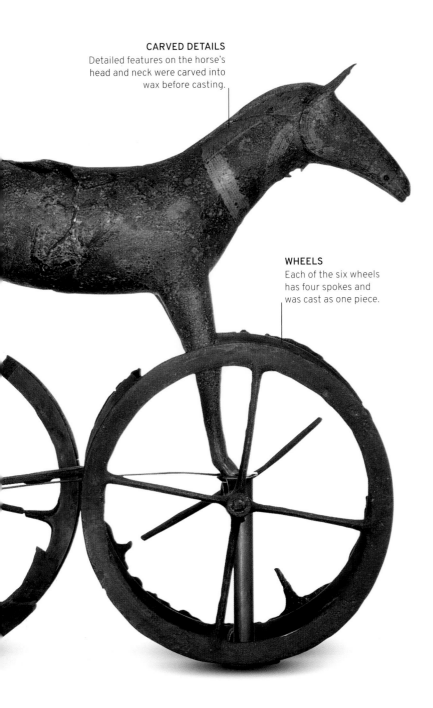

WHEELS
Each of the six wheels has four spokes and was cast as one piece.

In 1902, a farmer ploughing on Trundholm moor in Zealand, Denmark, unearthed what he thought was a metal toy. After cleaning it, he realized that the horse and carriage might be of historical interest. The National Museum of Denmark established its significance as an example of Nordic Bronze Age culture. Ninety-six years later, archaeologists found a further 21 parts of the chariot (mainly fragments of the wheel rings, axles, and spokes) in the same spot, making the model almost complete.

The horse-drawn chariot is cast in bronze, and dates from about 1400 BCE, near the beginning of the Nordic Bronze Age. Before the find, it had been thought that the use of horses as draught animals began in the area much later, at the end of the Bronze Age.

Pulling light across the sky

The elegantly stylized horse pulling a disc on a two-wheeled chariot is believed to represent an early version of the Nordic myth of the sun chariot. The disc is gilded on one side and ungilded the other, to represent day and night. As the chariot is drawn across the heavens from east to west it presents its bright side, the sun, or day, to the earth, while on its return journey from west to east, the dark side, or the shady underworld of night, is seen.

It is, as yet, the only example of a model of a horse-drawn sun chariot found in Scandinavia, although parts of a similar disc have been found at Jægersborg Hegn, in the same area. Its location in a peat bog and the fact that it was the only object found there suggest the chariot may have been placed in the bog deliberately.

Oracle Bones

Divination materials from the 2nd millennium BCE that give a glimpse into the lives and beliefs of the ancient Chinese

Anyang, China

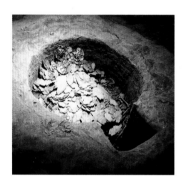

△ **ORACLE BONE PIT**
From 1928 to 1937, some 20,000 oracle bone fragments were discovered in pits in Yinxu, near modern Anyang in Henan province.

Oracle bones were animal bones used in divination rituals in ancient China, a practice that reached its peak in the late Shang dynasty (c.1600 BCE–1046 BCE). Deities and ancestors – who were thought to have divine power – were believed to communicate through the bones, and official diviners sought guidance from them on behalf of society's elite. A wide variety of topics were addressed, including military strategy, crop harvests, the ruling family, childbirth, auspicious timing for an event, and the cause of illness.

Reading the cracks

The plastrons (belly shells) of tortoises and the scapulae (shoulder bones) of cattle were used for the divination ceremony. After stripping the flesh from the shells and bones, the diviner cut them to shape and polished them. They then chiselled hollows or pits into their surface so that they would crack more easily, and washed them in blood to imbue them with spiritual power. When a question was posed, the bones would be heated, often by inserting a hot metal poker into the hollows, causing cracks to form. The diviner interpreted the pattern of fractures to gain an answer.

The divination was carved onto the bones with a knife or, by the time of the Zhou dynasty (1046 BCE–256 BCE), painted on with brush and ink. It usually consisted of a "preface", recording the place, the date, and the name of the diviner, the "charge", or question, the interpretation, and – very rarely – the outcome. The oldest known form of Chinese writing (*see box*), the inscriptions reveal a complex writing system, and offer an important insight into the lives of the Shang elite.

5,000 Shang characters have been **identified, with about 2,000** now **deciphered**

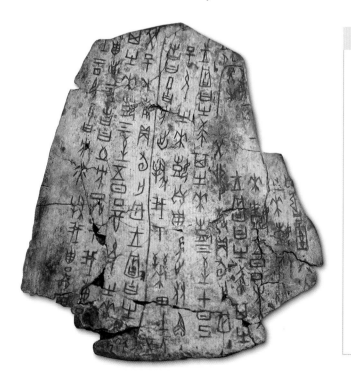

▷ **INSCRIBED OX BONE**
This ox scapula is inscribed with divinations relating to astronomy, hunting, and the threat of invaders from the north.

ORACLE BONE SCRIPT

Oracle bone script is the oldest known Chinese script, perhaps even pre-dating the Shang dynasty (c.1600–1046 BCE). The script shares similarities with the bronzeware scripts of the later Shang and the Zhou (1046–256 BCE) dynasties, which evolved into regular script, developed around 200 CE and still used today.

Heaven, sky	Dog	Troop; [to] journey	Father

■ ORACLE BONE SCRIPT	■ SHANG BRONZEWARE SCRIPT	■ REGULAR SCRIPT

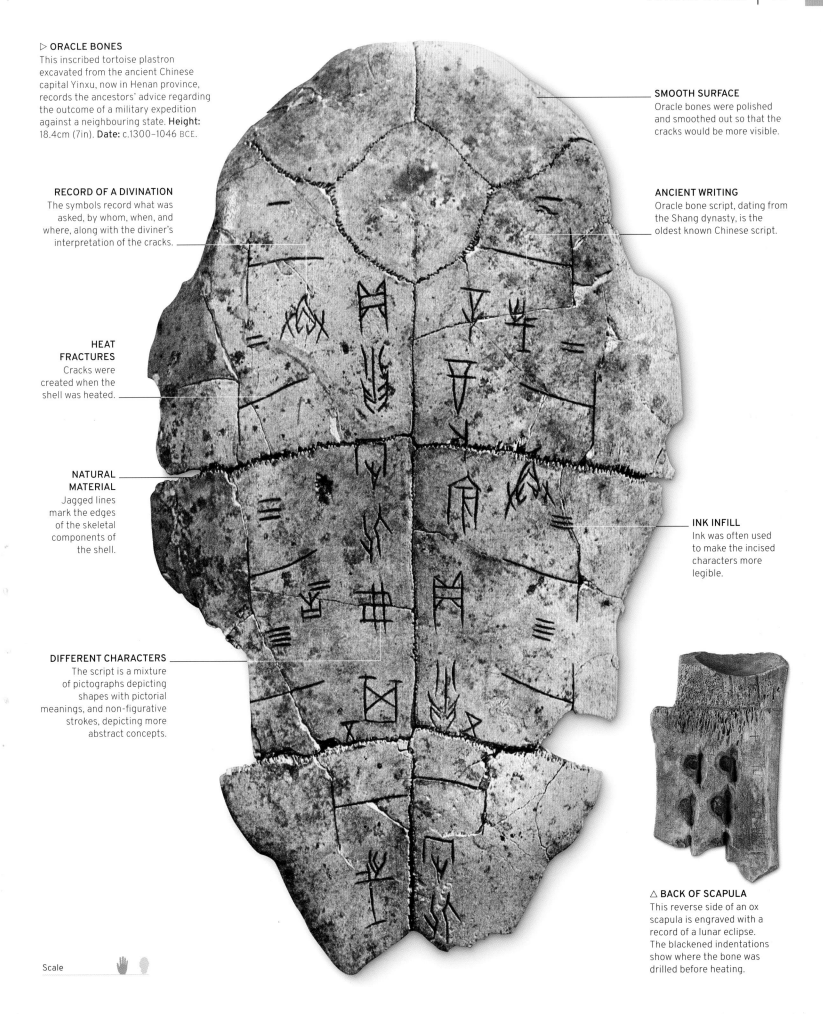

▷ **ORACLE BONES**
This inscribed tortoise plastron excavated from the ancient Chinese capital Yinxu, now in Henan province, records the ancestors' advice regarding the outcome of a military expedition against a neighbouring state. **Height:** 18.4cm (7in). **Date:** c.1300–1046 BCE.

RECORD OF A DIVINATION
The symbols record what was asked, by whom, when, and where, along with the diviner's interpretation of the cracks.

HEAT FRACTURES
Cracks were created when the shell was heated.

NATURAL MATERIAL
Jagged lines mark the edges of the skeletal components of the shell.

DIFFERENT CHARACTERS
The script is a mixture of pictographs depicting shapes with pictorial meanings, and non-figurative strokes, depicting more abstract concepts.

SMOOTH SURFACE
Oracle bones were polished and smoothed out so that the cracks would be more visible.

ANCIENT WRITING
Oracle bone script, dating from the Shang dynasty, is the oldest known Chinese script.

INK INFILL
Ink was often used to make the incised characters more legible.

△ **BACK OF SCAPULA**
This reverse side of an ox scapula is engraved with a record of a lunar eclipse. The blackened indentations show where the bone was drilled before heating.

Scale

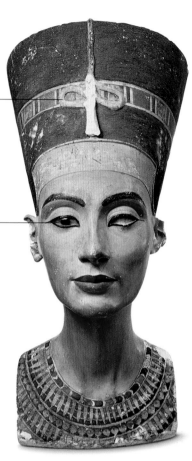

URAEUS
The decoration on the crown is a stylized uraeus or cobra image, a symbolic representation of royalty.

EYE
The remaining eye is inlaid with quartz, attached with black coloured wax.

△ **BUST OF NEFERTITI (ACTUAL)**
The painted bust incorporates layers of red ochre, yellow orpiment (a sulphide of arsenic), and the synthetic pigment known as "Egyptian blue" (made from calcium copper silicate), as well as other traditional pigments.

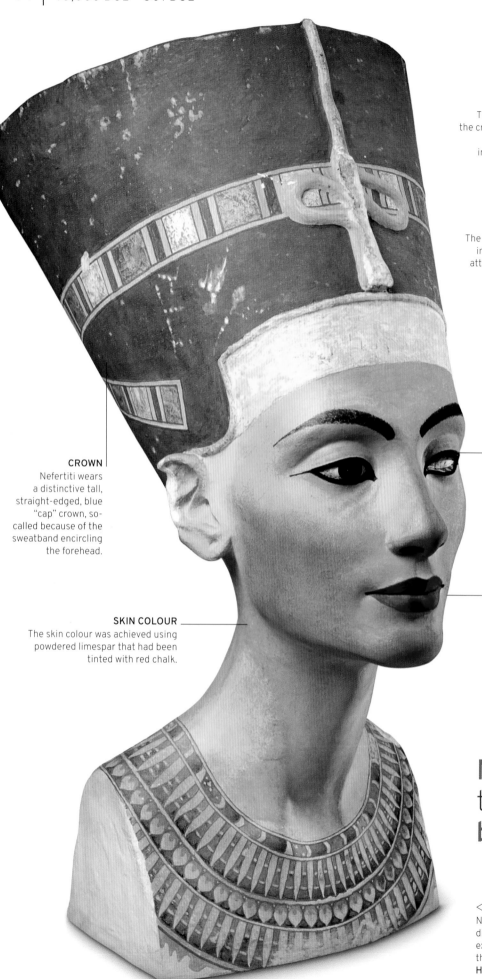

CROWN
Nefertiti wears a distinctive tall, straight-edged, blue "cap" crown, so-called because of the sweatband encircling the forehead.

COSMETICS
Ancient Egyptians of both genders made copious use of cosmetics, such as this eyeliner, made from kohl.

CT SCAN
A scan in 2006 revealed that the original carving had been made in limestone, which was refined in subsequent gypsum-based stucco coatings. For example, creases around the mouth and cheeks in the core layer were smoothed over in the outer, stucco layer.

SKIN COLOUR
The skin colour was achieved using powdered limespar that had been tinted with red chalk.

Nefertiti's name translates as "the beautiful one is come"

◁ **BUST OF NEFERTITI (REPLICA)**
Nefertiti is shown in regal majesty, wearing her distinctive royal headdress. The image is complete, except for one eyeball; the quartz insert representing the left pupil was missing at the time of its discovery. **Height:** 50cm (20in). **Date:** c.1340 BCE.

Bust of Nefertiti

A stunning 14th-century BCE bust of an Egyptian queen that remains a model of sophisticated beauty

el-Amarna, Egypt

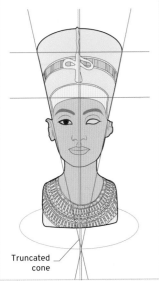

Truncated cone

In December 1912, a German archaeological expedition led by Ludwig Borchardt was investigating the site of the abandoned city of el-Amarna in the desert, 320km (200 miles) north of Thebes, the capital of ancient Egypt. There, they came across the remains of a house belonging to a renowned sculptor named Thutmose. The discovery turned up many fine artefacts, but one in particular stood out: the bust of a woman, evidently a queen. Borchardt noted down details of his finds each night, but in this case words failed him: he wrote, "Description futile: must be seen."

Rejecting tradition

The bust was identified as a portrait of Nefertiti, one of the most significant women in ancient Egyptian history. Wife of Akhenaten (ruled c.1353–36 BCE), she enjoyed greater status and influence than other Egyptian queens and may even have acted as co-ruler. There was much that was unconventional about her time in power, not least the development of a naturalistic style of art that was very much at odds with the stiff formality of earlier pharaonic imagery. For the first time, sculpted images showed the royal family in domestic settings, displaying their undoubted affection for one another. The bust of Nefertiti reflects this new realism, while also creating an image of timeless elegance.

Besides the extraordinary beauty, precision, and symmetry of the face, the work is remarkable for the colour preservation effected by the dry desert environment. The bust's overall appearance seems so modern that some writers have even questioned its authenticity, though this has now been confirmed by chemical analysis and CT scans.

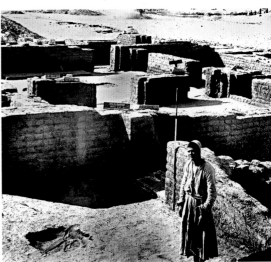

△ THE ARTIST'S QUARTERS, EL-ARMANA
This image, taken during the archaeological dig in 1912, shows the house of the sculptor Thutmose. The bust was found in a corner of his workshop.

◁ REAR VIEW
The painted diadem decorating the back of the blue crown is tied in a stylized representation of a ribbon fastened with a gemstone.

Scale

Scale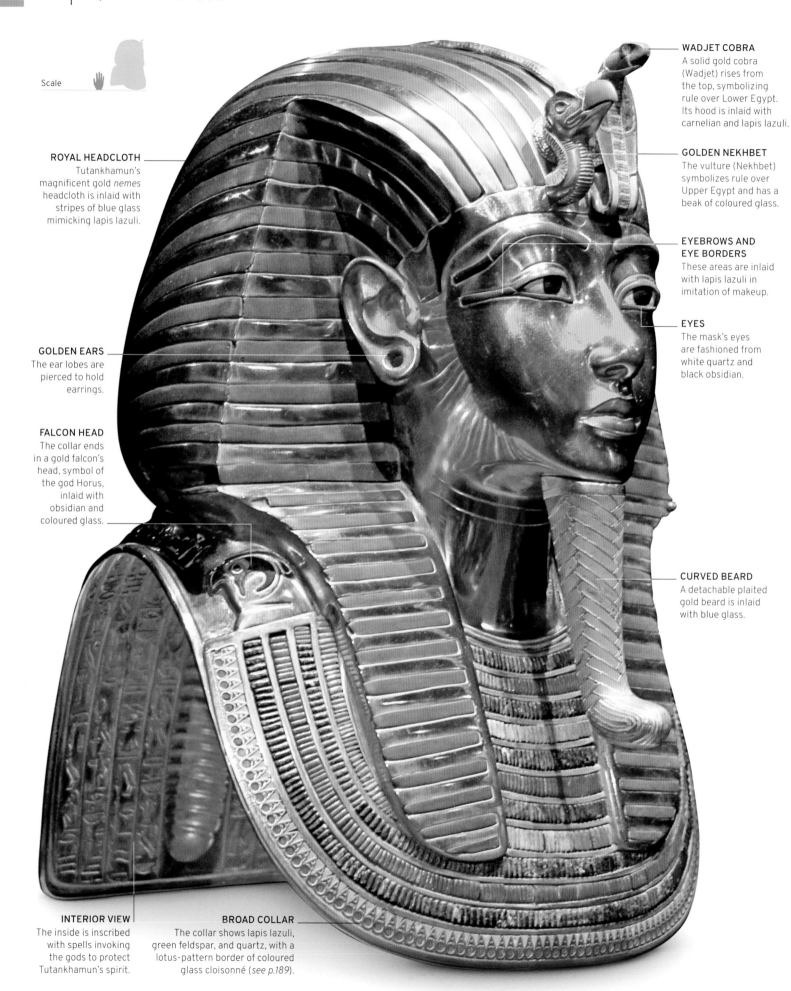

WADJET COBRA
A solid gold cobra (Wadjet) rises from the top, symbolizing rule over Lower Egypt. Its hood is inlaid with carnelian and lapis lazuli.

ROYAL HEADCLOTH
Tutankhamun's magnificent gold *nemes* headcloth is inlaid with stripes of blue glass mimicking lapis lazuli.

GOLDEN NEKHBET
The vulture (Nekhbet) symbolizes rule over Upper Egypt and has a beak of coloured glass.

EYEBROWS AND EYE BORDERS
These areas are inlaid with lapis lazuli in imitation of makeup.

GOLDEN EARS
The ear lobes are pierced to hold earrings.

EYES
The mask's eyes are fashioned from white quartz and black obsidian.

FALCON HEAD
The collar ends in a gold falcon's head, symbol of the god Horus, inlaid with obsidian and coloured glass.

CURVED BEARD
A detachable plaited gold beard is inlaid with blue glass.

INTERIOR VIEW
The inside is inscribed with spells invoking the gods to protect Tutankhamun's spirit.

BROAD COLLAR
The collar shows lapis lazuli, green feldspar, and quartz, with a lotus-pattern border of coloured glass cloisonné (see p.189).

◁ **MASK OF TUTANKHAMUN**
The spectacular death mask
weighs 11kg (24lb) and is largely of
burnished gold, with details in lapis
lazuli, carnelian, and coloured glass.
Height: 54cm (21in). **Date:** c.1323 BCE.

△ **REAR VIEW**
The back of the mask shows the
nemes headcloth gathered in a
braid. The inscriptions either side
of the braid are spells, taken from
the Book of the Dead, to aid the
pharaoh in the afterlife.

▽ **HOWARD CARTER**
British archaeologist Howard
Carter (left) is shown here with a
colleague examining the innermost
gold coffin of Tutankhamun in Egypt
in 1923. The discovery of the tomb
caused a worldwide sensation.

Mask of Tutankhamun

*A solid gold funerary mask that is among the most famous
and breathtaking artefacts to survive from ancient Egypt*

Thebes, Egypt

Tutankhamun (ruled 1333–23 BCE) was just eight or
nine years old when he ascended the Egyptian throne.
He reigned for nine years, dying prematurely, possibly
from a leg fracture. Even so, the young pharaoh's tomb
in the Valley of the Kings, Thebes, was packed with
treasures to accompany him in the afterlife, including
an astonishing solid gold death mask.

Treasures of the boy king

Opened by British archaeologist Howard Carter
in 1923, the tomb contained more than 5,000 items.
The most spectacular find was a series of four nested
shrines, a stone sarcophagus and three anthropoid
(human-shaped) coffins, which held hundreds of
pieces of jewellery, scarabs, and amulets to protect
the king's soul in the afterlife. The coffins, painted
with protective deities and spells, depicted the dead

pharaoh in the guise of Osiris, lord of the underworld,
with a crossed flail and sceptre. In the third, innermost
coffin was the king's mummy and, covering the face,
the lavish funerary mask.

Made from two sheets of burnished gold, the mask
was beaten into shape and inlaid with semiprecious
stones and gems. The face, with its high cheekbones
and full lips, has the features of Tutankhamun, but
the mask emphasizes his role as king: it bears a gold-
and-glass version of the blue-and-gold striped *nemes*
headcloth denoting kingship, and sports the false
beard worn by pharaohs. A collar is decorated with
striped inlays of semiprecious stones, such as feldspar,
and ends in falcon-headed terminals. Everything
about this and the other emblems in the tomb was
designed to protect the pharaoh's passage through
the underworld and ensure his resurrection as a god.

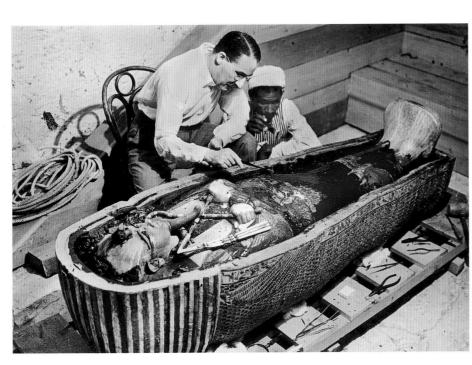

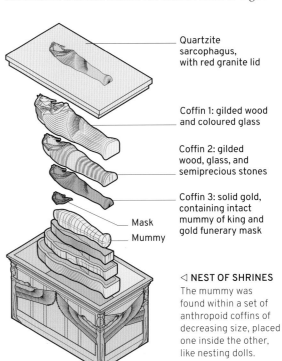

Quartzite
sarcophagus,
with red granite lid

Coffin 1: gilded wood
and coloured glass

Coffin 2: gilded
wood, glass, and
semiprecious stones

Coffin 3: solid gold,
containing intact
mummy of king and
gold funerary mask

Mask

Mummy

◁ **NEST OF SHRINES**
The mummy was
found within a set of
anthropoid coffins of
decreasing size, placed
one inside the other,
like nesting dolls.

Thebes, Egypt

Mummy of Katebet

An intriguing and incredible 3,000-year-old elite woman's mummy from the world of ancient Egypt's death rituals

The mummy of Katebet wears an impressive death mask of cartonnage (linen covered in layers of plaster) covered in pure gold leaf. She is depicted wearing an elaborate wig, a broad collar, earrings, bracelets, and rings, adornments appropriate to a chantress (singer) of the god Amun – a high-ranking female official who participated in public state rituals.

The mummy is made particularly interesting and intriguing by its anomalies. The wooden arms are crossed over the chest in a position reserved for males, and this, together with the length of the coffin, shows that it was originally crafted for a man, possibly her husband, and repurposed for Katebet. The finely wrought cartonnage burial ornaments and the inscription on the coffin were also intended for a man. The presence of the brain – normally removed from a mummy – and large quantities of mud packing suggest that Katebet may have been buried in a hurry.

THE MUMMIFICATION PROCESS

The mummification process took 70 days and involved many stages, performed by priest-embalmers. **1** Internal organs, including the brain but not the heart, were removed. **2** The body was both covered and filled with natron salt for about 40 days to dry it. **3** The salt was washed off and the body padded with linen or sand. **4** The body was wrapped in linen strips, alternating with resin; amulets and prayers were placed in the wrappings. **5** A final linen shroud was secured with linen bands, a mask often placed over the face, and the mummy transferred to a coffin.

1 2 3 4 5

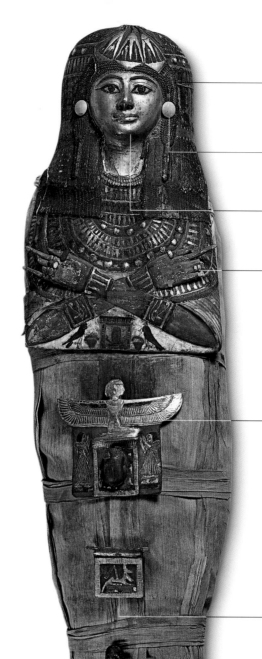

SWITCHED HEADDRESS
The original male headdress was carved out and replaced by a female headdress and painted hair.

EARRINGS
Two stud earrings of white calcite are positioned on the wig.

GOLDEN FACE
The funerary mask is of gilded cartonnage.

RINGS
Real rings are placed on carved wooden fingers.

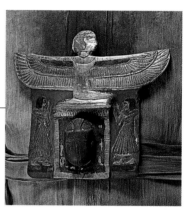

△ **PROTECTIVE FIGURES**
A figure of the sky goddess Nut and a stone scarab would protect Katebet in the afterlife. The grey-white metal is tin.

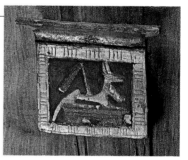

△ **ANUBIS**
A gilded cartonnage amulet of the jackal-headed god of the dead, Anubis, offers further protection.

SHABTI
A clay shabti (servant for the deceased) would serve Katebet in the afterlife.

◁ **MUMMY OF KATEBET**
Found in a tomb in Thebes, the mummy of Katebet is wrapped in linen bandages, with a mask over the face. **Height:** 165cm (65in). **Date:** 1330–1250 BCE.

Scale

Hittite Stag Bibru

An elaborately engraved 2nd-millennium BCE sacred drinking vessel showing the marriage of art and ritual in ancient Hittite society

Eastern Turkey

The art of the Hittites, who dominated what is now eastern Turkey and western Syria for a thousand years from 1700 BCE, was influenced by religious ritual. One distinctive form was the zoomorphic (animal-shaped) drinking vessels, or *bibru*, used in "god-drinking" rites, where the Hittite king imbibed sacred wine to become one with the deity. Bulls and stags, emblematic of powerful gods, were often depicted in Hittite art.

This exquisite drinking vessel terminates in the forepart of a stag; the fine silver sheet from which it is beaten captures the taut musculature and alertness of the animal, and, by extension, of the god believed to dwell within. The cylindrical part of the vessel is decorated with a ceremonial scene that includes divinities, suppliants, and a stag collapsed against a tree, perhaps hunted as an offering to the stag god.

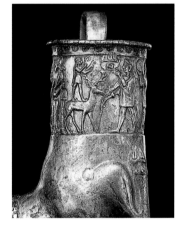

◁ **HITTITE STAG** *BIBRU*
The drinking cup was created in two pieces, the head and the body, with the ritual scene carved beneath the rim. **Height:** 18cm (7in). **Date:** c.1350–c.1200 BCE.

△ **IN USE**
When the vessel was tilted for use, the wine would have filled its hollow body right to the tip of the stag's nose.

The **vessel** may have been **designed** for the stag god's **personal use**

GODDESS
A goddess sits on a stool, holding a bird of prey in one hand and a cup in the other.

STAG GOD
A god holding a falcon and a curved staff is pictured standing on the back of a stag.

RITUAL SCENE
A frieze showing a religious ceremony adorns the body of the vessel.

VESSEL RIM
The outer rim of the cup has beadlike decorations.

CHECQUERED PATTERN
A ring with an elegant chequered pattern joins the head to the body.

BODY
The vessel's body was hammered out of a single sheet of silver.

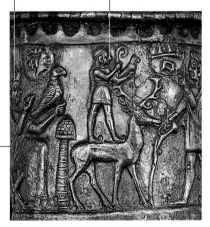

△ **RELIGIOUS FRIEZE**
The figures in the frieze are depicted in profile and have the large ears typically found in Hittite art. Three men bring offerings to the deities.

Scale

Originally a **statement of power**, today the *gui* is a **historical document**

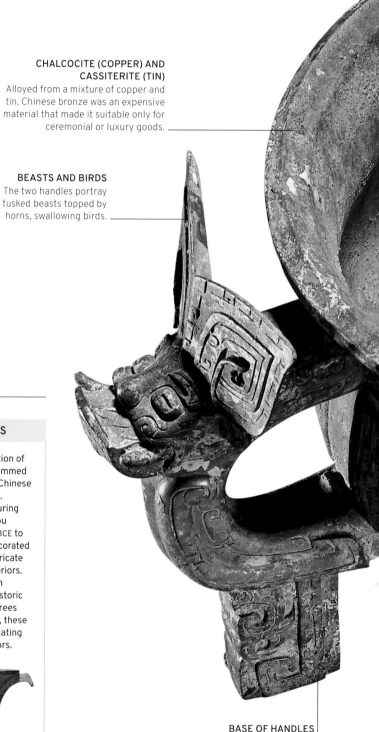

Huixian, China

Kang Hou Gui

An imposing Western Zhou bronze vessel used by Chinese warrior lords at ritual feasts honouring the ancestors

The 11th century BCE in China saw the Shang dynasty, which had ruled for more than 500 years, replaced by newcomers from the west – the Zhou. In the reign of the second Zhou king, a rebellion by remnants of the Shang was suppressed by Kang Hou, the king's brother. This magnificent *gui*, or bowl-shaped ritual vessel, famously commemorates Kang's role in a long inscription in its interior.

The *gui* would have been used as a centrepiece at ritual banquets in honour of the ancestors: the regular offering of food and drink to the dead was a way of retaining their favour and placating the gods, and such expensive bronze vessels were status symbols of the ruling elite. The lavish *gui* featured here, with its border of flower-like decoration above vertical ribbing, is particularly notable for its large, ornate handles in the form of horned animal heads, with birds' beaks emerging from their mouths. Its flared footring makes its solid form all the more imposing.

Bronze-casting technique

Shang bronze vessels were cast using a sophisticated process known as piece moulding. Clay was pressed against a ceramic model of the finished article to take an imprint of the form and decoration, and removed in sections for firing. The fired moulds were replaced over the model, shaved of its detailed surface, and molten bronze was poured into the space. After cooling, the outer casings were removed by breaking them. This *gui* would have been cast in pieces, using several moulds.

BRONZE VESSELS

The startling sophistication of bronze ritual vessels stemmed from a long tradition of Chinese craftsmanship in bronze. Reaching a high point during the Shang and early Zhou dynasties (from c.1300 BCE to c.850 BCE), the richly decorated wares often featured intricate inscriptions on their interiors. Recording anything from military campaigns or historic victories to imperial decrees or political relationships, these were a way of communicating directly with the ancestors.

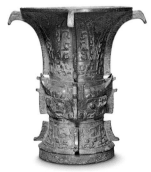

ZHOU WINE VESSEL, C.1000 BCE

BASE OF HANDLES
The base of the handles ends in a pendant decorated with birds' bodies, wings, and tails.

△ **KHANG HOU** *GUI*
This magnificent *gui* owes much of its historical importance to the inscription carved into its interior, which enables historians to accurately date the vessel.
Height: 22cm (8¾in). **Date:** 1100–1000 BCE.

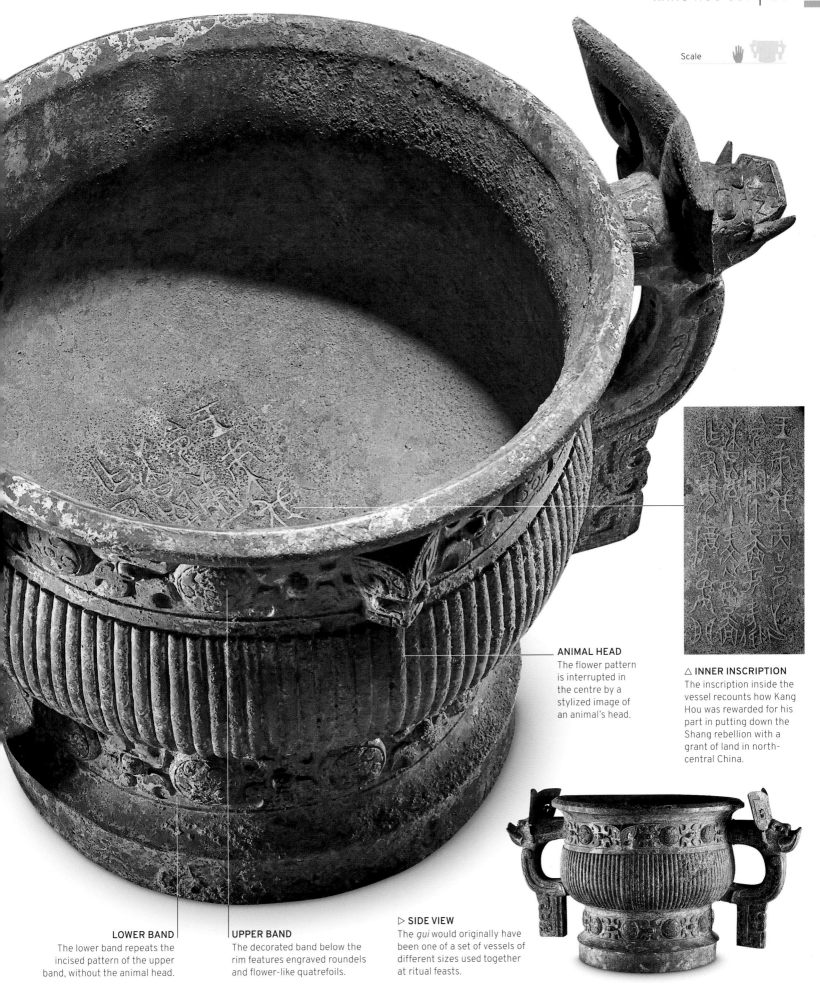

Scale

ANIMAL HEAD
The flower pattern
is interrupted in
the centre by a
stylized image of
an animal's head.

△ **INNER INSCRIPTION**
The inscription inside the
vessel recounts how Kang
Hou was rewarded for his
part in putting down the
Shang rebellion with a
grant of land in north-
central China.

LOWER BAND
The lower band repeats the
incised pattern of the upper
band, without the animal head.

UPPER BAND
The decorated band below the
rim features engraved roundels
and flower-like quatrefoils.

▷ **SIDE VIEW**
The *gui* would originally have
been one of a set of vessels of
different sizes used together
at ritual feasts.

Nimrud,
Iraq

Scale

Phoenician Ivory Plaque

One of the finest ivory carvings from the ancient world, showing the elegance and control of Phoenician craftsmen

The Phoenician civilization flourished around the eastern Mediterranean between 1100 and 200 BCE, its homeland ruled by the Assyrians between the 9th and 6th centuries BCE. Masters of work in ivory, the Phoenicians used saws, drills, and gouges to create vivid scenes, often showing Assyrian or Egyptian influence. This especially finely carved ivory plaque depicts an African man or boy being devoured by a lioness, against a backdrop of papyrus plants and lilies. The dramatic scene is a reshaping of an Egyptian theme, the lioness representing Pharaoh triumphant. The artist has lent the figures a plasticity and power that creates a surprising sense of movement. The effect was further enhanced by the addition of semi-precious stones and gold leaf to pick out details.

One of a matching pair found in the sludge at the bottom of a well near the palace of the Assyrian king Ashurnasirpal II (ruled 883–859 BCE) in the ancient Assyrian city of Nimrud (near Mosul in present-day Iraq), the plaque was probably made on the Phoenician coast and taken to Assyria as booty or tribute. It is an outstanding example of many such panels that have been found (*see box*).

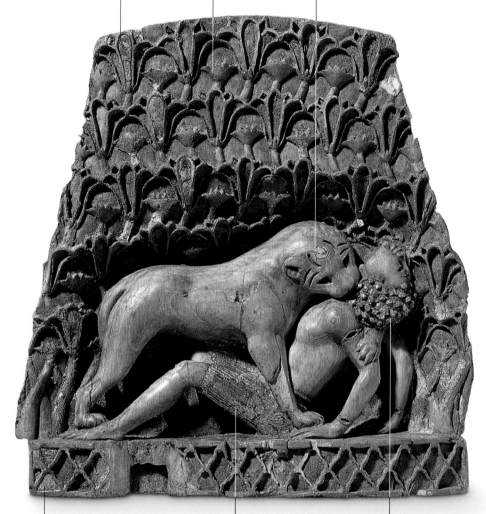

BLUE LOTUS
Lotus flowers inlaid with lapis are bedded on a mortar of calcium carbonate and blue powdered frit.

RED FLOWERS
Papyrus flowers are inlaid with red carnelian.

LIONESS'S HEAD
A lapis gemstone is embedded in the forehead of the lioness.

▽ **PHOENICIAN IVORY PLAQUE**
The plaque was originally affixed top and bottom by mortise joints, probably to a piece of furniture. **Height:** 10cm (4in). **Date:** 900–700 BCE.

BORDER
The lattice-work border was originally inlaid with lapis lazuli.

GOLDEN KILT
The man or boy wears a short kilt, decorated with a layer of gold leaf.

HAIR
The hair is created with gold-leaf-tipped ivory pegs.

THE NIMRUD IVORIES

Around 1,000 ivory plaques, panels, and carvings, many used to adorn furniture or boxes, have been excavated by archaeologists in the Assyrian city of Nimrud. They had been thrown down wells during the collapse of the Assyrian Empire in the 7th century BCE, or stacked in palace store rooms. Most were not locally made, but were produced across Mesopotamia and imported as luxury goods or looted by the Assyrian army in the 9th and 8th centuries BCE. Intricately worked and originally decorated with gold, silver, and gems, which were stripped by invaders, they are stunning examples of ancient ivory carving.

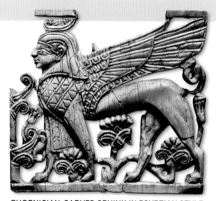

PHOENICIAN-CARVED SPHINX IN EGYPTIAN STYLE

The **matching pair** to this plaque was **looted** from **Baghdad**, Iraq, in 2002, and is **now lost**

Gulf Coast, Mexico

Scale

Olmec Mask

A Mesoamerican jade mask from the 1st millennium BCE capturing for all time the gaze of an ancient Olmec being

The Olmecs, a people of the Gulf Coast region of eastern Mexico, created the first advanced civilization in the Americas, which flourished between 1500 and 500 BCE. At sites such as La Venta and San Lorenzo, they produced sculptures in ceramic, jade, and stone, ranging from monumental heads, enigmatic "baby" figurines, and elongated human figures, to were-jaguars, whose symbolism is not well understood.

Few match the power of this small mask, with its finely sculpted outlines that capture perfectly the essence of the fleshy-lipped entity portrayed. Made of dense, hard jadeite – known to the Olmecs as greenstone – it was bored out with flint saws and scrapers, and then rubbed with abrasives and polished to create a lustrous green surface. Although the style is broadly realistic, the face incorporates traits typically found in Olmec portrayals of supernatural beings, such as the wide nose, the almond-shaped eyes, and the subtle frown of the toothless mouth.

GREENSTONE
Because of its green colour, jadeite was linked with ideas of fertility and abundance.

CLEFT FOREHEAD
The pronounced cleft in the forehead was a sign of the Maize God, a key Olmec deity.

ALMOND EYES
The sculptor's chisel marks are visible on the deeply incised almond-shaped eyes.

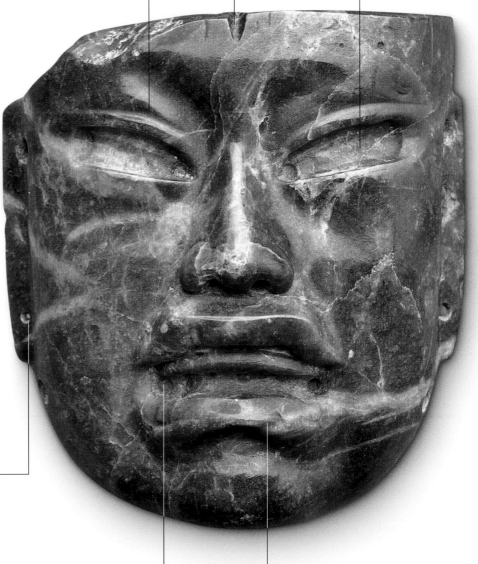

PERFORATIONS
Holes in the ears may have been for earrings, perhaps of gold.

DRILL HOLES
Indentations at the sides of the mouth and eyes may be drill marks used to guide the sculptor or may have held shell inlays.

INFANT LOOK
The fleshy, slightly down-turned lips are reminiscent of the earlier Olmec "baby-face" style.

△ OLMEC MASK
The mask may have been worn as a belt ornament, necklace, or headdress, or as some kind of funerary adornment. **Height:** 14.5cm (5³⁄₄in). **Date:** 900–400 BCE.

BABY-FACE FIGURINES

With its pudgy legs, forearms, and stomach, and its curious posture, this ceramic Olmec statue belongs to a group known as "baby-face" figurines. This example is particularly fine, with an intricately carved headdress coloured using powdered cinnabar and red ochre, and cross-hatching on its back to represent tattooing. The purpose of such figures is unknown, though the almond-shaped eyes, down-turned mouth, and square ears are linked in Olmec iconography with deities. Babies appear prominently in Olmec art and may be memorial images, ritual effigies, or connected to child sacrifice.

SEATED FIGURE, 1200–800 BCE

The mask is **too small** to have been placed **over the face**, and was probably used in **rituals**

Regolini-Galassi Fibula

A lavish golden fibula found in a tomb that is revered as one of the masterpieces of Etruscan art

Cerveteri, Italy

The grave in which the fibula was found was covered by a 46m (151ft) high tumulus

The Regolini-Galassi fibula – named for the priest and general who discovered it in 1836 – was found in one of the two burial chambers of a tomb near the ancient Etruscan town of Caere (now Cerveteri). Concealed beneath a huge tumulus, or mound of earth, the tomb (unusually) remained unlooted and contained rich grave goods, which date it to around 675 BCE, during an orientalizing phase of Etruscan culture, when it was influenced by Egyptian and Phoenician-Syrian motifs.

Elite tomb

Inscriptions on other items in the grave reveal that the deceased was a woman named Larthia Velthurus. She was clearly of high status: more than 300 objects are buried with her, including a massive gold pectoral (breastplate), other jewellery, an elaborate bronze cauldron, a funerary bed, and large quantities of pottery, as well as the fibula (brooch). Modelled

on clasps used to fasten cloaks, this may have been intended to secure her funeral shroud. It was made in three parts: the top part, adorned with five striking lions, was made by the repoussé technique (*see p.81*); the central, belt-like section was decorated with geometric zig-zag patterns more akin to the local Villanovan style than the fibula's other orientalizing features; the lower section was made by granulation – applying and fusing metal balls – to form tiny ducks amid a pattern of griffins. At the very end of the lower section is an image of the Egyptian goddess Hathor, who helped souls on their journey into the underworld: this suggests that the fibula was funerary jewellery or a grave offering rather than an object used in life.

Although several smaller Etruscan fibulas in this style have been found in and around Cerveteri, the Regolini-Galassi fibula is by far the largest and most extravagantly decorated of all.

THE REGOLINI-GALASSI TOMB

The tomb was cut into the tuff (rock made from volcanic ash) underlying the earth tumulus. A short entrance passage or dromos, in which several bronze cauldrons were deposited, led into a 37m (121ft) long corridor forming the main part of the tomb. Off this were two oval chambers:

silver and bronze vessels were discovered in one of them; the cremated remains of a male were found in the other. The main burial chamber – which was sealed off by a wall with a small viewing window – contained most of the tomb's gold and silver objects, including the fibula.

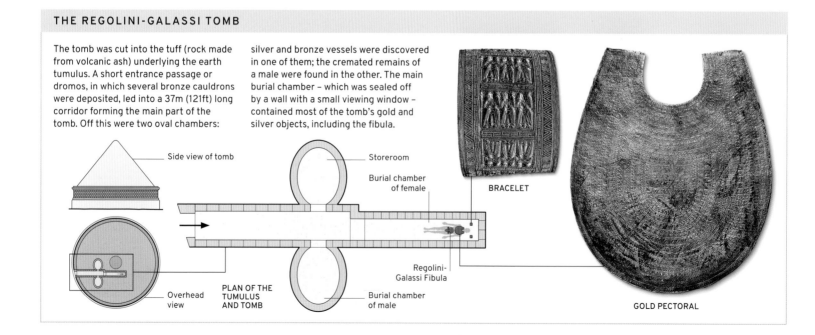

Side view of tomb

Storeroom

Burial chamber of female

BRACELET

Regolini-Galassi Fibula

Overhead view

PLAN OF THE TUMULUS AND TOMB

Burial chamber of male

GOLD PECTORAL

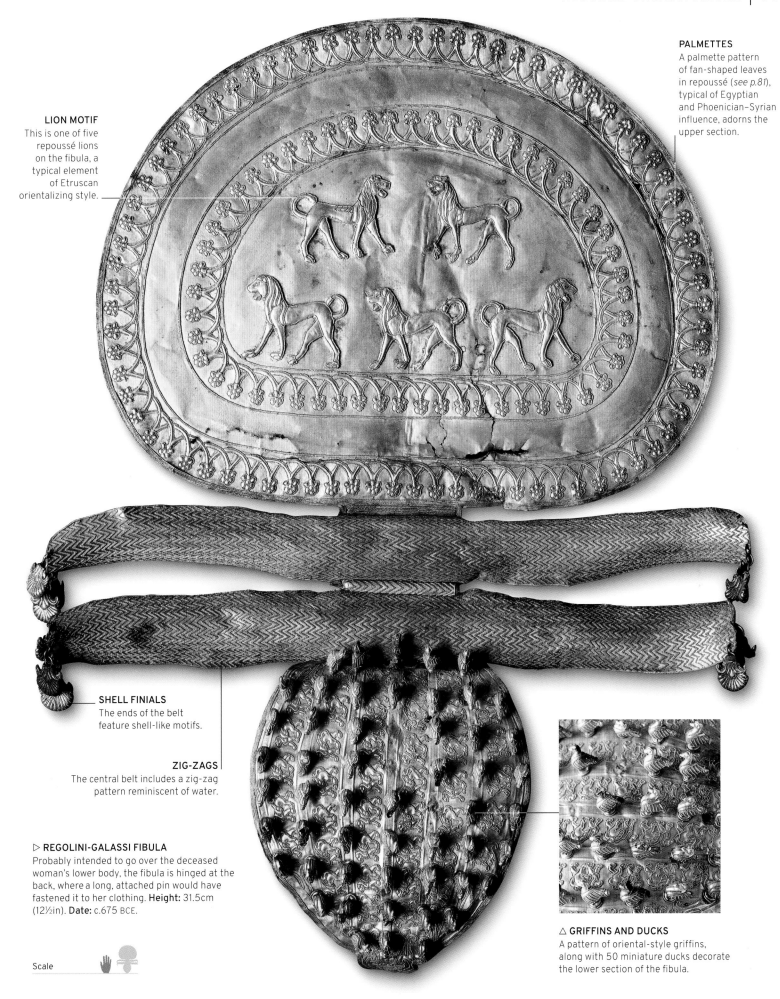

PALMETTES
A palmette pattern of fan-shaped leaves in repoussé (*see p.81*), typical of Egyptian and Phoenician–Syrian influence, adorns the upper section.

LION MOTIF
This is one of five repoussé lions on the fibula, a typical element of Etruscan orientalizing style.

SHELL FINIALS
The ends of the belt feature shell-like motifs.

ZIG-ZAGS
The central belt includes a zig-zag pattern reminiscent of water.

▷ **REGOLINI-GALASSI FIBULA**
Probably intended to go over the deceased woman's lower body, the fibula is hinged at the back, where a long, attached pin would have fastened it to her clothing. **Height:** 31.5cm (12½in). **Date:** c.675 BCE.

Scale

△ **GRIFFINS AND DUCKS**
A pattern of oriental-style griffins, along with 50 miniature ducks decorate the lower section of the fibula.

Strettweg Cult Wagon

A beautifully crafted and extremely rare example of a richly decorated, almost entirely preserved cult wagon from the Iron Age

Judenberg, Austria

The bronze Strettweg Cult Wagon was found in an elite grave in Strettweg, near Judenberg, Austria, in 1851, alongside weapons, bronze vessels, and jewellery. Although other cult wagons (wheeled vehicles) have been found, the Strettweg Wagon is linked to the Hallstatt culture – renowned for its sophisticated metalwork – and is distinguished by its extraordinary and skilfully made bronze figural decoration and by the fact it is virtually intact. A tall female figure holding a bowl above her head stands on top of

the base plate, which has a large wheel on each corner. Two groups of figures stand to the front and back: two genderless figures leading a stag by the antlers; and a man holding a hatchet and a woman. Two riders flank the two groups at both ends. The scene suggests a ceremonial procession, with the stag as a possible sacrificial offering. The object was designed to carry a bowl, probably utilized during libation rites, a blood sacrifice, or incense offering, and would have been reserved for use by a high-ranking individual.

▽ SIDE VIEW
The figures and animals are arranged symmetrically on the square base plate. The large bowl carried by the central figure is supported by four long scissor-like rods.

▷ STRETTWEG CULT WAGON
The mysterious Strettweg Wagon was found in a grave believed to date to around 600 BCE. Its purpose has been long disputed, but it clearly had ritual significance in both life and as a grave gift after death. Found in several pieces, the wagon has been reconstructed and restored several times. **Height:** 46.2cm (18in). **Date:** c.600 BCE

CENTRAL FIGURE
The central female figure, possibly a priestess or goddess, wears a broad belt and earrings and stands on top of a sun or wheel symbol.

MISSING SHIELD
Among the missing elements are this rider's shield and one of the riders (on the opposite corner).

ELONGATED FORMS
One of the distinctive features of this object is the elongated forms: the stags' antlers are disproportionately large, as are the legs of the humans and animals.

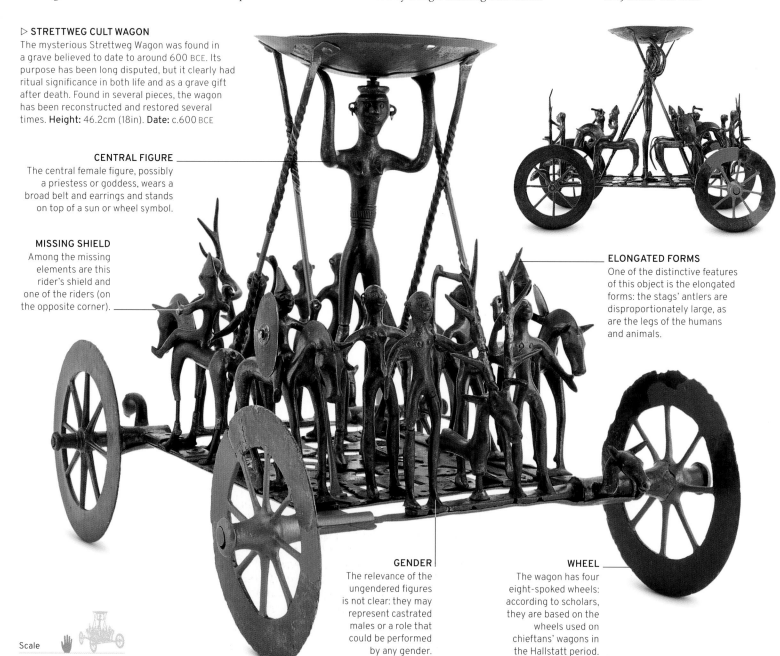

GENDER
The relevance of the ungendered figures is not clear: they may represent castrated males or a role that could be performed by any gender.

WHEEL
The wagon has four eight-spoked wheels: according to scholars, they are based on the wheels used on chieftans' wagons in the Hallstatt period.

Scale

The Cyrus Cylinder

A major document in the history of the Middle East that celebrates one of the greatest and most tolerant emperors of the ancient world

Near Baghdad, Iraq

The Cyrus Cylinder is a cylinder of baked clay inscribed with 45 lines of text in Old Babylonian cuneiform. The document praises the Persian Achaemenid ruler Cyrus II for his actions following his conquest of Babylon (near modern-day Baghdad, Iraq) in 539 BCE. It justifies this conquest by accusing Nabonidus, the former ruler of the city, of banning the worship of Marduk, god of Babylon. After overthrowing Nabonidus, Cyrus adopted more tolerant policies towards the city's inhabitants.

The Cyrus Cylinder's solid core consists of clay mixed with small pebbles to prevent cracking and ensure even firing; it was created either on a wheel or by hand-rolling, before a finer clay surface was applied. The text was inscribed on this surface using a stylus with a wedge-shaped tip to produce the elegant cuneiform characters. The cylinder was baked in an oven to harden and preserve it and later secreted in the walls of Babylon's temple of Esagil, in accordance with a Mesopotamian custom of burying such documents in sacred buildings. Not long after its discovery in 1879, several fragments broke off.

Part of the text refers to returning images of gods to their sanctuaries, to freedom of worship, and allowing exiles to go back to their homelands – the latter has been interpreted as referring to Cyrus's decision to allow Jewish people to return from Babylon to Jerusalem. The cylinder thereby offers a powerful and unique insight into the early development of human justice and the attempt to embrace the diversity of different peoples and belief systems. A copy of it was presented by Iran to the United Nations in 1971.

CYRUS THE GREAT

Cyrus II, or Cyrus the Great (ruled 559–530 BCE), founded the vast Achaemenid Persian Empire. Stretching from Asia Minor to northern India, it was the largest state created up to that time. Cyrus's rule was notably respectful towards conquered peoples. In Judaic tradition, Cyrus is honoured for allowing the Jews to return from Babylonian exile and rebuild Jerusalem, while in Iran he is remembered as the "father of the nation".

TOMB OF CYRUS AT PASARGADAE

TRANSLATION
This section of text translates as "I am Cyrus, king of the universe, the great king, the powerful king, king of Sumer and Akkad, king of the four quarters of the world."

CUNEIFORM SCRIPT
The characters read from left to right in rows; the rows are separated by lines scored into the clay.

▽ THE CYRUS CYLINDER
This is a unique document in the direct voice of a ruler governing a multi-racial empire through tolerance rather than by forced assimilation. **Length:** 22.5cm (8¾in). **Date:** c.539–530 BCE.

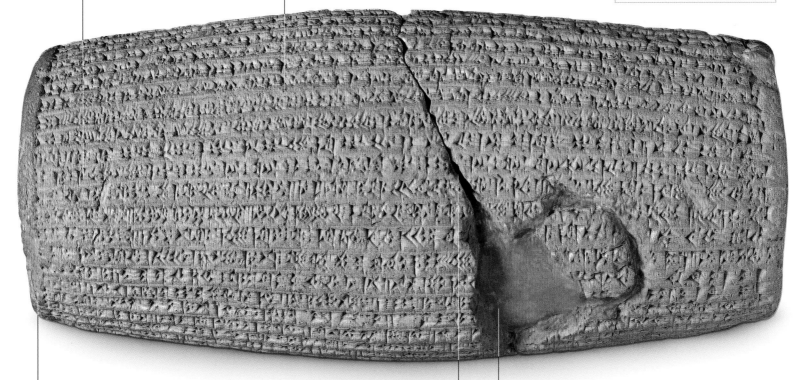

COLOUR CHANGE
Colour variation, from light brown to beige, suggests several cylinders were stacked on top of each other in the kiln, so some parts did not receive direct heat.

FRACTURE
This section shows a fracture in the cylinder and adjacent areas where fragments have broken off.

SOLID CLAY
A missing fragment exposes the solid clay core. The cylinder's surface clay is finer.

Scale

HEBE
The girl wearing the very ornate dress is Hebe, the goddess of youth.

THEMIS
As are all the female figures, the Titaness Themis is shown with pale-coloured skin.

SIGNATURE
Sophilos placed his signature between the columns of Peleus's house.

DIONYSUS
The second god to arrive is Dionysus, the god of wine, carrying a vine branch with grapes.

△ **CHEIRON**
Cheiron the centaur is shown as he returns from hunting, carrying his kills on a pole.

△ **PELEUS AND IRIS**
The bridegroom, Peleus, greets his guests, holding a wine-cup in his hand. Iris is the first to arrive. A messenger of the gods, she is shown holding a herald's wand.

△ **ARES AND APHRODITE**
In the upper register, Ares and Aphrodite are seen in their chariot, with five Muses behind them, one of whom is playing the pipes.

△ **SIREN**
This mythical being is one of the sirens, creatures who used their enchanted singing to lure sailors to their death by shipwreck.

△ **ALTERNATIVE VIEW**
Like the bowl, the stand is decorated with friezes of real and mythical animals, as well as geometric patterns influenced by Persian art.

Scale

◁ **ATTIC** *DINOS*
As was typical for Greek *dinoi*, this one has a rounded bottom and is placed on a stand. The *dinos* was carefully restored from fragments, with remarkably few areas of loss. These were filled using plaster of Paris and painted. **Height (with stand):** 71cm (28in). **Date:** c.580–c.570 BCE.

Attic Dinos

Unique early Attic vase of exceptional quality that marked a significant change of direction in black-figure painting

Attica, Greece

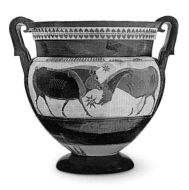

△ **SOPHILOS VOLUTE** *KRATER*
A *krater* is another type of vessel used for mixing wine. This style of terracotta vase gains the epithet "volute" (a spiral scroll form) for its scroll-shaped handles. This splendid example from the early 6th century BCE is attributed to Sophilos.

A *dinos* was a mixing bowl for wine; the Greeks prided themselves on diluting their wine with water, unlike the so-called barbarian races. This beautiful example was created during the Archaic period of Greek art (c.800 BCE–480 BCE). It was made in Attica – the area around Athens – by Sophilos, the first Greek vase painter whose name is known: his signature appears on four surviving vases, three times as painter and once as potter; his signature on this vase ("Sophilos painted me") emphasizes his chief skill.

Procession of the gods
Fragments of 37 different vessels have been attributed to Sophilos. A master vase painter in the black-figure style (*see box*), he was significant in increasing the importance of figural scenes in Greek vase painting. This black-figured *dinos* is Sophilos's most spectacular surviving work. Earlier Greek vases were mainly decorated with plant motifs – usually lotus flowers or palmettes – and friezes of animals and monsters. Sophilos used these on his *dinos* and its stand, but reserved the prominent upper register for a figural scene depicting the wedding procession of Peleus, a king, and Thetis, a sea nymph. Their marriage – a union between a mortal and an immortal – played a pivotal role in the Trojan cycle of legends, a popular subject for vase painters. Their son Achilles was the greatest hero of the Trojan war, and his mentor, the wise centaur Cheiron, is portrayed by Sophilos among the wedding guests. The other guests comprise a virtual roll-call of the Greek gods, who are pictured arriving in chariots or on foot, with groups of Fates, Graces, and Muses among them. Thetis is unseen and is presumed to be in the building behind Peleus.

The **name** of each **deity** is **neatly written** beside them in **classical Greek**

BLACK-FIGURE POTTERY

In black-figure pottery, figures and decoration were drawn in a silhouette-like style with incised details. Vessels were fired in three different stages to produce the coloration.
1 Figures and decoration were painted on the dried clay vase with slip (clay slurry); outlines and details were incised into the slip, while the background was left the colour of the clay. Red and white earth-based pigments were used to add further details. 2 During the first, oxidizing stage of firing, air was allowed into the kiln, so that the vase turned orange-red in colour. 3 The temperature was increased, the oxygen supply reduced, and green wood fed into the kiln, turning the vessel black. 4 The vents were reopened to allow oxygen into the kiln and the temperature was reduced; the vase returned to its red colour while the areas of slip remained black.

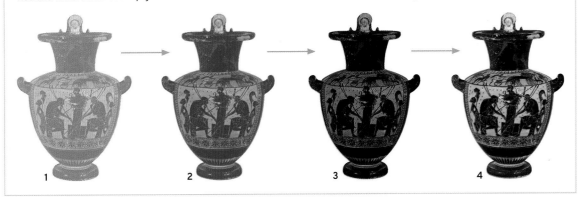

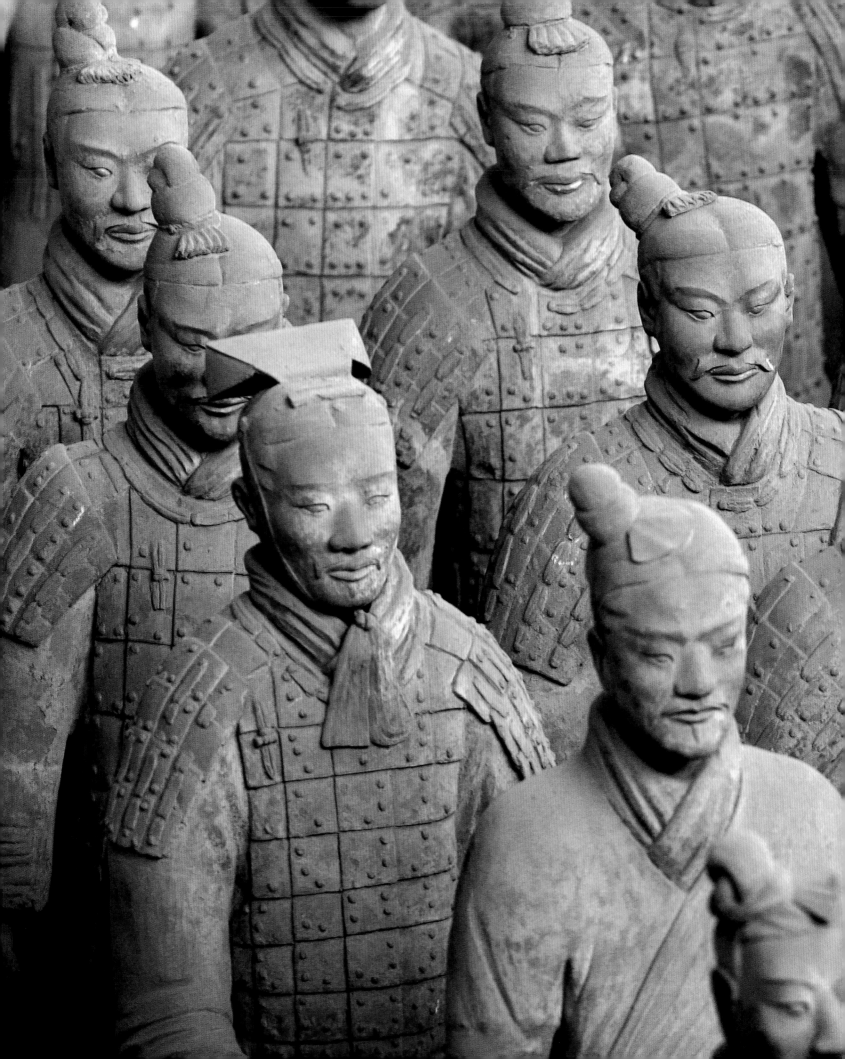

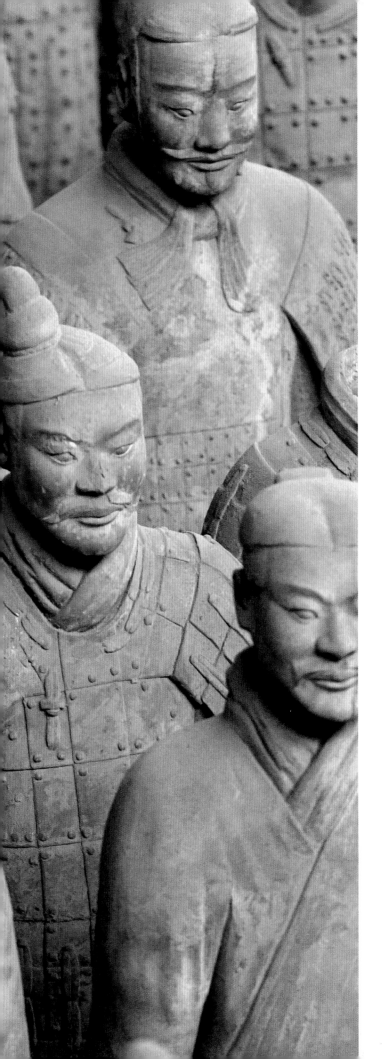

500 BCE – 499 CE

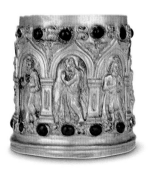

In Asia, Europe, and North Africa, this 1,000-year span was marked by the emergence and collapse of great empires. Objects such as the elegant sculptures and bronzes of ancient Greece and Rome, the large reliefs from Persia, and the army of terracotta soldiers buried with China's first emperor provide a glimpse into the mechanics of empire-building, how power was communicated across vast areas, and how new religions like Buddhism spread as connections between lands grew. Other artefacts trace the vibrant cultures that were subsumed by the great civilizations. Empire was also a feature in the Americas, as sophisticated cultures such as the Nazca in Peru, and the Maya and Zapotecs in Central America, began to flourish.

SON AND HEIR
Darius's status is enhanced by having his successor, the crown prince Xerxes, standing behind him.

LOTUS FLOWER
Each of the royal pair holds a lotus flower, a symbol of eternity.

TWICE THE SIZE
The king is the only seated figure, but to show his superior position is portrayed as roughly twice the size of the others.

▽ **PERSEPOLIS BAS-RELIEF, NORTHERN STAIRCASE**
It is thought that the central relief of the Persepolis Apadana shows the king Darius the Great, but it could be his son, Xerxes, flanked by Xerxes' own son, Artaxerxes. **Dimensions:** approx. life-size. **Date:** c.520–c.465 BCE.

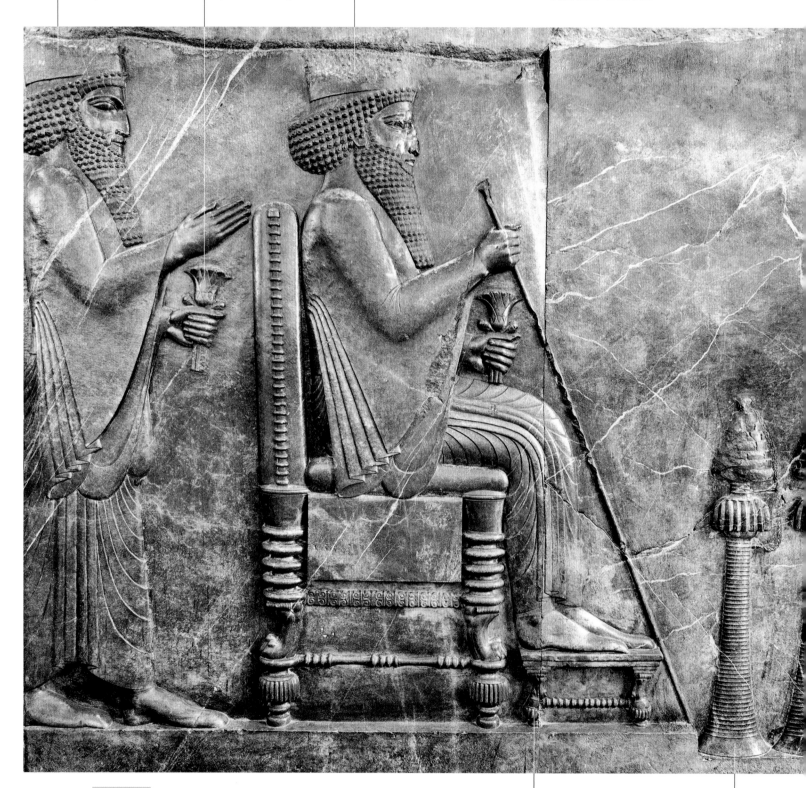

Scale

RAISED FEET
The footstool has a ritual significance in preventing the king's feet from touching the ground.

SCENTED HALL
Incense burners perfume the hall used for the reception of visiting dignitaries.

Persepolis, Iran

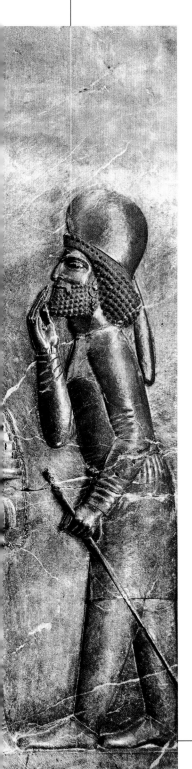

Persepolis Bas-Relief

The focal point of the magnificent bas-relief carvings around the great audience hall in the ceremonial centre of the Achaemenid Empire

After Darius I became king of the mighty Achaemenid Empire in 522 BCE, he commissioned the building of a new ceremonial capital, Persepolis. More a complex of grand palaces than a city, the buildings were designed to emphasize the power and extent of the vast empire. They were lavishly decorated with sculptures, and especially bas-relief carvings on the limestone walls.

Depicting the empire

One of the first structures to be built was the massive Apadana, or audience hall, where the king received guests from his subject nations. Built on a platform, it was accessed by two monumental stairways decorated with a continuous frieze of bas-relief panels depicting a parade of 23 delegations bearing tributes from across the empire. Each staircase had as its focus a larger central panel showing (probably) Darius the Great on his throne, towards whom all the figures are facing.

The central panel of the northern staircase is shown here. It is an important example of Achaemenid relief carving, and is matched by a similar, mirror-image panel on the eastern staircase. At some point, for reasons unknown, both panels were moved to the Treasury building, where they were discovered by archaeologists in the 1930s. The dominant figure is the king, whose status is enhanced rather than diminished by being the only seated figure. It is almost certainly a portrayal of Darius, with his son and heir, Xerxes, standing behind him, though other than the trappings of royalty, there are no features to identify him. The two royal faces are almost identical, implying that this is not a portrait of an individual, but an idealized embodiment of the monarchy (*see also pp.28–9*). The image of the enthroned king, attended by courtiers and guards and receiving gifts, served to glorify the ruler and underline his dominance over his subject peoples.

The **palaces** of **Persepolis** were **destroyed** by a fire started by **Alexander the Great's** army in **330** BCE

△ **THE APADANA PORCH AND MONUMENTAL STAIRCASE**
The illustration shows how the Apadana may have looked in the heyday of Persepolis. Begun by Darius and finished by Xerxes, it was used as a grand audience hall for the kings.

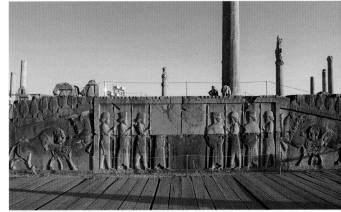

△ **THE APADANA TODAY, NORTH STAIRS**
Just 13 columns remain of the 72 that supported the Apadana roof. The north staircase is seen here; a later relief of Median and Persian soldiers has replaced the original central panel.

West Africa

Scale

Nok Sculptural Pottery

Simple yet wonderfully inventive and expressive terracotta heads and figures, representative of a distinctive culture

The Nok culture, which flourished in West Africa for about 2,000 years, was one of the first civilizations to develop techniques of smelting iron, perhaps as early as 1000 BCE. Their skill with fire was also used in the production of sculptural pottery, especially near life-size terracotta figures (thought to have been created by women artists) which provide important evidence of a sophisticated, technologically advanced culture. The figures are also the oldest examples of "African Proportion" whereby the heads are unnaturally large.

The magnificent sculpture shown here is notable for being one of the very few Nok figures to have survived largely intact (often, only the heads are found). It is typical of other figures, which are shown either sitting (as here), standing, or kneeling. The oversized heads are a key feature of these works, offering valuable insight into the distinctive elements of Nok sculpture: although stylized and abstracted, they present a truthful rather than idealized portrait. The basic shape and features, such as mouth and nose, are moulded in clay, with details, including simple eyebrows and items of jewellery, added on the surface; other elements, such as the triangular eyes, are inscribed or carved into the wet clay, with holes for the mouth, nostrils, and pupils.

HEADWEAR
The headdress is formed from coils of clay attached to the head.

SURFACE FINISH
The sculptures were covered with slip (liquified clay), then polished to a shine before firing.

PERFORATIONS
Pupils, nostrils, and mouth are perforated with holes to aid drying and firing.

HAIR
An elaborate hairstyle protrudes beneath the headress.

EYE AREA
The large eyes are typically triangular, with a simple arc for the eyebrow.

ADORNMENT
A large, coiled necklace adorns the figure's neck.

DAMAGE
The legs and one of the feet have been fragmented by age and damage.

▷ **NOK SCULPTURAL POTTERY**
The deceptive naivety of the Nok sculptural style is evident in this rare figurine. The simple, stylized features give the sculpture immense directness and beauty.
Height: 38cm (14³⁄₄in).
Date: c.500 BCE–200 CE.

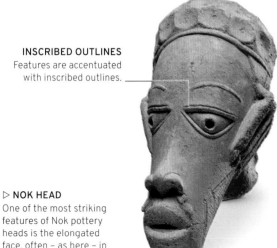

INSCRIBED OUTLINES
Features are accentuated with inscribed outlines.

▷ **NOK HEAD**
One of the most striking features of Nok pottery heads is the elongated face, often – as here – in an inverted pear shape.

The **Nok** sculptures were probably fired by **covering** with burning **leaves** and **branches** for **several** hours

Chavín de Huántar, Peru

Scale

Chavín Stone Heads

Massive heads of animals and mythological creatures carved in stone to adorn the walls of the Chavín New Temple

A unique feature of the New Temple complex of Chavín de Huántar, centre of the Chavín culture of pre-Incan Peru, was the array of carved stone heads jutting out from the exterior walls. Magnificent and often ferocious portrayals of sacred animals such as jaguars and snakes, birds, and anthropomorphic mythological creatures were placed at regular intervals, set into the stonework by means of the elongated squared tail or tenon at the back of each head (hence the name "tenon head").

Each of the tenon stones, sculpted from a single massive block of volcanic tuff or sandstone, depicted an individual creature with its own special character. However, there are some common features, especially among the felines and serpents. These are depicted, as in the jaguar-like figure shown here, as fierce and powerful, with prominent pointed fangs. They were perhaps intended as guardians of the sacred site, or representations of supernatural creatures from the spirit world; many have widely dilated pupils, possibly representing the drug-induced trances typical of shamanic rituals. The feline heads may symbolize earthly power, the birds the realm of the skies, and the anthropomorphic creatures the underworld.

HEAD SHAPE
The overall shape of the head, with its foreshortened snout and flattened crown, suggests that of a jaguar.

DILATED PUPILS
Wide-open eyes with dilated pupils are represented by spirals around circular indentations, mirroring those of the nostrils.

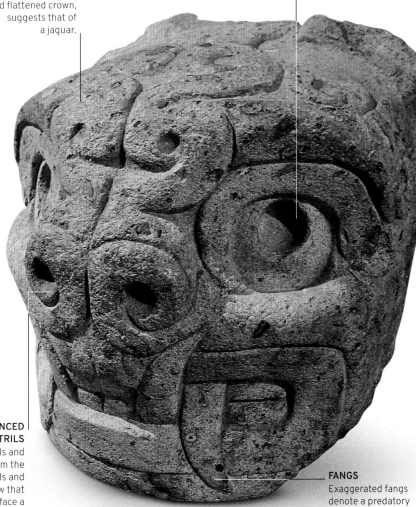

PRONOUNCED NOSTRILS
Spirals and S-shapes form the flared nostrils and furrowed brow that give the face a fierce expression.

FANGS
Exaggerated fangs denote a predatory feline nature.

△ **CHAVIN STONE HEAD**
Around half of the stone Chavín tenon heads, like this one, are representations of mythological felines or serpents. The highly stylized features such as the wide, staring eyes suggest that these magical creatures may be the products of hallucinatory drug-use, perhaps as part of shamanic ceremonies. **Diameter:** approx. 50cm (19½in). **Date:** 500–200 BCE.

FIXING THE TENON HEADS

Rather than being fixed to the wall, the stone heads were incorporated into the stonework. At the back of the head is a tenon, which fits between the blocks of the wall's stonework, like a mortice and tenon joint. The head and tenon are carved from the same block of stone.

Protruding front section

CARVED TENON HEAD AT THE NEW TEMPLE COMPLEX

Long tenon at the back of the head

Only **one** of more than **100** tenon heads **remains** in situ in the wall of the **New Temple**

HEAD BAND
Statue A has a band around the head, perhaps representing the wool band worn under a helmet.

HELMET
Statue B wears a Corinthinan helmet, pushed back from the forehead to reveal the face.

MISSING EYE
Unlike its more complete companion, this statue has lost the calcite inlay from the left eye.

ADDED DETAILS
The nipples of both statues are made of copper.

HANDLE
The handle of the shield buckler has survived.

EMPTY-HANDED
Both statues would probably have held spears or lances, now missing, in their right hands.

NEW ARM
Analysis of the metal has shown that Statue B's right arm is not original, having been replaced or restored at some time in antiquity.

MISSING SHIELD
The bent left arm would have carried a shield.

BRONZE SHELL
The smooth metal surface was achieved after casting by scraping, engraving, and polishing.

CONTRAPPOSTO
The contrapposto pose, with the weight on the back foot, gives the figures a more relaxed, informal look.

▷ **RIACE BRONZES**
Statue A (left) represents the younger and more assertive of the two figures. At 2.05m (6ft 7in), he stands 7cm (3in) taller than Statue B (right).
Date: c.450 BCE.

Scale

Riace Bronzes

*Two larger than life-size figures of naked warriors exemplifying
the Classical Greek concept of idealized masculinity*

Riace, Italy

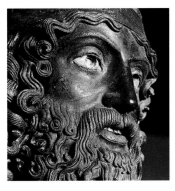

△ **MATERIAL DETAILS**
Both statues use additional materials
to pick out details, including copper
for the eyelashes and lips, and calcite
and glass paste for the eyes. Statue
A, shown here, also uses silver for
the teeth.

Discovered by an amateur scuba diver off Calabria, Italy's toe, the two statues have been dated to the mid-5th century BCE. This period was highly significant in ancient Greek history: the Greek city-states had just broken free from Persian rule, and the battles of Marathon and Thermopylae, fought in 490 and 480 BCE respectively, were already becoming the stuff of enduring legend.

Mystery and mastery

Because of their chance discovery the figures come with no explanatory context, so there is necessarily a degree of uncertainty about their exact provenance. But it is clear that they reflect the heroic ideal shared in Athens and its rival Sparta at the time; even their nudity was a condition reserved by Classical sculptors for gods or their nearest human equivalents. Dubbed

Statue A and Statue B, they are alike enough in style and presentation to be the work of a single master, although that too cannot be proved. Both consist of hollow bronze just a few millimetres thick, having been made by the lost-wax method, in which molten metal is poured over a moulded core (*see p.164*).

The statues' similar sizes (around 2m/6ft 6in) and postures also suggest that they might have once formed part of a group – possibly the Seven against Thebes, mythical warriors whose exploits dated back to before the Trojan War. Although this and so much else about the pair remain speculation, what is certain is the remarkable sense of force and power that they convey, reinforced by the extraordinary detail shown in their moulding: ribs, veins, and arteries can all be seen under the taut skin. Few artworks can make a similar claim to be as commanding as they are beautiful.

Idealized yet **realistic**, the statues may portray
heroes, **gods**, great **leaders**, or **warriors**

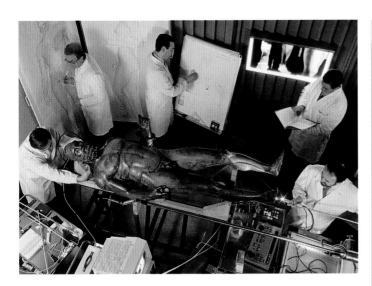

△ **THE RESTORATION OF THE BRONZES**
The warriors have undergone several rounds of restoration. Specialists are
seen here working on the second restoration in Reggio Calabria, Italy, in 1993,
when the earth that filled them during their firing was removed.

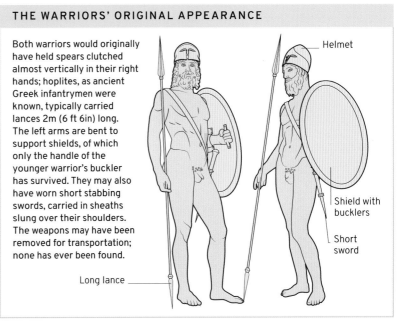

THE WARRIORS' ORIGINAL APPEARANCE

Both warriors would originally have held spears clutched almost vertically in their right hands; hoplites, as ancient Greek infantrymen were known, typically carried lances 2m (6 ft 6in) long. The left arms are bent to support shields, of which only the handle of the younger warrior's buckler has survived. They may also have worn short stabbing swords, carried in sheaths slung over their shoulders. The weapons may have been removed for transportation; none has ever been found.

Helmet

Shield with
bucklers

Short
sword

Long lance

The **gold chariot** is so **small** it could be held in the **palm of a hand**

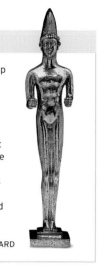

Oxus River, Tajikistan

The Oxus Treasure

A hoard of finely crafted gold and silver objects from ancient Persia

In the late 1870s, local people on the north bank of the Oxus River in what is now Tajikistan stumbled on a magnificent find: a trove of finely worked gold and silver objects, many quite small, along with hundreds of ancient coins. Among the spectacular hoard, now known as the Oxus Treasure, were animal figurines, jugs, bowls, votive plaques, statuettes, and jewellery, including pendants and two beautiful griffin-headed armlets. There were also two outstanding models of a chariot with two passengers, drawn by four horses, made from an alloy of gold, silver, and copper. To create the skilfully crafted objects, thin sheets of the metal would have been worked on and chased in separate sections and then soldered or hammered together, or attached with wires. The chariot has large wheels, which originally would have turned freely, and a carriage or cab that is open at the back; a benchlike seat has been crafted into the interior of the carriage.

The objects that comprise the Oxus Treasure were dated to the 5th and 4th centuries BCE, during Persia's Achaemenid period (c.550–330 BCE), when its empire stretched from beyond the Oxus River as far west as the borders of Greece. While the overall quality of the treasure is uneven, the finest examples, as here, display superb craftsmanship from what was then the largest empire the world had ever seen.

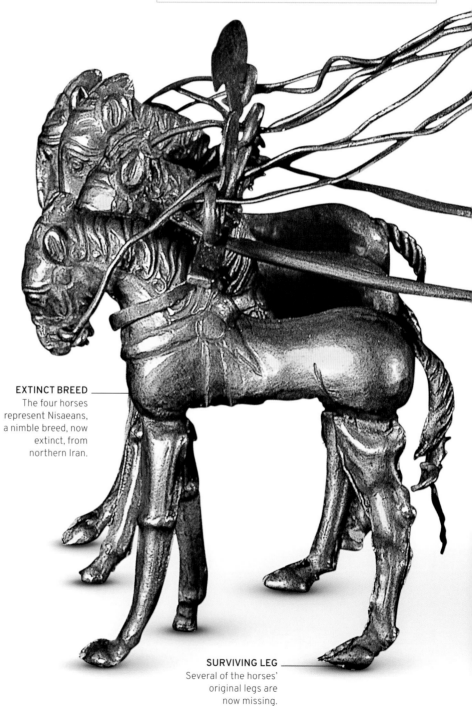

EXTINCT BREED
The four horses represent Nisaeans, a nimble breed, now extinct, from northern Iran.

SURVIVING LEG
Several of the horses' original legs are now missing.

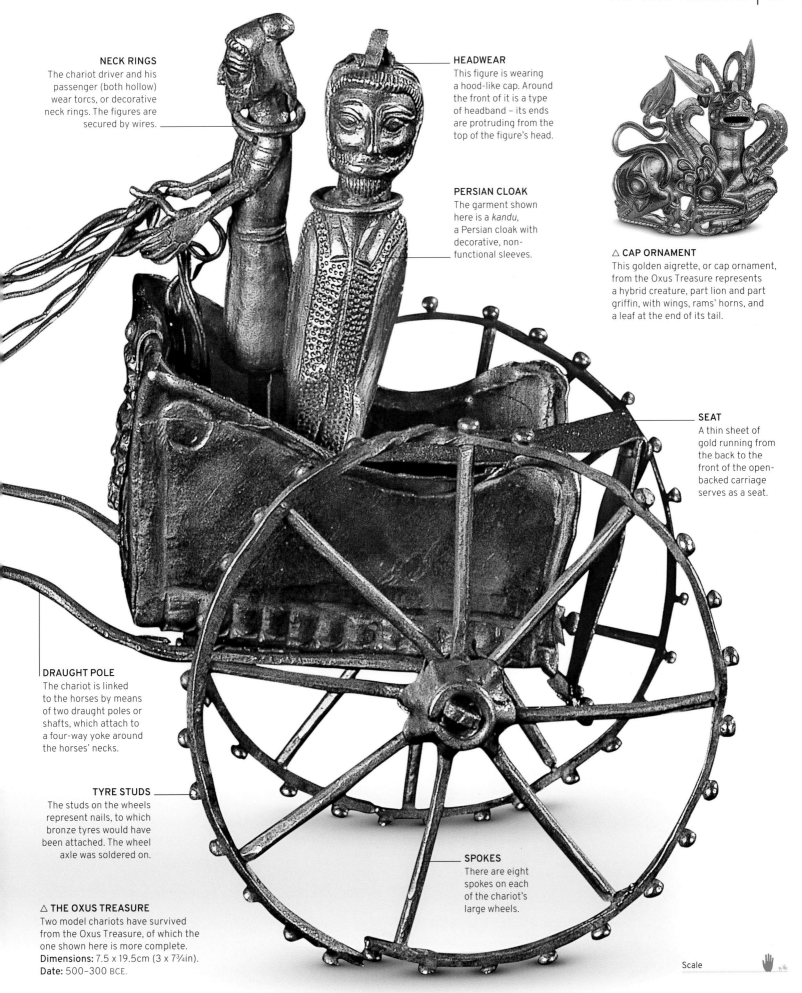

NECK RINGS
The chariot driver and his passenger (both hollow) wear torcs, or decorative neck rings. The figures are secured by wires.

HEADWEAR
This figure is wearing a hood-like cap. Around the front of it is a type of headband – its ends are protruding from the top of the figure's head.

PERSIAN CLOAK
The garment shown here is a *kandu*, a Persian cloak with decorative, non-functional sleeves.

△ **CAP ORNAMENT**
This golden aigrette, or cap ornament, from the Oxus Treasure represents a hybrid creature, part lion and part griffin, with wings, rams' horns, and a leaf at the end of its tail.

SEAT
A thin sheet of gold running from the back to the front of the open-backed carriage serves as a seat.

DRAUGHT POLE
The chariot is linked to the horses by means of two draught poles or shafts, which attach to a four-way yoke around the horses' necks.

TYRE STUDS
The studs on the wheels represent nails, to which bronze tyres would have been attached. The wheel axle was soldered on.

SPOKES
There are eight spokes on each of the chariot's large wheels.

△ **THE OXUS TREASURE**
Two model chariots have survived from the Oxus Treasure, of which the one shown here is more complete.
Dimensions: 7.5 x 19.5cm (3 x 7¾in).
Date: 500–300 BCE.

Scale

△ **LOCATION OF THE FRIEZE**
This illustration shows the exterior of
the Parthenon and highlights the inner
colonnade, where the frieze was located.

Athens,
Greece

Parthenon Frieze

An extraordinary sculptural relief in
marble created between 445 and 438 BCE

The Parthenon, a temple dedicated to the goddess Athena,
was part of a building programme ordered by the statesman
Pericles to beautify Athens and replace an older temple
that had been destroyed in a war with Persia in 480 BCE.
Framed by 46 towering Doric columns, it was adorned by
glorious sculptures: above the columns, 92 metopes, or
square panels, depicting scenes from the Trojan War and
battles between gods, giants, and centaurs; and running
around the main temple building, inside the colonnade, an
elaborate and quite spectacular low-relief frieze showing a
religious procession. The Greek sculptor Phidias is thought
to have overseen the artistic construction of the temple.

PHIDIAS

Phidias (c.490–430 BCE),
a revered sculptor and
architect, probably directed
the sculptural decoration
of the Parthenon. He is
particularly famous for
his golden statue of the
goddess Athena there
and for a huge statue
of Zeus on his throne at
the temple at Olympia.

▽ **PARTHENON FRIEZE**
Adorning all four sides of
the temple building, inside the
colonnade, the frieze depicts
the Panathenaic procession, part
of an annual festival dedicated
to Athena. **Dimensions:** 1 x 160m
(3 x 525ft). **Date:** 445–438 BCE.

START OF THE PARADE
This section is one of 47 slabs from the
north frieze and shows preparations
for the start of the procession.

CHISEL MARKS
Chisel marks from
the original working
of the marble.

NAKED HORSEMAN
A rider steadies his horse
and holds his wreath in
place as he awaits the start.

BRIDLE FITTINGS
The peg-holes are for attachment of horses' bronze bridle fittings.

PENTELIC MARBLE
Quarried from Mount Pentelicus, the marble is sculpted in low relief.

EXPRESSIVE DEPICTION
The figures are notable for their fluid forms and expressive poses.

Scale

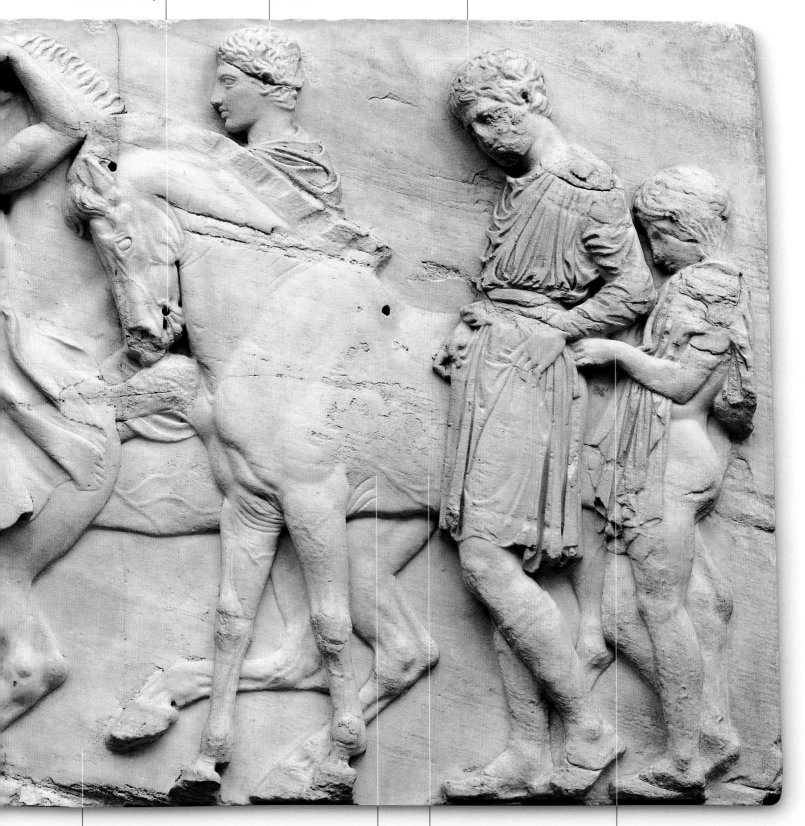

ORIGINAL COLOURS
The white marble would have been finished with coloured paint and metal details.

DISPROPORTION
Horses are shown disproportionately small in relation to humans.

MOUNTED CAVALCADE
Horses and riders form part of the mounted cavalcade of the Panathenaic procession.

PREPARATIONS
A boy groom focuses on fastening the belt of the rider in front of him.

Hamadan, Iran

Scale

Golden Lion Rhyton

A superb piece of metalwork exemplifying the vigorous and sophisticated art produced by the ancient Persian empire at its peak

A rhyton is a distinctive type of container used in the ancient world as a drinking vessel, to aerate wine, or for pouring liquid in a ceremony. Rhytons typically have a bowl-like upper part and a lower part shaped in the form of an animal. Some of them – as in the magnificent example shown here (*right*) – were used like cups, with the bowl raised to the lips, but others have a spout at the lower end of the vessel (*see below*), usually between the legs of the animal depicted.

Rhytons were produced over a wide area of the Near East and the Mediterranean, and in various materials, but the most splendid examples were made in gold during the time of the Achaemenid dynasty, which ruled the vast Persian empire from about 550 BCE until 330 BCE. This glorious 5th-century masterpiece comes from Hamadan, one of the oldest cities in Persia, and takes the form of a ferocious winged lion, a creature associated with the power of the dynasty. The banding around the cup and other decorative elements on the animal demonstrate superb craftsmanship and technical skill.

PLANT MOTIFS
Below the rim is a repeating pattern of stylized plant motifs – a common decorative treatment in Achaemenid art.

▽ GOLDEN LION RHYTON
Although this spectacular example is very elaborate, rhytons were probably a development of the simple drinking horn. **Height:** 22cm (8¾in). **Date:** c.400 BCE.

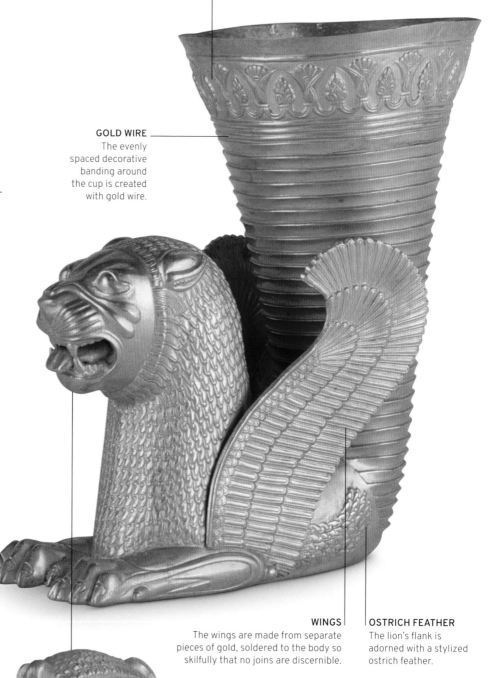

GOLD WIRE
The evenly spaced decorative banding around the cup is created with gold wire.

WINGS
The wings are made from separate pieces of gold, soldered to the body so skilfully that no joins are discernible.

OSTRICH FEATHER
The lion's flank is adorned with a stylized ostrich feather.

△ **FRESCO FROM POMPEII**
This detail from a 1st-century CE fresco from Pompeii, Italy, shows wine being poured from an open-bottomed rhyton into a situla (bucket-shaped vessel).

Winged lions were a **favourite motif** in Achaemenid art

◁ **FRONT VIEW**
The impressive, snarling lion is depicted with its mouth open and teeth bared; ridges adorn the snout.

Chimera of Arezzo

Probably the most famous work of Etruscan art, remarkable for its expressiveness and mastery of bronze casting

Arezzo, Italy

The Etruscans were the dominant people in ancient Italy until they were conquered by the Romans and absorbed into their republic. Etruscan art was strongly influenced by that of Greece, but it often has an earthy vigour of its own. In sculpture, the favourite material was terracotta (baked clay), but the Etruscans also excelled in bronze, and this ferocious beast, unearthed during building work in Arezzo in 1553, is their masterpiece in this material.

In Greek mythology, the Chimera was a fire-breathing monster with a lion's head, a goat's body (or, as here, a goat's head growing out of its back), and a serpent-headed tail. It was slain by the hero Bellerophon, and this bronze may originally have been part of a group showing their combat. However, as an independent work it is a superb example of bronze casting and – with its lean, sinewy body and bristling, snarling energy – one of the greatest of all animal sculptures.

Scale

BACK SPIKES
Along the Chimera's back runs a row of spiky hackles, echoing the decorative treatment of its mane.

SERPENT-HEADED TAIL
The original tail was missing when the sculpture was discovered; this is a replacement, added in 1785.

NECK WOUND
The goat's head has a bleeding wound, no doubt inflicted by the hero Bellerophon.

▽ **CHIMERA OF AREZZO**
The monster crouches tensely, as if about to spring at its enemy, its muscles and ribs masterfully suggested under the skin. **Dimensions:** 80 x 130cm (31½ x 51in). **Date:** c.400 BCE.

△ **SAVAGE HEAD**
The wounded beast snarls in fury and defiance; originally it would have had inset eyes, probably made of glass, but these have been lost.

INSCRIPTION
On the right foreleg is an inscription saying the sculpture is an offering to Tinia, the supreme Etruscan god.

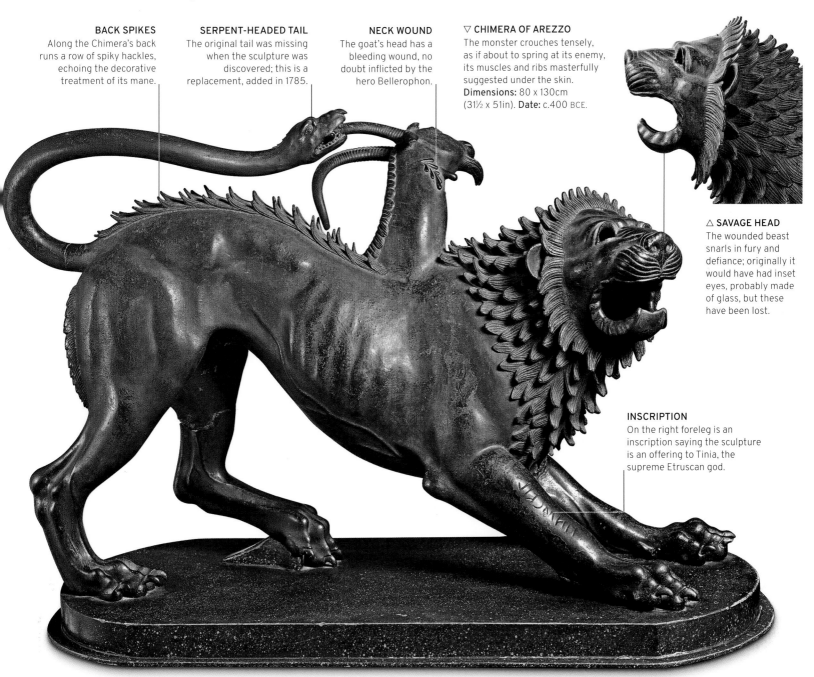

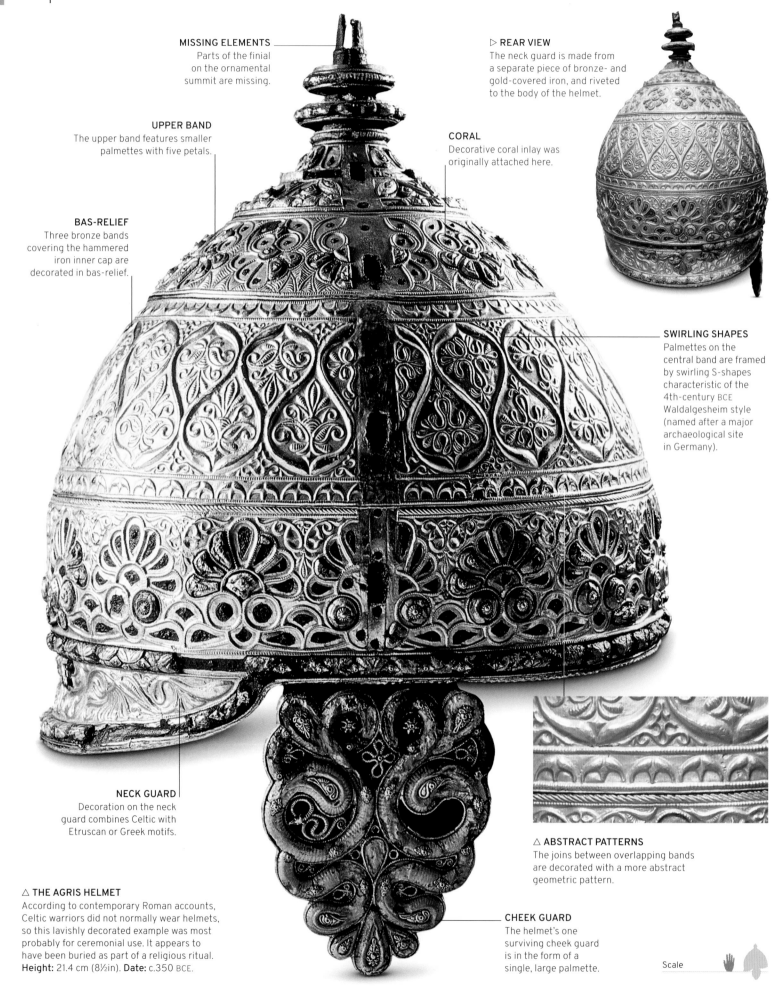

MISSING ELEMENTS
Parts of the finial on the ornamental summit are missing.

UPPER BAND
The upper band features smaller palmettes with five petals.

BAS-RELIEF
Three bronze bands covering the hammered iron inner cap are decorated in bas-relief.

▷ **REAR VIEW**
The neck guard is made from a separate piece of bronze- and gold-covered iron, and riveted to the body of the helmet.

CORAL
Decorative coral inlay was originally attached here.

SWIRLING SHAPES
Palmettes on the central band are framed by swirling S-shapes characteristic of the 4th-century BCE Waldalgesheim style (named after a major archaeological site in Germany).

NECK GUARD
Decoration on the neck guard combines Celtic with Etruscan or Greek motifs.

△ **ABSTRACT PATTERNS**
The joins between overlapping bands are decorated with a more abstract geometric pattern.

△ **THE AGRIS HELMET**
According to contemporary Roman accounts, Celtic warriors did not normally wear helmets, so this lavishly decorated example was most probably for ceremonial use. It appears to have been buried as part of a religious ritual.
Height: 21.4 cm (8½in). **Date:** c.350 BCE.

CHEEK GUARD
The helmet's one surviving cheek guard is in the form of a single, large palmette.

Scale

The Agris Helmet

A ceremonial helmet that is a masterpiece of Celtic art, decorated with motifs typical of 4th-century BCE La Tène culture

Agris, France

In 1981, fragments of gilded iron were unearthed in a cave near Agris in Charente, western France. Subsequent excavations uncovered enough for an almost complete reconstruction of what came to be known as the Agris helmet. The helmet dates from about 350 BCE, during the period of Celtic history known as La Tène culture, and features typically Celtic decorative abstract and plant-inspired designs.

Distinctive ornamentation

The exquisite artwork was realized with exemplary craftsmanship. Horizontal bands of hammered bronze were attached to a base cap made of iron. Each of these bands was ornamented with distinctive bas-relief patterns to form three friezes encircling the helmet, and heavily gilded with gold leaf. Similarly crafted pieces making up a neck guard, two cheek guards, and a spiked conical finial complete the structure.

The magnificent decorations are extremely finely detailed, depicting palmettes (fan-shaped leaf or petal motifs) that show the influence of Greek or Etruscan art while remaining distinctively Celtic, and swirling curves that are more characteristic of Celtic circle and spiral designs.

Scholars are uncertain about exactly where the Agris helmet was made. The "jockey-cap" shape of iron cap with a neck guard is similar in style to Italian helmets of the same period, and the Etruscan influence on the decoration also points to Italy as a likely place of origin. Some scholars have also suggested that the method of covering iron helmets with decorated bands of bronze was more typical of craftsmen in the Alpine regions. It is, however, possible that, along with a small number of other decorated helmets, this example originated in the Atlantic coast region where it was found.

The Agris helmet was **discovered** in a pile of debris **excavated** by a burrowing **badger**

Decorative coral inlay

Overlapping bands of gilded sheet bronze

Base cap of iron (pre-decoration)

△ **CONSTRUCTION TECHNIQUE**
Sheets of bronze were hammered into shape and embossed with decorative designs, then fitted to an iron base, and finally ornamented with coral inlay.

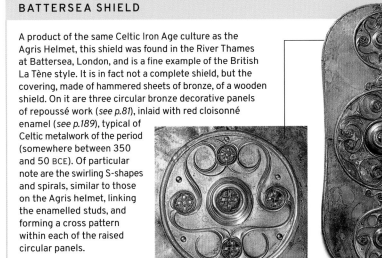

BATTERSEA SHIELD

A product of the same Celtic Iron Age culture as the Agris Helmet, this shield was found in the River Thames at Battersea, London, and is a fine example of the British La Tène style. It is in fact not a complete shield, but the covering, made of hammered sheets of bronze, of a wooden shield. On it are three circular bronze decorative panels of repoussé work (see p.81), inlaid with red cloisonné enamel (see p.189), typical of Celtic metalwork of the period (somewhere between 350 and 50 BCE). Of particular note are the swirling S-shapes and spirals, similar to those on the Agris helmet, linking the enamelled studs, and forming a cross pattern within each of the raised circular panels.

BATTERSEA SHIELD, 350–50 BCE

Xi'an, China

The Terracotta Army

A formidable army of terracotta warriors standing guard over an emperor's tomb is one of the world's most astonishing archaeological finds

△ **STAGES OF PRODUCTION**
This computer-generated image shows four key stages in the creation of the warriors. From bottom to top: the figures were crafted from clay (one) before being fired in a kiln (two); black lacquer was then applied as a base for painting (three); finally, they were painted in vibrant colours.

Qin Shi Huangdi (ruled 221–210 BCE), the emperor who first united China, ordered work on his massive mausoleum complex east of Xi'an 36 years before his death. The final structure covered a staggering 98km² (38 sq miles). Archaeologists began investigating the area in the 1960s, but in 1974 a peasant digging a well came across a pit containing clay fragments.

An astonishing find
What he had unearthed was the first of three pits containing around 8,000 astounding life-size clay warriors, together with horses, chariots, bronze animals, and other treasures – an army to serve the emperor in the afterlife. The warriors included cavalry, infantry, archers in battle formation, and, in the third pit, a command post, generals, and other officers.

Each warrior was made from separate pieces – a plinth, feet, legs, hands, torso, arms, and head. These were standardized, with only three types of plinth, eight forms of torso, and eight variations of head. Yet the hand-carved heads were given different facial expressions, hairstyles, and hats so that none of the 8,000 warriors looked the same. The horses, too, were made of separate sections and once assembled were, like the rest of the army, fired at temperatures of up to 1,050°C (1,922°F), lacquered, then painted (much of the once bright colouring has long ago flaked off).

Archaeologists have since made further astonishing discoveries at Xi'an, including 20 life-size bronze swans in 2001, but much of the tomb is unexcavated. Some sources warn it contains rivers of pure mercury and booby traps made from loaded crossbows.

Among the treasures was a **massive suit** of **stone armour**, composed of **612 pieces** joined together with **bronze wire**

MILITARY FORMATION IN PIT 1

The soldiers in the army were arranged as though in battle formation. The 6,000 warriors in Pit 1, the largest pit, had a three-line deep vanguard of unarmoured warriors, and then a main formation divided into columns – separated by earth partitions – of unarmoured infantry and archers, armoured footsoldiers, and horse-drawn chariots.

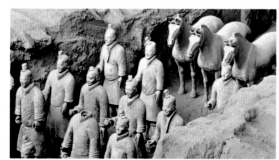

WARRIORS AND HORSES

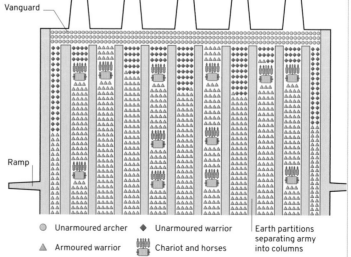

Vanguard

Ramp

○ Unarmoured archer	◆ Unarmoured warrior		Earth partitions separating army into columns
△ Armoured warrior	🏇 Chariot and horses		

LOST WEAPON
Originally, this warrior held a sword.

▷ **THE TERRACOTTA ARMY**
These two striking warriors represent a general (*right*) and a middle-ranking officer – part of the Qin army's command structure. **Height of figures:** 1.9m (6ft). **Date:** 250–220 BCE.

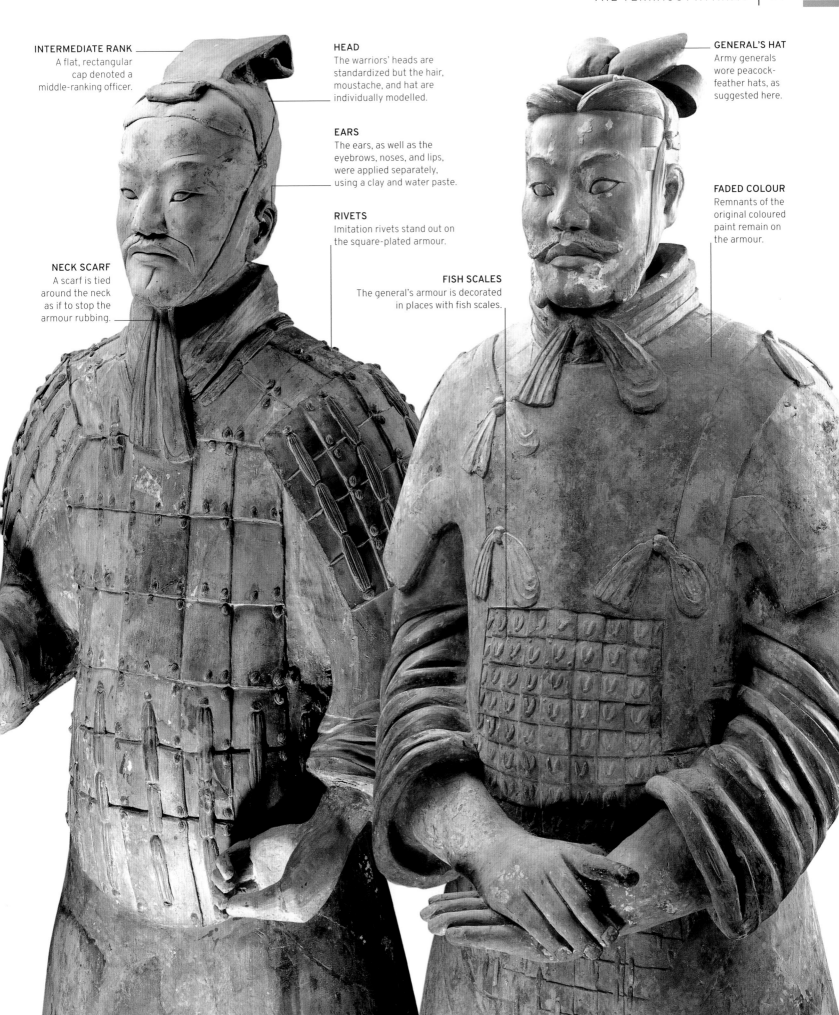

INTERMEDIATE RANK
A flat, rectangular cap denoted a middle-ranking officer.

HEAD
The warriors' heads are standardized but the hair, moustache, and hat are individually modelled.

GENERAL'S HAT
Army generals wore peacock-feather hats, as suggested here.

EARS
The ears, as well as the eyebrows, noses, and lips, were applied separately, using a clay and water paste.

FADED COLOUR
Remnants of the original coloured paint remain on the armour.

RIVETS
Imitation rivets stand out on the square-plated armour.

NECK SCARF
A scarf is tied around the neck as if to stop the armour rubbing.

FISH SCALES
The general's armour is decorated in places with fish scales.

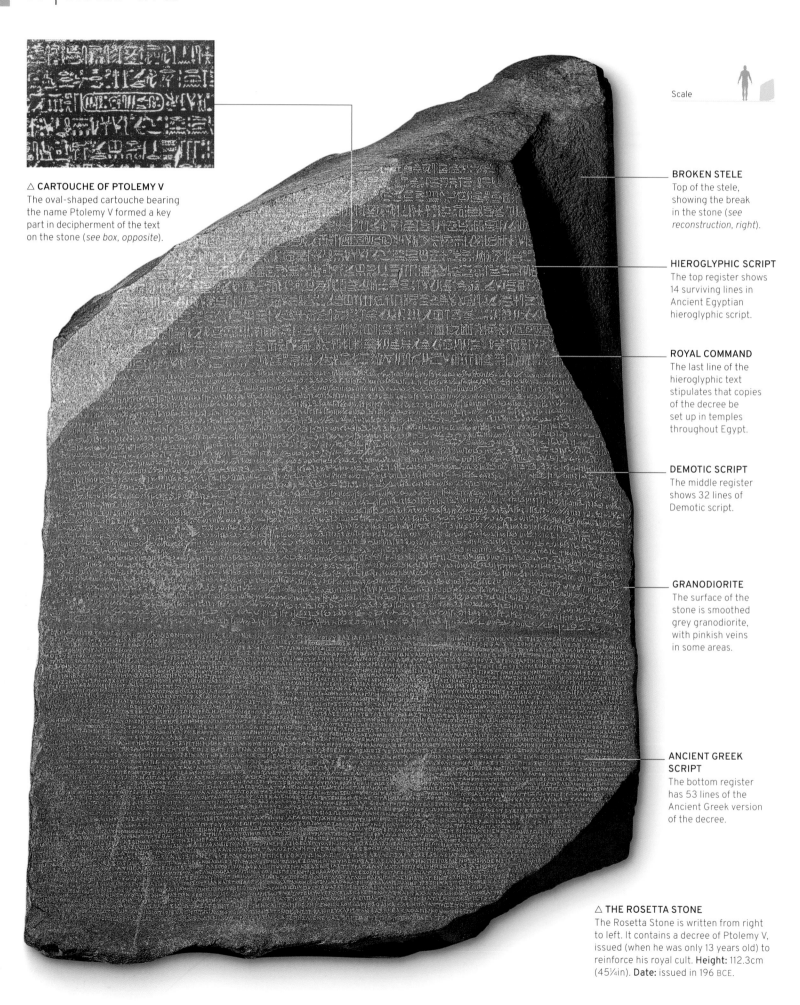

△ **CARTOUCHE OF PTOLEMY V**
The oval-shaped cartouche bearing the name Ptolemy V formed a key part in decipherment of the text on the stone (see box, opposite).

BROKEN STELE
Top of the stele, showing the break in the stone (see reconstruction, right).

HIEROGLYPHIC SCRIPT
The top register shows 14 surviving lines in Ancient Egyptian hieroglyphic script.

ROYAL COMMAND
The last line of the hieroglyphic text stipulates that copies of the decree be set up in temples throughout Egypt.

DEMOTIC SCRIPT
The middle register shows 32 lines of Demotic script.

GRANODIORITE
The surface of the stone is smoothed grey granodiorite, with pinkish veins in some areas.

ANCIENT GREEK SCRIPT
The bottom register has 53 lines of the Ancient Greek version of the decree.

Scale

△ **THE ROSETTA STONE**
The Rosetta Stone is written from right to left. It contains a decree of Ptolemy V, issued (when he was only 13 years old) to reinforce his royal cult. **Height:** 112.3cm (45¼in). **Date:** issued in 196 BCE.

Rosetta, Egypt

The Rosetta Stone

An irregular, 2nd-century BCE granite stele bearing three texts that held the key to unlocking hieroglyphic script and ancient Egyptian history

Various gods receive Ptolemy V, topped by a winged solar disc

Fourteen missing lines of hieroglyphs

The Rosetta Stone was unearthed by French troops in 1799 from Fort Julien at el-Rashid (Rosetta) near Alexandria, Egypt. It is one of the most important artefacts ever found from the ancient world. Made of grey and pink granodiorite (a type of granite), the broken stele weighs some 760kg (1,676lb). Inscribed on it is the same text, a decree of Ptolemy V (ruled 204–180 BCE), in two different languages and three scripts: Egptian hieroglyphs; Demotic Egyptian (a writing form used mainly on papyrus); and Ancient Greek. The symbols were lightly incised, chipped into the stone by masons rather than scribes, using metal hammers and chisels, twisting the chisel between each blow to create the characters and letters.

The stele was shipped to France and examined by scholars. Much of the initial decipherment is credited to the Englishman Thomas Young, but it was the French scholar Jean-François Champollion who is thought to have made the most significant discoveries. Although the hieroglyphics and Demotic script could not be deciphered, the Greek text could be read – this made it possible to compare the Egyptian texts with the known language. The work was painstaking, but by 1822 Champollion had managed to crack the code and many thousands of hieroglyphic and Demotic inscriptions became readable, revealing huge amounts of previously unknown information about Ancient Egyptian language and history.

In 1999, the stone was cleaned. When this process began it was black, but it became clear that the colour had been darkened by the discoverers' use of carnauba wax to protect the stone; originally, it would have been grey. The writing itself, initially pinkish in colour, had taken on a whitish hue from the use of chalk.

Analysis of the stone revealed that hieroglyphs are mainly **phonetic not symbolic** signs

△ **RECONSTRUCTION**
Over the ages, the top 49cm (19¼in) of the Rosetta Stone broke off and was lost. Scholars have reconstructed it (as shown in the lighter sections here) – including the images and the missing hieroglyphic inscriptions – using other, similar, stelae as models.

DECODING THE HIEROGLYPHICS

Scholars before Champollion had presumed hieroglyphs were symbolic (with a sign for a lion meaning "lion"). Champollion knew that Egyptian ruler names were enclosed in cartouches and easily identified the word "Ptolemy" in the Greek text (which he could already read). He found the corresponding cartouche in the hieroglyphic text, which had a similar number of characters, and matched the Greek letter sounds to the hieroglyphs. He confirmed this by testing "Ptolemy" against cartouches on other inscriptions with rulers' names (Kleopatra and Berenike) and found they matched.

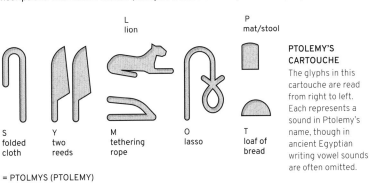

L
lion

P
mat/stool

S
folded cloth

Y
two reeds

M
tethering rope

O
lasso

T
loaf of bread

= PTOLMYS (PTOLEMY)

PTOLEMY'S CARTOUCHE
The glyphs in this cartouche are read from right to left. Each represents a sound in Ptolemy's name, though in ancient Egyptian writing vowel sounds are often omitted.

△ **FORT JULIEN**
The Rosetta Stone was unearthed when French soldiers were digging the foundations for an addition to Fort Julien at el-Rashid.

◁ RESURRECTION
OF WARRIORS
In this panel, a giant, god-
like figure is shown bringing
a line of fallen warriors back
to life by dipping them into
a ceremonial cauldron.

▷ HORNED FERTILITY GOD
The Celtic god Cernunnos,
associated with forests and
wildlife, is shown with antlers,
flanked by animals, and
holding a torc (ring) in one
hand and a ram-horned
serpent in the other.

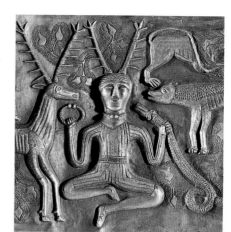

FIGURES
Figures were hammered
into shape from the back
of the panels, with the finer
details chased into the front.

JOINTS
The joints of the cauldron's
interior and exterior panels
are positioned so that
they are staggered.

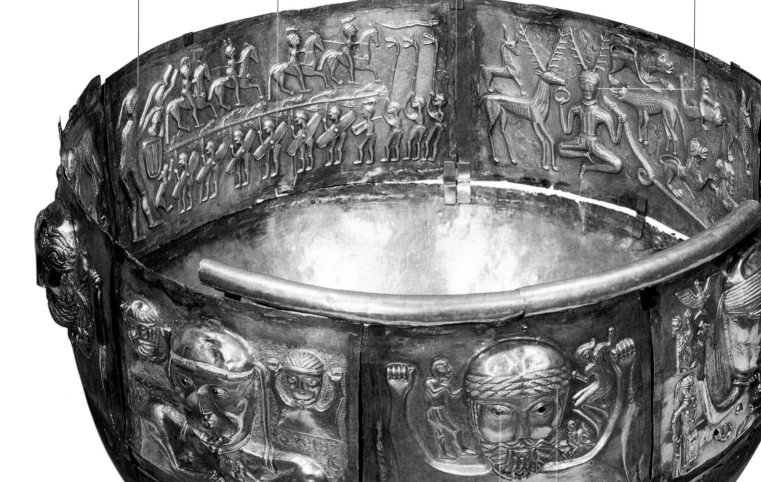

△ THE GUNDESTRUP CAULDRON
The result of the cross-fertilization
of cultures in Iron Age Europe,
this unusually large and elaborate
Celtic cauldron, decorated in high
relief, reflected the prestige of its
owner when offering hospitality.
Dimensions: 42 x 69cm (16½ x
27in). **Date:** c.100–1 BCE.

IRON AGE SOLDERING
Tin solder was originally
used to join the panels
and the base.

THE EYES
Glass inlay, now
missing, was originally
used for the eyes.

HEADBANDS
The heads are typically
depicted wearing
torcs (rings).

THE BASE
The rounded base
is hammered from a
single sheet of silver.

Scale

Modern **analysis** has shown the cauldron to be **97% pure silver** and **3% pure gold**

The Gundestrup Cauldron

A finely crafted silver vessel of the European Iron Age, probably 1st century BCE, decorated with Celtic mythological scenes

Thrace, Balkans

The Gundestrup cauldron was discovered, in pieces, in a bog near Gundestrup, Denmark, in 1891. However, it is clear from the style and workmanship that it was made elsewhere. The scenes from Celtic mythology adorning both the inside and outside of the vessel led scholars initially to suppose it was from Celtic Gaul, but on closer inspection they detected motifs with distinctly Near Eastern influences. More significantly, unlike other Celtic cauldrons, it is made of solid silver, and is similar in style and excellence to the work of the silversmiths of Thrace in the Balkans.

Astounding craftsmanship

The spectacular vessel is formed from a shallow bowl-shaped base, on which were soldered 13 curved panels to make up the sides: five interior panels and seven of the exterior panels have survived. The base is quite simply adorned with a medallion in the centre, but the panels are richly decorated with repoussé and chased relief figures (*see box, below*), with some gilding of important details, and glass inlay. Tubular pieces of silver were attached to the rim to soften the edge for drinking. Slight differences in the hammering of the silver also suggest that it could have been the work of several silversmiths.

The iconography of the scenes depicted similarly shows that the vessel is not purely Celtic, but a fusion of different cultural images and styles. Although the figures – gods, heroes, and animals – are recognizably those of Celtic lore, they are unlike other Celtic depictions, and the narrative differs from conventional Celtic mythology in some details.

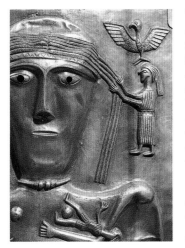

△ **NEAR-EASTERN INFLUENCE**
The small figure on the cauldron grooming a female Celtic deity's hair is accompanied by a bird with outstretched wings – a motif commonly found in Assyrian and Persian art – and is wearing Near Eastern-style long robes.

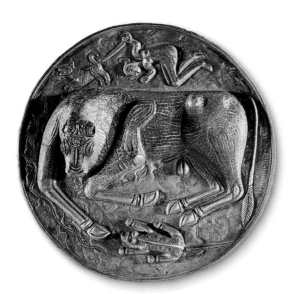

△ **BASE PLATE MEDALLION**
The centre of the interior base shows a female warrior with a raised sword, surrounded by her hounds, slaying a bull. There are holes where the bull's horns, probably made of gold, were originally fitted.

REPOUSSE AND CHASING TECHNIQUES

Repoussé ("pushed back") is a technique used to create relief designs on sheet metal. The metal is hammered from the rear or interior surface using chisel-like tools to form embossed shapes on the face of the sheet. Smooth surfaces are produced with round-faced punches, while finer details are added using more pointed tools, often on the face of the metal, a technique known as chasing.

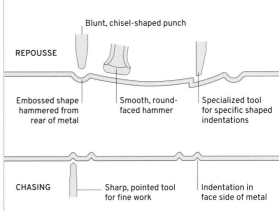

Blunt, chisel-shaped punch

REPOUSSE

Embossed shape hammered from rear of metal | Smooth, round-faced hammer | Specialized tool for specific shaped indentations

CHASING | Sharp, pointed tool for fine work | Indentation in face side of metal

LAOCOÖN ▷

Also known as *Laocoön and His Sons*, the
sculpture is made up of several blocks of marble,
although the joints are so skilfully handled that
they are not apparent to the casual observer.
Height: 2.08m (6ft 10in). **Date:** c.50 BCE–c.50 CE.

Laocoön

*A spectacular ancient sculpture that was discovered during the
Renaissance and has profoundly influenced Western artists*

Rome, Italy

STOLEN BY NAPOLEON

Napoleon first invaded Italy
in 1796, and from then until
his final defeat at the Battle
of Waterloo in 1815, much of
the country was under French
control. Like many conquerors
before and after him, he looted
art on a huge scale, taking
hundreds of famous paintings
and sculptures to Paris:
according to a popular song
of the day, "Rome is no longer
in Rome. It is all in Paris."
Laocoön was on display at
the Louvre in Paris from
1800 to 1815, when it was
returned to the Vatican.

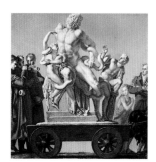

**THE LOOTED *LAOCOON* BEING
TRANSPORTED FROM PARIS**

On 14 January 1506, workmen digging in a vineyard
in Rome found an underground chamber containing
an extraordinary marble sculpture. Michelangelo and
other leading artists rushed to see it, and immediately
realized it was a famous lost masterpiece of antiquity,
extolled by the Roman writer Pliny the Elder as "a work
to be preferred to all other paintings and sculptures".
The reigning pope, Julius II, bought the sculpture and
displayed it in the Vatican, where its anatomical
mastery, energy, and emotional intensity hugely
impressed contemporary and later artists.

Myth and history
The sculpture depicts an incident in the legend of
the Trojan War. Laocoön was a Trojan priest who,
in the best-known version of the story, warned his
people not to trust the wooden horse left by their
Greek enemies, which was a ruse to enter the city. In
retaliation, one of the gods who supported the Greeks
sent two enormous sea serpents, which killed Laocoön
and his sons. Pliny recorded the names of the work's
sculptors, Agesander, Polydorus, and Athenodorus,
who came from the Greek island of Rhodes, but he
did not say when or for whom it was made. However,
in 1957, another great ancient treasure came to light
inscribed with the same sculptors' names. Found in a
marine grotto at Sperlonga, near Naples, this complex
sculpture ensemble comprises a number of figures
representing scenes from Homer's *Odyssey*. The grotto
formed part of the grounds of a villa belonging to the
emperor Tiberius (ruled 14–37 CE), and *Laocoön and
His Sons* may well date from around this time.

The **larger-than-life** sculpture expresses
extremes of **fear and suffering**

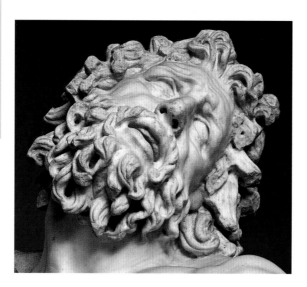

△ **VARIED INTERPRETATIONS**
To most observers Laocoön appears to be howling in pain
and terror, but some 18th-century critics thought he was
bearing his suffering stoically, as this agreed with their
idealized view of Greek art.

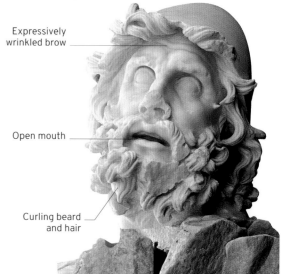

Expressively
wrinkled brow

Open mouth

Curling beard
and hair

△ **ODYSSEUS**
Many of the heavily damaged statues found at Sperlonga
have been reconstructed. The head of Odysseus, from a group
depicting his blinding of the cyclops Polyphemus, shows marked
similarities to the head of Laocoön.

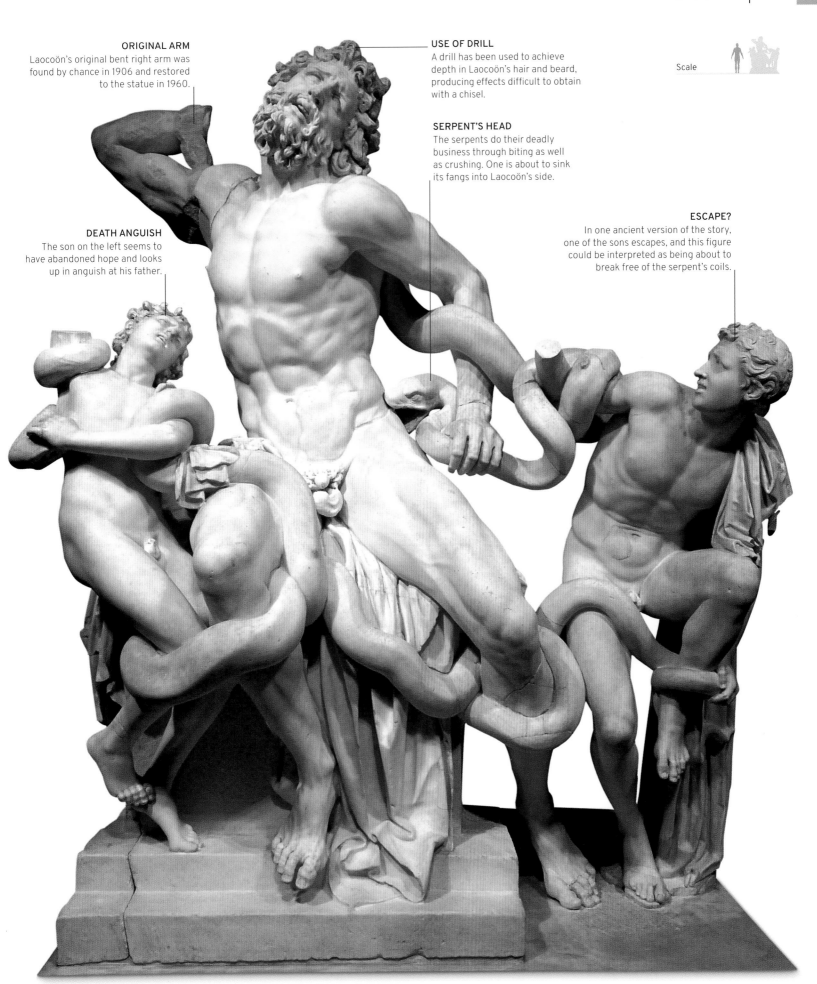

ORIGINAL ARM
Laocoön's original bent right arm was found by chance in 1906 and restored to the statue in 1960.

USE OF DRILL
A drill has been used to achieve depth in Laocoön's hair and beard, producing effects difficult to obtain with a chisel.

SERPENT'S HEAD
The serpents do their deadly business through biting as well as crushing. One is about to sink its fangs into Laocoön's side.

DEATH ANGUISH
The son on the left seems to have abandoned hope and looks up in anguish at his father.

ESCAPE?
In one ancient version of the story, one of the sons escapes, and this figure could be interpreted as being about to break free of the serpent's coils.

Scale

Scale

Bimaran Reliquary Casket

An exquisite golden reliquary casket found in Afghanistan, bearing one of the earliest images of the Buddha

Bimaran, Afghanistan

△ COINS
The casket was found with a collection of beads, along with four coins in the name of Azes II, an Indo-Scythian king who may not in fact have existed. The coins may be from the reign of Azes I or a later king and are thought to date from the 1st century CE.

Found in a Buddhist stupa (dome-shaped shrine) in the mid-1830s by the British archaeologist Charles Masson at Bimaran in Afghanistan's Gandhara region, this small reliquary casket was originally housed inside a steatite (soapstone) box. Inscriptions on the outer casket include a dedication by a man named Sivaraksita, although the reliquary did not, as they state, include any relics of the Buddha. Coins found with it date from the early 1st century CE, but the artistic style, fusing local craftsmanship with Hellenistic influences in a hybrid style known as Gandharan, is more typical of work from around a century later.

A human Buddha

The casket is made of hammered gold sheets – a technique rare in India, which may suggest a central Asian origin – decorated with repoussé ornamentation (*see p.81*). Eight figures – two near-identical sets of four – are separated by arched niches in Greco-Roman style. Aside from its size – it is larger than other Gandharan gold reliquaries – and intricacy, the great importance of this casket derives from the fact that it displays the first dateable artistic representation of the Buddha in human form. Previously, the Buddha was shown symbolically – by, for example, his footprints or an empty throne. Here, the figure can be identified as the Buddha by his prayer gesture and by his cranial bump. He is flanked by the Hindu deities Brahma and Indra. These sets of three figures are separated by the image of a devotee, whose headdress and earrings are those of a bodhisattva (an enlightened believer).

The lavish rows of inlaid garnets interspersed with four-lobed flowers that frame the central band of figures, the fine lotus flower decoration on the base, and the high level of craftmanship mark the casket out as one of the masterpieces of early Buddhist art.

MUDRAS (SACRED HAND GESTURES)

Mudras, or gestures with the hands and fingers, were widely depicted in traditional Buddhist sculpture, providing an additional level of esoteric meaning to images of deities, followers, or the Buddha himself. In one interpretation, each of the five fingers is associated with one of the five elements (sky, wind, fire, water, and earth) and the way the fingers touch creates a symbolic synthesis of these. Over time, the large number of mudras was reduced, some becoming associated with particular Buddhas, including the historical Buddha, Siddhartha Gautama. The mudra depicted on a particular statue may allow believers to identify which manifestation of the Buddha is shown.

ABHAYA
Gesture of courage, symbol of fearlessness, protection, peace, and reassurance.

NAMASKARA
Gesture of greeting and respect. Symbolizes prayer, offering, and devotion.

BHUMISPARSA
The "earth-touching" mudra or gesture of witness, associated with Siddhartha Gautama.

VITARKA
Symbolizes transmission of knowledge and debate, characteristic of teachers.

KARANA
Gesture to ward off evil, used as a sign for dispelling obstacles, fear, and negative influences.

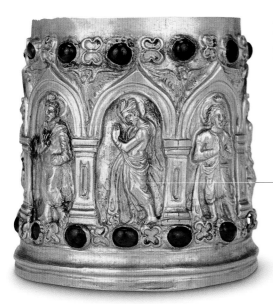

◁ ALTERNATIVE VIEW
The god Indra is portrayed as a prince, wearing a turban and bracelets, and praying to the Buddha.

Representation of Indra wearing a *paridhana* (early form of dhoti).

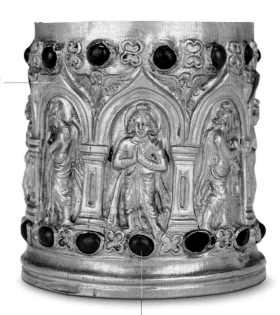

Pointed *chaitya* arch in Greco-Roman style.

ALTERNATIVE VIEW ▷
A haloed bodhisattva, hands clasped in the mudra of respect, *namaskara*, separates Indra and Brahma.

Row of inlaid garnets

▷ BIMARAN RELIQUARY CASKET
The casket contains a wealth of intricate figurative details. Tapering gently from its base to the rim, it originally included a lid, which has since been lost.
Height: 6.5cm (2½in). **Date:** c.1–100 CE.

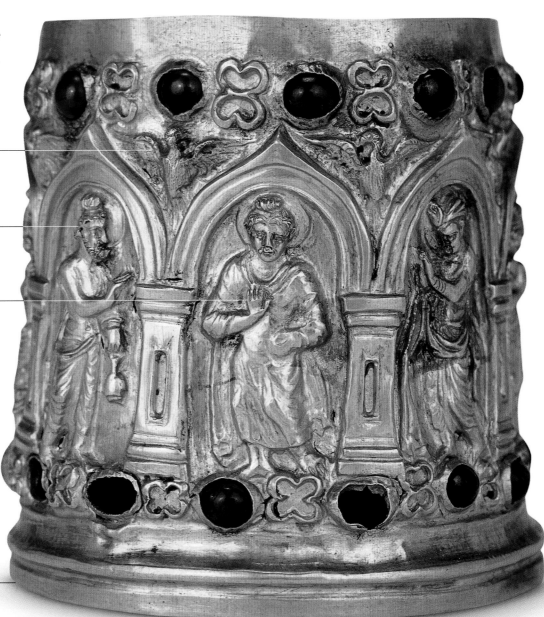

EAGLES
Eagles hover over the central figures with outstretched wings, the feathers shown by shallow grooves.

BRAHMA
The god Brahma is shown carrying a water pot in his left hand.

BUDDHA
The Buddha makes the *abhaya* mudra with his right hand, symbolizing fearlessness and protection.

▽ BASE DESIGN
The base of the casket depicts a lotus in full bloom, a Buddhist symbol of enlightenment and purification.

ORATORIAL POSE
Raising his right hand in the "adlocutio" gesture, Augustus is depicted on the verge of addressing his army.

IDEALIZED PORTRAIT
The face is an idealized portrayal of the emperor as young and handsome, yet sombre and serious.

SEPARATE HEAD
The head and neck were sculpted separately in fine marble from Paros and then fitted to the body.

EGYPTIAN CONNECTION
A sphinx on each epaulette represents Augustus's victory over Cleopatra.

▷ SUN AND SKY GODS
The presence of deities including the sun and sky gods (Sol, left, and, Caelus, right), and the earth, moon, and dawn goddesses (not seen here) symbolizes divine sanction for Augustus's rule.

▷ DIPLOMATIC VICTORY
The central bas-reliefs on the breastplate depict the enemy Parthian king (right) returning the Roman standard that had been lost in battle and was recovered by Augustus.

CONTRAPPOSTO POSE
The contrapposto stance, one leg straight, the other bent as if in motion, suggests confidence and determination.

DIVINE FAMILY
The addition of Cupid is a reference to the claim that the Julian family, to which Augustus belonged, descended from Cupid's mother, the goddess Venus.

BAREFOOT HERO
Usually only gods were depicted barefoot, a coded suggestion of Augustus's divine status.

▷ AUGUSTUS OF PRIMA PORTA
Originally, as was normal for classical sculpture, the Prima Porta statue would have been painted (*see box opposite*), but today it is displayed as it was found, with a clean marble surface. **Height:** 2m (6ft 6in). **Date:** c.1–100 CE.

Scale

MVNIF PII IX.P.M.
AN XVIII

Augustus of Prima Porta

An imposing marble statue of Augustus Caesar, first emperor
of the Roman Empire, from the 1st century CE

Rome, Italy

In 1863, excavations at the Villa of Livia at Prima Porta on the outskirts of Rome uncovered a white marble statue, a portrayal of the emperor Augustus. The statue was probably commissioned by the emperor's wife Livia in his memory, or perhaps by her son and Augustus's heir, Tiberius, and likely dates to the time of Livia's retirement to Prima Porta, before her death in 29 CE.

Father of the empire

One of the most renowned sculptures of the ancient world, this depiction of Augustus is a superb example of the way the Romans used art as propaganda. Carved in the Hellenistic style made famous by the ancient Greek sculptor Polykleitos, it may well have been based on Polykleitos's admired *Doryphoros*, or Spear-Bearer, thereby linking Augustus with youthful beauty and athleticism. His features are idealized in a departure from Roman realism, and he has a relaxed, confident, naturalistic stance. As befits the first emperor of the Roman Empire, the statue is larger than life-size, and has the pose of a great statesman and orator, his right hand raised and the consular baton (now lost) in the other. The dolphin by his right leg is the symbol of one of his great naval victories, the Battle of Actium.

The scenes on the breastplate form a key part of the statue's message. Bas-relief scenes depicting conquered peoples paying him tribute, together with allusions to certain military victories, highlight Augustus as a powerful but benevolent father of the empire, the patriarch who established the Pax Romana, a 200-year period of relative peace considered a golden age. Allegorical references to gods and legends cement the presentation of Augustus as an emperor worthy of elevation to divine status.

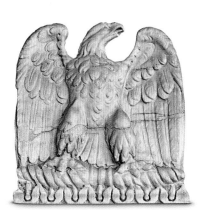

△ **IMPERIAL *AQUILA***
The *aquila*, a golden eagle with wings outstretched, was the most famous Roman military standard (banner); to lose one in battle was a great disgrace. Augustus used his recovery of *aquila* standards captured by the Parthians in his self-promotion.

Augustus is portrayed with his **distinctive hairstyle** and characteristic **fringe**, in what is known as the **Prima Porta style**

AUGUSTUS CAESAR

Revered as the first Roman emperor, Augustus (27 BCE–14 CE) was portrayed in numerous realistically painted statues erected throughout the empire in his honour. Octavian, as he was originally named, was the adopted son of Julius Caesar, and with Marcus Antony and Lepidus ruled the republic after his assassination. The triumvirate was an uncomfortable arrangement, however, and a power struggle eventually resulted in civil war. Octavian emerged triumphant, and was declared emperor by the Senate, taking the name Augustus. Under his reign the empire expanded, and Rome flourished.

Consular baton

Painted in bright colours

AUGUSTUS OF PRIMA PORTA AS IT MAY HAVE APPEARED

Bactria, Afghanistan

Tillya Tepe Hoard

Highlights of a c.1st-century CE collection of the opulent accoutrements of nomadic nobles, known as the Bactrian gold

△ DISCOVERY
The Tillya Tepe site was excavated by a team of Soviet and Afghan archaeologists. Unfortunately the Soviet invasion of Afghanistan in 1979 put a stop to the dig.

After the fall of the Greek kingdom of Bactria around 140 BCE, the plains of northern Afghanistan became the province of a nomadic people, whose lifestyle left little in the way of artefacts for posterity. However, in 1978 a team of archaeologists discovered an extraordinary site of six burial mounds at Tillya Tepe ("mound of gold") whose spectacular contents gave a unique insight into their culture.

Cross-cultural style

Tillya Tepe was situated at a crossroads of the network of trading routes across Asia. The Silk Road from China and trails from India connected with caravan routes to the Middle East and the Roman Empire. The cosmopolitan nature of the region is reflected in the more than 20,000 items of jewellery, coins, ornaments, and other grave goods found in the tombs at Tillya Tepe. It is clear from the opulence of the objects that the bodies were of high-ranking nobles, perhaps a

chieftain and his five wives. The male was buried with his head resting on a silk cushion on a gold plate, and with weapons, turquoise-studded daggers, and a braided gold belt nearby. The women were attired in rich textiles and stunning gold jewellery embellished with gemstones. The highest-ranking female wore a magnificent gold crown made of thin cut-gold pieces in intricate floral and tree patterns, which could be folded or dismantled for travel. One woman had a mirror with Chinese engravings, another a ring depicting the Greek goddess Athena. The nomads clearly had a rich artistic tradition, inspired by cultural elements from across the world.

The bodies were buried with coins from as far afield as Rome, India, and China, which helps to date the site and attests to the range of influences on their culture. Among the artefacts are depictions of Greek and Hindu gods and Persian, Chinese, and even Siberian mythology, blended into a distinctive Bactrian style.

The artefacts display an **astonishing level of skill** and **myriad aesthetic influences**

▷ NECK ORNAMENT
This ornament for the neck of a robe is made of gold, turquoise, garnet, and pyrite. Turquoise seems to have been particularly prized by the Tillya Tepe nomads.

△ "DRAGON MASTER" PENDANT
This opulent pendant was found in the tomb of a woman in her 30s or 40s. The two dragon-like beasts suggest the influence of Chinese art.

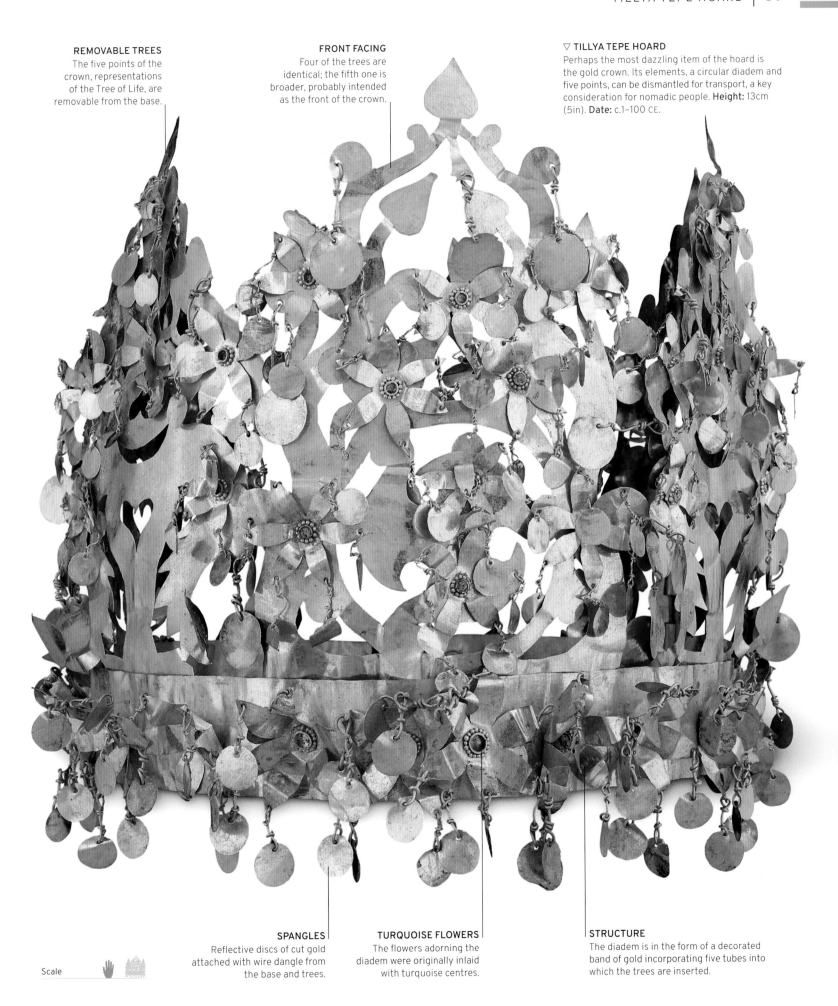

REMOVABLE TREES
The five points of the crown, representations of the Tree of Life, are removable from the base.

FRONT FACING
Four of the trees are identical; the fifth one is broader, probably intended as the front of the crown.

▽ **TILLYA TEPE HOARD**
Perhaps the most dazzling item of the hoard is the gold crown. Its elements, a circular diadem and five points, can be dismantled for transport, a key consideration for nomadic people. **Height:** 13cm (5in). **Date:** c.1–100 CE.

Scale

SPANGLES
Reflective discs of cut gold attached with wire dangle from the base and trees.

TURQUOISE FLOWERS
The flowers adorning the diadem were originally inlaid with turquoise centres.

STRUCTURE
The diadem is in the form of a decorated band of gold incorporating five tubes into which the trees are inserted.

NEWSPAPER ROCK ▷
For want of any documented background, the meanings of the Newspaper Rock petroglyphs are largely undecipherable. **Dimensions:** 18.5m² (220 sq ft). **Date:** c.1–2000.

Newspaper Rock

Mysterious symbols on a Utah rockface that attest to a human presence dating back 2,000 years

Utah, USA

Close to Canyonlands National Park in southeastern Utah, a sloping rock at the base of a low cliff contains an extraordinary assemblage of incised designs. There are about 650 separate images, many of animals, including deer, buffalo, pronghorn antelopes, bighorn sheep, lizards, and snakes, and others depicting human figures, including riders on horseback. Still others are abstract forms that may have had symbolic significance, such as spirals, circles, dots, and wavy lines. Most likely to have been created by the Puebloans, Ute, and Navajo, their meaning has been lost over time, but they may have been intended to convey hunting magic, clan symbols, storytelling, calendar events, or simple graffiti.

The petroglyphs were made with sharpened tools, with which the artists chiselled out shapes from the "desert varnish" – the name given to the dark manganese-iron deposits that form on the sandstone under the influence of rainfall and bacteria. The scraping served to reveal the lighter rock underneath. The oldest incisions have themselves subsequently been exposed to the elements and have started to darken, thereby enabling the relative ages of some of the images to be known.

Pictures through time

Although some of the petroglyphs have been added in recent times, experts believe that the earliest examples date back around two millennia. Individuals from many different Native American cultures made their own contributions over the intervening centuries. The multitude of markings they left behind has created a collage of images that remain to this day as enigmatic as they are historically impressive.

In the **Navajo** language the site is called *Tse' Hone* – "rock that tells a story"

A STORYBOARD FOR THE AGES

The first people to use the rock belonged to the Ancestral Puebloan culture, for whom overhanging cliffs like that above Newspaper Rock often served as shelters. Known as Anasazi by their Navajo successors, the Puebloans are renowned for their pictographic artwork. Other symbols at Newspaper Rock are attributed to the Fremont people, so called after the Fremont River in Utah, and considered by some archaeologists to have themselves been a breakaway Ancestral Pueblo grouping. In later times there were contributions from the Ute (from whom Utah takes its name) and from the Navajo, who are thought to have moved into the area in the 15th century. There have also been more modern additions; inscriptions can be seen dated as recently as 1954.

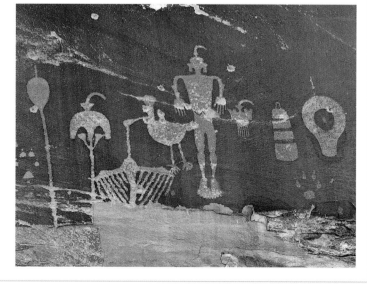

WOLFMAN PANEL, ANCESTRAL PUEBLOAN, UTAH

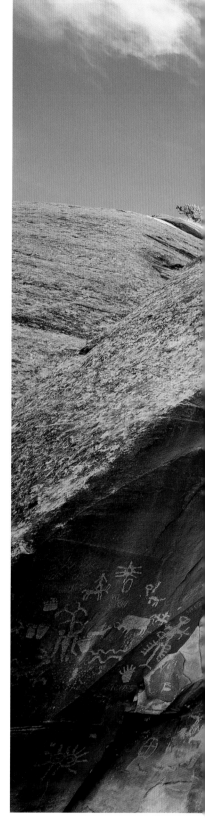

Scale

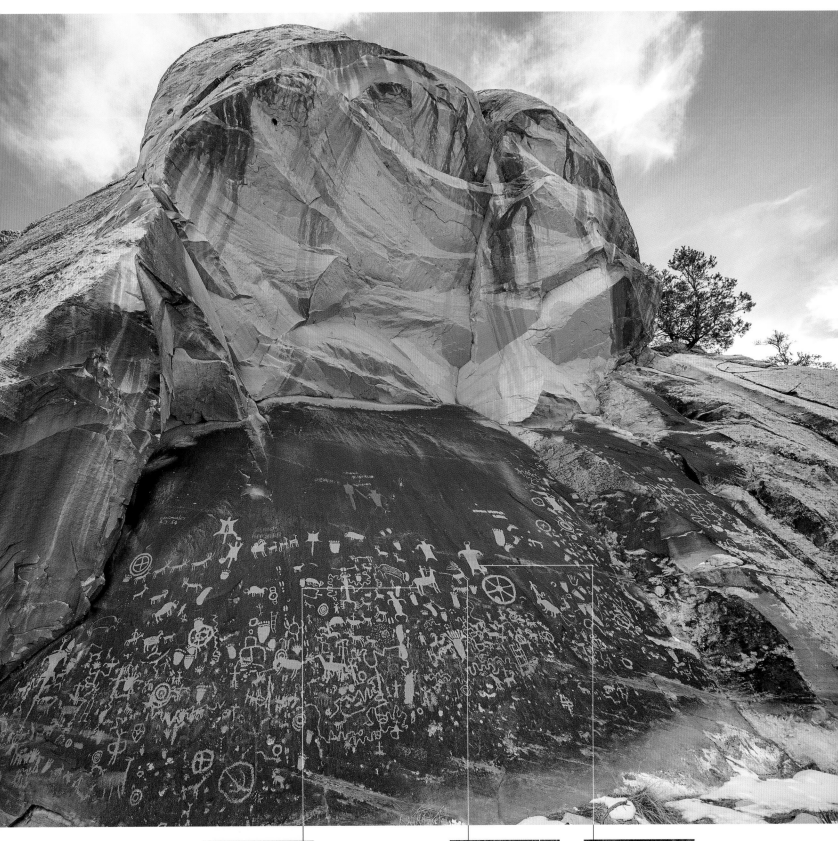

HORSE RIDER ▷
Figures on horseback with bows and arrows probably depict Ute people, who acquired horses in the 17th century.

DEERLIKE ANIMAL ▷
Animals are a common theme, reflecting their importance in most Indigenous Indian or Native American cultures.

◁ HORNED FIGURE
This pictograph may depict the buffalo spirit – buffalo were sacred to many Plains Indians.

Amaravati Pillar

*A carved limestone railing pillar evoking the splendour of a long-lost stupa,
once one of India's greatest Buddhist monuments*

Amaravati,
India

In the 2nd century CE, India's central Deccan region
was ruled by the Satavahanas, a Hindu dynasty
that also patronized Buddhist shrines. One of the
grandest of these rose in the eastern city of
Amaravati, which became one of the most important
centres of Buddhism in southeast India, until the
structure was abandoned after the 14th century.

This vertical slab was the inner face of a pillar that
formed part of the railing surrounding the central
stupa (*see box*). The images on the inner railing
would have been seen by devotees making their
ritual circuit, or *pradaksina*, around the shrine
and therefore showed scenes from the life of the
Buddha and from the Jatakas (Buddhist moral
fables) to aid spiritual contemplation. Here, the
upper roundel contains a devotional scene
depicting the sage Asita cradling the infant
Siddhartha Gautama (as the Buddha was born).
An adviser to Siddhartha's aristocratic father,
Asita prophesied that his son would become
a great religious leader, having received
knowledge of his birth in a vision.

The pillar displays all the busyness of
traditional Buddhist sculpture, and also
its attention to detail. Even the decorations
surrounding the lower half-lotus are carved
with exquisite exactitude.

THE AMARAVATI STUPA

By the 2nd century CE, the Amaravati stupa
consisted of a hemispherical dome on a circular
drum, surrounded by a stone railing that also
delimited the ritual circumambulatory path. Four
projecting entrances at the cardinal points were
marked with five pillars and guarded by seated
lions. Rich carvings decorated the whole complex.

Drum Dome Railing

▷ **AMARAVATI PILLAR**
The railing pillar is carved in a local limestone known as
"Palnad marble". The railing consisted of carved uprights like
this one, connected by three carved bars and topped with
a decorated coping. **Height:** 2m (6ft 6in). **Date:** 100–200 CE.

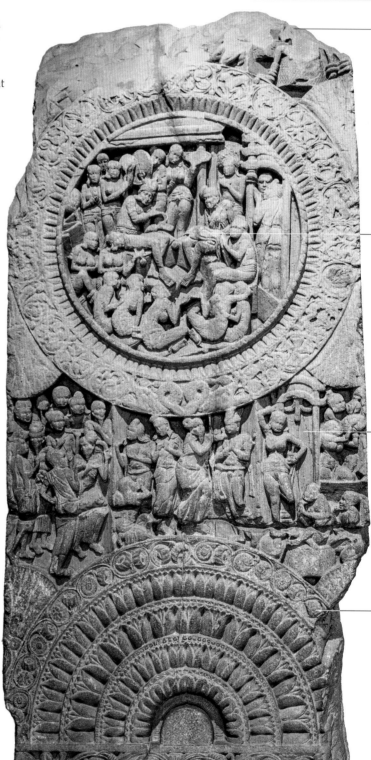

OUTER FACE
The outer face of the
pillar (now lost) would
have been decorated
with secular images,
such as lotus blossoms
or figures dancing or
playing instruments.

**SYMBOLIC
FOOTPRINTS**
The sage Asita holds
a swaddling-cloth on
his knees. As a mark
of reverence, the infant
Siddhartha appears
only symbolically,
represented by the
footprints on the cloth.

CENTRAL SCENE
The crowded central
scene is thought to
represent Asita's
journey to Siddhartha's
birthplace.

HALF-LOTUS
The borders of the
half-lotus at the
bottom of the pillar
contain some of the
finest foliage carving
found at Amaravati.

Scale

Artemis of Ephesus

A striking white marble statue from the 2nd century CE of the Anatolian protector goddess, with finely carved and enigmatic adornments

Ephesus, Turkey

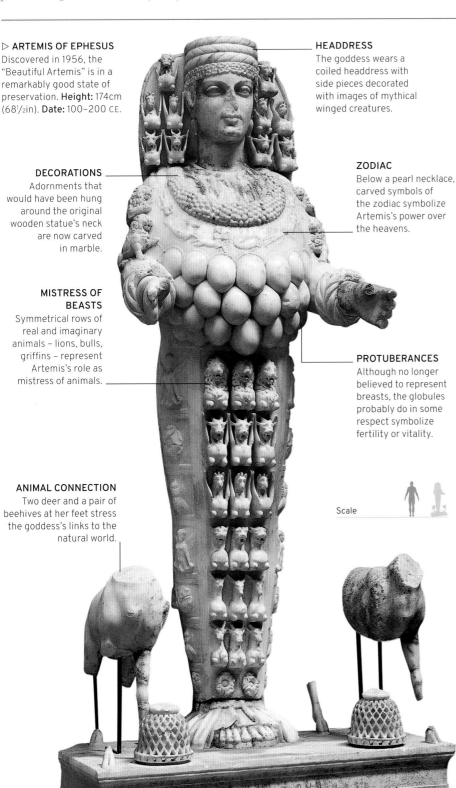

▷ **ARTEMIS OF EPHESUS**
Discovered in 1956, the "Beautiful Artemis" is in a remarkably good state of preservation. **Height:** 174cm (68½in). **Date:** 100–200 CE.

DECORATIONS
Adornments that would have been hung around the original wooden statue's neck are now carved in marble.

MISTRESS OF BEASTS
Symmetrical rows of real and imaginary animals – lions, bulls, griffins – represent Artemis's role as mistress of animals.

ANIMAL CONNECTION
Two deer and a pair of beehives at her feet stress the goddess's links to the natural world.

HEADDRESS
The goddess wears a coiled headdress with side pieces decorated with images of mythical winged creatures.

ZODIAC
Below a pearl necklace, carved symbols of the zodiac symbolize Artemis's power over the heavens.

PROTUBERANCES
Although no longer believed to represent breasts, the globules probably do in some respect symbolize fertility or vitality.

Scale

Located on the west coast of Anatolia (comprising most of present-day Turkey), the city of Ephesus was founded as a Greek colony in the 10th century BCE. From early times its patron goddess was Artemis. But while she was celebrated elsewhere in classical Greece as the goddess of the hunt, Ephesian Artemis was a very different figure. Although associated with animals like her Greek counterpart, she was seen primarily as a mother goddess and a protective deity.

Known as the "Beautiful Artemis", the marble statue shown here was discovered at the site of the temple of Artemis in Ephesus, one of the seven wonders of the ancient world. It has been dated to the 2nd century CE, by which time the city was in Roman hands, and is probably a copy of an original wooden cult image housed in the temple before its destruction. The statue's stiffly upright, static stance, along with the bent arms and long robe tapering to her feet, is characteristic of Anatolian deities. Her body is dressed and decorated to emphasize her power as mistress of wild beasts and queen of the cosmos. Perhaps most striking is the series of oval shapes around her midriff, long believed to be breasts, but now thought more likely to represent the testicles of sacrificial bulls (as an emblem of power and vitality), gourds, or bees' eggs.

The statue **exudes** an **uncanny** combination of **strength, serenity,** and **power**

ARTEMIS / DIANA

In the Greek heartland, Artemis was very different from the matriarch venerated at Ephesus. Like the Roman Diana, she was mainly goddess of the hunt. Although a chaste virgin, she was also associated with childbirth, aiding mothers in labour. This attribute may explain how, in Anatolia, her worship became conflated with that of the local divinity Cybele, creating the hybrid deity the Ephesians worshipped.

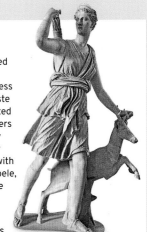

DIANA OF VERSAILLES

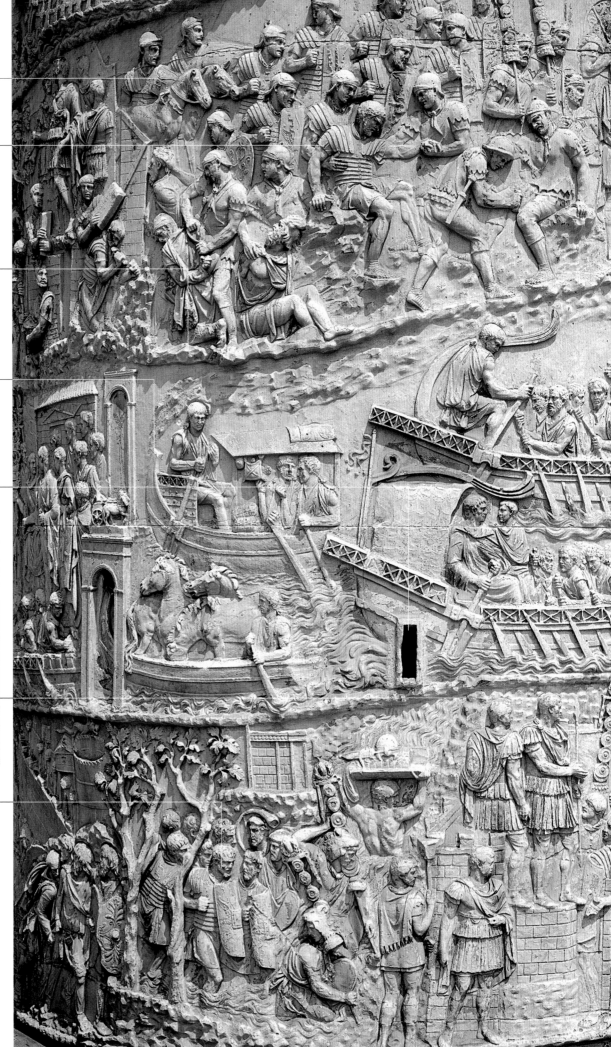

AT THE HEIGHT OF BATTLE
In this scene, Roman auxiliary cavalry charge the Dacians.

FALLEN WARRIOR
Roman soldiers help a wounded comrade from the battlefield.

RAISED BORDER
The sculptor added raised borders to separate the different spirals of the frieze.

SEA TRANSPORT
Roman military transport ships are shown here crossing the Danube River.

WINDOW
An "arrow-slit" window allows light into the column's interior stairwell.

EMPEROR TRAJAN ▽
Trajan, with a spear in hand, is depicted here addressing his troops from a podium.

BODYGUARDS
Roman auxiliary troops are shown here guarding the emperor.

Scale

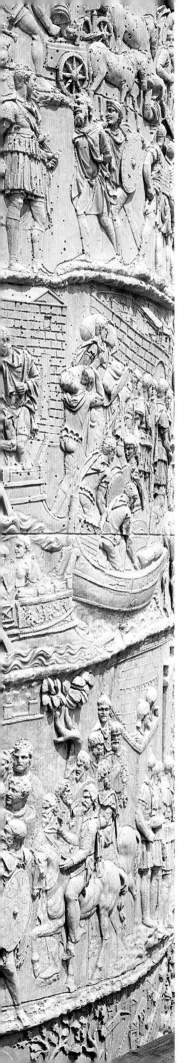

◁ **TRAJAN'S COLUMN**
The column's spectacular white marble frieze, which was probably once painted in bright colours, is conventionally divided into around 140 scenes. **Height:** 38m (125ft). **Date:** dedicated 113 CE.

Trajan's Column

A towering 2nd-century CE column carved with a spiral frieze that tells the story of the Roman emperor's conquests

Rome, Italy

Trajan's Column in Rome, erected on the orders of Emperor Trajan, is decorated by a spiralling narrative frieze that commemorates the ruler's military victories against Dacia (now Romania) in 101–02 CE and 105–06 CE. The white Luna (Carrara) marble column is spectacular, both for its detailed adornment and its immense size – around 38m (125ft) high and 3.7m (12ft) in diameter at the base. The 17 huge marble drums that make up the column's shaft are carved in the 190m (623ft) long, low-relief frieze, which wraps around the monument 23 times, from base to capital. The design and construction of the structure is thought to have been supervised by the Syrian architect and engineer Apollodorus of Damascus.

A marble wonder

At its completion in 113 CE, viewing balconies are said to have been added to nearby buildings to enable spectators to view the frieze at closer quarters.

An internal spiral staircase with 185 steps also allowed access to the top of the monument, which was capped by a gilt bronze statue of the emperor.

The column is an invaluable source of information about Roman military dress (and that of their Dacian adversaries), showing Roman legionaries, auxiliary cavalry, archers, and slingers, siege equipment, boats and the building of entrenchments and fortifications. A chamber in the column's pedestal, or base, may have been intended as Trajan's tomb, although it is unclear whether it ever served that purpose. A belief in the Middle Ages that the statue on top of the column represented St Peter helped preserve the monument from destruction, and in 1588 this was replaced by an actual statue of the saint.

The carvings are now eroded, but drawings and plaster casts of the structure, including a plaster cast copy set up in 1874 in the Victoria and Albert Museum in London, have retained the original appearance.

The frieze illustrates **2,662 human figures**, including **58** depictions of **Emperor Trajan**

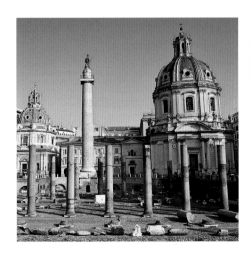

△ **TRAJAN'S FORUM**
The magnificent column (centre) would have towered above the Roman Forum, an imposing visual statement of the emperor's achievements.

CONSTRUCTING THE COLUMN

The column's marble was brought more than 350km (217 miles) from Carrara by sledges and river barges. Each drum was hollowed out on the ground and the interior stairway and window slits carved with chisels. The drums were then lifted by pulleys. These were pulled by men or horses, raising each drum onto a scaffold tower before transferring it to a platform to lower it into place. About seven or eight craftsmen chiselled the friezes after the surface had been smoothed, but it is unclear if they did this on the ground or from the scaffolding.

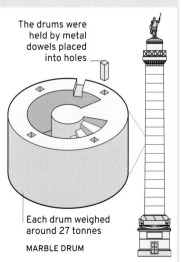

The drums were held by metal dowels placed into holes

Each drum weighed around 27 tonnes

MARBLE DRUM

Fayum Mummy Portraits

Compelling, naturalistic wooden panel portraits bringing to life the faces of affluent Roman-era Egyptians

Thebes, Egypt

Named after the area of Egypt in which they were found, the Fayum mummy portraits are realistic depictions of the dead that were enfolded into the linen bandages of their mummies, in a tradition that lasted from the late 1st century BCE to the mid-3rd century CE. More than 900 portraits survive, their vibrant colours preserved in Egypt's dry conditions. The portraits were created at a time of prosperity for Egypt, when its position as a Roman province gave it access to empire-wide trade networks. First noted by European travellers in the 17th century, many were catalogued by British archaeologist Flinders Petrie in the 1880s.

Subjects ranged from young to old, both male and female, and came from the upper echelons of Egyptian society. It is not known whether the portraits were created while the subjects were still alive or after death. Indicating the influence of Greco-Roman art, the poses are face-on, unlike traditional Egyptian paintings, which depicted faces laterally. The almost life-size faces are painted with a startling naturalism and vivacity, gazing out at the viewer from dark eyes that are slightly exaggerated in size.

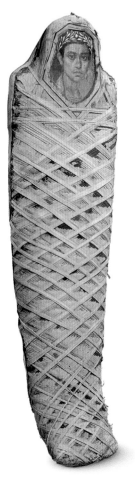

△ **MUMMY WITH PANEL**
This mummy from 80–100 CE retains the panel inserted over the face, showing how the portrait looked in situ. The youth depicted is probably in his early 20s. This portrait is in encaustic on a limewood panel.

△ **FAYUM PORTRAITS**
Fashion and hairstyles are useful for dating. Here, the woman on the left wears earrings favoured in the 2nd century CE; the hair style in the centre portrait is typical of Hadrian's era (117–38 CE); the woman on the right lived during Nero's reign (54–68 CE).

Painting techniques

The painters used two main techniques: encaustic, which produced rich, vivid colours not unlike oil paint; or water-soluble tempera. The works in encaustic are generally of a higher quality. With this method, the paint was applied as melted wax mixed with ground pigments. Large areas of colour were painted onto thin wood panels prepared with distemper, over which finer areas were added. The artists used a *penicillum*, or horse-hair brush, to apply the paint, and then blended and shaped it with tools. Four main colours – white, yellow, red, and black – were used, with blue, green, and purple for clothing and jewellery.

ARTISTS' TEMPLATE

Facial proportions analysis suggests that the mummy artists may have used some kind of a template, since all the portraits have similarly spaced features. Painters may have used basic forms that could be personalized with details such as hairstyles, beards, nose shape, and lip size.

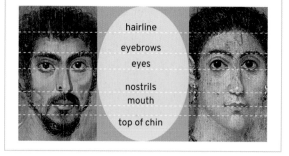

hairline
eyebrows
eyes
nostrils
mouth
top of chin

A few inscriptions on the portraits give the name of the subject

DIVINE GOLD
A laurel wreath, symbolizing divine favour, was created out of gold leaf.

BASE LAYER
A preparatory layer of distemper was laid down.

HAEMATITE
The earth-red pigment for the lips was made from ground haematite.

LAYERS OF COLOUR
The ochre base layer has finer colour details applied for skin tones.

HAIRSTYLE
The elaborate ringleted hairstyle is typical of c.100 CE.

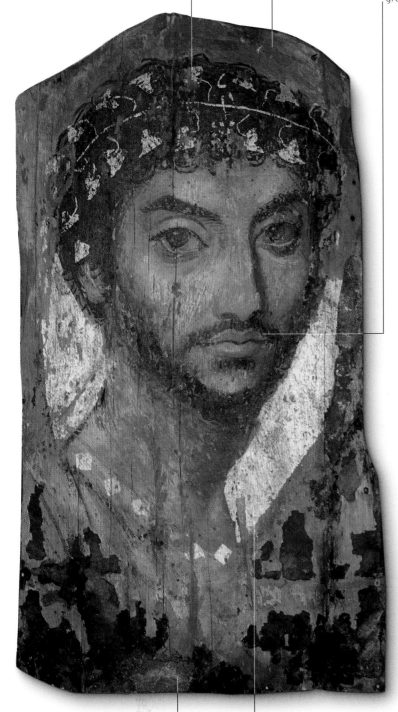

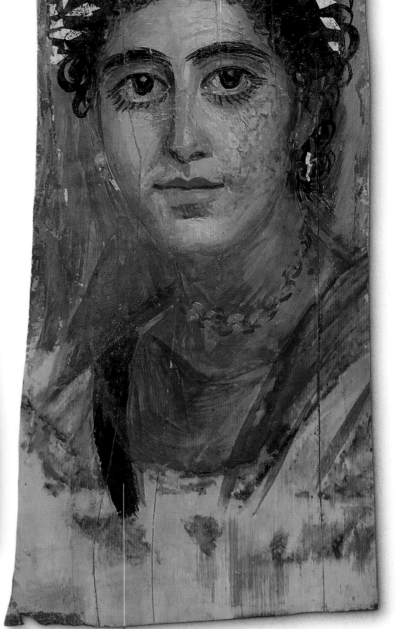

WOOD PANEL
The wooden surface of the panel is visible beneath the paint layer.

SHINING BACKGROUND
Gold leaf was made to adhere to the paint using an egg-white paste.

BRUSH STROKES
Broad brush strokes caused by the encaustic technique give an Impressionistic feel.

△ FAYUM MUMMY PORTRAITS
Both of these portraits were painted using the encaustic technique, giving a depth of colour reminiscent of oil paint. **Man: height** 39.5cm (15½in); **date:** 100–150 CE. **Woman: height** 38cm (15in); **date:** 90–120 CE.

Scale

Gansu Flying Horse

*An 1,800-year-old bronze sculpture that has become a
symbol of China's artistic heritage*

Gansu,
China

Horses were crucial to early imperial China in its struggles with the mounted warriors of the steppes, the Xiongnu; one breed in particular, from the Ferghana region, now in eastern Uzbekistan, acquired almost legendary status. Known as the heavenly horse, the Ferghana was fast, strong-limbed, and tough, and was prized also for the metallic sheen of its coat. The breed was much depicted in art; no single work has won as much renown in recent times as this small, vibrant bronze statue, made during the Eastern Han dynasty (25–220 CE) and unearthed in Gansu province in 1969.

The Gansu Flying Horse is also known as Horse Stepping on a Swallow, for the fact that it is treading on a bird's back – originally thought to be a swallow but now believed to be a falcon – which serves as a symbol of speed as well as a metaphor for flight. The statue is perfectly balanced, with that single grounded hoof forming its centre of gravity. Every other detail, from outstretched legs to rearing head, emphasizes the horse's strength and agility. The bronze statue, now green, would have had a metallic sheen, echoing the distinctive coat of the Ferghana breed.

▷ **FRONT VIEW**
The horse's head and face are vividly rendered, turned slightly to the side, with the mouth open in a neigh.

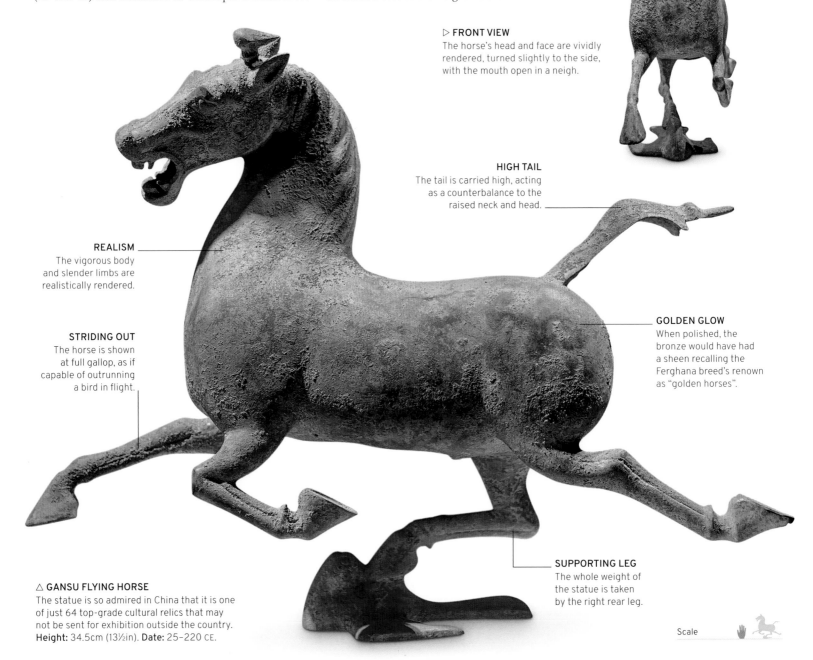

REALISM
The vigorous body and slender limbs are realistically rendered.

STRIDING OUT
The horse is shown at full gallop, as if capable of outrunning a bird in flight.

HIGH TAIL
The tail is carried high, acting as a counterbalance to the raised neck and head.

GOLDEN GLOW
When polished, the bronze would have had a sheen recalling the Ferghana breed's renown as "golden horses".

SUPPORTING LEG
The whole weight of the statue is taken by the right rear leg.

△ **GANSU FLYING HORSE**
The statue is so admired in China that it is one of just 64 top-grade cultural relics that may not be sent for exhibition outside the country.
Height: 34.5cm (13½in). **Date:** 25–220 CE.

Scale

Paracas Textile

A vividly coloured mantle used to wrap a body for burial, displaying the artistic talents of Peruvian weavers two millennia ago

Paracas, Peru

This spectacular mantle is one of the world's most celebrated pre-Columbian textile artefacts. It is one of the finest textiles found at ancient burial sites on the Paracas Peninsula in Peru, where more than 400 mummified bodies were wrapped in "mummy bundles" of layers of fabric and clothing. Although known as "the Paracas textile", it is now believed to belong to the slightly later Nazca culture (*see p.102*). Its bright, vivid colours were preserved by the bone-dry desert conditions and lack of sunlight.

Huge skill and attention to detail went into creating the textile. The central section consists of a pattern of 32 geometric faces woven from camelid (alpaca, llama, or vicuña) wool, using multicoloured threads. Attached to it is a bright-hued border made with a "cross-knit looping" technique (a kind of knitting with a single needle), comprising 90 figures, including humans, animals, and deities. The dyes that gave the threads their vivid coloration were mostly derived from plants, although the rich reds may be from cochineal beetles.

▷ PARACAS TEXTILE
Many different animals, as well as monstrous hybrids, are depicted on the mantle, including snakes, monkeys, and cats; about a third of the figures include a feline motif.
Dimensions: 149 x 62.5cm (58¼ x 24½in). **Date:** 100–300 CE.

CENTRAL PATTERN
The central design of faces was created by the technique of "warp-wrapping", combining beige cotton and coloured fleece.

▽ HUMAN AND SUPERNATURAL
Humans mingle with supernatural beings, differentiated by their feet – those of the non-humans resemble claws. Heads and bodies are consistently shown from the front, while feet are in profile.

PLANT LIFE
All the intricately worked figures are distinct. Many carry plants native to the region, both wild and cultivated, which help to give an insight into Nazca agricultural practices.

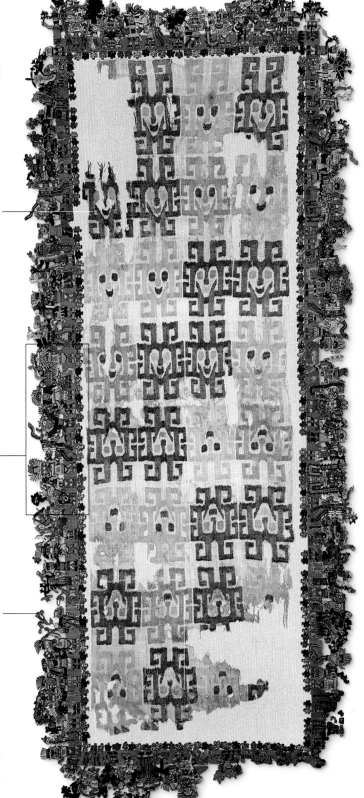

The **repeated central figure** is thought to represent the **Oculate Being,** an **agricultural** or **fertility deity**

Scale

Teotihuacán Sculpture

Finely carved anthropomorphic statues that stand as a testament to one of Mesoamerica's most enigmatic civilizations

Teotihuacán, Mexico

Teotihuacán ("the place where the gods were created"), situated on a high plateau in the northeastern Basin of Mexico, was seen by later Mesoamerican peoples, such as the Aztecs, as the forerunner of their cultures. A thriving metropolis of merchants and craftsmen, it was at its height around 300 CE, when these striking greenstone statues were deposited beneath the city's Pyramid of the Feathered Serpent.

Buried in the pyramid near mass graves of hundreds of people, including warriors, the statues, such as those shown here, may represent the city's founding shamans, positioned gazing out at the ritual centre of the universe. They were probably produced in workshops in the densely populated central district, using greenstone imported as oblong or prismatic blocks from distant quarries within the city's vast cultural sphere. The statues were worked with cutting instruments of flint, basalt, and tezontle (a volcanic stone), with details made by abrading the stone with cords impregnated with quartzite or powdered obsidian. They represent some of the finest artistic production of the city at its height, before (around 300 years later) its centre was burnt by unknown assailants, and the culture mysteriously collapsed.

Only around **a dozen** of the statues were originally carved **with legs**

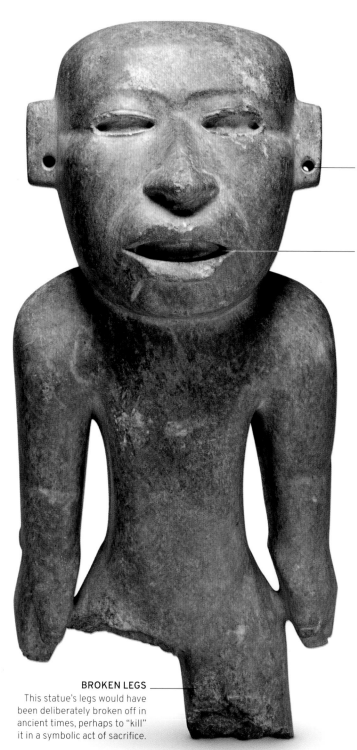

HOLE FOR EAR SPOOL
Holes in the lobes would have held ornamental ear spools (ear plugs).

MOUTH
A trapezoidal-shaped mouth that resembles those on larger Teotihuacán masks.

▷ **SIDE VIEW**
The figure has an oversized head and stands looking directly outwards, its hands held rigidly by its sides.

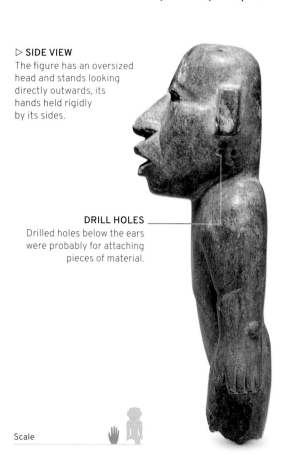

DRILL HOLES
Drilled holes below the ears were probably for attaching pieces of material.

Scale

BROKEN LEGS
This statue's legs would have been deliberately broken off in ancient times, perhaps to "kill" it in a symbolic act of sacrifice.

◁ **TEOTIHUACAN SCULPTURE**
The nudity of this figure carved in green schist rock may indicate it is of a prisoner of war, placed as a substitute sacrificial victim in the pyramid's foundations.
Height: 41cm (16in).
Date: 200–250 CE.

Moche Portrait Heads

A strikingly lifelike portrait in the form of a painted earthenware bottle, exemplifying the ceramic art of Late Moche culture

Peru

From about 100 to 750 CE, the northern coastal region of present-day Peru was inhabited by a number of autonomous communities with a common culture, the Moche culture, which was especially notable for its highly distinctive painted ceramics. Throughout the Moche region, a tradition evolved of magnificent earthenware vessels, often in the form of animals, plants, or human figures, painted with liquefied clay slips of earthy red and cream.

The craft reached its most sophisticated expression after about 500 CE, with the production of spouted bottles or flasks. In the southern Moche region in particular, these took the shape of human heads, as in the striking example shown here. The heads were often portrayals of specific people, presumably prominent members of the community. Multiple portrait-head bottles were made using a single mould or matrix, and were then separately painted to represent individuals with their specific distinguishing features, face paint, and decorated headdress. Moche portrait heads are believed to have had ritual significance, and some have been discovered at or near burial sites.

Some portrait **heads** depict the **same** individual at different **stages** of life

◁ **MOCHE PORTRAIT HEAD**
Although using only red and cream slips, the contrasting colours of this impressive 5th- or 6th-century Moche portrait-head bottle enhance the finely painted decoration, and the glowing earth tones help bring the realistic portrayal to life. **Height:** 32.4cm (12¾in) **Date:** c.200–550 CE.

PALETTE
Decoration with a limited palette of plain red and cream slips is typical of Moche portrait heads.

GEOMETRIC DESIGN
The border of the headcloth is decorated with a recurrent geometric design.

SERPENT
A distinctive headband features four finely painted serpents, their mouths open to show forked tongues and fangs.

FACIAL FEATURES
The eyes, nose, and mouth are realistically and recognizably portrayed.

Scale

METALWORK AND MICRO-MOSAICS

As the Moche culture became established, its communities fostered a flourishing tradition of mastercraftsmen. As well as the bold painted earthenware with which the culture is primarily associated, artists of the late Moche culture developed highly sophisticated metal- and stone-working techniques. Particularly striking are the micro-mosaics — miniature mosaic designs made from minute fragments of shell, turquoise, and other precious stones, painstakingly set in exquisite ornaments and jewellery of silver and gold, as in the ear ornament shown here.

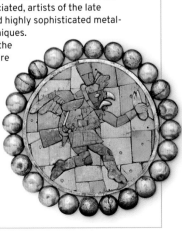

EAR ORNAMENT, WINGED RUNNER, 400–700 CE

DISTINCTIVE DETAILS
The face is painted with red slip, with a characteristic central white stripe; details on the nose and chin are also picked out in red.

HEADCLOTH
The cloth head-covering extends down the back of the neck.

Nazca Figure Vessels

Clay figure vessels boldly decorated in a variety of earth tones, demonstrating the Nazca culture's mastery of the art of painted slipware pottery

Nazca, Peru

The Nazca culture flourished in the south of what is now Peru from about 100 BCE until about 750 CE, and created huge designs cut in the desert soil known as the Nazca lines. The culture is also revered for its crafts, such as its inventive textiles and the highly distinctive ceramics shown here.

Rounded shapes and bold colours

Craftspeople of the ancient Nazca culture employed a method of painting their pottery with slip (liquified clay) before firing. By mixing slip with various mineral pigments, they achieved a range of different colour finishes, making it possible to produce their distinctive

and instantly recognizable polychrome pottery. Typical of their output were thin-walled clay vessels, such as bulbous single- or double-spouted bottles with a strap handle, or open jars and bowls. They were often modelled in the shape of stylized human or animal figures, and were decorated with bold, vivid designs painted on a generally white or earthy red background. Features were frequently outlined in black and filled in with a wide array of colours including red, orange, yellow, cream, blue-grey, maroon, and purple. As the culture evolved, the designs became increasingly abstract, demonstrating a love of geometric symbols and motifs that was also seen in Nazca textiles.

Scale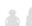

More than **fifteen distinct colours** can be identified in the decoration of **Nazca pottery**

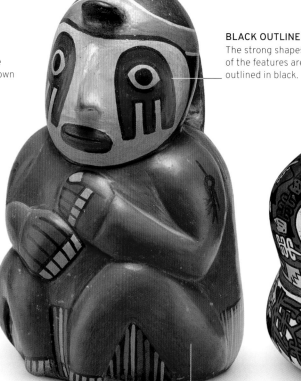

GEOMETRY
Later Nazca pottery features geometric designs, as shown on the clothing of the female figure.

BACKGROUND
Typically, the backgrounds are coloured red-brown or white.

BLACK OUTLINE
The strong shapes of the features are outlined in black.

△ **NAZCA FIGURE VESSELS**
The squat figures of these three spouted vessels are typical of Nazca pottery. The seated ruler (left) is in the earlier, realistic style; the seated figure (centre) is more stylized; the female figure (right) represents a move towards more abstract, geometric decoration. **LEFT Height:** 16.5cm (6¹/₂in); **Date:** 200 BCE–600 CE. **CENTRE Height:** 23cm (9in); **Date:** 1–200 CE. **RIGHT Height:** 14cm (5¹/₂in); **Date:** 300–600 CE.

SHINY SURFACE
Figures were polished to a high shine after firing.

BULBOUS FORM
The somewhat bulbous shape without a flat base is a common design for Nazca pottery vessels.

Lycurgus Cup

An outstanding example of a Roman diatretum, or cage-cup, made from glass that changes colour when light is shone through it

Rome, Italy

The most immediately striking feature of this 4th-century Roman drinking vessel is the exquisite relief cut into its exterior, depicting the death of the mythological King Lycurgus, ensnared by vines on the orders of the god Dionysus. By meticulously cutting and grinding away the surface of a thick blown or cast glass cup, a network of figures and vines is made to stand out in high relief, forming a decorative "cage" around the cup, in places completely undercut and raised above the background.

Just as impressive is the highly unusual optical property of the glass itself. Roman glassmakers had discovered that by adding silver and gold dust to glass, it turns dichroic: that is, it appears to change colour depending on whether light is reflected from it or transmitted through it (*see box, below*). The Lycurgus Cup is widely thought to be one of the most outstanding achievements of ancient glasswork, both for its astonishing colour-changing properties and its spectacular craftmanship.

Scale

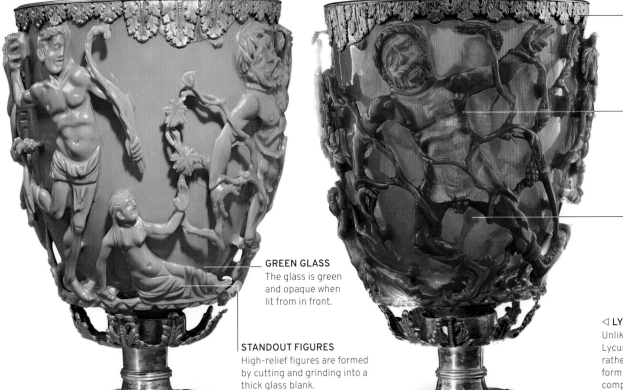

VINE-LEAF MOTIFS
The gilt-bronze rim and foot with vine-leaf motifs are 19th-century additions.

KING LYCURGUS
The relief cut into the glass depicts King Lycurgus, entangled in vines, being tormented by Dionysus and his followers.

RUBY RED GLASS
The glass is red and translucent when light is shone through it from within.

GREEN GLASS
The glass is green and opaque when lit from in front.

STANDOUT FIGURES
High-relief figures are formed by cutting and grinding into a thick glass blank.

◁ **LYCURGUS CUP**
Unlike other Roman cage-cups, the Lycurgus Cup features a figurative rather than abstract design, in the form of a mythological narrative composition around the outer surface that is dramatically enhanced when lit from within. **Height:** 16.5cm (16½in). **Date:** 300–400 CE.

DICHROIC GLASS

Made with minute amounts of powdered gold and silver, dichroic or "two-colour" glass is not perfectly transparent, but appears more or less opaque and tinted, depending on how it is lit. If light is shone onto it, the reflected light from the surface is seen as greenish, and the glass appears to be opaque; but when light is shone through it, the glass appears translucent and colours the light ruby red.

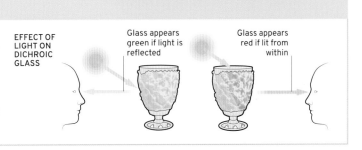

EFFECT OF LIGHT ON DICHROIC GLASS

Glass appears green if light is reflected

Glass appears red if lit from within

DETAILS
Hairstyles, jewellery, and
even striped ikat cloth
were depicted in detail
by the artists.

RENUNCIATION ▷
Mahajanaka talks to
his wife, Sivali, about his
decision to renounce
his throne.

PERSPECTIVE
The later Ajanta paintings
show a remarkable mastery of
perspective, especially in the
architectural backgrounds.

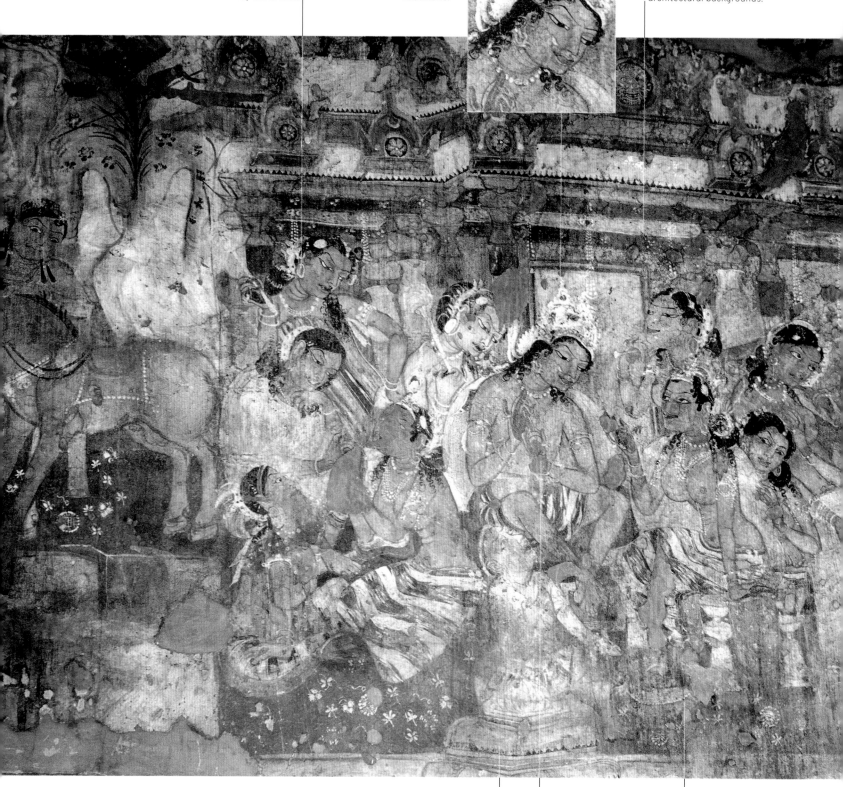

△ AJANTA CAVE PAINTINGS
A highlight of the interior of Cave 1, this painting shows
a scene from the Mahajanaka Jataka. The queen and
others in the king's retinue tempt him with music and
dance. **Height:** approx. 2m (6ft 6in). **Date:** c.475–500 CE.

PREPARATION FOR PAINT
The stone walls were rendered with a
thick coating of paste made from clay,
cow dung, animal hair, and vegetable
fibre, and a fine coat of white lime.

GESTURES
Carefully depicted
hand gestures reinforce
the didactic nature of the
central figure.

BURNISHING
Once dry, the painting
was polished to a sheen
using a smooth stone.

◁ **GREENS**
Pigments ranging from dark green to pale blue-green were derived from ground glauconite.

Ajanta Cave Paintings

Vibrantly coloured depictions of Buddhist legends painted on the walls of rock-cut monasteries in India's Ajanta Caves

Aurangabad District, India

Above the Waghur River in Maharashtra, India, high on the side of a horseshoe-shaped cliff, are the Ajanta Caves. This complex of 30 rock-cut caves contains the finest surviving examples of ancient Indian painting. They were built in two phases, the earliest dating to c.100 BCE–c.100 CE, with the later caves (the majority) being carved out in the 5th century CE. Some are halls of worship, but most are in the form of a Buddhist *vihara*, or monastery. These are usually square, and feature a cloister around a courtyard, cells for the monks, and a statue of the Buddha. They are richly decorated with carvings of Buddhist motifs and deities, but it is the vivid and well-preserved frescoes for which the Ajanta caves are especially renowned.

Buddhist tales brought to life

A wealth of ancient Indian art is visible on the rendered walls and ceilings of the caves, created using tempera in the "dry fresco" technique, by which the pigment is applied to the stucco after it has dried rather than directly onto fresh plaster. The paintings are striking in the richness of their colours, achieved using pigments made from kaolin chalk, lamp soot, green glauconite, yellow ochre, and ground lapis lazuli.

With unrivalled vigour and dynamism, and a dexterous use of colour and shading to give substance, the murals mainly depict scenes from the Jataka tales, moral fables narrating the past lives of the Buddha. Cave 1, for example, portrays the story of the king Mahajanaka, who renounced his kingdom to live as an ascetic. Among the other paintings in this cave is a stunning depiction of the bodhisattva Padmapani that in its physical detail and sublime serenity combines the material world and the divine.

CAVE 1

One of the later caves to be excavated, Cave 1 is located at one end of the horseshoe-shaped scarp. It has a veranda and entrance court (*below*) with elaborately carved pillars, an internal pillared hall with 14 monks' cells, and an inner shrine containing a colossal Buddha figure. The carvings and murals are of extremely high quality.

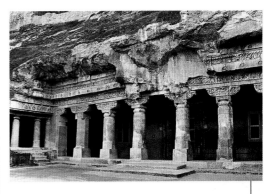

KEY
- ■ Phase 1 caves
- ■ Phase 2 caves

N

bridge

Waghur River

Cave 1

Early **Western observers** were **shocked** at the **sensuousness** of the paintings in a place of **worship** and **asceticism**

Scale

Kaifeng, China

The **scroll** embraces **three art forms:** **painting**, **poetry**, and **calligraphy**

Admonitions of the Instructress

An exquisite painted silk handscroll that is the most celebrated
example of early Chinese painting

The *Admonitions of the Instructress to the Court Ladies*
is a narrative handscroll painting on silk, illustrating
a poem (292 CE) by the courtier Zhang Hua. The poem
was intended as a rebuke to Empress Jia (256–300 CE)
about her unseemly conduct and corrupting influence
on her husband, Emperor Huidi (ruled 290–306 CE),
at a time of severe political disunity in China.

Early Chinese paintings

The beautiful scroll was long attributed to the artist
Gu Kaizhi (344–406 CE), whose light brushstrokes
and fine delineations secured his status as China's
most revered early artist. However, the calligraphy
and modelling of the figures are stronger than Gu's
abbreviated style, leading most scholars to conclude
that the highly treasured work is not a Gu original,
but is more likely based on an original by him, which
was copied at some time during the 5th or 6th century.

The *Admonitions* scroll is revered not only for its fine
linear style and the exquisite elegance of the figures
but also as one of the earliest examples of Chinese
handscroll painting. Executed in ink on mounted silk
and with brocade end panels bearing imperial seals,
it originally illustrated 12 scenes from the poem (of
which the first three are lost). The scenes variously
depict court ladies, courtly life, and exemplary conduct
that reflects virtues associated with the philosopher
Confucius, such as wisdom, respect, humility, and
loyalty. In the final scene, the instructress of the
title is shown writing her admonitions on a scroll.

The scroll was first recorded in a book written in
1103, when it was owned by an official in the Song
imperial palace. After the fall of the Song capital,
Kaifeng, to invading Jurchen nomads, it disappeared,
only to resurface in 1562 during the Ming dynasty,
after which it passed through a variety of owners.

◁ *PINE, BAMBOO, ROCK,
AND SPRING*
Painted as a frame for the seal of
imperial ownership, this work by
Zou Yigui (1686–1772) adorns the
colophon at the scroll's end. The
trees represent virtue and humanity.

▽ **COMPLETE SCROLL**
The scroll illustrates nine of 12
scenes in Zhang Hua's poem, with
each scene accompanied by lines
from it. Over time, inscriptions and
seals were added by various owners,
including Emperor Qianlong, who
had acquired the scroll by 1746
and painted an orchid on it.

▽ ADMONITIONS OF THE INSTRUCTRESS
This scroll was used to educate court ladies on correct moral behaviour. It was unrolled from right to left, and scene by scene. **Dimensions** (excluding additional sections): 25 x 349cm (9¾ x 137½in). **Date:** 400–600.

Scale

ART OF ADORNMENT
A maid helps a court lady with her hair. The artist uses red colourwash over fine, darker brush lines.

INNER TRUTH
A mirror (see also right), symbol of truth, hints at a moral message: that the inner self is as important as external appearance.

MAKEUP
Black lacquer cosmetic boxes dominate the foreground.

SONG SEAL
The Song dynasty (960–1279) left its mark in the form of an imperial seal.

REFLECTIONS
This court lady's face is reflected back for the viewer in the mirror she holds in her hand.

THE POEM
An extract from Zhang's poem begins: "Men and women know how to adorn their faces."

500–1199

During this period, the major world religions became firmly established, exerting their powerful influence on human creativity. There was an explosion of devotional art from the Hindu, Buddhist, Christian, and Islamic traditions that was expressed in written works and in a multitude of media from cave frescoes to large-scale pottery statues and stone carvings.

In the secular sphere, history was recorded in remarkable works like the Qingming Scroll and the Bayeux Tapestry. Cultures in Europe, Africa, and South America, as yet untouched by the major religions, produced extraordinary works of sculpture, metalwork, stonework, and painting that have given us a unique insight into their societies and beliefs.

MOSAICS OF SAN VITALE ▷
The reign of Emperor Justinian I (527–65) saw a flowering of Byzantine art known as the Golden Age. This is reflected in the complex and dazzling floor-to-ceiling mosaics in the sanctuary and apse of the Basilica of San Vitale. **Date:** c.526–c.547.

Mosaics of San Vitale

A tour de force of 6th-century Byzantine mosaic art, noted for its Christian iconography and images of imperial power

Ravenna, Italy

In 526, work began on the Basilica of San Vitale in Ravenna, Italy, then ruled by the Ostrogothic king Theoderic. The church was finished in 547 and dedicated to Ravenna's patron saint, Vitalis. By then, Ravenna was under the control of the Byzantine emperor, Justinian I, who conquered the town in 540. These political changes are reflected in the extraordinary, shimmering mosaics that line the walls and ceiling of the church, and which combine Christian symbols and images from the Bible with representations of imperial power. The sanctuary, whose mosaics were completed before 535, is filled with biblical scenes and characters, including Abraham, Moses, Cain and Abel, the Evangelists, and Christ. However, at the foot of the apse are two famous mosaics, completed after 540, showing Emperor Justinian, his wife, Theodora, and his court. Flanked by Bishop Maximian of Ravenna, members of the imperial administration, and soldiers, Justinian is shown as the figurehead of a Christian empire in which Church and State are intimately connected.

Byzantine innovation

The mosaics also illustrate the stylistic differences between classical Greek and Roman mosaics and those of the Byzantine empire. San Vitale's mosaics reflect earlier forms in their use of colourful, lively depictions of nature. However, the extensive use of gold leaf and gemstones in tesserae (the tiles used in mosaic) was a Byzantine innovation. Moreover, while classical mosaic focused on realism, Byzantine Christian mosaic was imbued with symbolism. The use of dazzling colours and gold and the sheer extent of the mosaics were intended to transport visitors to a spiritual realm.

The **mosaics** are one of the **most important testimonies** to the art of the **Justinian age**

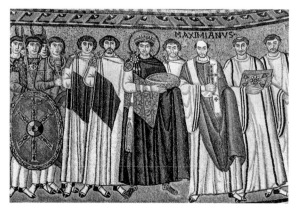
△ **EMPEROR JUSTINIAN I**
Justinian stands at the centre of a group of clerics and soldiers. His stylized halo echoes the image of Christ and serves as a reminder of the divine origin of imperial authority.

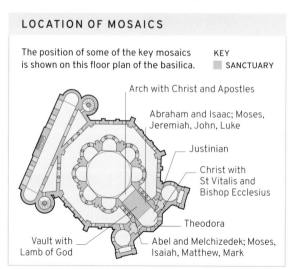
LOCATION OF MOSAICS
The position of some of the key mosaics is shown on this floor plan of the basilica.

KEY
☐ SANCTUARY

Arch with Christ and Apostles

Abraham and Isaac; Moses, Jeremiah, John, Luke

Justinian

Christ with St Vitalis and Bishop Ecclesius

Theodora

Vault with Lamb of God

Abel and Melchizedek; Moses, Isaiah, Matthew, Mark

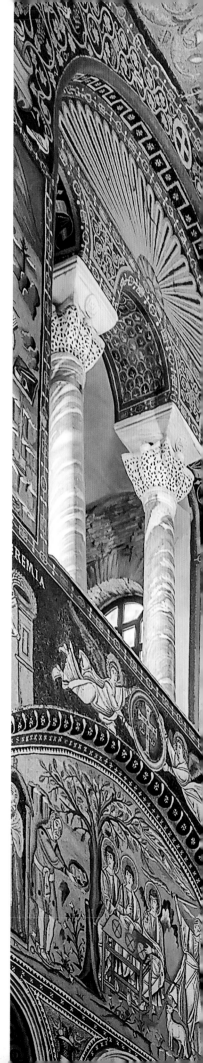

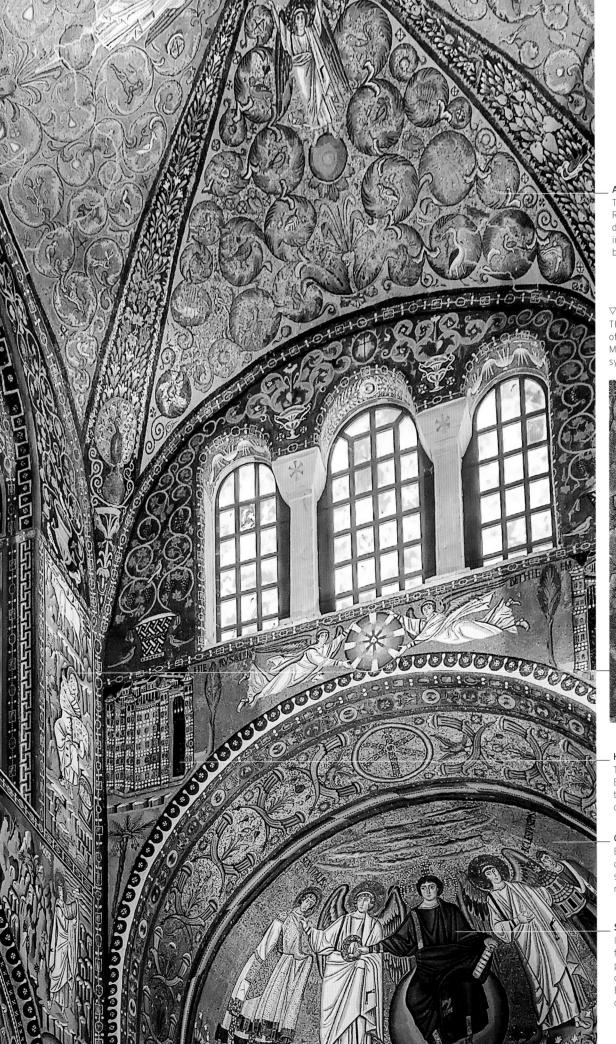

Scale

ANCIENT TECHNIQUES
The mosaics are in the Hellenistic-Roman tradition, full of colour and detail, with vivid depictions of nature, including stars, floral motifs, animals, birds, and even fish.

▽ SAINT LUKE AND OX
The sanctuary features images of the four Evangelists (Matthew, Mark, Luke, and John) under their symbols (angel, lion, ox, and eagle).

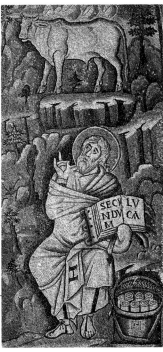

HOLY CITIES
The cities of Jerusalem and Bethlehem symbolize respectively the Jews and the Gentiles, and, overall, the human race.

GOLD TESSERAE
Byzantine mosaicists used gilded tesserae to increase the sense of awe and spirituality in religious spaces.

SEATED CHRIST
In the apse, Christ sits atop a globe from which flow the four rivers of paradise. He offers the martyr's crown to St Vitalis to his right, while Bishop Ecclesius offers him a model of the church.

△ GOLD BELT BUCKLE
This ornate hinged buckle found at Sutton Hoo uses a locking device with a complex system of sliders and internal rods that fit into slotted fixings.

▽ SUTTON HOO HELMET (REPLICA)
A replica, created at the Royal Armouries in Leeds, shows how the helmet is likely to have looked.
Height: 31.8cm (12½in).
Date: 600–700.

RAISED FIGURES
This decoration was made by the *pressblech* process, where metal foil is hammered on a die carved with the desired image.

BOAR'S HEAD
The eyebrows end in gilded boars' heads, which symbolize courage and strength.

MOUTHPIECE
The nose, mouth, and moustache were cast as one piece in copper alloy. Nostril-like holes allow the wearer to breathe.

FACEPLATE
The silvery faceplate is covered with bright tinned copper alloy panels.

Scale

Eastern Suffolk, England

Sutton Hoo Helmet

A 7th-century ceremonial helmet that sheds light on the wealth, connections, and beliefs of an early Anglo-Saxon leader

Original fragment Crest of gilded dragons (original)

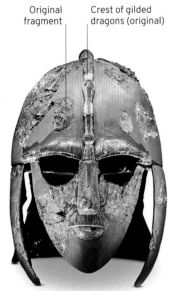

△ **RECONSTRUCTED HELMET**
Fragments of the original Sutton Hoo Helmet were painstakingly pieced together at the British Museum in London.

In 1939, excavations in a field at Sutton Hoo on England's east coast revealed a buried Anglo-Saxon ship, the resting place of a wealthy warrior. Ship burials of this type were practised by several seafaring cultures around the world but were uncommon in Anglo-Saxon England. The presence in the ship's burial chamber of hundreds of precious objects, among which was a helmet of exquisite artistry, indicated that this was the grave of an important ruler, perhaps the local king, Rædwald.

The helmet was corroded, and the collapse of the burial chamber in which it was found had broken it into hundreds of pieces. Reconstructing the helmet was a painstaking process that involved matching the fragments by their thickness, curvature, and texture. After reconstruction, the structure of the helmet emerged. It is made from several iron pieces: a cap shaped from one piece of metal, a neck guard, cheek guards, and a face mask. Each piece is fixed by leather hinges to give a snug but movable fit. The iron is overlaid with copper-alloy sheets stamped

The **helmet** was broken into more than **500 fragments**

with patterns and motifs, including fierce creatures and dancing warriors, similar to 7th-century finds from Scandinavia linked to the cult of Wodan (Odin), the one-eyed Germanic god of war.

On the helmet's crest, two gilded dragon heads with garnet eyes lead to the facemask. There, a dragon's outstretched wings, lined with garnets and patterned with silver inlay, form the mask's eyebrows, its body the nose, and its tail the moustache. The garnets that form part of the left eyebrow are backed with gold reflectors that would have made these stones glow while the other eyebrow remained dark, possibly in reference to Odin's one eye.

THE SHIP AND THE BURIAL MOUND

The ship excavated at Sutton Hoo in 1939 (*see right*) was 27m (89ft) in length. The body of the ruler for which it had been made had decomposed. The cross-section here (*see right, below*) shows what was thought to be the original profile of the mound compared to its profile when it was excavated in 1939. It also shows the position of the ship and burial chamber and the existence of a robber's pit, which indicates that 16th-century treasure seekers were very close to uncovering the burial chamber, which also contained the treasure. The many objects found there (*see also far right*) reflected the attributes of the man they were buried with. A sword with inlaid garnet and gold plate spoke of his success as a warrior, while silver-gilt drinking horns testified to his generosity as a host.

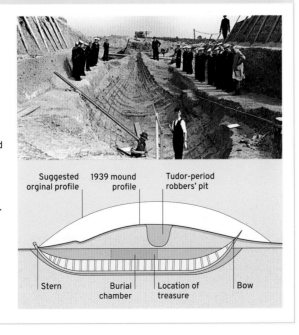

Suggested orginal profile | 1939 mound profile | Tudor-period robbers' pit

Stern | Burial chamber | Location of treasure | Bow

Each gold coin came from a different mint in Francia Two small gold ingots were among the hoard

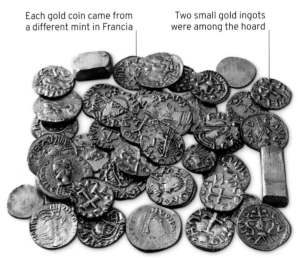

△ **THE TREASURE**
Among the buried artefacts at Sutton Hoo were garnets from Sri Lanka, silverware from Byzantium, and 37 coins from Francia, dating from c.610–635. These precious objects indicated the existence of a sophisticated, internationally connected society and threw new light on the so-called "Dark Ages" that followed the collapse of the Roman Empire in Western Europe.

△ **ORIGINAL MURAL, TOMB 105**
The artists used a vibrant palette to adorn the walls (*see reconstruction, right*), but the mural has faded and darkened greatly over the years, as evident in this detail from the original tomb.

Monte Albán, Mexico

Zapotec Mural

A spectacular Zapotec tomb painting from Monte Albán, Mexico

The indigenous people of the Oaxaca region of southern Mexico, the Zapotecs, began to establish their civilization some time before 500 BCE, building an empire that would last until the Spanish invasion in the 16th century. At its centre was Monte Albán, the first great city of Mesoamerica, with its complex of ceremonial buildings as well as magnificent dwellings.

Under these houses were burial chambers for the remains of the noble families. These tombs – of which almost 250 have so far been discovered – were lined with murals depicting scenes of the afterlife, ancestors, and Zapotec deities. Tomb 105 contains perhaps the finest example of Zapotec funerary wall paintings, although since the tomb's opening in the 1930s, the glorious, vivid red and turquoise colouring has faded, and a reproduction is shown here. The tomb dates from between 600 and 750, when burial chambers were cut out of the rock, unlike the earlier practice of building with stone blocks. This new method provided a stable surface for the render on which the murals were painted. The side and back walls of Tomb 105 feature intricate depictions of a procession of 18 mostly elderly individuals in ceremonial clothing, including elaborate headdresses. Facing forward within a defined sacred space, they are believed to represent ancestors of the deceased performing a funerary ritual.

Scale

▽ **ZAPOTEC MURAL (RECONSTRUCTION)**
Tomb 105 at Monte Albán was discovered by Mexican archaeologist Alfonso Caso in the 1930s; shown here is a reproduction of a mural on its north wall. **Height:** approx. 1.5m (5ft). **Date:** 600–750.

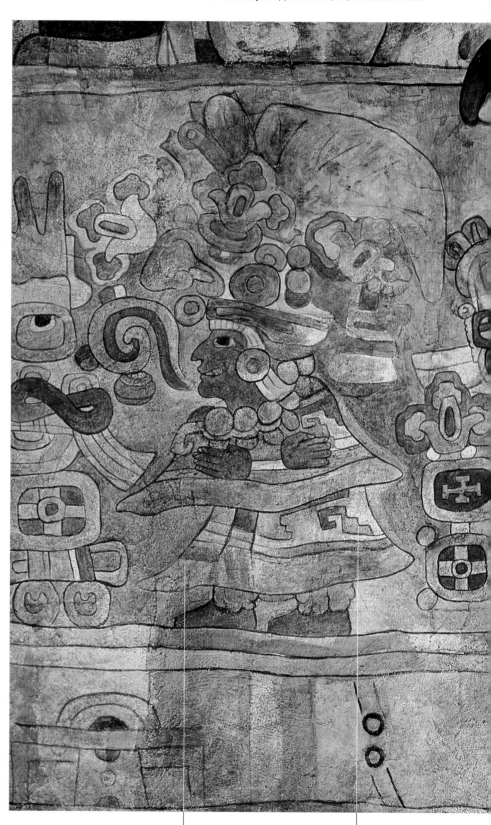

FEMALE FIGURE
The bare-footed female figure shown here is wearing a skirt, a shawl, and a striking headdress.

GEOMETRIC DESIGN
This typical Mexican design is similar to the Greek key pattern (a repeating geometric motif).

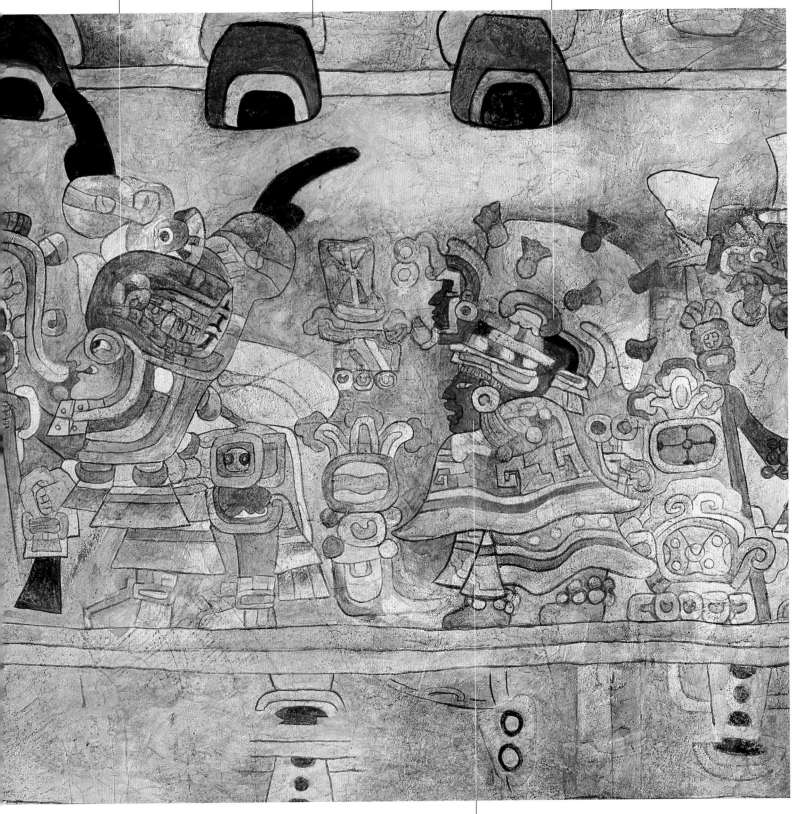

GLORIFICATION
Ceremonial clothes, headgear, and regalia may portray the ancestors as deified, or performing funeral rites.

BLUE-GREEN
A bluish-green colouring emphasizes the opulence of the tomb – the turquoise stone was highly prized in Mesoamerica.

ANCESTOR PROCESSION
The ancestor figures are depicted in profile, marching in procession.

The Zapotecs used **red** to depict the **light** of the **underworld**

◁ **ZAPOTEC RED**
The Zapotecs created a vibrant, glistening red that was a combination of cinnabar (mercury sulphide), cochineal, and haematite.

MARCUS
The calligraphy is so complex that Mark's name was added as a quick identifier for the page.

LEO
This refers to Mark's emblem, a lion. Evangelical symbols played a major part in the decoration of the manuscript.

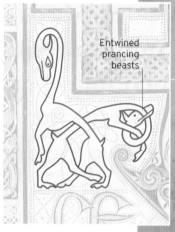

Entwined prancing beasts

△ **DECORATIVE BEASTS**
The outline of these Celtic beasts was formed by rows of tiny drops of red lead. This type of decoration was quite rare in early manuscripts, but was used profusely in the Lindisfarne Gospels. The initial page of St Luke features a phenomenal 10,600 dots.

TRANSLATION
The tiny black script is an Anglo-Saxon translation of the text.

TERMINALS
The most elaborate decoration was reserved for the terminals. These feature trumpet spirals and peltas (crescent-like shield motifs) borrowed from Celtic jewellery.

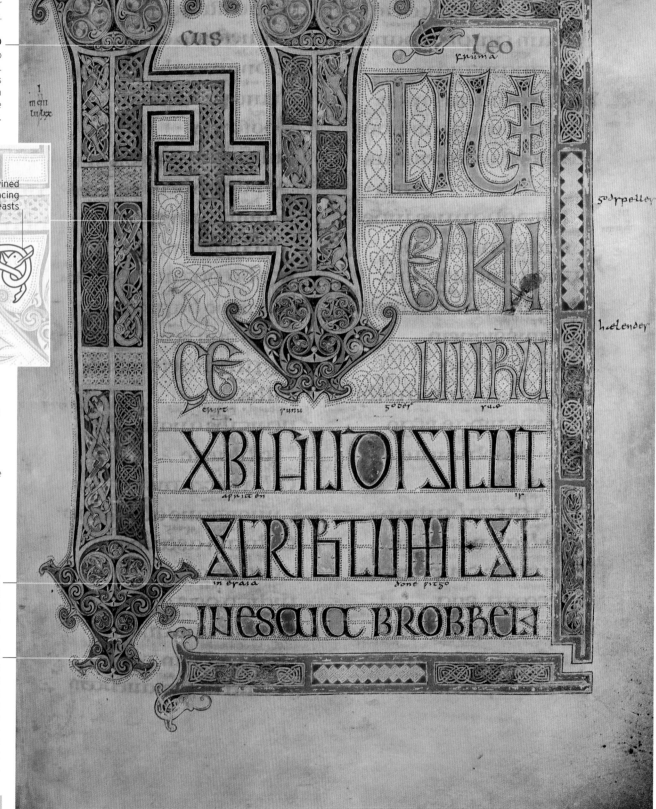

Scale

Isle of Lindisfarne,
England

The Lindisfarne Gospels

*A spectacular manuscript from Anglo-Saxon England, with
decorative calligraphy inspired by ancient Celtic metalwork*

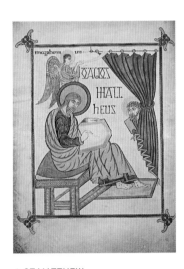

△ **ST MATTHEW**
The book features a variety of cross-
cultural influences. Calligraphy
and "carpet" (ornamental) pages
are often Celtic, but portraits of
the Evangelists have, as here, a
Mediterranean feel. This picture
has links with a Latin Bible, the
Codex Amiatinus, but part of its
inscription is Greek ("O Agios").

▷ **ST LUKE'S CARPET PAGE**
This ornamental page at the start
of St Luke's Gospel would have
required considerable planning,
and there is evidence of prick
marks, compass holes, grid lines,
and rule marks in parts of the book.
A preparatory "sketch" may have
been produced on a wax tablet.

The Lindisfarne Gospels, produced around 698, is
one of the world's finest illuminated manuscripts. An
inscription in the book records that it was written "for
God and St Cuthbert", a key figure in the conversion
of England to Christianity. After Cuthbert's death,
the book was displayed at his shrine on the island
of Lindisfarne, off the northeast coast of England.

The book is thought to have been scribed by a monk
called Eadfrith, but its ornamentation and adornment
with gems, gold, and silver gilt would have been the
work of others. It was written on vellum – parchment
made out of animal skin. The scribe probably used
a pen cut from a reed or quill – quite possibly a local
goose quill in this case – and would have had a wide
range of pigments at his disposal, including yellow
ochre, verdigris, red and white lead, and indigo.

Illuminated gospel books helped missionaries in their
work. They were often highly ornate, with entire pages
devoted to portraits of the Evangelists and the opening
lines of their gospels – the calligraphy of these initial
pages is one of the delights of the Lindisfarne Gospels.
The exquisite penmanship and the illuminated nature
of the work helped the priest to navigate his way
around the lengthy text; but more importantly, they
served to impress on illiterate congregations that the
Word of God was a thing of wonder and mystery.

The dominant visual influence in the book came
from the metalwork and stonework of the Iron
Age Celts, who had settled in Britain and Ireland
far earlier. Their taste for swirling, tightly packed
patterns of spirals, interlacing, and strange, ribbon-like
creatures helped ornament this timeless masterpiece.

ST CUTHBERT

For centuries, Cuthbert (c.634–687) was the most
venerated saint in northern England and the Scottish
borders. He trained at Melrose monastery, becoming
prior there around 661, and was appointed bishop of
Lindisfarne some 23 years later. He carried out missionary
work, but preferred a contemplative life. The Lindisfarne
Gospels, written in his honour, became a showpiece at his
shrine, which was a popular place of pilgrimage after its
creation in 698. Cuthbert's coffin bears carvings closely
related to the Evangelist symbols in the manuscript.

RUINS OF LINDISFARNE PRIORY

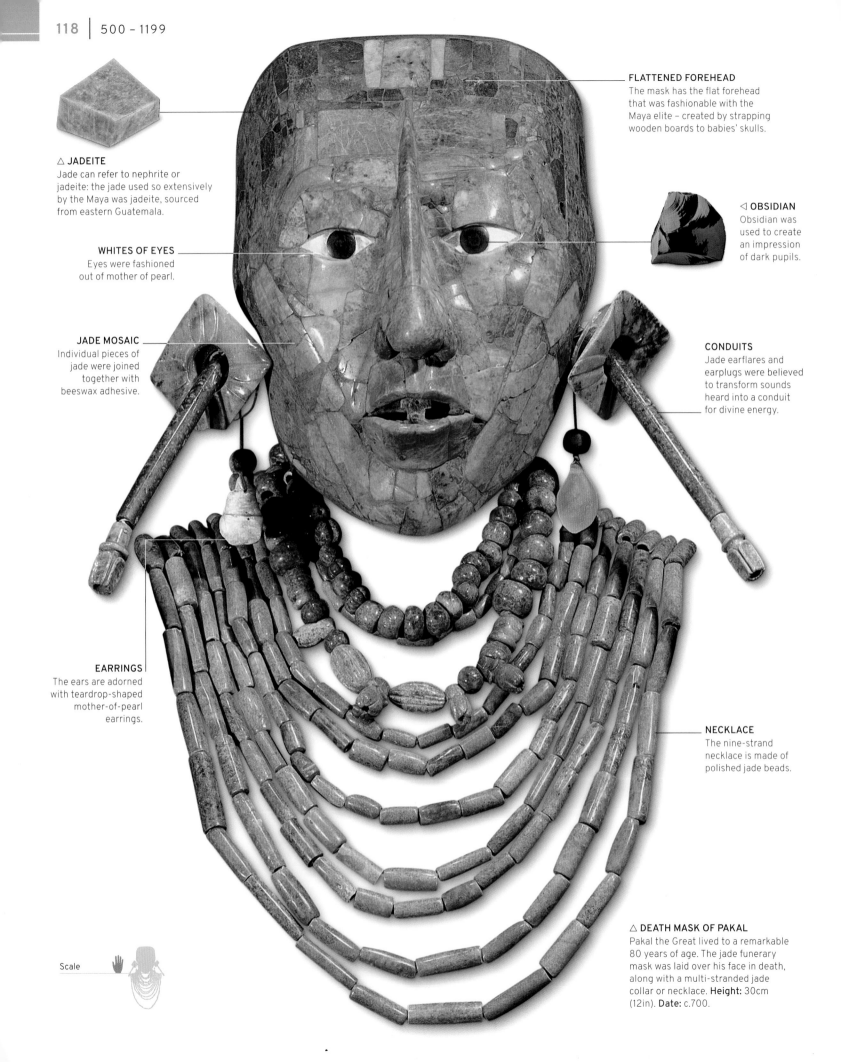

△ **JADEITE**
Jade can refer to nephrite or jadeite: the jade used so extensively by the Maya was jadeite, sourced from eastern Guatemala.

FLATTENED FOREHEAD
The mask has the flat forehead that was fashionable with the Maya elite – created by strapping wooden boards to babies' skulls.

◁ **OBSIDIAN**
Obsidian was used to create an impression of dark pupils.

WHITES OF EYES
Eyes were fashioned out of mother of pearl.

JADE MOSAIC
Individual pieces of jade were joined together with beeswax adhesive.

CONDUITS
Jade earflares and earplugs were believed to transform sounds heard into a conduit for divine energy.

EARRINGS
The ears are adorned with teardrop-shaped mother-of-pearl earrings.

NECKLACE
The nine-strand necklace is made of polished jade beads.

△ **DEATH MASK OF PAKAL**
Pakal the Great lived to a remarkable 80 years of age. The jade funerary mask was laid over his face in death, along with a multi-stranded jade collar or necklace. **Height:** 30cm (12in). **Date:** c.700.

Scale

The mask **conveyed a sense** of **Pakal's power** to the **gods** of the **underworld**

Death Mask of Pakal

A stunning jade mask covering the face of a Maya king, entombed for over a millennium

Palenque, Mexico

Deep inside the Temple of the Inscriptions, the largest monument of the Maya city of Palenque in Mexico's Chiapas province, a crypt lay hidden for centuries. A 25m (82ft) stairwell in the dark interior of the pyramid, discovered by the Mexican archaeologist Alberto Ruz Lhuillier in 1952, led to a tomb containing the sarcophagus of K'inich Janaab' Pakal, Palenque's greatest ruler. Ascending to the throne in 615, at the age of 12, he ruled for 68 years, constructing a series of monumental buildings and making Palenque a powerful force in the Maya world. New architectural techniques lent the buildings elegance, and they were decorated with stucco and sculpted reliefs.

The treasures of the tomb

Inside the sarcophagus were jade statuettes of the Maya maize god and jade cubes, but most startling of all was the death mask of the king, a mosaic formed of large pieces of jade. Obtainable only from one source in the Motagua River Valley in neighbouring Guatemala, the precious green jadeite was reserved for use by the Maya elite, its hardness making it a symbol of immortality. To create the mask, the Maya artisans used drills and saws to grind and chip slowly away at the stone until they fashioned the required shape, which they then polished to bring out the deepest shades of green. So mysterious was the vibrant, shifting hue of the jade that the Maya considered it a living thing. The king's body was also decorated with several jade necklaces, earplugs, bracelets, and rings to emphasize his regality.

Pakal's mask was intended to protect him as he entered Xibalba ("the place of terror"), the Maya underworld. Five human sacrifices found at the entrance to the tomb would also have been intended to accompany him on his journey after death.

SARCOPHAGUS LID

In the carved image on the lid of Pakal's sarcophagus, the king is seen suspended between the heavens and the underworld, with the Cosmic Tree rising above him and the jaws of a funerary serpent below. He wears a turtle ornament on his chest, an attribute of the maize god.

Body depicted in a position that probably symbolizes rebirth

△ **TEMPLE OF THE INSCRIPTIONS**
The temple containing Pakal's tomb gains its name from the inscriptions in the hieroglyphic Maya script on the outer piers and on tablets found inside the structure.

▷ **BONAMPAK MURALS**
On the east wall of Room 1, the figures in the lower register depict musicians; at the top is a group of lords (all the figures are about two-thirds life-size). Between them is a band with inscriptions. **Height of room:** approx. 7m (23ft). **Date:** c.790.

NAME LABELS
These small, light blue rectangles were used as name tags of the people represented. Not all of them have been filled out.

MAYA BLUE
Maya art made extensive use of a bright blue pigment, known as Maya blue. It was made by combining indigo dye with clay-like minerals.

▽ **GOURD RATTLES**
Several of the musicians shake rattles made from the hollowed-out and dried skin of gourd fruits filled with suitable material, such as seeds or shells.

DRUMMERS
The three musicians on the left play drums held at chest height. Typically, such drums were made of turtle carapaces, struck with the hand or (as here) with a stick.

ELABORATE COSTUMES
The musicians wear tall, white headdresses and colourful skirts.

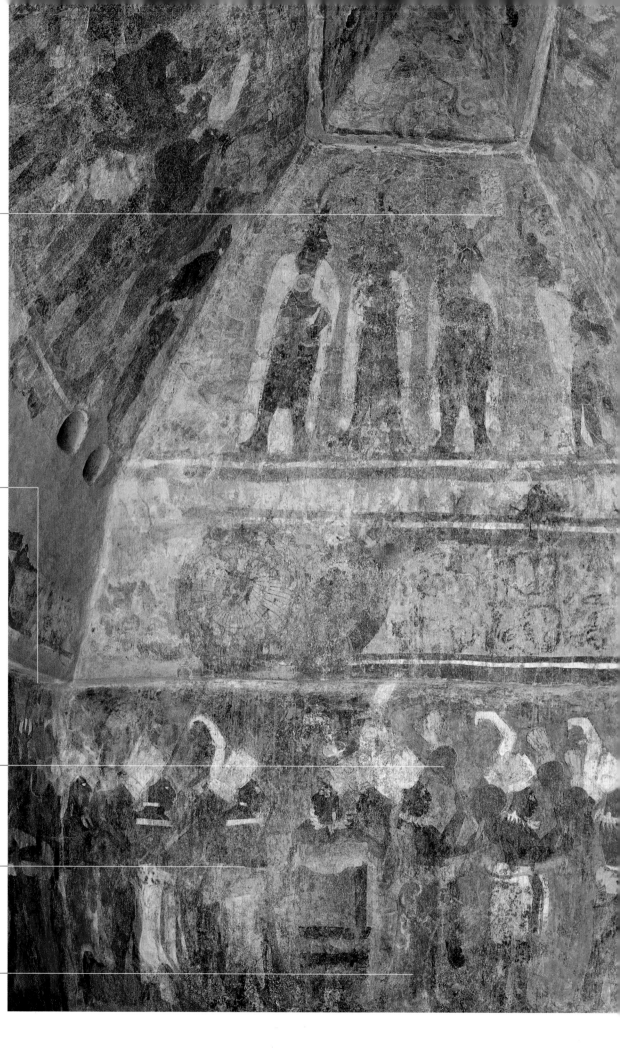

Scale

Bonampak Murals

Spectacular late 8th-century paintings that have overturned long-held assumptions about the Maya civilization

Bonampak, Mexico

Bonampak is the site of a small Maya city deep in Mexico's tropical rainforest. It was unknown to the outside world until 1946, when Giles Healey, a US archaeologist, came across the site; in 1949, he published illustrations of the murals that made them famous. The murals' survival is due to a protective layer of calcium carbonate that formed on them after water penetrated the building's limestone ceilings.

The art of the Maya

The Maya were highly sophisticated in many ways and were often characterized as serene and placid, particularly in contrast with the bloodthirsty Aztecs. The Bonampak murals, which offer an unequalled insight into Maya society, dealt a decisive blow to this image of a peace-loving culture by revealing brutal scenes of warfare, including torture and sacrifice.

The murals cover the walls and vaulted ceilings of a small building that is perched part-way up a stepped temple mound. Inscriptions show that it was dedicated in 791 and that the murals celebrate events relating to the reign of Bonampak's ruler Yajaw Chan Muwaan. The artists made use of a vibrant palette of blues, greens, reds, oranges, and browns (now faded).

The paintings in the building's three rooms are mainly concerned with dance, celebration, warfare, and violence, including sacrifice and dismemberment: in one scene, for example, a sacrificial victim has had his heart removed. There are more than a hundred figures, which provide fascinating information about Maya civilization. Elaborate textiles and magnificent headdresses feature prominently, the musical instruments include drums, rattles, and trumpets, and a courtier casually smokes a cigar – a Maya invention.

The murals are the most important paintings surviving from the ancient Americas

THE TEMPLE OF THE MURALS

The building housing the murals, known as the Temple of the Murals, has three rooms, each with its own entrance (the rooms do not interconnect). Originally the exterior of the building was brightly painted, but few traces of this survive.

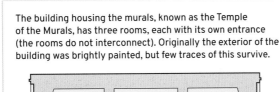

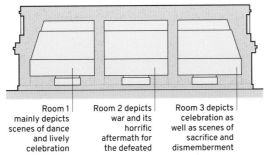

Room 1 mainly depicts scenes of dance and lively celebration

Room 2 depicts war and its horrific aftermath for the defeated

Room 3 depicts celebration as well as scenes of sacrifice and dismemberment

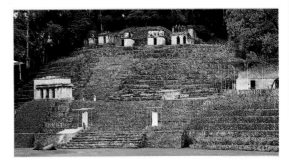

△ STEPPED TEMPLE MOUND
The small, three-roomed, windowless building containing the murals is shown here on the right of the stepped temple mound. The exact purpose of the building is unknown.

FULL TITLE
The text's full title can be translated as "The Diamond that Cuts through Illusion", emphasizing the illusory nature of life.

SEPARATE PRINTS
The book is made up of seven separate rectangular woodblock prints on paper, pasted together into a long scroll.

▷ *DIAMOND SUTRA*
Sutras are the canonical scriptures of Buddhism, and the *Diamond Sutra* is a key text. The beautifully illustrated frontispiece shown here (with text), with its dense symbolism, conveyed a message even to illiterate followers. **Length:** 5m (16ft 5in). **Date:** 868.

Dunhuang, China

Diamond Sutra

A 9th-century feat of intricately detailed woodblock craftsmanship

Found with 40,000 other manuscripts in the Dunhuang caves in Gansu province, China, the Buddhist *Diamond Sutra* is the world's first-known dated printed book, taking the form of a scroll. It ends with a note reading: "Reverently made for universal free distribution by Wang Jie for his two parents on [11 May 868]." The text would have been written on thin paper, then pasted face down on a wood block. A carver whittled out the reversed shape of the characters, creating a carved block that could be used to produce 1,000 sheets a day.

PRINTING AND FAITH

Printing developed in China in the Tang dynasty (618–906), and its refinement was linked to the spread of Buddhism. The reciting of sutras was a recognized way of gaining spiritual merit, and printing them multiplied this effect. Sacred texts and images were believed able to ward off evil.

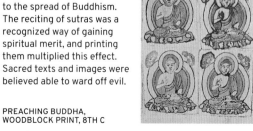

PREACHING BUDDHA, WOODBLOCK PRINT, 8TH C

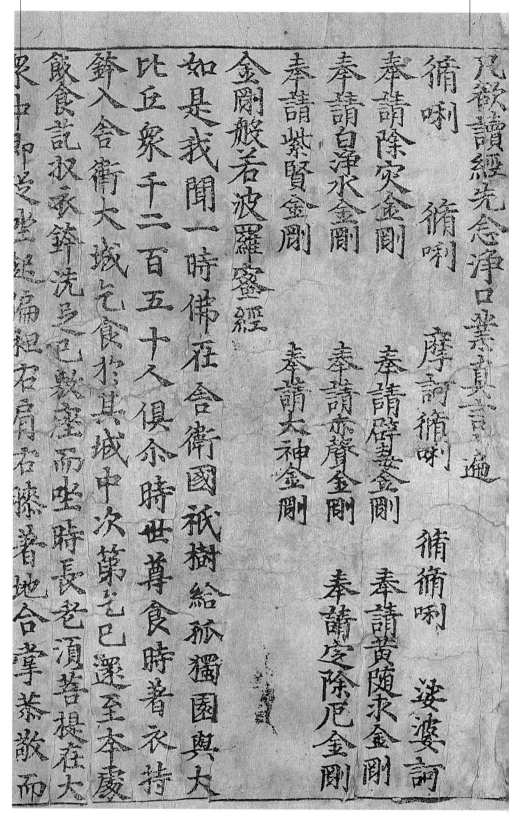

Scale

PROTECTIVE DEITY
A fearsome deity protecting the Buddha wields a *vajra*, meaning "thunderbolt" or "diamond".

TRANSCRIBED DIALOGUE
The sutra is a conversation between the Buddha and his disciple Subhuti, leading him and all beings towards enlightenment.

THE BUDDHA
The Buddha sits on a lotus throne surrounded by a halo of purifying flame.

READING THE SCROLL
The scroll unrolls from right to left, so the illustration of the Buddha scene is the first thing a reader sees.

SUBHUTI
Subhuti was an early follower of the Buddha, celebrated for his meditations on loving-kindness.

The **paper** for **sutras** was often dyed **yellow** with an **insecticidal dye** from **cork trees**

MOON AND SUN
Above the inscription, the Moon and Sun are shown in mourning.

△ INSCRIPTION
The Latin inscription reads *Hic est Rex Iudeorum* ("Here is the King of the Jews").

MARY AND JOHN
The figures below the arms of the cross are the Virgin Mary (left) and John the Evangelist (right).

MOURNING FIGURES
The mourning figures at the base of the cross have not been definitively identified; one is possibly Mary Magdalene.

GEMSTONES
The inlaid precious stones include pearls, amethysts, emeralds, garnets, and sapphires.

Scale

REPOUSSE GOLDWORK
Christ and the other figures have been created in a technique called repoussé (*see p.81*), meaning they are shaped from the reverse side of the gold, using tiny hammers and punches.

△ LINDAU GOSPELS TREASURE BINDING
The front cover is remarkable for the sheer richness and density of the ornamentation, using precious stones as well as gold on a wooden board backing.
Height: 35cm (13¾in). **Date:** c.880.

The **treasure binding** of this **Gospel book** is **richer** and **more lavish** than its **interior**

Lindau Gospels Treasure Binding

A sumptuous bejewelled cover made for an illuminated manuscript in the late 9th century

Eastern France and Austria

This spectacular book cover is one of the most important "treasure bindings" from the Middle Ages. Its name comes from a convent on the island of Lindau on Lake Constance in Bavaria, Germany. The book is first recorded there in 1691; its history before and after this date is complex and at times obscure.

Different styles

Unusually, the three parts that make up the book – an illuminated manuscript of the four Gospels; the resplendent front cover; and the intricately worked back cover – were produced at different times and in different places. The front cover (c.880) was probably made in eastern France, possibly in the workshops of Charles the Bald, Holy Roman Emperor and grandson of Charlemagne. It is an example of late Carolingian work, typical of which are its triumphant Christ and its emulation of classical works – as in, for example, the treatment of Christ's drapery. The back cover dates from about a century earlier. Its visually intricate,

dense decoration is in the style of Insular art of the British Isles (a post-Roman style beginning around 600), although it was probably made in Austria; the cover has been extended around the edges to match its companion in size. The manuscript was written and illuminated at the Abbey of St Gallen in Switzerland around 890, and the covers were perhaps gifts to the abbey that were used to embellish the book. How it came to Lindau is unknown.

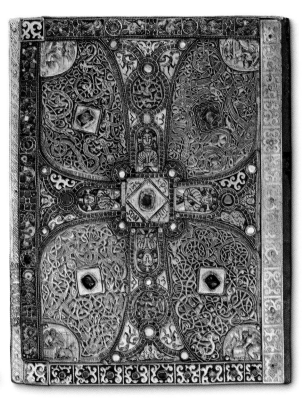

△ **BACK COVER**
Made c.760–90, probably in Salzburg, Austria, the back cover has ornate decoration that includes a central enamelled cross with cloisonné depictions of Christ, on a silver-gilt background engraved with complex patterns of interlaced animals.

▽ **PRIVATE COLLECTIONS**
The convent at Lindau was dissolved in 1803, and the book passed through various private collections until it was bought by the American industrialist J. Pierpont Morgan in 1901.

SPINE
The leather spine was added later, and is stamped with the date 1594.

BOSSES
The four large bosses were practical as well as decorative: when the book was open for reading, they protected the gold figures from contact with the surface on which it lay.

Ramayana Bowl

A richly decorated late 9th-century gold bowl, part of Indonesia's richly decorated late 9th-century gold bowl, part of Indonesia's richest ever trove of gold and silver artefacts

Prambanan, Indonesia

The power and wealth of central and eastern Java's ancient Mataram (or Medang) Kingdom in the 8th and 9th centuries produced towering temples, such as the Buddhist shrine of Borobodur and the Hindu Prambanan temple complex. In 1990, at Wonoboyo village, near Prambanan, farmers digging a rice field unearthed several terracotta jars. Inside was a spectacular hoard of gold and silver artefacts, including jewellery, utensils, and 6,000 gold and silver coins.

Ramayana scenes

There were more than 20 gold bowls in the hoard, of which the tiny, four-lobed oval *Ramayana* bowl is the finest. Made of gold hammered from the inside using the repoussé technique (*see p.81*), its four panels reproduce key scenes from the *Ramayana*, the great

Hindu mythological epic of Rama, a prince of Ayodhya (and the human avatar of the god Vishnu), and his profound love for his wife, Sita (the human avatar of the god Lakshmi). Scenes depict episodes in the story of Rama's exile and the abduction of Sita. Exquisitely crafted, the finely detailed human figures are set amid a profusion of abstract floral motifs and decorative elements.

Among the other items recovered at Wonoboyo were water dippers, jewellery, and a gold handbag. The hoard's lavishness implies the treasures belonged to someone of high rank at the court, if not the king. It may date to the era of King Bailitung (r. 899–911). After his reign, the centre of the kingdom moved east following a volcanic eruption of Mount Merapi. The hoard was found beneath the lava a millennium later.

The **golden bowl** may have been used to contain **holy water** in **sacred rituals**

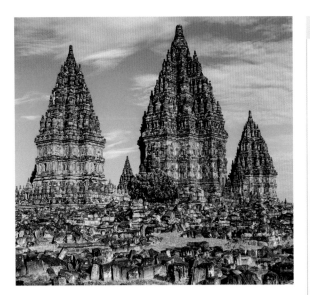

△ **PRAMBANAN TEMPLE COMPLEX**
The *Ramayana* bowl was found near the spectacular mid-9th-century Prambanan temple compound, which also features scenes from the *Ramayana* in carved bas-relief friezes.

THE *RAMAYANA*

Composed around 500 BCE, the 24,000-verse *Ramayana* is one of the most important and popular Hindu epics. It tells of the efforts of Rama and his loyal brother Lakshmana to rescue Rama's wife, Sita, who is kidnapped by the *Asura* (demon) king Ravana. Finally, with the aid of the monkey god Hanuman, they rescue her and return in triumph to their kingdom, Ayodhya. Thousands of manuscripts and carvings depicting the *Ramayana* story survive from around the Hindu world.

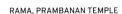

RAMA, PRAMBANAN TEMPLE

The **Wonoboyo hoard** comprised nearly **17kg (37½lb)** of **gold** and **silver** objects, including **97 bracelets**

▷ **STORY SCENES**
Each lobe of the bowl shows a different *Ramayana* scene from the story of the abduction of Sita.

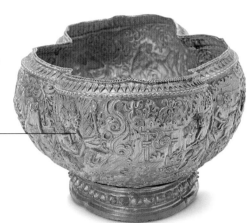

DEMON
This scene depicts the wounded stag turning into the demon Maricha.

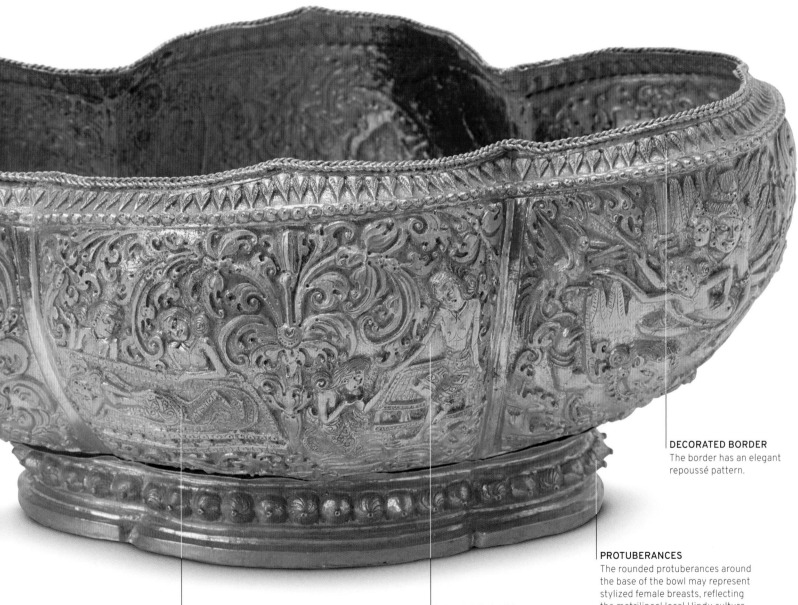

DECORATED BORDER
The border has an elegant repoussé pattern.

PROTUBERANCES
The rounded protuberances around the base of the bowl may represent stylized female breasts, reflecting the matrilineal local Hindu culture of the time.

THREE WOMEN
This scene follows the one on the right. The woman lying on a bench is probably Sita, either being taunted by two of Ravana's female demons or else being watched over in her lamentations.

SITA AND RAVANA
This scene has several possible interpretations, but it may show Sita pleading with the demon king Ravana at the beginning of their confrontation.

Scale

Igbo-Ukwu, Nigeria

IGBO-UKWU BRONZE WARES ▷
This stunning double-egg pendant with bird or turtle and fly decoration was cast in leaded bronze. It was found with copper wire and glass bead elements that are attached by loops cast on the object's sides. The beads are evidence of Igbo-Ukwu's wealth and connections to trade networks.
Height: 21.6cm (8½in). **Date:** c.800–1000.

Igbo-Ukwu Bronze Wares

The astonishing work of the earliest copper metalworkers and lost-wax bronze casters in West Africa, dating to around the 9th century

In 1938, a farmer in the town of Igbo-Ukwu, Nigeria, uncovered a number of ancient bronze objects while digging a cistern. Three archaeological sites in the area were identified – named Igbo Isaiah, Igbo Richard, and Igbo Jonah – and excavations between 1959 and 1964 revealed hundreds of prestige objects cast in bronze, including ritual vessels, pendants, crowns and breastplates, swords, and fly-whisk handles, that pointed to a highly sophisticated metalworking society. In fact, the inhabitants of Igbo-Ukwu were probably the earliest in West Africa to work copper and its alloys and the first to use the lost-wax process to produce bronze sculptures (*see p.164*). They worked by hammering, bending, twisting, and incising the metal, although it seems they were not familiar with such common techniques as raising, riveting, and soldering. Nonetheless, their skill was remarkable: they were able to make pieces in multiple parts, and even placed small decorative cast items, such as insects and spirals, into the wax casting moulds for bowls and other objects.

Symbolic decoration

The Igbo-Ukwu bronze objects are characterized by their highly decorated surfaces, whose motifs fall into four categories: geometric (triangles, concentric circles, raised dots), curvilinear (two-edged spirals, netlike curves, interlace with loops), skeuomorphic (made of one material to resemble another material, here including woven fabric and rope), and animal and human (snakes, snails, monkey heads, human heads, birds, fish). Insects that threaten agriculture, such as flies, beetles, and grasshoppers, also frequently appear. These motifs have complex, multilayered meanings that add to the intrigue of these extraordinary objects.

▽ BRONZE ROPED POT
The bronzework of this slender pear-shaped pot mimics ceramic and ropework. It was made by the "burning-in" technique, in which up to eight separate parts were fused together in subsequent firings.
Height: 32.3cm (12¾in). **Date:** c.800–1000.

21 **animal**, 35 **geometric**, 4 **curvilinear** and 7 **skeuomorphic** motifs have been identified on Igbo-Ukwu bronzes

IGBO-UKWU ARCHAEOLOGICAL EVIDENCE

The three sites at Igbo-Ukwu revealed tantalizing clues to the culture that made the objects found there. Igbo Isaiah contained bronze ceremonial vessels, pot stands, jewellery, and various ornamental regalia; Igbo Richard contained evidence of an elite burial with human remains and 100,000 glass beads (probably from Egypt or India), alongside ornamental regalia; Igbo Jonah was a possible rubbish pit, containing ceramic shards, glass beads, and bronze objects. Together, these objects point to wealth, a thriving local industry, and significant trade. While scarification marks, known as *ichi*, seen on some objects suggest cultural connections between the ancient Igbo-Ukwu people and more modern Igbo, debate continues around the meaning of the finds.

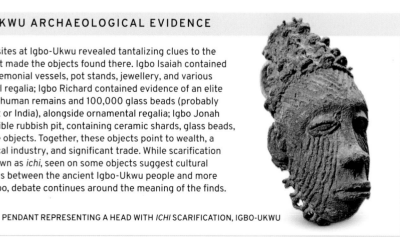

PENDANT REPRESENTING A HEAD WITH *ICHI* SCARIFICATION, IGBO-UKWU

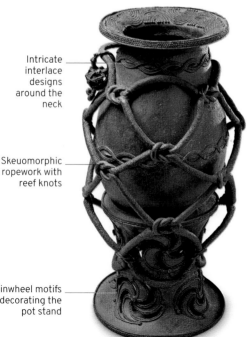

Intricate interlace designs around the neck

Skeuomorphic ropework with reef knots

Pinwheel motifs decorating the pot stand

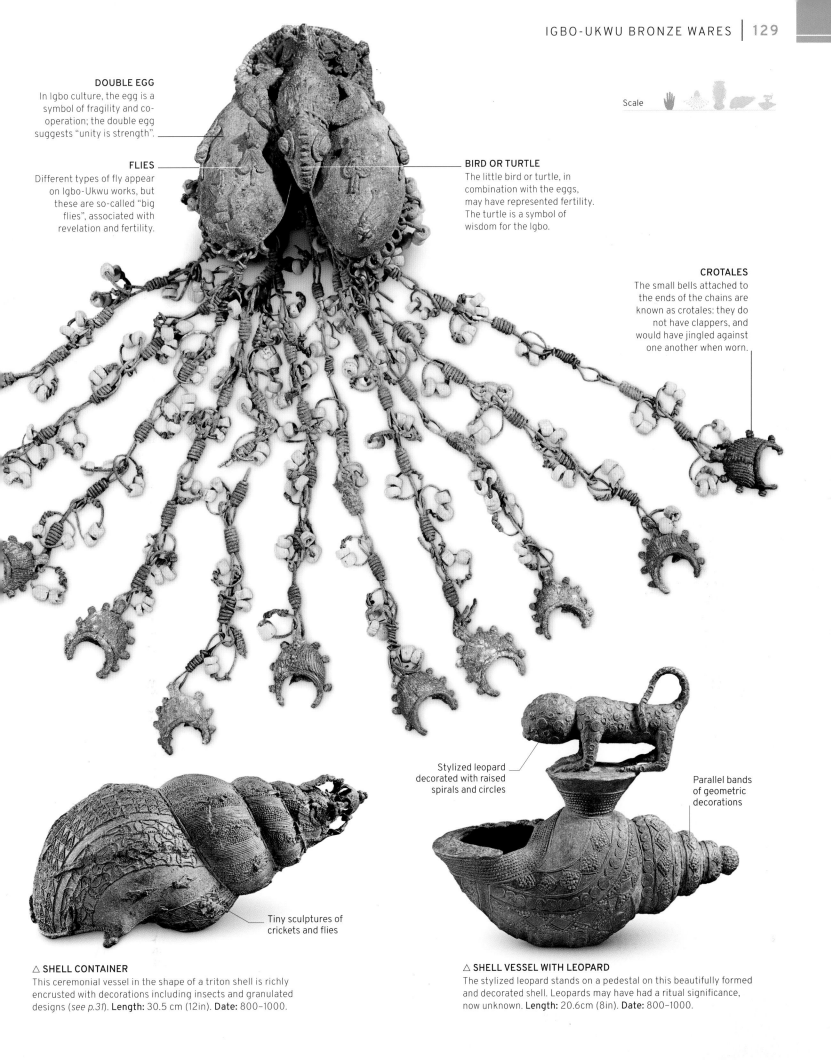

Scale

DOUBLE EGG
In Igbo culture, the egg is a symbol of fragility and co-operation; the double egg suggests "unity is strength".

FLIES
Different types of fly appear on Igbo-Ukwu works, but these are so-called "big flies", associated with revelation and fertility.

BIRD OR TURTLE
The little bird or turtle, in combination with the eggs, may have represented fertility. The turtle is a symbol of wisdom for the Igbo.

CROTALES
The small bells attached to the ends of the chains are known as crotales: they do not have clappers, and would have jingled against one another when worn.

Stylized leopard decorated with raised spirals and circles

Parallel bands of geometric decorations

Tiny sculptures of crickets and flies

△ **SHELL CONTAINER**
This ceremonial vessel in the shape of a triton shell is richly encrusted with decorations including insects and granulated designs (*see p.31*). **Length:** 30.5 cm (12in). **Date:** 800–1000.

△ **SHELL VESSEL WITH LEOPARD**
The stylized leopard stands on a pedestal on this beautifully formed and decorated shell. Leopards may have had a ritual significance, now unknown. **Length:** 20.6cm (8in). **Date:** 800–1000.

CORDOBA MOSQUE MIHRAB ▷
The mihrab sits at the end of the *maqsura*, the space reserved for the imam and the ruler. The horseshoe arch, the blind arches above it, and the dome all create a sense of soaring space that still focuses the eye on the mihrab room beyond. **Height of doorway:** approx. 2m (6ft 6in). **Date:** 965.

Córdoba Mosque Mihrab

A superlative gem of Islamic architecture offering a window into the artistic splendour of Islamic Spain

Córdoba, Spain

The mihrab (prayer niche) in the Grand Mosque (now cathedral) of Córdoba, Spain, represents the fusion of Islamic and Byzantine artistic traditions to create a unique architectural masterpiece. The mosque was founded by Abd al-Rahman I, the Umayyad emir of Córdoba, around 70 years after the Islamic conquest of Spain in 711. His successors expanded the mosque, enlarging the prayer hall and adding a minaret.

Further embellishment

In 961, the caliph al-Hakam II began a major building programme. He made the prayer hall wider, creating a forest of red brick and white marble arches. At the south end, where the mihrab lay, he created an entirely new structure. A mihrab indicates the direction of prayer, and is usually an alcove or niche: here, the alcove became a room, its dazzling entrance seeming a gateway to paradise. The visual pinnacle of the mosque, it is approached via a *maqsura* (an enclosed space reserved for the ruler) beneath a spectacular

> ## The **mihrab** was a **sumptuous** statement of both the **caliph's power** and **his faith**

dome, and entered through a horseshoe arch of marble and coloured stone. The arch is decorated with verses from the Qur'an and floral and vegetal designs in intricate mosaic, produced by skilled craftsmen sent by the Byzantine emperor. The interior is an octagonal room roofed with a shell-shaped, white marble dome, its walls inset with lobed blind arches and profusely decorated with carved plant motifs. The mihrab remained at the heart of Muslim prayer in Córdoba until 1236, when Ferdinand III of Castile captured the city and converted the mosque into a church.

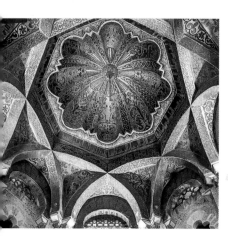

△ **DOME**
The interlacing arches of the *maqsura* form a frame to the soaring scallop-shell dome in the extension added by al-Hakam II in the 960s.

△ **CEILING OF INNER CHAMBER**
The scallop-shell form of the dome of the mihrab was intended to represent the divine light, and was a link to the Umayyad mosque in Damascus, the ancestral home of the Córdoba caliphs' dynasty.

MIHRABS

The mihrab, or prayer-niche, indicates the qibla (direction of Mecca), towards which the faithful face at prayer, and is one of a mosque's most important features. Often decorated with dense geometric and vegetal designs, as well as Quranic verses in exquisite calligraphy, it is the central focus of worship. The mihrab is often flanked by a minbar, or pulpit, from where the imam (prayer leader) speaks. They may be highly ornate, such as this one from Isfahan, Iran, with its superb glazed tiles.

MIHRAB FROM THE MADRASA IMAMI, ISFAHAN, 14TH C

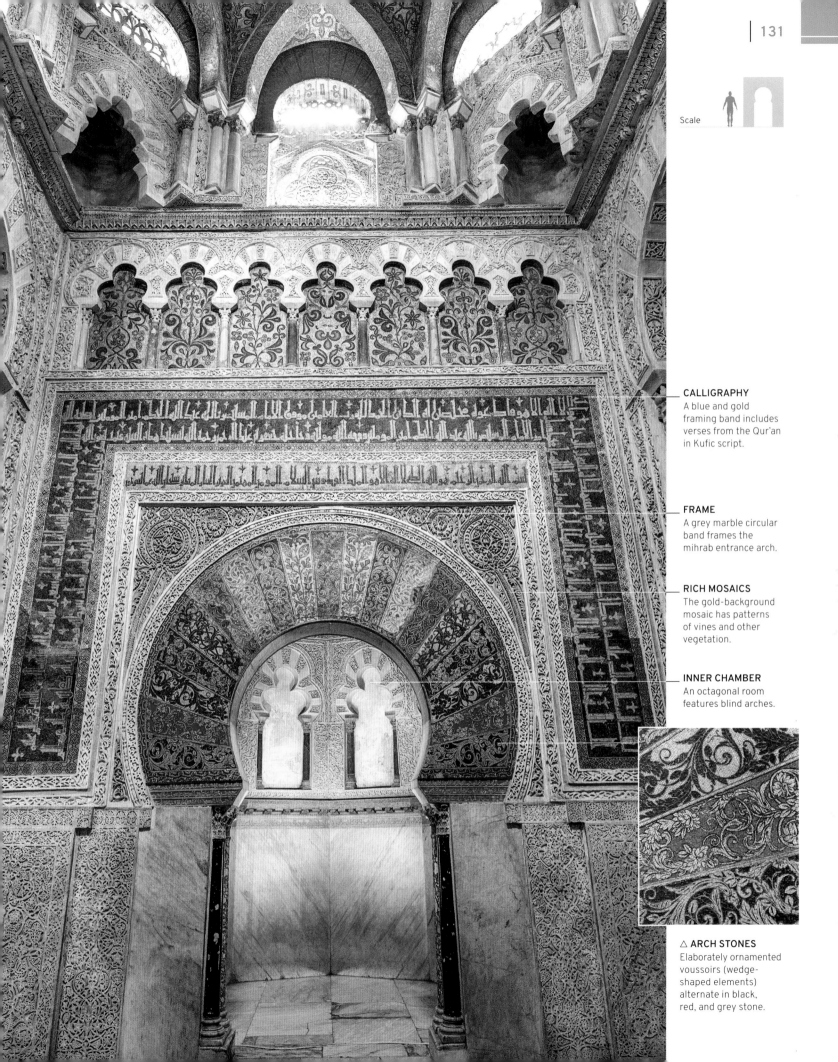

Scale

CALLIGRAPHY
A blue and gold
framing band includes
verses from the Qur'an
in Kufic script.

FRAME
A grey marble circular
band frames the
mihrab entrance arch.

RICH MOSAICS
The gold-background
mosaic has patterns
of vines and other
vegetation.

INNER CHAMBER
An octagonal room
features blind arches.

△ **ARCH STONES**
Elaborately ornamented
voussoirs (wedge-
shaped elements)
alternate in black,
red, and grey stone.

▽ **BANTEAY SREI (PEDIMENT)**
This pediment above the northern library shows the *Deva* (god) Indra trying to put out a fire in the forest, while Krishna (human avatar of Vishnu) attempts to stop him. **Height (of pediment):** approx. 108cm (42in). **Date:** c.968.

BAS-RELIEF
The scene is carved in bas-relief, a technique whereby figures are cut in and so raised above a flat surface.

COSMIC CONFLICT
The god Indra sends down rain to put out the fire created to kill Takshaka, king of the *Naga* (see below).

◁ **INDRA'S STEED**
Indra rides on the three-headed elephant Airavata, which can suck up water from the underworld.

FOREST FIRE
Flames curl around the edges of the pediment's central scene.

FANNING THE FLAMES
Krishna, armed with a bow, stands on a chariot, trying to shoot down the rain sent by Indra.

FLEEING THE FOREST
Animals flee in terror from the fire in the Khandava Forest.

SNAKE BEINGS
The *Naga* were the part-serpent beings of the forest.

ARROWS
Krishna's arrows are shown in two layers holding back the rain, which is represented by rippling water in the section above.

FRAMED BY FLOWERS
An intricate decorative frieze of flowers surrounds the pediment's main narrative carvings.

Banteay Srei

A small but magnificently decorated Khmer temple distinguished for exquisite carvings from the Hindu epics

Angkor, Cambodia

The Banteay Srei temple, northeast of Siem Reap, is a creative highlight of Cambodia's Khmer empire, which ruled the region from the 9th to the 15th centuries. The temple's exquisitely carved surfaces, and particularly the glorious relief sculpture of its pediments (*see left*), have meant that it is widely renowned as the jewel of Khmer art. Part of the Angkor complex, in which a succession of Khmer capitals were sited, the temple was dedicated in 968, at the start of the reign of Jayavarman V.

A temple in miniature

Banteay Srei was not commissioned by a king, but by the priest-courtier Yajnavaraha. Building the shrine at a small scale was likely an act of deference – the Khmer rulers were regarded as god-kings whose grandeur could not be challenged. The outermost of its three enclosures was only 110m (360ft) long and 95m (312ft) wide. The temple and its flanking libraries had doors just 108cm (42in) high and niches for the many *apsaras* (heavenly dancers) and lion- and monkey-headed guardians that were a mere 70cm (27in) high. The temple's modern name means "citadel of the women",

The temple remained in use by **Hindu worshippers** until the **14th century**

reflecting the idea that its reliefs are so delicate they could only have been carved by women; the Khmers called the temple Tribhuvanamehsvara ("The Great Lord of the Threefold World"), in honour of the god Shiva. They built it of hard red sandstone, in contrast to the brick of earlier temples, which allowed the sculptors to cover almost every surface, especially the pediments over the temple doors, with wonderfully exuberant scenes from the Hindu epic, *Ramayana*.

Banteay Srei was abandoned in the 15th century and remained unknown outside the region until French colonial officials rediscovered it in 1914, and began the long, slow process of cleaning and restoration.

THE INNER TEMPLE COURTYARD

The temple is an elaborate complex of buildings, its central courtyard accessed by a pair of *gopura* (stairways), flanked by guardian figures. The main building has three *prasat* (sanctuary towers) dedicated to Shiva and Vishnu, and is flanked by a pair of *copuram* (meditation houses) and two libraries for the study of texts.

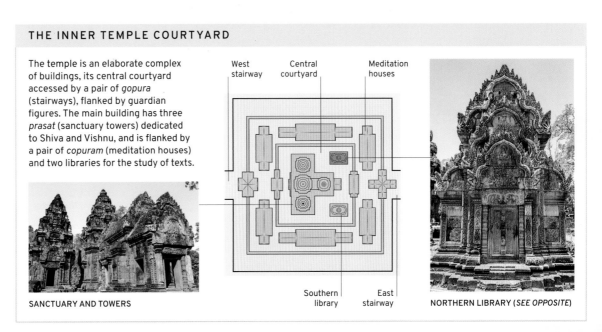

West stairway Central courtyard Meditation houses

Southern library East stairway

SANCTUARY AND TOWERS

NORTHERN LIBRARY (*SEE OPPOSITE*)

Scale

Catalonia, Spain

Carolingian Astrolabe

The oldest surviving astrolabe from Christian Europe, also testament to the 10th-century Islamic world's astronomical knowledge and skill

An astrolabe was an early astronomical instrument with multiple applications, including calculating time and latitude, and locating the celestial bodies in the sky. Known in ancient Greece and Rome, it was in wide use in the Islamic Golden Age (8th–14th centuries).

Made from precisely cut and engraved brass pieces, the Carolingian astrolabe is engraved with Latin characters, suggesting that it was made in Europe. Yet its construction required a detailed knowledge

of mathematics and astronomy that 10th-century Christian Europe did not possess, while the Islamic world was at the forefront of this learning. It is thought that the astrolabe was made in Muslim Andalusia and completed in a Christian monastery in northern Spain, as it is engraved with a projection of latitude 41° 30' – that of Barcelona, Catalonia. It is also engraved with the words ROMA ET FRANCIA, a reference to Carolingian France, of which Catalonia was a part.

ASTROLABE WORKINGS

The astrolabe is a two-dimensional representation of the heavens. It consists of a deep plate called the mater, or mother, engraved with celestial coordinates, which houses the rete, an open disc that serves as a sky map, and a tympan, or plate, engraved with coordinate lines for a specific latitude. When the rete is turned, it moves over the coordinates on the tympan. A rule, or alidade, (from al-'idāda, the Arabic word for "arm"), is used for sighting objects in the sky.

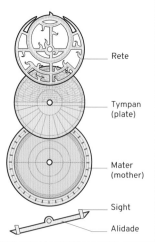

Rete

Tympan (plate)

Mater (mother)

Sight

Alidade

▽ **CAROLINGIAN ASTROLABE**
The Carolingian astrolabe was a sophisticated tool, but errors in its engraving suggest it may have been inaccurately copied from an earlier model. **Diam.:** 15cm (6in). **Date:** c.980.

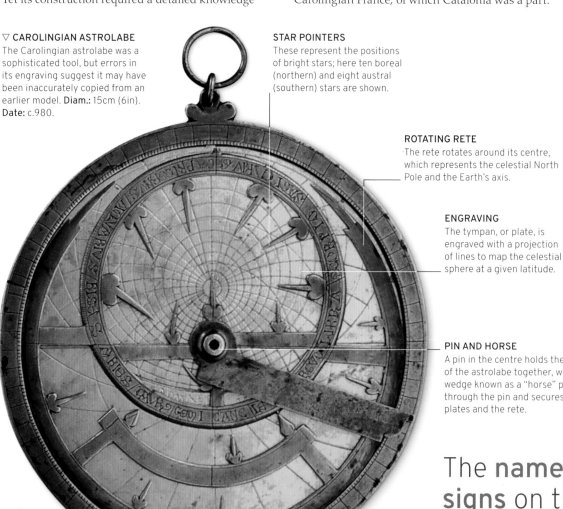

STAR POINTERS
These represent the positions of bright stars; here ten boreal (northern) and eight austral (southern) stars are shown.

ROTATING RETE
The rete rotates around its centre, which represents the celestial North Pole and the Earth's axis.

ENGRAVING
The tympan, or plate, is engraved with a projection of lines to map the celestial sphere at a given latitude.

PIN AND HORSE
A pin in the centre holds the parts of the astrolabe together, while a wedge known as a "horse" passes through the pin and secures the plates and the rete.

Scale

The **names** of the **zodiac signs** on the **rete** were probably added **two or three centuries later**

Yixian Luohan Statue

One of a set of spectacular life-size glazed stoneware figures from Liao-dynasty China, portraying a disciple of the Buddha

Yixian, China

Discovered in a cave in Yixian, Hebei province, China, around 1912, this splendid, life-size figure represents an arhat (a Buddhist monk who has achieved spiritual enlightenment), known in China as a *luohan*. A tour de force of ceramic sculpture, the figure dates to the Liao dynasty (916–1125), and is one of a group of eight to ten extant individually modelled statues, probably part of a larger group of 16 or 18 *luohan*s awaiting the arrival of Maitreya, the Future Buddha. It is remarkable for its large size, and for the quality of its technically challenging three-toned (*sancai*) glaze. Rendered in a naturalistic style, the face, with its severe yet tranquil expression, appears to be that of a real individual.

The statue was made from several pieces of glazed stoneware that were either formed with moulds or hand-built from slabs, then "luted" (joined) together using clay slip before firing. Firing such large pieces without sinkage or warping required great skill, and the piece is supported by internal iron rods.

The **sculpture** may be a **portrait** of a **distinguished** monk of the time

SANCAI WARE

Literally meaning "three colours", *sancai* ware developed under the Tang dynasty (618–907 CE). An easier and cheaper alternative to porcelain, it proved particularly suitable for making large figures. *Sancai* ware is sometimes dubbed "egg and spinach" in the West because of the three key colours used – cream, green (created by adding copper oxide to a lead glaze), and amber (from iron oxide) – although blue, purple, and brown sometimes feature. *Sancai* ware also features streaks and mixed colours created when the glazes run together during firing, which give it a lively, organic look.

TANG-DYNASTY TOMB GUARDIAN

GREEN HAIR
The green hair is a surprising departure from the overall realism of the statue.

NATURALISTIC PORTRAIT
The delicate sculpting of the face gives the figure its individual character while offering an idealized portrait.

Scale

BUDDHIST ICONOGRAPHY
Elongated earlobes symbolize the Buddha's rejection of the material world in favour of spiritual enlightenment.

SCROLL
The monk holds a scroll in his left hand.

MONK'S GARMENTS
Over a green inner garment, the *luohan* wears a green and orange robe, which would have been one of his only possessions.

△ **YIXIAN *LUOHAN* STATUE**
This statue depicts an older *luohan*, one of the historical disciples of the Buddha. He is depicted cross-legged in a typical pose of meditation. The base is evocative of a monk's secluded mountain retreat. **Height:** (figure) 105cm (41¼in); (base) 16.5cm (6½in). **Date:** c.1000.

BERNWARD BRONZE DOORS ▷
The doors were made for St Michael's
Church, but were moved to Hildesheim
Cathedral soon after Bernward's death.
Height: 4.7m (15ft 6in). **Date:** 1015.

Bernward Bronze Doors

*One of the masterpieces of 11th-century sculpture and
a landmark in the history of bronze casting*

Hildesheim,
Germany

St Bernward of Hildesheim was one of the greatest
art patrons of the Middle Ages. Bishop of Hildesheim
in northern Germany from 993 until his death, he
did much to turn the city into a major artistic centre.
In 1010 he founded the abbey church of St Michael,
for which he commissioned various works, most
importantly these superb bronze doors. They are
remarkable not only as outstanding works of sculpture,
but also as marvels of metalworking technique. Using
the lost-wax method (*see p.164*), each door was cast as
a single, enormously heavy piece of bronze: individual
scenes were carved into large wax or tallow tablets and
then assembled, with the moulds stood on their long
sides for the molten bronze to be poured in. The result
is testimony to an ambition and skill with the material
that had not been seen since the ancient Romans.

Narrative in metal

Relief images tell the biblical story of salvation over
16 bronze panels. The left door has eight scenes from
the Old Testament representing man's fall from grace,

The massive solid bronze doors each weigh c.1.85 tonnes

while the right door depicts eight scenes from the New
Testament, showing the life of Christ. Chronologically
the sequence begins at top left, with God creating Eve
from Adam's rib, and proceeds down to Cain killing
Abel. The sequence then moves up from bottom right
(the Annunciation) to top right (Mary Magdalene
seeing Christ after the Resurrection). There are many
links visually and thematically between the two sides.
For example, in the third row down, the central tree in
the Garden of Eden has an echo in Christ's cross. The
overall theme is that Adam and Eve's sin is redeemed
by Christ's sacrifice. The unknown artist or artists of
the doors created scenes of vivid immediacy, stripped
to essentials, and full of drama and pathos.

◁ **THE DOORS IN POSITION**
The Romanesque cathedral was
renovated in 2010–15, with the
Bernward Doors being positioned
in a vestibule inside the west
entrance, opening into the nave.

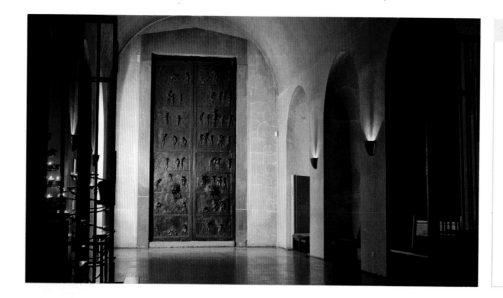

BERNWARD OF HILDESHEIM

One of the most
remarkable men of his
time, Bernward (c.960–
1022) came from a Saxon
noble family, and was
widely travelled and
multi-talented. As well
as being intellectually
gifted and an efficient
administrator, he is said
to have been a skilful
artist and craftsman.
Before becoming Bishop
of Hildesheim in 993, he
was tutor to the future
Holy Roman Emperor
Otto III. Bernward was
canonized in 1193.

Scale

SALVATION STORY
Reading downward and then upward, the 16 panels tell the Christian story of the Fall and Redemption of Man.

TWO GARDENS
The first scene (*opposite*) takes place in the Garden of Eden; here, in the last panel, the post-Resurrection scene is also set in a garden – one of many such parallels.

CHRIST BEFORE PILATE
Here Christ is brought captive before Pontius Pilate, the Roman governor who sentences him to death by crucifixion.

INSCRIPTION
A Latin inscription across the centre of the doors gives their date as 1015.

△ **VIVID NARRATION**
The fifth panel depicts the Expulsion from Paradise, in which the angel (*above*) drives Adam and Eve from Eden as a result of their sinfulness.

LIONS' HEADS
The door handles are set in large lions' heads, which were cast as an integral part of the door. The lion is often found in Christian art because of various symbolic associations.

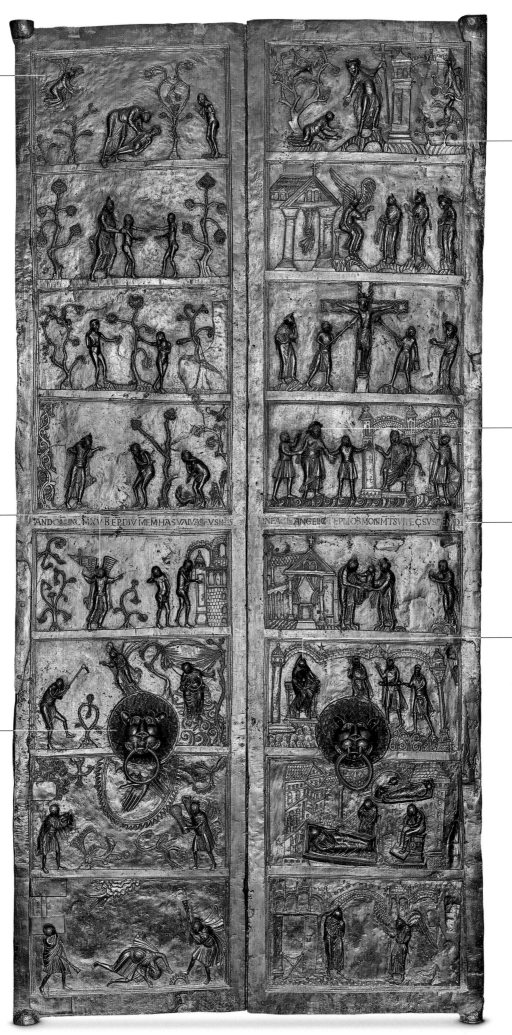

△ **PROJECTING HEADS**
The depth of relief varies, with the heads projecting furthest, so that the figures sometimes seem to lean out of the panels. Mary with the infant Jesus is seen here.

Scale

The Bayeux Tapestry shows **623** people, **202** horses, **55** dogs and **506** birds and other animals

Bayeux, France

The Bayeux Tapestry

A magnificent 11th-century tapestry that tells the story of the Norman conquest of England

The Bayeux Tapestry is thought to have been commissioned by Bishop Odo of Bayeux to celebrate the victory of his half-brother, William the Conqueror, against the Anglo-Saxons at the Battle of Hastings in 1066. Made a few years after the battle, c.1070, it is actually an embroidery, about 68m (223ft) long and 70cm (20in) high, made by sewing wool thread dyed with woad, madder, and dyer's rocket pigments onto a linen base; it is likely that the designs were drawn onto the linen before being embroidered. The tapestry was first recorded in an inventory of Bayeux Cathedral in 1476.

MAKING THE TAPESTRY

The tapestry's stitching pattern is visible on this reverse section of one of its eight conjoined strips. The embroiderers used bronze needles to stitch through the off-white linen base. The stitching is tight (around 19 threads per square centimetre) and reveals the use of, for example, laid and couch stitch (*see p.276*), also known as "Bayeux stitch", to fill large areas, chain stitch, stem stitch (overlapping stitches that form a long line), and outline stitch to create borders and faces.

▽ **THE BAYEUX TAPESTRY**
This 1m (3ft) long section of the tapestry shows the Norman cavalry (left) charging the Anglo-Saxons, who are led by King Harold. **Date:** c.1070.

EXPLANATORY TEXT
People, places, and events are explained with the use of Latin captions (*see also image below*).

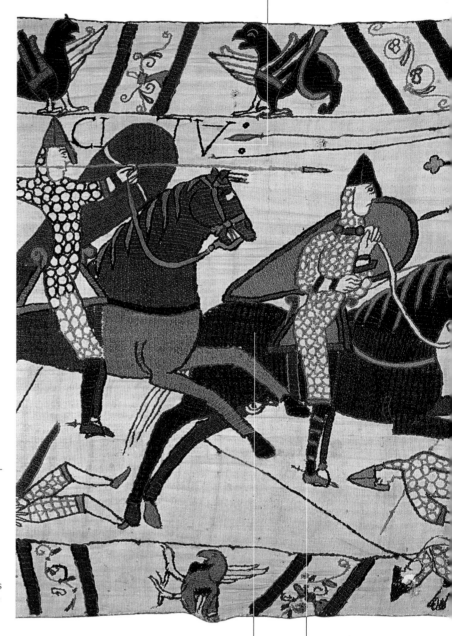

BAYEUX STITCH
The primary stitch used in the work is couch stitch, or "Bayeux stitch", which enabled large areas to be quickly filled.

CAVALRYMAN
Norman cavalryman braces his lance ready for impact with the Anglo-Saxon line.

▷ **WAR PREPARATION**
The complete text of the Latin caption shown here (partially obscured in this section from the tapestry) translates as: "[Duke William instructs his soldiers to] prepare with courage and wisdom for battle against the English army."

PROTECTION
Long shields are carried by both sides and give high levels of protection.

PRINCIPAL COLOURS
Eight colours are used in the work, including terracotta, yellow, buff, and various blues and greens.

FACIAL PROTECTION
A conical iron helmet with a long nose-strip protects the head and centre of the face.

FANTASTIC BEASTS
Mythical creatures such as griffins and dragons form decorative borders.

METAL ARMOUR
Soldiers on both sides wear mail hauberks, long coats of interlinked iron rings that deflect arrows and other blades.

BARRIER FORMATION
The Anglo-Saxon huscarls (elite troops) form a wall of interlocking shields on the top of a ridge.

LONE ARCHER
A solitary Anglo-Saxon archer has far less protection than the elite Anglo-Saxon troops.

Qingming Scroll

A lavish Song-dynasty handscroll showing the vibrant life of a city at festival time

Kaifeng, China

The *Qingming shanghe tu* ("Going Along the River at Spring Festival"), considered one of China's artistic masterpieces, is a scroll painting by the 12th-century Chinese artist Zhang Zheduan, whose only known work this is. The silk scroll bears inscriptions from some of its many owners over the years, the earliest of which dates to 1186. The title may refer to the Qingming festival in April, when families traditionally honoured their ancestors by sweeping their tombs.

The handscroll format allowed a reader to unroll a section at a time, reading the scenes from right to left. The visual narrative, painted in delicate, geometrically precise brush strokes in monochrome ink, depicts festival time, and may show the city of Bianjing (now Kaifeng), the capital of the Northern Song; the fact that there are no definitely identifiable buildings leads some scholars to suggest that this is an idealized location.

The painting portrays people – mainly men – from all walks of life. As the scroll is unrolled, the picture moves along the river, from bucolic rural life to the bustling city, with the climactic bridge scene (*below*) at the halfway point. Merchants, scholars, and peasants jostle, haggle, and stroll, while both inside and outside the great gate the city teems with commerce.

▽ **QINGMING SCROLL**
The climactic central scene shows a commotion as a boat approaches a bridge outside the city. It comes in at a difficult angle, while onlookers encourage the boatman and try to prevent a disastrous crash.
Dimensions of whole scroll: 25.5cm x 5.25m (10in x 17ft 2in). **Date:** 1100–1200.

SHOPS AND STALLS
Rows of shops and stalls line either side of the bridge.

SEDAN CHAIR
A well-to-do person is carried over the bridge in a sedan chair.

NIGHT LIGHTS
Lanterns hung from poles by the bridge act as warning lights at night.

AVOIDING A CRASH
Bystanders on the bridge try to guide the boat using ropes and poles.

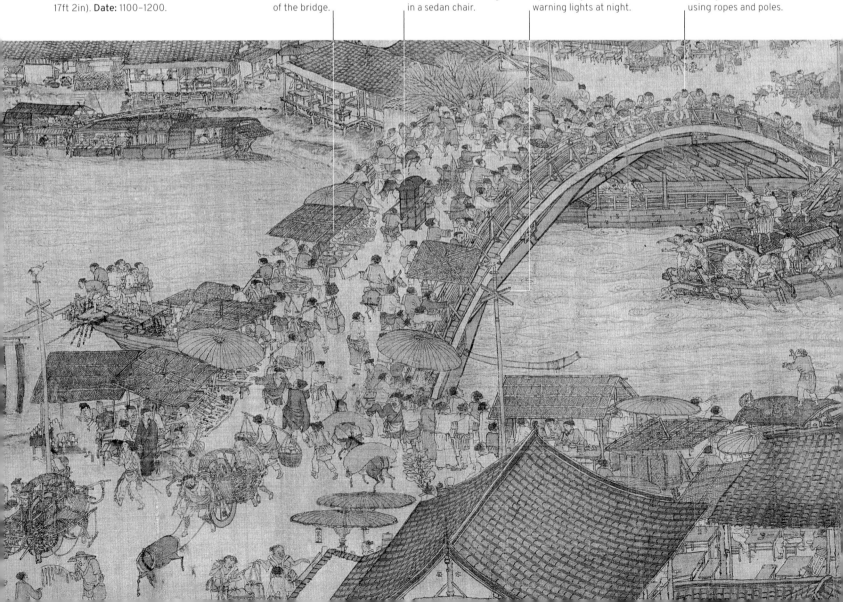

COPIES OF THE QINGMING SCROLL

As one of the most admired works of Chinese art and a prized possession of emperors, the Qingming Scroll was copied many times over the centuries. There are more than 20 extant versions, the earliest being one made during the Yuan dynasty in the 13th century. A Ming version by the artist Qiu Ying (1494–1552) replaces the wooden bridge with a stone one and updates the style of clothes and vehicles. The most important copy, shown here, was made by five Qing court artists in 1736 for the Qianlong Emperor. Longer than the original, at 11.5m (37ft 8in), it also depicts a greater number of people (more than 4,000) and shows additional scenes within the imperial palace. The frontispiece includes a poem by the emperor himself, added in 1742.

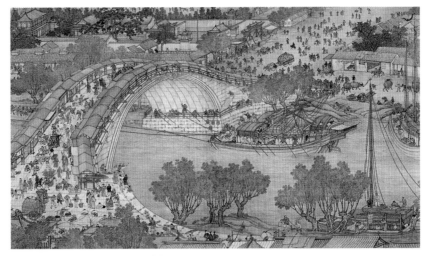

18TH-CENTURY QING-DYNASTY VERSION

LOST CONTROL
An out-of-control river barge heads towards the side of the bridge.

RIVERBANK DISCUSSION
Two people, perhaps parent and child, are engaged in a lively discussion.

Scale

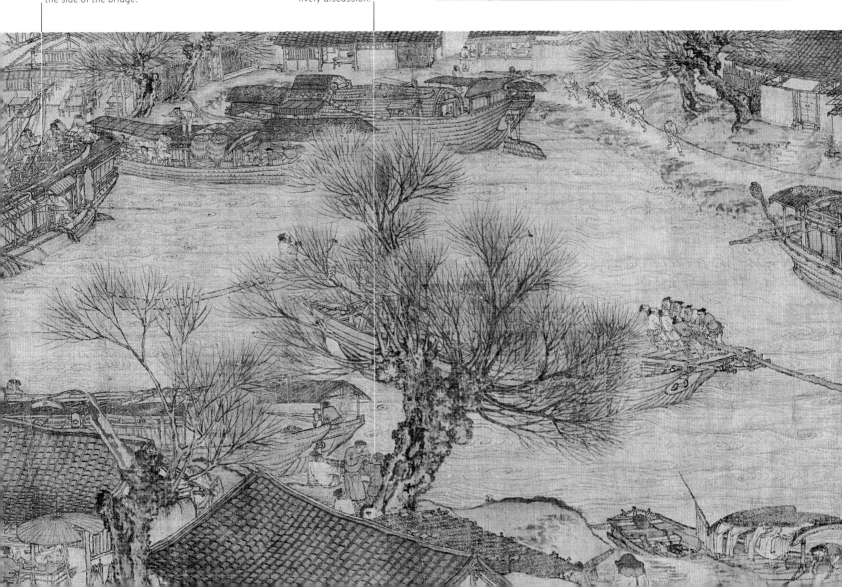

Madhya Pradesh,
India

Scale

Dancing Celestial Deity

A life-size sandstone statue from a Hindu temple, capturing the graceful movement of traditional Indian dance

This glorious statue, dating from the mid-11th century, is notable for its beauty and elegance, and is one of the finest of the sandstone sculptures to adorn the Hindu temples of Madhya Pradesh in Central India. Even though its limbs are broken, and the feet and hands are missing, the pose of the exquisitely sculpted statue still conveys a powerful impression of sensuous movement and balanced composition. The *devi*, or "feminine celestial deity", is shown dancing in honour of the (*deva*) gods of the temple, and the exaggeratedly sinuous pose conveys her sense of joyous celebration.

The statue echoes the often erotic sculptures that typically cover the walls of these Hindu temples (*see p.152*). The dancer is an idealized depiction of Indian female beauty, with highly stylized facial features. Expanses of smooth stone represent an abundance of bare flesh and emphasize the contours and amplified roundness of the female figure. In contrast, the eyecatching jewelled crown, necklace, and bracelet are carved in intricate detail, and the skirt's finely depicted swaying fringes and tassels add to the magnificent sense of rhythmic movement.

DANCING CELESTIAL DEITY ▽
This spectacular statue of a dancing *devi*, a semi-divine spirit, was sculpted in local sandstone in the Madhya Pradesh region of India at the height of the Hindu temple-building era of the Chandela period. **Height:** 88.3cm (34³⁄₄in). **Date:** c.1050.

JEWELLED CROWN
Ornaments on the spiked crown are carved in fine detail.

EROTICISM
The shape of the breasts is accentuated for artistic effect.

TILTED HEAD
Tilting the head back balances the projecting left thigh both aesthetically and physically.

TWISTED TORSO
The torso is impossibly twisted to give a sense of movement.

FRINGED SKIRT
Tassels and ornaments on the skirt emphasize the impression of swirling motion.

THE DEVI'S POSE

The classical Sanskrit treatise on the performing arts, the *Natyashastra*, describes Indian dance as being built from 108 *karana*, or basic poses, which are often portrayed in artworks and statues. In this artist's impression of the *devi* statue in its entirety, the assumed positions of the missing limbs complete the figure in one such pose, adding to a sense of movement. The expressive gestures of the arms and hands enhance the sensuality of the sinuous body.

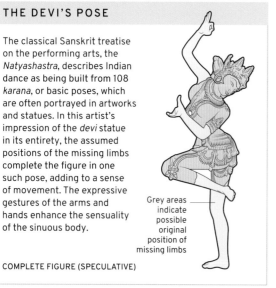

Grey areas indicate possible original position of missing limbs

COMPLETE FIGURE (SPECULATIVE)

FLESH AND ADORNMENT
The warm texture of smooth sandstone gives the impression of soft flesh, contrasting with the finely detailed carving of the ornaments.

STANDING LEG
The right leg (now missing) would have been behind the figure's centre of gravity, giving the statue a sense of forward movement.

Tula, Mexico

Scale

Toltec Warrior Head

An intriguing sculpture from an enigmatic Mesoamerican civilization, depicting a warrior's head in the jaws of a coyote

The Toltecs, who held sway over central Mexico for two centuries from around 900, were a martial culture, a fact reflected in their art. Reliefs in their capital, Tula, depict sacrificial processions and predators feasting on human hearts. The city was sacked around 1150; this exquisite warrior's-head ceramic is one of few survivals.

The entwined coyote and warrior's head is one of the finest ceramics from any Mesoamerican culture. Moulded in a glossy grey clay known as plumbate, it is covered in a mosaic of fine mother-of-pearl pieces, giving a furred effect to both the tusked coyote and the bearded warrior who emerges from its jaw. The head may represent the helmet of one of an elite group of warriors whose armour mimicked the bodies of fierce animals, in particular eagles, jaguars, and coyotes: such helmets had an opening between the jaws for the warrior's face (*see box*). Here, the jaws of coyote and warrior seem to fuse together, emphasizing the identification of the one with the other.

ANIMAL WARRIOR HELMETS

Aztec warriors are known to have worn armour associated with fierce animals, including eagles, jaguars, and coyotes, a custom they may have derived from their much-admired predecessors, the Toltecs. Elite jaguar warriors dressed in jaguar skins, while eagle warriors wore feathered robes; fanged or beaked helmets protected their heads. Wearing such a costume was a way of symbolically harnessing the power and fearsomeness of the given animal in battle.

Jaguar helmet

Coyote helmet

▽ TOLTEC WARRIOR HEAD
This finely crafted ceramic may be the lid of a Toltic effigy jar – a vessel in the form of an animal or human. **Height:** 13.5cm (5in). **Date:** 1100–1300.

EARS
The ears are formed from a larger mother-of-pearl piece.

BONE TEETH
The teeth of the warrior are made from bone.

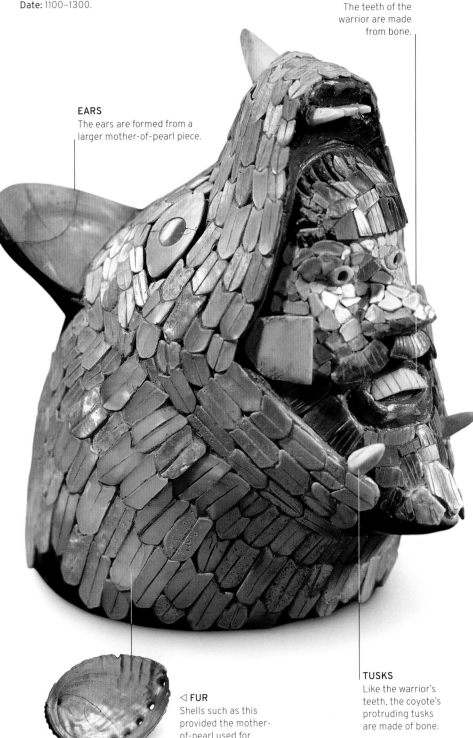

◁ **FUR**
Shells such as this provided the mother-of-pearl used for the fur.

TUSKS
Like the warrior's teeth, the coyote's protruding tusks are made of bone.

An alternative **interpretation** is that the piece may represent the **god Quetzalcoatl** with **human features**

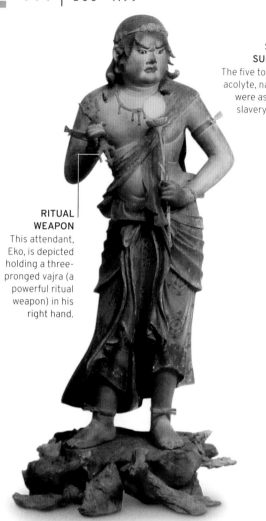

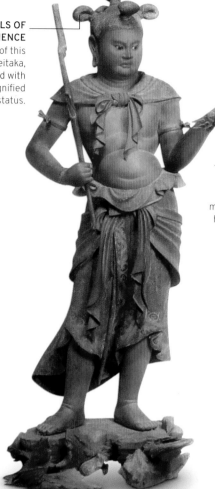

SYMBOLS OF SUBSERVIENCE
The five topknots of this acolyte, named Seitaka, were associated with slavery and signified low status.

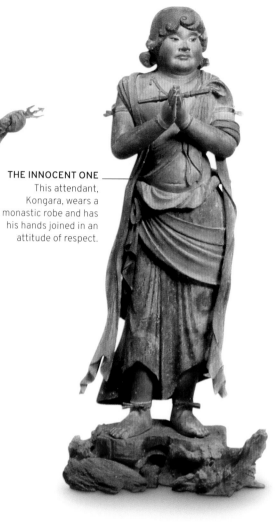

RITUAL WEAPON
This attendant, Eko, is depicted holding a three-pronged vajra (a powerful ritual weapon) in his right hand.

THE INNOCENT ONE
This attendant, Kongara, wears a monastic robe and has his hands joined in an attitude of respect.

△ **ATTENDANTS OF FUDO MYO'O**
The statues represent acolytes of the deity Fudō Myō'ō, one of the five great wisdom kings of East Asian Esoteric Buddhism.
Height (each): c.100cm (39in).
Date: c.1197.

Scale

Attendants of Fudō Myō'ō

A masterly new realism and drama in Japanese sculpture from the end of the 12th century

Kōyasan, Japan

Japan has a wide selection of heritage works known as National Treasures, ranging from castles and temples to samurai swords, pottery, and the arts, including 140 sculptures and sculptural groups. For sheer vitality and presence, few in the latter category can compare with this group of attendants of Fudō Myō'ō, a venerable, if wrathful, Buddhist deity, also known as the Immovable.

Exuberant realism
For Unkei (c.1150–1223), who made the statues, sculpture was a family business. His father, Kōkei, was a renowned artist, and Unkei's own sons would carry on the tradition. Unkei was a devout Buddhist, adhering to the esoteric form that flourished under the Kamakura shogunate. His best-known works are religious in theme and context.

What Unkei brought that was new was a realism and attention to detail that stretched to delineating the lines on chin and paunch, or sometimes even the veins on a neck. He favoured solid figures with well-developed musculature, leading some art historians to think he used wrestlers as models. The poses too are full of life, often with arms akimbo and hips thrown to the side.

This physical casualness is nowhere more marked than in this group, which, in its theatrical ease and exuberant vitality, could hardly be further from the stiff postures traditionally associated with religious statues. Here Unkei was helped by his subject-matter; Fudō's attendants were held to symbolize aspects of the god's own character, so in the different figures the sculptor could run the gamut from righteous anger to slothful ignorance (which Fudō combatted) and monastic piety.

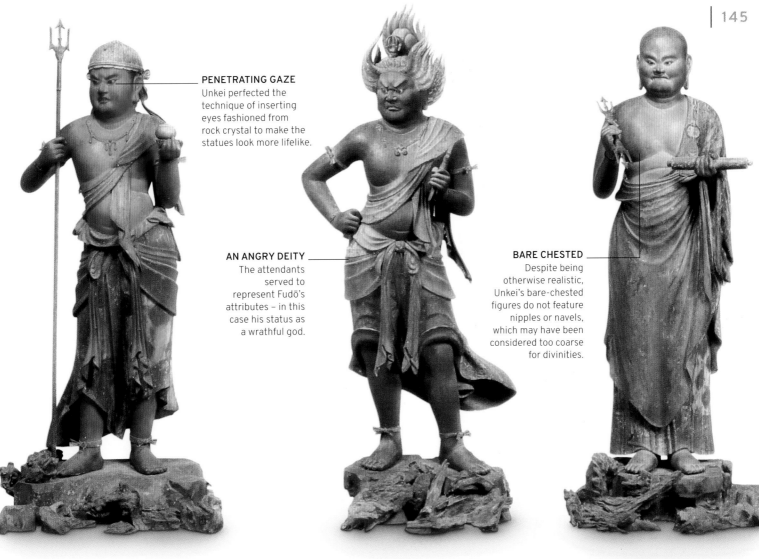

PENETRATING GAZE
Unkei perfected the technique of inserting eyes fashioned from rock crystal to make the statues look more lifelike.

AN ANGRY DEITY
The attendants served to represent Fudō's attributes – in this case his status as a wrathful god.

BARE CHESTED
Despite being otherwise realistic, Unkei's bare-chested figures do not feature nipples or navels, which may have been considered too coarse for divinities.

Eight statues survive in the group, but only the six works attributed to Unkei are classed among Japan's National Treasures

ART IN THE KAMAKURA PERIOD

Lasting from 1180 to 1330, the Kamakura period of Japanese history saw power pass from the courtly aristocracy to the samurai class of warriors. To match the tastes of their new patrons, artists embraced a more vigorous, naturalistic manner – a shift that also suited the proselytizing Buddhist priesthood of the day, eager to reach out to illiterate converts. The changing manner was particularly marked in sculpture, finding its highest expression in the work of Unkei. He is believed to be the creator of this powerfully realistic statue of Chōgen (1121–1206), an ascetic Buddhist monk who devoted 25 years to restoring the Tōdai-ji temple in Nara after its destruction by fire.

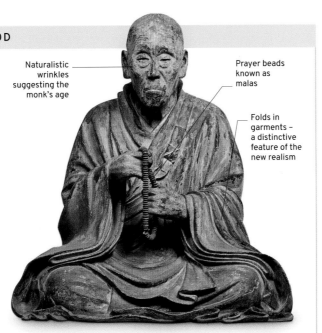

Naturalistic wrinkles suggesting the monk's age

Prayer beads known as malas

Folds in garments – a distinctive feature of the new realism

CHOGEN, PRESERVED IN THE TODAI-JI COMPLEX

△ **A FLEXIBLE MEDIUM**
The figures are carved from the wood of the hinoki cypress, a species admired in Japan and elsewhere for its high-quality timber.

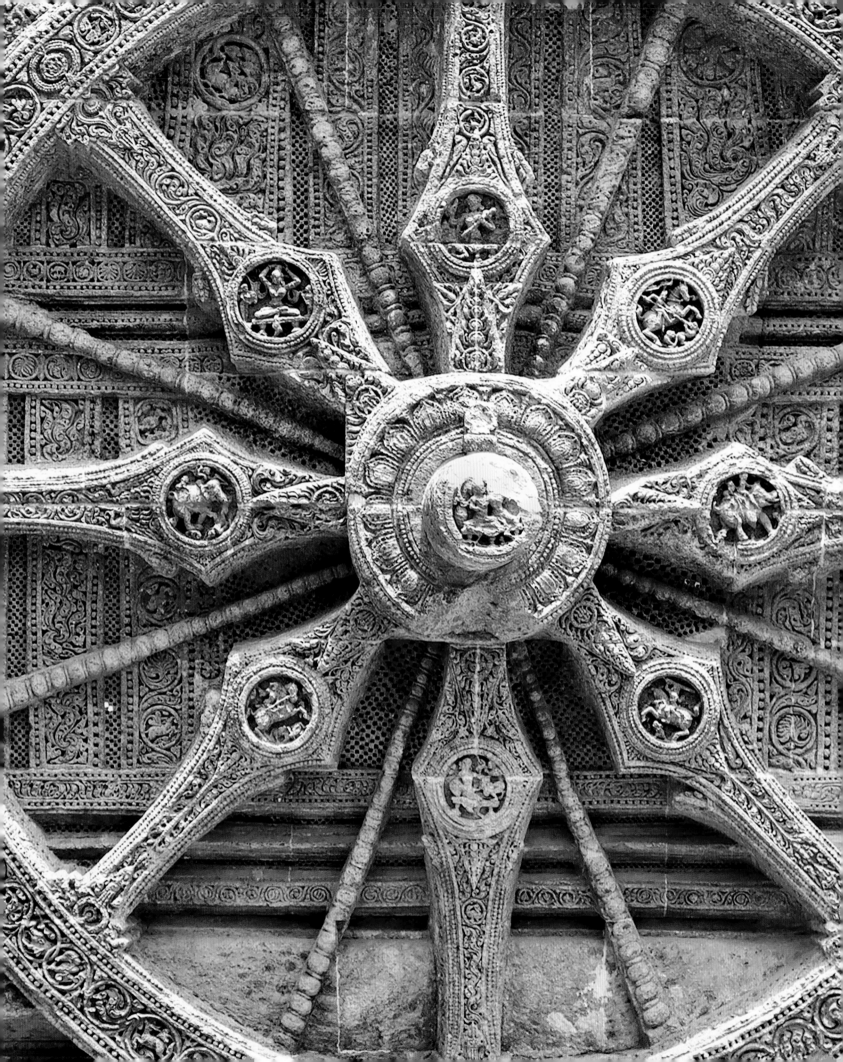

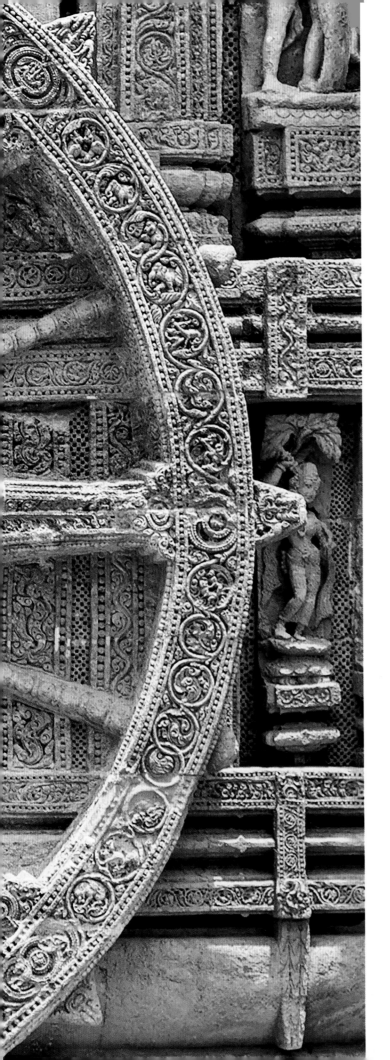

1200–1499

This was a time of change across Europe and Asia: early in the period, universities were established and territories expanded, but in the 14th century, waves of plague, war, and famine devastated populations. Religion continued to dominate cultural production, leaving its mark on the fabric and artefacts of mosques, temples, and churches in mosaic, sculpture, painting, and sophisticated stained glass. Sculpture remained a key art in Africa, where the people of Ife were masters of bronze casting, and in the Americas, where the Toltecs produced monumental stone statues. Pottery and scroll painting continued to develop in China and Japan, while book production leapt forward with the introduction of movable type.

Lewis Chessmen

Ivory pieces from 12th- to 13th-century chess sets that display astonishing technical skill and appealingly human expressions

Isle of Lewis,
Scotland

The Lewis chessmen are some of the most singular artefacts of the Middle Ages. They are carved from walrus ivory and whale's teeth in a confident style that displays craftsmanship of the highest order. Discovered in 1831 buried on a beach near Uig on the Scottish island of Lewis as part of a hoard of 93 elements, they make up some of the very few surviving medieval chess sets. In fact, the 78 chessmen form part of four separate sets, although some pieces are missing.

The pieces were probably produced in Trondheim in Norway, and the style of the bishops' mitres and the warriors' weapons suggests that they were probably made between 1170 and 1230. Only the pawns, carved as simple obelisks, do not have human features. Four of the "warders" (castles, or rooks) are shaped as berserkers – elite Viking warriors – biting their shields in anticipation of battle. With their round, staring eyes and apparently lugubrious expressions, to the modern eye the pieces display a whimsical humour – the berserkers are half-comical, half-menacing; the knights look too big for their mounts; the queens all lean on their hands in a quizzical gesture – but such effects were doubtless more likely intended to convey fury, fierceness, or a contemplative reverie.

Scale

▽ **LEWIS CHESSMEN**
The chessmen's impeccable condition, with some having the remains of red paint (for the "black" pieces), suggests they are unused and might have been part of a merchant's stock. **Height:** 6–10cm (2¼–4in). **Date:** 1170–1230.

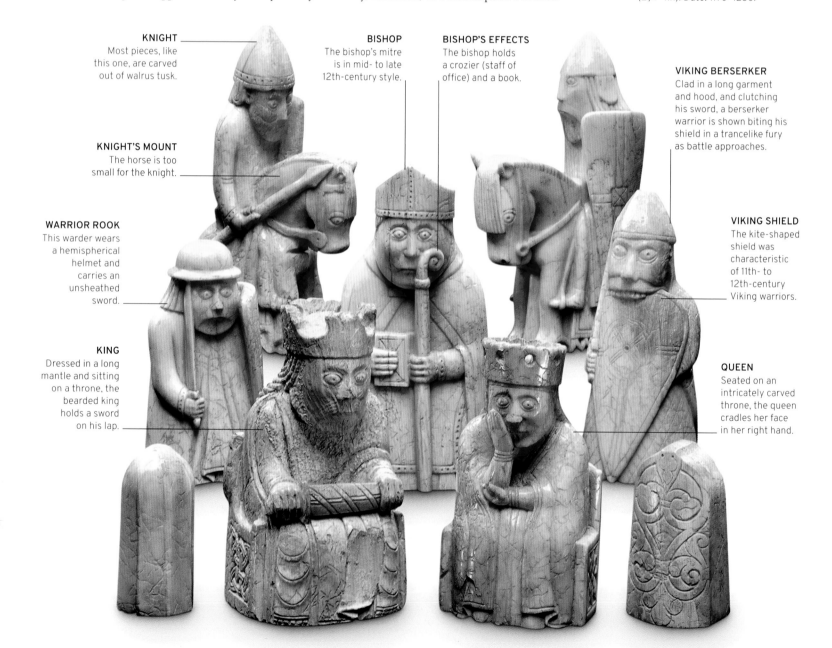

KNIGHT
Most pieces, like this one, are carved out of walrus tusk.

BISHOP
The bishop's mitre is in mid- to late 12th-century style.

BISHOP'S EFFECTS
The bishop holds a crozier (staff of office) and a book.

VIKING BERSERKER
Clad in a long garment and hood, and clutching his sword, a berserker warrior is shown biting his shield in a trancelike fury as battle approaches.

KNIGHT'S MOUNT
The horse is too small for the knight.

WARRIOR ROOK
This warder wears a hemispherical helmet and carries an unsheathed sword.

VIKING SHIELD
The kite-shaped shield was characteristic of 11th- to 12th-century Viking warriors.

KING
Dressed in a long mantle and sitting on a throne, the bearded king holds a sword on his lap.

QUEEN
Seated on an intricately carved throne, the queen cradles her face in her right hand.

Golden Rhinoceros of Mapungubwe

A powerfully portrayed rhinoceros in miniature from South Africa that is carved in wood and plated with sheets of burnished gold

Mapungubwe, South Africa

The Golden Rhinoceros was one of several gold-covered wooden artefacts found around 1933 at the burial site of the Kingdom of Mapungubwe, which flourished in the 11th and 12th centuries next to the Shashe and Limpopo rivers. Although just a few centimetres long, the rhinoceros has a monumental quality, and a symbolic significance that preserves its iconic status in the present: it depicts the massiveness of its animal subject and the symbolic power of gold in an area that was renowned as a major trading centre.

Like other funerary goods found at Mapungubwe, it was made by carving a figure in wood, which was then covered with thin, closely fitting sheets of gold, mimicking the armour-plating of a rhinoceros's hide. These were fixed to the base with tiny, handmade golden nails, hammered in along the seams where the sheets overlap. More delicate features, such as the protruding eyes, and the separately cut and attached ears and tail, emphasize rather than detract from the muscularity of the beast.

Scale

▽ BOVINE FIGURE
A companion piece to the Rhino of Mapungupwe, this similarly sized and constructed gold figure depicts a more docile bovine animal.

OVERLAPPING GOLD
The base is completely covered with gold by overlapping the sheets.

CONTOURS
The sheets have been moulded to fit snugly over the contours of the base at the shoulders and haunches.

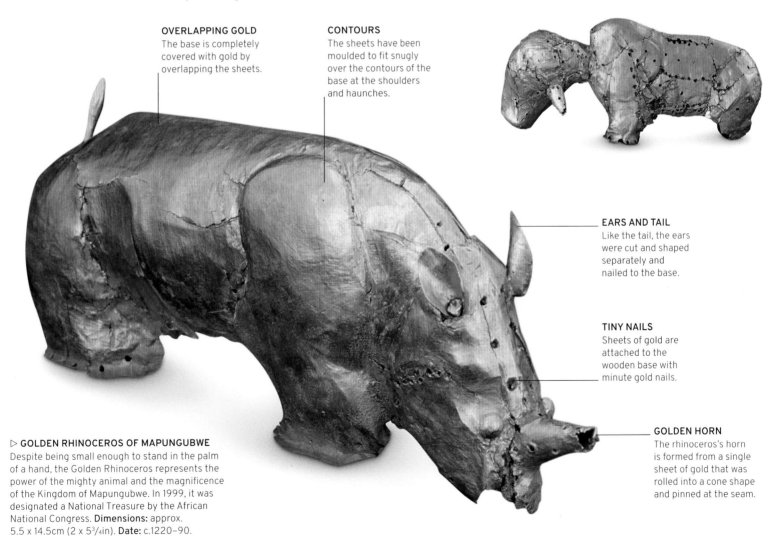

EARS AND TAIL
Like the tail, the ears were cut and shaped separately and nailed to the base.

TINY NAILS
Sheets of gold are attached to the wooden base with minute gold nails.

GOLDEN HORN
The rhinoceros's horn is formed from a single sheet of gold that was rolled into a cone shape and pinned at the seam.

▷ GOLDEN RHINOCEROS OF MAPUNGUBWE
Despite being small enough to stand in the palm of a hand, the Golden Rhinoceros represents the power of the mighty animal and the magnificence of the Kingdom of Mapungubwe. In 1999, it was designated a National Treasure by the African National Congress. **Dimensions:** approx. 5.5 x 14.5cm (2 x 5³⁄₄in). **Date:** c.1220–90.

The **Golden Rhinoceros** weighs just **37g (1¼oz)**

CHARTRES STAINED GLASS ▷
This magnificent group of windows
is in the north transept; below it is
one of the main entrances to the
cathedral. **Diam. of rose window:**
approx. 10.2m (33ft). **Date:** c.1230.

Chartres Cathedral Stained Glass

The greatest of all collections of medieval stained glass, made at a high point of Gothic art

Chartres, France

The stained glass of the Gothic cathedral of Chartres is unrivalled in extent and quality, ranking as one of the chief glories of medieval art. The present cathedral was begun in about 1145, but was devastated by fire in 1194 and rebuilt over the next quarter-century. A few stained-glass windows made before the fire survive, but most of those at Chartres (more than 150) were produced between about 1200 and 1235, a period when the art was at its peak.

The light of spiritual intensity

The windows are arranged according to a sophisticated narrative scheme that would appeal to and enchant a largely illiterate audience, though one profoundly familiar with the stories of the Bible: the message was less to instruct than to glorify God. The lower windows relate stories from the Scriptures and the lives of the saints; the upper rows show saints and prophets; and three glorious rose windows present great composite pictures. Many windows were paid for by local trade guilds, and labourers and tradesmen themselves were portrayed – the first time that such secular activities were depicted as part of the iconography in a church. The wonderful grouping shown here (the north rose window above five lancets, or tall pointed windows) was donated by Louis IX of France and his mother, Blanche of Castile. This explains why the fleur-de-lis, associated with French royalty, figures so prominently.

As well as such specific symbols and associations, the radiant beauty of the glass was linked by medieval philosophers with the light of God and the spiritual awakening brought by Christ. To worshippers, the great church glowing with resplendent colours was more than simply decorative – it gave a foretaste of Heaven.

▽ **CHOIR WINDOWS AND VAULTS**
Chartres is often considered the most "complete" of the great Gothic cathedrals, with its wealth of stained glass and sculptural decoration integrated into the fabric of an outstanding work of architecture.

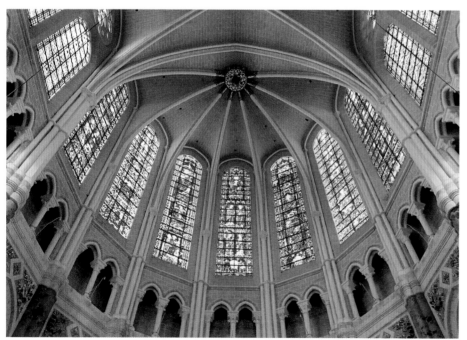

△ **JESUS AND THE GOOD SAMARITAN**
The parable of the Good Samaritan is related over nine panels (4–8 seen here) of a larger window. The intense blue colour for which Chartres stained glass is renowned is evidenced here.

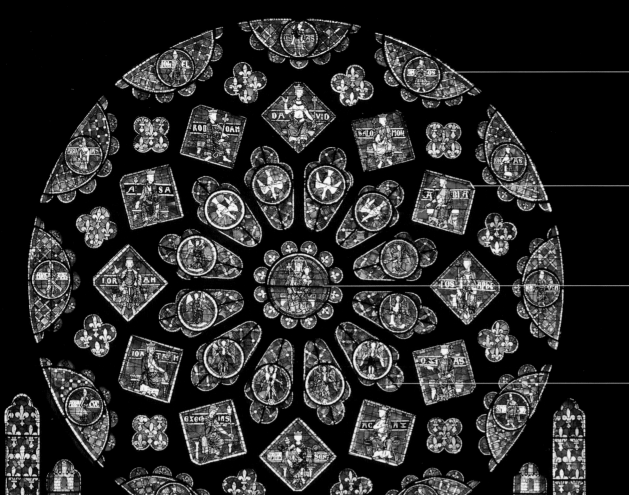

RING OF PROPHETS
In the outer ring, various prophets are depicted in roughly semicircular panels.

SQUARE PANELS
The 12 square panels depict kings of Judah, who were regarded as ancestors of Christ.

CENTRAL ROUNDEL
At the centre of the rose window, the Virgin Mary sits enthroned, holding the Christ Child.

ANGELS AND DOVES
An inner ring of 12 panels surrounding Mary features eight angels and four doves.

▽ **ST ANNE**
The central figure of the lancets is St Anne, mother of the Virgin Mary. She was particularly venerated at Chartres, which claimed to have a relic of her head.

OLD TESTAMENT FIGURES
Flanking St Anne are various Old Testament figures, including King David, who holds his harp. The small figure below him is King Saul, killing himself with his sword.

Scale

Odisha,
India

Konark Sun Temple Sculptures

A spectacular display of carved stone reliefs and sculptures adorning every surface of the temple of the Deva Surya (Hindu sun god) at Konark

Since its completion in the mid-13th century, the colossal sun temple at Konark, in Odisha, India, has stood as probably the finest example of the Odisha style of temple architecture, not least because of the lavish decoration of its exterior.

Glorious embellishment
Carved into the stone walls, from the ground to the pinnacle, are relief panels, pillars, and friezes depicting Hindu deities, royalty, musicians, dancers, ordinary people, and animals (real and mythical), embellished with geometric and floral designs. The sculptures range in size from the monumental to the miniature, and the skill of their execution marks the high point of the art of the Eastern Ganga dynasty (c.505–c.1434).

Commissioned by Narasimhadeva I (ruled 1238–64), the temple was built as a representation of the chariot of the sun god Surya, drawn by seven massive horses. Although dedicated to Surya, the sculptures on the walls honour the whole pantheon of Hindu gods. Panels around the building show stories from Hindu texts, or scenes of the life of the king, but most of the depictions celebrate ordinary life. These are arranged in sections, on a variety of themes: the lower frieze, for example, includes a hunting scene, soldiers, travellers, and animals. Most striking are the pillars and tableaux featuring some mythical beasts, but mainly people, the lowly as well as the aristocratic, going about their daily business, indulging in music and dance, or enjoying the sensual pleasures of courtship and intimacy.

Two of the temple's chariot wheels also act as sundials, accurate to within one minute

TEMPLE STRUCTURE

The original temple complex at Konark consisted of a main temple building (or *deul*) beneath a tower known as a *shikhara*, in front of which was an assembly hall, the *jagamohana* (or *mandapa*). Although the magnificent *shikhara* collapsed in the 16th century, the *jagamohana*, a richly decorated monumental depiction of Surya's chariot, has survived.

Shikhara
(now in
ruins)

Jagamohana
(surviving)

Deul

Wheels

Horses

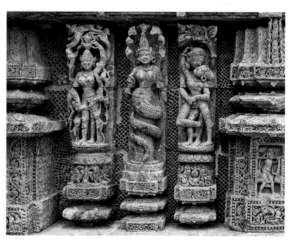

△ **TEMPLE SCULPTURE**
The outer walls of the temple are adorned with groups of columns bearing elaborately sculpted figures, including deities, mythological creatures, and couples in erotic poses.

TYPE OF STONE
The predominant stone used for the carved walls and pillars was khondalite, sculpted after the blocks had been put in place.

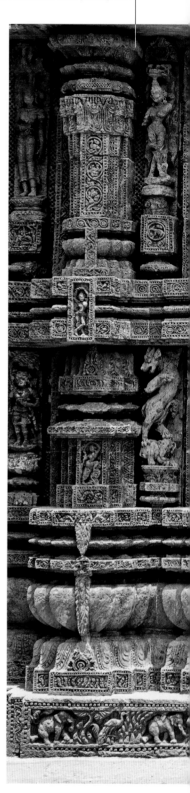

Scale

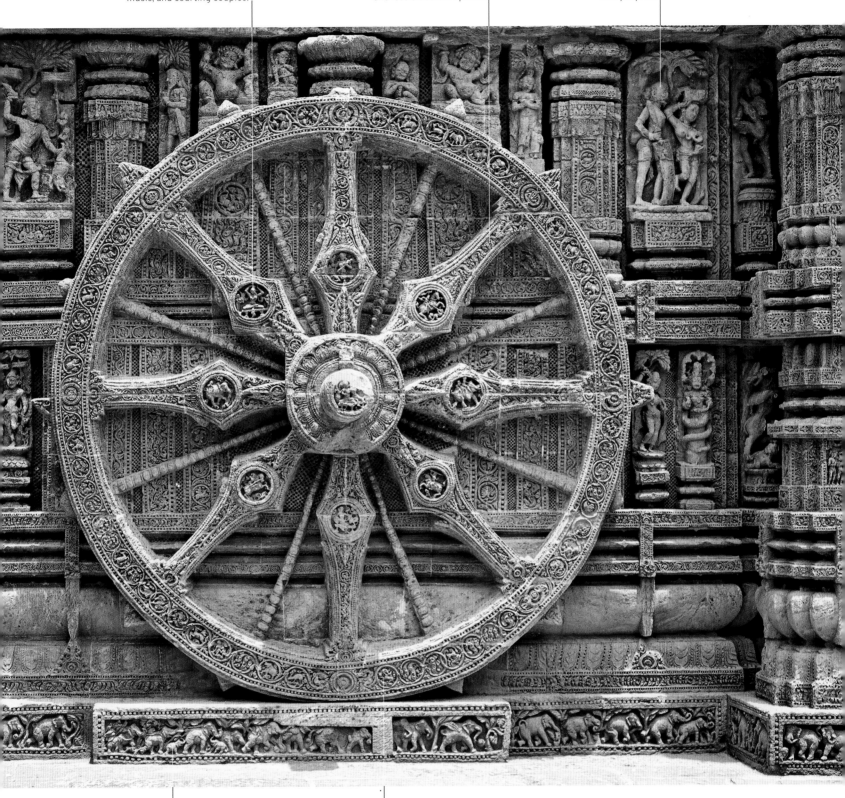

MEDALLION
The medallions on the spokes of this wheel show various Hindu deities; those on other wheels depict themes such as dancing, music, and courting couples.

SPOKES
Each wheel has eight ornate main spokes with central medallions, and eight thinner and less elaborate spokes.

EVERYDAY LIFE
Spectacular figures in high relief form tableaux depicting scenes from everyday life.

ELEPHANTS
The temple's lower frieze shows a procession of elephants – they are sacred animals in Hindu culture.

WHEEL RIMS
Geometric designs containing miniature relief carvings of animals cover the rim of the wheel.

△ KONARK SUN TEMPLE
To depict the temple as a depiction of Surya's chariot, 24 huge wheels are carved on the walls either side of the *jagamohana* (*see opposite*); the 12 pairs of wheels symbolize the months of the year. **Dimensions: diameter (each wheel)** 3m (9ft 9in); height (surviving temple) approx. 30m (98ft).**Date:** c.1250.

Istanbul, Turkey

Mosaics of Hagia Sophia

Spectacular decorations that include a majestic 13th-century image of the head of Christ revered as one of the high points of the art of mosaic

Hagia Sophia (Greek for Holy Wisdom) in Istanbul (Constantinople), Turkey, is one of the world's supreme architectural achievements. The history of the building and of its decoration is long and complex. It was built in 532–37 and was a Christian church until 1453, when (following the Islamic conquest of Constantinople) it became a mosque. It was a museum from 1935 until 2020, when it was re-hallowed as a mosque.

Lavish mosaics

From the beginning, Hagia Sophia had lavish mosaic decoration, and over the centuries this has been added to, modified, repaired, and replaced – damage or destruction to the mosaics has been caused by earthquakes and by people whose beliefs forbade figurative imagery, such as iconoclasts in the 8th and 9th centuries and Muslims after the Islamic conquest.

Of all the mosaics in Hagia Sophia, none is more revered than this spectacular head of Christ. It is the best-preserved part of a huge panel of the Deesis, a term given to Byzantine images of Christ flanked by the Virgin Mary and John the Baptist, who intercede with the Saviour on behalf of humankind (the term is Greek for "entreaty"). The figure of Christ, holding a holy book in his left hand and raising his right hand in blessing, is remarkable for its serene majesty and also for the technical sophistication with which it has been created. The tesserae (individual pieces of glass or stone) are particularly small, allowing great subtlety in the treatment of shapes and finely blended colours. Christ's face, neck, and hands in particular have been skilfully crafted using light and dark to give an almost three-dimensional effect.

The **tesserae** are set at slightly **varied angles** to **catch the light** and create a **sparkling surface**

THE CHANGING IDENTITIES OF HAGIA SOPHIA

After Hagia Sophia was converted from a church to a mosque in 1453, the changes included adding minarets that soar like giant pencils. Major renovations in 1847–49 included the installation of eight wooden roundels (around 7.5m/25ft in diameter) inside the mosque, bearing, in elegant Arabic calligraphy, the names of God (*Allah* in Arabic), Mohammed, and six other major figures in Islamic history. Since being re-hallowed as a mosque, the Christian mosaics have been temporarily covered with curtains during prayer, after which they are revealed again.

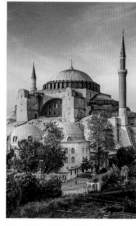

EXTERIOR OF HAGIA SOPHIA

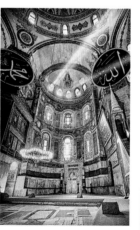

INTERIOR, SHOWING ROUNDELS

△ MOSAIC OF VIRGIN AND CHILD
The Virgin and Child are shown here flanked by the emperor John II Comnenus and his wife St Irene of Hungary. The mosaic was probably made to celebrate their accession in 1118.

Scale

HALO
The halo around the head incorporates the shape of a cross, a type usually restricted to representations of Christ.

△ **DELICATE DETAIL**
This close-up of the eye shows how subtly the tesserae have been used to suggest the forms and colours of the face.

GOLD BACKGROUND
The gold background, as found in many Byzantine mosaics, evokes divine light and the glory of God.

STYLIZED DRAPERY
Although the face is naturalistic, folds in Christ's drapery are indicated by stylized lines.

RAISED HAND
Christ's right hand is raised in a gesture of blessing.

◁ **MOSAICS OF HAGIA SOPHIA: HEAD OF CHRIST**
Only about a third of this mosaic panel survives, but fortunately the most important parts are well preserved. **Height (of detail shown):** approx. 2m (6ft 6in). **Date:** c.1200–1300.

Kyoto, Japan

Illustrated Legends of the Kitano Tenjin Shrine

A beautiful example of painted narrative handscroll art from 13th-century Japan

Narrative picture scrolls known as *emaki,* unrolling from right to left to reveal the story, became popular in 12th- and 13th-century Japan. This handscroll set relates the events leading up to the creation of the Tenjin cult: the unjust exile and death of 9th-century courtier Sugawara no Michizane; his return as a vengeful ghost; his deification as Tenjin; and the founding of the shrine to honour him. Of over 30 surviving unique versions, this is the only one to depict the monk Nichizō's full journey to Heaven and Hell (*see box*).

PACIFYING THE SPIRITS

Vengeful spirits (*onryō*) were believed to cause both death and natural disasters. Michizane's vengeful spirit was pacified after the monk Nichizō travelled to Hell, where Emperor Daigo instructed him to create a shrine in Michizane's honour.

DAIGO AND NICHIZO MEET IN HELL (FOURTH SCROLL)

▽ *LEGENDS OF THE KITANO TENJIN SHRINE*
These illustrations are from the third and fourth of a five-scroll set. **Height:** 29cm (11½in); **length of longest scroll:** 8.95m (29ft 6in). **Date:** 1200–1300.

INK AND COLOUR
The scrolls are painted in ink and colour wash, with sparsely rendered, evocative landscapes.

SUPERNATURAL BEINGS
The scrolls are full of supernatural elements, including this demon tormenting souls.

MONK'S PROGRESS
The itinerant monk Nichizō journeys into the mountains.

VENGEFUL GHOST
Michizane's spirit takes revenge as the thunder god, plaguing Emperor Daigo's sons with disasters and illness.

PATHWAY
A path leads the reader through the story.

Scale

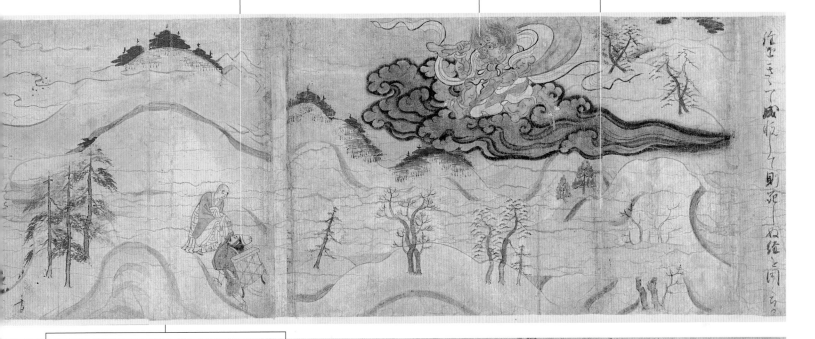

HEIGHTENED DRAMA
The contrast between the simplicity to the right and the hellish flames to the left of the scene increases the drama.

THE GATES OF HELL
Nichizō approaches the gates of Hell, which are guarded by an eight-headed beast.

London, UK Scale

Coronation Chair

An iconic piece of medieval furniture that has played an important ceremonial role in British history

In the 13th and 14th centuries, Scotland fought to regain independence from England. During the warfare, in 1296, Edward I of England seized the Stone of Scone, an ancient symbol of Scottish monarchy, and installed it in Westminster Abbey, enclosed underneath the seat of this specially built oak chair. In this way he demonstrated his authority over Scotland. The chair was used at the coronation of his son, Edward II, in 1308, and at the coronation of every subsequent monarch of England (and later of Great Britain and the United Kingdom, including the present queen). The royal painter Walter of Durham supervised the creation of the chair, which was richly ornamented with gilding, painting, and glass mosaic.

Over the centuries the decoration of the chair has become battered and faded. In addition to the normal erosion of time, it has suffered more serious injuries: in the 18th and 19th centuries, for example, it was defaced by graffiti, while in 1914 it was slightly damaged by a suffragette bomb that was placed beneath it. In 2010–12 the chair underwent significant cleaning and restoration.

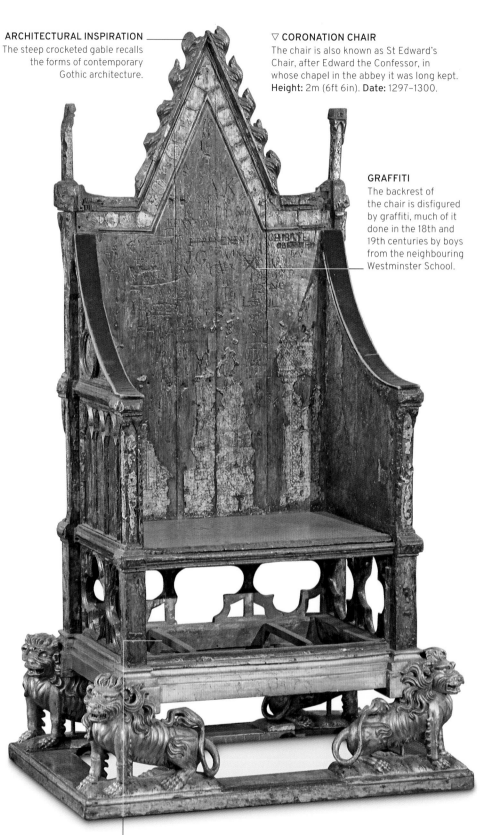

ARCHITECTURAL INSPIRATION
The steep crocketed gable recalls the forms of contemporary Gothic architecture.

▽ CORONATION CHAIR
The chair is also known as St Edward's Chair, after Edward the Confessor, in whose chapel in the abbey it was long kept. Height: 2m (6ft 6in). **Date:** 1297–1300.

GRAFFITI
The backrest of the chair is disfigured by graffiti, much of it done in the 18th and 19th centuries by boys from the neighbouring Westminster School.

△ LEAF DECORATION
The best-preserved parts of the original decoration are naturalistic foliage patterns on the left arm of the chair.

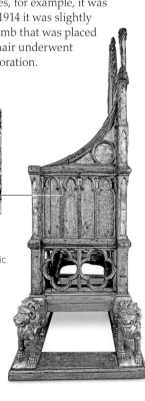

▷ SIDE VIEW
Carved gilt lions, added in 1727, adorn the base of the chair, replacing ones dating from the early 16th century.

EMPTY COMPARTMENT
The Stone of Scone was returned to Scotland in 1996, with the requirement that it be taken to England for coronations.

At the 1689 coronation of **William III** and **Mary II**, Mary sat in a specially made **companion chair**

Northern Peru | Scale

Chimú Collar

A magnificent piece of personal adornment from one of the major cultures of ancient South America

The Chimú were a people of what is now Peru, whose civilization was the most important in the region from about 1000 until about 1470, when they were conquered by the Incas. They excelled in metalwork, pottery, and shellwork, in particular making highly creative use of *Spondylus* shell (spiny or thorny oyster).

Spondylus was associated by the Chimú with water, fertility, and divine power, and the shells were valued more highly than gold. They were used in jewellery and adornments such as the superb collar shown here, in which thousands of tiny beads are attached to a cotton backing. Such a garment would have taken great skill and many hours to create and would have been worn by a person of high rank, symbolizing their links to sacred power. Some Chimú collars have abstract or pictorial designs, but the splendour of this one rests largely on the broad expanse of intense and beautiful colour, set off by the black border, with the stepped and tasselled front lying on the wearer's chest.

CHIMU CIVILIZATION

The Chimú people were the main predecessors of the Incas, who took over and enriched various features of their culture, notably expertise in road-building and irrigation. At its peak, the Chimú Empire occupied a band of territory extending about 1000km (620 miles) along the coast of what is now northern Peru. The capital, Chan Chan, was the largest city in Pre-Columbian South America. It was built entirely of adobe (sun-dried clay bricks). Extensive remains have been excavated, including temples, burial chambers, reservoirs, and huge defensive walls.

CHAN CHAN RUINS, TRUJILLO, PERU

▽ **CHIMU COLLAR**
Highly skilled divers would have harvested the shells that were used in the creation of this spectacular collar. **Height:** 44.5cm (17½in). **Date:** c.1100–1400.

COTTON CORDS
The collar was tied at the back with cotton cords.

VERTICAL ROWS
The thousands of tiny beads made from *Spondylus* shell are strung in vertical rows.

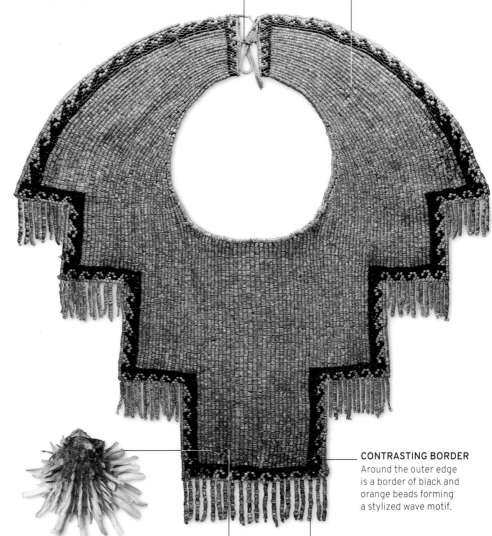

△ *SPONDYLUS PRINCEPS*
Most of the beads on the collar were probably made from *Spondylus princeps*, which has a more vibrant red colour than other species of the shell.

CONTRASTING BORDER
Around the outer edge is a border of black and orange beads forming a stylized wave motif.

TASSELS
A tasselled fringe hangs down from each of the frontal levels of the collar.

BRILLIANT COLOUR
Spondylus shells were prized for their beautiful reddish-orange hues – it is these above all that create the collar's dramatic effect.

Powdered *Spondylus* shells were **strewn** before Chimú kings to create a kind of **red carpet** for them to **walk on**

▽ **EASTER ISLAND MOAI (TONGARIKI SITE)**
The moai were generally placed in groups along an ahu
(platform), all of them facing inland, away from the sea.
Those now in place were re-erected in modern times.
Height: 2–10m (6ft 6in–33ft). **Date:** 1100–1600.

▷ **WHITE CORAL**
The deep eye sockets
originally held white coral,
with pupils made from red
scoria (*see also image right*).

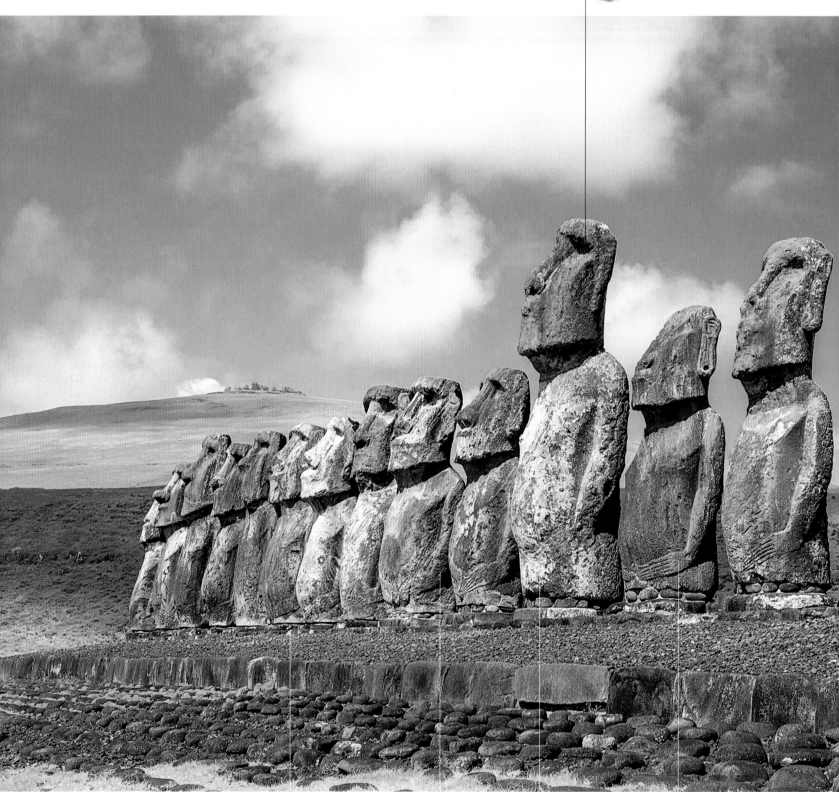

CEREMONIAL PLATFORM
Fifteen moai are arranged in a line on the ahu (stone
platform) at Tongariki. Around 100m (330ft) long,
it is the largest ceremonial structure on the island.

VOLCANIC ROCK
The maoi are carved from
yellowish-brown volcanic
rock called tuff.

LOINCLOTH
A *hami* or loincloth
covers the base of
the statue.

CEREMONIAL POSE
The figures' arms are all
held in the same position,
as if in a ceremonial pose.

RED HAT
Many moai originally had a *pukao*, a red cylindrical hat made from red volcanic scoria stone.

OVERSIZED
The figures are particularly distinctive for their large heads and elongated ears and chins.

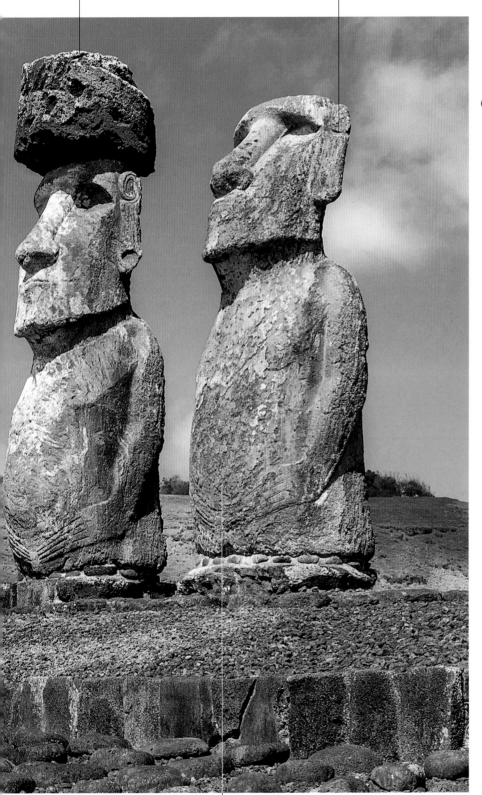

FORMER TATTOO
The statue's traditional tattoo pattern has been worn away.

Scale

◁ **EASTER ISLAND**
This map shows the distribution of the moai throughout the island, as well as the location of the quarry and the largest ceremonial site, Tongariki.

Tongariki

Rano Raraku quarry

Easter Island, Chile

Easter Island Moai

Massive stone heads reflect the skill of one of the world's most remote cultures

Arranged on long ahu (stone platforms), the colossal moai (statues) of Easter Island, 3,500km (2,175 miles) west of Chile, are revered above all for the ingenuity, skill, and resourcefulness that went into their creation. The islanders quarried the volcanic tuff stone from inland sites with adzes and picks made of basalt, then transported and erected more than 800 moai, ranging from 2m (6ft 6in) to 10m (33ft) in height, and weighing an average of 22 tonnes. The erection of the statues, thought to represent ancestor figures, took place from around 1100 to 1600. A gradual decline in soil fertility led to food shortages and a rejection of traditional religious beliefs, causing the Easter Islanders to topple the moai from their platforms.

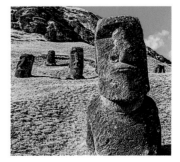

◁ **MOAI QUARRY**
Most of the statues were carved from tuff stone at the Rano Raraku quarry. Some of them – but by no means all – were then moved to different parts of the island, either by being pulled with ropes or by using log rollers.

Five types of weapon are shown: swords, clubs, bows, a lance, and a spear

▽ **MAMLUK ENAMELLED GLASS BOTTLE**
With its remarkable figural sequence, far from being typical of Mamluk glasswork, the bottle reflects illuminated manuscripts from the Mamluk Sultanate and the Persian Empire. Handblowing, gilding, and enamelling such a large piece would have been immensely challenging. **Height:** 43.5cm (17in). **Date:** c.1300.

▷ *SIMURGH*
The fantastical *simurgh* (phoenix-like bird) reflects the influence of Persian art on the Mamluk artisans.

CENTRAL MEDALLION
One of the three large medallions on the bottle – each one is painted in a complex, bold design around an eight-pointed star, using red, blue, and green interspersed with gilding (now faded).

BORDERS
The central scene is framed by a border with a crosshatched motif that also loops around the medallions.

WARRIORS
The main scene features what appear to be both Ilkhanid and Mamluk warriors, each depicted in a different costume, carrying distinct weapons, and riding differently coloured and decorated horses.

RELIGIOUS MOTIF
An Islamic arabesque pattern of intertwining plants and abstract curvilinear motifs is believed to reflect the perfection and infinite nature of the Divine.

GILDED BACKGROUND
Ground gold-leaf is mixed with oil, honey, or mercury, painted on, then fired in a low-temperature kiln.

BASE
The base is formed from a hand-blown green glass bottle with a folded foot; the rim of the foot is folded under to protect against chipping.

VIBRANT COLOURS
Chemical analyses of Mamluk glass have shown that the blue enamel was derived from lapis lazuli or cobalt, the yellow from antimony, and the white from tin oxide precipitates.

Cairo,
Egypt

Mamluk Enamelled Glass Bottle

*An exceptionally large and finely decorated example of gilded and
enamelled glass from late 13th-century Mamluk Egypt*

Under the Ayyubid (1171–1250) and Mamluk
(1250–1517) dynasties in the 13th and 14th centuries,
Syria and Egypt became renowned centres of glass
production. The Mamluk glassmakers were masters
of the complex process of creating enamelled glass,
whereby gold and enamels (powdered opaque glass)
were mixed with a binder and applied with a brush or
a reed pen to the glass and then dragged with a stylus
into the intended design before being fired in a kiln.

Masterpiece of Mamluk glasswork

The example seen here is exceptional for both its size
and the quality of its complex decoration, which rivals
that of the best illustrated manuscripts and inlaid
metalwork of the period, including the Baptistière
of Saint Louis (*see p.170*). It is considered one of the
finest pieces of glasswork in the world. The bottle
is completely gilded, with several bands of enamel

decoration. Between bands of loose scrollwork on
the neck is a delicately painted *simurgh* (a phoenix-
like bird) from Persian mythology that reflects the
Mamluks' fascination with the art of the Persian
Empire. Below the *simurgh* are three large medallions
with a complex scrolling pattern that radiates out
from a central eight-pointed star. The medallions
are surrounded by delicate vegetal decoration that
is outlined in red and with details in red, yellow,
blue, white, and green enamel.

The lower band features an extraordinary scene in
which 14 individuals on horseback – each differentiated
by costume, weapon, gesture, and attitude – engage in
a series of duels. Some of the horsemen are depicted
as Ilkhanids (the Mamluks' biggest enemies), others
wear turbans, presumably depicting Mamluks; but the
scene most probably represents a Mamluk *furusiyya*
(horsemanship contest), rather than a war scene.

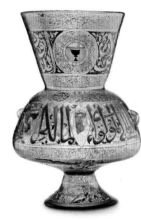

△ **MOSQUE LAMP, C.1329–35**
This glass lamp is more typical
of Mamluk enamelled glass
than the bottle shown opposite;
it is beautifully decorated but
has no figural scene.

△ **THE INFLUENCE OF MANUSCRIPT ILLUSTRATION**
The warrior scenes on the Mamluk bottle recall manuscript
illustrations from the Mongol Ilkhanid dynasty in Persia (1256–
1335), as in this image of soldiers from the *Jami' al-tavarikh* or
Compendium of Chronicles by historian Rashīd al-Dīn (1247–1318).

CREATING ENAMELLED GLASS

Enamelling glass is a delicate process
in which powdered glass is melted and
fused with the base vessel by firing in
a kiln. If fired at too low a temperature,
the colours may not melt; if too high,
then the vessel can become misshapen.

1 Either coloured glass or clear glass
and coloured pigments are crushed in
a pestle and mortar with a little water.
2 A binder, such as gum arabic, is added
to the mixture to create a thick liquid.
3 Blobs of the mixture are painted
onto a base vessel and dragged with
a stylus to create the decoration. Gum
can be used to prevent the painted
areas from running into each other.
4 Once dry, the vessel is attached to
a pontil (long iron rod) and fired in a
kiln; it is constantly rotated to prevent
the glass from deforming.

Ife Head

A 14th–15th-century brass sculpture from the Kingdom of Ife, displaying astonishing realism and craftsmanship

Ife, Nigeria

In 1938, 18 brass and copper heads, and the upper half of a brass figure, were discovered at Wunmonije Compound in Ife, Nigeria, the religious and political centre of the Yoruba people. They were among a huge number of stone, terracotta, copper, and brass works made in Ife from the 9th to the 15th centuries.

Artistic pinnacle

The lifelike modelling of the sculptures is unique in Africa, and bears testimony to African artist's mastery of both naturalistic aesthetics, as well as semi-abstract forms, known as "African Proportion" (*see p.64*), where heads are unnaturally large. Today, the Ife heads are considered to be one of the highest achievements of African art, combining technical skill with aesthetic beauty. Made during a period of great prosperity for the Yoruba, the heads are testament to the sophistication of Ife's artistic and cultural life.

The elaborate headdress of the Ife head shown here indicates that it represents an ooni, or king. Theories suggest that the head was used either in a second burial ceremony after the funeral of the king, or in annual rites of renewal and purification. Near life-size, the head was skilfully made in brass using the lost-wax technique. Prominent vertical striations on the face may represent scarification or may be for artistic effect, as the Yoruba people were not known to have scarified themselves in this way. Beaded adornments further indicate the head's association with royalty: beads, as well as metal, were a sign of power and wealth.

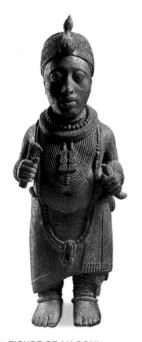

△ FIGURE OF AN OONI
For the Yoruba, Ife is the birthplace of humankind, and the king, or ooni, a descendant of the first god-king. This early 14th-century copper-alloy figure represents one of these sacred kings, wearing the traditional beaded crown and holding the symbols of his authority, a sceptre and a horn.

LOST-WAX CASTING

In the process of lost-wax casting, an original clay or wax model is used in the making of a final sculpture of metal, often bronze. The technique has been known since ancient times and is found across the world. The variant shown here is known as indirect lost-wax casting, and uses a mould that can be reused repeatedly to produce multiple casts. Conversely, in direct lost-wax casting, the clay mould must be destroyed in order to retrieve the final sculpture. Accessories such as the Ife head's plume are often moulded separately.

Mould

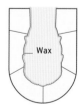

Wax

1 An original model of the intended sculpture is created, traditionally out of a material such as clay or wax.

2 A mould, often of plaster, is taken from the model. This may be made in several pieces to aid later removal.

3 The inside of the mould is lined with even layers of molten wax to the desired thickness and allowed to dry.

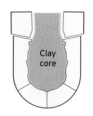

Clay core

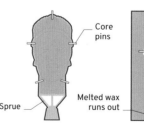

Core pins

Sprue

Melted wax runs out

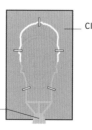

Clay

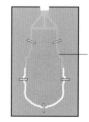

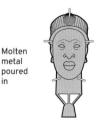

Molten metal poured in

4 The wax shell is filled with heat-resistant material. The mould is carefully removed and may be reused.

5 Wax tubes (sprues) are added, which will form ducts, and pins are hammered in to secure the core.

6 The wax shell is covered with a fire-proof material and heated. The molten wax runs out through the sprues.

7 A detailed mould has been created. Molten metal is poured through the sprues into the gap left by the wax.

8 The outer shell and core are removed to reveal the cast, ready for finishing. The sprues are cut off.

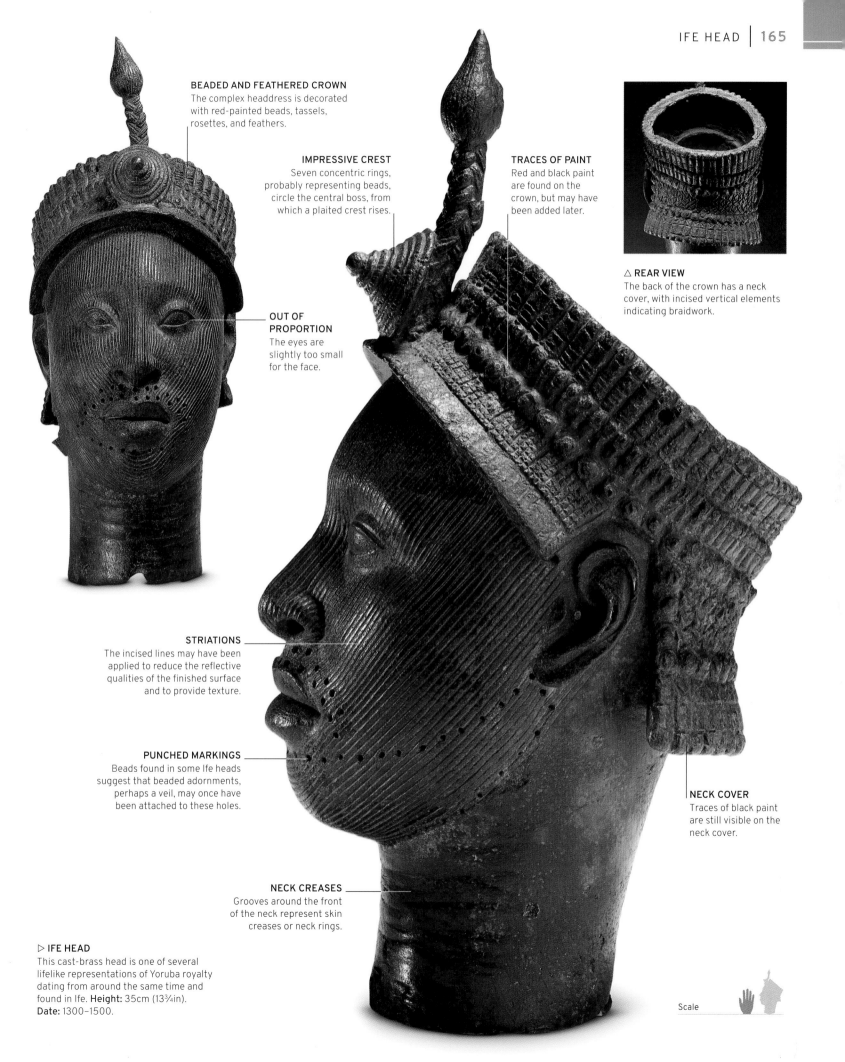

BEADED AND FEATHERED CROWN
The complex headdress is decorated with red-painted beads, tassels, rosettes, and feathers.

IMPRESSIVE CREST
Seven concentric rings, probably representing beads, circle the central boss, from which a plaited crest rises.

TRACES OF PAINT
Red and black paint are found on the crown, but may have been added later.

OUT OF PROPORTION
The eyes are slightly too small for the face.

△ **REAR VIEW**
The back of the crown has a neck cover, with incised vertical elements indicating braidwork.

STRIATIONS
The incised lines may have been applied to reduce the reflective qualities of the finished surface and to provide texture.

PUNCHED MARKINGS
Beads found in some Ife heads suggest that beaded adornments, perhaps a veil, may once have been attached to these holes.

NECK COVER
Traces of black paint are still visible on the neck cover.

NECK CREASES
Grooves around the front of the neck represent skin creases or neck rings.

▷ **IFE HEAD**
This cast-brass head is one of several lifelike representations of Yoruba royalty dating from around the same time and found in Ife. **Height:** 35cm (13¾in).
Date: 1300–1500.

Scale

The Hereford Mappa Mundi

The world's largest medieval map, which reveals how Christian scholars interpreted the world

Hereford, England

TRIPARTITE MAP OF THE WORLD

There were three main types of world map in the Middle Ages, of which over 1,000 have survived from the period. Tripartite or T-O maps showed the world as a circle divided into three continents (Africa, Asia, and Europe) by a T-shape formed by the Mediterranean Sea and the Nile and Don rivers. T-O maps formed the basis of complex or "great" maps, like the Hereford Mappa Mundi, which included details such as coasts, rivers, towns, and mountains, and often illustrations of myths and natural history. Quadripartite maps added a fourth land mass to the right, the Antipodes, while zonal maps divided the world into zones of climate and habitation.

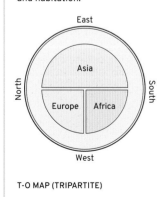

T-O MAP (TRIPARTITE)

Created from a single sheet of vellum (animal skin), the Mappa Mundi kept at Hereford Cathedral is the largest of its kind to have survived from the Middle Ages. It cites its creator as "Richard of Haldingham or Lafford" (both in Lincolnshire) and was long thought to have been made in Lincoln. Analysis of the wooden frame, however, suggests that it was produced in or near Hereford around 1300.

More than a map

The Mappa Mundi is more than a representation of the physical world; it is a record of knowledge and a tool for storytelling that reveals how history, natural history, and human destiny were understood by medieval Christians. The world is contained within a 132cm (52in) circle, presided over by Christ. At its centre is Jerusalem, "the centre of the nations", according to an Old Testament verse. It shows only the inhabited parts of the world as then known – Europe, Asia, and North Africa – oriented with the east at the top as the direction to which medieval Christians looked for the Second Coming of Christ.

The map was extraordinarily well-planned, with the text carefully fitted around more than 500 drawings. Created in black, red, blue, and green ink with quill pens, the map retains the marks of some of the tools used. Perforations in the centre of Jerusalem and the labyrinth show where a compass had been used to draw circles, and rulers were clearly employed to create straight lines. The scribe also cleverly uses visible guidelines to differentiate labels from depictions of announcements or writing.

The map illustrates **420** towns, **15** biblical events, **33** plants and creatures, **32** peoples, and **8** classical myths

△ DOOMSDAY IMAGE
Christ sits in majesty. The saved enter Heaven to his right, while to his left, the damned, in chains, are dragged to Hell by a demon.

△ PARADISE ON EARTH
Nearly inaccessible but still on Earth, the Garden of Eden is depicted in the east – at the top of the map – as an island cut off by water, fire, and walls.

△ MONSTERS IN AFRICA
Monstrous beings and races encircle the map but are unequally distributed: very few appear in Western Europe, while Africa is far more densely populated.

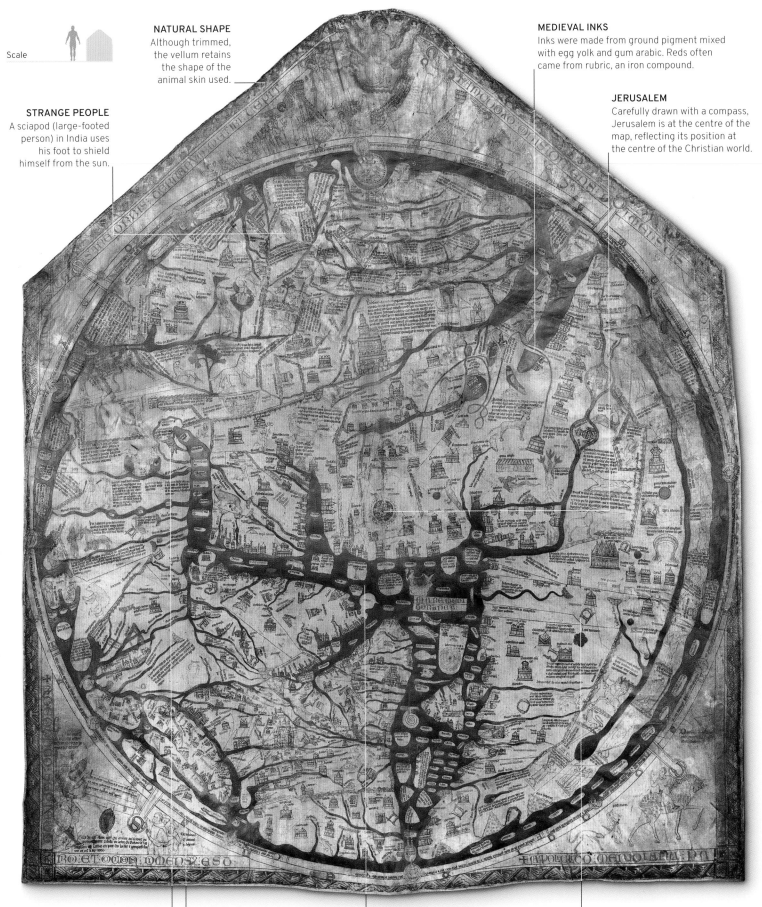

Scale

NATURAL SHAPE
Although trimmed, the vellum retains the shape of the animal skin used.

MEDIEVAL INKS
Inks were made from ground pigment mixed with egg yolk and gum arabic. Reds often came from rubric, an iron compound.

JERUSALEM
Carefully drawn with a compass, Jerusalem is at the centre of the map, reflecting its position at the centre of the Christian world.

STRANGE PEOPLE
A sciapod (large-footed person) in India uses his foot to shield himself from the sun.

GREEK MYTHS
Greek myths decorate the map, including the Golden Fleece, shown here on the Black Sea coast.

ENCIRCLING OCEAN
The continents are surrounded by an ocean full of islands, including the British Isles.

MEDITERRANEAN SEA
The Mediterranean Sea – with the rivers Nile to the right and Don to the left – forms a T-shape dividing Europe, Asia, and Africa.

GILDED CAPITALS
These ornamental letters were outlined in pen and filled with sticky gesso on which gold leaf was laid, then burnished.

GOLD BACKGROUND
Most panel paintings of the time had backgrounds covered in gold leaf. Its beautiful luminosity suggested the light of Heaven.

BLUE ROBE
The Virgin Mary traditionally wears a robe of deep blue, a colour symbolizing Heaven and spirituality.

BENEDICTION
As in many representations of the Virgin and Child, the infant Jesus raises his hand in a gesture of blessing.

△ **SCROLL**
In his left hand Jesus holds a scroll, which has been interpreted as symbolizing knowledge.

CROWN
A standing angel at left holds a crown, a fitting attribute for the Queen of Heaven.

SYMBOLIC FLOWERS
The kneeling angels hold vases of lilies and roses, which were closely associated with the Virgin Mary because of their beauty and purity.

THRONE
The base of the throne is richly decorated with geometric motifs, and the step is a slab of sumptuously patterned marble.

Scale

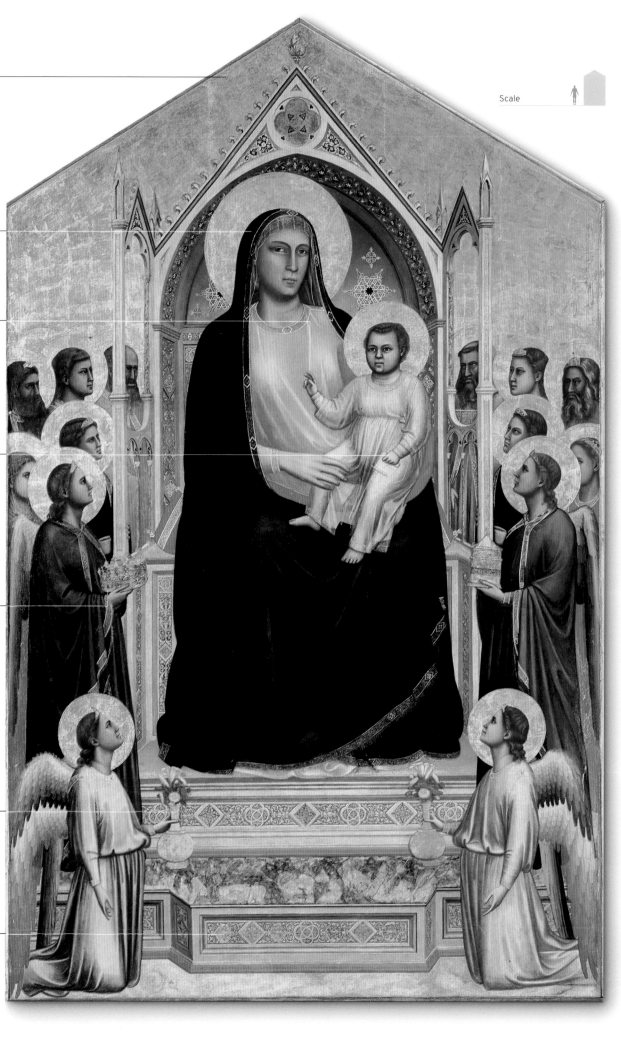

◁ **OGNISSANTI MADONNA**
This is Giotto's largest surviving panel painting and the only one that is universally regarded as a work from his own hand (rather than a product of his studio). **Dimensions:** 325 x 204cm (128 x 80in). **Date:** c.1310.

Ognissanti Madonna

A majestic 14th-century altarpiece that stands at the head of the central tradition of European painting

Florence, Italy

Giotto was incomparably the most important painter of his time, bringing about a revolution in art. He broke away from the flat and otherworldly Byzantine style that dominated painting for centuries, creating images that had a new and convincing sense of volume and weight, as well as a rich variety of human feeling. Most of his surviving works are in fresco, including a famous series in the Arena Chapel in Padua, but he also painted in tempera on panel – and this is his masterpiece in the medium.

Towards a new style

The painting was made to adorn an altar in the church of Ognissanti (All Saints) in Florence, although nothing is known of the circumstances in which it was commissioned. Painted around 1310, it remained in the church until 1810, when it was transferred to Florence's Accademia Gallery. The theme of the painting, with Mary holding the Christ Child on her lap, surrounded by angels and saints, was a traditional one known as a Maestà. Giotto retains the flat gold background typical of Byzantine art, yet, whereas earlier paintings of the subject show the figures rather stiffly lined up, here they (and the magnificent throne) are persuasively arranged in depth. Although the figures have a regal dignity and authority, they are also believably human, with the contours of their bodies visible under their clothes. Reflecting the conventional hierarchy of scale, the flanking angels and saints are smaller than the Madonna, but they are likewise vividly and subtly characterized, contributing to the delicate balance of awe and compassion that the painting creates.

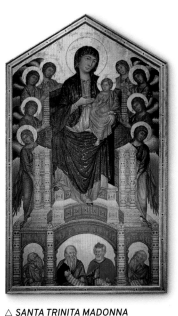

△ **SANTA TRINITA MADONNA**
This altarpiece was painted around 1280 by Cimabue, who was probably Giotto's teacher. The figures are flatter, stiffer, and less individualized than those of Giotto's masterpiece.

Giotto brought about a new era of naturalism in painting

GIOTTO

Giotto di Bondone (c.1270–1337) was recognized in his lifetime as an artist of towering stature. Around 1305 he completed his most influential work, an ambitious fresco cycle in the Arena Chapel in Padua. Demand for his work took him to many places in Italy. Late in his career he turned to architecture and designed the bell tower of Florence Cathedral. Giotto was given a state funeral and buried in the cathedral, unprecedented honours for an artist.

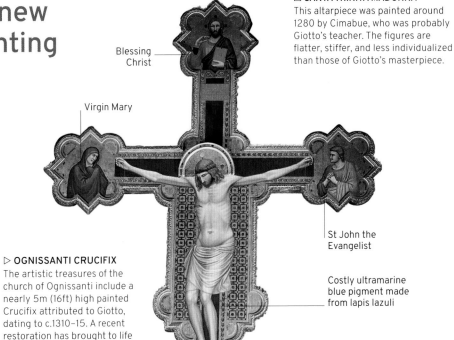

Blessing Christ

Virgin Mary

St John the Evangelist

Costly ultramarine blue pigment made from lapis lazuli

▷ **OGNISSANTI CRUCIFIX**
The artistic treasures of the church of Ognissanti include a nearly 5m (16ft) high painted Crucifix attributed to Giotto, dating to c.1310–15. A recent restoration has brought to life its vivid colour and detail.

Baptistère de Saint Louis

A spectacular example of 14th-century Islamic metalwork that functioned as the baptismal font of French royalty

Egypt or Syria

The Baptistère de Saint Louis is a hammered brass basin, inlaid with gold, silver, and niello, that for at least 300 years functioned as the baptismal font of French royalty. However, its history is somewhat mysterious. The name of its maker is inscribed on the vessel six times, with one inscription reading "Work of the Master (al-mu'allim) Muhammad ibn al-Zain", suggesting it was a work of some prestige. However, there is little indication of who it was made for or why. Even its date and place of origin are contentious, although Egypt or Syria around 1320–40 seem likely. The basin arrived in France some time before 1440, where it somehow became associated with Louis IX of France (1226–70), known as St Louis.

Exceptional workmanship
The basin is an exceptionally high-quality example of medieval Islamic metalwork, which focused on the production of practical objects in brass, bronze, or steel, elaborately decorated with inlays. Almost every possible area, inside and out, is covered with ornament created by hammering small pieces of gold and silver

onto the brass before engraving the details and applying black niello. Two friezes showing Mamluk (warrior slaves whose generals formed a dynasty that ruled Egypt from 1250 to 1517) court scenes, battles, and hunting expeditions are interspersed with medallions of figures and coats of arms. These are bordered by decorative friezes of animals and set against a backdrop of plant foliage typical of Islamic ornament. Debate continues on the meaning of the design and whether it depicts real events or people; clues in the coats of arms and clothing hint at a link with Mongolian ruler Berke Khan (ruled 1257–67) and Egyptian sultan Baybars I (ruled 1260–77).

The Baptistère was last used at the baptism of Prince Napoléon Eugène in 1856

NIELLO INLAY

Niello is a black metallic alloy used as an inlay on the engraved surfaces of metal objects (often silver). It is made by fusing silver, copper, and lead together and then mixing with molten sulphur; the resulting black sulphides are powdered to form niello. It is then spread on the engraved metal and heated to flow into the lines of the engraving. Any excess is removed so that it only remains in the engraved channels. The whole object is then polished, creating a contrast between the shiny metal surface and the black niello.

SILVER AND NIELLO HARE

△ MISSING ELEMENTS
Decoration is missing in parts of the bowl. Here, the silver inlay is absent from a face and some of the clothing. It is likely these areas had been poorly applied and were lost over the centuries.

▽ BAPTISTERE DE SAINT LOUIS
This basin is a beautiful example of Islamic ornamentation, characterized by all-over surface decoration, including calligraphy, vegetal and geometric patterns, and figural representation. **Height:** 22.2cm (8¾in). **Date:** c.1320–40.

HIGH CONTRAST
The use of black niello creates a strong contrast with the silver and gold, highlighting the engraved details.

△ SIGNATURE
The maker's name appears several times on the basin: once in silver letters under the lip (as here), and several times hidden in thrones and goblets in three of the medallions.

PRECIOUS METALS
Small pieces of gold and silver were cut to shape and hammered onto the basin to create the design.

FIGURATIVE MEDALLION
One of the basin's eight figurative medallions shows a king on a throne supported by two lions and flanked by two men.

CARNIVAL OF ANIMALS
The basin is covered with numerous animals, including fish, crabs, frogs, elephants, leopards, and a crocodile.

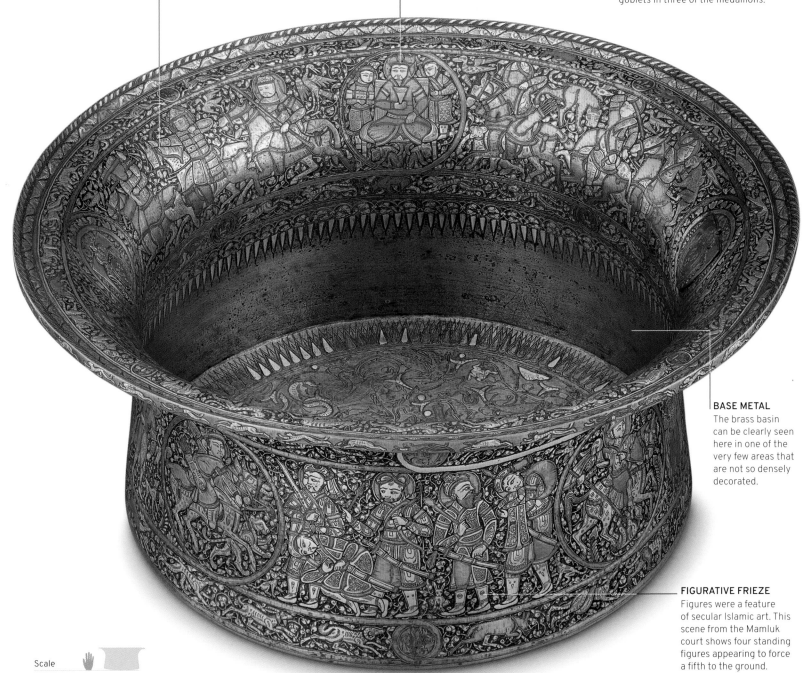

BASE METAL
The brass basin can be clearly seen here in one of the very few areas that are not so densely decorated.

FIGURATIVE FRIEZE
Figures were a feature of secular Islamic art. This scene from the Mamluk court shows four standing figures appearing to force a fifth to the ground.

Scale

Scale

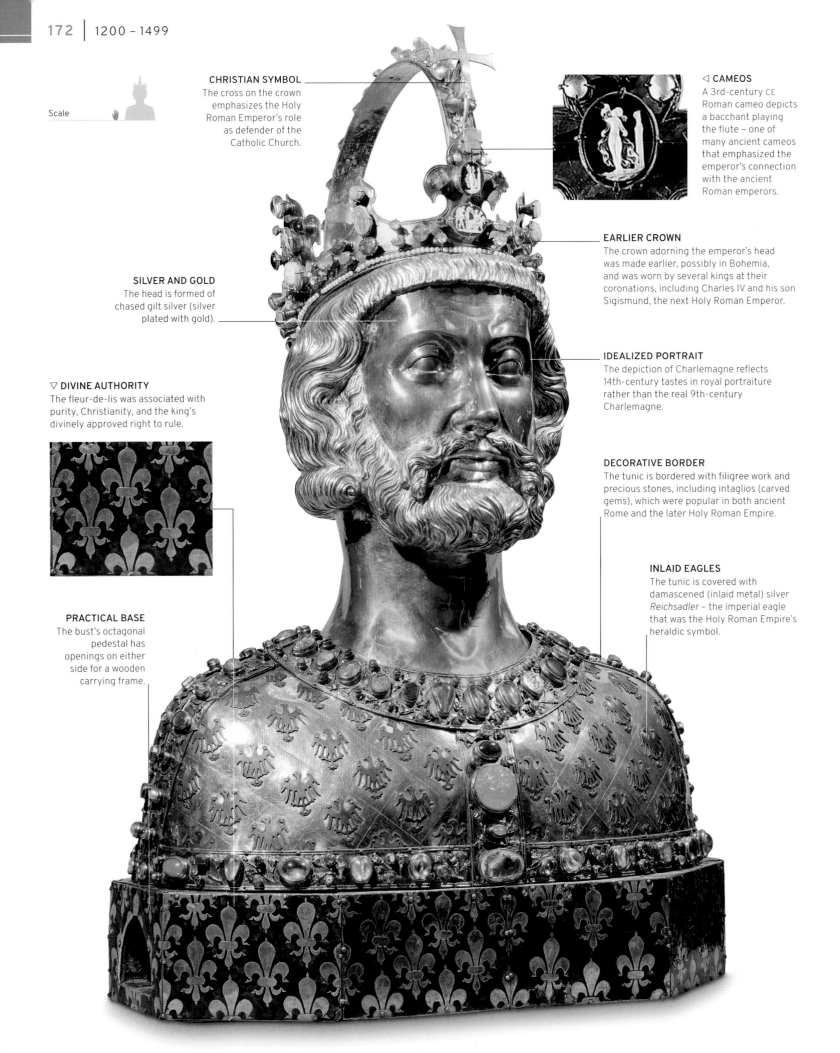

CHRISTIAN SYMBOL
The cross on the crown emphasizes the Holy Roman Emperor's role as defender of the Catholic Church.

◁ **CAMEOS**
A 3rd-century CE Roman cameo depicts a bacchant playing the flute – one of many ancient cameos that emphasized the emperor's connection with the ancient Roman emperors.

SILVER AND GOLD
The head is formed of chased gilt silver (silver plated with gold).

EARLIER CROWN
The crown adorning the emperor's head was made earlier, possibly in Bohemia, and was worn by several kings at their coronations, including Charles IV and his son Sigismund, the next Holy Roman Emperor.

IDEALIZED PORTRAIT
The depiction of Charlemagne reflects 14th-century tastes in royal portraiture rather than the real 9th-century Charlemagne.

▽ **DIVINE AUTHORITY**
The fleur-de-lis was associated with purity, Christianity, and the king's divinely approved right to rule.

DECORATIVE BORDER
The tunic is bordered with filigree work and precious stones, including intaglios (carved gems), which were popular in both ancient Rome and the later Holy Roman Empire.

INLAID EAGLES
The tunic is covered with damascened (inlaid metal) silver *Reichsadler* – the imperial eagle that was the Holy Roman Empire's heraldic symbol.

PRACTICAL BASE
The bust's octagonal pedestal has openings on either side for a wooden carrying frame.

◁ **BUST OF CHARLEMAGNE**
The bust of Charlemagne was made 500 years after his death, signalling the importance Western European rulers in the Middle Ages attached to association with him. **Height:** 86cm (34in). **Date:** 1300–1400.

Bust of Charlemagne

A mid-14th-century masterpiece of Mosan goldwork, reliquary for the emperor Charlemagne, and symbol of imperial power

Aachen, Germany

Charlemagne (Charles the Great) was ruler of the Franks from 768 to 814. A warrior king and a powerful protector of the papacy, he reunited most of Western Europe for the first time since the collapse of the Western Roman Empire in the 5th century CE. In 800, he was crowned emperor of the Romans, becoming the first ruler of the Holy Roman Empire. Charlemagne's reign saw a great flourishing of intellectual and cultural activity in Western Christianity known as the Carolingian Renaissance (780–900).

Gothic goldwork
Keen to associate themselves with Charlemagne, several of his successors exhumed his bones, buried in Aachen, Germany – where Charlemagne had based his court – to rebury them in increasingly elaborate tombs. In the mid-14th century, Charles IV of Bohemia raided the bones once again and commissioned a bust as a reliquary for the emperor's skull. He was embroiled in a contest with Louis IV of Bavaria for the title of king of the Romans, and in laying claim to Charlemagne, Charles helped to legitimize his position.

The bust is a masterpiece of late Gothic goldwork from the Mosan region (the valley of the Meuse, in present-day Germany, Belgium, and the Netherlands), a renowned centre of metalwork production since the 11th century. The depiction of the emperor is idealized, yet the face is expressive and naturalistic. The bust features techniques such as chasing, gilding, and filigree, and is decorated with gems, ancient intaglios and cameos, and imperial symbols. Eagles and fleurs-de-lis, respectively emblems of the Holy Roman Empire and France, indicate the vast extent of the emperor's power – a power Charles IV tapped by association. The head bears a separate crown, worn by Charles IV for his coronation at Aachen in 1349.

△ **CHARLEMAGNE'S SHRINE**
Charlemagne's remains lie in the Karlschrein (1215), in Aachen Cathedral. The casket is covered with gilt silver and gilt copper and adorned with filigree, enamel, and precious stones. The front gable end shows Charlemagne on his throne.

The bust **depicts Charlemagne** as the **flawless ideal** of a ruler

▷ **CHARLES IV OF BOHEMIA**
Charles IV (1316–1378) was crowned Holy Roman Emperor in 1355. He made his capital at Prague, which flourished as the empire's political, economic, and cultural centre.

RELIQUARIES

Reliquaries were receptacles for the supposed relics of Christian saints and martyrs. Beautifully crafted from priceless materials, they transformed unappealing remnants of saintly hair, bone, and clothing into objects worthy of veneration. Charlemagne's body was divided among several reliquaries, including a gold arm 85cm (33½in) in length, commissioned by Louis XI of France in 1481 to contain the forearm bones of his right arm.

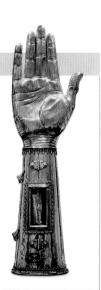

CHARLEMAGNE ARM RELIQUARY

Javanese Funerary Mask

A 14th-century gold death mask highlighting ancient Javanese death practices and the importance of the precious metal in the ancient Indonesian kingdoms

Java, Indonesia

From its capital in eastern Java, the Majapahit empire extended its influence across much of present-day Indonesia from the late 13th century, enjoying a golden age in the mid-14th century under the reign of Hayam Wuruk (ruled 1350–89). Gold was readily available to the Javanese, and artisans were skilled in creating gold jewellery, sculpture, containers, and accessories.

Prestige goods, including those made of gold, were often buried with bodies in Javanese burials, and gold face covers, such as the one shown, are among the artefacts to have survived from sites across Indonesia. Laid on the face of the deceased, such covers may take the form of full masks of beaten gold, or simpler pieces cut to cover the eyes or outline the facial features. Their exact purpose is unknown, but they may have been a type of amulet to protect the deceased and scare away evil spirits; they may form part of an ancestor cult, reflecting the importance of ancestors in Javanese culture; or they might simply represent a kind of status symbol for the afterlife.

It has been said Java was so rich in gold that even the dog collars were made of gold

GEOMETRIC DESIGN
The simple spiral patterning perhaps indicates a headdress.

SHEET OF GOLD
The mask is made from a thin sheet of hammered gold.

▽ **JAVANESE FUNERARY MASK**
This gold funerary mask from the ancient Javanese Majapahit empire was probably part of the burial goods of a king or other royal figure. **Diam.:** 19cm (7¹/₂in). **Date:** 1300–1400.

▷ **FINE FEATURES**
The gold is worked to form distinct features, including the extraordinary eyelashes and eyebrows.

MAJAPAHIT EMPIRE

Founded in the 13th century, the Majapahit (1293–1527) was a Hindu maritime empire based in Java, with territories stretching across present-day Indonesia and Malaysia. It reached its peak in the mid-14th century under Hayam Wuruk and his prime minister, Gajah Mada. Gold played a major part in Majapahit culture, communicating wealth, status, and ritual power.

BAJANG RATU TEMPLE, TROWULAN, JAVA

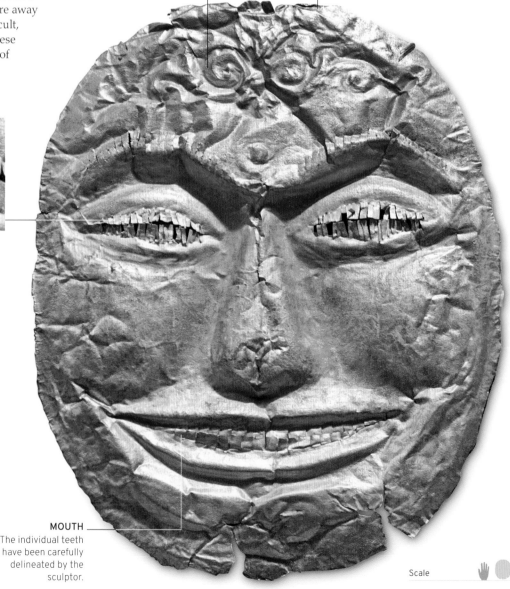

MOUTH
The individual teeth have been carefully delineated by the sculptor.

Scale

Golden Buddha

A monumental 13th- to 14th-century statue of the Buddha that is the world's largest solid gold sculpture

Bangkok, Thailand

The Golden Buddha, or Phra Phuttha Maha Suwanna Patimakon, is a spectacular, solid gold statue of the seated Buddha, now kept in the temple of Wat Traimit in Bangkok, Thailand. It was created, probably during the Sukhothai era (1238–1438), to record the physical characteristics of the Buddha, and to encourage meditation and reverence for divine power. Written evidence on a stele of 1292 suggests that it may have been cast during the reign of Ramkhamhaeng the Great (1279–98). Buddha images in the graceful and elegant Sukhothai style, as here, are characterized by smooth, long limbs, an oval face, and the flamelike *ushnisha* on the head, among other features. At some time, probably in the 18th century, a thick layer of plaster was applied to the statue to conceal and protect it. Its true nature was discovered only in 1955, when it was dropped while being transferred to a new temple and the plaster chipped off, revealing the gold beneath.

▷ **GOLDEN BUDDHA OF WAT TRAIMIT**
Weighing 5.5 tonnes, the Golden Buddha was built on a colossal scale. It helped to establish the stylistic "formula" for Thai Buddha statues. **Height:** 3.04m (10ft). **Date:** c.1200–1400.

USHNISHA
The flame shape of the *ushnisha* (the cranial bump on the Buddha's head) was a Sukhothai development.

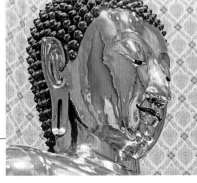

△ **SUKHOTHAI-STYLE HEAD**
The Sukhothai style is seen in the elongated oval head, the aquiline nose, the strong, curving eyes, nose, brows, and mouth, the long earlobes, and the whorls of curled hair.

SPIRITUAL ATTRIBUTES
Serenity is expressed in the smoothness of the gold, while the lack of anatomical detail reflects the Buddha's lack of interest in the material world.

SENSUOUS FORM
The statue's sinuous curves create a sense of weightless elegance.

THIN ROBE
The Buddha is dressed in a light monastic robe moulded closely to the body.

TRADITIONAL POSE
The Buddha exhibits the *bhumisparsa* mudra or "earth witness" pose, the right hand pointing to the earth (*see p.84*).

Scale

Scale

BURYING THE ASHES
The jaguar-shaped symbol and body-shaped mound of earth are thought to show Twelve-Earthquake's burial site.

△ **NATURAL PIGMENTS**
The codices were painted using mineral pigments from rocks and soils, and organic ones from pine charcoal, tree sap, plants, and beetles. Yellow to red pigment, for example, was derived from the yellow cosmos flower.

INCINERATING THE WEAPONS
Following Twelve-Earthquake's cremation, his weapons are ceremonially burned.

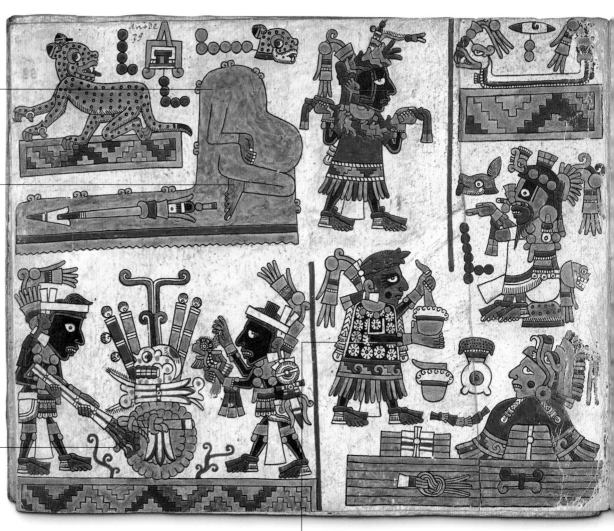

ANOINTING THE DEAD
Priests bearing bowls of paint (right) and a funeral garment approach Twelve-Earthquake's robed and masked skeleton.

WARRIOR LORDS
Eight-Deer is shown in ceremonial dress, accompanied by other nobles including Twelve-Earthquake below him.

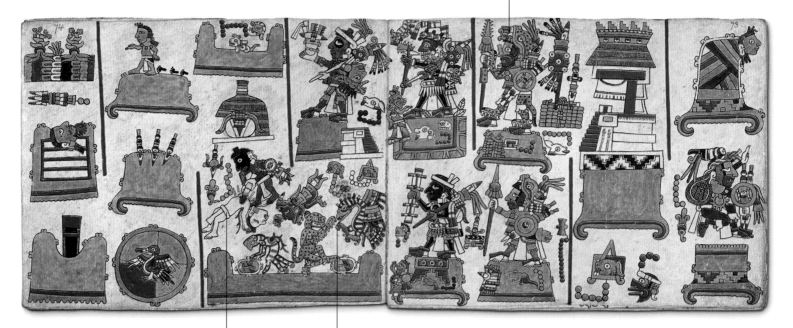

SACRIFICIAL KILLING
This image is thought to show the ritual sacrifice of another of Eight-Deer's half-brothers, this one named Nine-Flower.

SYMBOL OF STRIFE
The fighting eagle and ocelot represent conflict, typically in the form of dynastic rivalries or rebellions.

△ **SACRIFICE, CONFLICT, AND CEREMONY**
This view shows a later panel in the codex. The pictograms functioned as a record of Eight-Deer's descendants' claim to the royal lineage.

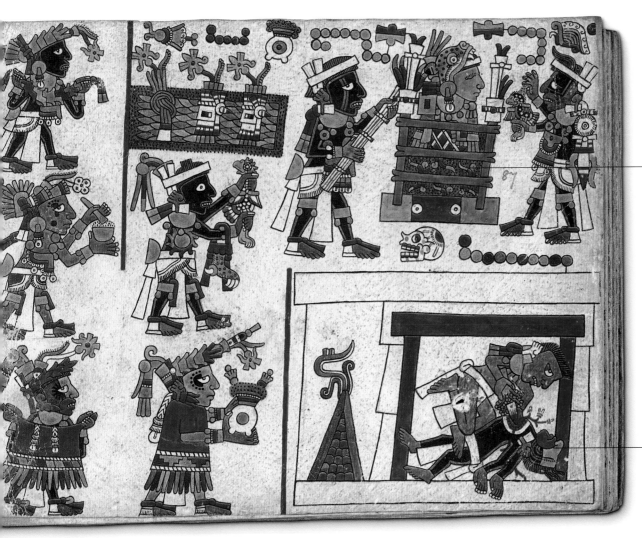

◁ *CODEX ZOUCHE-NUTALL*
The pages read in columns, moving up, then down. So this account of an execution starts bottom right and tracks up and down. **Page dimensions:** 19 x 23.5cm (7¹⁄₂ x 9¹⁄₄in); **overall length of codex:** 11.35m (37ft 3in). **Date:** 1350–1450.

△ **A RITUAL CREMATION**
The sacrificial victim is cremated with full honours at a place identified as Seven-Flower Hill.

REMOVING A RIVAL
The ruler's half-brother Twelve-Earthquake is ritually sacrificed to strengthen Eight-Deer's hold on power.

Codex Zouche-Nuttall

A 14th-century Mixtec manuscript that uses images to recount a colourfully rendered epic of blood and sacrifice

Oaxaca, Mexico

In pre-Columbian times, the Mixtecs or "Cloud People" inhabited a small highland region of southern Mexico on the fringes of what would become the Aztec Empire. Their competing city-states were only once united into a single realm, under the leadership of an 11th-century ruler named Eight-Deer, who later had the honorific title of Jaguar Claw added to his name.

Folded books
To record their history, myths, and family trees, Mixtec artists used complex pictograms to create codices – manuscripts copied out on deerskin pages that folded together, accordion-like, into books. The brilliantly colourful images that are depicted would have served as visual reminders to spoken-word narrators, who would then recount their story orally to listening audiences.

The exploits of Eight-Deer form the subject-matter of several of the surviving manuscripts, most notably the *Codex Zouche-Nuttall*, so named for its one-time owner and the anthropologist who first realized its significance. Its 47 separate panels, joined together to form a continuous screen, tell a tale of conquest and military expansion, but also of the blood sacrifices that Eight-Deer commanded in order to cement his hold on power. Painted some three centuries after his death, they together form a unique pictorial record of a proud people's early history and origin myths.

FOLDING AND BINDING

Rather than turning pages, as in printed books, Mesoamerican peoples unfolded codices to explore their contents. Separate sheets of animal skin were whitewashed and painted on both sides, then bound together with an adhesive paste to form a single skin that could be bent and folded in a continuous strip. Within it, the narrative moved from right to left and up and down the successive leaves.

Separate pages were glued together

CONCERTINA FOLDING

PEONIES
Especially loved in China
and known as the "king
of flowers", the peony
was linked with wealth
and honour.

HANDLES
The handles take the
form of elephant heads;
the animal was a symbol
of strength and wisdom.

PHOENIX
This mythological bird was
associated with harmony
and prosperity.

DRAGON
The dragon, the most
prominent motif, played
a highly important role in
Chinese culture; rather
than being destructive, as
in the West, it had many
positive qualities.

CLOUDS
The dragons move among
stylized clouds, which
were associated with
life-giving rain. Dragons
were said to create clouds
with their breath.

△ **COBALT ORE**
The cobalt used to make
the blue glaze on Chinese
porcelain came from Persia
and was known as "huihui
qing", or "Islamic blue".

Scale

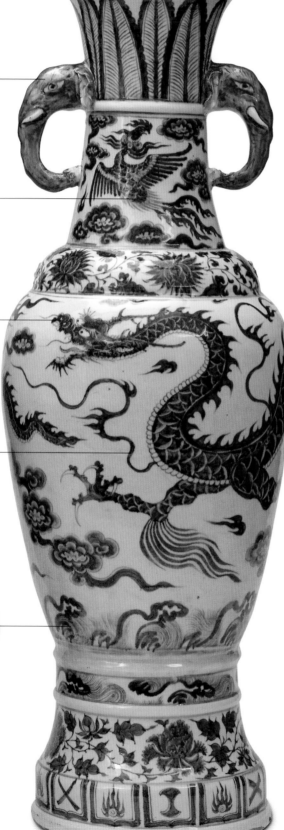

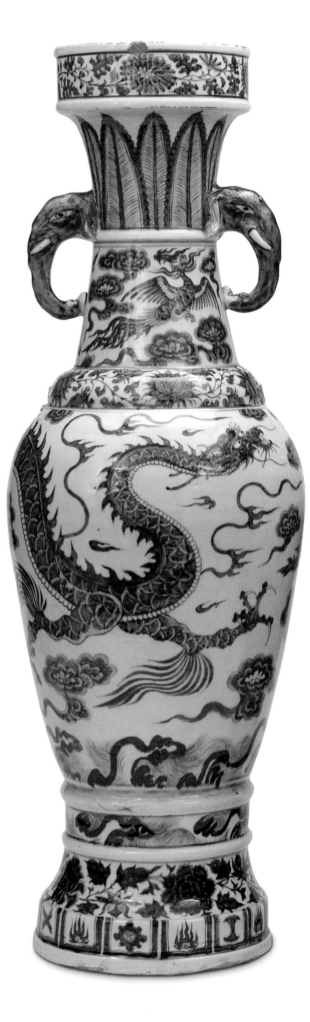

◁ **THE DAVID VASES**
At some point in their history the two vases were separated, but they were reunited by Sir Percival David, who bought them from different sources in 1927 and 1935. **Height:** 64cm (25in). **Date:** 1351.

The David Vases

Magnificent pieces of 14th-century Chinese porcelain that form a major landmark in the history of ceramics

Jingdezhen, China

These imposing vases are named after Sir Percival David (1892–1964), who amassed one of the world's greatest collections of Chinese ceramics, comprising almost 1,700 pieces. The David Vases have been described as the most famous pieces of porcelain in the world. This is owing partly to their size and splendour, but even more to the circumstances of their creation.

Blue-and-white porcelain

Early ceramics can usually be dated and assigned a place of origin only roughly, on circumstantial or stylistic evidence, but thanks to detailed inscriptions on the vases, we know exactly when, where, and why they were made. The inscriptions record that on a date equivalent to 13 May 1351 in the Western calendar, a man called Zhang Wenjin presented the vases to a Daoist temple in Xingyuan in honour of a general who had recently been made a god. He also presented an incense burner, which does not survive.

The vases, which would have held flowers on an altar, were made at Jingdezhen, the major centre of the Chinese porcelain industry. They are the earliest dated examples of blue-and-white porcelain, in which the blue colouring is created with pigment made from cobalt ore. This type of porcelain is associated with the Ming dynasty (1368–1644), yet the dating on Zhang Wenjin's vases makes clear that high-quality blue-and-white wares were already being made during the Yuan dynasty (1279–1368), when China was part of the huge Mongol empire. As trade flourished along the Silk Road between China and the Middle East, porcelain makers created many blue-and-white wares for the Chinese but also for the Persian market and beyond, influenced by Persian tastes and motifs. In the 17th century Dutch traders took large quantities of blue-and-white porcelain to Europe, where it had an enormous influence on European ceramics.

From **Persia** to **China** to **Europe**, blue-and-white porcelain proved **endlessly adaptable**

EUROPEAN PORCELAIN

Porcelain developed in China from around the 7th century. It is the most luxurious type of pottery, translucent and particularly suited to painted decoration. It is made from fine white clay mixed with powdered rock or mineral and fired at a high temperature. Marco Polo is said to have first brought porcelain from China to Europe in 1295. The material became highly prized, but Westerners had difficulty discovering exactly how it was made and it was not until 1710 that the first European porcelain factory opened at Meissen, Germany.

MEISSEN VASE, C.1730

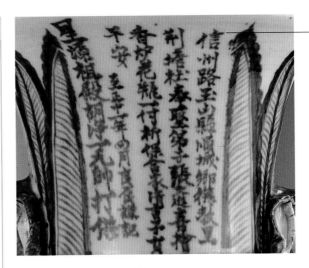

△ **REAR VIEW: INSCRIPTIONS**
Each vase has an inscription on the upper neck; the wording is similar on both. Zhang Wenjin offers the vases "as a prayer for the protection and blessing of the whole family".

▷ CROWN
Originally there were gems in the crown around the prince's forehead, but these have disappeared.

▽ TOMB OF THE BLACK PRINCE
The tomb glorifies the prince in death, reflecting the warrior attributes for which he was famous, while the pious epitaph shows a different side to his character. **Length of tomb:** 2.58m (8ft 4in). **Date:** c.1380.

EFFIGY
The effigy is made of a material called latten – essentially brass (copper and zinc) with some tin and lead – embellished with a thin layer of gold.

INSCRIPTION
The inscription is written in French, which was still the main language of the English court at this time.

LION CREST
The prince's head rests on his helmet (recreated in sculpture), which is topped with a crest of a lion.

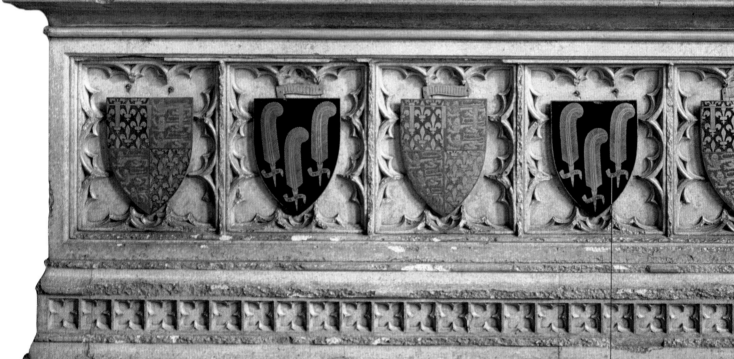

PURBECK MARBLE
The tomb chest is made of "Purbeck marble" (from Purbeck in Dorset), a hard limestone that is the nearest to true marble quarried in England.

OSTRICH FEATHERS
The prince adopted three ostrich feathers as a device on his "shield for peace" (probably used in jousting). The feathers are still used as the badge of the Prince of Wales.

ROYAL ARMS
The royal coat of arms of the time included the fleur-de-lis of France, indicating the English claim to the French crown.

Scale

ANIMAL AT FEET
This odd-looking beast has been variously described as a leopard, a lioness, and a dog (a symbol of fidelity).

Canterbury, England

Tomb of the Black Prince

One of the most imposing English tombs of the 14th century, which fulfils the dying wishes of the warrior it commemorates

On 7 June 1376, the day before he died, the great medieval warrior prince Edward of Woodstock – who later came to be known as the Black Prince – signed his will. In it he expressed his wish to be buried in Canterbury Cathedral, and gave detailed instructions for the form his tomb should take.

Prestige and piety
One of the finest medieval tombs in England, Edward's monument was probably commissioned by his son, Richard II, and it closely follows the prince's specifications. Nothing is known of its makers, though it was possibly designed by the architect Henry Yevele. The effigy is made in a gilded copper alloy, with finely worked details. The prince is shown recumbent in full armour, his hands in prayer, his eyes raised to an image of the Holy Trinity painted on a tester (canopy) overhead. His feet rest on an animal, perhaps a leopard, while his head lies on his helm, or helmet. Around the top of the stone tomb chest runs the extraordinary inscription that Edward specified, in the form of a French poem: it says he used to have great worldly riches and power but is now a rotting corpse, and asks passers-by to pray for his soul.

The Black Prince's **epitaph** presents him as a **"caitiff"**, or man **worthy of contempt**

THE BLACK PRINCE

Edward, the Black Prince (1330–1376), was the eldest son of Edward III and one of the great military leaders of his time. The origin of his nickname is uncertain: it may refer to the black ground of his shield, or perhaps to the dread he inspired in his enemies. He first distinguished himself at the Battle of Crécy (1346), aged only 16, and won another great victory against France at the Battle of Poitiers (1356). He died, possibly of dysentery, a year before his father, who was succeeded by the prince's son, Richard II.

THE BLACK PRINCE WITH HIS FATHER, EDWARD III

▷ **HERALDIC "ACHIEVEMENTS"**
Above the tomb hang replicas of the prince's helmet, gauntlets, shield, scabbard, and tunic. The originals are undergoing conservation.

ST EDMUND THE MARTYR
At far left stands Edmund the Martyr,
King of East Anglia, who was killed by
invading Danes in 869; he holds an
arrow symbolizing his martyrdom.

ST EDMUND THE MARTYR
At far left stands Edmund the Martyr,
King of East Anglia, who was killed by
invading Danes in 869; he holds an
arrow symbolizing his martyrdom.

ST JOHN THE BAPTIST
John is dressed in animal skins (alluding to
his ascetic life in the desert) and holds his
traditional symbol of a lamb, a reference to
his description of Jesus as the Lamb of God.

London, UK

The Wilton Diptych

*One of the most beautiful paintings of
the Middle Ages, by an unknown artist*

The formal title of this exquisite painting is *Richard II
Presented to the Virgin and Child by his Patron Saint John
the Baptist and Saints Edward and Edmund*. Its familiar
name derives from Wilton House in Wiltshire, England
(where it was kept until 1929), and from its format (a
diptych is a painting in two halves arranged like an
open book). Diptychs were often hinged, as this one
is, so they could be folded, and they were typically
used for portable altarpieces. The Wilton Diptych is
first recorded in 1639, in the collection of Charles I.
It is generally presumed to have been commissioned
by Richard II for his own use, but it may have been
made as a memorial after his death in 1400.

A treasure fit for a king

Whatever its exact purpose, the diptych is certainly
a treasure fit for a king, with lavish use of gold and
ultramarine blue (made from the semi-precious stone
lapis lazuli) and consummate craftsmanship in the
ravishingly beautiful depiction of faces, flowers, and
costumes. It is a leading example of the International
Gothic style that flourished at sophisticated European
courts in this period, characterized by aristocratic
elegance and delicate detail. Because of the wide
diffusion of the style, there is uncertainty about
the nationality of the artist who created the painting.

ST EDWARD THE CONFESSOR
King of England 1042–66, Edward the
Confessor was renowned for his piety. He
holds a ring, a reference to a story that he
gave his own costly ring to a poor pilgrim.

RICHARD II
Richard is depicted kneeling in
devotion on rough ground in a
wooded landscape, his hands open,
gazing towards the Virgin and Child.

BANNER
The staff held by an angel has a banner that has been interpreted as the flag of St George, England's patron saint, or as the banner often held by Jesus in depictions of the Resurrection.

BLUE ROBES
The deep ultramarine blue of Mary's and the angels' robes comes from lapis lazuli, a pigment costlier than gold.

Scale

◁ **THE WILTON DIPTYCH**
Richard was especially devoted to the three saints who appear with him. Edmund and Edward were former English kings, so Richard is portrayed as part of a line of saintly monarchs. **Dimensions (each panel):** 53 x 37cm (21 x 14½in). **Date:** c.1395–99.

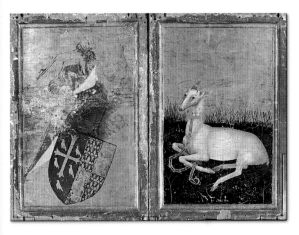

△ **REAR VIEW**
The reverse of the diptych depicts heraldic devices referring to Richard II. On the left is Richard's coat of arms; on the right his emblem, a white hart, wearing a golden collar and chain. The hart is also shown as badges worn by the angels on the interior.

KISS OF HOMAGE
The Virgin Mary holds out Jesus' foot for Richard to kiss in an act of homage.

PAINTING WITH GOLD

If gold leaf is applied to a white surface it looks rather cold and greenish, so in the backgrounds of paintings such as this it was applied over a layer of bole (reddish-brown clay mixed with glue), which imparts a deep, rich glow. It could be burnished or left unburnished for different effects. The gold ground could be worked with a variety of tiny punches to create surface textures, allowing the gold to sparkle and reflect. Various techniques were used to apply gold in other parts of the painting: for example, gold paint for fine details was made from powdered gold mixed with egg.

GESTURE OF BLESSING
The infant Jesus raises his right hand to bless Richard or the banner (or both).

FLOWERY MEADOW
The flowers include species that were used as emblems by each of Richard's wives – Anne of Bohemia and Isabelle of France.

Mali, Africa

Soninke Sculpture

A rare survival of African wooden sculpture from around the 15th century, with a powerful and enigmatic ritual presence

Wood is abundant in Africa and has often been used as a sculptural material, but it is unusual for a piece to survive for centuries in good condition. This kneeling female figure, however, is in an exceptional state of preservation. It is one of a small number of statues that were found in the 1930s in virtually inaccessible caves on the Bandiagara Escarpment in Mali, a dry and stable environment that preserved the wood from rot.

This area is now lived in by the Dogon people (*see p.318*), but the statues are believed to have been made by an earlier culture known as the Soninke. They were perhaps placed in the caves for safekeeping from invaders, suggesting that they were of great ritual significance, although their precise function is unknown. However, there is no doubting the authority and vigour of this carving, with its long body, thin face, protuberant eyes and mouth, and narrow nose. The rounded belly is probably an indicator of fecundity.

SONINKE AND BANDIAGARA

The Soninke people were the founders of the ancient kingdom of Ghana (unconnected to modern Ghana), which flourished from around the 4th to the 13th century. Little is known of their history, but the country had converted to Islam by the 12th century, and was later subsumed into the Mali Empire. The rare surviving works of art preserved in the Bandiagara Escarpment that pre-date the Dogon and influenced them are ascribed to the Soninke as part of a web of interconnected cultures in West Africa.

BANDIAGARA ESCARPMENT, MALI

The **statue** may be a **goddess** or important **female ancestor**

EYES
The large eyes help give the figure a sense of mesmeric power.

▽ **SIDE VIEW**
The head is elongated and crowned with a bun, accentuating the length of the face.

SCARIFICATION
The raised scars on the face are a form of ritual body decoration called scarification, which may show elite status, or indicate clan membership.

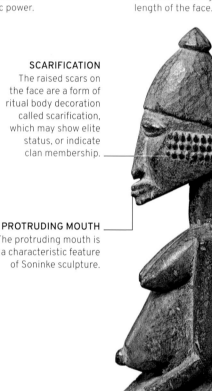

PROTRUDING MOUTH
The protruding mouth is a characteristic feature of Soninke sculpture.

SWOLLEN ABDOMEN
The swollen abdomen, which occurs in other Soninke figures, may be an allusion to fertility and motherhood.

BRACELETS
Like other Soninke figures, both male and female, the woman wears bracelets on her lower arms.

△ **SONINKE SCULPTURE**
The figure has no symbols of a woman's domestic or everyday roles and so perhaps has some otherworldly significance.
Height: 35cm (14in). **Date:** c.1400–1500.

Scale

Old Testament Trinity

A magnificent and revered work of 15th-century religious art by a celebrated but little-known Russian artist

Moscow, Russia

Painted by Andrei Rublev (c.1360–c.1430), this is the most famous of Russian icons and one of the most revered masterpieces of the country's art, beloved for its lyrical gracefulness of line, tender intimacy of expression, and subtle beauty of colour. In spite of its great renown, nothing is known for certain about the circumstances of its creation. However, according to traditions that date back almost to Rublev's lifetime, he painted it for the Trinity-St Sergius Monastery, near Moscow, one of Russia's most important religious sites.

The subject is taken from the Old Testament story of the biblical patriarch Abraham: he was visited by three otherworldly strangers who told him that his wife, Sarah, would give birth to a son, even though the couple were elderly. The strangers are often characterized as angels and are usually depicted as such in art, as in this painting. They were regarded as a symbol of the Trinity (Father, Son, and Holy Spirit) and their prophecy about Abraham's son was interpreted as prefiguring the Annunciation of Christ's birth.

▽ *OLD TESTAMENT TRINITY*
Rublev's masterpiece has many symbolic details that underline its theological meaning. **Dimensions:** 142 x 114cm (56 x 45in). **Date:** c.1410–c.1430.

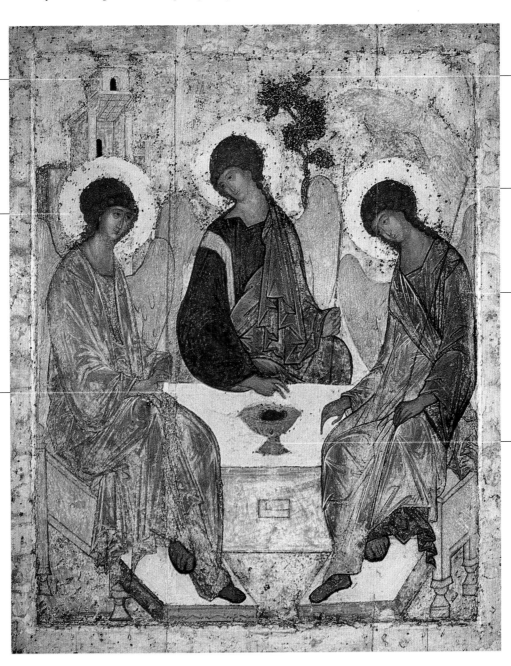

SYMBOLIC BUILDING
The building above the first angel (thought to represent God the Father) has been interpreted as the House of God.

ANGELIC ATTRIBUTES
The haloes and golden wings leave no doubt that Abraham's three visitors are angels.

ALTAR TABLE
Abraham brought food for his visitors; the table on which it is laid resembles an altar.

SYMBOLIC TREE
The tree alludes to the Tree of Life in the Garden of Eden and to the cross on which Christ was crucified.

STAFF
Each of the figures holds a slim staff, usually interpreted as a symbol of authority.

RIGHT-HAND FIGURE
This angel is interpreted as representing the Holy Spirit, with the blue and green of his garments symbolizing Heaven and Earth respectively.

GOLD VESSEL
The gold chalice or bowl contains meat from a calf sacrificed in honour of the three guests.

Scale

Mask of Tezcatlipoca

An astonishing 15th–16th century mosaic mask representing the Aztec god Tezcatlipoca, crafted from a human skull

Mexico City, Mexico

△ **TEZCATLIPOCA**
This drawing of Tezcatlipoca in full regalia is from the *Codex Borgia*, a 16th-century manuscript from Central Mexico.

The Aztecs flourished in central Mexico from the 14th century until the arrival of Spanish conquistadors around the 1520s. The culture was dominated by rituals associated with its polytheistic religion.

Tezcatlipoca (Smoking Mirror) was one of the four major creator gods of the Aztec pantheon. He was commonly depicted in the costume of a warrior, and wearing a distinctive mask made from turquoise and black bands. One of the most striking representations of Tezcatlipoca is a mask created from a human skull, richly decorated with mosaic.

The rear of the skull has been removed and the inside lined with deerskin straps, suggesting that the mask was not simply ornamental, but designed to be worn, and most probably had some kind of ceremonial or ritual significance. The face is almost completely covered with tiles of vibrant turquoise and black lignite, revealing little of the bone that lies beneath, while drawing attention to the exposed teeth. Also prominent in the spectacular mosaic background are eyes made from pyrite and a nasal cavity lined with vivid red shell.

The mask makes spectacular use of **turquoise**, which was **highly prized** by the Aztecs

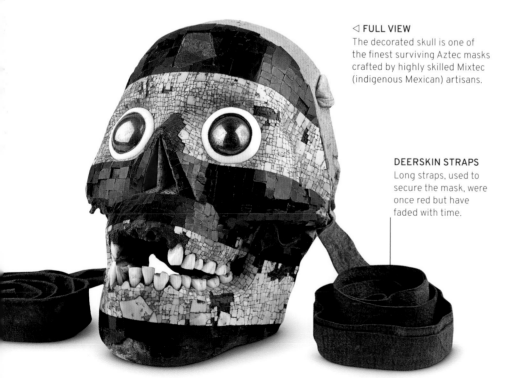

◁ **FULL VIEW**
The decorated skull is one of the finest surviving Aztec masks crafted by highly skilled Mixtec (indigenous Mexican) artisans.

DEERSKIN STRAPS
Long straps, used to secure the mask, were once red but have faded with time.

AZTEC MASK CEREMONIES

In the Aztec calendar, the 20-day month of Toxcatl was dedicated to Tezcatlipoca: ceremonies included sacrifices, particularly the sacrifice of a young man, often seen as the incarnation of the deity. Dressed in a costume and mask in imitation of the god, the young man would present himself at the temple for a ceremony that ended in his sacrifice: his heart was cut out and offered up to the real god.

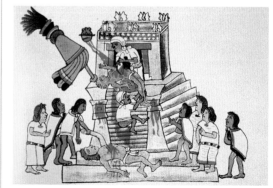

FROM *CODEX MAGLIABECHIANO*, 16TH C

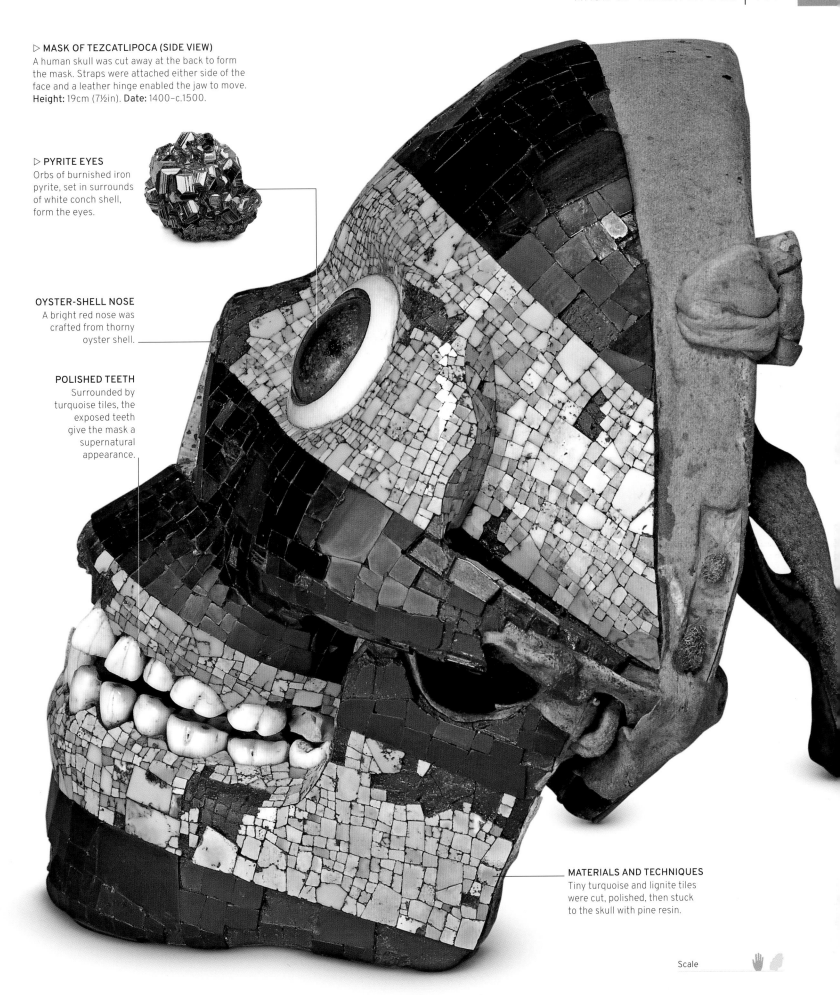

▷ **MASK OF TEZCATLIPOCA (SIDE VIEW)**
A human skull was cut away at the back to form the mask. Straps were attached either side of the face and a leather hinge enabled the jaw to move. **Height:** 19cm (7½in). **Date:** 1400–c.1500.

▷ **PYRITE EYES**
Orbs of burnished iron pyrite, set in surrounds of white conch shell, form the eyes.

OYSTER-SHELL NOSE
A bright red nose was crafted from thorny oyster shell.

POLISHED TEETH
Surrounded by turquoise tiles, the exposed teeth give the mask a supernatural appearance.

MATERIALS AND TECHNIQUES
Tiny turquoise and lignite tiles were cut, polished, then stuck to the skull with pine resin.

Scale

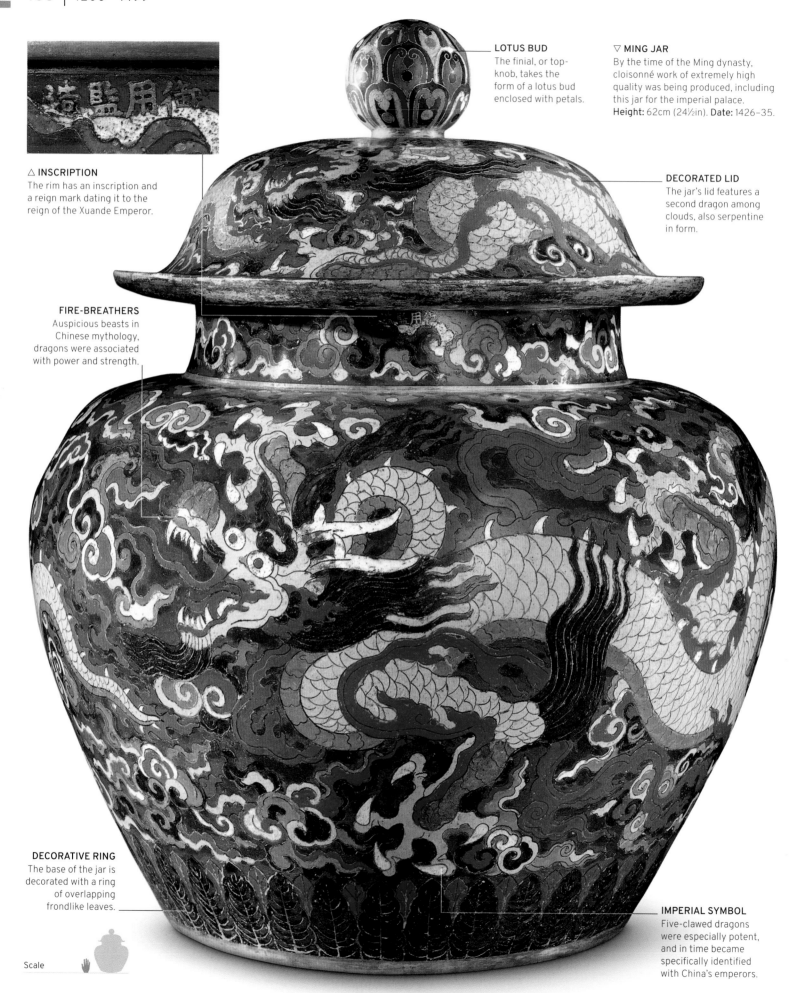

△ INSCRIPTION
The rim has an inscription and a reign mark dating it to the reign of the Xuande Emperor.

LOTUS BUD
The finial, or top-knob, takes the form of a lotus bud enclosed with petals.

▽ MING JAR
By the time of the Ming dynasty, cloisonné work of extremely high quality was being produced, including this jar for the imperial palace.
Height: 62cm (24½in). **Date:** 1426–35.

DECORATED LID
The jar's lid features a second dragon among clouds, also serpentine in form.

FIRE-BREATHERS
Auspicious beasts in Chinese mythology, dragons were associated with power and strength.

DECORATIVE RING
The base of the jar is decorated with a ring of overlapping frondlike leaves.

Scale

IMPERIAL SYMBOL
Five-clawed dragons were especially potent, and in time became specifically identified with China's emperors.

Ming Jar

A spectacular enamelware jar with brilliant cloisonné decoration from Ming-dynasty China

China

In its polychromatic flair and decorative subject-matter, this jar is unmistakably Chinese. Yet the technique used to make it was a relative novelty in China at the time it was produced, around 1430. In a method known as cloisonné, the vessel is decorated with cells of vitreous enamel, produced by fusing powdered glass to a metal base to create a slightly glossy effect. The technique has a long history, dating back to the 2nd millennium BCE, but the Chinese were late to adopt it. The first written reference in China dates from less than 50 years before this jar was produced – making its skilful execution all the more impressive.

The arrival of cloisonné enamelware in China in the late 14th to early 15th century came at a time of widening horizons in the Chinese decorative arts. The Ming rulers showed great curiosity about foreign cultures, sending trading expeditions to distant parts. Knowledge of enamelware was one of the imports that came back with them, probably from Byzantium or the Islamic world. In its new home the method took inspiration from ceramics, a significant part of Chinese cultural tradition for more than three millennia.

Flamboyance fit for a palace

This spectacular large jar with domed lid features a motif of a swirling dragon chasing a pearl among clouds. Colours vary from red and yellow to turquoise, green, and aubergine. While the elaborate design is similar to those found on the typical blue-and-white ceramics of the period, the bright colours of cloisonné were initially regarded as making it suitable only for ladies. By the time of this jar, however, cloisonné was considered a royal art, and its sumptuous flamboyance was appreciated as fit for palaces and temples. Indeed, an inscription on the jar's neck reveals that it was made for the imperial household. The vibrant colours that must have seemed so startling are today seen as marking a pinnacle of the nation's artistic tradition.

△ **DISH WITH FLORAL SCROLLS**
This 15th-century cloisonné dish is decorated with lotus flowers and acanthus leaves. Each separate enamel colour is in an individual cloison, or cell.

The **intense, brilliant colours** of cloisonné work were at first considered **crude and strident** by Chinese experts

CLOISONNE ENAMEL

Cloisonné is an ancient technique of decorating metalware with a design using wire and enamel. Thin wires, often of gold or silver, are twisted into shape and fixed to the surface. The compartments (or cloisons, from the French for "partition") are filled with vitreous enamel paste. The item is fired at around 800ºC (1470ºF) to fuse the enamel. Some shrinkage takes place, so where necessary, areas are filled and the item is fired again, a process that is repeated until each cloison is full. The surface is then polished so that the edges of the wires are visible.

CREATING THE FILIGREE DESIGN
Thin, ribbon-like wires are glued or soldered to the metal surface in the desired pattern.

FILLING THE DESIGN WITH ENAMEL
Each cloison is individually filled with vitreous enamel paste, coloured with metallic oxides.

ADAM
Adam and Eve represent humanity, the beneficiary of Christ's sacrifice. (Eve is seen on the far right panel.) The near life-size figures are depicted with extraordinary realism.

ENTHRONED FIGURES
The upper register is dominated by the monumental figures of God the Almighty, flanked by the Virgin Mary and John the Baptist.

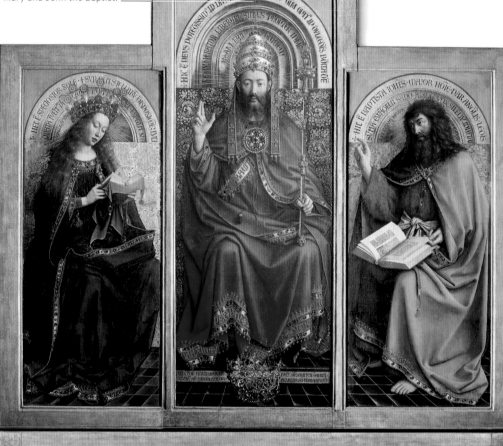

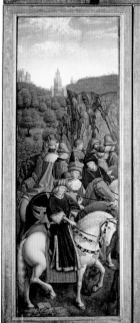

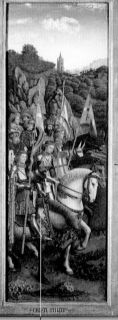

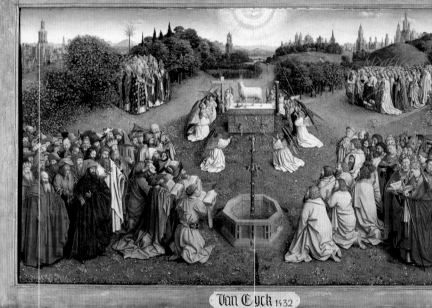

REPLACEMENT PANEL
The panel of the Just Judges was stolen in 1934. This is a 1957 copy by the famous art forger Jef van der Veken.

SOLDIERS OF CHRIST
Groups of knights and judges proceed towards the central scene.

HEAVENLY STRUCTURES
A minutely detailed cityscape represents the Heavenly Jerusalem; its buildings are based on actual structures, mainly in Ghent, but also in Utrecht, the Netherlands.

THE FOUNTAIN OF LIFE
The blood of the sacrificial Lamb is channelled into the Fountain of Life, from where the water gushes out as if down towards the real altar.

HEAVENLY MUSIC

A heavenly choir of angels sings and plays music, wearing rich, contemporary brocades.

◁ **THE GHENT ALTARPIECE**

Composed of 12 oak panels, this huge artwork is also known as *The Adoration of the Mystic Lamb*, after the scene depicted in its principal panel. **Dimensions (open):** 350 x 470cm (11ft 6in x 15ft 5in). **Date:** 1432.

Scale

The Ghent Altarpiece

The first great masterpiece of Netherlandish art and one of the foundation stones of the Northern Renaissance

Ghent, Belgium

Few artworks have had a more eventful history than the Ghent Altarpiece, a huge polyptych in St Bavo's Cathedral, Ghent, Belgium. It has been looted by Napoleon, attacked by vandals, seized by the Nazis, damaged in a fire, and hidden in a salt mine. Mystery surrounds its origins. An inscription on the frame proclaimed: "Hubert van Eyck, the greatest of all painters, began this work. Jan, second in the art, completed it." Hubert is a shadowy figure, while Jan van Eyck, his brother, was one of the greatest Early Netherlandish artists. Historians struggle to agree about the precise contributions of each.

The seeds of a new realism

Painted in oil on 12 hinged panels, the altarpiece is a pivotal landmark, combining archaic, medieval elements with some of the earliest

signs of the Northern Renaissance. The Gothic features include the disparity of scale between the figures, the cramped space in some panels, and the intuitive (rather than mathematical) approach to perspective. Contrasting with this, there is a new interest in portraying the material world. Landscapes, flowers, and physical objects (jewelled crowns, gleaming armour, silk and fur clothing) are depicted in meticulous detail. This was aided by Jan van Eyck's pioneering use of oil paint and glazes, with which he achieved complex light effects and surface textures.

The central theme is Christ's sacrifice, symbolized by the Mystic Lamb. The Lamb stands triumphantly on the altar, surrounded by crowds of holy figures – kneeling angels, saints, pilgrims, churchmen, and Christian soldiers – who bear witness to the sacred event.

APPROACHING PILGRIMS

A group of holy hermits and pilgrims witnesses the scene, led by the gigantic figure of St Christopher.

CLOSED ALTARPIECE

Although relatively muted, the outer panels of the altarpiece exhibit the same virtuoso use of oil paint, and include portraits of the work's donor and his wife (*below*).

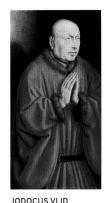

JODOCUS VIJD

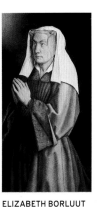

ELIZABETH BORLUUT

Erythraean Sibyl

Cumaean Sibyl

Prophet Zacharias

Prophet Micah

Archangel Gabriel

Virgin Mary

John the Baptist

John the Evangelist

Florence, Italy

Scale

The Annunciation

A radiantly colourful altarpiece by one of the greatest Italian painters of the early Renaissance

The Annunciation is one of the most popular subjects in Christian art, celebrating the moment when the archangel Gabriel tells the Virgin Mary that she will bear a son called Jesus. No artist treated the subject more joyously and sensitively than Fra Angelico, who depicted it in panel paintings such as this, in frescoes, and also in manuscript illumination.

Perspective and radiant beauty

Fra Angelico painted three altarpieces on the subject of the Annunciation; this one was for the Convent of San Domenico in Fiesole, where the artist was himself a friar. It is regarded as one of his first masterworks and, by some scholars, as the first Florentine altarpiece in the Renaissance style to employ perspective to define space. The painting shows the richness of invention, splendour of colour,

and delicacy of technique that was typical of Fra Angelico's work. It is divided vertically into three parts, from Adam and Eve's banishment from the Garden of Eden, to the archangel Gabriel, to a seated Mary. Uniting the thirds is a shaft of light emanating from the hands of God.

In the Garden of Eden, Fra Angelico depicts a paradise dense with plants that seem almost to be pushing Adam and Eve out of the painting. In contrast, Mary, reflecting the angel's crossed hands as a symbol of respect and acceptance, is shown enclosed by the ordered geometry of the building. Far from being overwhelmed by their surroundings, the figures of Mary and Gabriel are too large in relation to the building; the interest for the artist, a man of God, was in expressing the magnitude of the event rather than achieving lifelike proportions.

△ **ADAM AND EVE**
In the background, Adam and Eve are expelled from the Garden of Eden; this secondary scene conveys the message that Christ was born to bring salvation from the sin with which they had infected the world.

Fra Angelico trained as a **miniaturist** and used very **fine brushes** for details such as **eyelashes**

FRA ANGELICO

Fra Angelico (c.1395–1455) is first recorded working as a painter in 1417, and by 1423 he had joined the Dominican order at Fiesole. He spent most of his life there and in nearby Florence, but he was acknowledged as one of the outstanding artists of the day and his services were widely sought. He carried out commissions for major churches in Orvieto and Perugia, and he spent much of his final decade in Rome, painting frescoes for Pope Eugene IV and his successor, Nicholas V.

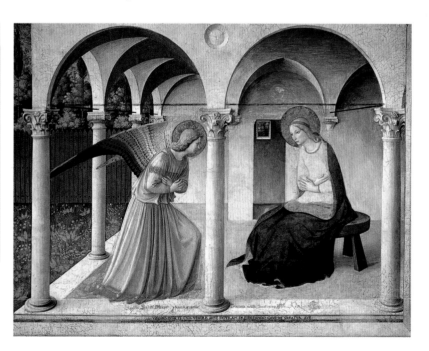

▷ **SAN MARCO** *ANNUNCIATION*
In about 1440 Fra Angelico painted this fresco of the Annunciation in the convent of San Marco, Florence. As is characteristic of fresco, it is paler in colour and less exquisite in detail than the panel painting, but it has a wonderful serenity and dignity.

THE LIGHT OF GOD
From top left God's hands send down a dove (symbol of the Holy Spirit) on a shaft of golden light.

FOLIAGE, FLOWERS, AND FRUIT
The Garden of Eden is lushly depicted, with magnificent details of plant life.

▷ **SYMBOLIC BIRD**
The black-and-white bird has sometimes been described as a magpie (perhaps as a reference to the Dominicans, who wear black cloaks over white habits), but it is more likely a swallow, regarded as a herald of spring and new life.

ARCHITECTURE
The architecture shows an interest in the new science of perspective, but it is not used to create a realistic setting: if Mary stood up, her head would touch the ceiling.

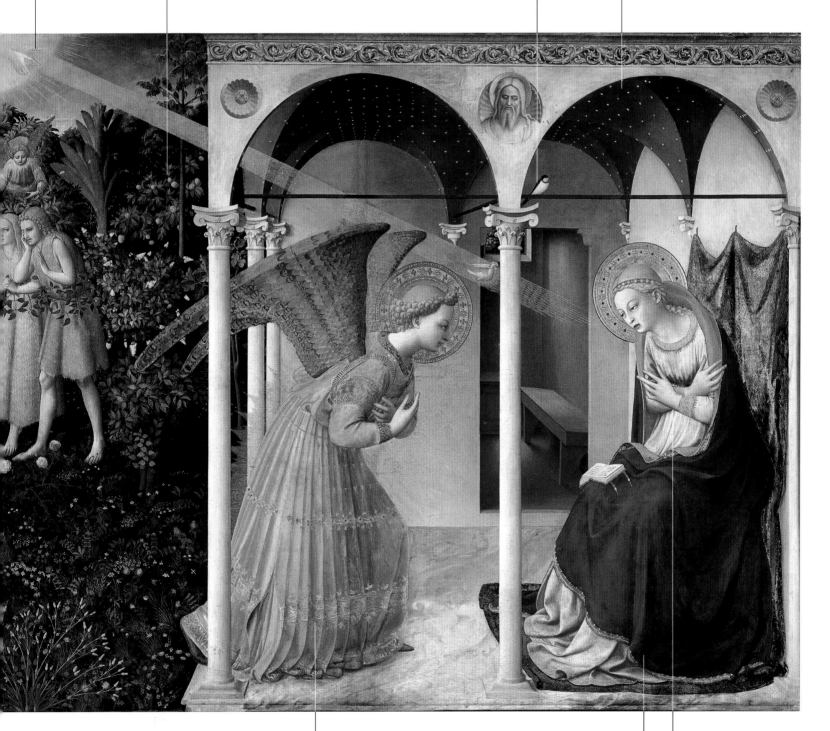

△ *THE ANNUNCIATION*
Fra Angelico's 16th-century biographer Giorgio Vasari wrote that the figures of Gabriel and Mary in this painting "seem to have been made in Paradise rather than by the hand of man". **Dimensions:** 162 x 191cm (64 x 75in). **Date:** c.1430.

GABRIEL
Gabriel's face is simply modelled, in marked comparison to the details of his wings and halo.

EXPENSIVE MATERIALS
In addition to lavish use of gold leaf in the haloes and other details, the painting has large areas (Mary's costume and the vaulted ceiling) in ultramarine blue, made from the semi-precious stone lapis lazuli.

MARY
Mary, who was reading a book when Gabriel appeared, crosses her arms in a gesture indicating acceptance of her destiny.

FORE-EDGE ORNAMENTATION
The fore-edge is lightly embellished with floral motifs.

◁ **NEW BINDING**
This volume was rebound in 1885 by William Matthews, the leading American bookbinder of the time.

◁ **INITIAL LETTER**
This initial letter B begins Psalm 1: "Beatus vir …" ("Blessed is the man …").

▽ **GUTENBERG BIBLE**
Because decoration was added by hand, no two copies of the Gutenberg Bible are exactly alike. **Page size:** 44.5 x 31cm (17½ x 12in). **Date:** c.1455.

FORTY-TWO LINES
The book is sometimes known as the 42-line Bible because of the number of lines of text on each page.

PAPER
This Bible is printed on high-quality paper manufactured in northern Italy.

PLANT DECORATION
Plant decoration in the borders of the page is a feature adopted from illuminated manuscripts.

RUBRICATION
Gutenberg started off printing the rubrics (beginnings of sections) in red ink, but abandoned this as too time-consuming, and most copies were rubricated by hand.

Scale

Gutenberg Bible

The first great landmark in the development of the printed book, beginning a revolution in the communication of ideas

Mainz, Germany

The invention of the printed book is one of the most momentous turning points in history, transforming the spread of information in the 15th century as radically as the internet has today. Printing with movable type originated in China and Korea, but had relatively little initial impact there, whereas Johannes Gutenberg's breakthrough in Europe was rapidly and widely influential. He showed that the printed book was commercially as well as technically viable (his Bible quickly sold out). By 1500 about a thousand presses were operating all over Europe.

Technology, craft, and beauty

Gutenberg set up a workshop in Mainz, Germany, in about 1448 and printed a few fairly minor works, before completing the printing of his Bible around 1455. Such an ambitious, pioneering venture would have involved solving numerous problems, concerning the manufacture of the type, the operation of the press, the composition of the ink, and so on, but Gutenberg mastered his new technology so completely that the book is a majestic masterpiece of the printer's art. Around 180 copies were printed, of which about 50 survive complete or in part. Most copies were bound in two volumes, the first containing the majority of the Old Testament, the second the remainder of the Old Testament plus the New Testament. The extra-large volume shown here, however, contains the whole of the Old Testament, without the New Testament.

Like most copies, this Bible is printed on paper (a few were printed on more expensive vellum, made from calfskin). The Gothic, or blackletter, text is set in double columns and printed in a rich, lustrous black, using ink that was oil- rather than water-based – an innovation of Gutenberg's – to make it adhere to the metal type. Page borders and capital letters were hand decorated by a skilled artisan to make the pages resemble an illuminated manuscript. The book is an outstanding combination of fine printing, high-quality materials, and superb craftsmanship.

GUTENBERG

The life of Johannes Gutenberg (c.1400–1468) is obscure at many points. Born in Mainz, Germany, he worked on a method of polishing gemstones and was involved in the making of metal mirrors, before turning to printing. Shortly after his Bible was completed, he lost a legal case against his business partner and had to hand over his printing equipment, leaving him ruined. He may have continued elsewhere as a printer, but this is uncertain.

Each **vellum** copy of the **Bible** required the skin of about **170 calves**

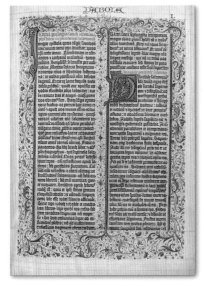

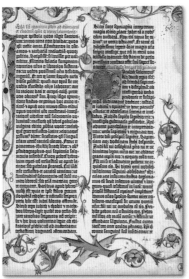

◁ **THREE VERSIONS**
The same page of text is shown here from three copies of the Gutenberg Bible, demonstrating how much the hand decoration varies from one to another. The illuminated letter P begins the Book of Proverbs: "Parabole Salomonis" (The Parables of Solomon).

Zytglogge Astronomical Clock

A complex mechanism tracking the heavenly bodies, and the star attraction of the tower that is the chief landmark of Bern, Switzerland

Bern, Switzerland

The heart of historic Bern, the capital of Switzerland, is dominated by a medieval clock tower named the Zytglogge ("time bell" in the Bernese German dialect). This major monument features three clock faces and an ancient bell, which has tolled the hours since 1405.

The Zytglogge's most outstanding element is its complex astronomical clock, on the eastern façade of the tower. Painted in bright colours that draw the eye, the clock takes the form of an astrolabe (*see p.134*), designed to show the passage of the zodiac against the turning of the Earth, represented by a background planisphere of blue (for daylight) and black (night), with a grey area for dawn and twilight in between. Moved by a rotating mechanism called the rete, the zodiacal ring turns in conjunction with another disc representing the 365 days of the year. As well as the time, the display indicates the day and date, the current moon phase and zodiac sign, and the times of sunset and sunrise. Twenty-four gold-painted Roman numerals (from I to XII twice) circle the black outer ring of the clock to indicate the time. As the clockwork does not allow for leap years, the mechanism is adjusted manually every 29 February.

ZYTGLOGGE ASTRONOMICAL CLOCK ▷
For four centuries, all clocks in Bern were set to this one. The clockwork movement was designed and built by Kaspar Brunner in 1527–30 and has remained unchanged to this day.
Height (tower): 54.5m (179ft).
Date: 1467–83/1530.

THE CLOCK TOWER

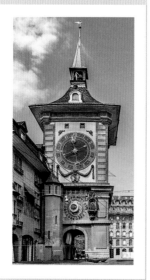

The Zytglogge clock tower has undergone many incarnations since it was first built. Starting life around 1220 as a 15m (50ft) high fortified gateway and guard tower in Bern's western city wall, it later served as a prison in the 14th century, mainly for women accused of sexual relations with priests. In the following century, the tower was extended upwards and endowed with both a conventional clock face and, beneath it, the astronomical mechanism that remains to this day.

HOURS OF THE DAY
A long pointer with a stylized hand at its end indicates the time of day, as shown on an outer ring of 24 gold-painted Roman numerals.

DAYS OF THE WEEK
A semicircular panel at the top of the clock face displays the day of the week – in this case *Montag*, or Monday.

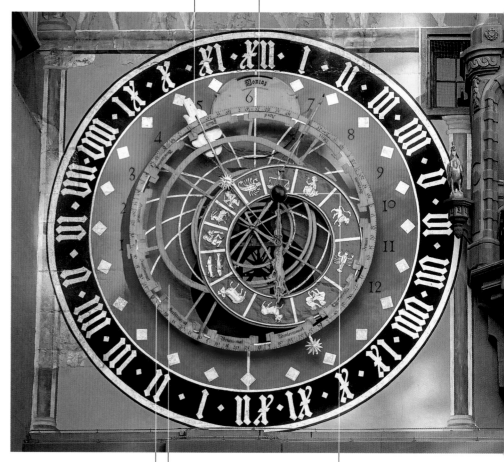

THE ANNUAL ROUND
Linked to the main clock mechanism, an inner circle lists the 12 months and, on its outer rim, the days within each one.

THE PASSAGE OF THE HEAVENS
A background planisphere marks the passage through daylight (shaded blue), twilight (grey), and night (black) every 24 hours.

ZODIACAL SIGNS
An inner hand, here pointing to Libra's scales, tracks the phases of the moon.

The clock reportedly **inspired Einstein's speculations** on **time** and the **speed of light**

Scale

Sierra Leone, West Africa

Ivory Hunting Horn

A beautiful example of 15th-century Sierra Leonean ivory carving created as a gift for royalty

In the late 15th and 16th centuries, ivory objects carved by West African craftspeople were desirable luxuries for the collectors of Renaissance Europe. Expert ivory carvers, the Sierra Leoneans adapted their work to be attractive to the European market, especially the Portuguese. The intricate elephant tusk hunting horn shown here was made by a master artist, probably from Sierra Leone's Temne or Bullom people, as a gift from Manuel I of Portugal (ruled 1495–1521) to the Spanish monarchs Ferdinand and Isabella. The suspension lugs and the position of its mouthpiece (at the end rather than on the side) indicate that the horn was made for export. The profusion of high- and low-relief carvings includes African-style figures, geometric patterns, and animals, mingling with Latin inscriptions, Greek letters, heraldic shields, and hunting scenes in a fertile fusion of local and European elements.

CARVING A HORN

Elephant tusks were cut into sections for different items; the part containing the pulp cavity was used for horns as it was naturally hollow. The carver thinned the outer bark, or rind, of the tusk with an adze before smoothing the surface with a float and carving the design using chisels, fretsaws, and gauges. Millions of elephants were slaughtered for ivory, but an international ban on the trade in 1990 has made ivory carving a vanishing art.

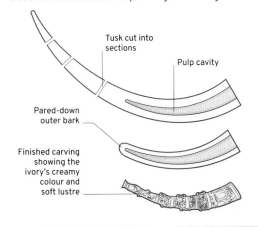

Tusk cut into sections

Pulp cavity

Pared-down outer bark

Finished carving showing the ivory's creamy colour and soft lustre

▷ **IVORY HUNTING HORN**
This exceptional ivory horn is one of three carved by the same unknown Sierra Leonean artist. It is one of about 100 surviving examples of West and Central African ivories that blend African and European forms, motifs, styles, and patterns. **Length:** 64.2cm (25¼in)
Date: 1494–1500.

▽ **AFRICAN STYLE**
This figure's face reflects African figure carving; he carries what may be a leopard on his shoulders.

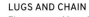

△ **EUROPEAN ELEMENT**
The armillary sphere was a symbol of the Portuguese empire, being associated with Manuel I of Portugal.

LUGS AND CHAIN
These carved lugs hold the remnants of what was probably a metal hanging chain for the horn.

DARKER PATINA
Over time ivory develops a brownish-yellow patina that adds depth to the cream colour of freshly carved ivory.

TIERED CARVING
The horn is carved in tiers of animals, humans, plant forms, and letters, separated by lattice, beading or braiding.

HERALDIC ARMS
The coat of arms of Manuel I of Portugal is carved on the horn.

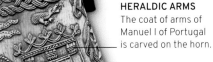
A **hunting horn** made from an elephant's tusk is known as an **oliphant**

Scale

Scale

MERCURY
At the end of the group, Mercury, god of the month of May, holds a staff in his right hand to banish winter clouds.

ORANGES
The scene is set in an orange grove, partly no doubt because oranges were linked to the Medici coat of arms.

CUPID
Cupid aims his arrow at the Three Graces. He was often shown blindfolded, to illustrate the idea that "love is blind".

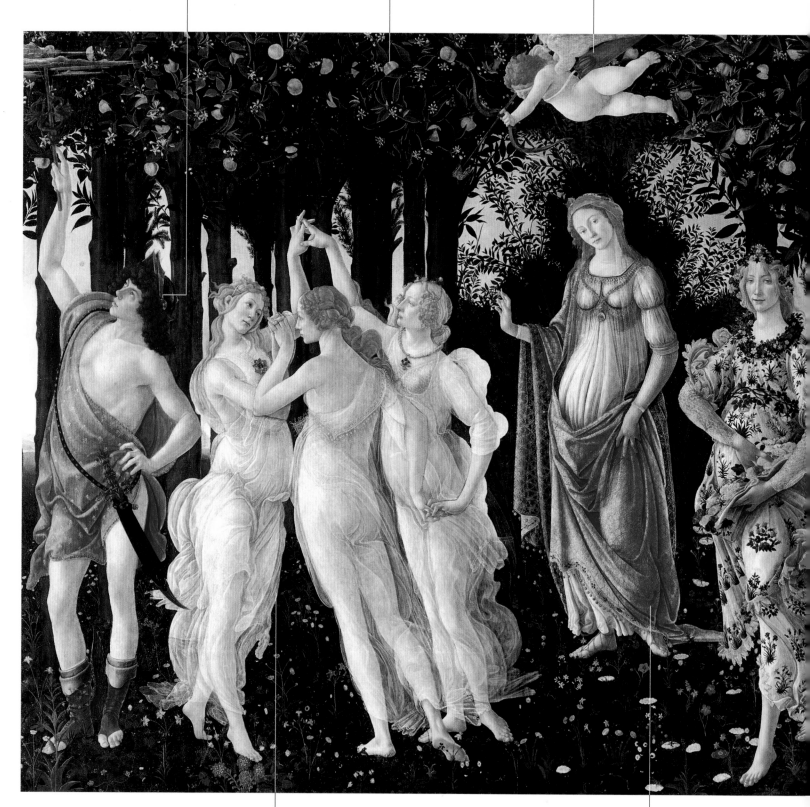

△ PRIMAVERA
This beautiful painting is probably Botticelli's most famous picture. Its complex imagery has puzzled historians for centuries, but it remains an immensely popular work. **Dimensions:** 207 x 319 cm, (81½ x 125½in). **Date:** c.1477–82.

THREE GRACES
The Three Graces are shown here as handmaidens of Venus. They are usually identified as Chastity, Beauty, and Love.

VENUS
The goddess of love, Venus, stands at the centre of the painting, framed by the arched branches of the orange trees and with a halo of light behind her.

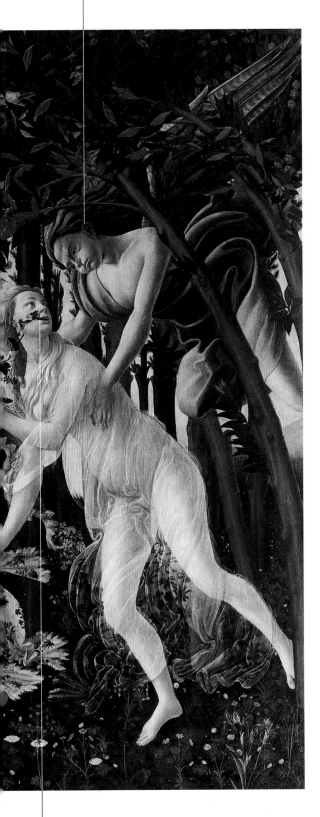

ZEPHYR
Zephyr is blue-skinned, to suggest the chilliness of the wind. He is shown here pursuing Chloris.

CHLORIS
Flowers issue from the mouth of Chloris who transforms into Flora (to her right), shown scattering blossoms.

At least **138 different species of plants** have been identified in the painting

Florence, Italy

Primavera

A supreme masterpiece of Renaissance art noted for its pale, graceful forms and elegant lines

Sandro Botticelli's *Primavera* (*Spring*), 1477–82, was probably created for the artist's chief patron, Lorenzo di Pierfrancesco de' Medici, possibly as a wedding present; it was certainly displayed in Medici's villa at Castello, near Florence, Italy. Painted in tempera on wood, it has been admired above all for its exceptional draughtsmanship and graceful figures.

Complex allegory

The highly cultivated Medici family would have been involved in planning the complex allegorical details of the work. Historians have speculated endlessly about its meaning, without offering a definitive answer. What does seem clear, however, is that the picture is primarily an allegory of spring – a remarkable, dream-like scene that is designed to be "read" from right to left. Zephyr, the cold March wind, enters from the right pursuing the nymph Chloris. As he catches her, she is transformed into Flora, goddess of spring, who scatters flowers on the ground. The celebration of her work continues through to Mercury on the left, who disperses the last of the winter clouds.

Other interpretations assigned more complex meanings to the mythological figures. This is most obvious in the case of Venus, who looks remarkably demure for a goddess of love. Her pose has been compared to depictions of the Virgin at the Annunciation in Christian art. Marsilio Ficino, who was tutor to one of the Medici, described her as "Humanitas", a personification of both spiritual and sensual love.

BOTTICELLI

Alessandro di Mariano Filipepi (c.1445–1510), known as Sandro Botticelli, was born in Florence. He studied under the painter Fra Filippo Lippi to become one of the greatest artists of the Early Italian Renaissance. His most famous works include *Pallas and the Centaur* (c.1482–84) and *The Birth of Venus* (c.1482–85). His popularity declined in the 1490s but was revived in the late 19th century.

FOUNTAIN OF LIFE
This is the Fountain of Life. Most Netherlandish artists visualized it in architectural terms, but Bosch preferred organic, plantlike forms, which are echoed in the next panel.

's-Hertogenbosch, Netherlands

The Garden of Earthly Delights

A visionary masterwork of Netherlandish art, whose bizarre fantasies inspired many future generations of painters

Netherlandish master Hieronymus Bosch (c.1450–1516) was a maverick, his idiosyncratic paintings adhering to no fixed school or tradition. While he could not have been ignorant of the developments of the Renaissance, he hewed more to the late Gothic mode of depicting religious scenes with complex symbolism and minute detail. But the piety and morality in his paintings was filtered through an individual sense of fantasy and wit.

From Heaven to Hell

Painted in oil on oak panel, the *Garden* is a triptych, a format typically used for altarpieces. The left-hand panel is set in the Garden of Eden, just as a somewhat youthful God is presenting Eve to Adam. The events in the central panel, set in what appears to be the same landscape, occur later, after their expulsion from Eden. The bizarre scenes of naked men and women frolicking among outsize birds, animals, fruits, fish with legs, and hybrid creatures contain an ambiguous, even innocent eroticism that seems to make it a less than wholehearted condemnation of the sin of lust. Much of the imagery that is so enigmatic to us today was drawn from songs, proverbs, and manuscripts, and would have been readily understood by contemporary viewers. In the final panel, with its dark tones, grotesque scenes of fiery damnation are evoked with a similar surreal glee.

THE OUTER PANELS

THE TRIPTYCH WHEN CLOSED

The external faces of the triptych, painted in grisaille (neutral grey tones), show the Earth as a crystal sphere half-full of water, containing plant forms but no humans or animals. This represents the third day of the Creation, when Eden was formed; or possibly the Earth after the Flood, when God sent waters to cleanse the world. God is seen as a tiny figure in the top left corner.

SNAKE IN THE GARDEN
Even in Paradise, there are hints of future trouble. Here, the serpent slithers round the Tree of Knowledge.

 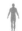
Scale

▷ HYBRID CREATURES
Bosch loved combining different creatures. The confrontation between a mermaid and a merknight was borrowed from contemporary manuscripts.

STRAWBERRY TREE
Plucking fruit was a reference to the sexual act. In the Spanish royal collection, the work was known for many years as "the strawberry painting".

▷ SELF-PORTRAIT?
The "Tree Man", gazing out at the viewer with a wry smile, is interpreted by some as a possible artist's self-portrait.

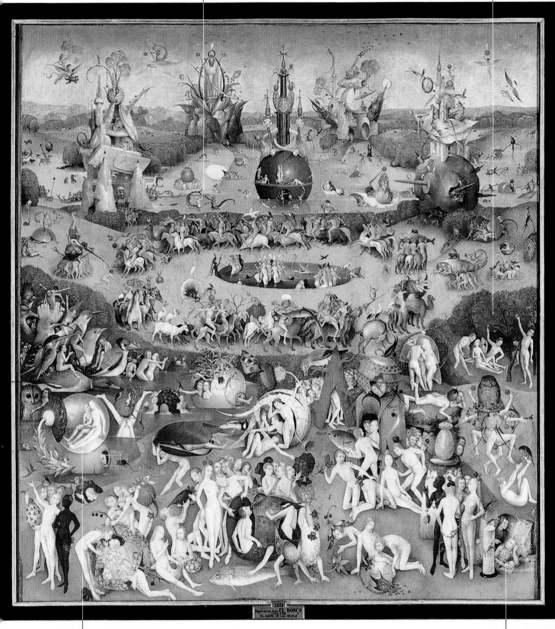

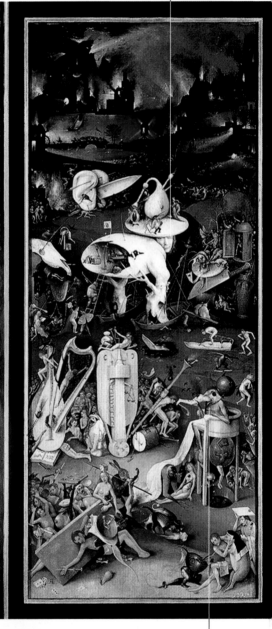

◁ ENGLOBED
A naked man and woman enact their passion inside a transparent bubble, which is a fruit borne by a strange plant.

▷ CAVE DWELLERS
Adam and Eve, clothed in animal skins, appear in a cave. Half-concealed behind Adam, a third figure may be Noah, foreshadowing the Flood, God's punishment for man's sin.

PRINCE OF HELL
A giant bird-monster, enthroned on a latrine chair and wearing a chamber-pot crown, devours the avaricious and excretes them into a well.

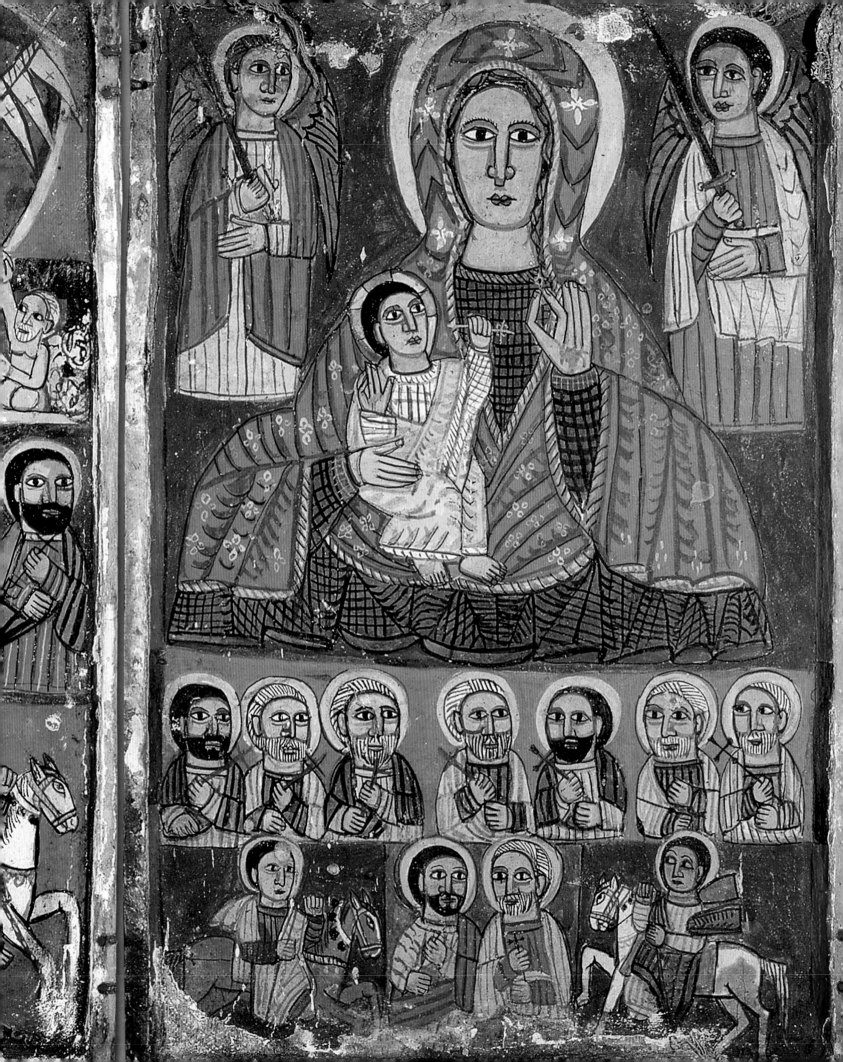

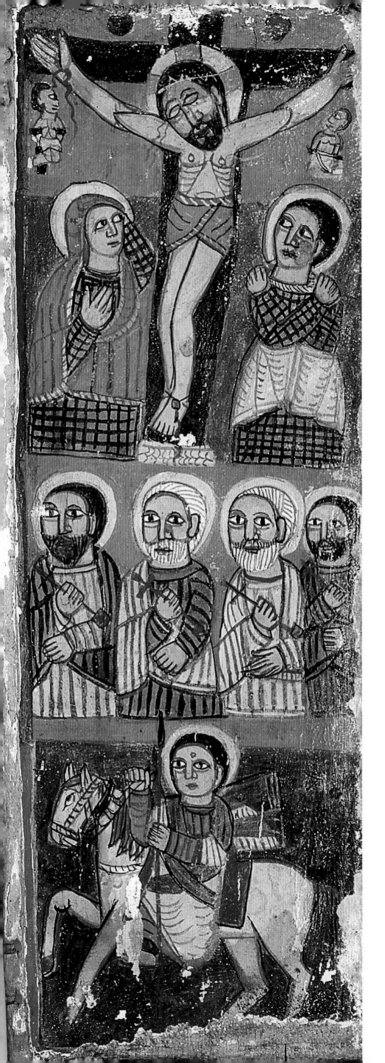

1500–1699

This period saw some of the world's most recognizable art – including Leonardo's *Mona Lisa* and Rembrandt's *Night Watch* – produced in the workshops of Europe. There was a shift away from religious subjects in art in the West as the Renaissance revived interest in Greek and Roman forms, while exquisitely crafted objects, such as Cellini's Salt Cellar, exhibited the wealth and status of powerful patrons. Beyond Europe, artisanal production of carpets and illustrated manuscripts in Persia, bronzes in West Africa, ceramics in Turkey, and ink paintings in Japan reached new heights of beauty and quality. Remarkable survivals from the period of the Aztecs of Mexico provide a reminder of lost cultures.

MONA LISA ▷
Leonardo's extraordinary delicacy of
brushwork is combined with a serene,
relaxed dignity of pose, bringing a
new naturalism to portraiture.
Dimensions: 77 x 53cm (30¼ x 21in).
Date: c.1503–07.

Mona Lisa

The most famous painting in the world, revered for its subtle brushwork and its naturalness of pose and expression

Florence,
Italy

A tour de force of Renaissance portraiture, the *Mona Lisa*, by Leonardo da Vinci (1452–1519), depicts Lisa Gherardini del Giocondo, an upper-class Florentine woman; the Italian word *mona* is a polite form of address – a contraction of *mia donna* ("my lady").

Leonardo is known to have been at work on the portrait in 1503, but it is not clear when he began or finished it. Indeed, it is uncertain if he ever finished the painting: evidently he never delivered it to the patron (it was probably commissioned by Lisa's husband, a wealthy merchant) and still had it with him when he settled in France in 1516 or 1517 at the invitation of Francis I. It was through the king that the *Mona Lisa* became part of the French royal collection and subsequently the French national museum, the Louvre, where it went on display in 1804. By this time, the painting was well known in artistic circles, but its enormous popular fame did not develop until the later 19th century, when it became a byword for feminine mystery and allure – a "sphinx of beauty", as the French writer Théophile Gautier termed it in 1859.

Subtlety and elusiveness

The portrait's sense of mystery depends largely on the subtlety and elusiveness of the sitter's expression: her "unfathomable smile". This phrase comes from a rhapsodic essay on Leonardo by the British writer Walter Pater, which was published in 1869. For Pater the painting evoked "strange thoughts … fantastic reveries … exquisite passions" and it has similarly seduced countless other writers, inspiring commentary and speculation of all kinds. One of the many eccentric theories is that it does not depict a woman, but Leonardo himself.

▽ **KNOTWORK**
Intricate knotwork like that around the top of the gown is found in several of Leonardo's works, making a punning reference to his name: in Italian, *vinci* can mean "chains".

Napoleon kept the *Mona Lisa* **in his bedroom** for **four years** before having it moved to the **Louvre**

THE INFLUENCE OF THE *MONA LISA*

The *Mona Lisa* began to influence other artists while Leonardo was still working on it. Raphael, who was mainly based in Florence at this time, painted several portraits clearly inspired by it, and this drawing (*right*) borrows so many features from it that it is almost a free copy. The Frans Hals portrait (*centre*) is a more distant reflection of the Leonardo, but the turn of the head, the smile, and the folded hands all go back to it. Hals never saw the original painting, but could have known one of the many copies and adaptations of it. Corot's painting (*far right*) is a more deliberate act of homage, produced at a time when the *Mona Lisa* was becoming widely known to the general public, not just to art connoisseurs. It is almost exactly the same size as the *Mona Lisa*.

YOUNG WOMAN ON A BALCONY,
RAPHAEL, C.1505

*PORTRAIT OF A SEATED WOMAN HOLDING
A FAN,* FRANS HALS, C.1648–50

THE WOMAN WITH A PEARL, CAMILLE
COROT, C.1868–70

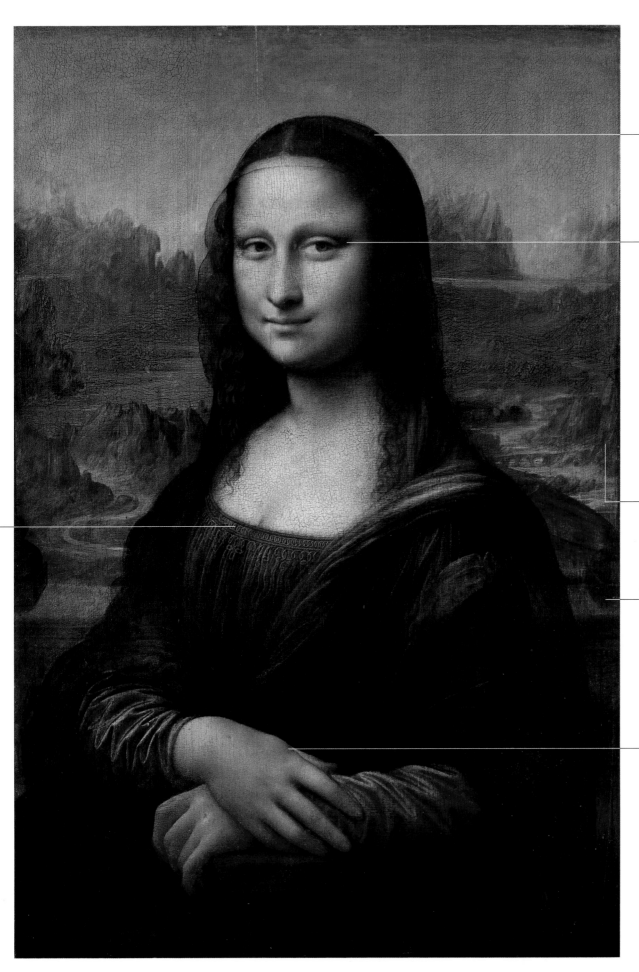

VEIL
The fine black veil has been interpreted as a sign of mourning, but such veils were worn as fashionable accessories.

△ SFUMATO
Leonardo was an unrivalled exponent of *sfumato* – the blending of tones so subtly that they melt into each other like smoke fading away.

LANDSCAPE
A mysterious, deserted, rocky landscape such as this appears in several of Leonardo's paintings.

COLUMN BASES
At either side of the sitter a base of a column can be glimpsed; it is possible that the painting has been trimmed and more of the columns were originally visible.

HANDS
The hands, arranged in casual repose, contribute to the feeling of fluid naturalism.

Scale

Scale

SENSE OF MOTION
David is turning his head to face his foe. With supreme skill, Michelangelo manages to convey a sense of movement in his figure.

SLING
David holds his sling loosely over his left shoulder.

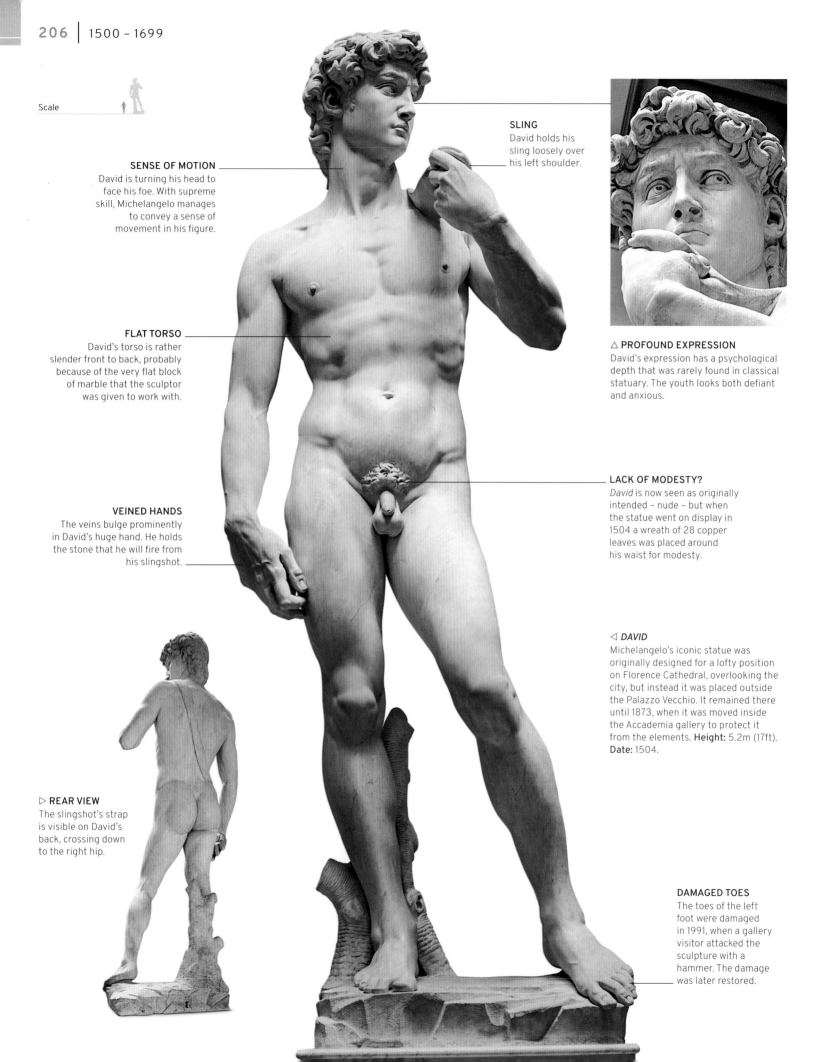

△ PROFOUND EXPRESSION
David's expression has a psychological depth that was rarely found in classical statuary. The youth looks both defiant and anxious.

FLAT TORSO
David's torso is rather slender front to back, probably because of the very flat block of marble that the sculptor was given to work with.

VEINED HANDS
The veins bulge prominently in David's huge hand. He holds the stone that he will fire from his slingshot.

LACK OF MODESTY?
David is now seen as originally intended – nude – but when the statue went on display in 1504 a wreath of 28 copper leaves was placed around his waist for modesty.

◁ DAVID
Michelangelo's iconic statue was originally designed for a lofty position on Florence Cathedral, overlooking the city, but instead it was placed outside the Palazzo Vecchio. It remained there until 1873, when it was moved inside the Accademia gallery to protect it from the elements. **Height:** 5.2m (17ft). **Date:** 1504.

▷ REAR VIEW
The slingshot's strap is visible on David's back, crossing down to the right hip.

DAMAGED TOES
The toes of the left foot were damaged in 1991, when a gallery visitor attacked the sculpture with a hammer. The damage was later restored.

David

One of the most famous statues in the world, and a supreme achievement of the High Renaissance in Italy

Florence, Italy

Along with Leonardo da Vinci, Michelangelo was the quintessential Renaissance man. He was an outstanding painter, but he also excelled as an architect, a poet, and, above all, a sculptor. Begun when he was just 26, *David* may well be his finest achievement in this field. It has attained iconic status, recognized and copied around the world.

Radical new emphasis

The biblical story of David and Goliath, in which a young shepherd boy defeats a gigantic foe, held a special significance for Florentines. The authorities regarded it as a symbol of their tiny republic – a heroic and indomitable underdog, capable of triumphing against larger and more powerful adversaries. Statues of David had been commissioned before – there are notable versions by Donatello and Verrocchio – but Michelangelo's figure was a radical new departure.

Traditionally, artists portrayed the victorious outcome, with David posing by the head of Goliath, but Michelangelo concentrated instead on the tense preliminaries, with the youth gazing warily at his foe.

Quite apart from the subject matter, Michelangelo relished the technical challenge of emulating the contrapposto pose that he so admired in classical art. This involved setting the weight of the figure on one leg and shifting the angles of the hips. To this, he added the distinctly modern feature of a facial expression that was at once dramatic and realistic.

Michelangelo's achievement is all the more remarkable given that he was using an old block of marble, which had already been worked – and rejected – by two other sculptors. He was also labouring under the impression that his statue would be seen high up and from a distance, which led him to exaggerate the size of its head and hands.

Confident, outward-looking gaze

Close-fitting tunic with gilded ornaments

Head of the vanquished giant

△ **ANDREA DEL VERROCCHIO**
Verrocchio's bronze *David* (c.1473–75) depicts an elegant youth similarly posed in triumph, but this hero is confident and extroverted.

It took **four days** to **transport** the statue less than **a mile** to the **Palazzo Vecchio**

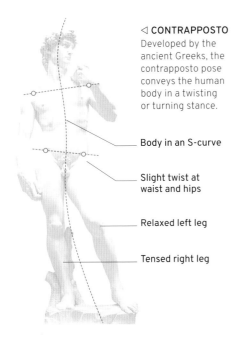

◁ **CONTRAPPOSTO**
Developed by the ancient Greeks, the contrapposto pose conveys the human body in a twisting or turning stance.

Body in an S-curve

Slight twist at waist and hips

Relaxed left leg

Tensed right leg

DETAILS IN SCULPTURE

Michelangelo's supreme skill as a sculptor was based on a thorough knowledge of anatomy. Early art historian Giorgio Vasari (1511–1574) records that, as a young man, Michelangelo "was constantly flaying corpses", both human and animal, in order to learn about the structure of bones, muscles, nerves, and veins. These dissections were carried out at the hospital of the convent of Santa Maria del Santo Spirito in Florence, where a special room was placed at his disposal. His understanding of the workings of the body beneath the skin underlies the detailed realism of both his sculpture and his paintings.

ECORCHE OF A MALE TORSO

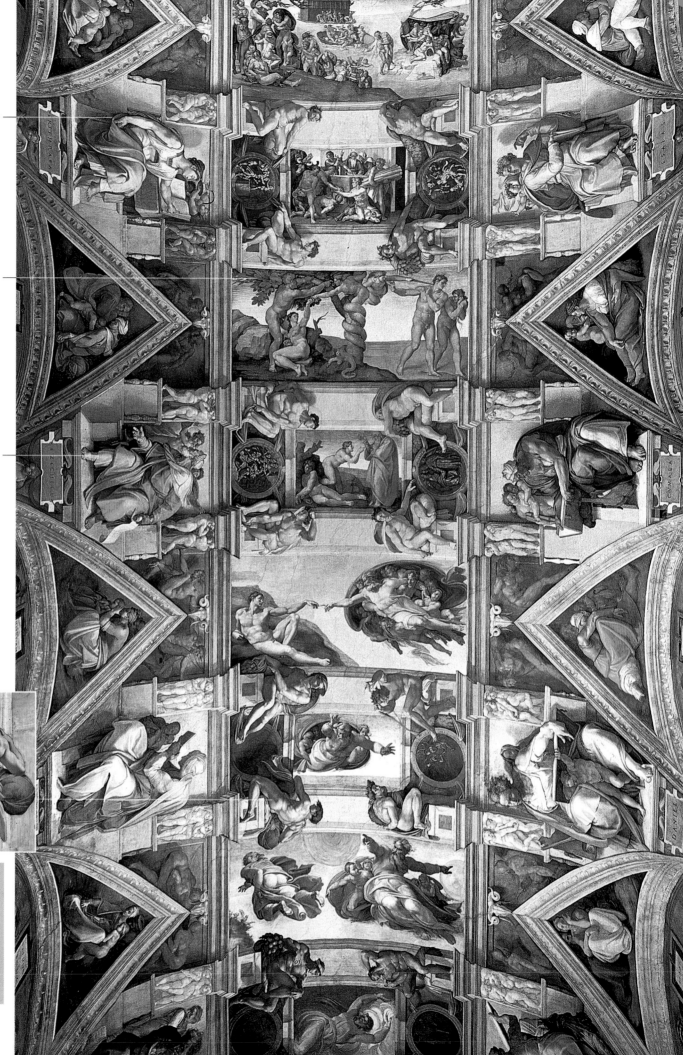

ERYTHRAEAN SIBYL
This prophetess is named after an ancient city in what is now Turkey, where she presided over an oracle. She foretold the coming of Christ.

THE FALL OF MAN
Michelangelo combines two stages of the story in one scene: at left Adam and Eve are tempted to eat the forbidden fruit; and at right they are expelled from the Garden of Eden for disobeying God.

EZEKIEL
Ezekiel, shown with a scroll of prophecy in his left hand, was one of the major biblical prophets, the central figure of the Old Testament Book of Ezekiel.

▽ *IGNUDI*
The athletic nudes (*ignudi* in Italian) might seem incongruous in a chapel, but they convey the idea that every human soul is naked before God.

Scale

◁ **THE SISTINE CHAPEL CEILING**
Michelangelo painted the Sistine Ceiling virtually unaided, using assistants only for mechanical parts of the work, such as applying plaster to the surface. **Dimensions:** approx. 40 x 13m (131 x 43ft)
Date: 1508–12.

The Sistine Chapel Ceiling

A supreme masterpiece of the Renaissance, Michelangelo's ceiling combines overwhelming grandeur with deep spirituality

Rome, Italy

The Sistine Chapel, the main chapel of the Vatican in Rome, was begun in 1477 under Pope Sixtus IV (from whom the building takes its name) and inaugurated in 1483. By this time, the walls had been decorated with a series of frescoes by some of the leading painters of the time, including Botticelli. Impressive though these are, they are completely outshone by the breathtaking works added by Michelangelo: the ceiling, painted in 1508–12 for Pope Julius II (nephew of Sixtus IV), and the Last Judgement on the altar wall, commissioned by Pope Paul III and painted in 1536–41.

The ceiling frescoes
The wall paintings depict scenes from the lives of Moses and Christ. Michelangelo's ceiling frescoes represent an earlier stage in biblical history, from the creation of the world to the story of Noah.

Nine large narrative scenes of events from the Book of Genesis, including the sublime Creation of Adam, run along the centre of the ceiling. Along the sides and at the ends are huge individual figures of prophets and sibyls (who are said to have foretold elements of the Christian story). Above the windows are smaller figures of various ancestors of Christ and in the corners are four Old Testament scenes on the theme of salvation. In addition to the biblical characters, at the corners of the central scenes there are glorious figures of nude youths, which have been interpreted as images of divine perfection. When the ceiling was unveiled in 1512 it was acclaimed as an almost superhuman achievement, firmly establishing Michelangelo, at the age of 37, as the greatest living artist. Contemporaries were awestruck by his genius, referring to him as "the divine Michelangelo".

MICHELANGELO

Pre-eminent as a sculptor, painter, and architect, Michelangelo Buonarroti (1475–1564) had a working life of almost three-quarters of a century and for much of that time was the most famous, admired, and influential artist in the world. His career was divided mainly between Florence, where he worked for the powerful Medici family, and Rome, where he served a succession of popes. In spite of his triumphs, he lived frugally, devoted to art and religion.

The ceiling was immediately acclaimed as an almost **superhuman achievement**

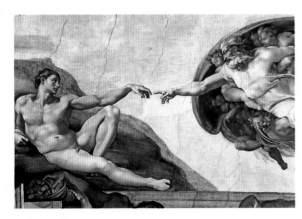

△ **THE CREATION OF ADAM**
This detail from the ceiling depicts Adam and God with outstretched forefingers at the moment of Adam's "birth". The figure of Adam is one of the greatest nudes in the history of art.

Ceiling Wooden platform

Movable wall brackets supported the platform

Steps for access

△ **INGENIOUS SCAFFOLDING**
Michelangelo designed scaffolding that was supported on the walls rather than rising from the floor so that the chapel's activities could continue while he worked on the ceiling.

DYED PAPER
Paper was dyed with natural substances, such as flowers and herbs, burnished, and often sprinkled with gold or silver for a sumptuous effect.

▽ **FINAL TOUCHES**
One of the final stages of painting was *pardakht* (meaning perfection or correction). With the finest of hair brushes the artist added details that brought to life people, animals, and nature.

OUTLINES
Underdrawings were outlined in fine black ink before the images were painted, and outlined again afterwards.

NATURAL PIGMENTS
Mineral, organic, and herbal pigments, including lapis lazuli, ochre, and rose madder, mixed with water or gum arabic, were used.

LAYERED COLOURS
Opaque and transparent colours were applied to create different hues and produce highlights.

ELEGANT CALLIGRAPHY
The fluid *nasta'liq* script developed in 14th–15th-century Persia; it was written with a trimmed reed called a *qalam*.

Scale

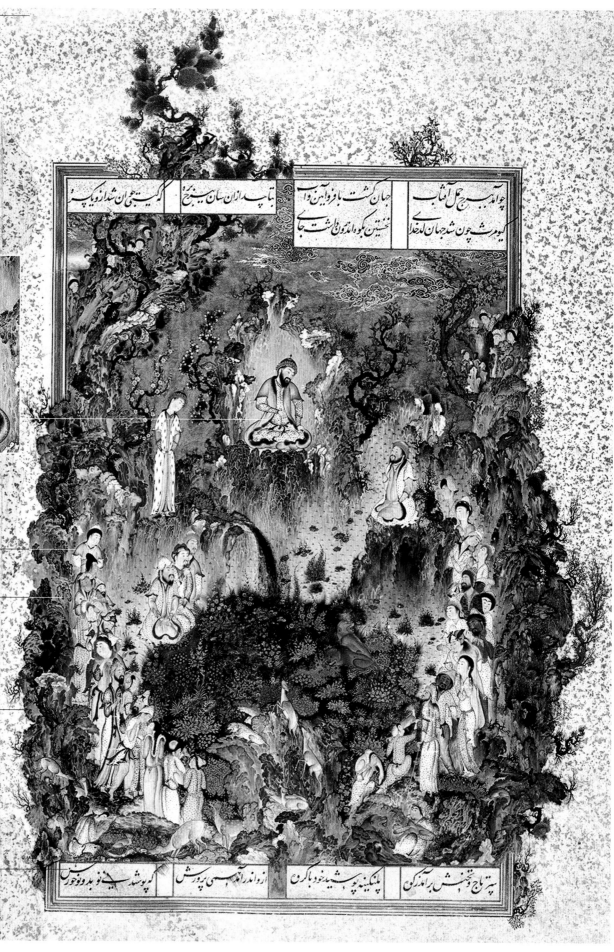

◁ *SHAHNAMEH* OF
SHAH TAHMASP
This miniature depicts Persia's first
shah, Gayumarth (or Kayumars),
enthroned among his courtiers, clad
in leopard skins. The image opens
the *Shahnameh* of Tahmasp. The
epic was written by the Persian poet
Firdausi between c.977 and 1010 CE.
Height: 48cm (19in). **Date:** c.1520–40.

Shahnameh of Shah Tahmasp

*The most famous illustrated manuscript of Persia's national
epic and a triumph of 16th-century Persian miniature art*

Tabriz, Iran

Persia's rulers were great patrons of the arts, and
miniature painting and manuscript illumination
were important features of Persian art from the 13th
century. A new style of miniature painting emerged
under the Safavid dynasty that ruled Persia from
1501 to 1722. It combined the restrained elegance
and balanced compositions of earlier schools with
the brighter palette and more expressive idiom typical
of artists in Tabriz - the first capital of the Safavid
dynasty. The new style was characterized by depictions
of popular pastimes, such as falconry or poetry
reading; stylized flowers and delicate drawings of
animals; multiple-character scenes; the use of many
colours and gold; a rise in the quality of portraiture;
and the elegance of its script and decorated borders.

In the early 1520s, keen to associate himself with
Persia's ancient kings, the first Safavid ruler, Shah

Isma'il (ruled 1501–24), commissioned an edition
of Persia's voluminous 11th-century national epic,
the *Shahnameh* ("Book of Kings"). The work was
undertaken at the royal atelier, or studio, in Tabriz by
the most renowned artists of the time, including Sultan
Muhammad, Mir Musavvir, and Aqa Mirak. The book
took around 20 years to complete, and was ultimately
dedicated to Isma'il's son, Tahmasp (ruled 1524–76).

An exquisite epic

The *Shahnameh* of Shah Tahmasp is perhaps the most
luxuriously illustrated copy of the epic ever produced,
reflecting the wealth of Shah Isma'il's court, and is
considered a pinnacle of Islamic book art. Larger
than many contemporary illustrated works, its gold-
sprinkled pages include 759 folios of text and 258
miniature paintings of outstanding quality.

△ **BALANCED COMPOSITION**
Balance was important in Safavid
manuscripts, affecting both the
composition of the miniatures
and the relationship between
text and image.

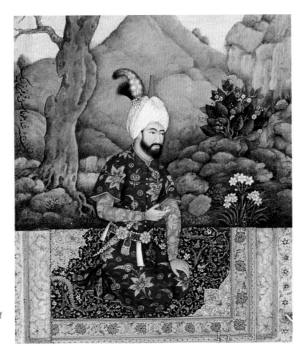

▷ **TAHMASP I**
This portrait of Shah Tahmasp I is by
famed Persian miniaturist Farrukh
Beg (c.1545–c.1615). Tahmasp himself
was a trained artist and a passionate
patron of the arts.

THE ARTS OF ISLAMIC BOOKS

Exquisite manuscripts were created by skilled artists in the
Islamic world in the 17th to 19th centuries. Paper was made
by hand and often marbled or gilded. A scribe copied text
in calligraphic writing and passed the pages to a painter.
Illuminators and gilders embellished the pages. Finally,
the sheets were gathered into a book, with a lavish binding.

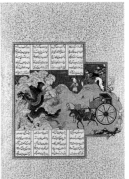

TWO PAGES FROM THE *SHAHNAMEH* OF SHAH TAHMASP

The painting is the **frontispiece** of a handscroll **more** than 8m (25ft) long

Suzhou, China

The Cassia Grove Studio

A 16th-century painting showing the intense sensitivity of Chinese art to the natural world

Born into a family of high officials and coming late to art after a failed career in bureaucracy, Wen Zhengming (1470–1559) was part of a group of amateur scholar-artists working in the affluent Ming-dynasty years of the 15th and 16th centuries. Prolific and highly influential, he is known as one of the "Four Masters" of Ming art and was a leading figure of the Wu School, under whose founder, Shen Zhou, he studied. Painted in ink and colour on paper, *The Cassia Grove Studio* continues a long tradition of Chinese landscape art, bringing to it freshness and sensitivity. Created when Wen was in his 60s, with its fine brushwork and subtle use of colour, it is a superb portrait of a scholar in his garden; it also epitomizes the veneration for nature shown by Wen and his peers, steeped in the Confucian concept of harmony with the natural world.

AN AUTUMNAL SCENE
The red colouring of the vine leaves places the scene in the autumn, the season in which the civil-service exams took place.

TREE SYMBOLISM
Cassia, or Chinese cinnamon, trees were proverbially associated with success in the state exams, heard in the phrase "plucking the cassia".

◁ **AFTER A LONG SUMMER RAIN**
Wen Zhengming was multi-talented, admired as much for his poetry and calligraphy as for his painting; some of his works combined all three skills. Seen here is a folding fan with calligraphy by Wen on gold-flecked paper.

CONTEMPLATIVE LIFE
Partially obscured by a wall,
Zheng Zichong gazes outward,
contemplating the beauty of
his mountain-top view.

THE BEAUTY OF ROCKS
The Chinese tradition of sensitively
delineating mountains and crags
stretched back for more than a
millennium before Wen's day.

▽ *THE CASSIA GROVE STUDIO*
Wen's scroll celebrates fellow scholar
Zheng Zichong's achievement in passing
the civil-service exam. **Dimensions:** 32 x
56cm (12½ x 22in). **Date:** c.1532.

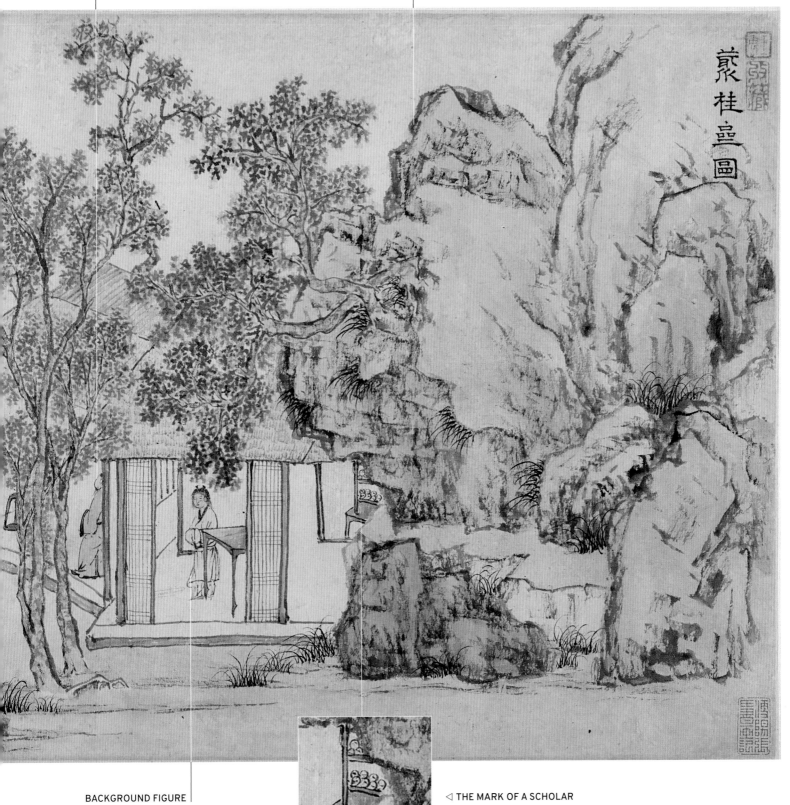

BACKGROUND FIGURE
The figure dressed in white
is thought to be a servant.

◁ **THE MARK OF A SCHOLAR**
The scrolls packed inside a cabinet
in Zheng's studio indicate his love
of learning. Wen himself was
renowned as a poet.

Scale

▷ *VENUS OF URBINO*
Titian displays his matchless ability to use oil paint to create varied and subtle effects of light, colour, and texture.
Dimensions: 119 x 165cm (47 x 65in).
Date: c.1538.

Venice, Italy

Venus of Urbino

A highly sensual nude, remarkable for its artistic splendour and vast influence

One of the most beautiful nudes of the Renaissance, powerfully erotic yet full of allusions to marital love, Titian's *Venus of Urbino* had a huge influence on other artists. While various identities have been proposed for her – goddess, mistress, courtesan, bride – the naked young woman reclining on a bed is no demure damsel, but looks out at the viewer with a bold, provocative gaze. The painting was bought by the duke of Urbino around the time of his marriage, and it may celebrate the physical intimacy between husband and wife.

TITIAN

The Venetian artist Tiziano Vecellio (c.1480/5–1576), known as Titian, is one of the most illustrious figures in the entire history of art. He excelled at portraiture, religious subjects, and mythologies, and was the first artist to exploit the full expressive potential of oil paint, especially in his late work. His contemporaries thought him an artistic giant.

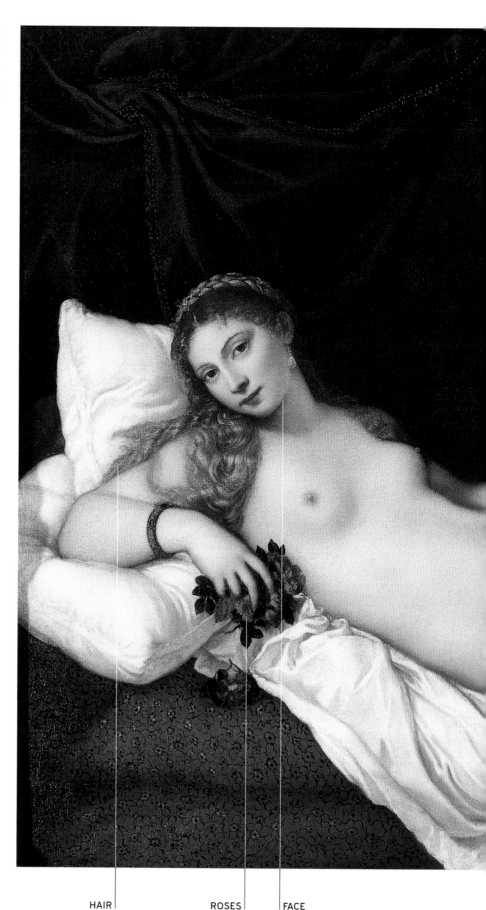

HAIR
Golden-brown hair falling over plump flesh is almost a Titian trademark.

ROSES
In her right hand the woman holds a posy of roses, flowers traditionally associated with love.

FACE
Very similar facial features occur in several other Titian paintings, so the artist may have used a favourite model.

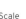
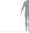

MYRTLE
On the windowsill is a pot of myrtle, sacred to Venus and an emblem of love.

BACKGROUND FIGURES
The two background figures are believed to be a lady-in-waiting and a maidservant, who is looking inside a cassone (marriage chest), presumably for a garment for her mistress.

DOG
Curled up at the foot of the bed is a little dog; such animals were often used in art as symbols of fidelity.

FEET
The feet are notably small, one of the ways in which Titian smooths the forms of the body into a melodious contour.

HAND
The woman's left hand casually rests over her genitals, a gesture – derived from ancient sculpture – that here, however, entices as much as it conceals.

An **idealized image** of **beauty** rather than a depiction of a **specific woman**?

Scale

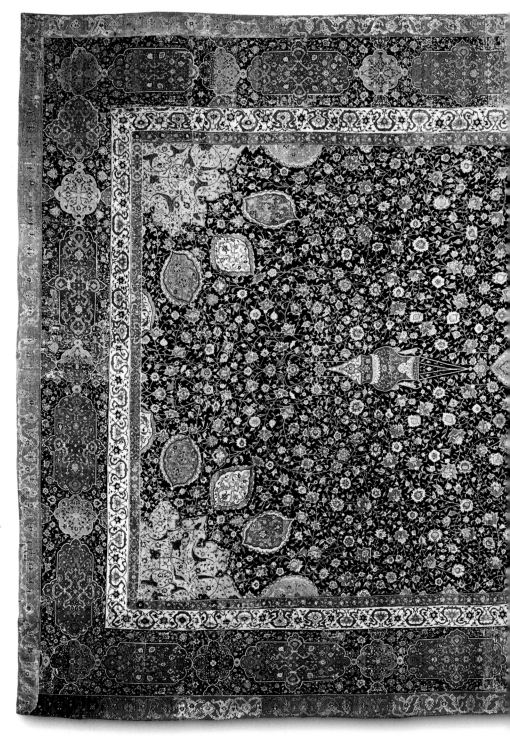

▷ **THE ARDABIL CARPETS**
This is the larger of the two (probably once identical) Ardabil carpets; originally, it may have been even larger. Its colourful yet balanced composition reflects the artistic style that developed at the Safavid court in the 16th century. **Dimensions:** 10.51 x 5.34m (34ft 6in x 17ft 6in). **Date:** c.1539–40.

Ardabil, Iran

The Ardabil Carpets

The world's oldest dated carpets, which are among the most renowned examples of exquisite Safavid-era Persian workmanship

In 1539–40, the Safavid shah Tahmasp I (ruled 1524–76) commissioned the creation of two vast knotted-pile wool carpets for the shrine of poet, mystic, and teacher Safi al-Din Ardabili at Ardabil. In the 19th century, fragments of one of the carpets were used to repair the other, creating the two differently sized carpets that exist today, the larger of which is shown here.

These glorious carpets are exceptional not only for being the world's oldest dated carpets, but also for their beautiful design and the tremendous skill and astounding precision with which they were made. At any one time, up to 10 weavers may have worked on the carpets, which took several years to complete. The extraordinary density of knots used – around 5,300 knots per 100cm² (340 knots per 1 in²), each hand-knotted – enabled the ingenious weavers to create the carpets' highly intricate design: a central medallion with a ring of almond shapes and two lamps on a field of dark blue, decorated with blossom-laden vines, surrounded by decorative borders.

The carpets contain over **35,000,000** knots of wool

KNOTTING TECHNIQUES

Two types of knotting are typically used in Persian carpets: the symmetrical (Turkish) knot, in which the yarn is looped around two warps leaving the tufts between them; and the asymmetrical (Persian) knot, in which the yarn is looped around one warp thread and stays loose under the other. The Ardabil Carpet was woven with asymmetrical knots on a base of white silk weft (horizontal) and warp (longitudinal) threads. The asymmetrical knot made it possible to weave a carpet with such a high knot density and detail.

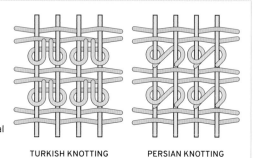

TURKISH KNOTTING PERSIAN KNOTTING

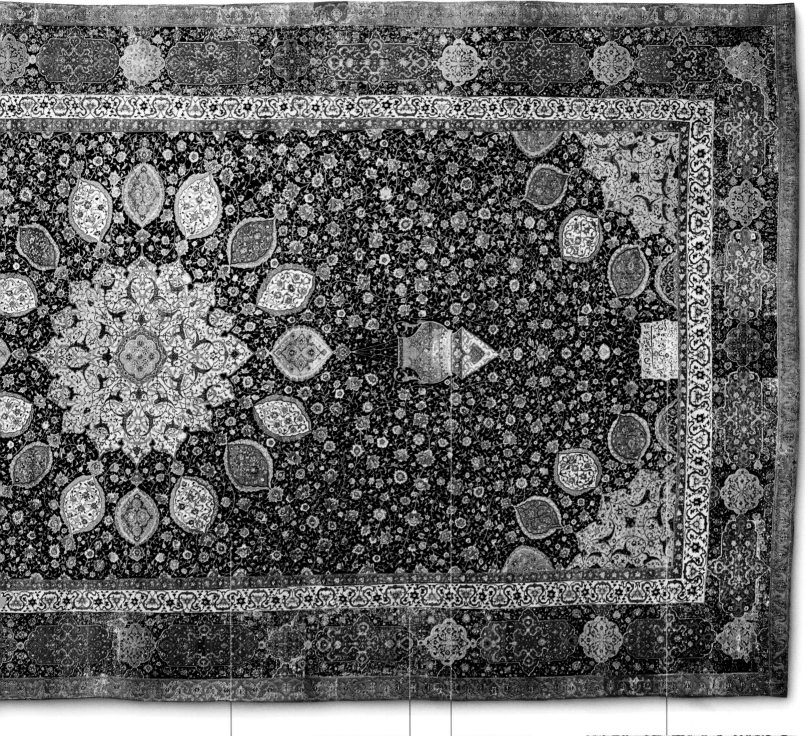

MULTIPLE COLOURS
The carpet uses 10 colours of wool, dyed with natural materials, such as pomegranate rind and indigo; shades vary, creating a lively speckled effect known as *abrash*.

UNEQUAL LAMPS
The two lamps are unequal in size: believing that only Allah is perfect, Islamic artists often leave deliberate imperfections in their work.

◁ **SCROLLWORK**
The carpet's magnificent swirling flowers and leaves are characteristic of Safavid-era design.

▷ **INSCRIPTION**
A small panel identifies the date, and the court official who oversaw the carpet's creation, Maqsud Kashani.

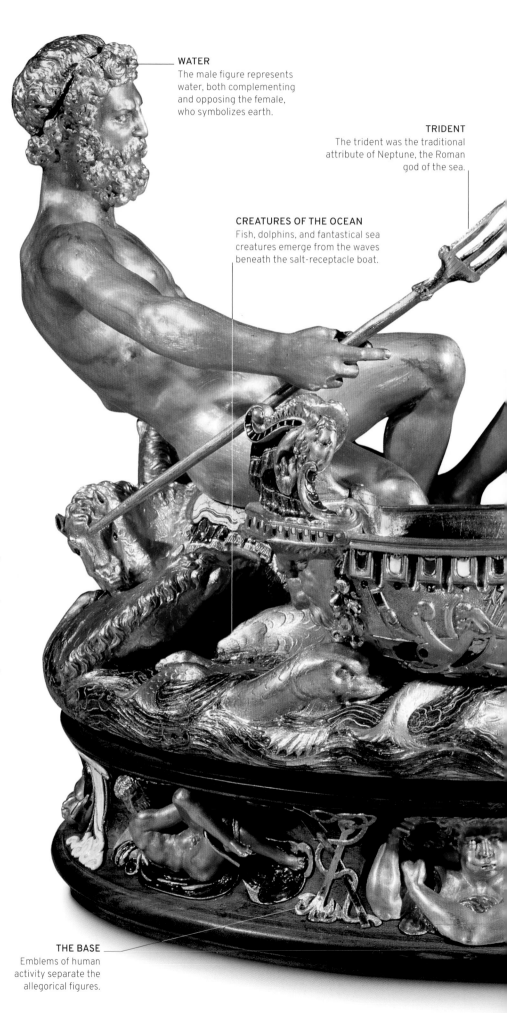

▷ **CELLINI SALT CELLAR**
The salt cellar, or *saliera*, was made in the sophisticated, elegant style of the late Renaissance. The gold was hammered into shape by hand rather than cast. **Height:** 26cm (10in). **Date:** 1540–43.

WATER
The male figure represents water, both complementing and opposing the female, who symbolizes earth.

TRIDENT
The trident was the traditional attribute of Neptune, the Roman god of the sea.

CREATURES OF THE OCEAN
Fish, dolphins, and fantastical sea creatures emerge from the waves beneath the salt-receptacle boat.

Paris,
France

Cellini Salt Cellar

The greatest piece of goldsmiths' work of the Renaissance, combining exquisite craftsmanship with intricate allegory

Cellini was the outstanding goldsmith of his time, but most of his work in precious metal has not survived. Apart from a few coins, this salt cellar dating from 1540–43 is the only surviving work in gold indisputably by him. He originally conceived it for a patron in Rome, Cardinal Ippolito d'Este. When the cardinal declined to finance it, Cellini took the wax model to France, where he worked for five years (1540–55) for Francis I, a great admirer of Italian culture. Francis immediately advanced the money for the gold.

Craftsmanship and symbolism
Cellini described the salt cellar in detail in his autobiography. The two main figures, reclining among sea horses and dolphins, represent Sea (or the sea god Neptune) and Land (or the earth goddess Tellus), their legs intertwined to suggest how "the arms of the sea extend into the mountains". They form an allegory for the origins of salt, believed to be made by mixing substances from land and sea. At their sides are receptacles for salt (a ship) and peppercorns (a temple). Around the ebony base are personifications of the four winds, interspersed with four allegorical reclining figures – Day, Night, Twilight, and Dawn. Their poses show the influence of Cellini's hero, Michelangelo.

THE BASE
Emblems of human activity separate the allegorical figures.

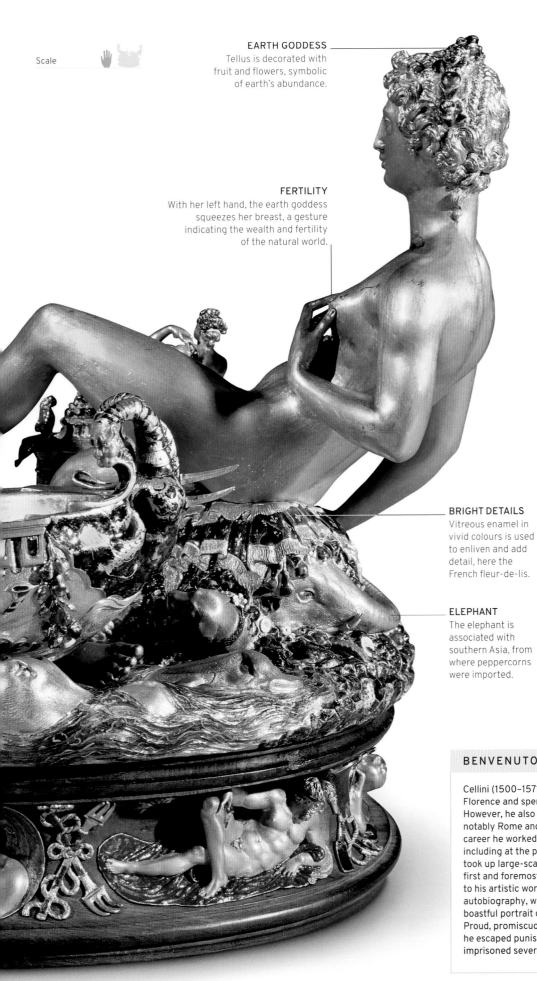

Scale

EARTH GODDESS
Tellus is decorated with fruit and flowers, symbolic of earth's abundance.

FERTILITY
With her left hand, the earth goddess squeezes her breast, a gesture indicating the wealth and fertility of the natural world.

BRIGHT DETAILS
Vitreous enamel in vivid colours is used to enliven and add detail, here the French fleur-de-lis.

ELEPHANT
The elephant is associated with southern Asia, from where peppercorns were imported.

▷ **SALAMANDER**
The salamander, seen here raising its head, was a favourite emblem of Francis I and is often found decorating his buildings.

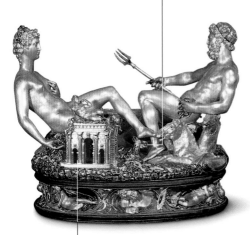

△ **ALTERNATIVE VIEW**
Ivory bearings in the base allow the salt cellar to be rolled around to be viewed from all angles.

△ **TINY TEMPLE**
The richly decorated temple is designed to store peppercorns for the king's table. The tiny female figure forms a handle for the lid.

BENVENUTO CELLINI

Cellini (1500–1571) was born and died in Florence and spent most of his life there. However, he also worked in other places, notably Rome and France. Early in his career he worked a good deal as a medallist, including at the papal mint, and he later took up large-scale sculpture, but he was first and foremost a goldsmith. In addition to his artistic works, he is famous for his autobiography, which gives a vividly boastful portrait of his tempestuous life. Proud, promiscuous, and extremely violent, he escaped punishment for murder but was imprisoned several times for other crimes.

Benin City,
Nigeria

Benin Bronzes

*Exquisitely refined reliefs and sculptures that embellished
the royal palace of Benin in 16th–17th-century West Africa*

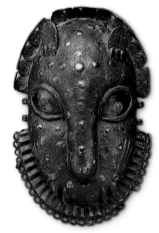

△ **LEOPARD OF WAR**
This brass hip ornament representing
a leopard head was worn at the waist
by soldiers as a sign of distinction or
for protection in battle.

Founded in c.900 CE by the Edo people of what is now Nigeria, by the 16th century the Kingdom of Benin had grown rich on conquest and trade. At the royal palace in Benin City, skilled artisans toiled to satisfy the demands of the oba (king) for objects to celebrate his power and enhance the splendour of his court. Working chiefly in bronze or brass, they created sophisticated representations of the ruling family, court officials, soldiers, and sacred animals that are masterpieces equal to any from Renaissance Europe.

The Benin craftworkers used the notoriously difficult lost-wax method of metal casting (*see p.164*). Their works included hundreds of thin metal relief plaques that were nailed to pillars throughout the palace. Some portrayed the thriving life of the court,

including foreign traders and soldiers, while others commemorated past victories or other historical events. As such, the plaques offer a valuable record of dynastic and social history, and insights into court rituals and traditional practices. The Edo also produced fine heads of kings and queens, some of ivory rather than metal, which were displayed on altars for ancestor reverence.

Trade with Europe

The finest bronzes were produced in the 16th century, under Oba Esigie (ruled c.1504–50), when output was stimulated by an increased supply of metals, in the form of brass and copper bracelets from Portuguese traders. Such contact also led the Edo to create works depicting Europeans, including Portuguese soldiers.

The **bronze plaques** are **testament** to the **skill** and **creativity** of **Benin** metal workers

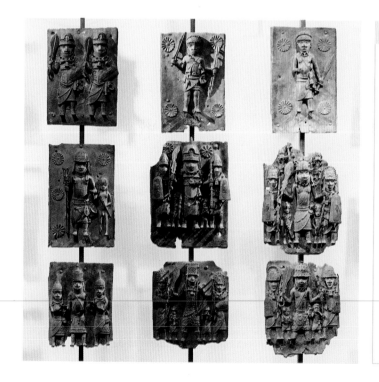

▷ **PALACE PLAQUES**
These brass plaques from the
royal palace of the Kingdom of
Benin are pictured on display at
the British Museum in London.
Around 850 such plaques once
adorned the columns of the oba's
court in Benin City.

BENIN AND EUROPE

The first Europeans to reach Benin were Portuguese merchants who arrived by sea in the late 15th century. While building up an extensive trade with Europeans, Benin's rulers maintained strict control over foreigners in their territory through to the 19th century. The kingdom became increasingly vulnerable during the European "Scramble for Africa", as Britain sought to extend its influence over Nigeria. In 1897, a British military force attacked Benin. The palace was burned, and the bronzes looted. They are now mostly displayed in British, German, and other Western museums.

CAST-BRASS FIGURE OF A
PORTUGUESE SOLDIER, 17TH C

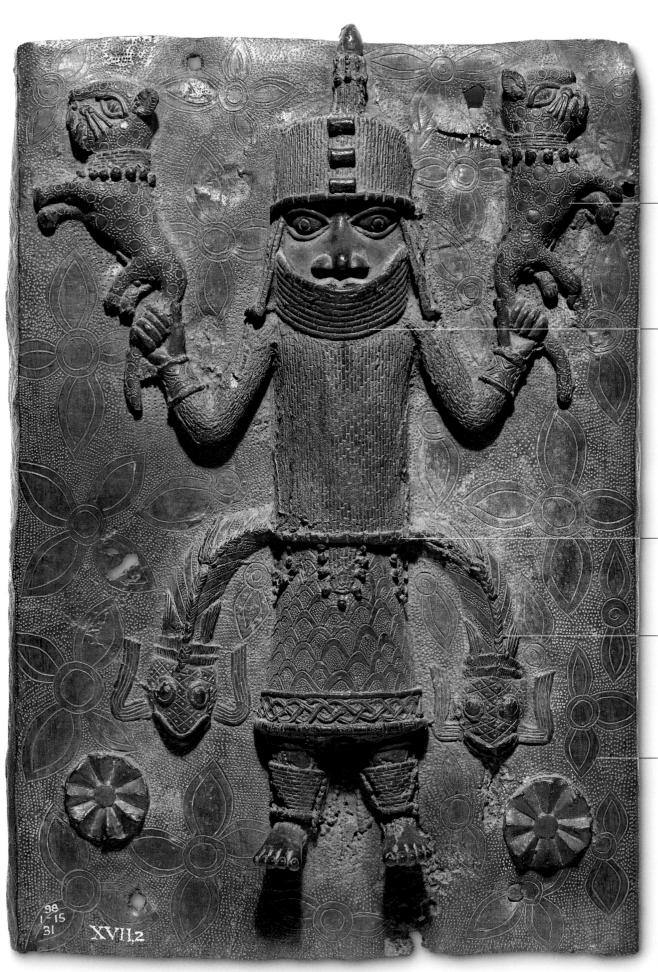

◁ **BENIN BRONZES**
This plaque depicts an oba holding two leopards by the tail. Leopards symbolized royalty and were revered in Edo culture. **Height:** 49cm (19¼in). **Date:** c.1500–1600.

LEOPARD
These two leopards wear collars of small bells, indicating that they were domesticated; the oba often kept tame leopards in the palace.

CORAL BEADS
The oba wears a multistranded collar of coral beads. The polished red beads were an indicator of power and status among Edo chiefs.

BEADED TUNIC
The oba's tunic is hung with beaded ornaments fringed with bells.

LIVING MUDFISH
Two mudfish hang from the oba's belt. The mudfish was another symbolic royal animal, representing the oba's power over water.

FOLIATE PATTERN
The stippled background is incised with a characteristic pattern of leaves known as the *ebe-ame*, or "river leaf", design.

Scale

Aztec Sun Stone

A massive, intricately carved basalt block from the 16th century hinting at hidden mysteries of Aztec lore

Mexico City, Mexico

Weighing almost 25 tonnes, the Sun Stone is a huge monument carved by the Aztecs, the exact purpose of which is unknown. There is more certainty about its creation, as it bears the glyph of Moctezuma II (ruled 1502–20), the last Aztec emperor to rule before the Spanish conquest. As a monument to paganism, it was buried face down by the Catholic Spanish in the main square of Mexico City, where it lay for two centuries until 1790, when it was rediscovered and recognized as an extraordinary example of Mesoamerican art.

Scholars have long argued about the meaning of the stone's complex web of symbols. Carved glyphs representing the days and months led it to its being thought of as a calendar stone for many years. However, most experts think that it had a more sinister purpose, as a sacrificial altar, known by the Aztecs as a *cuauhxicalli*, or "eagle vessel". On the centre of the stone, which bears a carving of the sun god, a captive would have been put to death once every 260 days, on the date in the Aztec year when the world was expected to come to an end. Such an offering of human blood to the sun would stave off the end of the world for another year.

▽ **THE FIFTH SUN**
The line around the squares forms the glyph for the Fifth Sun – the era in which the stone was carved.

▽ **AZTEC SUN STONE**
Concentric rings filled with symbols surround the central image. Although the stone is now exhibited in an upright position, it would originally have lain flat on the ground. **Diam.:** 3.58m (11ft 9in). **Date:** 1502–21.

FOUR AGES OF HISTORY
The squares around the central face represent the four previous "suns", or ages of human history.

DAY SIGNS
The symbols in the inner ring indicate the 20 days of the Aztec calendar, which combine with 13 numbers to make up a 260-day year.

GOD OF SACRIFICE
The central image is thought to represent the sun god Tonatiuh, shown holding a human heart in each hand.

GODS OF FIRE
The bodies of two fire serpents run around the outer ring, heads at the bottom centre and tails at the top.

Scale

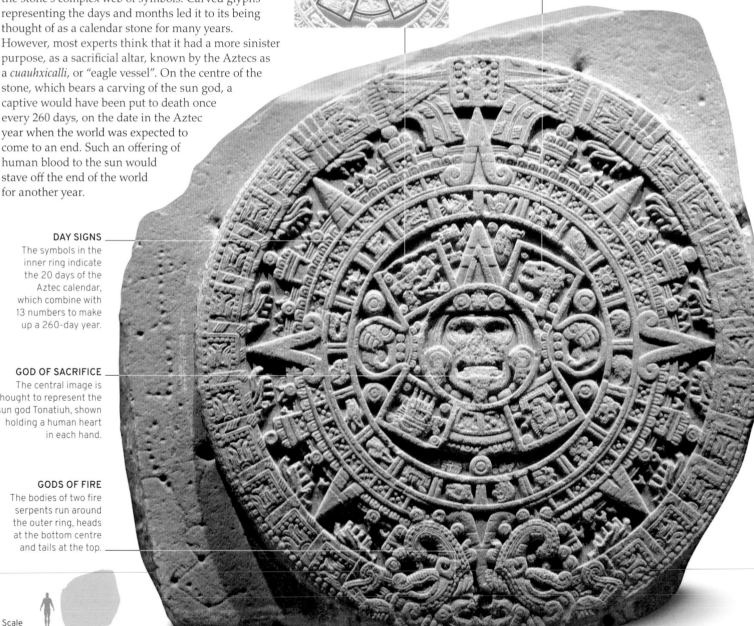

Tughra of Suleiman the Magnificent

A complex and beautiful work of art that was also a royal signature and emblem of authority in the Ottoman Empire

Istanbul, Turkey

The custom of attaching a seal to state documents to confirm their authority was common to governments in many parts of the world, but in the empire ruled by the Ottoman dynasty, the royal emblems, or tughras, themselves became objects of beauty. The superb tughra seen here belonged to Suleiman the Magnificent (1494–1566), who ruled the Ottoman Empire at its peak.

Tughras were drawn in outline by an official calligrapher, with the intricate detail filled in by an illuminator. Here, cobalt-blue ink is used for the main lines of the inscription, while the inside of the flowing double loop and other spaces teem with exquisite scrolling floral designs in pink, green, and blue

watercolour and gold leaf. The origin of the elegant form is not known, but it may have been inspired by the shape of a bird of prey or represent a thumbprint and three fingerprints. The inscription reads "Sultan Suleiman, son of Sultan Selim Khan, ever victorious". The sultan was a poet as well as a military ruler, and his care for the arts was shown in the attention he paid to the graceful sweep of his own signature.

Scale 🖐

▽ **TUGHRA OF SULEIMAN THE MAGNIFICENT**
Suleiman's tughra was probably the most elaborate of all tughras; this one is drawn in ink and watercolour on paper. **Dimensions:** 63.5 x 76cm (30 x 25in). **Date:** c.1555–60.

PILLARS OF AUTHORITY
The three vertical elements at the top were known as *tuğ* (flagstaff), symbolizing independence.

▽ **A FLOWERING MEADOW**
The centre of the tughra is a riot of leaves and blossoms, featuring roses, carnations, and *saz* (spiky reed) leaves. Such complex floral patterns played a central part in Islamic art.

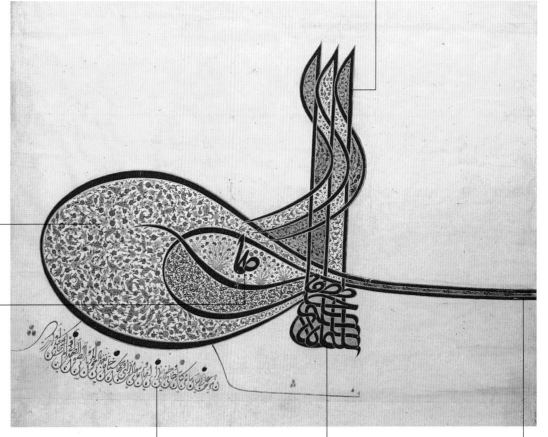

△ **CONQUERORS' BOAST**
Prominent in the centre of the design is a motto that all Ottoman sultans proclaimed and that featured in all their tughras. It pronounced the ruler "ever victorious".

INJUNCTION TO OBEDIENCE
The smaller inscription instructs readers of the document to which the tughra was attached to carry out its orders.

SULTAN'S NAME
The ruler's name – in this case "Sultan Suleiman Khan" – appears in the lower section, known as the *sere*.

ARM OF JUSTICE
The *hançer* (sword or dagger), as the right-hand extension was called, symbolized the sultan's military might.

HELMET OF CHARLES IX ▷
The helmet was made in the
French Mannerist style of the late
Renaissance from steel hammered
into shape and plated with gold.
Height: 45cm (17¾in). **Date:** 1555–60.

Helmet of Charles IX

*A rare and magnificent example of armour made
in the Mannerist style of 16th-century France*

Paris, France

CHARLES IX OF FRANCE

Second son of King Henry II
and Catherine de' Medici,
Charles (ruled 1560–74) was
just 10 years old when he
succeeded his brother, Francis
II, as king of France. Under his
mother's influence, during
the Wars of Religion (1562–98)
between the Protestant
Huguenots and the Catholic
League, he ordered the murder
of the thousands of Huguenots
across France during the St
Bartholomew's Day massacre
(August 1572). The king's
already weak mental and
physical health declined
dramatically following the
massacre and thereafter
he was haunted by the
horrific events. He died,
aged 23, from tuberculosis.

The rulers of Renaissance Europe had a passion for
elaborately decorated armour. French rulers in the
16th century were no exception, although only a few
examples of such helmets survive from the period.
Among them is the helmet created for Charles IX
(ruled 1560–74). French armoury from this period
lacks hallmarks, so very few pieces can be traced
back to their creators. However, a receipt for the
work on Charles's helmet points to the Parisian
goldsmith Pierre Redon, the king's valet and a
favoured goldsmith of the French court.

A Mannerist masterpiece

From 1520, Italian art was dominated by Mannerism,
a style characterized by artificiality, extravagance,
technical skill, and touches of the bizarre, which
spread across northern Europe, inspiring the artists
of the French court at Fontainebleau. The helmet –
an open-faced helmet with a broad brim and a comb,
known as a morion – is an excellent example of French
Mannerist style. The lively central scenes on both sides
of the helmet, the meanings of which are not always
clear, along with depictions of leather straps, ribbons,
garlands, and mascarons were common to the style.
However, the finesse of the repoussé work on the
helmet – in which metal is hammered from behind
to create a design (*see p.81*) – is exceptional. Although
the design is in low relief, the illusion of depth has
been created by subtle variations in the modelling.
This, combined with the other techniques used on
the helmet, such as enamelling and gold plating,
makes it an exquisite example of the goldsmith's art.

△ **COMBAT CENTREPIECE (DETAIL)**
This central scene shows a cavalry battle taking place in front of
an island citadel. The blackened steel adds contrast and drama,
while silvered elements suggest water.

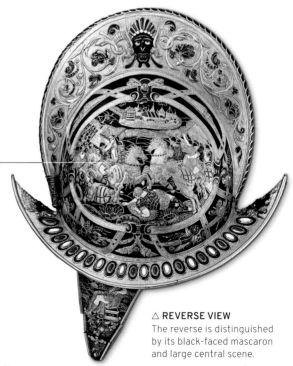

△ **REVERSE VIEW**
The reverse is distinguished
by its black-faced mascaron
and large central scene.

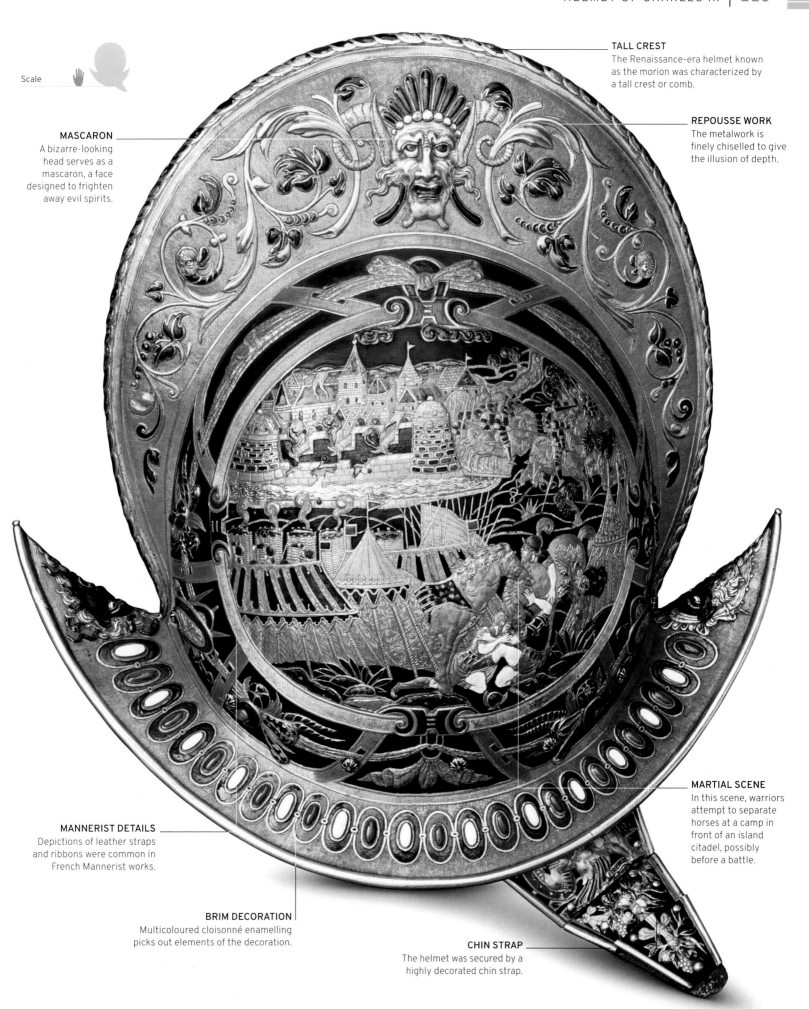

Scale

TALL CREST
The Renaissance-era helmet known as the morion was characterized by a tall crest or comb.

REPOUSSE WORK
The metalwork is finely chiselled to give the illusion of depth.

MASCARON
A bizarre-looking head serves as a mascaron, a face designed to frighten away evil spirits.

MARTIAL SCENE
In this scene, warriors attempt to separate horses at a camp in front of an island citadel, possibly before a battle.

MANNERIST DETAILS
Depictions of leather straps and ribbons were common in French Mannerist works.

BRIM DECORATION
Multicoloured cloisonné enamelling picks out elements of the decoration.

CHIN STRAP
The helmet was secured by a highly decorated chin strap.

Scale

▷ IZNIK CERAMICS
Lidded bowls like this one were used for serving food and were also found in mosques. Along with plates, they were at first the most common products of the Iznik potteries.
Height: 37cm (14½in). **Date:** late 1500s.

BLUE FLOWERS
Flowers are outlined in cobalt blue, with a raised red centre.

BUSY BACKGROUND
Curl shapes resembling snail shells provide a dense backdrop for the central decorations.

CONTRASTING PATTERNS
The bowl is decorated in the so-called *saz* style, mingling long, serrated *saz* (reed) leaves with smaller rosettes.

FIRM FOUNDATION
Lappets (decorative flaps) and florets alternate around the bowl's flared foot.

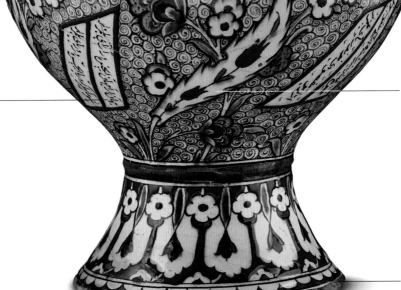

△ WORDS AND IMAGES
Excerpts of poetry written in the Ottoman Turkish language contrast with the surrounding decoration.

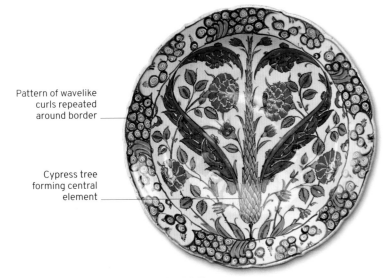

Pattern of wavelike curls repeated around border

Cypress tree forming central element

△ SHALLOW BOWL
This shallow bowl with a delicately scalloped edge (1570–75) features a near-symmetrical vegetal and floral design painted on a white ground.

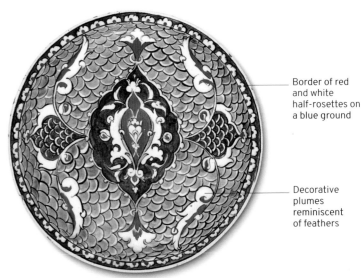

Border of red and white half-rosettes on a blue ground

Decorative plumes reminiscent of feathers

△ DISH
Surrounded by sky-blue scales, the central floral design of this plate features a motif of bole red, a colour achieved by applying an iron-oxide-rich slip under the glaze.

Iznik Ceramics

Pottery that in the 16th century made the Turkish town of Iznik one of the world's great centres of ceramic art

Iznik, Turkey

After the conquering Ottomans established their seat of government in Constantinople (now Istanbul) in 1453, the lands they ruled over became central to the development of Islamic art. Chinese porcelain was a source of inspiration, particularly the blue-and-white ware that had found its way west over the previous century. Local potters sought to produce similar goods, and the Anatolian town of Iznik, 100km (60 miles) south-east of the capital, became the focal point.

Brilliant and intricate

Iznik was already known for its simple earthenware vessels, but from the late 15th century its artisans started producing more sophisticated pieces. In place of porcelain, they used "fritware", made by a technique known for at least two centuries in the Middle East. The process involved mixing quartz sand with clay and finely ground glass. When heated, the glass melted, and the resulting paste was shaped, fired, and painted.

At first the only colour used to decorate the vessels was cobalt blue, but over the next century new hues were added, among them turquoise, purple, and green;

"bole red" (made with bole, a reddish clay) was introduced around 1560. Decoration included motifs borrowed from Chinese ware, as well as traditional Ottoman arabesques and floral, vegetal, and geometric designs, most often on a white ground. In addition to bowls, jugs, and dishes, tiles became increasingly important from the mid-16th century, used to decorate the mosques and palaces of the Ottoman sultans. Iznik ware declined in quality during the 17th century, but in its 200-year heyday, the city produced works that in their brilliant colours and intricate patterns are among the finest examples of ceramic art.

Tens of **thousands** of **polychrome tiles** were made for **imperial buildings**

△ COVERING WALLS IN ART
The tiles that formed a major part of Iznik pottery production from the mid-16th century onwards featured vivid colours laid on a clean white base. The patterns were geometric, featuring repeated floral motifs.

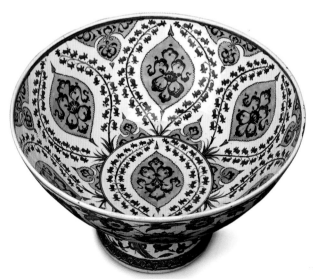

△ FOOTED BASIN
The interior of this footed basin (c.1545–50), which may have been made for the imperial court, is decorated with delicate blue flowers and turquoise medallions enclosing cloud scrolls.

AN IZNIK SHOWCASE

Built for Suleiman the Magnificent (ruled 1520–66) by his principal architect Mimar Sinan, the Rüstem Pasha Mosque was named for the sultan's son-in-law and grand vizier (prime minister). Its interior glows with the rich coloration of some 2,300 Iznik tiles, featuring at least 80 distinct designs. Floral patterns are particularly abundant, and experts have calculated that, for example, no fewer than 41 different tulip motifs are featured in the building.

INTERIOR OF THE RUSTEM PASHA MOSQUE, ISTANBUL

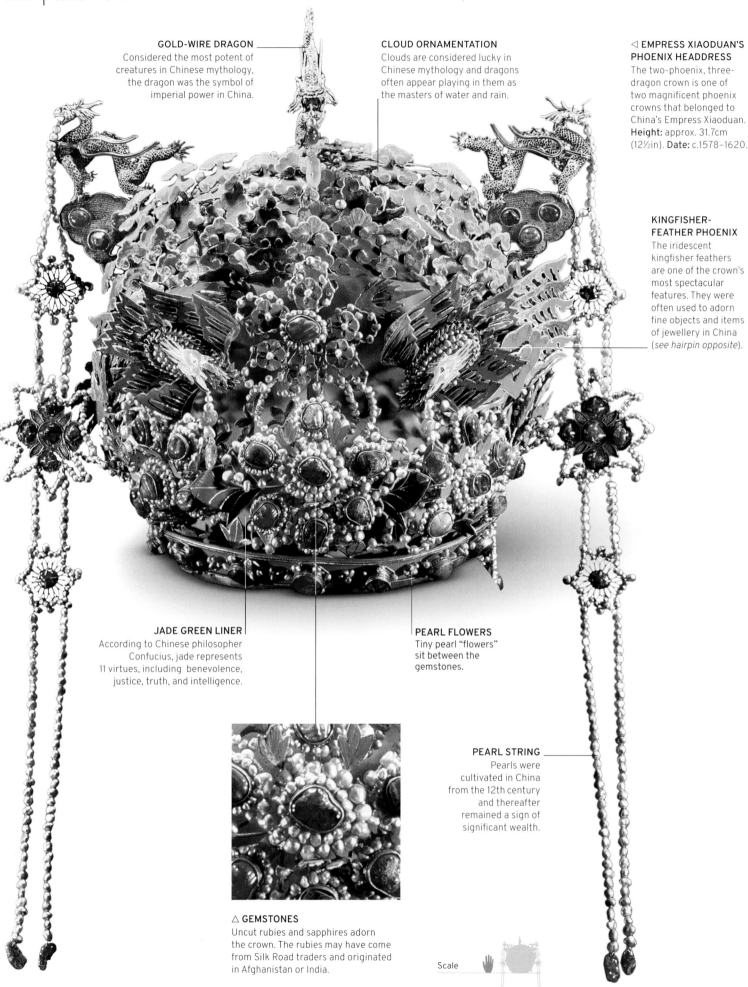

GOLD-WIRE DRAGON
Considered the most potent of creatures in Chinese mythology, the dragon was the symbol of imperial power in China.

CLOUD ORNAMENTATION
Clouds are considered lucky in Chinese mythology and dragons often appear playing in them as the masters of water and rain.

◁ **EMPRESS XIAODUAN'S PHOENIX HEADDRESS**
The two-phoenix, three-dragon crown is one of two magnificent phoenix crowns that belonged to China's Empress Xiaoduan. **Height:** approx. 31.7cm (12½in). **Date:** c.1578–1620.

KINGFISHER-FEATHER PHOENIX
The iridescent kingfisher feathers are one of the crown's most spectacular features. They were often used to adorn fine objects and items of jewellery in China (see hairpin opposite).

JADE GREEN LINER
According to Chinese philosopher Confucius, jade represents 11 virtues, including benevolence, justice, truth, and intelligence.

PEARL FLOWERS
Tiny pearl "flowers" sit between the gemstones.

PEARL STRING
Pearls were cultivated in China from the 12th century and thereafter remained a sign of significant wealth.

△ **GEMSTONES**
Uncut rubies and sapphires adorn the crown. The rubies may have come from Silk Road traders and originated in Afghanistan or India.

Scale

Beijing,
China

Empress Xiaoduan's Phoenix Headdress

*An exquisitely decorated crown of a Ming-era Chinese empress that
is a spectacular example of Chinese craftsmanship and symbolism*

In 1957, excavations of the underground palaces of
the Dingling Tomb in Changping province – burial
place of the Wanli Emperor (ruled 1572–1620) and
the empresses Xiaoduan and Xiaojing – uncovered
four lacquer caskets. Each held an exquisite phoenix
crown (*fengguan*), two belonging to Xiaoduan and
two to Xiaojing. They are the only four phoenix
crowns to have survived from the Ming era (1368–
1644), although the earliest crown still in existence
dates from the start of the 7th century. These types
of crown were introduced during the Tang era
(618–907) and were worn by China's empresses
on ceremonial and official occasions.

Complex construction
The construction of the headdresses became
increasingly elaborate over time. They were
magnificently decorated with intricate sculptures
of dragons (representing the emperor) and phoenixes
(associated with the empress and female beauty). On
Xiaoduan's glorious three-dragon two-phoenix crown,
shown here, the dragons sit at the top of the structure,
while the phoenixes adorn the front.

The phoenix crowns were constructed in a similar
way, built around a frame of lacquered bamboo that
is lined with green silk. Crafted from gold wire, the
dragons are skilfully woven and soldered into shape.
The phoenixes are made from silver gilt, edged with
gold wire, and inlaid with blue kingfisher feathers,
using a technique called *tian-tsui* or *diancui* ("dotting
with kingfishers"). The headdresses are adorned with
uncut rubies, sapphires, and pearls. They also feature
spectacular moving, decorated fan sections, which
(when attached) would have swung outwards as the
empress walked, adding to the astonishing display
of colour, light, and movement.

Numerous **gemstones** and around **3,500 pearls** adorn Xiaoduan's crown

▽ *TIAN-TSUI* **(KINGFISHER-
FEATHER) HAIRPIN**
The phoenix crown was a
development of the hairpin,
which Chinese empresses
wore from the 3rd century BCE.

Kingfisher-feather
decoration

Gold or silver
gilt pin

Swastika – an
ancient good
luck symbol

EMPRESS XIAODUAN

In 1577, Empress Dowager
Xiaoding (1545–1614) held
an event to choose a wife
for her son, the 14-year-old Wanli
Emperor. She chose a 12-year-
old girl called Wang Xijie. The
children were formally married
in 1578 and Wang Xijie became
Empress Xiaoduan. She ruled for
42 years, becoming the longest-
serving empress consort in
Chinese history. She bore a
daughter, Princess Rongchang,
in 1582 and died in the same
year as her husband – 1620.

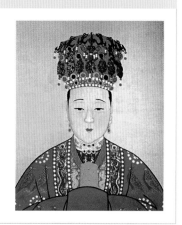

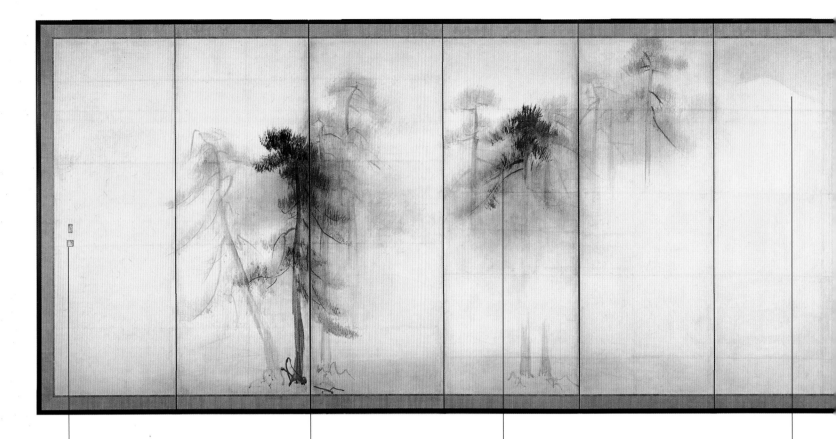

SEALS
The seals show Tōhaku's names but do not follow his usual style, so may have been added by someone else.

PERSPECTIVE
The way in which the screen is folded directs the branches of the trees towards or away from the viewer.

SHORT BRUSHSTROKES
Bold, short, and dark brushstrokes bring some of the trees into the foreground.

THE SETTING
A snow-capped mountain is suggested in the distance, indicating the larger landscape.

△ **PINE TREES**
Although it was painted five centuries ago, Hasegawa Tōhaku's masterpiece of minimalist art remains timeless in its simplicity.
Dimensions (each screen):
156.8 x 356cm (61¾in x 140¼in).
Date: c.1595.

Pine Trees

A ground-breaking 16th-century work in a style that anticipated Minimalist art some 400 years later

Kyoto, Japan

During Japan's Azuchi-Momoyama Period (1573–1600), the prevailing taste of wealthy warlords was for elaborate, grand paintings that were intended to show off their affluence and power; the plentiful use of gold leaf, combined with intricate decoration and often scenes of powerful hunting animals that symbolized the painting's owners, typified the style that successful artists produced. In this context, Hasegawa Tōhaku's *Pine Trees* was astounding in its minimalist approach. While Tōhaku was influenced by the long tradition of Chinese ink painting, a monochrome piece on such a large scale was a revolutionary work never before seen in either China or Japan. Today, it is still considered a masterpiece of ink and wash paintings.

Tōhaku was lauded for his *byōbu*, or folding screens, of which *Pine Trees* is an exceptional example. This minimalist piece shows the influence of Chinese landscape scrolls and the ink wash paintings of the

Japanese painter Sesshū Tōyō of the previous century, which Tōhaku is known to have studied; he was also an admirer of the tea master and Zen practitioner Sen no Rikyū, which probably contributed to the pared-back aesthetic of *Pine Trees*. The negative space in the work is as much a part of the landscape as the trees themselves. Shown in groups of four, the pines encompass a tonal range from the darker foreground trunks and branches to the fainter indications of those in the background, which appear to sway at different angles, implying a moist atmosphere with a breeze through the branches. It is possible that the individual panels were created from preparatory works, since they are smaller than other, more typical, screens; the paper is not of the highest quality, the horizontal seams are not aligned, and the seals at the end of each panel were possibly added later. Nevertheless, it is a work of great sophistication, executed by a master of ink and wash.

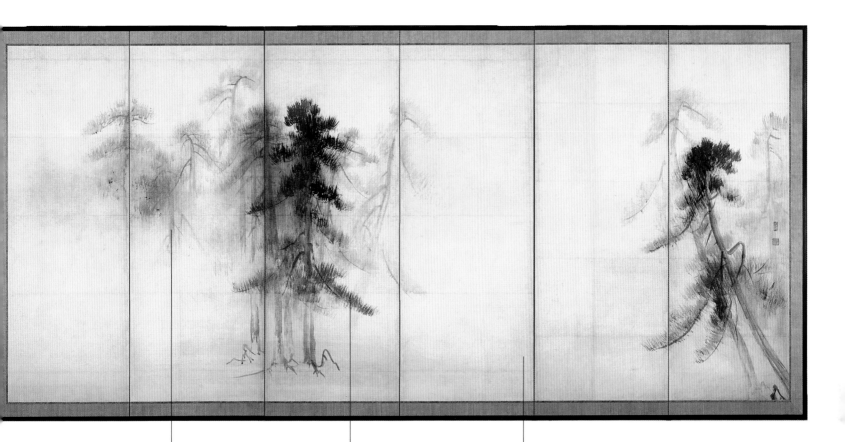

LONG BRUSHSTROKES
Diluted, sparsely applied long brushstrokes imply that the trees are fading into mist.

APPLYING INK
Tōhaku may have used brushes tied together, bamboo sticks with split ends, or rice straws to apply the ink.

NEGATIVE SPACE
The empty spaces add to the sense of an expansive landscape beyond the viewer's reach.

Scale

TOHAKU

Born in Noto Province, Hasegawa Tōhaku (1539–1610) was a professional artist by the age of 20, originally producing paintings on Buddhist themes. In his 30s he moved to Kyoto, where he studied at the influential Kanō school, renowned for large paintings in the form of sliding panels and folding screens, with liberal use of vivid colour and gold leaf – a style known as *kinpekiga*. After founding his own small Hasegawa school, Tōhaku found favour with the Imperial Regent of Japan, Toyotomi Hideyoshi, who commissioned him to make wall and screen paintings for the Shōun-ji of Daitoku-ji, a mortuary temple that the regent had built upon the death of his three-year-old son in 1591. Tōhaku's *Maple Tree*, which formed part of the Shōun-ji commission, uses the dynamic, massive landscape forms that were favoured by the wealthy patrons of the time. Following Emperor Hideyoshi's death in 1598, Tōhaku was given the honorific title of *hōgen* (priest, or monk) by the shogun Tokugawa Ieyasu. He died in Edo (now Tokyo) at the age of 72.

Warm reds in the leaves indicate that this is an autumn scene

The massive trunk makes a strong diagonal across the centre

Due to his many wealthy patrons, Tōhaku could use gold leaf liberally

MAPLE TREE, C.1593

Scale

SELF-PORTRAIT AS A LUTE PLAYER ▷
Bold, confident, and dramatic, Gentileschi's
arresting self-portrait reflects her status as
one of the most skilful and accomplished
painters of her generation. **Dimensions:**
77.5 x 72cm (30½ x 28½in), **Date:** c.1615–18.

Self-Portrait as a Lute Player

An imposing self-portrait by the greatest 17th-century female painter, remarkable for its use of texture, colour, and chiaroscuro

Florence, Italy

FEMALE ARTISTS

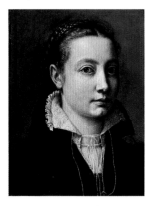

Owing to the constraints on women in society, the rare successful female artists in the Renaissance were usually either nuns, such as Plautilla Nelli (1524–88), or daughters or wives of male artists. The renowned Italian painter Sofonisba Anguissola (c.1532–1625, *see self-portrait above*) benefited from a noble background and parental encouragement. Most women made pictures of modest size and ambition, but Gentileschi, the greatest female painter of the 17th century, created large, full-blooded, serious works, matching herself against the leading male artists.

Artemisia Gentileschi (1593–c.1654) was recognized in her day as an outstanding artist in a mainly male field. Aged 17, she was raped by the painter Agostino Tassi, and at his trial she was tortured to test her honesty. Tassi was convicted, but never served his sentence. To retain the family honour, Gentileschi was married off, but she later separated from her husband and lived an unusually independent life for a woman in this era.

Self-representation

In 1616, while living in Florence, Gentileschi became the first woman to be made a member of the Florentine art academy, an indication of her high reputation, and she probably painted this arresting self-portrait around this time, possibly for the powerful Medici family.

One of several self-portraits Gentileschi painted, possibly as a means of promoting her career, it is the only one that presents her as herself rather than as an allegory. She looks out at the viewer with a confident, almost defiant gaze, her expression perhaps a reflection of her determination to excel in a male-dominated world. Her beautiful and opulent royal-blue dress with gold embroidery is typical of the local Florentine style. She plays a lute, her arms, hands, and fingers positioned in a way that indicates she really knew how to play. A heightened dramatic effect is achieved by Gentileschi's masterly use of chiaroscuro (contrast between light and dark), showing the influence of Caravaggio. The self-portrait combines magnificent boldness and sureness of design with delicacy of detail.

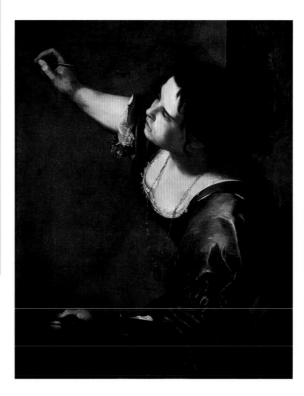

▷ *SELF-PORTRAIT AS LA PITTURA*
Traditional details indicate that here Artemisia has portrayed herself as the personification of painting – for example the dishevelled hair, which shows "the fury of creation".

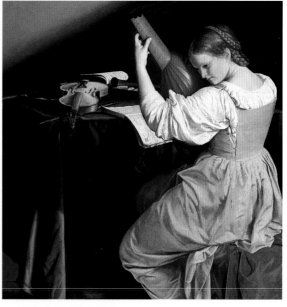

△ *THE LUTE PLAYER*, ORAZIO GENTILESCHI, C.1615
Artemisia's father, Orazio, also created a memorable painting of a woman with a lute. Remarkable for its exquisite depiction of the golden dress, it is often described as his masterpiece.

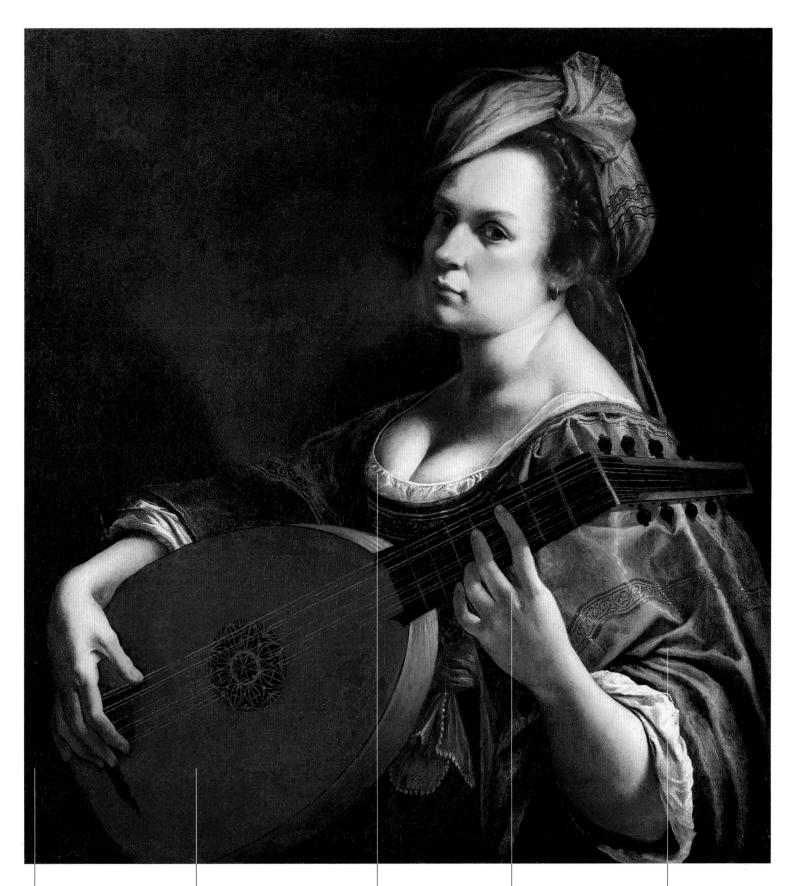

MURKY BACKGROUND
The dark, shadowy
background recalls the
work of Caravaggio, who
was a friend of Gentileschi's
father, Orazio Gentileschi.

AMOROUS ASSOCIATIONS
Musical instruments were
often used in art as symbols
of love. The lute in particular
was associated with romance,
or sometimes lasciviousness.

LOW-CUT GOWN
The revealing gown has
led some commentators
to suggest that Gentileschi
has depicted herself as
a courtesan.

FINGERING
The fingers of the left hand
are accurately positioned to
play a chord, and it is known
that Gentileschi was an
accomplished musician.

**SHIMMERING
DRAPERIES**
The beautiful blue
draperies of the gown
show Gentileschi's skill
as a colourist.

The Judgement of Paris

A masterpiece of 17th-century mythological painting by one of the greatest of all painters of the nude

Antwerp, Belgium

From the Renaissance onwards, the Judgement of Paris has been a popular subject with painters of the nude, giving them an opportunity to depict three beautiful women from three different angles, showing the front, side, and back of the body.

Magisterial richness

Rubens was unsurpassed at painting the female body and treated the subject several times. This is his most impressive interpretation, displaying his immense skill at capturing musculature, curves, and skin tone. The skin of the goddesses appears bathed in light, shining out against the sky and dark trees in the background.

The subject of the painting is a famous incident in classical mythology. Eris, the goddess of strife, has provoked conflict among her fellow deities with a golden apple inscribed "To the fairest". Three goddesses – Juno, Minerva, and Venus – claim to be the most beautiful, and Jupiter, king of the gods, commands the shepherd Paris to judge which of them should be awarded the apple. He chooses Venus – his decision brings discord and triggers events that lead to the Trojan War. Rubens makes from the story a visual feast, setting it in an idyllic landscape and embellishing it with vivid details, notably of animal life. It is a work of such magisterial richness that it is universally regarded as a masterpiece of Rubens's ripe maturity.

▽ **YOUTHFUL INTERPRETATION (*THE JUDGEMENT OF PARIS*)**
This is Rubens's first painting of the subject, produced around 1600, at the outset of his career. His immaturity shows particularly in the harsh lighting.

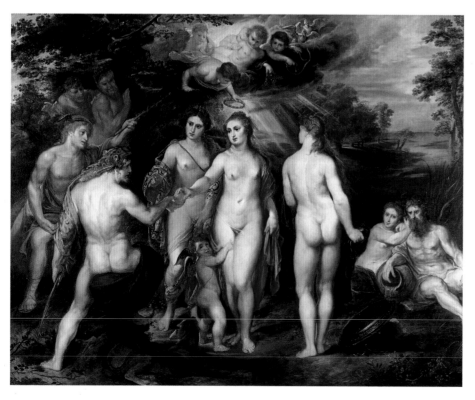

Venus resembles Rubens's **second wife**, Hélène Fourment, one of his **favourite** models

RUBENS

Peter Paul Rubens (1577–1640) was the most famous and influential artist of his time in northern Europe. He was hugely prolific and versatile, excelling in virtually every branch of painting then practised and also producing design work, particularly for books and tapestries. He was mainly based in Antwerp, but travelled extensively.

MINERVA
The goddess of wisdom, Minerva, is recognizable by her owl, to her right (a traditional symbol of wisdom), and her shield, shown next to her (*see also below*).

JUNO
Juno, the queen of the gods, is accompanied by her peacock; it hisses at Paris's sheepdog, presaging the conflict to come.

▷ ALECTO'S SNAKE
In the sky, Alecto, one of the Furies (spirits of punishment), holds a writhing snake in her hand. She has been ordered by Juno to destroy the Trojans.

BLUE SKY
A magnificent colourist, Rubens uses touches of bright colour to bring life and depth to the painting.

▽ *THE JUDGEMENT OF PARIS*
Rubens was an excellent classical scholar and would have been familiar with ancient literary sources for the story of Paris. **Dimensions:** 145 x 194cm (57 x 76in). **Date:** c.1635.

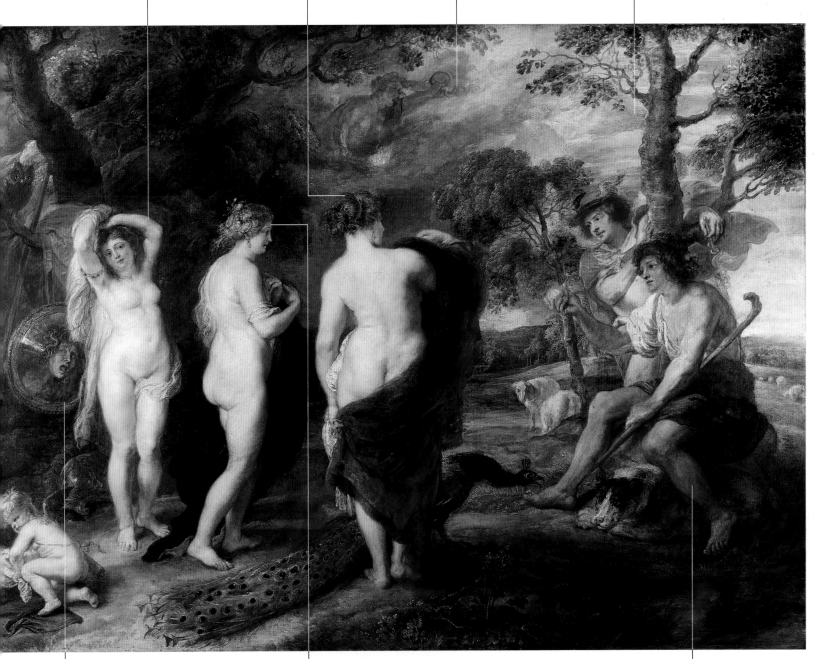

◁ MEDUSA
The head of Medusa, the snake-haired Gorgon – along with the hissing peacock, snarling dog, and the presence of Alecto (*see above*) – adds to the sense of menace and foreboding, suggesting that peace may be temporary.

◁ VENUS
Venus, the goddess of love, has elaborately adorned her hair with roses, jewels, and pearls (closely associated with her as she is said to have been born of the sea).

PARIS
Paris was born a prince of Troy, but because it was prophesied he would bring about the destruction of the city, he was abandoned to die; he was rescued and brought up by shepherds.

Scale

Scale

The Night Watch

The most famous painting of the 17th-century golden age of Dutch art, regarded almost as a painted national anthem

Amsterdam,
The Netherlands

REMBRANDT

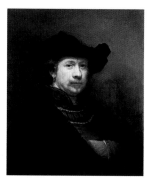

SELF-PORTRAIT IN A FLAT CAP, 1642

Rembrandt van Rijn (1606–1669) was the greatest of all Dutch artists, supreme in etching and drawing as well as in painting. He spent his early career in his native Leiden and settled in Amsterdam in 1631–32. Initially he enjoyed great success, but during the 1640s his fortunes began to decline, as his art became more inward-looking and he painted more to please himself than his clients. In 1656 he was declared insolvent, but he remained a respected artist and a renowned teacher. Portraits and religious works make up the bulk of his work as a painter, but his large output includes other subjects, such as landscape and mythology.

One of the most distinctive types of painting in Dutch art is the group portrait of civic guards – citizen militias trained to defend their city in an emergency. Such portraits, first made in the 1520s, became especially popular after the Dutch rebelled against their Spanish overlords in 1568. The Dutch effectively achieved independence from Spain in 1609, and the militia units became more like social clubs than serious fighting forces. Rembrandt's *Night Watch* is both the culmination and the swansong of the tradition.

Civic guards in action

The painting is formally called *The Militia Company of Captain Frans Banning Cocq and Lieutenant Willem van Ruytenburch*, and does not in fact depict a night scene; its familiar title was first used in the 18th century, when discoloured varnish had darkened its appearance (it has since been cleaned). It depicts Captain Banning Cocq and his lieutenant among a crowd of militia guards and other characters. In contrast to conventional, static militia portraits, the painting is dynamic and full of vitality, showing the company preparing to move out. With its host of jostling figures, a barking dog, and a drummer, it teems with activity. Rembrandt's use of light and shade draws the eye to the central characters (the captain in his red sash, the elegant lieutenant, and the girl "mascot"), and also lends an almost three-dimensional effect in places, such as the captain's hand as it reaches out of the picture. Well received at the time, the painting later became a major patriotic symbol, epitomizing the bravery and sense of duty of the people who had won the country its freedom.

The Night Watch was the **largest picture painted** by a **Dutch artist** up to this date

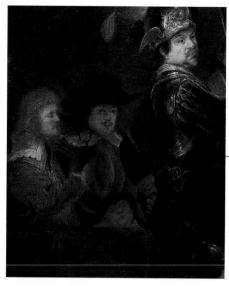

△ **MISSING FIGURES**
The original left-hand section contained three onlookers – two men and a boy – which had the effect of drawing the viewer into the scene.

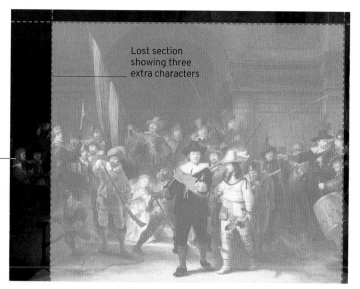

Lost section showing three extra characters

△ **GERRIT LUNDENS'S COPY**
In 1715, Rembrandt's huge painting was trimmed at the edges, mainly the left, on being moved to Amsterdam Town Hall. A much smaller contemporary copy of the original, made by Gerrit Lundens, shows the lost sections.

STANDARD-BEARER
Ensign Jan Visscher Cornelissen proudly holds aloft the company's flag.

◁ **SELF-PORTRAIT?**
A head in the background, only partly visible next to the standard-bearer, has sometimes been claimed to be a self-portrait.

◁ **CARTOUCHE**
A cartouche (shield) bearing the names of the 18 company members who contributed to the cost of the painting was probably added after Rembrandt's death.

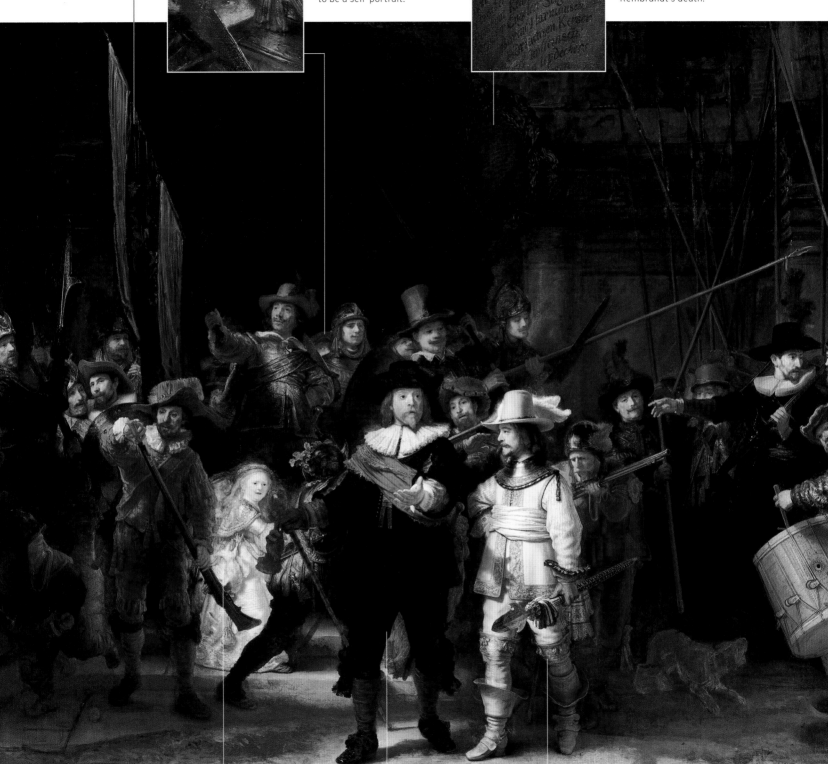

GIRL MASCOT
The brightly illuminated girl is probably a mascot. The dead fowl hanging from her waist may be an allusion to the company's emblem (a bird's claw) and a pun on Captain Cocq's name.

COMPANY COMMANDER
The leader of the company, Captain Frans Banning Cocq, gestures for his lieutenant to give the order for the men to march.

LIEUTENANT
The second-in-command, Willem van Ruytenburch, wears a beautiful pale yellow uniform and carries a ceremonial weapon.

△ *THE NIGHT WATCH*
The scene of a militia company preparing to march had no special significance, but Rembrandt turns it into a splendid pictorial drama, full of lively detail. **Dimensions:** 379 x 453cm (149 x 178in). **Date:** 1642.

Scale

THE ECSTASY OF ST TERESA ▷
Bernini's masterpiece exemplifies the emotional intensity, vigorous movement, sense of drama, and technical virtuosity typical of his work and of Baroque art in general. **Height of figure group:** approx. 2m (6ft 6in). **Date:** 1647–52.

The Ecstasy of St Teresa

The most famous work of 17th-century sculpture, depicting a mystical event with unprecedented intensity

Rome, Italy

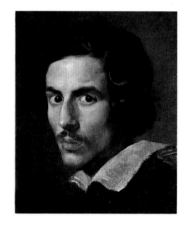

△ **GIAN LORENZO BERNINI**
A versatile and prolific sculptor, Bernini was also a brilliant recreational painter, as seen in this self-portrait from c.1623.

Gian Lorenzo Bernini (1598–1680) was the leading Italian artist of the 17th century. He was primarily a sculptor but also one of the greatest architects of the age, and he dominated art in Rome. His career was a story of triumphs, yet it was during a period of setback that he produced his most celebrated sculpture.

Expressing exaltation in stone
Bernini served all eight popes who reigned during his career, but during a temporary withdrawal of papal favour, the wealthy Cardinal Federico Cornaro commissioned him to design his funeral chapel in the church of Santa Maria della Vittoria, Rome, of which *The Ecstasy of St Teresa* forms the centrepiece.

St Teresa of Avila (1515–1582) was a Spanish nun who had been canonized in 1622. In her autobiography she described a vision in which she experienced mystical union with God. An angel seemed to thrust a gold spear into her heart and "to pierce my very entrails, leaving me all on fire with a great love of God. The pain was so great it made me moan … but so sweet that I could not wish to be rid of it." Bernini showed extraordinary imaginative power and technical skill in convincingly representing such a strange, incorporeal incident in solid marble. Through the saint's rapturous swoon, the flowing drapery, and the dramatic setting he triumphantly succeeded in blending the physical and the spiritual.

According to the **self-critical Bernini**, this was "the **least bad thing** I have ever done"

CHAPEL DESIGN BY BERNINI

Bernini designed the whole chapel, which brilliantly blends architecture, sculpture, painting, stucco, gilded bronze, marble inlay, and natural light (from a concealed window). As though in a theatre, two groups of observers, carved in relief (principally by Bernini's assistants), flank either side of the main sculpture. The portrait of his patron, Cardinal Cornaro, is differentiated from the other marble "onlookers", being an individualized likeness rather than a generalized image, and the only one of these figures who looks out to make eye contact with the spectator.

THEATRE BOXES
Cardinal Federico Cornaro appears second from right in one of two "theatre boxes" at the sides of the chapel.

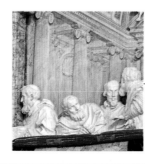

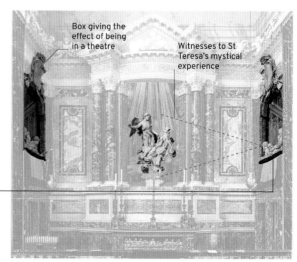

Box giving the effect of being in a theatre

Witnesses to St Teresa's mystical experience

GOLDEN RAYS
The gilt-bronze rays, representing the light of Heaven, are suffused with light descending from a hidden window on the outside wall.

ANGEL
The angel's sweet and luminous face conveys a feeling of celestial grace and gentleness. St Teresa describes him in her vision as "very beautiful ... his face aflame".

△ **OPEN MOUTH**
St Teresa's eyes are closed, but her mouth is slightly open, as if releasing the quiet moan she mentions in her autobiography, "not aloud ... but inwardly, out of pain".

DRAPERY
The billowing drapery of St Teresa's habit pulsates with life, helping to create the sculpture's sense of drama and movement.

CLOUDS
The two figures are supported on a bank of cloud, which Bernini differentiates from the polished skin and robes with a rougher texture.

BARE FEET
St Teresa is appropriately shown with bare feet, as she was co-founder of the austere order of Discalced ("barefoot") Carmelite nuns.

Sri Lankan Ivory Cabinet

A small wooden cabinet overlaid with ivory panels, intricately carved with a mixture of European and Sri Lankan imagery

Sri Lanka

During the 17th century, the Dutch East India Company – at the invitation of the Sinhalese king, Rajasinghe II – helped to expel the Portuguese colonizers who had controlled the island's coastal region for over a hundred years. A treaty in 1638 led to a mutually beneficial, but short-lived, relationship between Sri Lanka and the Dutch, which ended in sporadic wars for control of the lucrative trade routes.

Exquisite carvings

The Dutch settlers, like the Portuguese before them, appreciated the skill of the indigenous wood and ivory carvers, and commissioned furniture and ornaments from local craftsmen, who in turn produced items that satisfied their taste for the unfamiliar, while also incorporating elements of European style. One of the finest examples of this hybrid style is this superb

ivory-panelled cabinet, celebrating the arrival of the Dutch merchants. Probably made for an official of the Dutch East India Company, or for export to the Netherlands, it is a simple wooden cabinet, covered with finely carved ivory panels, decorated with a mixture of traditional motifs and contemporary scenes.

The doors, drawers, and side panels, for example, feature common Sri Lankan themes: the auspicious lion-headed hamsa bird, parrots, and intricately sculpted leaf and floral patterns. In contrast, the cabinet's rear panel shows a depiction of a wild elephant hunt, with six elephants being shut into a stockade and, significantly, a group of Dutch soldiers in attendance. More overtly celebrating the presence of the Dutch, the top panel portrays Dutch ships arriving in a Sri Lankan port and the merchants being welcomed by locals.

In **traditional** Sri Lankan culture, ivory was considered to be a **symbol** of **dignity**

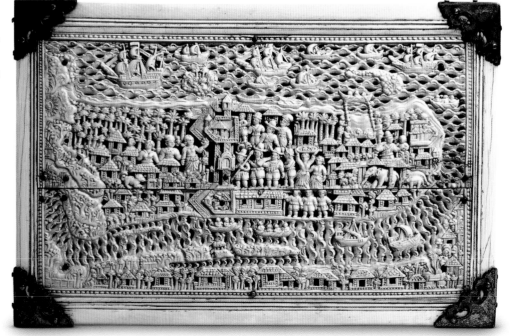

▷ **TOP PANEL**
The meeting of two cultures, Sri Lankan and European, is emphasized in this panel. At the top, Dutch ships arrive by sea; in the centre, the Dutch merchants are greeted by a throng of locals; and towards the bottom of the panel, Sri Lankan boats are shown sailing downriver to the port.

▽ SRI LANKAN IVORY CABINET

This intricately crafted cabinet shows the hybrid style developed to cater for Dutch and Portuguese markets, combining the indigenous Sri Lankan tradition of wood and ivory carving with contemporary European styles. **Height:** 19cm (7½in). **Date:** c.1650.

▷ BACK PANEL

Because of its size, this tableau depicting an elephant hunt is (like the top panel) carved on two sheets of ivory. The scene is depicted with great symmetry either side of the butt joint.

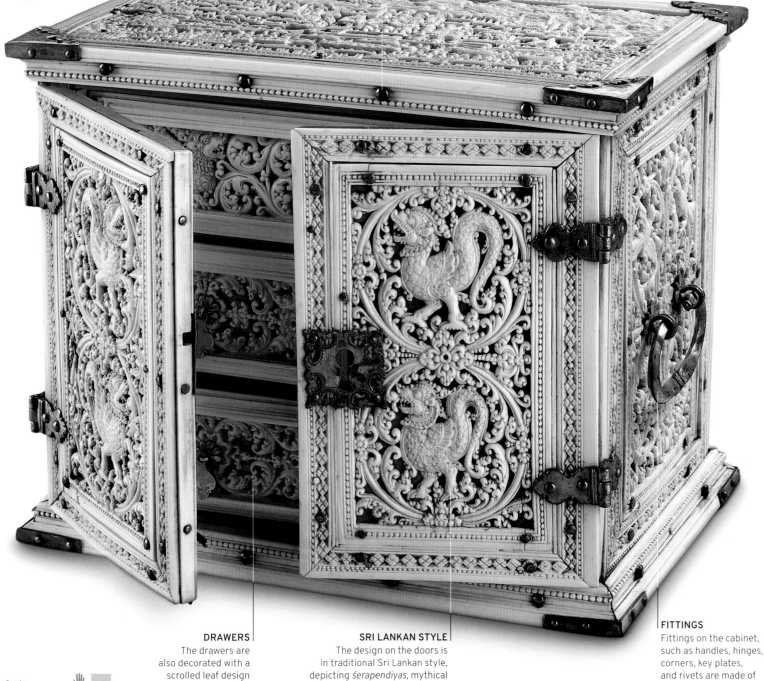

ADORNMENT
The spectacular ivory panels completely encase a simple wooden cabinet.

HEAD PINS
Polished round-headed pins are used to secure the panels to the wooden base.

Scale

DRAWERS
The drawers are also decorated with a scrolled leaf design and *śerapendiyas*.

SRI LANKAN STYLE
The design on the doors is in traditional Sri Lankan style, depicting *śerapendiyas*, mythical lion-headed hamsa birds.

FITTINGS
Fittings on the cabinet, such as handles, hinges, corners, key plates, and rivets are made of gilded brass and silver.

JOSE NIETO
The dark figure pausing in the brightly lit doorway is Queen Mariana's chamberlain, José Nieto.

△ **THE KING AND QUEEN OF SPAIN**
The royal couple appear indirectly, as blurred figures in a mirror. Are they the subjects of the painting on the easel or spectators, like us, observing the scene before them?

THE ARTIST'S PALETTE
Velázquez depicts himself in the act of painting. The colours on his palette here reflect the colours he used in *Las Meninas*: mainly earthy tones, white, and touches of red.

MAIDS OF HONOUR
Two *meninas* (maids), who give the painting its title, frame the princess. One of them offers her a drink on a silver tray.

INFANTA MARGARITA
The princess stands bathed in light at the centre of the painting, although it is unclear whether she is also its main subject.

▷ *LAS MENINAS*
Velázquez's masterpiece has sparked debate on issues such as spectatorship, the relationship between the viewer and the viewed, and the role of portraiture in art. **Dimensions:** 318 x 276cm (125¼ x 108¾in). **Date:** 1656.

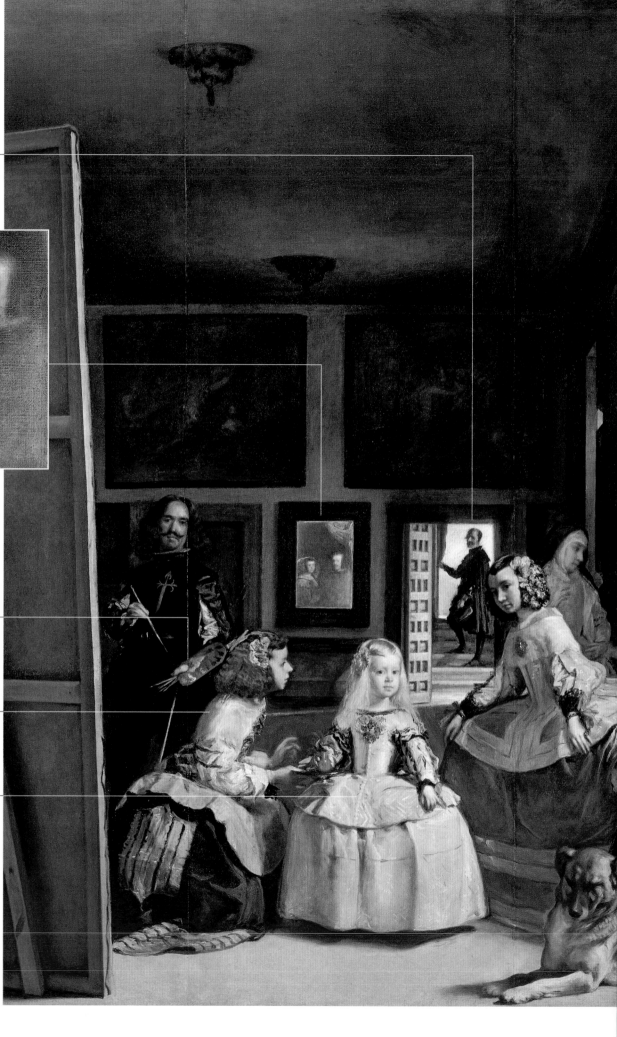

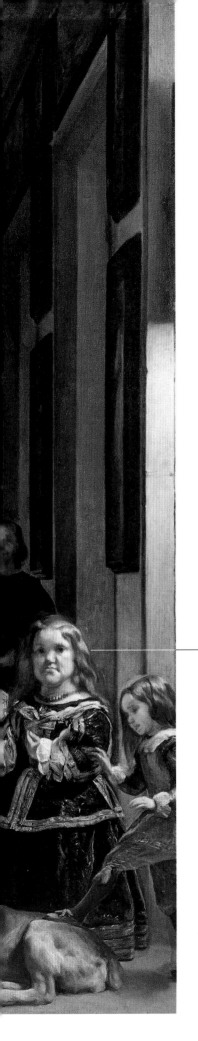

Scale

Las Meninas

A 17th-century painting that has inspired a flood of commentary and interpretation, but whose meaning remains elusive

Madrid, Spain

Diego Velázquez's *Las Meninas* (*The Maids of Honour*), is an informal court portrait depicting the king's daughter, Infanta (Princess) Margarita of Spain, and her various attendants. The artist's near-contemporary biographer, Antonio Palomino, gave a detailed account of the painting, thanks to which scholars know the precise identities of almost all the people portrayed.

Velázquez is shown in his studio in the Alcázar Palace, Madrid. He stands at left working on a huge painting, of which we see only the back. In the centre is the young princess, aged about four, accompanied by various attendants, including two *meninas*. On the rear wall of the studio, two figures are reflected in a mirror: they are King Philip IV of Spain and his second wife, Queen Mariana of Austria.

Palomino extols *Las Meninas* as Velázquez's "most illustrious work", saying it was "highly esteemed" by the king, but he does not explain exactly what is taking place in the scene, so there is scope for interpretation. One idea is that the king and queen are shown visiting Velázquez's studio as he paints the princess; another suggestion, equally plausible, reverses the roles, with the princess and her retinue interrupting the artist as he paints her parents. On a deeper level, the painting has been seen as a representation about representation itself and also as a kind of manifesto by Velázquez proclaiming the dignity of his art. What is not in doubt is the extraordinary feeling of actuality it creates – a sense of living people interacting in a palpable space.

Are the king and queen **subjects** or **spectators**?

△ **MARI BARBOLA**
Standing to the far right of the canvas, and looking directly out towards the viewer, is Mari Bárbola, an attendant at the royal court, whom Palomino described as "a dwarf of formidable appearance".

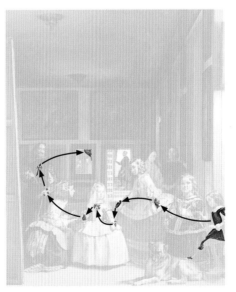

△ **BRIGHT ACCENTS**
Velázquez includes red accents in his painting, which enliven the otherwise restrained palette. The viewer's eye is drawn from the red garment bottom right, via the dresses and ceramic jug, to the red on the artist's palette and tunic, and from there to the red drapes shown in the mirror.

VELAZQUEZ

Diego Velázquez (1599–1660) was born in Seville and trained there under Francisco Pacheco. In 1623, aged 24, he moved to Madrid, where he enjoyed a career of unbroken success as the favourite painter of Philip IV. Velázquez worked predominantly as a portraitist, mainly of the royal family and court. In 1659, he was knighted – an unprecedented honour for a Spanish painter.

Ethiopia

Ethiopian Christian Icon

A magnificent 17th- or 18th-century example of devotional art from Ethiopia, the first African country to convert to Christianity

ETHIOPIAN CHRISTIAN ICON ▽
This triptych is marked by icons in bright, plain colours, with figures in embellished clothing and with well-defined faces.
Dimensions: 31 x 41.5cm (12¼ x 16¼in). **Date:** c.1682–1755.

Ethiopia was the world's second country to adopt Christianity as it's state religion, which began with the conversion of Ezana, king of Ethiopia, by a Syrian Christian in the 4th century CE. Over time, a distinctive Ethiopian Christian art form developed that was expressed in illuminated manuscripts, church building, and objects used in worship, including icons – flat, painted panels, often showing scenes with Jesus, Mary, and saints. Europeans brought techniques of icon construction to Ethiopia in the 15th century, and from then churches began to commission artist priests to create painted icons.

Devotional images

The earliest surviving Ethiopian icons date from the 15th century, when production increased substantially after King Zara Yaqob (ruled 1434–68) decreed that a portrait of Mary be present during Mass. Consequently, many icons show Mary, either with or without Christ, often flanked by archangels, saints, and St George and the Dragon. Ethiopian Orthodox art, in which icons feature heavily, is generally characterized by simplified figures with almond-shaped eyes and bright, vivid colours. The striking example from the 17th or 18th century shown here (*see opposite*), is, like many icons, painted on cloth-covered wooden boards, in this case, a triptych – although single panels and diptychs were sometimes used. Several coats of gesso would have been applied to this to give a white, paintable surface. The composition would then have been drawn on this layer, before being painted over with distemper – a water-based paint containing glue or a binder and pigment.

Some icons have **sequential narratives** that can be read like a **story**

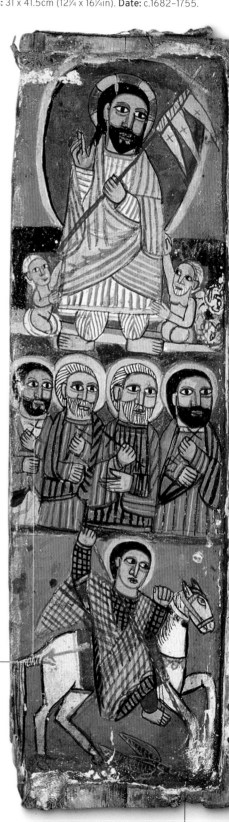

STYLISTIC CONVENTIONS
Good people were traditionally depicted in three-quarter or full view (as here), while villains were depicted in profile (*see opposite, top*).

LEFT PANEL
From top to bottom: Christ descends into Sheol (the Underworld) with Adam and Eve; saints; St George and the dragon.

ST GEORGE AND ETHIOPIA

St George may have been introduced to Ethiopia via contact with the Eastern Orthodox Church, where he is particularly connected to Mary: he is said to carry messages or intervene in human affairs on her behalf. It is also claimed that in the 13th century, he visited the Ethiopian emperor Gebre Mesqel Lalibela in a vision to instruct him to carve a church out of the rock in his honour; the church remains a popular pilgrimage site. St George is now Ethiopia's patron saint, and many churches in the country are dedicated to him.

CHURCH OF ST GEORGE IN LALIBELA

DISTEMPER-BASED PAINT
The distemper-based paint included mineral pigments such as cinnabar (red), indigo (blue), and orpiment (yellow).

HINGES
String hinges allowed the icon to be closed up, protecting the paintings inside.

THE CRUCIFIXION OF THIEVES
This biblical scene shows the Crucixion of Jesus and the two thieves. The villain here, his face in profile, has his arms tucked over the crossbar and his feet pinned to the post.

CLOTH SURFACE
Cloth was sometimes adhered to the board to provide a smoother painting surface.

CENTRE PANEL
Mary and Jesus flanked by archangels Michael and Gabriel; saints or apostles, and two Ethiopian saints.

RIGHT PANEL
The Crucifixion with Mary and St John the Evangelist and two crucified thieves; saints; St Theodore, conventionally shown on a red horse.

WOODEN BASE
A wooden plank from an olive or wanza tree was split to create the three panels.

Scale

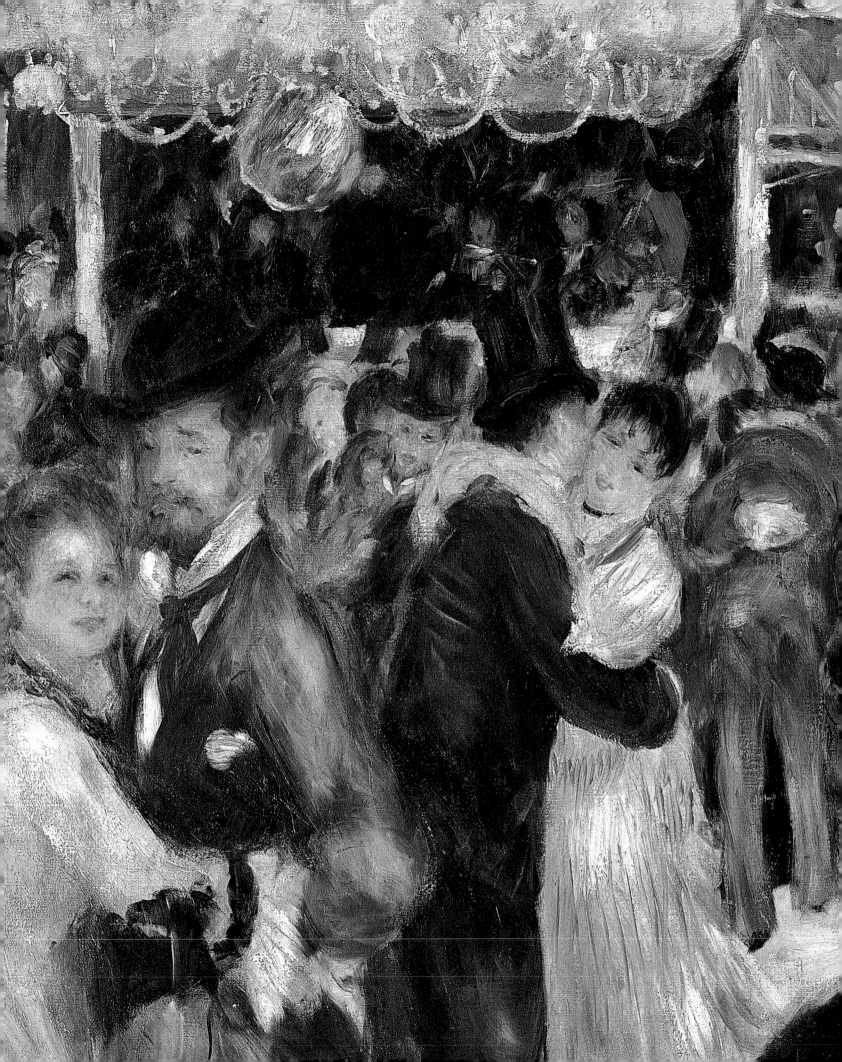

6

1700—1899

Objects from this period reflect a world reshaped by the forces of empire, nationalism, and growing industrialization. Rebellion and resistance are represented in artefacts such as the US Star-Spangled Banner and the Sacred Eagle Feather Bonnet, which embodies the Native American fight against US encroachment. Some objects mark the extension of European influence in the Pacific; others, like Japanese Samurai armour, speak of a culture lost to the forces of mechanization. In spite of the upheaval of these centuries, the arts continued to flourish: Peking opera and Japanese scroll painting endured, and in Europe there was an eruption of experimentation, most visible in the works of the Impressionists.

Tokyo, Japan

Scale

Japanese Lacquerware

An 18th-century Japanese sake bottle illustrating the deliate beauty of the ancient craft of maki-e

Perfected around 1,200 years ago, *maki-e* is a Japanese decorative lacquerware technique that literally means "sprinkled picture". In *maki-e* work, metal powders, often gold or silver, of different fineness are sprinkled onto a design painted in *urushi*, or lacquer (derived from the sap of the urushi tree), on a surface. *Maki-e* production reached its peak in the 17th and 18th centuries, when Japan's lords and shoguns employed lacquerers to produce ceremonial and decorative items for their homes, including bottles, boxes, and furniture.

The elegant sake flask pictured uses the *hiramaki-e* style of *maki-e* and dates to the 18th century. Made in the shape of a gourd, it has a pattern of delicate cherry branches and blossom, and a netlike design of hexagons in gold on a black background. The *aoi* (triple hollyhock) *mon* (crest) of the Tokugawa dynasty – the shogun clan that ruled Japan from 1603 to 1868 – is prominently depicted within a gold circle.

▷ JAPANESE LACQUERWARE
This gourd-shaped sake bottle was probably produced in Edo (now Tokyo), centre of the Tokugawa shogunate. **Height:** 30.5cm (12in). **Date:** 1700–1800.

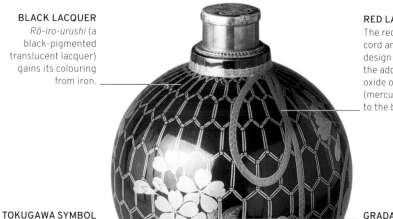

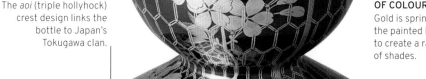

BLACK LACQUER
Rō-iro-urushi (a black-pigmented translucent lacquer) gains its colouring from iron.

RED LACQUER
The red of the cord and tassel design is created by the addition of iron oxide or cinnabar (mercury sulphide) to the base lacquer.

TOKUGAWA SYMBOL
The *aoi* (triple hollyhock) crest design links the bottle to Japan's Tokugawa clan.

GRADATIONS OF COLOUR
Gold is sprinkled on the painted lacquer to create a range of shades.

PRODUCTION OF *HIRAMAKI-E*

There are three main techniques of *maki-e*, of which *hiramaki-e*, developed towards the end of the Heian period (794–1185), is the simplest, characterized by a flat or very low-relief design. An initial stage involves a surface being prepared by applying layers of lacquer, drying and polishing each one, until a thick foundation layer is achieved. Next, a design drawn on paper (step 1) is transferred onto the prepared surface (step 2). This design is traced over in lacquer (step 3), and, while still wet, sprinkled with fine metal powder, often gold (step 4). After drying, any residual powder is brushed off. A layer of clear lacquer is applied to the pattern (step 5) and a series of polishing processes takes place to produce a deep, glossy design that may be slightly raised above the surface (step 6).

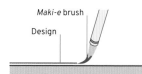

Maki-e brush

Design

1 A pattern is drawn onto paper with brush and ink, then traced on the reverse with wet lacquer and pigment.

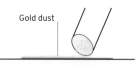

Gold dust

4 In this step, *funmaki*, a bamboo tube or the shaft of a feather is used to sprinkle metal powder on the wet lacquer design.

Pattern transfer

2 The pattern is transferred to the prepared surface by rubbing with the fingertips, a process known as *okime*.

Powdered charcoal

5 Clear lacquer is applied over the design, and when dry, it is polished with powdered charcoal in the *funtogi* process.

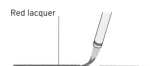

Red lacquer

3 The artist paints over the transferred pattern with lacquer, often coloured red, in a process called *jigaki*.

Linseed oil and abrasive powder

6 Further layers of clear lacquer are added, dried, and polished with linseed oil and various abrasives.

Gondar, Ethiopia

Scale

Maqdala Crown

An intricate 18th-century tiered gold crown that is an important symbol of the Ethiopian Orthodox Church

A work of extraordinary craftsmanship, the Maqdala crown is believed to have been made in the 1740s for Empress Mentewab (ruled 1730–69) and her co-ruler and son Emperor Iyasu II (ruled 1730–55). They then probably presented it to the Church of Our Lady of Qusquam, a church built by the empress in the mountains outside the Ethiopian capital, Gondar.

The crown is formed of an 18-carat-gold domed cylinder, the top portion of which is decorated with embossed and chased figures of the four Evangelists, and eight filigree bead casings. Below this, two pierced gold tiers surrounding the cylinder are stamped or cut from sheet metal and decorated with depictions of the 12 Apostles, flowers, and other motifs. It is thought that the inner structure of the crown was once covered with fabric that would have provided a colourful backdrop for the tiers; only a few scraps of crumpled green material now remain.

EMPRESS MENTEWAB

Empress Mentewab (c.1706–1773), who commissioned the crown as well as many important architectural works, was one of the most powerful women in Ethiopian history. Consort of Emperor Bakaffa, on his death she became empress and co-ruler with her son, Iyasu II. However, she outlived both him and her grandson, Iyoas I, and spent the rest of her life in seclusion.

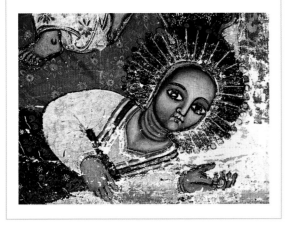

◁ **CHASED GOLD EVANGELISTS**
The four Gospel writers are each shown with their traditional symbols (here, Mark and lion).

LOST DECORATION
This decorated bead and traces of pigment suggest the crown was once even more elaborately decorated.

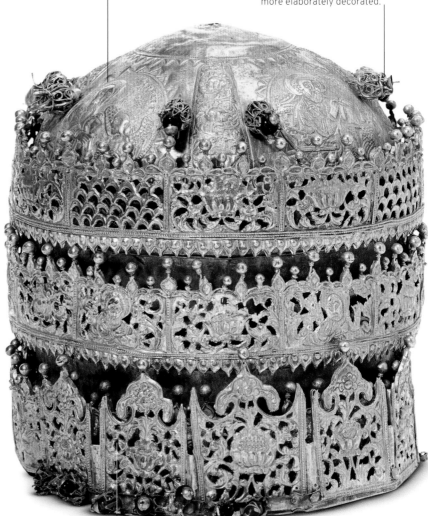

FILIGREE GOLD TIERS
The tiers are held away from the central cylinder, allowing light to shine through the filigree.

△ **MAQDALA CROWN**
Donating precious objects to churches was a duty for Ethiopia's emperors and a way of ensuring that the clergy would pray for them.
Height: 21.5cm (8¹⁄₂in). **Date:** c.1740s.

The 19th-century Ethiopian emperor **Tewodros II** raided **Gondar**, taking the **crown** with him to **Maqdala**

DIAMOND CROSS
The spinel is surmounted by a cross with five diamonds, representing the tsar's Christian faith and the God-given authority of the monarchy.

The crown is decorated with 4,936 diamonds and 74 pearls

TWO CONTINENTS
The crown is split in two basketwork hemispheres, representing Europe and Asia – the two continents spanned by Russia.

HIGH, CENTRAL ARCH
The central arch is decorated with a diamond garland of oak leaves and acorns, representing strength and resilience.

◁ **SPINEL (UNCUT EXAMPLE)**
The crown's spectacular deep red spinel gemstone was cut from a stone similar to the one shown here. The cut stone weighs nearly 398.7 carats and sits on a 12-petalled diamond rosette.

PALM LEAVES
Pairs of crossed palm leaves adorn the front and back; the coloured stones originally used were replaced with diamonds in 1797.

CIRCLET
At the base of the crown, two bands of diamonds enclose 19 larger diamonds, each one weighing 5 carats.

△ **THE IMPERIAL CROWN OF RUSSIA**
The crown's estimated value in 1920 was $52 million, but its connection to the doomed Romanov family and Russia's last tsars led to it being declared priceless in 1998.
Height (with cross): approx. 27.5cm (10¾in). **Date:** c.1762.

Scale

The Imperial Crown of Russia

A sumptuous diamond-encrusted crown, the largest imperial crown ever made and a potent symbol of power and ambition

St Petersburg, Russia

Soon after Catherine II ascended the Russian throne in 1762, she commissioned the eminent Swiss jewellers George Eckart and Jeremiah Pozier to melt down the settings of some of the imperial jewellery to create a crown that was larger and more opulent than any of the earlier imperial crowns (*see box, below*).

The skilled craftsmen drew inspiration from the crowns that had been created for Catherine I (1725–27) and Anna Ivanovna (1730–40), which themselves were inspired by the Imperial Crown of Austria. All four crowns were designed with a circlet on which sat two domed hemispheres, divided by a high central arch and topped by a large stone and cross. What made the new Imperial State Crown so extraordinary

was the femininity of its delicate basketwork frame and the elaborate central arch, which dazzled with light from thousands of diamonds. The crown was more than simply a piece of jewellery – with it, Catherine was making a clear statement about female power and her ambition that Russia would succeed in outshining Europe's great powers.

After the 1917 revolutions, which resulted in the execution of Nicholas II (who wore the crown at his coronation) and his family, the crown jewels fell into the hands of the Bolsheviks. A State Diamond Fund was established in 1922 to manage the jewels. Some were sold off, but attempts to sell the Imperial Crown failed as word spread that it was "stained with blood".

CROWNS OF RUSSIA'S MONARCHS

From the 14th century to the accession of Peter the Great in 1721, the crowns created for Russia's royalty imitated the 14th-century Monomakh Cap – a fur-trimmed, gold filigree cap overlaid with scrolled gold and inlaid with precious stones. The Kazan Crown and the crown made for Tsar Michael Fyodorovich,

for example, were fur-lined gold caps. However, wanting to modernize Russia's regalia, for the coronation of his wife Catherine I in 1724, Peter the Great commissioned a Western-style, domed, hemispheric crown. This set the template for Russian crowns, including those of Empress Anna Ivanovna and Catherine the Great.

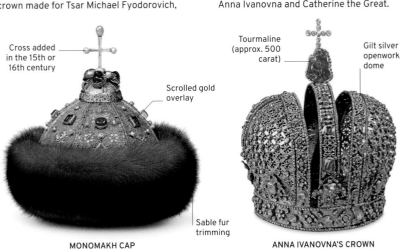

Cross added in the 15th or 16th century

Scrolled gold overlay

Sable fur trimming

MONOMAKH CAP

Tourmaline (approx. 500 carat)

Gilt silver openwork dome

ANNA IVANOVNA'S CROWN

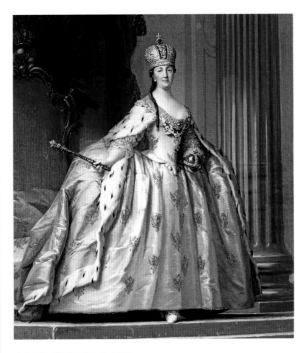

△ **CATHERINE THE GREAT**
Shown here in the Imperial Crown and a bejewelled cape, Catherine was a renowned jewellery lover.

The Swing

An 18th-century masterpiece that encapsulates the elegance, wit, and grace of aristocratic French society before the Revolution

Paris, France

FRAGONARD

Jean-Honoré Fragonard (1732–1806) was born in Grasse, France. He spent most of his life in Paris, but his career included two visits to Italy. Initially, he aimed to succeed with grand historical subjects, but realized that his talents lay in more intimate scenes for private clients. They included powerful people of his time, notably Madame du Barry, a mistress of Louis XV. After giving up painting in about 1792, Fragonard worked for a few years as an administrator at the Louvre museum in Paris. At the time of his death, he was almost forgotten and he continued to be little regarded for more than half a century.

Fragonard was one of the most successful French painters of the mid-18th century, specializing in playfully erotic scenes, of which *The Swing* is the best known. Thanks to a contemporary account by the poet Charles Collé, we know something of the circumstances of its creation. According to Collé, the painter Gabriel-François Doyen was summoned by a "gentleman of the court", who – pointing to his mistress – said, "I should like you to paint Madame … on a swing pushed by a bishop. Myself you will position where I can observe this charming girl's legs." Doyen, who had just won acclaim for a large religious painting, was "petrified" at the risqué idea and recommended Fragonard instead. Collé does not name the "gentleman of the court", but the most likely candidate is the Baron de Saint-Julien. He held a government tax post relating to Church finances, so the inclusion of a bishop was no doubt a private joke.

The art of pleasure

The first recorded owner of the painting, François-Marie Ménage de Pressigny, was likewise a senior tax official. He was guillotined in 1794 during the French Revolution, an upheaval that virtually ended Fragonard's career, sweeping away the world of frivolous aristocratic pleasure that was his province. It is this overwhelming sense of frivolity and playfulness – typical of the Rococo style, of which Fragonard was the last great master – that the artist creates so successfully in *The Swing*. The charmingly artificial-looking foliage helps produce the painting's enchanted atmosphere.

In 1859, the Louvre turned down an opportunity to acquire *The Swing*

△ **VILLA D'ESTE**
Fragonard made numerous drawings of the lush, overgrown gardens of the 16th-century Villa d'Este in Tivoli, near Rome, Italy. The magnificent gardens inspired many of his settings.

△ **CUPID**
The statue of Cupid raises a finger to his lips, playfully urging secrecy.

△ **DOG**
A traditional symbol of fidelity, the dog yaps, perhaps to try to alert the unsuspecting husband.

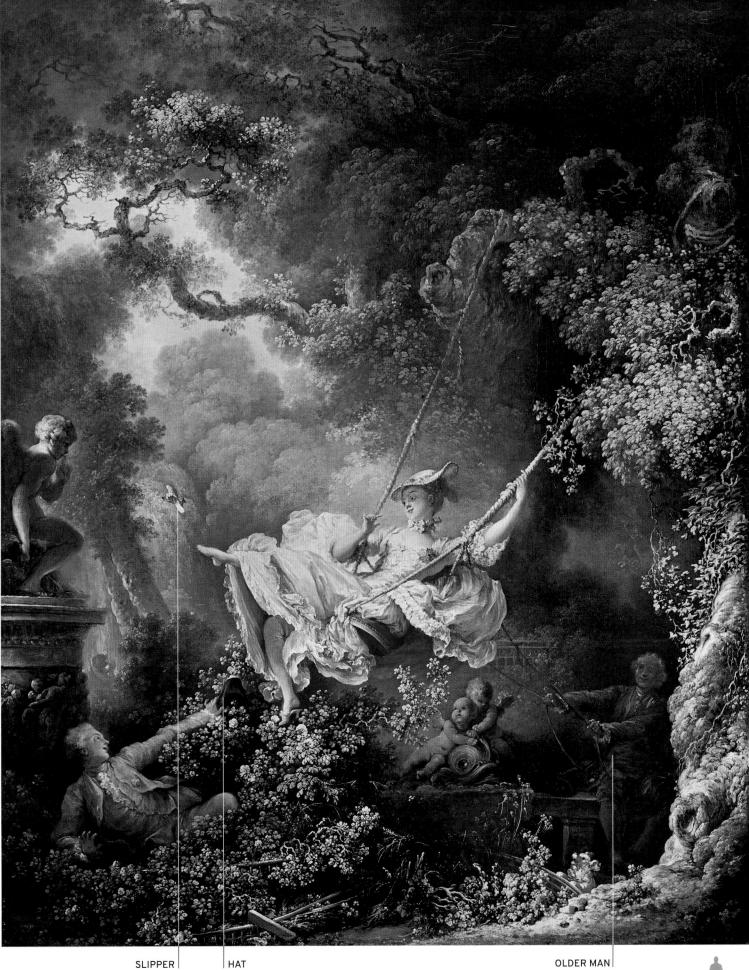

SLIPPER
At this time, a loosened shoe or slipper could be interpreted as a sign of lax morals.

HAT
The young man holds out a hat, sometimes interpreted as a phallic symbol.

OLDER MAN
Fragonard replaces the proposed bishop with a man much older than the woman on the swing, presumably intended as her cuckolded husband.

Scale

Kinshasa,
Congo

Ndop of Mishe miShyaang maMbul

One of the oldest traditional ndop *wooden statues of a king crafted by the Kuba people of the Congo*

Ndop (statue) figures are idealized carved wooden representations of individual *nyim* (rulers) of the Kuba people of southeast Congo. The Kuba were expert carvers who worked with an adze, knives, and burnishers to create naturalistic sculptures full of realistic detail. These figures typically have the same form and stylized features, depicting the king adorned, as here (*see right*), in the royal regalia of armbands, bracelets, belts, shoulder ornaments, and a special headdress, sitting cross-legged on a platform with his right hand on his right knee, his left on a knife. Here the handle points outwards, indicating peacefulness.

Individual rulers are only identified by the inclusion of patterns and symbols specific to their reign. In this example – notable for being one of the oldest known *ndop* (c.1760–80) – the king sits with a drum decorated with a severed hand, the identifying symbol (*ibol*) of Mishe miShyaang maMbul (ruled c.1710). The wood in the statue has aged to a wonderful rich patina, partly from being rubbed regularly with oil.

A *ndop* represents the spirit of the ruler

KUBA ART

The Kuba have a highly developed artistic tradition expressed in textiles, wooden carvings, and metalwork, characterized by intricate geometric surface design. The most striking Kuba pieces include wooden masks, decorated with patterned and textured designs, and ornamented with hair, hide, beads, shells, and feathers. They are used in court rituals and initiations, and at funerals. This mask shows Woot, the first human in Kuba mythology.

KUBA MASK

ROYAL HEADDRESS
Known as a *shody*, the headdress is decorated with carved cowrie shells around the edge and an interlocking pattern on the top.

PROPORTIONS
All *ndop* figures have a head that is one third the size of the total stature, reflecting the Kuba ideal of kingly intelligence.

ARM RING
Finely chiselled details highlight objects – such as arm rings and belts – that signified the prestige of the king.

STYLISTIC CONVENTIONS
The position of the body and calm facial expression are conventions of Kuba *ndop*.

DRUM WITH SEVERED HAND
All *ndop* sculptures feature a prominent geometric motif, which acts as an identifying emblem.

TROPICAL HARDWOOD
The *ndop* is carved from the wood of a small tree called *Crossopteryx febrifuga*.

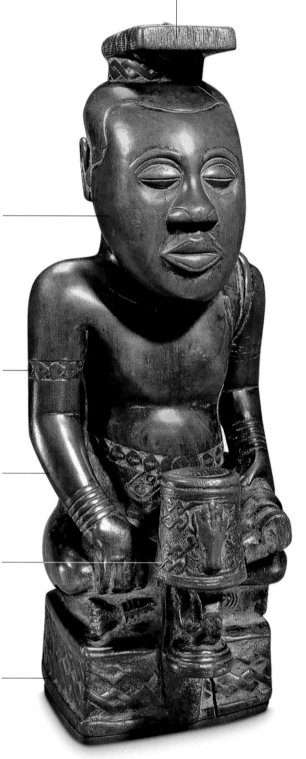

Scale

△ *NDOP* OF MISHE MISHYAANG MAMBUL
This *ndop* portrays Mishe miShyaang maMbul (ruled c.1710) and is one of the oldest surviving works in wood from Africa. *Ndop* sculptures were not actual portraits of the ruler, but served as a vessel for his soul, which was transferred to his successor.
Height: 49.5 cm (19½in). **Date:** c.1760–80.

London, England

Scale

Qianlong-Era Clock

A British custom-made automata clock created for the late-18th century Qing court

From the 17th century, China's emperors were fascinated by Western striking clocks, which Europeans often gave them as gifts, hoping to gain access to the imperial court. The early Qing emperors were particularly passionate about them, building a large collection of musical automata clocks.

Signed by London-based clockmaker Peter Torckler, this large ormolu (gilt-bronze) clock, made for export to Emperor Qianlong's court, is an especially striking example. Its design references the landscapes and people of China as well as Greek mythology, with its depiction of Atlas. Every three hours the clock springs into life: its pineapple finial spins, the glass "waterfall" rods turn, and the waterwheels rotate while the trunk of the elephant moves up and down, its ears and tail flap, and its eyes roll in time to a choice of six tunes.

AUTOMATA CLOCKS

An automata clock is a striking clock that features mechanical human or animal figures that move by clockwork. Clocks began to incorporate such automata in the Middle Ages. By the 17th century, automata clocks had become considerably smaller, and were sophisticated machines with multiple moving parts and musical elements, such as the tiny organ and spinet (an early keyboard instrument) in the impressive example shown here. The 18th century was a golden age for automata clocks when, known as "sing-songs", intricate, lavishly decorated clocks with amusing automata became the favoured toys of the rich, including the Qianlong emperor.

MUSICAL CLOCK WITH SPINET AND ORGAN, GERMAN, c.1625

PASTE JEWELS Made from glass, these paste jewels, designed to imitate precious gems, adorn the rotating whirligig beneath the pineapple finial.

The clock once belonged to **Naser Al-Din (1831–1896), the Shah of Persia**

MOVING PARTS Articulated plates enable the elephant to wave its trunk and tail in a lifelike way.

ATLAS The legendary Greek god Atlas holds up a rotating sphere used for representing the movements of the heavens.

HIDDEN MECHANISMS The rockwork base hides the clock's winding mechanism; clockwork within the elephant drives the finial, sphere, and the animal's movements.

PEASANT FIGURES Chinese peasant figures hold up the clock.

MUSIC BOX The clock's music box sits inside the lower section of painted metal landscapes and ormolu rockwork, and features a moving glass "waterfall".

△ **QIANLONG-ERA CLOCK** This clock is remarkable for the precision of its engineering and the complexity of its design and mechanisms. It is also a fascinating example of how clocks were used as gifts to promote relations between China and the West in the 18th century. **Height:** 97cm (38¼in). **Date:** 1780–83.

Hawaiian Feather Cloak

A spectacular 18th-century cloak crafted for a Hawaiian chief from the plumage of strikingly beautiful birds

Hawaii, USA

▷ HAWAIIAN FEATHER CLOAK
Requiring a huge number of feathers and human hours to create, Chief Kalani'ōpu'u's cloak was a symbol of the highest rank among Hawaii's chiefly class. **Length:** (neckline to bottom hem) 145cm (57 in). **Date:** c.1779.

In January 1779, the British explorer Captain James Cook reached Kealakekua Bay on the island of Hawaii. There, he was met by Chief Kalani'ōpu'u, who is said to have removed the feathered cloak ('*ahu 'ula*) from his shoulders and a helmet (*mahiole*) from his head and given them to Cook as a gesture of greeting and good will. The chief then laid five or six further feather capes and cloaks on the ground before Cook. Feather cloaks were designed and created for a specific individual and acted as a powerful symbol of a chief's divinity, rank, and power; in Hawaiian culture, all such featherwork was reserved for royalty. The shape and wing-like designs of the cloak connected the chief to Hawaii's feathered gods; red and yellow feathers were thought to attract the gods' protection.

Hawaiian treasures

Kalani'ōpu'u's cloak is an extraordinary piece of work, crafted from the tiny red and yellow feathers of the '*i'iwi* (*Vestiaria coccinea*), a common red honeycreeper, and the now extinct '*ō'ō* (*Moho nobilis*), a yellow and

> The **cloak** is made from an estimated **four million** red and yellow feathers

black honeyeater. Some twenty thousand birds are thought to have had their feathers harvested for the cloak (*see box, below*). These feathers were collected as taxes by Hawaiian chiefs, who would have needed a substantial land base from which to draw the huge numbers of feathers required for a cloak. Bundles of six or so feathers, their shafts broken, were then tied together and sewn by highly skilled workers, using a bone needle and thread, to a net cloth made from the fibre of the olonā shrub, one of the most durable natural fibres in the world.

'O'O BIRD

The beautiful Hawaii '*ō'ō* (*Moho nobilis*) is a member of the extinct Mohoidae family of birds. For centuries, its plumage was used to create robes, capes, and feathered staffs for Hawaiian nobility. The Native Hawaiians would capture the birds, carefully pluck a few feathers at time, and then release them. The population remained stable, despite great demand for the feathers. Increased hunting, disease, and deforestation took their toll on numbers, and the last known sighting of the bird was in 1934.

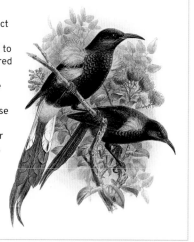

MOHO NOBILIS

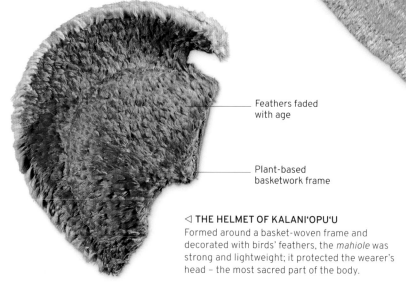

Feathers faded with age

Plant-based basketwork frame

◁ THE HELMET OF KALANI'OPU'U
Formed around a basket-woven frame and decorated with birds' feathers, the *mahiole* was strong and lightweight; it protected the wearer's head – the most sacred part of the body.

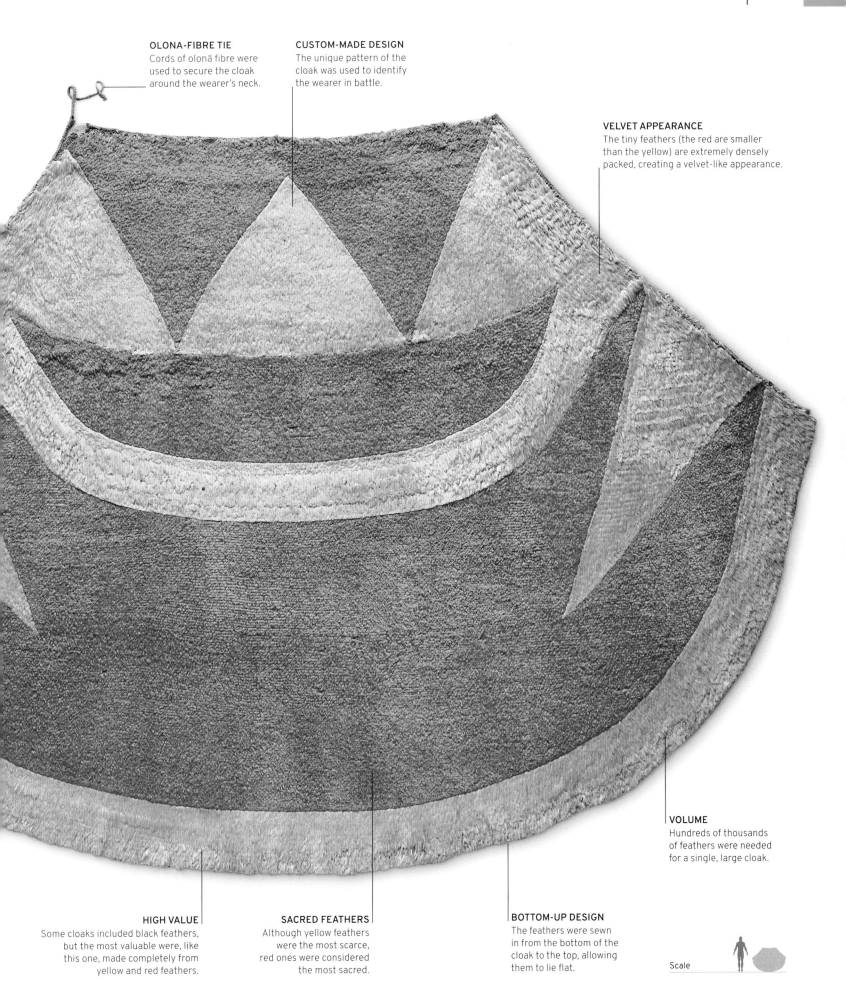

OLONA-FIBRE TIE
Cords of olonā fibre were used to secure the cloak around the wearer's neck.

CUSTOM-MADE DESIGN
The unique pattern of the cloak was used to identify the wearer in battle.

VELVET APPEARANCE
The tiny feathers (the red are smaller than the yellow) are extremely densely packed, creating a velvet-like appearance.

VOLUME
Hundreds of thousands of feathers were needed for a single, large cloak.

HIGH VALUE
Some cloaks included black feathers, but the most valuable were, like this one, made completely from yellow and red feathers.

SACRED FEATHERS
Although yellow feathers were the most scarce, red ones were considered the most sacred.

BOTTOM-UP DESIGN
The feathers were sewn in from the bottom of the cloak to the top, allowing them to lie flat.

Scale

Hawaii, USA

Kū, Hawaiian God of War

A rare, colossal temple statue created for Hawaii's first king in the late 18th or early 19th century

In 1782, Kamehameha I united the Hawaiian islands under his authority, creating the kingdom of Hawaii. He built several temples to Kūkā'ilimoku or Kū ("the snatcher of land"), god of war. The statue of Kū seen here is one of just three surviving colossal carvings of the god created for Kamehameha and is revered as an important symbol of Hawaii's indigenous culture.

Carved from a single piece of wood from the breadfruit tree, the impressive statue is larger than life-size and executed in the highly expressionistic style known as Kona. The Kona carvings share various features with other Polynesian styles but are marked by several unique characteristics: a dynamic stance, a figure-of-eight grimace, and distended eyes that merge into an elaborate hairstyle. The figure is identified as Kū by his disrespectful open mouth and the rows of stylized pig heads that form his hair.

The **statue weighs** a substantial **196kg (432lb)**

KU AND THE BREADFRUIT TREE

Breadfruit trees are extremely important in Hawaiian culture and were brought to the islands by ancient Polynesians. They are major sources of wood, food, craft materials, and medicines. They also form the basis of myth, including a story of how the god Kū married a Hawaiian woman, but kept his status as a god secret. The couple had many children. When famine struck, Kū sacrificed himself to feed his family by burying himself in the earth, leaving just his toes above the ground – from them a glorious breadfruit tree grew.

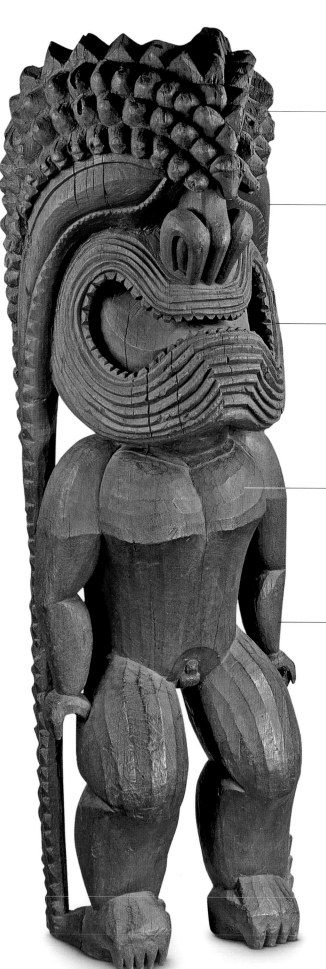

FORMALIZED HAIR
The figure's hair is formed from rows of pig heads, perhaps representing the animals sacrificed to Kū.

PASSION PIECE
The deeply slanted eyes and flaring nostrils indicate the war god's passion.

GRIMACE
The figure-of-eight shape mouth is a grimace of contempt, representing a challenge to an enemy.

CARVING MARKS
Adze marks have purposefully been left on the figure, adding to the decoration and energy of the piece.

DISTINCTIVE PATINA
The wood has darkened with age; fresh breadfruit wood is light in colour.

◁ **KU, HAWAIIAN GOD OF WAR**
A physically imposing depiction of one of Hawaii's four main deities, the statue has the stance of a fighter: chest inflated, fists clenched as if ready to box and knees bent as if ready to wrestle – both important martial arts in Hawaii. **Height:** 2.67m (8ft 9in). **Date:** c.1790–1820.

Scale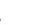

Cameroon, Africa

Bangwa Queen

One of the world's most renowned pieces of African art with tremendous spiritual significance for Cameroonians

The Bangwa "Queen" is a commemorative wooden figure, known as a *lefem*, made by the Bangwa people of the Cameroon Grassfields in southwest Cameroon. *Lefem* statues were often created as portraits of major ancestors and esteemed or royal figures, and acted as a visual record of dynastic power and authority.

The statue's creation date is unknown, but the figure certainly pre-dates 1899, when it was taken from Cameroon to Germany. Famous and revered for her dynamic stance and highly expressive demeanour, the Bangwa figure stands with her mouth open in song and knees bent, her weight resting on the tips of her toes, and her shoulders rounded forward to indicate that she is dancing. Women were highly regarded in Bangwa culture, in part for their reproductive capacity, and the figure may therefore represent the mother of twins or some kind of special child, and may not necessarily have been created to depict a queen. Her designation as such is more likely to reflect Western ideas than Bangwa culture; in the West, she has also been referred to as a "princess" and a "dancer".

MASKS OF THE BANGWA NIGHT SOCIETY

Bangwa society is policed by a secretive organization called the Night Society, which maintains social order. To remain anonymous, members cover their faces while carrying large wooden masks on their shoulders. These masks are sacred, designed to incite fear, and thought to be imbued with a power so strong they cannot be placed on the human head. They are also worn at ceremonies and funerals and, when not in use, are stored on the roof of the mask-keeper's hut, gathering soot and dust that increases their power.

BANGWA NIGHT SOCIETY MASK

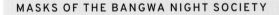

LEFEM STYLE
Lefem figures often have open mouths, showing prominent teeth, and protruding eyes.

Scale

ROUGH-HEWN WOOD
The figure's surface retains the marks made by the carver and has not been made smooth.

RED CAMWOOD POWDER
The red powder signifies the prestige the ancestor portrayed had among the Bangwa.

RATTLE
The statue holds a ceremonial basketry rattle in her right hand.

ACTIVE STANCE
The form is dynamic, capturing a moment of movement rather than a pose.

▷ **BANGWA QUEEN**
The carved wooden Bangwa "Queen" from Cameroon was once housed in the king's palace with other ancestral statues that were brought out to participate in rituals and important occasions. **Height:** 81cm (32in). **Date:** unknown (pre-1899).

The Bangwa Queen was **originally described** as a *njuindem,* **"a woman of God"**

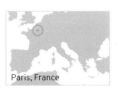

Paris, France

▷ *NAPOLEON CROSSING THE ALPS*
David combines heroic idealization
of conception with sharp-focus
accuracy in the depiction of details.
Dimensions: 260 x 221cm
(102 x 87in). **Date:** 1801.

Napoleon Crossing the Alps

A 19th-century painting that is the most heroic of all portraits of Napoleon, showing him at the peak of his youthful military success

DAVID

French artist Jacques-Louis David (1748–1825) was one of the most important painters of his time, not only because of the quality of his work, but also because he was a great teacher, influencing many artists of the following generation. His career was closely linked with political events. He found fame with severely heroic paintings that were thought to be in tune with the spirit of the French Revolution, in which he took an active part. Later he was closely associated with Napoleon, whose career he glorified. After Napoleon's final defeat in 1815, David went into exile in Brussels.

In May 1800, Napoleon's army crossed the Alps to invade northern Italy – an episode in the French Revolutionary Wars, fought between France and alliances of other countries, notably Austria and Great Britain. By this time, although he was only 30, Napoleon Bonaparte was effectively dictator of France and was hailed as a military genius. At the Battle of Marengo on 14 June, he won a major victory against Austria and immediately returned in triumph to Paris.

Iconographic painting

Among Napoleon's most ardent admirers was Jacques-Louis David, the leading French painter of the time, who had first met him in 1797 and declared him "my hero". He painted several portraits of Napoleon,

although this one was not commissioned by the subject himself but by Charles IV of Spain as a flattering diplomatic gesture after the French victory in Italy.

Napoleon instructed David that he wanted to be shown "calm, on a fiery steed". He had in fact crossed the Alps riding on a mule led by a guide, so the painting is a stirring piece of propaganda rather than an accurate recreation of a historical event. David finished the painting in January 1801; it was judged such a success that he immediately began a second version, and he and his studio went on to produce three more (one of which he kept for the rest of his life). The five versions are all virtually the same size and almost identical in essentials, but they differ in certain respects, such as the colour of the horse.

Napoleon wanted to be immortalized as "calm, on a fiery steed"

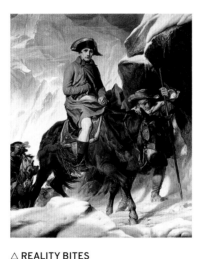

△ **REALITY BITES**
Paul Delaroche's *Bonaparte Crossing the Alps* (1850) depicts a grittier and more realistic version of the historic event.

△ **BEAUTIFUL HEAD**
After first meeting Napoleon, David is said to have told his students: "What a beautiful head he has … like the antique."

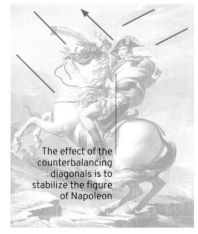

The effect of the counterbalancing diagonals is to stabilize the figure of Napoleon

△ **COMPOSITION**
The heavy clouds to the right balance the diagonals of Napoleon's raised arm, the rearing horse, and the flowing cloak.

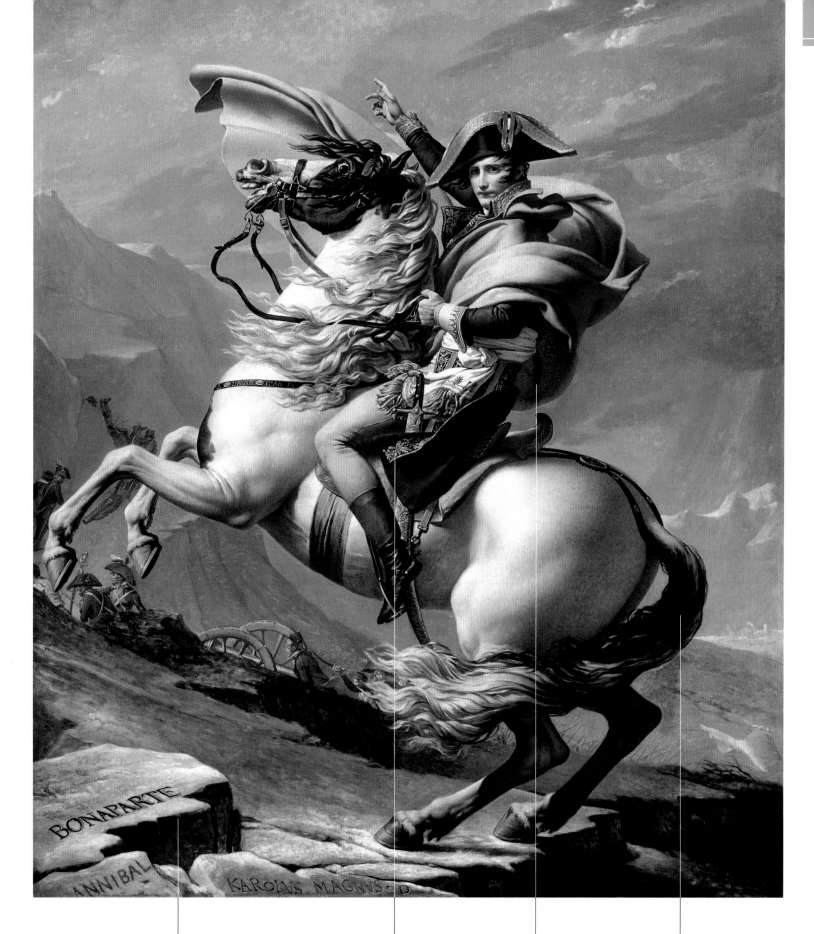

INSCRIPTIONS
Inscriptions on the rocks link Napoleon with two earlier great generals who crossed the Alps, Hannibal and Charlemagne ("Karolus Magnus").

UNIFORM
David borrowed the uniform Napoleon wore at the Battle of Marengo to copy its details faithfully.

CLOAK
The windswept cloak helps create an air of dashing movement. In reality, Napoleon would have worn a heavy greatcoat.

HORSE
Two of Napoleon's own horses served David as models, including the grey he rode at the Battle of Marengo.

Scale

STARS
Each star measures about 61cm (24in) across and was hand sewn onto the blue bunting background.

STARS AND STRIPES
The flag was originally made with 15 stars and 15 stripes, representing the states belonging to the Union in 1813.

LOST STAR
One star is missing; it was cut out and given away as a memento.

Scale

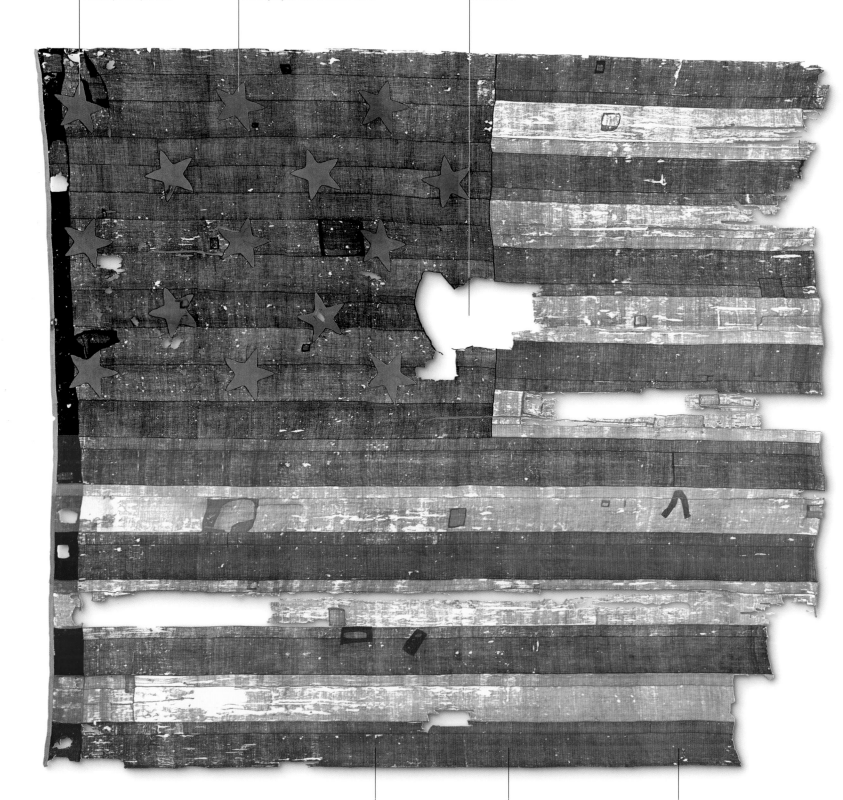

△ STAR-SPANGLED BANNER
The scale of the Star-Spangled Banner (or Great Garrison Flag) is impressive, even given the missing sections. It originally measured 9.1 x 12.8m (30 x 42ft), but over time snippets were given away as souvenirs, leaving it 2.4m (8ft) shorter.
Dimensions: 9.1 x 10.4m (30 x 34ft). **Date:** 1813.

MATERIALS
The flag is made of red, white, and blue lightweight wool fabric called bunting; the stars are white cotton.

STURDY FABRIC
The wool fabric was inexpensive, hard-wearing, and water resistant; it was frequently used to make flags until the mid-20th century.

STRIPES
The stripes are about 61cm (24in) wide, and are made from 35–46cm (12–18in) strips of bunting sewn together.

Star-Spangled Banner

The huge flag that inspired America's state anthem and became a national treasure

Baltimore, USA

△ **FORT McHENRY, BALTIMORE**
In this 19th-century print of Fort McHenry, the huge flag is clearly visible to the ships out in the harbour, from where it was seen by Francis Scott Key on the morning of victory.

On the morning of 14 September 1814, the garrison at Fort McHenry on the edge of Baltimore, Maryland, raised a huge flag to mark the American victory over the British in the Battle of Baltimore. Inspired by the sight of the flag and the hope of eventual victory in the ongoing War of 1812, Francis Scott Key wrote a poem called "Defence of Fort M'Henry". Set to the tune of "To Anacreon in Heaven", the new song became hugely popular under the title "The Star-Spangled Banner". It was adopted as America's national anthem in 1931.

The Great Garrison Flag

The flag known as the Star-Spangled Banner is what is known as a garrison flag – an oversized flag intended to be visible from a great distance. It would have flown from a flagpole around 27m (90ft) tall. Along with a smaller "storm flag" (now lost), it was commissioned by Major George Armistead, commander of Fort McHenry, from Baltimore flagmaker Mary Pickersgill. Aided by her daughter, nieces, and a young African-American

The Star-Spangled Banner is the only US flag to have more than 13 stripes

girl named Grace Wisher, Pickersgill stitched the two flags over a period of six to eight weeks. The garrison banner was made of English dyed woollen bunting and white cotton. Its 15 stars and 15 stripes reflected the then-current number of states in the Union; in 1818, the number of stripes on the US flag was limited to 13 in honour of the original colonies, with one star to be added for each newly admitted state. After being taken down, the flag was given to Armistead, and remained with his family for more than 90 years.

RESTORATION

In 1914, the Smithsonian Institution, to which the flag had been donated two years earlier, commissioned a flag restorer, Amelia Fowler, to preserve the banner. Fowler and her team sewed it to a linen backing using around 1.7 million stitches. It was then hung on display in the museum. Starting in 1999, the flag underwent a decade-long conservation process, including the removal of Fowler's stitches. Restorers worked in a purpose-built laboratory to clean the flag, document its condition, and undo harmful repairs. It was then fixed to a support backing and installed in a controlled display environment.

RESTORING THE FLAG, 1914

RESTORING THE FLAG, EARLY 21ST C

▷ MARTYR'S POSE
The outstretched arms of the man in white clearly evoke figures of the crucified Christ; he even has marks on his palms recalling Christ's nail wounds.

Scale

DISTORTION OF SCALE
The figure in the white shirt is kneeling, and if he stood up he would be gigantic compared with the others; Goya accepts this discrepancy for the sake of dramatic effect.

LANTERN
The scene is lit by an enormous lantern that harshly illuminates the most conspicuous figure.

EARTHY COLOURS
Goya uses predominantly earthy colours – greys, browns, dull greens – making the central figure in white and yellow stand out starkly.

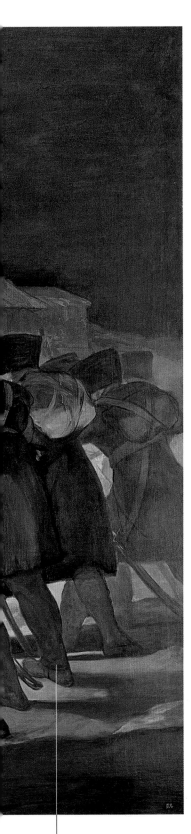

◁ THE THIRD OF MAY 1808
Goya is said to have used his fingers, knives, and rags when painting, as well as brushes, as part of his remarkable freedom of expression. **Dimensions:** 266 x 345cm (105 x 136in). **Date:** 1814.

The Third of May 1808

A harrowing depiction of a contemporary atrocity that broke new ground in painting in the early 19th century

Madrid, Spain

This shatteringly intense painting commemorates an appalling episode during the Peninsular War (part of the Napoleonic Wars of 1803–15), when Madrid was occupied by French troops. On 2 May 1808, the people of the city rebelled against the French, but the uprising was soon quashed and terrible reprisals were exacted in the form of mass executions. These began the next morning and continued into the night. After the French were driven out of Spain in 1814, Goya (sponsored by the Spanish government) produced two large paintings of the revolt, "to perpetuate by means of the brush the most notable and heroic actions and scenes of our glorious insurrection against the tyrant of Europe [Napoleon]". The first painting, *The Second of May 1808*, depicts brutal street fighting during the revolt, and this companion (*see opposite*) shows the ghastly aftermath.

Remorseless inhumanity
It is not known if Goya witnessed the bloodshed. Certainly he did not try to present a documentary-like reconstruction, but rather to convey the overwhelming

During the **Spanish Civil War** the painting was moved, for **safety**, to Valencia, Barcelona, and finally Geneva

horror of the executions, mixing patriotic fury with a sense of pity for the victims. He dispenses with all the heroic gestures and trappings that had traditionally been used in paintings of momentous historical events and instead strips the scene to essentials, contrasting the despair of the prisoners with the inhumanity of the faceless killers. Goya's technique is appropriately bold. Forms are distorted or simplified to suit the pictorial drama, and the handling of paint is raw and energetic.

FIRING SQUAD
The executioners stand closer to the victims than they would have done in actuality; the compression of space underlines the feeling of brutal force.

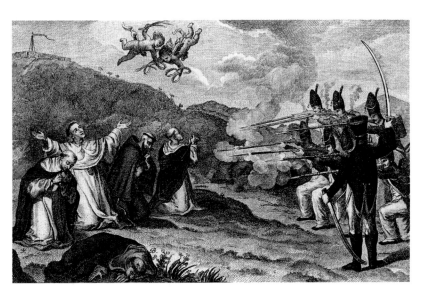

◁ POPULAR INSPIRATION
Goya based several elements of his composition on this print (1813) by Miguel Gamborino, which shows the killing of five Spanish monks by French soldiers. However, Goya transforms the print's tepid pieties into overpowering tragedy.

WANDERER ABOVE THE SEA OF FOG ▷
The painting is one of the finest examples of Friedrich's
taste for immense, mystical landscapes. Its unusual
vertical format emphasizes the upright form of the figure.
Dimensions: 98 x 75cm (38½ x 29½in). **Date:** c.1818.

Wanderer above the Sea of Fog

*The most iconic image of German Romantic art, celebrating
the awe-inspiring power and majesty of nature*

Dresden,
Germany

FRIEDRICH

Born in a town near the Baltic
coast of what is now Germany,
Caspar David Friedrich (1774–
1840) was raised in a strict
Protestant household. He
suffered early tragedies,
losing both his mother and his
brother prematurely, and this
contributed to his melancholy
temperament. After studying
in Copenhagen, Denmark,
Friedrich settled in Dresden,
Germany. There, he made
contact with a flourishing
circle of Romantic writers
and philosophers and, through
them, began to develop his
unique ideas about art. He took
up oil painting only in 1807,
but soon made a mark with his
hauntingly beautiful landscapes
and allegories.

Wanderer above the Sea of Fog is one of the most famous
paintings ever produced in Germany. Though based
on real places, the landscape is imaginary, composed
by Friedrich from sketches he had made in the Elbe
Sandstone Mountains in southeastern Germany. He
shaped these elements into a familiar format, using
one of his favourite devices, a *Rückenfigur,* or figure
seen from behind, leading the viewer into the painting.
The lone traveller stands on a rocky outcrop, surveying
a vast panorama, half-shrouded in mist.

This type of landscape, emphasizing the essential
insignificance of humanity when contrasted with the
awe-inspiring grandeur of the natural world, is a
typical feature of German Romanticism, in which man
was often represented as isolated and alone in nature.
Friedrich, in paintings that are imbued with spiritual
intensity, makes nature as much an emotive force as
human figures – in *Wanderer*, the drifts of mist heighten
the sublime grandeur of the landscape. Melancholic
and introspective, Friedrich believed that art should
be a reflection of the artist's "soul and emotion". His

The **lone wanderer** may be a **self-portrait**

landscapes have an allegorical dimension – here, the
distant mountain may signify salvation, with the rocky
terrain leading up to it symbolizing the trials of life. It
is unknown who the model for the wanderer was, but
some scholars believe it was an officer called Friedrich
Gotthard von Brincken, who was killed in action
against Napoleon around 1814: the picture may have
been commissioned as a patriotic memorial.

The real and the spiritual

Friedrich did not produce detailed preparatory studies
for his oil paintings, though he did employ three layers
of under-drawing – in chalk, pencil, and ink. He
visualized the precise composition in his imagination,
avowing, "The artist should paint not only what he has
in front of him but also what he sees inside himself."

△ **THE ZIRKELSTEIN**
The Zirkelstein is a wooded hill topped by a distinctive 40m
(130ft) high sandstone block, located in a mountainous zone
known in Germany as Saxon Switzerland. Friedrich travelled
there in 1818 to make detailed sketches for his painting.

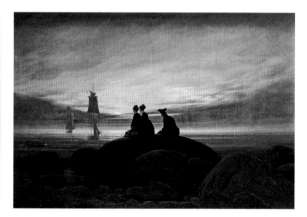

△ *MOONRISE OVER THE SEA*, 1822
With the magical light of the moon reflected in the sea, this
quiet painting lacks Friedrich's dramatic scenery and swirling
mists; rather, the sailing ships and three silhouetted figures in
the dreamy scene evoke a sense of deep yearning and mystery.

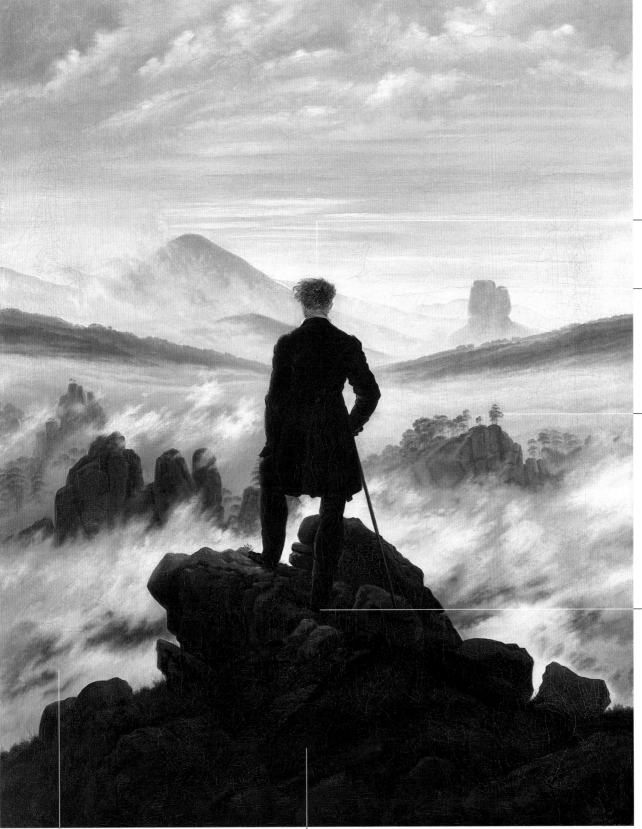

▽ SENSE OF WEATHER
The man's tousled hair is blown by the wind and his collar is turned up to keep out the cold.

MOUNTAIN PEAK
The distant mountains are identifiable. This is the Zirkelstein, in the Saxony region of Germany.

△ DISTANT TREES
The swirling fog makes it difficult to judge the distances portrayed. Only the tiny trees give an idea of the scale.

CONTRAPPOSTO
The man is standing in the contrapposto pose, with his weight on his right leg and his left leg slightly forward and bent, giving his figure a natural and aesthetically pleasing shape.

WAVES OF FOG
The fog, seemingly illuminated by light coming up from beneath the rocks, parts only to reveal further jagged peaks and crags.

ROCKY OUTCROP
The outcrop of rock on which the wanderer stands is a recognizable group of oddly shaped stones on the Kaiserkrone hill.

Scale

INSCRIPTIONS
The smaller of the two inscriptions is Hokusai's signature; the larger one, in the box, gives the work's title.

NEW BLUE
Hokusai made vivid use of Prussian blue, a new synthetic pigment from Europe. Although imports were generally forbidden, Dutch traders had limited access to Japan.

FOAM
The froth on the wave takes on the appearance of claws or tentacles threatening the three boats below.

Around **5,000** copies of *The Great Wave* were originally printed

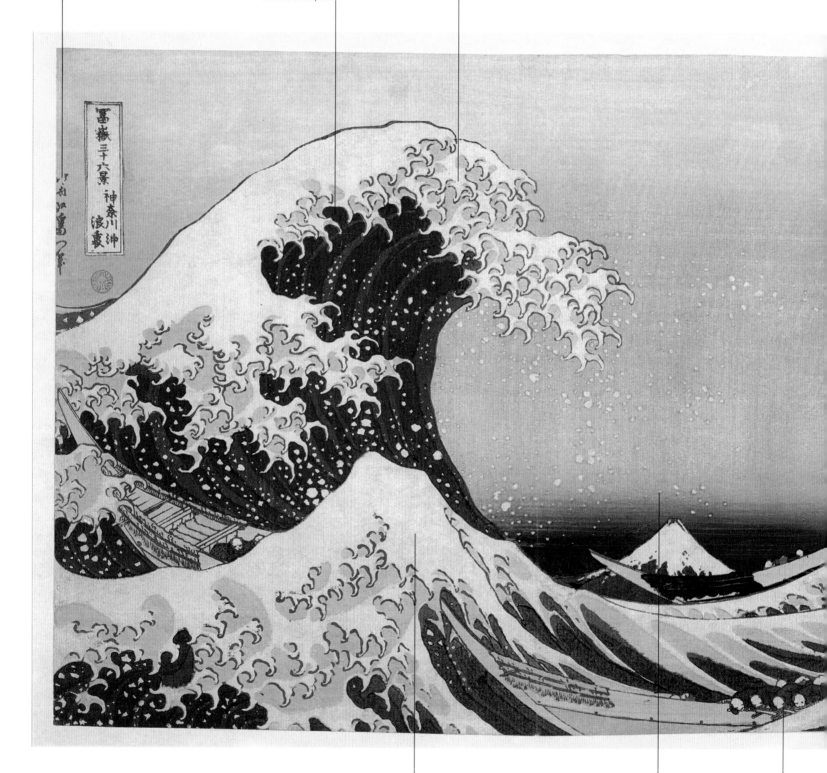

Scale

VISUAL ECHO
The foreground wave echoes the appearance of the snow-capped Mount Fuji.

VISUAL PUN
The spray from the wave creates the effect of snow falling over Mount Fuji.

FISHERMEN
The fishermen lie flat, desperately clinging on to their boats.

The Great Wave

The most famous of all Japanese prints, notable for its impact on European art in the late 19th century

Tokyo, Japan

The Great Wave is one of the best-known images in world art, familiar not only as a museum object but also from its endless use in advertising and popular culture. Also known as *Under the Wave at Kanagawa*, it is part of a series of prints by the Japanese artist Katsushika Hokusai ((1760–1849) entitled "Thirty-six Views of Mount Fuji", showing the sacred mountain from various viewpoints, in all seasons and weathers.

A towering menace

Japan's self-identity was long defined by its geography as a country of islands both protected and isolated by the sea; winds and waves were thought of as divine forces. Over the course of his decades-long career Hokusai created countless pictures of the ocean, including several images of a single gigantic wave, which crystallized into his *Great Wave* towards the end of his life. This great wave is not a tsunami but a rogue wave, towering over three slender fishing boats and visually encircling the tiny, distant form of Mount Fuji. Hokusai uses a European-informed sense of perspective to relegate the iconic mountain to the background, yet Fuji remains the still, calm focus to which the viewer's eye returns. Shades of dark Prussian blue emphasize the feeling of menace, while the white curls of froth, and the peaks and troughs in which the fragile boats are tossed, evoke the sea's tumultuous power.

The Great Wave contributed to the European craze for Japanese art in the 19th century known as Japonisme. Japanese prints appealed in particular to the Impressionists and Post-Impressionists, who were influenced by the characteristic bold, flat colours and vigorous patterning.

JAPANESE WOODBLOCK PRINTING

1 To create a traditional woodblock print, an artist made the initial design on thin paper. 2 Highly skilled craftsmen then glued the paper onto a wooden block and, following the outlines of the artwork, carved the image onto the surface through the drawing, which was destroyed in the process. 3 Ink was then applied to the block and covered with a sheet of paper. 4 The back of the paper was rubbed with a baren (flat pressing tool) to transfer the ink. A separate block was needed for each colour.

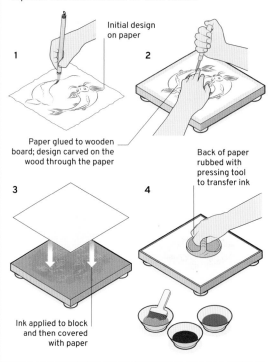

Initial design on paper

1

2

Paper glued to wooden board; design carved on the wood through the paper

Back of paper rubbed with pressing tool to transfer ink

3

4

Ink applied to block and then covered with paper

△ *THE GREAT WAVE*
Hokusai was in his 70s when he created this masterpiece, but he was still at the height of his powers. **Dimensions:** 26 x 38cm (10 x 15in). **Date:** c.1830–33.

△ *EJIRI IN SURUGA PROVINCE*
This print from "Thirty-six Views of Mount Fuji" shows Hokusai's gift for humour as travellers battle against the wind. A hat has been blown away, as have sheets of tissue paper, which women carried in their kimonos. The lively action contrasts with the serene mass of Fuji, evoked in a masterfully simple outline.

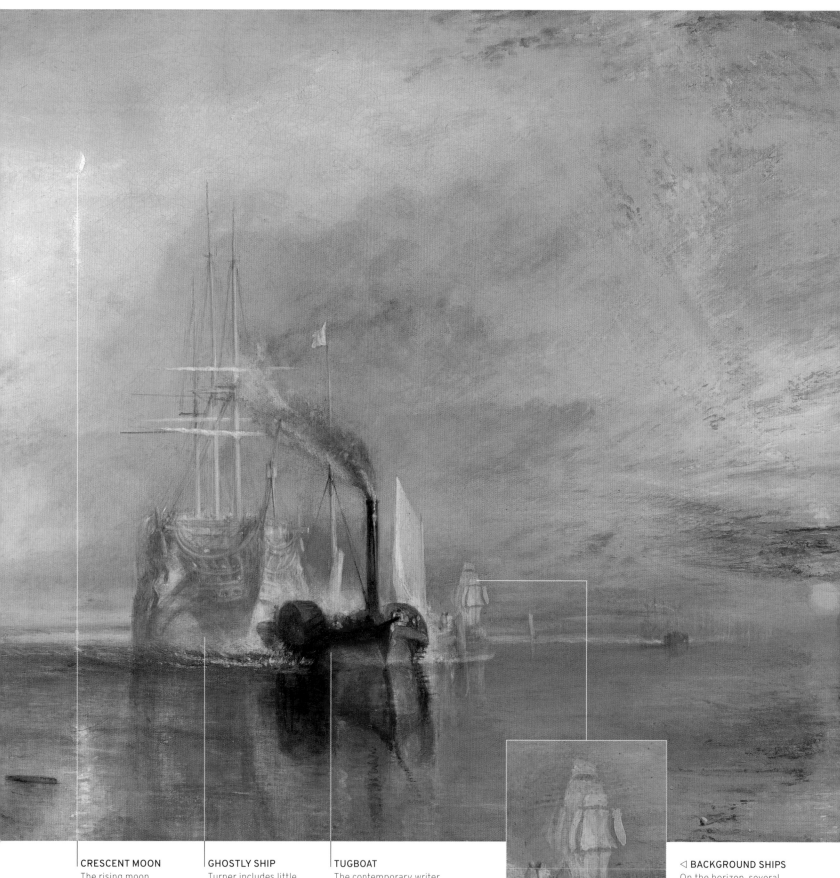

CRESCENT MOON
The rising moon is glimpsed at top left, its silvery light contrasting with the fiery sunset.

GHOSTLY SHIP
Turner includes little detail in the *Temeraire* and depicts it in pale gold colours, giving it the feeling of an eerie vision.

TUGBOAT
The contemporary writer WM Thackeray described the tug as "a little, spiteful, diabolical steamer", with something of the air of an executioner.

◁ **BACKGROUND SHIPS**
On the horizon, several ships are faintly depicted, including one under full sail – a poignant reminder of the *Temeraire*'s glory days.

◁ *THE FIGHTING TEMERAIRE*
The ship's journey to be broken up was made along the Thames, from Kent to London. The vessel was 40 years old and decaying. **Dimensions:** 91 x 122cm (36 x 48in). **Date:** 1839.

Scale

The Fighting Temeraire

A much-loved Victorian masterpiece that poignantly evokes Britain's heroic naval history

London, England

Turner referred to *The Fighting Temeraire* as "my darling" and it has always been one of his most famous and admired works. When the oil painting was first exhibited, at the Royal Academy in London in 1839, it was almost universally praised; since then it has often been cited as one of Britain's favourite paintings. Its popularity derives partly from patriotic sentiment, but mainly from its sheer splendour as a work of art.

Final voyage
The warship *Temeraire* was launched in 1798, its unusual name coming from a French ship, *Le Téméraire* (meaning daring or reckless), that had been captured in 1759. In 1805, the *Temeraire* played a leading role at the Battle of Trafalgar, but peace made many such vessels redundant. Some were used as prison hulks

or supply depots, but by 1838, 14 of the 27 British ships that had fought at Trafalgar had been sold for scrap. On 5–6 September that year, the *Temeraire* was towed along the Thames on its final journey to the breaker's yard – from Sheerness in Kent to Rotherhithe in London – and this is the event Turner depicts.

The artist imaginatively evokes the scene rather than trying to make a factual record. For example, the *Temeraire*'s masts had already been removed by this time, but Turner shows them still in place, increasing the dignity of the doomed ship in contrast with the prosaic functionality of the squat tugboat. Newspapers at the time commented on the haunting, elegiac quality of the painting, one saying that the ship's passing "affects us almost as deeply as the death of a human being".

Turner refused all offers to buy the painting

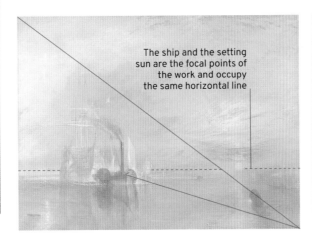

The ship and the setting sun are the focal points of the work and occupy the same horizontal line

△ **FORWARD MOVEMENT**
The viewer's eye is led diagonally, from the top left to the bottom right of the painting, across the line of mast-tops; the dark shapes of the tug and buoy suggest a second diagonal. These two lines form a point at the bottom right-hand corner, towards which the doomed ship appears to be moving.

SUNSET
Turner was famous for his glorious sunsets. A contemporary reviewer wrote that here the "blood red light" created a feeling of "sacrificial solemnity".

TURNER

Joseph Mallord William Turner (1775–1851) is generally regarded as the greatest of all British painters. He was almost exclusively a landscape painter but showed a range and power in this field unmatched by any other artist. Initially, he worked in watercolour, but soon took up oils, and developed a technique of immense freedom and subtlety in both media, with detail subordinated to ravishing effects of light and colour. He died wealthy and acclaimed.

SELF-PORTRAIT, C.1799

Samurai Armour

An outstanding 19th-century example of magnificently decorated black-lacquered samurai armour

Tokyo, Japan

Samurai (meaning "one who serves") were a class of elite soldiers and officials in Japan. They served feudal lords called *daimyo*, some of whom rose to become the shoguns (military leaders) who effectively ruled the country from 1192 to 1868. Members of the samurai caste followed a code of conduct known as *bushido* ("the way of the warrior"), embracing values such as loyalty, obedience, and self-sacrifice. Their armour and weaponry were crucial elements of their identity.

The design of samurai armour developed from the 12th century. Initially intended for cavalry use, it incorporated rows of small iron or leather scales (*kozane*), or larger plates for greater flexibility. Created from multiple elements – including a helmet (*kabuto*), a cuirass (*dō*), or chest- and backplate, shoulder guards (*sode*), and leg guards (*haidate* and *suneate*) – the armour protected its wearer from head to toe.

The complex construction of the impressive suit shown here is typical of samurai armour, which involved many different crafts, including blacksmithing and fine metalwork (such as engraving, chasing, and gilding), lacquering, braiding, and sewing. It is highly decorative and would have been time-consuming and costly to make. A suit could include several thousand individual *kozane*, each one lacquered upward of 10 times to protect the wearer from harsh weather. The braiding alone, often made from more than 1,000 strands of silk, used to lace the plates together, could take months to create. Samurai armour was a huge status symbol, reflecting both the taste and power of the *daimyo*.

By the 19th century, however, samurai armour was mainly ceremonial and, after imperial forces defeated the last shogun of Japan, Tokugawa Yoshinobu, in the Bioshin War (1868–69), samurai status was abolished.

CEREMONIAL ▷
SAMURAI ARMOUR
This magnificent example showcases the suit's decorative beauty and formidable nature. Samurai armour was the perfect combination of form and function.
Dimensions: life-size. **Date:** c.1850.

Samurai armour was worn in battle by both mounted and foot troops

SAMURAI SWORDS

Samurai used the elegant *katana* – a curved sword with a single-edged blade and long handle that is designed to be held with two hands. Made from a specialized Japanese steel called *tamahagane*, *katanas* are prized for the beautiful patterns resembling fingerprints, tree rings, and bark on the surface of the blade, formed by the repeated folding and forging of the steel. They were kept in simple, undecorated mountings (*shirasaya*) when not worn, but in ornate mountings (*koshirae*) – including hand guards, decorated scabbards with end caps, and hanging cords – when they were worn.

Hilt (*tsuka*) of white ray skin wrapped with string

Plain wooden scabbard (*shirasaya*)

KATANA SAMURAI SWORD ON LACQUER STAND, EDO PERIOD (1603–1867)

▷ **INDIVIDUAL ELEMENTS**
Some elements of Samurai armour were thought more essential than others in terms of protection. When fully suited, the warrior was covered from head to toe, while also having the flexibility needed to fight.

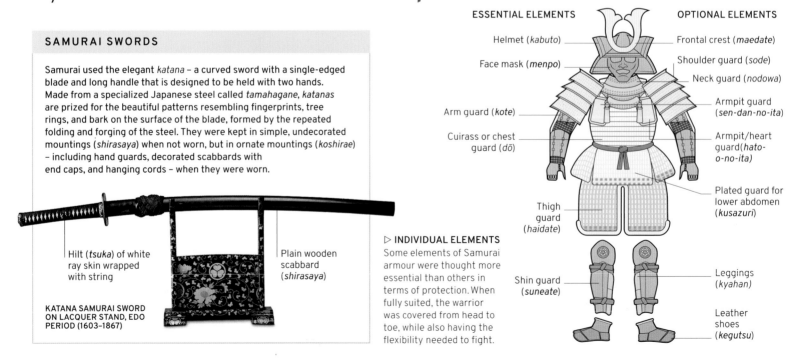

ESSENTIAL ELEMENTS

Helmet (*kabuto*)
Face mask (*menpo*)
Arm guard (*kote*)
Cuirass or chest guard (*dō*)
Thigh guard (*haidate*)
Shin guard (*suneate*)

OPTIONAL ELEMENTS

Frontal crest (*maedate*)
Shoulder guard (*sode*)
Neck guard (*nodowa*)
Armpit guard (*sen-dan-no-ita*)
Armpit/heart guard (*hato-o-no-ita*)
Plated guard for lower abdomen (*kusazuri*)
Leggings (*kyahan*)
Leather shoes (*kegutsu*)

△ GILDED CREST
The decorative chased metalwork crest (*datemono*) is said to imitate the deer antlers worn by a famous 15th-century samurai.

FACE MASK
Face armour (*menpo*) was designed to protect the wearer and scare the enemy; masks often featured moustaches made from real hair.

LIGHTWEIGHT LACING
The *sugake odoshi* or "sparse" lacing seen here was used to hold together solid plates of either iron or leather.

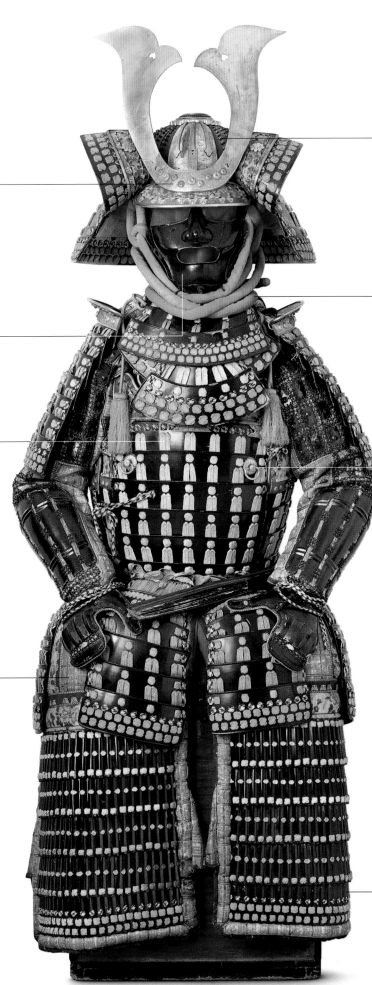

△ RIVETED PLATES
The helmet (*kabuto*) is composed of vertical plates riveted together.

CHIN CORD
The chin chord (*shinobi-no-o*) secured the helmet and the face mask to the wearer's head.

RING
Gilded copper or iron rings (*ageki no kan*) were used for attaching small identification flags or silk bows.

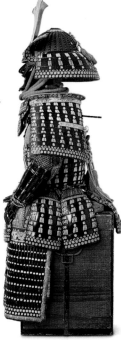

▷ SIDE VIEW
For display purposes, the individual pieces of armour are tied together around a metal armature, which sits on top of a box in which the suit is stored.

△ FABRIC
The armour featured several textile elements. Here, the decorative fabric – trellis-patterned silk and cotton or linen chintz (possibly from Europe) – to which the armoured plate was attached, is visible.

BLACK LACQUERED PLATES
The armour's iron (or sometimes leather) plates (*kozane*) were individually lacquered several times before being put together.

Scale

Ivory Coast/Ghana

Scale

Akan Gold-Weights

Beautiful 18th- and 19th-century brass weights used by the Akan communities of West Africa to weigh gold

From around 1400 to 1900, the Akan people of West Africa created gold-weights (known locally as *mrammuo*) for use in a well-established system for measuring their primary currency – gold dust and nuggets. The weights were made of brass, cast using the lost-wax method (*see p.164*). Holes could be drilled in the finished pieces or drops of solder or copper plugs added to ensure the the accuracy of the weight.

These tiny sculptures were highly detailed and intricate; earlier examples tended to be geometric, with the later ones figurative, representing people, animals, plants, and objects. They were inspired by the countless proverbs that the Akan people used (and still use) to communicate their culture, values, and stories (*see box*), and in this way transcended their immediate practical use as essential tools of the marketplace.

Sets of gold-weights were passed down as family heirlooms

GOLD-WEIGHT SYMBOLISM

Akan culture had a rich oral tradition of proverbs, many of which were communicated through the gold-weights. The meaning of these nonverbal communications could vary according to context, and who was speaking. They might recall a debt, or act as a warning or a token of friendship. Understanding these messages was key to creating successful trading relationships. The mythical *sankofa* bird, for example, which always looks backwards, means "it is wise to learn from hindsight", or "do not forget your roots". Today, it has become a powerful symbol of the reclamation of Black history, destroyed through slavery.

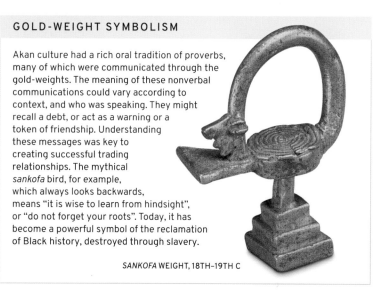

SANKOFA WEIGHT, 18TH–19TH C

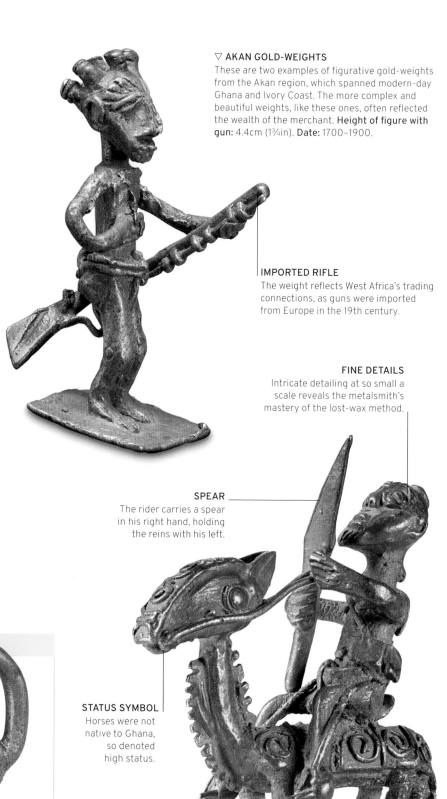

▽ **AKAN GOLD-WEIGHTS**
These are two examples of figurative gold-weights from the Akan region, which spanned modern-day Ghana and Ivory Coast. The more complex and beautiful weights, like these ones, often reflected the wealth of the merchant. **Height of figure with gun:** 4.4cm (1¾in). **Date:** 1700–1900.

IMPORTED RIFLE
The weight reflects West Africa's trading connections, as guns were imported from Europe in the 19th century.

FINE DETAILS
Intricate detailing at so small a scale reveals the metalsmith's mastery of the lost-wax method.

SPEAR
The rider carries a spear in his right hand, holding the reins with his left.

STATUS SYMBOL
Horses were not native to Ghana, so denoted high status.

Nkisi Nkondi

A 19th-century statuette made by the Kongo people and said to be home to a powerful spirit

Republic of Congo

In the religion of the Kongo people of the Congo region of Africa, a *nkisi* (plural: *minkisi*) is an object that houses a spirit. The assemblages that house these spirits are made collaboratively by carvers and religious specialists, or *nganga*. *Minkisi* come in many forms, including pots and cauldrons, but a *nkisi nkondi* – or power figure – takes the shape of a carved, often human, figure, as seen here, and represents a particularly aggressive type of *nkisi*, believed to be able to hunt down wrongdoers and cause or cure illness. Included in or on the carving is spiritually charged material known as *bilongo* – magical/medicinal substances that imbue the *nkisi* with its power. The *bilongo* are made of a variety of animal, vegetable, and mineral materials, each with a different purpose. Seeds may tell a spirit to replicate itself, white soil to invoke the support of the spirit world, and claws to incite the spirit to catch something. The *bilongo* are placed at key sites, including behind the eyes, in the stomach, around the jawline, and around the waist.

The *nkisi nkondi* evokes the spiritual force of law and order, and is used during consultations with a *nganga*, serving as a witness to oaths, in dispute resolution, and as an avenger or guardian if sorcery or wrongdoing is suspected. Nails, blades, and other sharp objects are driven into the object at each consultation to "activate" the spirit and urge it to take action over the issue in question; well-used *minkisi* end up bristling with hardware.

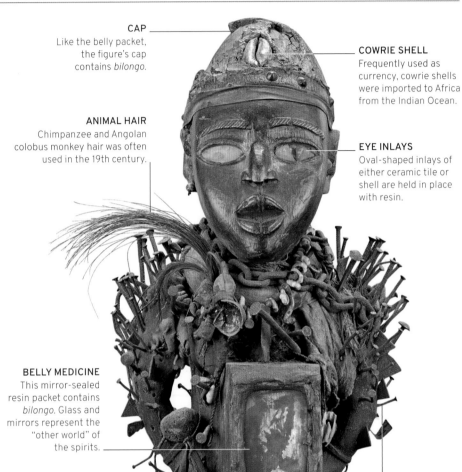

CAP
Like the belly packet, the figure's cap contains *bilongo*.

COWRIE SHELL
Frequently used as currency, cowrie shells were imported to Africa from the Indian Ocean.

ANIMAL HAIR
Chimpanzee and Angolan colobus monkey hair was often used in the 19th century.

EYE INLAYS
Oval-shaped inlays of either ceramic tile or shell are held in place with resin.

BELLY MEDICINE
This mirror-sealed resin packet contains *bilongo*. Glass and mirrors represent the "other world" of the spirits.

NAILS AND PEGS
Sharp items are driven into the figure by the *nganga* to awaken the spirit, and may represent the offence or dispute, and its severity.

BLACK COATING
The figure is covered in a black coating, possibly a tannic dye.

▷ **NKISI NKONDI**
This *nkisi nkondi* is assembled from wood, metal, glass, fabric, fibre, cowrie shells, bone, leather, gourd, hair, and feathers. Its human form reflects its ability to influence human affairs. **Height:** 72cm (28½in). **Date:** 1801–75.

Scale

KONGO RELIGION

In the traditional religion of the Kongo people, the cosmos is divided in two – this world and the spirit world of ancestors – above which lives the creator, Nzambi a Mpungu. When a person dies, they join the spirit world, unless they died a violent death, when their spirit roams the earth until avenged. A *nganga* can interact with these spirits using *minkisi*. As dogs are thought to be able to move between the worlds, *minkisi* may be shaped like a dog, or *kozo*, often double-headed: these are called on in particular to hunt out witches.

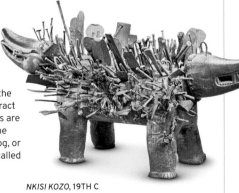

NKISI KOZO, 19TH C

Beijing, China

Peking Opera Robe

A 19th-century example of the exquisite craftsmanship of Peking opera's sumptuous, flamboyant costumes

Drawing on several Chinese opera traditions, *jingxi* (Peking opera) developed as a distinct art form after 1790 and gradually spread throughout China. In this highly conventionalized drama, the actors must master four key skills: song, speech, dance, and combat. There are also four fixed role types – *sheng* (male), *dan* (female), *jing* (male, painted-face characters), and *chou* (male, clowns) – each of which has its own conventions that dictate the actor's makeup and costumes.

Craftsmanship and luxury

Peking opera's costumes, called *xingtou*, are luxurious, colourful, and elaborately embroidered. They convey the character's gender, role, occupation, and social status to the audience and are based on clothing of

the Ming era (1368–1644), with influences from earlier dynasties. There are 20 main types of costume, including *mang* (ceremonial robe), *pei* (informal robe), and *kao* (armour for soldiers); these use 10 colours: red, green, yellow, white, black, pink, blue, purple, pale brown, and pale blue. The mix of style, colour, and pattern provides a complete picture of the character: a red *mang* – as in the 19th-century example shown here – suggests majesty and nobility; a black one a rough but honest character. Meticulously crafted in high-grade silk and hand-embroidered with coloured silks, including silver and gold, the robes were the work of artisans who were not only skilled in design and embroidery, but also had great knowledge of the fine arts and the complex symbolism of Chinese opera.

MAROON *MANG*
The use of darker red satin indicates that the character is older; bright red would indicate youth or middle age.

▷ **PEKING OPERA ROBE**
Peking opera audiences must be able to identify the performer's gender and status immediately – this *mang* was designed for a respectable male character of high rank. Hand-embroidered in silk, it would have been a costly item to produce. **Length:** 142cm (56in). **Date:** 1800–1900.

The robe's **complex** embroidery would have taken **several embroiderers many months** to complete

SATIN STITCH AND COUCH STITCH

Two techniques are central to the embroidery on Peking opera robes – satin stitch and couching. Working on small areas at a time with multistrand silk thread, the embroiderers use satin stitches – a series of long, flat stitches sewn closely together – to entirely cover a section with embroidery. These shapes may then be "couched" to help define the details. Couching is a "laid work" technique in which small stitches are used to secure a length of thread or cord, often wrapped silver or gold, to the surface of the fabric. This adds great depth, texture, and drama to the finished embroidery.

Loose thread to be stitched down

Small, holding stitch

COUCH STITCH

Long stitches used to cover the area

SATIN STITCH

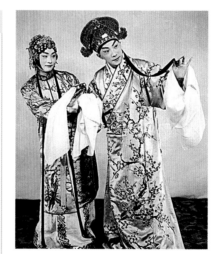

△ **MEI LANGFANG**
Celebrated opera performer Mei Lanfang (1894–1961), left, was renowned for playing female roles. The actor on the right wears a robe with distinctive white "water sleeves".

△ **JING CHARACTER**
The boldness and mightiness of *jing* characters, distinguished by their elaborate makeup, is reflected in the intense colours of their costumes.

SYMMETRICAL MOTIFS
Stylized peonies or chrysanthemums help to create a symmetrical pattern on both sides of the central motif.

THE DRAGON
The prominently displayed dragon suggests the robe may have been a costume for a minister in the imperial court.

EMBROIDERY
The *mang* costume is covered in couched embroidery in coloured silk, including gold and three shades of blue.

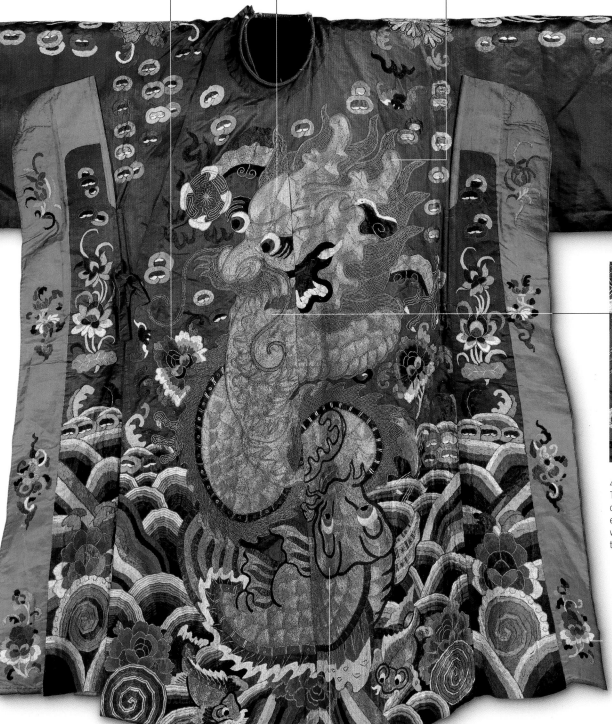

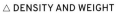

△ **DENSITY AND WEIGHT**
This detail of the dragon's head clearly shows the density of the embroidery, which adds significant weight to the robe, forcing the actor to move slowly and with dignity.

LUCKY MOTIF
The robe features several carp, the auspicious creature associated with leaping through the Dragon Gate – a metaphor for doing well in civil service examinations.

WATER HEM
The semicircles and diagonal lines on the robe's deep hem symbolize different forms of water, and serve to further identify the character.

Scale

▽ *OPHELIA*
The haunting work was painted by Millais when he was just 22. It epitomizes the new style introduced by the Pre-Raphaelites. **Dimensions:** 76 x 112cm (30 x 44in). **Date:** 1851–52.

◁ **ARTIST'S MODEL**
The model is Elizabeth Siddal, future wife of the English painter and poet Dante Gabriel Rossetti. Siddal later died by suicide (*see opposite, below*).

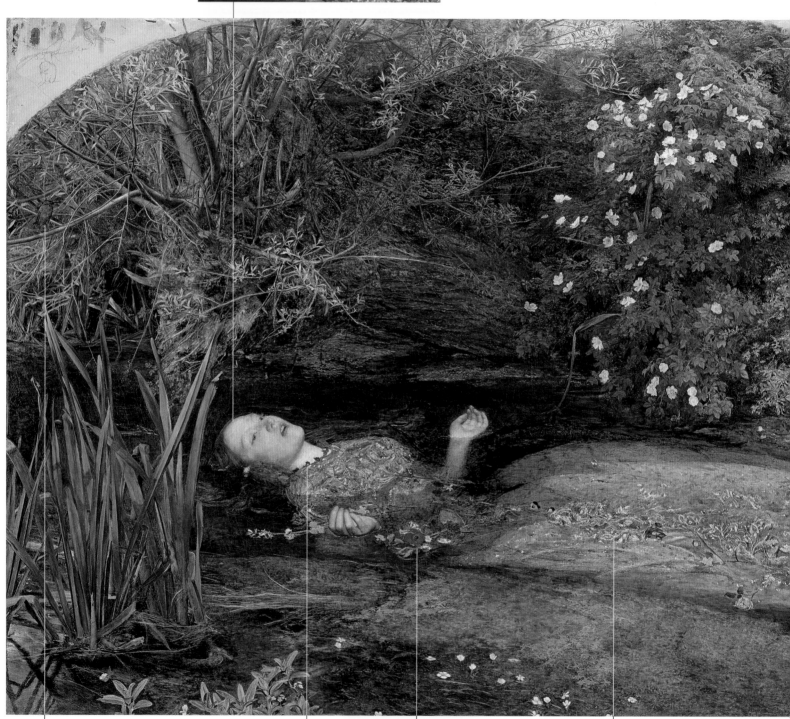

ROBIN
The inclusion of this bird is a reference to "For bonny sweet Robin is all my joy", one of the songs Ophelia had been singing.

NECKLACE
Ophelia wears a chain of violets around her neck. These flowers are associated with fidelity, melancholy, and early death.

◁ **POPPY**
Floating near Ophelia's right hand, there is a poppy, a traditional symbol of death.

DRESS
Millais purchased "an ancient dress, all flowered over in silver embroidery" for the picture. It cost him four pounds, "old and dirty as it is".

◁ **SKULL**
In the foliage next to the forget-me-nots, Millais added a shape that vaguely resembles the outline of a human skull.

Scale

Ophelia

One of the most famous pictures from Victorian England, painted from nature with an astonishing eye for detail

London and Surrey, England

John Everett Millais's *Ophelia* is probably the most beautiful painting produced by any member of the Pre-Raphaelite Brotherhood – a group that shocked Victorian art lovers by launching an attack on academic art, declaring it sterile and artificial. In its place, they advocated a return to the freshness and natural appeal of Early Italian art, before the time of Raphael (1483-1520), who was the archetypal academic painter.

Attention to detail

The subject matter is drawn from Shakespeare's play *Hamlet*. Ophelia, driven mad by grief, drowns herself. Distractedly, "she sang snatches of old tunes", before the weight of her brocade dress dragged her down. The Pre-Raphaelites were anxious, above all, to "study nature attentively". Accordingly, Millais painted the scene as if it were a real, rather than theatrical, event.

He spent several months by the River Hogsmill in Surrey, England, painting the phenomenally detailed background, before adding in the model, Elizabeth Siddall, from sketches that he had made in the studio. The flowers have symbolic meanings, borrowed either from Shakespeare or from Victorian manuals on the language of flowers. Thus, the pansies represent "love in vain", while the pheasant's eyes symbolize "sorrow".

Millais painted on a wet white ground and used a porcelain palette that could be wiped absolutely clean, so that his colours were never adulterated. This gave *Ophelia* its sharp, luminous quality, but it was a slow process, and Millais soon decided it was impractical to spend a whole day working on an area that was the size of "a five shilling piece". Fortunately, the jewel-like quality of the painting was readily apparent and it was sold long before it was actually finished.

Millais's model posed in a **tin bath** full of water, **heated** from underneath by **oil lamps**

▷ *BEATA BEATRIX, 1877*
Like Ophelia's, Siddal's death is linked to poppies (*see opposite: left and above*): she overdosed on laudanum, a poppy-based opiate. As a tribute, Rossetti portrayed her as Beatrice (the muse of his namesake, the poet Dante), holding the flowers.

MILLAIS

John Everett Millais (1829–1896) was a child prodigy, entering the Royal Academy Schools when he was just 11 years old. In 1848, he became a founder member of the Pre-Raphaelite Brotherhood. *Ophelia* is a shining example of the group's guiding principles, but Millais gradually adopted a looser, more popular style. He enjoyed a hugely successful career, producing book illustrations, society portraits, and sentimental pictures of children. He was probably the best-known British artist of his time and achieved such fame that he was made President of the Royal Academy. He was also awarded a baronetcy.

TITLE INSCRIPTIONS
The long red box gives the title of the series, while the square box next to it gives that of the print.

FAR BANK
The far bank of the river is almost lost in gloom, but buildings can be vaguely discerned.

△ OBLIQUE FORMS
Hiroshige often used dynamic oblique forms in his compositions, as here in the bridge and the tilted line of the horizon.

BOATMAN
In the middle distance a boatman propels a log raft to local timberyards.

TWO WOMEN
Identically dressed women brace themselves against the elements, their red dresses providing a splash of bright colour in an otherwise muted palette.

SIGNATURE
Hiroshige's signature is in the red box at bottom left; next to it, in the border, is the publisher's seal.

Scale

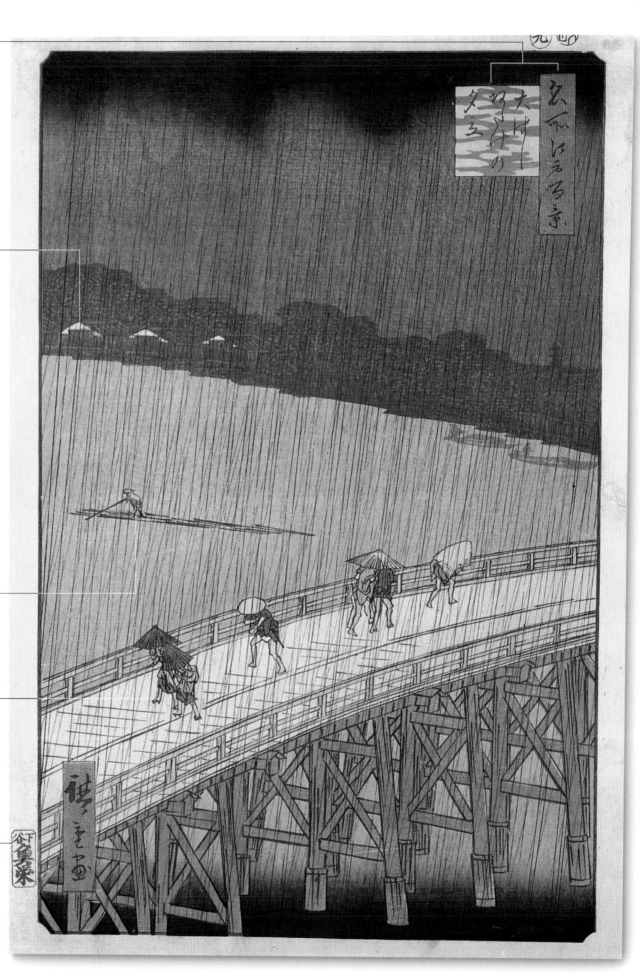

◁ *SUDDEN SHOWER OVER SHIN-OHASHI BRIDGE AND ATAKE*
Hiroshige created the striking effect of torrential rain by using two printing blocks cut with great skill to produce needle-fine parallel lines. **Dimensions:** 37 x 25cm (14¹/₂ x 10in). **Date:** 1857.

Tokyo, Japan

Sudden Shower over Shin-Ohashi Bridge

A masterpiece of Japanese printmaking that exerted a powerful influence on Van Gogh and other 19th-century European artists

Next to Hokusai (*see pp.268–69*), Hiroshige is probably the most revered of all Japanese printmakers, and the celebrated *Sudden Shower over Shin-Ohashi Bridge and Atake* is acknowledged as one of the summits of his art. He often depicted the sights he saw when travelling around Japan, but he was also endlessly inspired by the capital city, Edo (now Tokyo), where he lived all his life. The scene shown here is from his last, most ambitious series, "One Hundred Famous Views of Edo", and is recognized as the masterpiece of that series.

Scenes of everyday life
Hiroshige's work often features affectionate observations of ordinary people going about their daily lives, a subject typical of *ukiyo-e* ("floating world") prints, of which Hiroshige was a master. Here he shows two elegant ladies and several bare-legged men using umbrellas, a hat, and a straw mat to keep off a

Hiroshige was **renowned** for his skill at depicting **rain**

sudden summer downpour as they scurry for shelter across a wooden bridge over the Sumida River in Tokyo. The artist uses a technique known as *bokashi* to create a gradation of colour in the sky, evoking the menacing air of the storm through the gradual darkening of the Prussian blue. In the absence of geometric, Western-style perspective, this helps to create a sense of depth, along with the use of a high viewpoint and the diagonal of the bridge (*see opposite*). Hiroshige's print combines boldness of design with subtlety of atmosphere and ravishingly delicate colour.

HIROSHIGE

Utagawa Hiroshige (1797–1858) studied art under the *ukiyo-e* master Utagawa Toyohiro. Early in his career he combined artistic work with duties as a fire warden, but he passed these on to a family member. Hiroshige was versatile and prolific, but is renowned chiefly for landscapes, which he produced in numerous series. His other subjects included flowers, birds, and beautiful women – all popular themes at the time. He had an uneventful life, devoted to his work, and is said to have been gentle and genial in character. Hiroshige died before his major series "One Hundred Famous Views of Edo" was completed and it was finished by a pupil, running (in spite of the title) to 118 prints.

◁ *BRIDGE IN THE RAIN, VAN GOGH*
Many major European artists drew inspiration from Hiroshige's work, including Vincent Van Gogh, whose oil painting of a bridge in rain, made in 1887, is a copy of Hiroshige's famous print.

Sacred Eagle Feather Bonnet

A powerful emblem of leadership and Native American resistance to the influx of European settlers in the 19th century

Montana or North/ South Dakota, USA

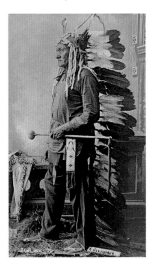

Feather bonnets are symbolic headdresses worn by Native Americans. Among the Plains Indians, they were worn only by leaders who had earned the greatest respect of their people. One of the most famous to have survived from the 19th century is this headdress belonging to Tȟatȟáŋka Iyotake, or Sitting Bull.

Symbol of resistance

Head of the Hunkpapa Lakota Sioux, Sitting Bull led the Native American resistance to the USA as it sought to confine indigenous peoples of North America into reservations from the 1860s, leaving their land for European settlers. In 1876, he led the Sioux to a major victory over US forces at the Battle of the Little Bighorn, known by the Lakota and other Plains Indians as the Battle of the Greasy Grass.

Sitting Bull's feather bonnet serves as a potent symbol of that resistance. The bonnet also represented the wearer's achievements in Lakota Sioux culture. The feathers come from the golden eagle, considered to be the greatest, most powerful of all birds, and a messenger between Man and the Creator. Eagle feathers were often given in recognition of acts of courage or honour that benefited the community. Skilfully crafted in the flaring bonnet style, in which the feathers fan out, Sitting Bull's bonnet recalls the rays of the sun, revered by the Plains Indians. It also shows European influence in the beadwork and cloth wrappings on the feathers, both of which are of European origin and were traded along the well-established Native trade routes even before Europeans began settling on the Plains in the 1850s.

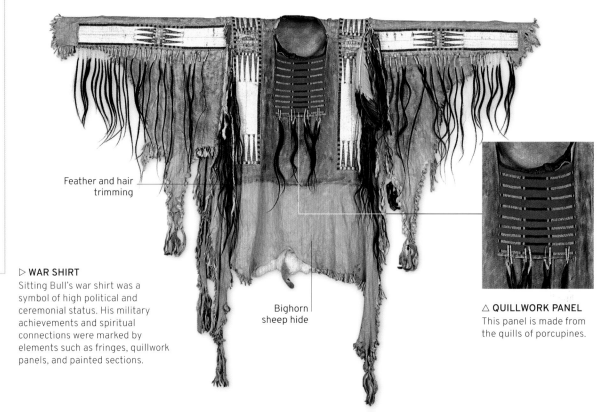

Feather and hair trimming

Bighorn sheep hide

▷ WAR SHIRT
Sitting Bull's war shirt was a symbol of high political and ceremonial status. His military achievements and spiritual connections were marked by elements such as fringes, quillwork panels, and painted sections.

△ QUILLWORK PANEL
This panel is made from the quills of porcupines.

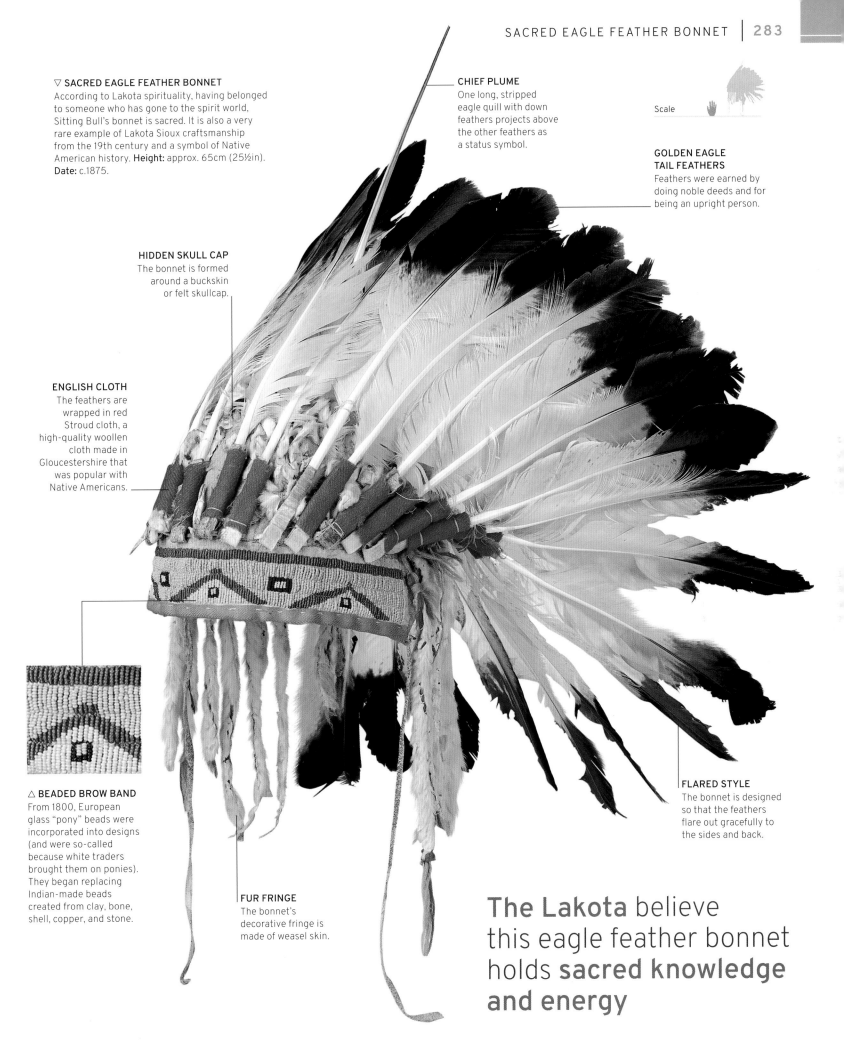

▽ **SACRED EAGLE FEATHER BONNET**
According to Lakota spirituality, having belonged to someone who has gone to the spirit world, Sitting Bull's bonnet is sacred. It is also a very rare example of Lakota Sioux craftsmanship from the 19th century and a symbol of Native American history. **Height:** approx. 65cm (25½in). **Date:** c.1875.

CHIEF PLUME
One long, stripped eagle quill with down feathers projects above the other feathers as a status symbol.

Scale

GOLDEN EAGLE TAIL FEATHERS
Feathers were earned by doing noble deeds and for being an upright person.

HIDDEN SKULL CAP
The bonnet is formed around a buckskin or felt skullcap.

ENGLISH CLOTH
The feathers are wrapped in red Stroud cloth, a high-quality woollen cloth made in Gloucestershire that was popular with Native Americans.

△ **BEADED BROW BAND**
From 1800, European glass "pony" beads were incorporated into designs (and were so-called because white traders brought them on ponies). They began replacing Indian-made beads created from clay, bone, shell, copper, and stone.

FUR FRINGE
The bonnet's decorative fringe is made of weasel skin.

FLARED STYLE
The bonnet is designed so that the feathers flare out gracefully to the sides and back.

The Lakota believe this eagle feather bonnet holds **sacred knowledge and energy**

Paris,
France

Dance at the Moulin de la Galette

One of the most joyful and ambitious works of Impressionism, painted at the height of the movement

The Moulin de la Galette was a dance hall in Montmartre, Paris. The name comes from an adjacent 17th-century windmill (*moulin* in French) and a type of pastry called a *galette* that was sold on the premises. At this time Montmartre was a working-class district, with a fairly rough reputation. It was much frequented by artists, and several famous painters depicted the mill or the dance hall. Renoir was living in the area when he painted this radiant picture, which was shown at the third Impressionist exhibition in 1877.

Capturing movement and light

Although the Impressionists attracted much critical abuse and often suffered financial hardship in their early careers, they also had admirers, and this painting was warmly praised at the exhibition. One newspaper reviewer wrote, "The painter has caught perfectly the raucous and slightly bohemian atmosphere of this open-air dance hall" and added that "the whole painting shimmers like a rainbow". Loose brush strokes and bright, vibrant colours bring to life the mixed crowd enjoying the open-air Sunday dance, while the capture of a moment in time is enhanced by Renoir's exceptional ability to convey dappled light.

Various friends and acquaintances of the artist are depicted in the painting and one of them, Georges Rivière, later provided a detailed description of the work. Rivière records that it was painted entirely on the spot, with friends helping Renoir to carry the large canvas there from his nearby studio every day. Most of the prominent figures in the painting can be identified thanks to Rivière's account.

◁ **THE WINDMILL**
The Moulin de la Galette was built in 1622, when Montmartre was still a village. In the 1830s the site developed into a café and dance hall, seen here around 1900.

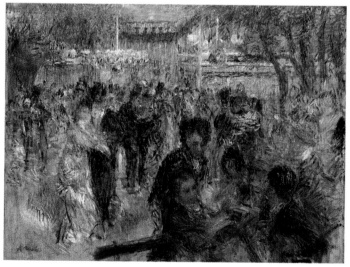

△ *LE MOULIN DE LA GALETTE* (STUDY), 1875–76
This vigorous oil sketch is a preliminary study for the finished work. It is rapidly painted with small, nimble strokes.

▽ *DANCE AT THE
MOULIN DE LA GALETTE*
As in many of his paintings,
Renoir openly celebrates
the beauties and pleasures
of life. **Dimensions:**
131 x 175cm (52 x 69in).
Date: 1876.

◁ **PROFESSIONAL MODEL**
The prominent dancing woman
is Marguerite Legrand, known
as Margot, a professional model.
Her partner, the tall figure with
the rakishly angled hat, is a
Cuban painter, Pedro Vidal de
Solares y Cárdenas.

▷ **MAN WITH A PIPE**
The man with a pipe is
Norbert Goeneutte, an artist
friend of Renoir. He wears a
top hat, but most other men
wear boaters, an indication
that this is not a high-class
establishment.

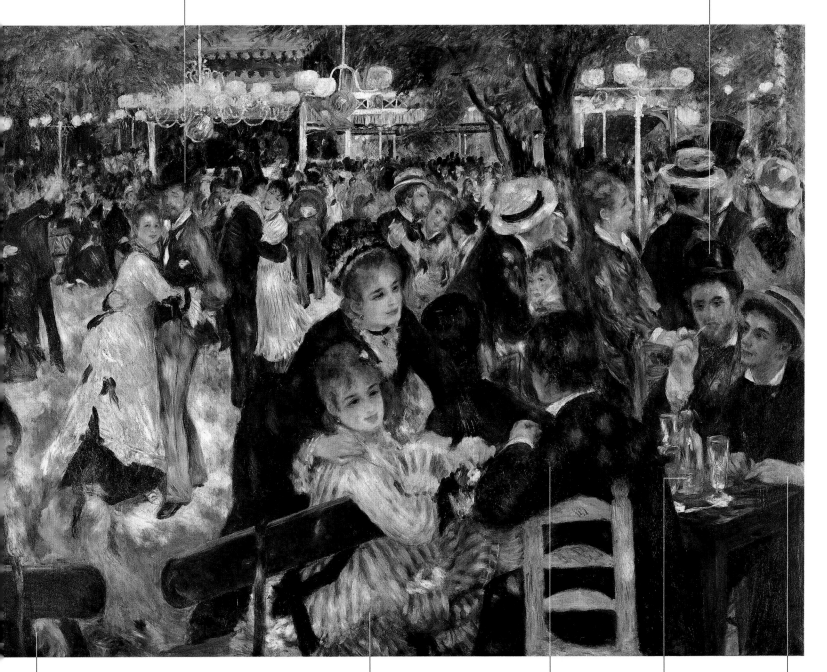

CROPPED FIGURES
At the left-hand edge of the
painting a figure is cropped,
a practice – recalling snapshot
photography – often seen in
Impressionist works.

EYE-CATCHING COSTUME
The beautiful pink-and-blue striped
dress is worn by the 16-year-old
Estelle Samary. The woman leaning
over her is possibly her elder sister,
Jeanne Samary, an actress.

DAPPLED SUNLIGHT
Sunlight streaming through
foliage boldly creates an
effect almost like polka dots
on the dark jacket of the man
in the foreground.

STILL-LIFE DETAIL
Renoir has
relished painting
the glassware on the
table with luscious
broad strokes.

ART CRITIC FRIEND
Georges Rivière
was one of Renoir's
closest friends and
one of the leading
literary supporters of
the Impressionists.
Appropriately, he is
shown pen in hand.

Scale

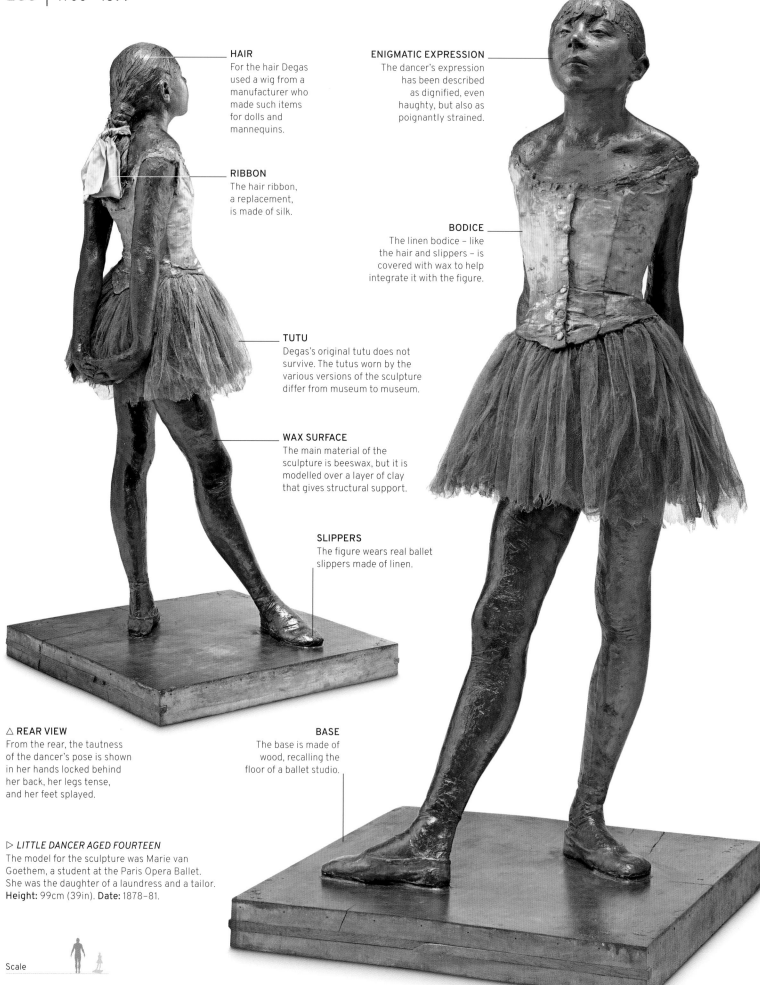

HAIR
For the hair Degas used a wig from a manufacturer who made such items for dolls and mannequins.

RIBBON
The hair ribbon, a replacement, is made of silk.

TUTU
Degas's original tutu does not survive. The tutus worn by the various versions of the sculpture differ from museum to museum.

WAX SURFACE
The main material of the sculpture is beeswax, but it is modelled over a layer of clay that gives structural support.

SLIPPERS
The figure wears real ballet slippers made of linen.

ENIGMATIC EXPRESSION
The dancer's expression has been described as dignified, even haughty, but also as poignantly strained.

BODICE
The linen bodice – like the hair and slippers – is covered with wax to help integrate it with the figure.

△ **REAR VIEW**
From the rear, the tautness of the dancer's pose is shown in her hands locked behind her back, her legs tense, and her feet splayed.

BASE
The base is made of wood, recalling the floor of a ballet studio.

▷ *LITTLE DANCER AGED FOURTEEN*
The model for the sculpture was Marie van Goethem, a student at the Paris Opera Ballet. She was the daughter of a laundress and a tailor.
Height: 99cm (39in). **Date:** 1878–81.

Scale

Little Dancer Aged Fourteen

One of the most original works of 19th-century sculpture, marking a breakthrough in the use of unusual materials

Paris, France

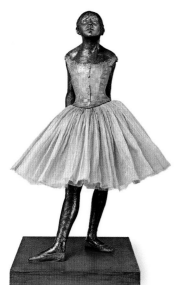

△ BRONZE CAST, 1922
The sculpture has traditionally been shown with a short tutu, but this replacement from 2018 is longer and fuller, closer to Degas's drawings.

Edgar Degas started making small wax figures in the late 1860s, and after his sight began to fail in the 1880s, sculpture became of increasing importance to him, his sense of touch compensating for the declining power of his eyes. These sculptures were mainly intimate, sketchlike works; *Little Dancer Aged Fourteen* is by far the most ambitious of them, and the only one he exhibited during his lifetime.

A quiet revolution in sculpture
Little Dancer was shown at the sixth Impressionist exhibition in 1881 and caused an uproar because of its originality in incorporating real clothes and accessories, such as human hair and linen ballet slippers. Some hostile critics compared it to a shop-window dummy or a doll, but others admired its inventiveness and its emotional insight in the way that it revealed the stressful impact of ballet training on an adolescent girl. After Degas's death, about 25

casts in bronze were made of *Little Dancer*, but the one shown opposite is the original wax, as exhibited in 1881. As wax is a fragile medium, the figure is supported by an internal armature, a skeleton of metal and wood around which Degas modelled the soft material (*see box*). The statue is now regarded as a key work in the history of sculpture. With it, Degas liberated the art from its traditional boundaries by demonstrating how any materials or techniques can be used if they serve the creator's purpose.

An **outraged** reviewer in the English journal *Artist* asked: "Can **art descend** lower?"

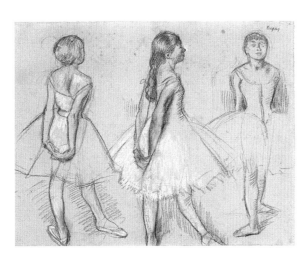

△ THREE STUDIES OF A DANCER, C.1878–81
Degas made numerous drawings of his model, Marie van Goethem, as he developed his ideas for the sculpture. Sometimes he concentrated on details such as the head or the feet, but here he was concerned with the general pose.

INTERNAL CONSTRUCTION

X-rays have shown the complex internal armature that Degas used. Lead pipes form the basic structure, over which the body was shaped and bulked out. The central torso consists of wood, with cotton padding bound over it with rope, and an extra layer of padding over the stomach. The entire structure was covered in clay and then a final layer of wax. The arms were attached separately, using paintbrushes as a framework.

- ☐ CLAY
- ■ ROPE
- ■ WIRE
- ▦ LEAD PIPES
- ▦ COTTON PADDING
- ■ COTTON PADDING OVER WOOD
- ■ PAINTBRUSHES
- ■ WOOD

▽ *BATHERS AT ASNIERES*
The painting was rejected by the official state Salon and shown instead at the newly founded Salon des Indépendants, where anyone could exhibit on payment of a fee.
Dimensions: 201 x 300cm (79 x 118in).
Date: 1884.

INDUSTRIAL FEATURES
In the background are a railway bridge and factory chimneys at Clichy on the opposite bank of the river.

▷ BOURGEOIS COUPLE
A bourgeois couple (*see caption opposite, bottom right*), as indicated by the top hat and parasol, is being ferried across the river in a boat that bears the French flag.

BOWLER HAT
The bowler hat and other features of clothing indicate that the figures are workmen or from the lower middle class.

COLOUR AND TECHNIQUE
The painting features dabs of colour and cross-hatched patterns, which are particularly evident in the treatment of the grass. Seurat added Pointillist details later, notably in the orange hat (*right*).

EXPRESSIONLESS FACES
Seurat gives little expression to the faces, being more interested in the figures' placement in the composition than in their individuality.

LA GRANDE JATTE
The clump of trees at upper right is on the tip of the island of La Grande Jatte, the setting for Seurat's next major painting (*see below, right*).

Scale

Bathers at Asnières

A key work of late 19th-century painting, marking a reaction against Impressionism's focus on the fleeting moment

Paris, France

Bathers at Asnières was the first major painting exhibited by the French artist Georges Seurat (1859–1891). Painted when he was just 24 years old, it depicts ordinary people, possibly factory workers, relaxing on a hot summer's day in an industrial suburb of Paris. Each figure is shown isolated and absorbed in their own thoughts. The painting is remarkable for its large size, imposing composition, and innovative use of colour, as well as for the manner in which it captures the heat and stillness of the day. The picture made little impact when it was first exhibited, but it contained the seeds of momentous future developments in art.

A radical departure

Seurat admired the Impressionists' use of colour and light (*see pp.284–85*) and, as evident here, he shared their great interest in subjects from everyday contemporary life. However, he rejected Impressionist spontaneity and informality in favour of a more methodical and structured approach, making numerous preparatory drawings and oil sketches as he developed his elaborate compositions (*see below, left*).

Seurat was particularly concerned to apply scientific principles to the use of colour in painting. In *Bathers at Asnières* he began to develop a technique of using small touches or dabs of pure colour in such a way that they create a more vibrant effect than if the colours had been physically blended together. Many other painters (including, briefly, Van Gogh) experimented with this technique, which developed into Pointillism (*see below*), and Seurat's work stands at the head of Post-Impressionism, the broad movement in which artists moved away from the naturalism of Impressionism to explore new ways of depicting the world.

REWORKED PASSAGE
Around 1887 Seurat slightly amended the painting, reworking the orange hat in the Pointillist (dotted) technique he had developed.

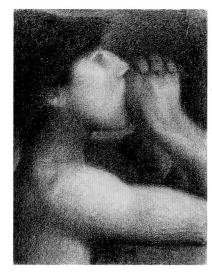

△ **CONTE CRAYON STUDY, 1883–84**
In this magnificent preparatory study for *Bathers at Asnières*, Seurat shows a man cupping his hands as if in the process of hailing someone.

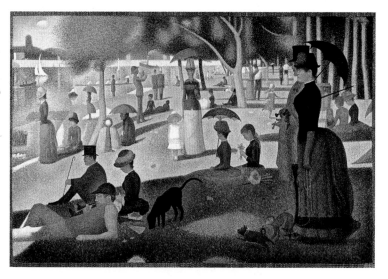

△ *A SUNDAY AFTERNOON ON THE ISLAND OF LA GRANDE JATTE*, 1884-86
In *Bathers at Asnières*, Seurat shows working-class men lounging on a grassy bank by the River Seine, but here he depicts the bourgeoisie in all its finery on a nearby island in the same river. Completed two years after *Bathers*, this work is painted with tiny dots of colour, which, if seen from a distance, blend together.

SEEDHEAD
Texture was crucial to
Van Gogh. In some areas,
such as the seedheads, the
paint is applied very thickly.

CYCLE OF LIFE
Van Gogh painted the
flowers throughout their
cycle, without discarding
dead or wilting ones.

GREEN AND YELLOW
In this version of
Sunflowers, green is
virtually the only other
colour apart from yellow.

△ **SYNTHETIC PIGMENTS**
Newly available synthetic
pigments, such as chrome
yellow, allowed Van Gogh
to produce great vibrancy
of colour. However, in recent
years they have caused
some of his works to fade.

EXPRESSIVE FLOWERS
The nodding flowers with
their thick, bendy stems
bring life and animation
to the picture.

SIGNATURE
Van Gogh placed his
signature on the vase
so that it looked like
the potter's mark.

JAPANESE INFLUENCE
Under the influence of
Japanese prints, Van Gogh
used firm, thick outlines
when delineating objects.

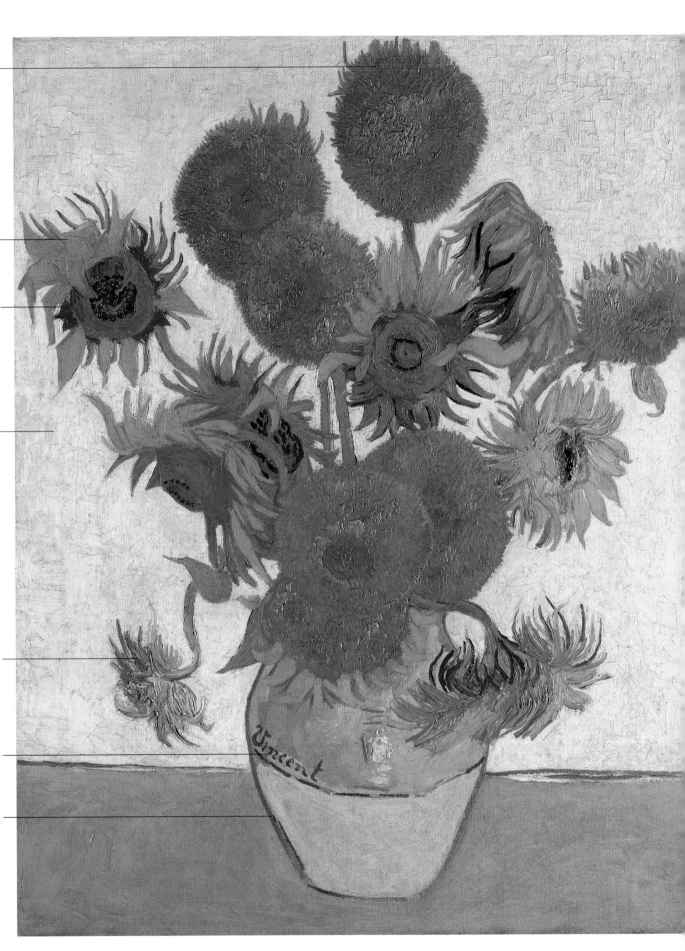

Scale

◁ *SUNFLOWERS*
This is probably the finest of the series of sunflowers Van Gogh produced in the summer of 1888. He was inspired by the light, bright Impressionists' palette and the colours, simplicity, and clarity of Japanese prints. The work is remarkable for its texture and intense colouring.
Dimensions: 92 x 73cm (36¼ x 28¾in).
Date: 1888.

Sunflowers

Van Gogh's best-loved painting and one of the most famous images in Western art

Arles, France

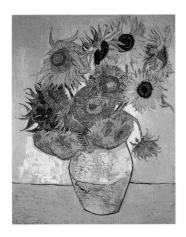

△ *SUNFLOWERS*
This is the third of four paintings in the sunflowers series that Van Gogh produced in Arles in summer 1888. In this version, he uses a distinctive blue-green background to contrast with the yellow flowers.

In the summer of 1888, Dutch artist Vincent Van Gogh (1853–1890) painted a series of pictures of sunflowers with the aim of decorating the walls of a house in Arles, in the South of France. These paintings have since become recognized as among his most iconic, representing the point at which the various strands of his style coalesced, unleashing the immense burst of creativity that consumed him in his final years.

Composition and technique
The works are admired above all for their bold use of texture and rich, intense colouring, made possible by the vibrant synthetic pigments such as chrome yellow that had only recently come on the market. Van Gogh worked at a furious pace on several of these canvases at once, at a time of unusual optimism in his life, after fellow-artist Paul Gauguin agreed to visit him in Arles.

The first three oil paintings in the series contrast blues and yellows; the backgrounds of two of them are in different shades of turquoise while the other is deep blue. In the fouth painting (*see opposite*), often considered one of the finest in the series, the composition is restricted to a single main colour, yellow, used in different shades and in combination with green. The surface is rough from the use of thick impasto (layered paint), giving a three-dimensional effect in some parts; in other areas, paint is far more thinly applied. One of the most dynamic aspects of this life-affirming painting is its dazzling light yellow background, which seems to leap out from the canvas. The work was highly unconventional in its day, when flower pictures tended to be decorative, with smooth surfaces, considerable variation in colour, and perfect blooms – Van Gogh's flowers differ in every respect.

At Van Gogh's **funeral**, friends placed **sunflowers** on his **coffin**

THE STUDIO IN ARLES

In February 1888, Van Gogh left the gloom of a Parisian winter and headed for Arles, in the South of France, where he rented rooms in a yellow house with green shutters. His spirits were immediately lifted by the region's warmth and bright colours, which reminded him of Japanese prints (he described Arles as his "Japan of the South"). He hoped that other progressive artists might join him there, forming a new artists' colony – but in the end only Gauguin visited him. During this period, Van Gogh added the last, crucial and highly distinctive component of his personal style – a rich and intense colouring.

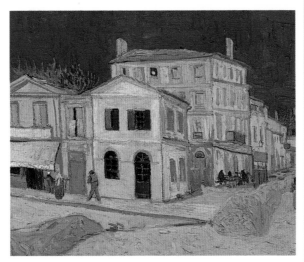
THE YELLOW HOUSE (1888), ARLES

△ *VINCENT VAN GOGH PAINTING SUNFLOWERS*
Paul Gauguin made this portrait in December 1888, after having stayed with Van Gogh in Arles. Van Gogh later commented that Gauguin's painting depicted him "extremely tired and charged with electricity".

THE CHILD'S BATH ▷
The painting shows the boldness and vigour that was praised by fellow artists, including Paul Gauguin.
Dimensions: 100 x 66cm (39½ x 26in). **Date:** 1893.

The Child's Bath

An intimate family scene by one of the leading female participants in the Impressionist movement

Paris, France

The US artist Mary Cassatt never married or had children, but her favourite subject was a mother and child. Like her friend Edgar Degas (*see below, left, and pp.286–87*), she avoided conventional academic poses, instead, as in *The Child's Bath*, depicting figures in attitudes that suggest snapshots of the real world.

Tenderness and intimacy

Cassatt's ability to convey the awkwardness and plumpness of young bodies is evident in this painting, as in other of her works (*see below*) – few artists have matched her skill and inventiveness in this respect. This is one of her most famous pictures, showing her at the height of her powers, when she combined great strength of design with delicacy of detail.

The painting depicts a young girl sitting on her mother's lap having her feet washed in a basin. The unusual angle, whereby the viewer looks down on the scene from above, emphasizes the sense of intimacy in the painting. Earlier in her career Cassatt had used the light colours and sketchy brushwork that were typical of Impressionism, but by the time she painted this work she had developed a firmer, more linear style. In this, and in her preference for unorthodox, close-up viewpoints, she was influenced by Japanese prints, a large exhibition of which she saw in Paris in 1890. She was so captivated by the exhibition that she soon embarked on a series of 18 colour prints that she described as being made "in imitation of Japanese art", as illustrated here.

△ *MARY CASSATT*, EDGAR DEGAS, C.1880–84
Degas was Cassatt's artistic mentor and she described his work as having changed her life. In this oil portrait, Degas shows his friend sitting informally holding some cards.

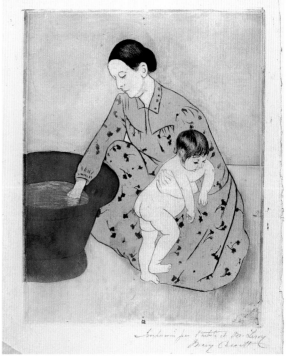

△ *THE BATH*, MARY CASSATT, 1891
In the early 1890s, Cassatt made a series of colour prints that show the Japanese influence in her work. In this example, a woman holds a child while checking the heat of the bathwater.

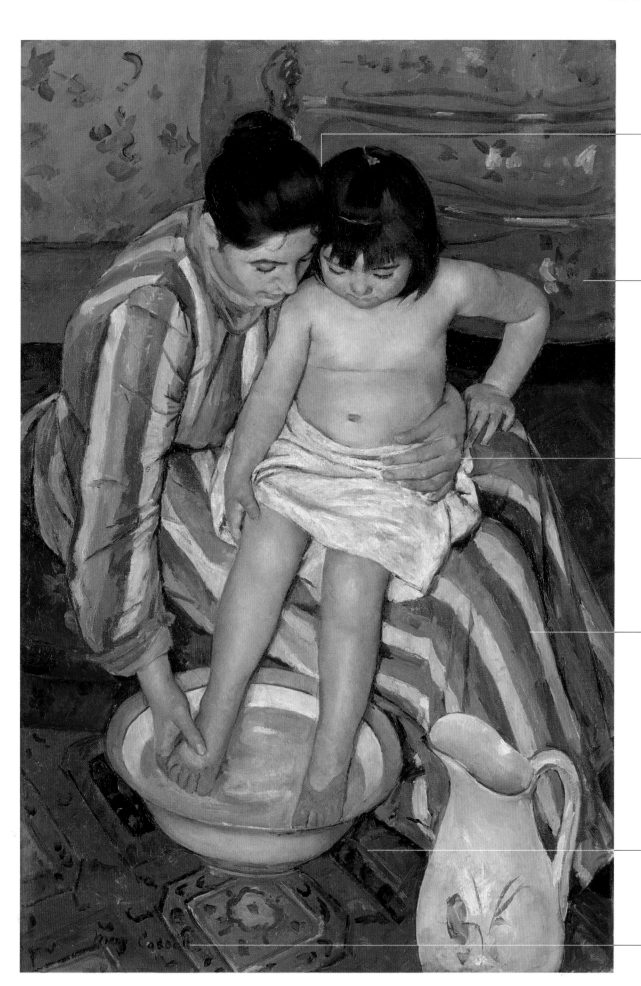

Scale

HEADS TOUCHING
The two heads brush against one another, helping to create a feeling of lovingness. Although Cassatt depicted children with great tenderness, she never lapsed into sentimentality.

LIVELY BRUSHWORK
The background furniture and wallpaper are loosely depicted with energetic daubs of paint.

UNUSUAL VIEWPOINT
The high viewpoint and closeness of the figures to the front of the picture give the viewer a sense of intimacy, as if standing over the scene.

STRIPED DRESS
The bold, striped dress is a superb example of Cassatt's ability to create eye-catching effects.

CARPET
The floral and geometric motifs of the carpet are part of the vigorous patterning that is such a conspicuous feature of the painting.

SIGNATURE
Cassatt's signature blends in with the patterning of the carpet.

▽ **PICTORIAL QUILT**
In the quilt, biblical scenes are juxtaposed with real-life events. **Dimensions:** 175 x 267cm (68½ x 105in)
Date: 1895–98.

DARK DAY
New England's "Dark Day" occurred on 19 May 1780, when darkness fell in daytime and people were obliged to light candles.

PATCHWORK
The base of the quilt is formed of small pieces of fabric stitched together into 15 panels.

◁ **COMPLEX APPLIQUE**
The cosmic bodies – stars, suns, and so on – are made from tiny pieces of fabric cut in sharply pointed forms and sewn together by hand.

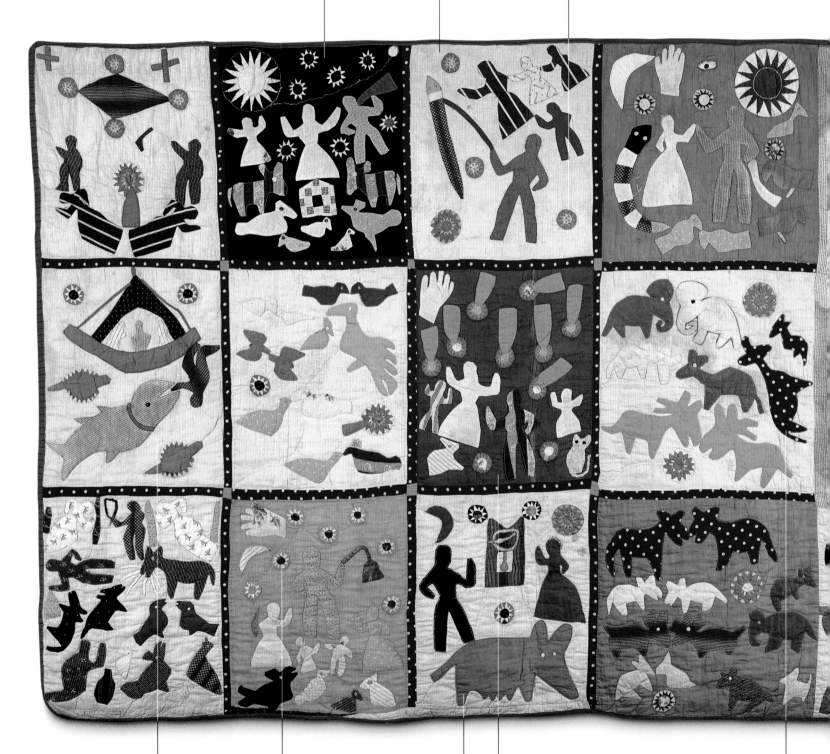

OLD TESTAMENT SCENE
Jonah is cast overboard from the ship and swallowed by the whale sent by God to save him; turtles swim around.

CELESTIAL BODIES
Stars, meteors, the sun, and the moon provide a recurring motif that brings the panels together.

BETTS THE PIG
This is "the independent hog which ran 500 miles from Georgia to Virginia, her name was Betts".

LOCAL EVENTS
Powers depicts the meteor shower of 13 November 1833, with people reacting in fear, and God's hand protecting them.

MOVEMENT
The patterned material and irregularly positioned figures lend a sense of motion.

BAPTISM
This panel portrays John baptizing Christ and the spirit of God descending in the form of a dove.

Scale

Pictorial Quilt

A powerful example of visual storytelling folk art by a 19th-century African-American woman

Athens, Georgia, USA

Just two quilts by Harriet Powers survive – the Pictorial Quilt and the Bible Quilt – but these are recognized as two of the most accomplished examples of 19th-century quilting from the American South. Powers was born into slavery in Athens, Georgia, in 1837; she was emancipated at the end of the Civil War in 1865, and ran a small farm with her family. Her two quilts are made of cotton, and are hand and machine sewn using patchwork and appliqué, in which shapes are cut from fabric and sewn onto the base.

Unable to read or write, Powers created her own visual language in her remarkable works. While most contemporary quilts were pattern-based, she broke with convention and created narrative scenes. As seen in the extraordinary Pictorial Quilt – more complex thematically than the earlier Bible Quilt – she used her own distinct style, perhaps influenced by West African textiles, cutting figures from patterned or coloured cloth and setting them on a contrasting plain background.

Symbolic stitching

For all their apparent simplicity, the images in the 15 panels of the Pictorial Quilt draw on both Bible stories and the orally transmitted stories of the African-American community to create a compelling "sermon" on punishment and redemption. Here, Job, Jonah, the Apocalypse, and Jesus sit beside natural phenomena, such as a meteor storm, and local tales of rich sinners, and a pig that ran 800km (500 miles) from Georgia to Virginia. This pig may be a reference to the route followed by escaped slaves before the Civil War, adding a further layer of meaning to Powers's work.

The **quilt** features a fish, camels, elephants, **"gheraffs"**, lions, chickens, a pig, turtles, a mule, and an **apocalyptic beast**

THE HISTORY PANELS

Five panels depict historical events, some that occurred before Powers's own lifetime. In her own words (abridged), these are: **1** The dark day of May 19, 1780. The seven stars were seen 12N. in the day. The sun went off to a small spot and then to darkness. **2** The falling of the stars on Nov. 13, 1833. The varmints rushed out of their beds. **3** Cold Thursday, 10 February, 1895. A woman frozen while at prayer. All blue birds killed. **4** The red light night of 1846. A man tolling the bell to notify the people of the wonder. **5** Rich people who were taught nothing of God. Bob Johnson and Kate Bell of Virginia.

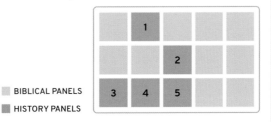

BIBLICAL PANELS
HISTORY PANELS

NEW TESTAMENT SCENE
This shows the Crucifixion: the sun turns dark, blood red and water runs from Christ's side, while Mary and Martha weep at his feet.

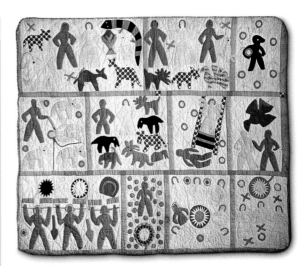

△ **BIBLE QUILT**
The Bible Quilt is admired for its bold style and innovative inclusion of living creatures, not conventionally depicted in quilts. Bible scenes include the Garden of Eden and the Holy Family.

TA MOKO PANEL ▷
Tene Waitere's carved wooden panel
masterfully brings together the two
worlds of Māori traditional craft and
European art. **Height:** 78cm (31in).
Date: 1896–99.

Wellington,
New Zealand

Tā Moko Panel

A striking carved wooden Māori panel from the late 19th century, featuring traditional tā moko facial decoration.

At the time this iconic panel was commissioned by the Colonial Museum of New Zealand in 1896, many of the traditional Māori woodcarvers had adopted a more European style of carving to appeal to the tastes of European buyers. Master carver Tene Waitere (1854–1931), however, chose to continue the Māori tradition and incorporate modern European elements into it. Neither pandering to the market nor stubbornly resisting change, he created an innovative modern style that was distinctively New Zealand.

Blend of cultures

The three heads of the Tā Moko panel, two male and one female, are instantly recognizable as Māori because of their facial tattooing – the "tā moko" of the title – yet they are realistically carved in a style that is untypical of Māori art. Rather than the traditional stylized tiki (mythical human-like figure), Waitere presents highly polished, shaven heads, to clearly show the patterns of facial decoration.

The panel is nevertheless firmly rooted in the "whakairo" tradition of wood carving, placing the heads against a background of typical Māori patterns and manaia (mythical animal) figures. Panels such as this, carved in the wood of the native kauri and totara trees, featured in communal Māori meeting houses, and similar designs appear on the prows of boats. More than merely decorative, they are rich in symbolism, and carry a narrative of tribal culture and history. In this way, Waitere's Tā Moko panel can be appreciated as symbolic of the culture of modern New Zealand, blending old and new, Māori and European.

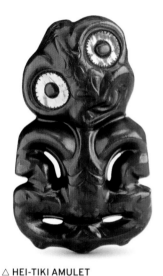

△ **HEI-TIKI AMULET**
This 18th-century hei-tiki amulet –
a Māori charm valued for its magical
powers – is carved from pounamu,
or greenstone. Tools fashioned out
of greenstone were traditionally
used for whakairo carving.

Special rituals accompanied the felling of trees used for **whakairo** (carving), as the **wood** represented the **god of the forest**

TA MOKO

Traditional Maori tattooing, tā moko, is more than mere decoration: the various patterns and symbols and their positions are indications of the wearer's rank and ancestry. The authority of a chief, for example, would instantly be recognized and acknowledged by his distinctive moko. Full facial tattoos were normally reserved for men, while women tended to have less extensive moko around their lips and on their chins. Traditionally, the moko was created using a bone chisel, or uhi, to make deep cuts into the skin, and then tapping burnt pigments into the wounds. Unlike the flat surface retained when tattooing with needles, the moko consists of grooves that are scarred as well as dyed.

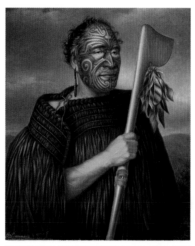

TAMATI WAKA NENE, GOTTFRIED LINDAUER, 1809

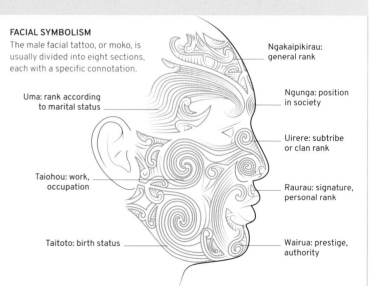

FACIAL SYMBOLISM
The male facial tattoo, or moko, is
usually divided into eight sections,
each with a specific connotation.

Ngakaipikirau:
general rank

Ngunga: position
in society

Uma: rank according
to marital status

Uirere: subtribe
or clan rank

Taiohou: work,
occupation

Raurau: signature,
personal rank

Taitoto: birth status

Wairua: prestige,
authority

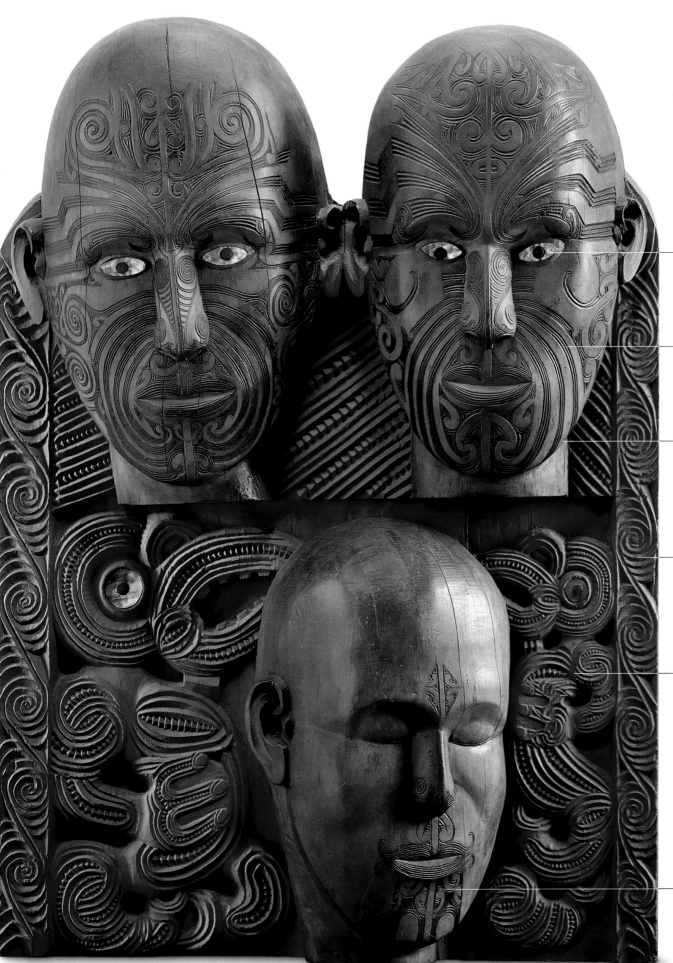

BRIGHT EYES
The eyes of the two male heads and of the creatures behind the female head are embellished with mother-of-pearl inlay.

BLACK LINES
The traditional designs are cut in grooves and picked out in black, as in the tā moko process.

REALISTIC STYLE
The faces are represented in a realistic way that is a departure from traditional whakairo wood carving.

SPIRAL DECORATION
The panel is framed with a pattern of swirling spirals similar to those on the upper two heads.

TRADITIONAL DESIGNS
The detailed background uses traditional Māori designs: lines and dots on the upper panel, stylized manaia (mythical animal) designs on the lower.

FEMALE TATTOOS
Women were traditionally tattooed only on the lips, the chin, and sometimes the nostrils.

Giverny, France

The Water-Lily Pond

An Impressionist gem that marks the beginning of Monet's love affair in paint with the beautiful water garden he created at his home

This is **one** of **18 versions** of this view in **varying light conditions** that **Monet began** work on in 1899

In 1883 Monet settled at Giverny, a village on the River Seine about 80km (50 miles) northwest of Paris. When he moved there he was in his early 40s and beginning to prosper. He had always loved gardens, but now for the first time he had the means to create one specially to suit his tastes, and over the next few years he transformed the area in front of his large rented house into a showpiece of colourful flowers.

Shimmering colours

By 1890 he was wealthy enough to buy the house, and in 1893 he bought an adjacent plot, which he developed into his famous water garden, centred on a large water-lily pond. Monet did not start painting the pond until

1899, but the following year he exhibited 12 paintings of the garden, including *The Water-Lily Pond* seen here, at the gallery of his dealer, Paul Durand-Ruel, in Paris.

Once he began to paint the pond, Monet grew ever more absorbed by it. In the exquisite composition seen here, he represents the water garden as a whole, with trees and reeds forming a dense, lush framework for the bridge, which floats above the water. The viewpoint seems to shift between looking up at the elegant curve of the bridge and down on the surface of the pond. Evoked with Monet's characteristic short, thick brush strokes and daubs of colour, the red and white flowers of the water lilies form lively, flickering patterns against the cool colours of the water and foliage.

MONET

Although he occasionally worked on other subjects, Claude Monet (1840–1926) is famous chiefly as one of the greatest of all landscape painters. A central figure of Impressionism, he was the most single-minded of its exponents in his devotion to their ideal of painting out of doors. By working in this way he aimed to capture what he called "the most fleeting effects" of light and atmosphere. In spite of failing eyesight he continued painting until the end of his life, by which time he was a nationally revered figure.

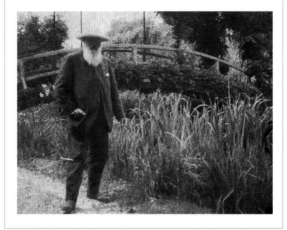

▷ *WISTERIA AT KAMEIDO TENJIN SHRINE*, **HIROSHIGE, 1856**
Monet owned a copy of this enchanting Japanese print by Hiroshige (*see also pp.280–81*), which was a likely inspiration for the Japanese-style bridge over his pond.

Scale

WEEPING WILLOW
At top left is a weeping willow, its foliage suggested with broad vertical strokes of green, yellow, and blue.

DENSE BACKGROUND
Monet made the background foliage look denser than it was in reality, creating a sense of luxuriant enclosure.

BRIDGE
The gently curving bridge that Monet had built over the pond was inspired by similar structures in Japanese prints.

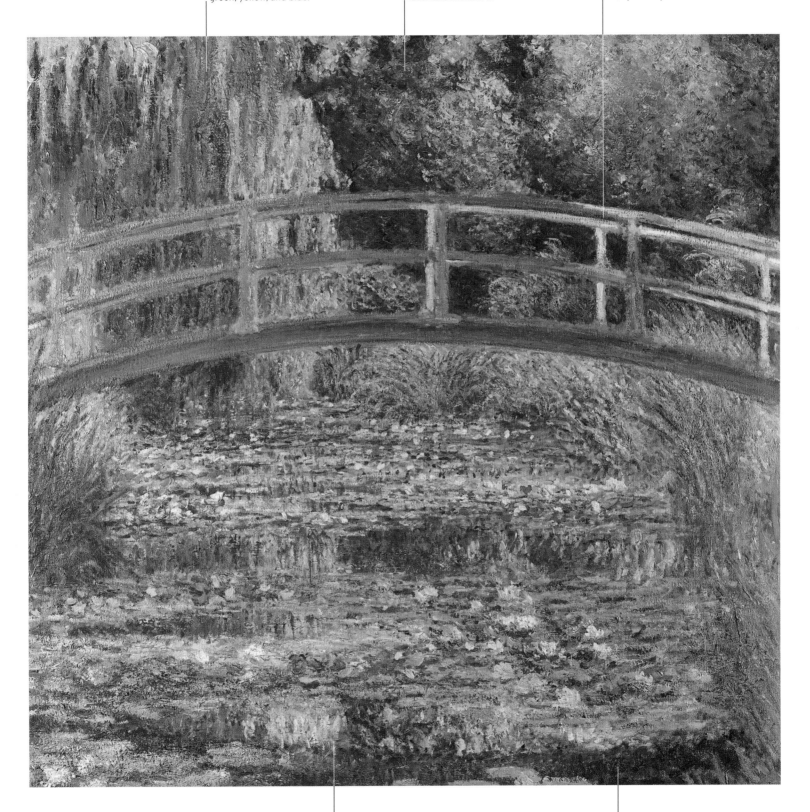

△ *THE WATER-LILY POND*
Monet initially cultivated water lilies without any thought of painting them – "then, suddenly, I had the revelation of the magic of my pond". **Dimensions:** 88.3 x 93cm (34¾ x 36¾in). **Date:** 1899.

REFLECTIONS
The dark horizontal reflection of the bridge modified by the vertical yellow reflections of the trees shows how closely Monet observed the scene and how subtly he depicted it.

SIGNATURE
Monet signed and dated the painting in the same dark red as the undersides of the lilies, in contrast with the prevailing greens.

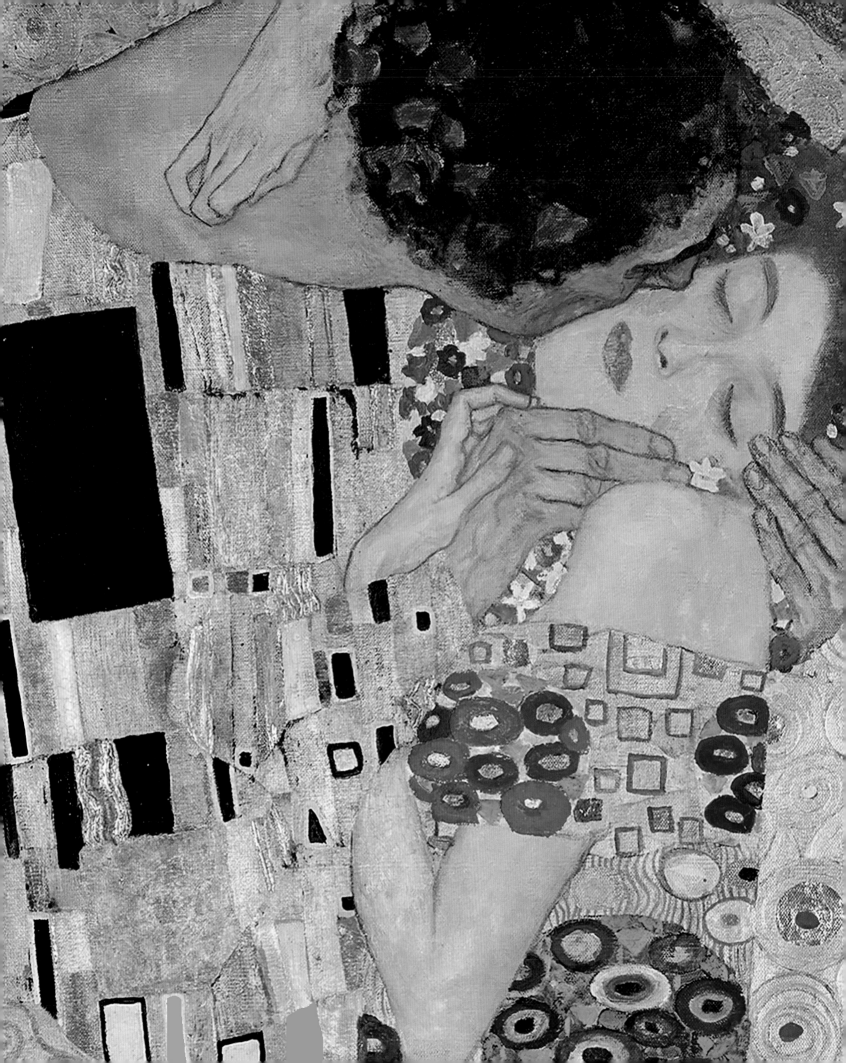

1900 – Present

The 20th century was a time of unprecedented change as two world wars brutally transformed society and culture. The objects from this period present an interesting mix. There are touches of the opulent world of earlier times in the Fabergé eggs of the Russian Empire, and the British Crown Jewels, but these sit alongside the mass-produced world referenced in art by Andy Warhol and his peers. The human capacity for destruction is captured by Picasso's painting of the bombing of Guernica and by Anne Frank's heartbreaking diary, but other achievements show a capacity to break free of convention to create new worlds – for example, in Surrealist and abstract art and theatre – and to reach beyond Earth and touch the moon itself.

Fabergé Imperial Eggs

Astoundingly intricate and ornate works of jewel-encrusted decorative art that are among Russia's most revered treasures

St Petersburg, Russia

FABERGE

Peter Carl Fabergé (1846-1920) was the greatest Russian goldsmith of the late 19th and early 20th centuries. Under his direction, the House of Fabergé produced hundreds of exquisite works, including cigarette cases, desk equipment, and animal sculptures, as well as the astonishing Imperial Easter Eggs that were created for the Russian royal family.

Between 1885 and 1916, the Russian luxury jewellers House of Fabergé, St Petersburg, created 50 Easter eggs for the Romanov tsars Alexander III and Nicholas II. Created as gifts for their wives and mothers, each egg was crafted from the most expensive materials, including platinum, gold, precious gems, and crystal. Together, the eggs demonstrated a tremendous range of skills, including enamelling, miniature painting, clockwork, metal casting, gilding, and carving.

Each Fabergé egg also featured a "surprise". Inside the first egg – the enamel Hen Egg – was a gold yolk that opened to reveal a gold chicken containing a miniature diamond replica of the imperial crown and a ruby pendant. The tsar and tsarina were so pleased with it that they gave Peter Carl Fabergé and his craftsmen freedom over the design of all future imperial Easter eggs. Fabergé subsequently created ever-more elaborate designs, many of which reflected the history, passion, and sentimentality of the Russian royal family.

Sentiment and ingenuity

The selection of eggs shown here includes some of the finest and most intriguing made by Fabergé – all were commissioned by Nicholas II as gifts for his wife, Alexandra Feodorovna. The Trans-Siberian Railway Egg, for example, hides an astonishing clockwork locomotive, just 2cm (¾in) long, pulling four carriages (*see beow*). Among the most sentimental eggs (*opposite*) are the Rosebud Egg, the first given by Nicholas to Alexandra, which is set with diamond Cupid's arrows; the delicate Rose Trellis Egg; and the Alexander Palace Egg, adorned with portraits of the couple's five children and containing a model of their home. The Bouquet of Lilies Clock Egg features a clock, where time is marked not on a traditional face, but on a rotating dial. Its surprise (now missing) was a ruby pendant.

Green enamel overlay decorated with acanthus leaves

The central silver section is inscribed "The Great Siberian Railway in the year 1900"

The chapel coach is based on a real travelling chapel dedicated to St Olga, the namesake saint of the emperor's eldest daughter

The train is wound with a key to run on clockwork

◁ **TRANS-SIBERIAN RAILWAY EGG**
Many believe that the ingenuity and beauty of this fabulous objet d'art has never been surpassed. Fabergé's imperial eggs also marked the last years of imperial Russia. **Height:** 26cm (10¼in). **Date:** 1900.

Scale

▷ ROSEBUD EGG

This scarlet translucent-enamelled egg is adorned with diamonds and a portrait of the emperor. The enamelled rosebud inside once contained a diamond-set crown and a ruby pendant. **Height:** 7.4cm (3in). **Date:** 1895.

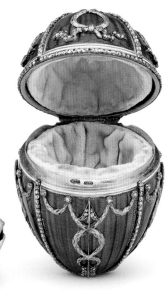

Yellow enamelled rose petals

▷ BOUQUET OF LILIES CLOCK EGG

The egg is a working clock in the French Louis XIV style, whereby a single arrow-shaped diamond clock-hand points to the time on a rotating dial. **Height:** 27cm (10½in). **Date:** 1899.

CROWN OF LILIES
The clock is crowned by a bouquet of Madonna lilies with tinted gold leaves and stems and carved white onyx flowers. The flowers' pistils are each set with three tiny diamonds.

DIVISIONS
The egg is divided into 12 sections by diamond-studded strips. The gold base is engraved and overlaid with translucent yellow enamel in a technique called guilloché.

DIAL
A white enamel clock dial, with hours marked in diamond-set Roman numerals, rotates around the egg.

▷ ALEXANDER PALACE EGG

Made of nephrite (a type of jade) inlaid with gold and gems, the egg contains a tiny gold, silver, and enamel model of the imperial residence. **Height:** 11cm (4¼in). **Date:** 1908.

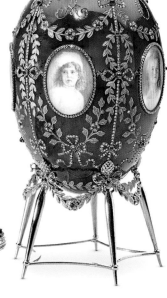

Replica of Alexander Palace, near St Petersburg

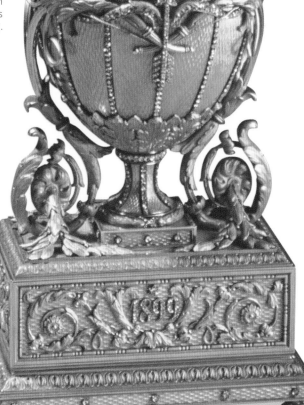

Pink enamel rose with green leaves

▷ ROSE TRELLIS EGG

This egg is made from pale green enamel covered with a latticework of diamonds and enamel leaves and roses; it has portrait diamonds at top and bottom. **Height:** 7.7cm (3in). **Date:** 1907.

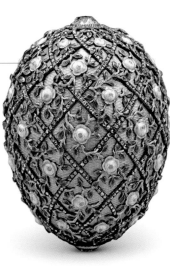

The Thinker

One of the most famous of all works of sculpture, casts of which are found throughout the world

Paris, France

Sculptor Auguste Rodin never specifically said what his muscular *Thinker* was thinking about, but the figure is so powerful and memorable that it has become a timeless, universal symbol of introspection or creative dreaming, adopted and parodied in countless ways, both serious and frivolous. In its combination of strong, muscular physique and contemplative pose, *The Thinker* embodies both quietude and potential for action.

The statue was intended to sit over the lintel of a pair of huge bronze doors called *The Gates of Hell* that Rodin was commissioned to make in 1880 for a new museum of decorative arts in Paris. Based on Dante's epic 14th-century poem *Inferno*, the doors were never cast in Rodin's lifetime, but he developed several of their components into independent sculptures, including *The Thinker*. The figure thus originated as a man looking down on the tormented circles of Hell.

The Thinker was first cast in bronze in 1884 and monumental (larger-than-life) versions were made from 1904 onwards. Rodin wanted his work to be widely distributed, and he authorized the production of smaller versions, which were made available to private collectors.

A **larger-than-life** cast of *The Thinker* marks the **grave of Rodin** and his **wife** at Meudon, Paris

▽ **THE THINKER**
Rodin said of this figure, "he thinks not only with his brain ... but with every muscle of his arms, back, and legs, with his clenched fist and gripping toes."
Height: 180cm (71in). **Date:** 1904.

LOWERED HEAD
The figure looks downward partly because it was planned to be positioned at the top of *The Gates of Hell*; the undefined treatment of the hair likewise reflects the fact that the figure was intended to be seen from below.

EXAGGERATED UPPER BODY
The shoulders are massive and the arms unnaturally long so that they would appear in correct proportion when viewed from below.

MICHELANGELO'S INFLUENCE
One inspiration for *The Thinker* was probably Michelangelo's tomb of Lorenzo de' Medici in Florence, which features a deeply pensive seated figure with his hand raised to his face.

VIGOROUS SURFACES
Rodin's lively handling, which creates a highly textured effect, contrasts with the smooth finish often found in sculpture by his contemporaries.

BASE
The base is inscribed with Rodin's name and the mark of the Alexis Rudier foundry in Paris, where the sculpture was cast.

Scale

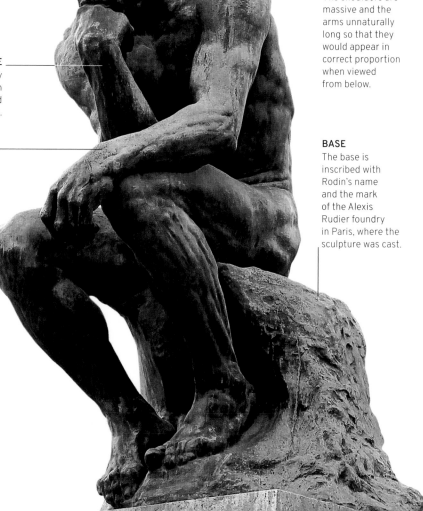

RODIN

French sculptor Auguste Rodin (1840–1917) struggled to achieve success early in his career, when he earned his living mainly as an ornamental mason. It was not until he was in his late 30s that he began to make a mark in the art world, but by about 1900 he was widely acclaimed as the world's leading sculptor. His large output included public monuments, allegorical figures, and portrait busts. He was also a prolific draughtsman. His work is remarkable for its vigour and emotional intensity.

Group IV, The Ten Largest, No. 7, Adulthood

A spectacular work by an unconventional Swedish painter who has been claimed as the "mother of abstract art"

Stockholm, Sweden

This huge painting is part of a group of works that were produced as an attempt at communicating ideas from a supposed spirit world. The creator of these bold, brilliantly coloured paintings, Swedish artist Hilma af Klint (1862–1944), was deeply interested in the occult, and during a séance in 1904 she believed that she was contacted by a spirit being called Amaliel, who asked her to paint pictures "on the astral plane" that would "proclaim a new philosophy of life". She began work in 1906 and over the next decade produced almost 200 paintings in fulfilment of her "great commission".

The paintings are divided into several series on various themes. "The Ten Largest" deals with the different phases of life, from infancy to old age. The seventh, shown here, is an ecstatic evocation of adulthood in full flower, depicting leafy or petal-like forms, spiralling tendrils and threads, and colourful, amoebic shapes. While the images hint at meaning – and af Klint produced detailed explanations of her complex symbolism – the immediate effect is one of a swirling fantasy world unconstrained by reality.

During af Klint's lifetime, her groundbreaking, multilayered, non-representational works were known to only a few close associates. However, from the 1980s they have been shown to great acclaim, winning her a posthumous reputation as a remarkable, if unwitting, pioneer of abstract art.

SPIRAL FORMS
In af Klint's symbolic lexicon, spirals – sometimes shown as snail shells – represent growth, development, or evolution.

YELLOW FORM
The large yellow form suggests a bloom emerging from a bulb; for af Klint, yellow represented masculinity, blue femininity, and green harmony.

▽ *GROUP IV, THE TEN LARGEST, NO. 7, ADULTHOOD*
Hilma af Klint said that pictures such as this "were painted directly through me, without any preliminary drawings and with great force". **Dimensions:** 328 x 240cm (129 x 94in). **Date:** 1907.

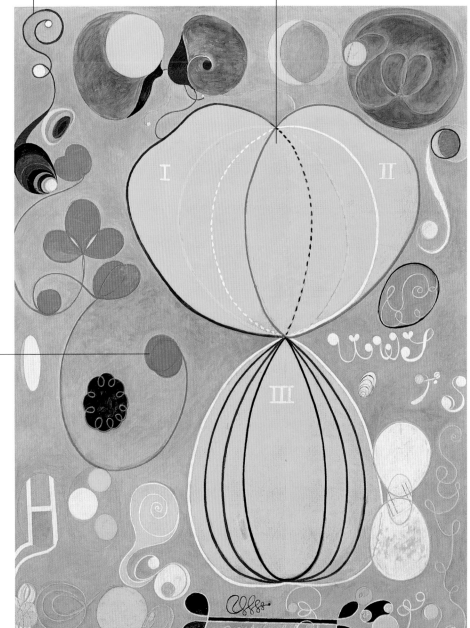

PLANT MOTIFS
The red forms evoke leaves and tendrils; in her early career af Klint was a skilful botanical illustrator.

VESTALASKET
This word, loosely translated as "vestal virgin", appears in curly script in several of af Klint's works. With its allusion to the priestesses who followed a strict code of conduct in their service of the Roman goddess Vesta, it may indicate af Klint's adherence to spiritual principles via her painting.

Scale

THE KISS ▷
With its extravagant use of rich
materials, this stunning, life-size
canvas is the highlight of the
artist's so-called "Golden Phase".
Dimensions: 180 x 180cm
(70¾ x 70¾in). **Date:** 1907–08.

The Kiss

*A sensual masterpiece that is Gustav Klimt's most famous
painting, and a unique blend of Symbolism and Art Nouveau*

Vienna, Austria

△ **KLIMT AND FLÖGE**
Klimt and his companion, fashion
designer Emilie Flöge, are pictured
here in 1910 in a garden in Kammer
on Lake Attersee, Austria. Both
are wearing loose-fitting garments
reminiscent of the robes in *The Kiss*.

Gustav Klimt (1862–1918) was a controversial figure
when he created his masterpiece *The Kiss* in 1907–08.
His taste for sexual imagery had provoked conservative
critics, who condemned his work as immoral; his
interest in the latest avant-garde trends proved
equally divisive. This led him to co-found the Vienna
Secession, an influential art group that challenged
the restrictive views of the traditional art world.

A golden cocoon
The Kiss was first put on public display at an
independent exhibition, the *Kunstschau*. The show
itself was a financial disaster, but even Klimt's fiercest
critics recognized the quality of this picture. For many,
it is the supreme achievement of his "Golden Phase".
Klimt had always been fascinated by gold (his father
was a goldsmith), but he employed it most lavishly in

these early years of the new century. He used it in the
way some medieval artists had treated religious scenes,
setting their figures in an opulent, golden background.

Klimt had already tackled the popular Symbolist
theme of the kiss twice before, but the 1907–08
painting is considered his definitive version. In this
perfectly square canvas, the lovers embrace in a golden
cocoon, which sets them apart from the everyday
world. Their ornate, shimmering environment, total
self-absorption, and complete abandonment may
seem magical, but there are also unsettling elements.
The woman is kneeling: if she stood up, she would
tower over her partner. In addition, her closed eyes
may indicate rapture, but her ashen complexion and
the painfully horizontal tilt of her face have also
prompted comparisons with another popular
Symbolist theme – that of the severed head.

In 2003, the **Austrian mint** issued a **100 euro
gold coin** that featured a copy of *The Kiss*

BYZANTINE MOSAICS

Klimt's work was greatly inspired
by Byzantine mosaics in the
church of San Vitale, Italy (*see
pp.110–11*), which he first visited
in 1903. He was dazzled by the
contrast between the coloured
tesserae (pieces of glass) and the
golden ones (gold leaf fused inside
clear glass). He only gained one
commission for an authentic
mosaic – the frieze in the Palais
Stoclet, Belgium – but the process
had a major impact on his work.
In many of his society portraits,
for example, he clothed his figures
in mosaic-like shards of patterns,
which merged into a shimmering
golden background. In this way,
he endowed his patrons with the
same glorious aura as the sacred
and imperial figures at Ravenna.

MOSAICS OF SAN VITALE, RAVENNA, ITALY, C.547 BCE

△ **"FULFILMENT" (DETAIL), THE STOCLET FRIEZE, 1909–11**
This is a preparatory study for part of the Stoclet Frieze in the
Stoclet Palace, Belgium. In it, Klimt combines exploration of the
theme of embracing figures and his mosaic style of portraiture.

COSTUMES
The artist chose different patterns for the costumes: hard, angular forms for the man and circular and floral motifs for the woman.

IVY CROWN
The man's ivy crown hints at associations with satyrs, the lustful companions of the god Bacchus.

GOLD DUST
Klimt loved to add interesting textures to the surface of his paintings. In *The Kiss* he used a powdered coating of gold dust to create a shimmering effect.

FLORAL BASE
The stylized bank of flowers is typical of Klimt's landscape style. He was particularly fond of wild flowers, allowing them to grow freely in his garden.

ORNAMENTAL CIRCLES
The circles adorning the female side of the lovers' golden cocoon may represent the circle of life. They are a recurrent motif in Klimt's work (*see also left*).

FEET
The woman's feet dangle precariously over the edge of an abyss – hinting, perhaps, at the perils of love.

Scale

Head of a Woman

A powerful sculpture by one of the most individual and colourful figures of a momentous period in modern art

Paris, France

Modigliani is often described as the greatest Italian painter of the 20th century, but for five years (1909–14) of his short career, spent mainly in Paris, he worked almost exclusively as a sculptor. He had no professional training in sculpture and his early carvings are fairly crude in workmanship, but he soon became much more skilful, combining elegance with authority.

Essential qualities

With only two exceptions, all of Modigliani's surviving sculptures are brooding heads such as the one shown here. The most obvious characteristic of *Head of a Woman* is its extreme elongation of form, which later became a distinctive feature of his painting too. The features are stylized and simplified, as Modigliani worked to refine his notion of an idealized, sublime beauty: the smooth, masklike face with its centred, puckered mouth, curlicued hair, trapezoidal nose, and protruding, perfectly symmetrical eyes. His

Modigliani **conceived seven** heads as a **"decorative ensemble"**

bold distortions and simplifications show the impact of African, Cycladic (*see p.23*), Egyptian, and other ancient art, but these influences were subtle and generalized rather than based on specific borrowings. The result was a unique style that, as in *Head of a Woman*, evokes a sense of meditative tranquillity, timelessness, and monumentality. Intended to be collectively displayed, the heads have a strange ritualistic aura; the British sculptor Jacob Epstein said that at night his friend Modigliani "would place candles on top of each one and the effect was that of a primitive temple".

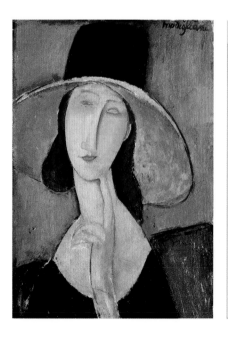

▷ **JEANNE HEBUTERNE, C.1918**
The elongated form of Modigliani's sculptures was also a characteristic aspect of his portraits. His favourite model in his final years was his lover Jeanne Hébuterne, whom he painted about two dozen times.

MODIGLIANI

An Italian artist who lived and worked mainly in France, Amedeo Modigliani (1884–1920) was part of a remarkable generation of painters and sculptors who revolutionized art in the early 20th century, using colours and forms for emotional effect rather than to imitate natural appearances. He is also famous for his dissipated and tragic life, which has established him in the popular imagination as a doomed genius in the same vein as Van Gogh. A renowned womanizer, Modigliani was charming when sober but often brutal when drunk. He had tuberculosis, and his physical condition was also undermined by alcohol, drugs, and poverty; he died aged just 35.

Scale

STYLIZED HAIR
On the woman's forehead, Modigliani
has carved the hair in stylized curls.

EYES
The eyes and eyebrows are the most
elaborately carved of the facial features,
although still exquisitely formalized
rather than naturalistic.

MASKLIKE FACE
The face recalls the African masks that
were admired by numerous avant-garde
artists in Paris at this time.

CONTRASTING TEXTURES
Most of the hair is left in
a rough state, contrasting
with the smooth flesh.

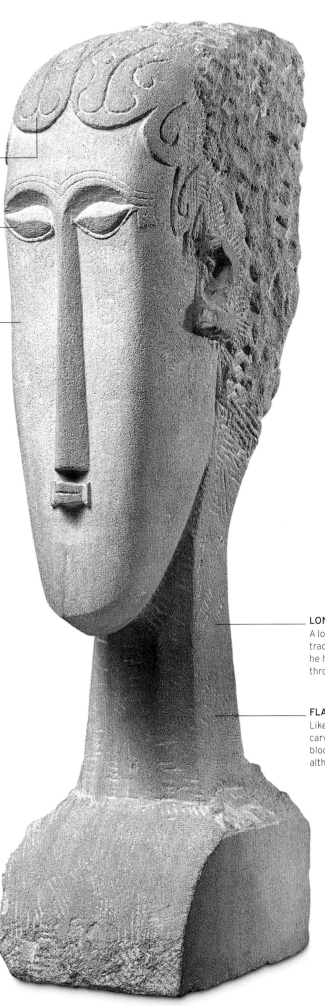

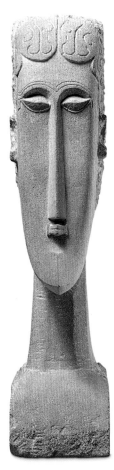

△ **FRONT VIEW**
By stripping back to the
essentials, Modigliani sought
to express the elemental
qualities of the human form.

LONG NECK
A long, elegant neck is almost a Modigliani
trademark; according to one unlikely account,
he hit on the idea upon seeing a woman
through the distorting glass of a bottle neck.

FLAT BLOCK
Like most of Modigliani's sculptures, this is
carved from a flat (relatively inexpensive)
block of stone; this head is in limestone,
although he also used sandstone.

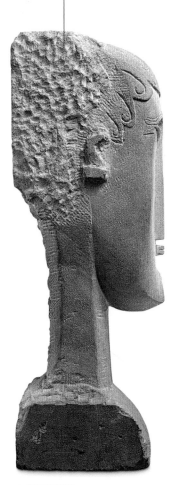

△ **SIDE VIEW**
From the side, the radical
flattening of the face is
strikingly visible.

◁ *HEAD OF A WOMAN*
This is one of 23 surviving
stone heads by Modigliani;
some are rough-hewn, but
others, like this, are carefully
finished. **Height:** 68.3cm
(27in). **Date:** 1912.

▷ **THREE CENTRES**
Kandinsky identified three distinct centres in this canvas: a "gentle, pink one" on the left; a slightly dissonant, red-blue one further to the right; and, between them, a third one, where pink and white colours "foam together".

LINE
Linear elements instil drama and direction into the composition. In this section, Kandinsky said he enjoyed the interplay between his "long, solemn" lines and the transverse lines that intersect them at the top.

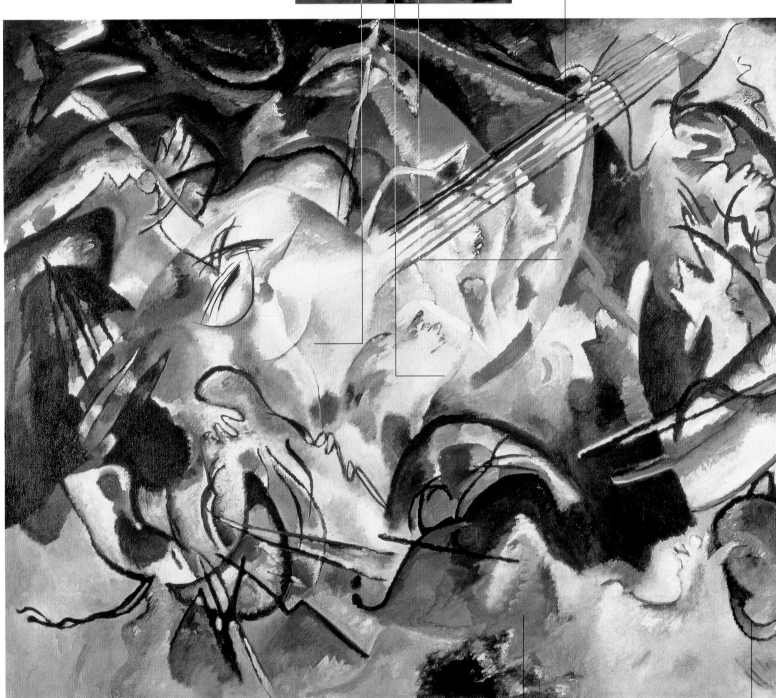

△ *COMPOSITION VI*
Kandinsky was at the peak of his creative powers when he produced this swirling masterpiece. At first glance, all 10 works in the *Compositions* series may appear chaotic, but they represent a thoughtful and considered summary of his artistic philosophy. **Dimensions:** 195 x 300cm (76¾ x 118in). **Date:** 1913.

COLOUR
Colour was the key element in the *Compositions*. Each hue had a personal meaning for Kandinsky, setting the expressive and spiritual mood of the picture.

TEXTURE
Kandinsky liked to vary his picture surface, often juxtaposing smooth and rough areas of the canvas so that viewers would experience different emotions as they got closer to the painting.

Composition VI

A landmark in the history of abstract art and one of Kandinsky's most admired works

Munich, Germany

The first truly abstract paintings in Western art were created in the early years of the 20th century. Russian-born painter Wassily Kandinsky (1866–1944) is usually recognized as a leading pioneer in this field. The artist drew inspiration from a number of styles and movements, including Russian folk art, as well as Fauvism and Expressionism, which were notable for their free and expressive use of colour.

Visual music
Kandinsky's experiments in abstraction date from 1909, when he began producing a series called *Improvisations*, *Compositions*, and *Impressions*. The *Compositions*, comprising 10 works, created between 1910 and 1939, were the most important of these – meticulously planned, they achieved a milestone in abstract art. His use of musical terminology when naming and discussing his work was deliberate as he made a close association between sound and colour;

the critic Roger Fry described his work as "pure visual music". Kandinsky himself also saw *Compositions* as "expressions of a slowly formed inner feeling". His aim was to create a purer and more spiritual form of art by attempting to eliminate objectivity, realistic depictions, and representational content.

One of his most famous and ambitious works in this respect is his masterpiece *Composition VI*, a large, dazzling oil painting, produced in 1913. According to the artist, he created the piece over a period of some eight months by totally submerging himself in "the resonance of colour and shape". He specified a theme for the painting – the Deluge – but deliberately avoided making any descriptive references to a physical flood. Instead, he was anxious to convey the impression of "a tremendous disaster", a great tumult, but also, cathartically, passages of great calm and hope, which suggest "a warm song of praise", an anthem for a new creation emerging out of the chaos.

Kandinsky believed that art has a spiritual effect on the viewer and colour exerts a direct and powerful influence on the soul

DER BLAUE REITER

Der Blaue Reiter (Blue Rider) was an avant-garde group of artists linked primarily with German Expressionism. Centred around the work of Kandinsky, Franz Marc, and August Macke, the group held exhibitions and published an influential *Almanac*. Marc specialized in brightly coloured paintings of animals. Initially, these were optimistic, even joyous, but with the approach of war, he turned to violent, apocalyptic visions. On the back of *Fate of the Animals* he wrote: "And all being is flaming, suffering". The right-hand side of the painting was damaged in a fire in 1916, the same year in which Marc was killed in action. The Austrian-born composer Arnold Schoenberg contributed an important article to the *Almanac*, delighting in the parallels between Kandinsky's experiments and his own.

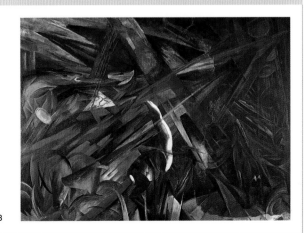

FATE OF THE ANIMALS, FRANZ MARC, 1913

Scale

St Petersburg,
Russia

Costumes for The Rite of Spring

Exuberant, unconventional costumes that had immense visual impact in a ballet that contributed to the explosion of new ideas in early 20th-century culture

THE BALLETS RUSSES

This famous ballet company operated from 1909 until the death of its founder, the Russian impresario Sergei Diaghilev, in 1929. During these 20 years it toured widely in Europe and North and South America (but it never performed in Russia). Some of the foremost dancers, composers, and artists of the time were involved in its productions, which were renowned for exotic splendour.

SERGEI PAVLOVICH DIAGHILEV
(1872–1929)

The premiere of the ballet *The Rite of Spring* at the Théâtre des Champs-Elysées, Paris, in May 1913 has become legendary as the most scandalous opening night in stage history. With poundingly percussive music by Igor Stravinsky and strange, jerky choreography by Vaslav Nijinsky, it was a world away from the smooth harmonies and graceful movements typical of classical dance. The setting, an imaginary pagan Russia, was likewise unconventional. Traditionalists in the audience clashed with supporters of the avant-garde – the hostilities are said to have escalated into fist-fights and a near-riot.

Colour and exuberance

The performance was staged by the Ballets Russes, a company founded by Sergei Diaghilev (*see box, left*). He placed great importance on the visual spectacle of ballet and commissioned outstanding artists to design sets and costumes. Those for *The Rite of Spring* are by

Stravinsky **dedicated** the **score** for the ballet to **Roerich**

Nikolai Roerich, whose colourful and exuberant style was ideally suited to the scenario, which he created with Stravinsky. Roerich was steeped in Russian history and mythology, and his designs were based partly on old folk costumes collected by his wealthy patron, Princess Maria Tenisheva. The classically trained dancers found Roerich's heavy, primitive, shift-like costumes difficult to move in and extremely hot under the theatre lights. The sheer richness of the colours (orange, red, maroon, purple, turquoise, green, and yellow) was also unfamiliar and a huge contrast to the pastel tints associated with traditional ballet.

△ **ORIGINAL COSTUME DESIGN**
Roerich's designs for the costumes, such as this, are made in gouache (opaque watercolour) and ink.

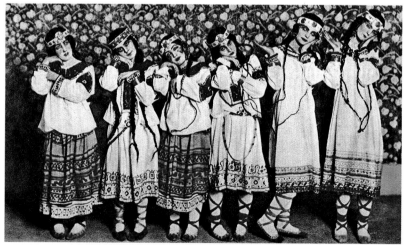

△ *THE RITE OF SPRING*, 1913
Six female dancers from the original production of *The Rite of Spring* are shown here. The figure second from left is Polish-born Marie Rambert, who later became a major figure in British ballet.

▽ **COSTUMES FOR** *THE RITE OF SPRING*
These costumes for a maiden (left) and young man (right) show the bold forms and sumptuous colours typical of Nikolai Roerich. **Length (of each costume):** approx. 150cm (59in). **Date:** 1913.

Scale

GEOMETRICAL SHAPES
Roerich uses a range of shapes – squares, circles, crosses, dots, diamonds, and triangles – to create vibrant patterns.

MEDALLION
The medallion is stitched to the costume to prevent it from flying about when the dancer was in movement.

MITRE-LIKE CAP
The cap is Roerich's invention but recalls a type of helmet worn by Russian grenadiers in the Napoleonic Wars.

SUBSTANTIAL MATERIALS
The costumes are predominantly made of wool and heavy cotton; the dancers found them very cumbersome (as they did the wigs they had to wear).

FLOWING DECORATION
In the lower part of the man's costume, Roerich uses a series of bands of flowing ornament, mainly in orange.

LENGTH
For the performance, the costume was gathered more at the waist with a belt and worn shorter than shown here.

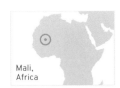

Mali,
Africa

Dogon Dance Mask

A impressive 20th-century example of the symbolic kanaga *masquerade masks made by the Dogon people of Mali*

Masks play a crucial role in the culture and rituals of the Dogon people of Mali, who believe that they create an opening to the spiritual world of the ancestors. They are worn by members of the secretive Awa, a male initiation society, during dance masquerades at the *sigi* ritual – held every 60 years to commemorate the first ancestor and also thought to coincide with certain celestial events – and at the *dama* ritual (*see below*). Masks are made in secret, using wood, fibre, hide, and pigment, and can reach 4–6m (15–20ft) tall. They can represent important figures such as hunters, warriors, and healers, as well as animals, objects, and abstract concepts. The mask shown here is a *kanaga* mask that was worn during the *dama* ceremony by a dancer in an elaborately coloured and multilayered costume.

THE *DAMA* CEREMONY

Held every 10 to 15 years during a good harvest, the *dama* ceremony is a funerary ritual in which masked dancers lead the spirits of the village's dead into the realm of the ancestors, where they will act as guardians of their clan. The *kanaga* dancers energetically re-enact the Dogon creation story, swinging their masks in circles and touching the tip to the ground to represent the sun and its life-giving power.

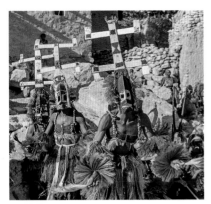

DANCERS AT BANDIAGARA ESCARPMENT, MALI

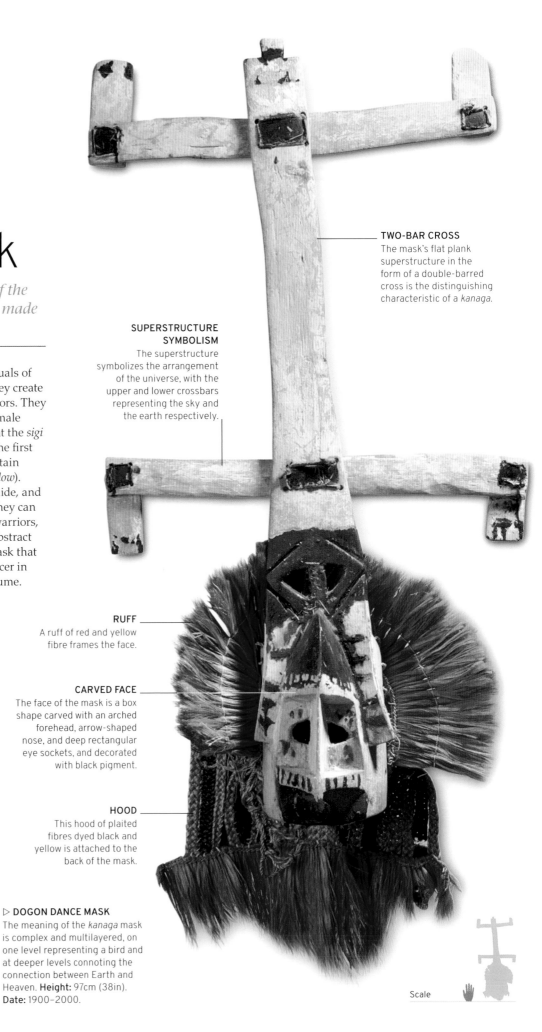

TWO-BAR CROSS
The mask's flat plank superstructure in the form of a double-barred cross is the distinguishing characteristic of a *kanaga*.

SUPERSTRUCTURE SYMBOLISM
The superstructure symbolizes the arrangement of the universe, with the upper and lower crossbars representing the sky and the earth respectively.

RUFF
A ruff of red and yellow fibre frames the face.

CARVED FACE
The face of the mask is a box shape carved with an arched forehead, arrow-shaped nose, and deep rectangular eye sockets, and decorated with black pigment.

HOOD
This hood of plaited fibres dyed black and yellow is attached to the back of the mask.

▷ **DOGON DANCE MASK**
The meaning of the *kanaga* mask is complex and multilayered, on one level representing a bird and at deeper levels connoting the connection between Earth and Heaven. **Height:** 97cm (38in). **Date:** 1900–2000.

Scale

Patiala Necklace

An opulent ceremonial necklace made in 1928 by the Parisian House of Cartier for the fabulously wealthy Maharaja of Patiala

Paris, France

For many centuries, the Indian subcontinent was a patchwork of states ruled by kings, or maharajas. After India became a British colony in 1858, the maharajas continued to rule, but under the auspices of the British Empire. Among these wealthy rulers, the Maharaja of Patiala, Bhupinder Singh (1891–1938), was renowned for his extravagance. In the mid-1920s, he despatched a trove of thousands of gemstones – including the 234-carat yellow De Beers diamond, the seventh-largest polished diamond in the world – to the House of Cartier in Paris, one of the world's most prestigious jewellers, with an order to make a necklace that would eclipse the wealth of other maharajas. The necklace was designed in an Art Deco style that Cartier had helped to popularize, and consisted of five rows of platinum chains set with diamonds, zirconias, topazes, rubies, smoky quartz, and citrine. It took jewellers three years to complete. The necklace vanished from Patiala's treasury in 1948, but parts, including the platinum chain, were rediscovered in London in 1998. It was then restored by Cartier, albeit with synthetic diamonds in place of some lost stones.

Scale

THE MAHARAJAS

The title maharaja (from the Sanskrit for "great king") was originally reserved for rulers of the most powerful Indian states, but under the British Raj (1858–1947) it extended to lesser rulers who supported the colonial power. The maharajas were great patrons of the arts, not least because they subscribed to the concept of *darshan* – that seeing a king in his splendour was a propitious act – and so organized lavish events where they could be admired by their subjects.

A MAHARAJA IN PROCESSION

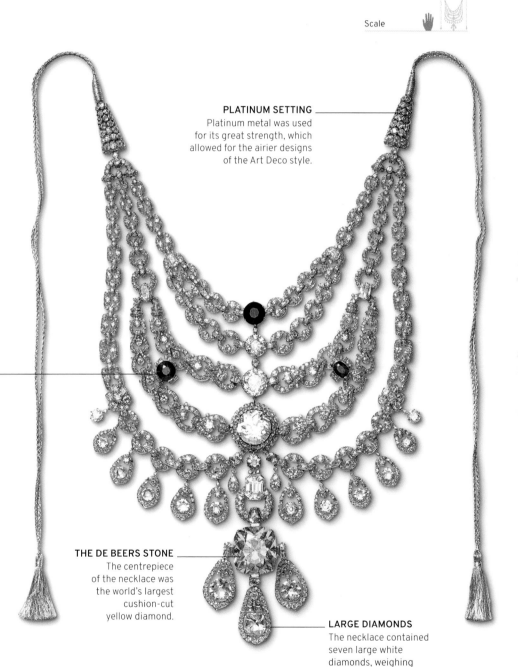

PLATINUM SETTING
Platinum metal was used for its great strength, which allowed for the airier designs of the Art Deco style.

BURMESE RUBIES
Two rare Burmese rubies, blood red in colour, flanked the De Beers diamond.

THE DE BEERS STONE
The centrepiece of the necklace was the world's largest cushion-cut yellow diamond.

LARGE DIAMONDS
The necklace contained seven large white diamonds, weighing from 18 to 73 carats.

△ PATIALA NECKLACE
The bib-like necklace, Cartier's largest-ever commission, was presented to the Maharaja of Patiala in 1928. He wore it regularly until his death in 1938. **Dimensions:** approx. 38 x 25cm (15 x 10in). **Date:** 1928.

The **necklace** was encrusted with more than **2,930** diamonds

▷ **CHRIST THE REDEEMER**
The statue of Christ was originally conceived as holding a cross and a globe; the idea of outstretched arms is credited to the artist Carlos Oswald.
Height: 30m (98ft).
Date: 1922–31.

HEART
In the middle of Christ's chest there is a small (in terms of the size of the figure) heart motif; inside the sculpture there is a scaled-up representation of a human heart, covered, like the exterior surface, in soapstone tiles.

FACE
Although Paul Landowski is generally credited as the sculptor of the statue, Christ's face was created by Gheorghe Leonida, a Romanian artist who assisted Landowski for a time.

△ **LIGHTNING RODS**
Invisible to the normal viewer, there are small lightning rods on the head, shoulders, arms, and fingers of the figure, which is typically struck by lightning several times each year. Occasionally this has caused damage, particularly to the fingertips. Also visible here are some of the six million soapstone tiles that cover the statue.

STYLIZED DRAPERY
The stylized folds of Christ's robe, resembling the flutes of a column, are in line with the Art Deco style, which was fashionable at the time.

In 2007, the **Art Deco** statue was voted one of the **New Seven Wonders of the World**

Scale

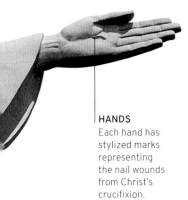

HANDS
Each hand has stylized marks representing the nail wounds from Christ's crucifixion.

▽ **COMMANDING POSITION**
The statue stands resplendent on the summit of the precipitously steep Mount Corcovado, towering over Guanabara Bay and Rio de Janeiro. Funding for the sculpture came mainly from countless small donations from ordinary citizens. The foundation stone was laid on 4 April 1922 – the centennial of Brazil's independence from Portugal.

Christ the Redeemer

One of the most spectacular works of religious art created in the 20th century, forming Brazil's most familiar landmark

Rio de Janeiro, Brazil

Giant statues are major landmarks in numerous countries throughout the world, but none of them has such a breathtaking setting as that of Christ the Redeemer on the summit of the dizzyingly steep, 700m (2,300ft) tall Mount Corcovado, overlooking Rio de Janeiro in Brazil. The country has the world's largest Catholic population and a vigorous tradition of popular religious art.

A majestic symbol

Erecting a colossal figure of Christ on the site was first proposed in the 1850s. Nothing came of the idea, but it was revived in 1921 and the foundation stone was laid the following year, even though the exact form for the statue had not yet been decided. A competition for the design was won by Heitor da Silva Costa, a local civil engineer, and the figure's final structure

and appearance were developed in collaboration with various specialists, notably the Brazilian artist Carlos Oswald and the French sculptor Paul Landowski. Building work began in 1926, with materials being brought up the mountain by railway, and the statue was inaugurated on 12 October 1931.

The sculpture is coated with soapstone tiles and faces towards the rising sun. It stands 30m (98ft) tall; the outstretched arms span 28m (92ft); and the head is 3.75m (12ft) high. The black granite base contains a small chapel, dedicated in 2006 to Our Lady of Aperecida (a local title of the Virgin Mary). Various renovations have been made to the sculpture over the years, and from 2002 ascent to the statue was made easier for visitors by the installation of escalators and elevators. The statue has become a symbol of the city, the country, and the Catholic Church.

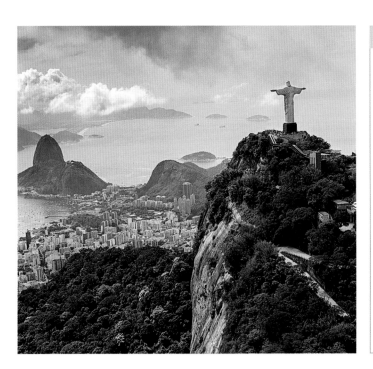

CONSTRUCTION AND MATERIALS

The main material of the statue is reinforced concrete – that is, concrete embedded with metal bars or mesh to increase its tensile strength. It was poured on site, using moulds that were made in Paul Landowski's studio in France and shipped to Brazil. To produce a more attractive surface, the concrete is coated with a mosaic of millions of small triangular tiles made of soapstone, a material often used in Brazilian churches. Inside the statue is a network of narrow stairs for maintenance access. Hatches on the right arm open to facilitate work on the exterior. The base or pedestal of the statue is made of granite.

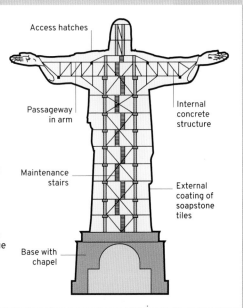

Access hatches

Passageway in arm

Internal concrete structure

Maintenance stairs

External coating of soapstone tiles

Base with chapel

▽ *THE PERSISTENCE OF MEMORY*
Dalí's memorable term for his paintings in this vein was "hand-painted dream photographs". **Dimensions:** 24 x 33cm (9½ x 13in). **Date:** 1931.

TONGUE-LIKE FORM
Dalí delighted in visual puns, double-images, and bizarre transformations, and this watch clearly evokes a human tongue.

BARE TREE
Trees are often used in art as symbols of renewal, but this bleak specimen suggests time's destructiveness.

LOCAL LANDSCAPE
The landform at upper right is inspired by a stretch of coastline near Port Lligat, a village in Spain where Dalí was living at this time.

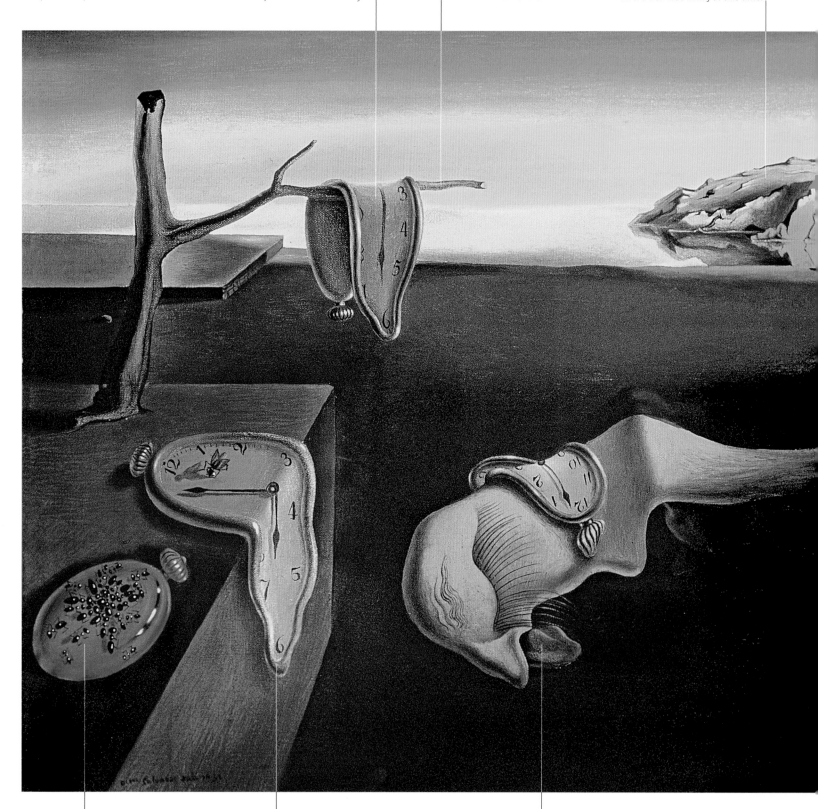

ANTS
Ants scurrying over a watch perhaps suggest the implacable advance of time, eating away at our lives.

SOFT WATCH
It was in this painting that Dalí first made prominent use of melting watches (all show different times). They soon became a trademark motif.

AMORPHOUS SHAPE
The strange form in the centre of the painting has characteristics suggesting a heavily distorted human face and has been interpreted as a self-portrait of Dalí.

Scale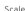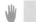

The Persistence of Memory

An acknowledged masterpiece of Surrealism, painted by one of the most colourful and controversial figures in 20th-century art

Port Lligat, Spain

Salvador Dalí is the best-known of all Surrealist artists and *The Persistence of Memory* is probably his best-known painting – one of the most familiar images in modern art. Surrealism was the most pervasive avant-garde art movement of the 1920s and 1930s. Its adherents thought that the world had been corrupted by materialism and rationalism, and they aimed to combat this by giving new emphasis to emotional and imaginative values, specifically by deriving inspiration from the unconscious mind, including dreams.

A bleak and haunting landscape

Dalí pursued this path through strange, hallucinatory, dream-like images such as this – scenes that make no logical sense but are painted in a clear, neatly detailed manner, creating a mesmeric tension between the oddness of what is depicted and the matter-of-factness of how it is depicted. Dalí himself described how he came to paint *The Persistence of Memory*. One evening he had eaten a runny Camembert cheese, which led him to ponder the idea of softness.

Dali claimed he **painted** this canvas **to help discredit** the world of **reality**

Before going to bed that night, he looked at a painting on which he was working – a forlorn landscape. He thought it needed something to enliven it; the idea of melting watches sprang into his mind, and he finished the picture in only two hours. Subsequently, the painting has been interpreted in numerous ways: for example, as representing humankind's fascination with the nature of time, or suggesting through its flaccid forms Dalí's fear of impotence. Whatever its exact meaning, it is one of the most haunting and disturbing images of its period.

△ **PORT LLIGAT BAY**
This view of the bay at Port Lligat in Catalonia, Spain, shows the kind of landform that Dalí depicted in the background of *The Persistence of Memory* (*see opposite, top right*).

DALI

Salvador Dalí (1904–1989) worked mainly in his native Spain, but also in Paris and New York. His large output embraced various fields of design as well as painting, sculpture, and printmaking, and he was also a prolific writer. He became famous for his eccentric behaviour, and he was accused of being more interested in making money than in creating serious art. But his finest works, notably those of his peak Surrealist period in the 1930s, have stood the test of time.

THE BULL

Picasso painted bulls or minotaurs many times during his career, sometimes as symbols of brutality, other times as a form of self-portrait. Here, the creature just seems dumbfounded by the hideous carnage that surrounds it.

△ **HIDDEN SKULL**

Images of death abound. Here, the nostrils and teeth of the wounded horse form the shape of a skull.

SLAUGHTER OF THE INNOCENT

An anguished mother holds the limp body of her dead child. The image echoes the Pietà (the term applied to paintings and sculptures of the Virgin Mary with the dead Christ), often displayed in Spanish churches.

Scale

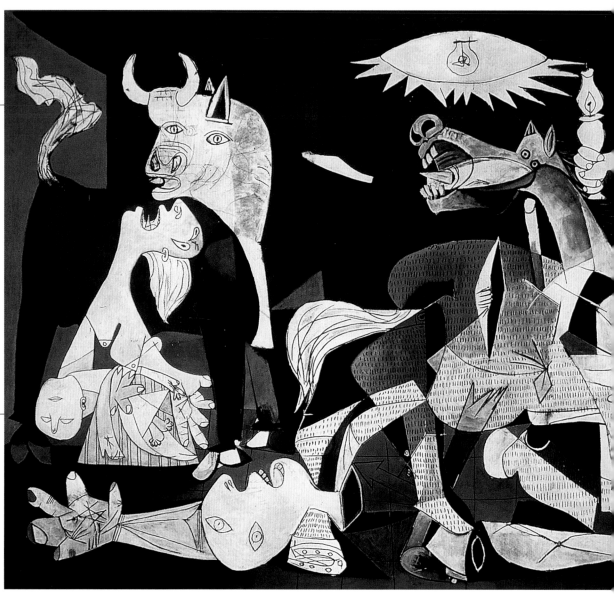

Guernica

Pablo Picasso's most powerful and moving work is considered by many to be the greatest painting of the 20th century

Paris, France

If any painting can be said to epitomize the soul of a nation it is Picasso's masterpiece *Guernica*. It is named for the city in northern Spain that was bombed in April 1937, during the Spanish Civil War (1936–39), by the German and Italian fascist allies of Spain's General Franco. The loss of civilian lives caused global outrage and provided the Spanish artist with a powerful theme for his painting at the World's Fair in Paris, France. Working at immense speed, his tour de force was ready for its unveiling at the fair in June 1937.

Devoid of colour, *Guernica* is painted entirely in white, grey, and black, giving it the character of an urgent, journalistic report. Its overwhelming size – around 349 x 776cm (137 x 306in) – contributes to its tremendous intensity and sense of inescapable horror. There are no direct references to the bombing – instead, the scene is a room filled with a chaos of fractured, distorted forms, including a bull with a mask-like face; a horse with a spiked tongue and a spear through its body; and tormented women. These principal elements are themes that Picasso had refined and developed in earlier works over the course of many years. A sinister-looking light-bulb at the top of the painting resembles the common religious motif of the eye of God, while its sharp, irregular rays also suggest an explosive device.

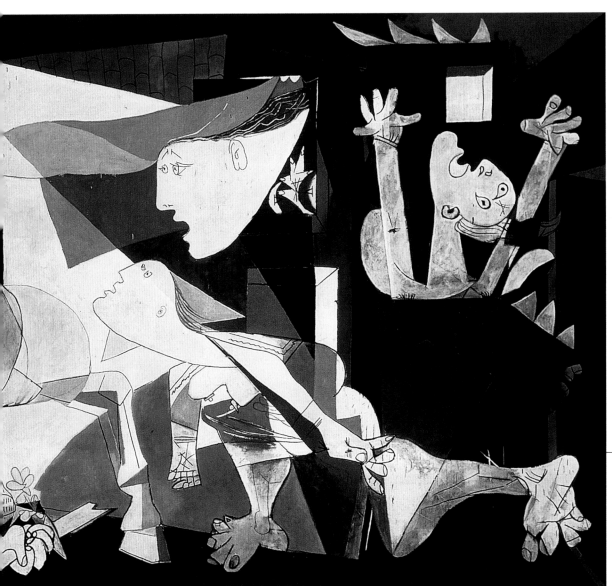

◁ *GUERNICA*
Pablo Picasso's huge monochrome painting encapsulates the suffering and horror caused by human conflict. **Dimensions:** approx. 349 x 776cm (137 x 306in). **Date:** 1937.

△ THE TERROR OF WAR
This terrified figure, thought to be a woman, is engulfed by flames, with no hope of escape through the tiny window shown above her.

DISTRAUGHT WOMEN
Picasso included several distraught women in his painting. In his earliest preparatory sketches, this one appeared to be carrying a dead child in her arms.

FALLEN WARRIOR
The figure on the ground has been interpreted as either a decapitated soldier or a broken statue. In his hand, he holds a broken sword and a ghostly flower.

STARK CONTRASTS
The contrast of white and grey against the black ground gives a photographic quality to the painting, adding to its powerful, nightmarish atmosphere.

MATERIALS AND TECHNIQUES

Picasso created *Guernica* while he was sharing a studio with his lover, Dora Maar, in rue des Grands-Augustins, Paris. She was a talented photographer and recorded each of the numerous, different stages of the work, as Picasso tirelessly refined its complex imagery. He began by stretching the huge canvas and then working on it with a matte house paint, which he had ordered specially, stipulating it should contain as little gloss as possible. The size of the canvas created obvious practical difficulties. Picasso had to stand on a ladder to complete the upper part of the mural, while for the lower sections, he attached long handles to his normal brushes.

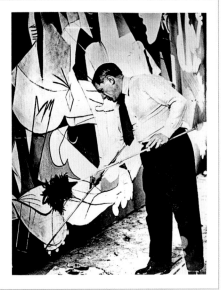

PICASSO PAINTING *GUERNICA*, PARIS 1937

Picasso wanted to donate *Guernica* to the **Spanish nation**, but not while **Franco** was alive; it eventually arrived in Spain in **1981**

The British Crown Jewels

The most complete collection of royal regalia in the world, with some elements believed to date from the 12th century

London, England

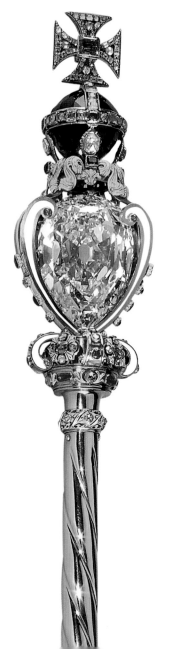

▽ SOVEREIGN'S SCEPTRE
The Sceptre was remodelled in 1910 to include the huge Star of Africa, set in a hinged mount so that it can be removed and worn separately.

The British Crown Jewels is a collection of some 140 sacred and ceremonial objects, including crowns, orbs, sceptres, banqueting and altar plates, rings, and swords. The core of the collection is the Coronation Regalia – created for Charles II and used since 1661 to crown sovereigns of England – and the Imperial State Crown, used by Britain's monarchs on important occasions, such as the State Opening of Parliament.

Beauty and craftmanship

Following the execution of Charles I in 1649, Parliament ordered that the medieval coronation regalia used for centuries be "totallie Broken and defaced"; the gems were prised out and sold and the gold was melted down for coinage. When the monarchy was restored in 1660, the Royal Goldsmith Robert Vyner created an elegant 11-piece set of gold regalia for Charles II's coronation. This included the heavy, solid-gold-framed St Edward's Crown, weighing 2.23kg (5lbs) and used only at the moment of crowning; the Sovereign's Orb, a hollow gold sphere mounted with emeralds, rubies, sapphires,

The Imperial State Crown has 2,868 **diamonds**, 17 **sapphires**, 11 **emeralds**, and 269 **pearls**

and rose-cut diamonds, each in an enamel mount; and the Sovereign's Sceptre with Cross, a gold rod in three sections with enamel collars at the joins, set with diamonds, an amethyst monde, and other gems.

Since 1660, there have been about 10 versions of the Imperial State Crown, as each version wears out from use. The current version (*see opposite*) is a spectacular gold-framed, hooped crown encrusted with diamonds and royal gems, some believed to date to the Middle Ages. It was created in 1937 and adjusted to fit and suit Queen Elizabeth II for her coronation in 1953.

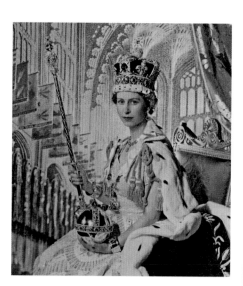

△ QUEEN ELIZABETH II (RULED 1952–)
The Queen is shown here at her coronation on 2 June 1953 wearing the Imperial State Crown and holding the Sovereign's Orb and Sceptre.

CULLINAN DIAMOND

The 3,106-carat Cullinan diamond, found on 26 January 1905 at the Premier Mine near Pretoria, South Africa, is the largest diamond ever discovered. It was named after Thomas Cullinan, chairman of the mining company, and presented to Edward VII in 1907. The priceless stone arrived in London by post while the South African government distracted attention with a display of armed guards transporting a decoy. The diamond was cut by Asschers of Amsterdam into nine large and 97 small stones. The largest stone, Cullinan I, the Great Star of Africa (530.2 carats) was placed in the Sovereign's Sceptre; the second-largest, Cullinan II, the Second Star of Africa (317.4 carats), adorned the Imperial State Crown.

THE ROUGH DIAMOND

GREAT STAR OF AFRICA

SECOND STAR OF AFRICA

▽ THE IMPERIAL STATE CROWN

Created for King George VI by Garrard jewellers in 1937 and modelled on Queen Victoria's crown from 1838, the Imperial State Crown weighs 1.06kg (2lb 5oz). It is worn by the monarch when leaving Westminster Abbey after the coronation ceremony and also on formal occasions, such as the State Opening of Parliament. **Height:** 31.5cm (12½in). **Date:** 1937.

ST EDWARD'S SAPPHIRE
This rose-cut sapphire is said to have been removed from the tomb of Edward the Confessor in the 12th century.

Scale

DEPICTING THE WORLD
A fretted silver representation of the world, set with numerous brilliant cut diamonds.

GOLD FRAME
The Crown's openwork gold frame is set with gems in gold or silver mounts, some screwed into the frame.

ACORN ARCHES
The four half-arches are cast as oak leaves, set with diamonds and pearl acorns.

ELIZABETH'S EARRINGS
Suspended from the arches are four large pear-shaped pearls once said to have belonged to Elizabeth I.

INSET STONE
A small cabochon ruby was used to fill a hole that had once been made in the red spinel to create a pendant.

BLACK PRINCE'S RUBY
This red spinel is thought to have been given to Edward the Black Prince by the King of Castile in 1367.

ERMINE BAND
Ermine, the winter coat of the stoat, has long been associated with royalty.

SECOND STAR OF AFRICA
This is the second largest stone cut from the Cullinan Diamond, the largest ever found (*see box*).

CROSS PATTÉE
There are five cross pattée on the crown – these early medieval Christian cross symbols have arms that are narrower at the centre than at the ends.

The Two Fridas

Mexico City, Mexico

An intensely personal self-portrait by one of the most intriguing personalities in 20th-century art

Many painters have produced revealing self-portraits, but few have approached the unrelenting self-scrutiny shown by Frida Kahlo. She depicted herself in about a third of her 200 or so paintings, many of them – such as this – making a harrowing commentary on the physical and emotional suffering she endured during her remarkable career. The physical suffering was principally the result of a traffic accident when she was 18 – she was injured so badly that for the rest of her life she was often in severe pain; the emotional suffering derived mainly from her stormy relationship with Diego Rivera, Mexico's most famous artist.

Two halves of one whole

Considered one of Kahlo's most remarkable paintings, as well as being her first large-scale work, *The Two Fridas* is a striking double self-portrait. Produced soon after Kahlo's divorce from Rivera in 1939 (the couple remarried the following year), it shows her divided into two personalities, who hold hands. On the right, Kahlo depicts herself in traditional Mexican costume:

this has been interpreted as indicating the part of her that was loved and respected by Rivera. On the left, she wears a more European-style dress, reflecting her mixed heritage (her father was German by birth but settled in Mexico) and perhaps representing the part of her rejected by Rivera. The hearts of the two Fridas are exposed to view – one broken, one whole – and connected to each other by a single artery, which also snakes around and down an arm of each Frida, further linking each figure. Together the two can be seen as representing Kahlo's combination of physical frailty and spiritual strength.

△ *THE TWO SISTERS*, THEODORE CHASSERIAU, 1843
Kahlo was reportedly inspired by Chassériau's painting *The Two Sisters*, which she saw at the Louvre in 1939. The sisters, although not twins, find a clear echo in Kahlo's twinlike Fridas.

With *The Two Fridas*, **Kahlo** **earned** the **highest fee** in her **lifetime** for one of her works

KAHLO

Frida Kahlo (1907–1954) was born and died in Mexico City, and spent most of her career there. She achieved only modest success in her lifetime, being overshadowed by her more famous husband, Diego Rivera; her paintings are usually small and intimate, whereas he produced vast murals in major public buildings. However, since about 1980 she has achieved increasing recognition as an artist, and has also become established as a feminist heroine because of her indomitable spirit, refusing to be defeated by her afflictions.

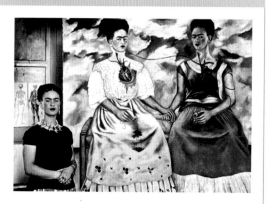

▽ THE TWO FRIDAS
This is Kahlo's largest painting, the figures being approximately life-size; usually her paintings are much smaller (many of them were painted in bed). **Dimensions:** 173 x 173cm (68 x 68in). **Date:** 1939.

HEARTS
"Mexican" Frida's heart appears healthy, whereas "European" Frida's heart is cut open. Hearts and blood played a prominent role in Mexican culture – a tradition going back to the human sacrifices of the Aztecs.

STORMY BACKGROUND
The stormy sky is in keeping with Kahlo's inner turmoil.

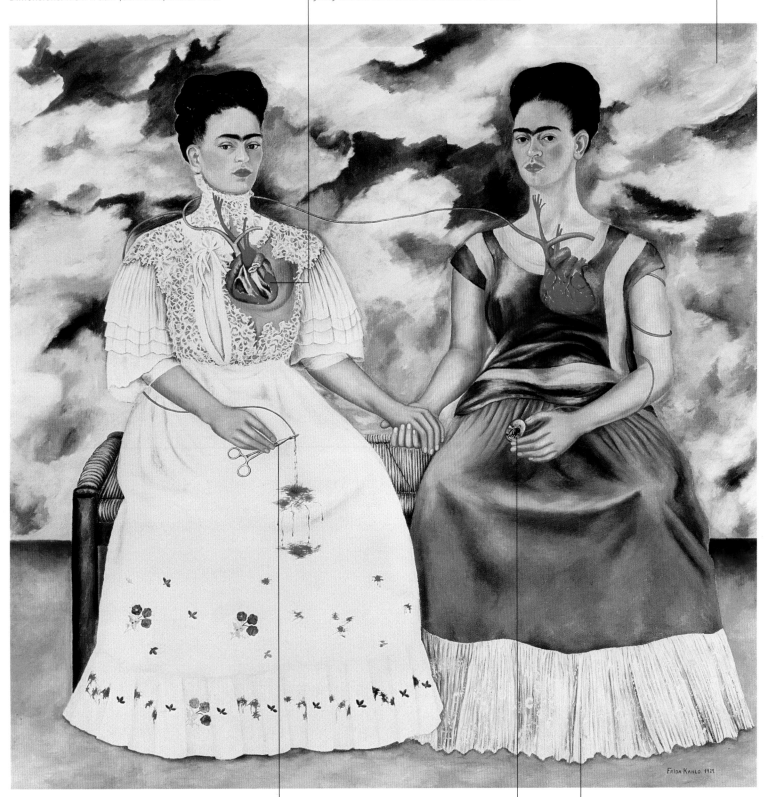

Scale

SURGICAL CLAMP
"European" Frida holds a surgical clamp, with which she tries to stem the flow of blood from a severed artery.

MINIATURE PORTRAIT
"Mexican" Frida holds a miniature portrait of her husband, linked by an artery to her heart; the miniature was still in her possession at her death.

LONG DRESSES
Kahlo liked to wear long dresses and skirts, partly to help hide her disabilities; childhood polio had made one of her legs shorter than the other.

As well as **posing** for the figure of the woman, **Hopper's wife,** Jo, came up with the **painting's title**

Chicago, USA

Nighthawks

An unforgettable depiction of the loneliness of modern urban life

From the 1920s onwards a number of US painters repudiated influence from avant-garde European art and turned to subjects specific to their own country, treated in a more or less naturalistic style. The most illustrious figure of this trend, known as American Scene Painting, was Edward Hopper, who found rich pictorial material in such seemingly unpromising subjects as gas stations, motel rooms, or (as here, in his most famous work) an almost deserted all-night diner.

This masterpiece, like many of Hopper's paintings, is revered for its insight into the human condition, hauntingly conveying the feelings of isolation, loneliness, and transience experienced by many people in big cities. The viewer looks upon four figures in a brightly lit diner, the harsh fluorescent light emphasizing the sense of melancholy and the gloom and darkness of the city outside. The adjacent red-brick building is typical of Greenwich Village, where Hopper lived and worked most of his life.

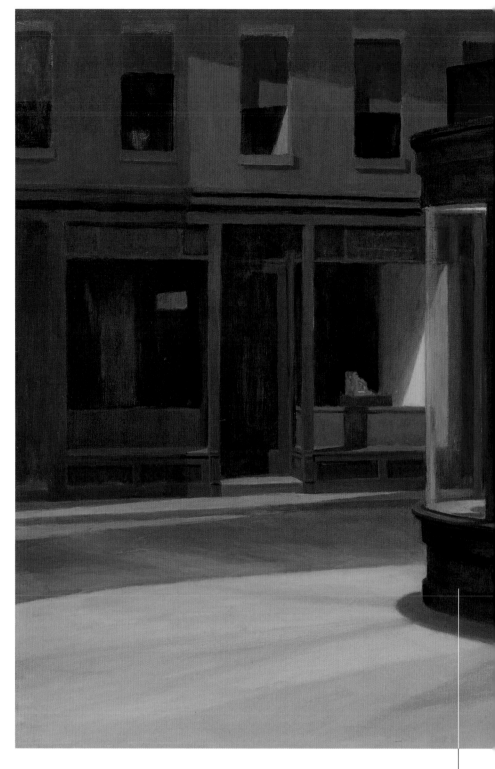

HOPPER

Edward Hopper (1882–1967) spent most of his life in New York, but he also drew inspiration from Cape Cod, Massachusetts, where he had a holiday home, and from other parts of the USA that he visited on his extensive travels. Until he was in his early 40s he earned his living as a commercial illustrator, but after a successful exhibition in 1924 he was able to become a full-time artist. In addition to being one of the leading US painters of his time, he was also an outstanding etcher.

△ *NIGHTHAWKS*
Hopper said of this painting (in which the three customers seem isolated and lost in their own thoughts): "I didn't see it as particularly lonely . . . Unconsciously, probably, I was painting the loneliness of a big city." **Dimensions:** 84 x 152cm (33 x 60in). **Date:** 1942.

Scale

BOLD COMPOSITION
Hopper uses strong, simplified architectural forms and contrasting slabs of light and dark to create an arresting setting for his four figures.

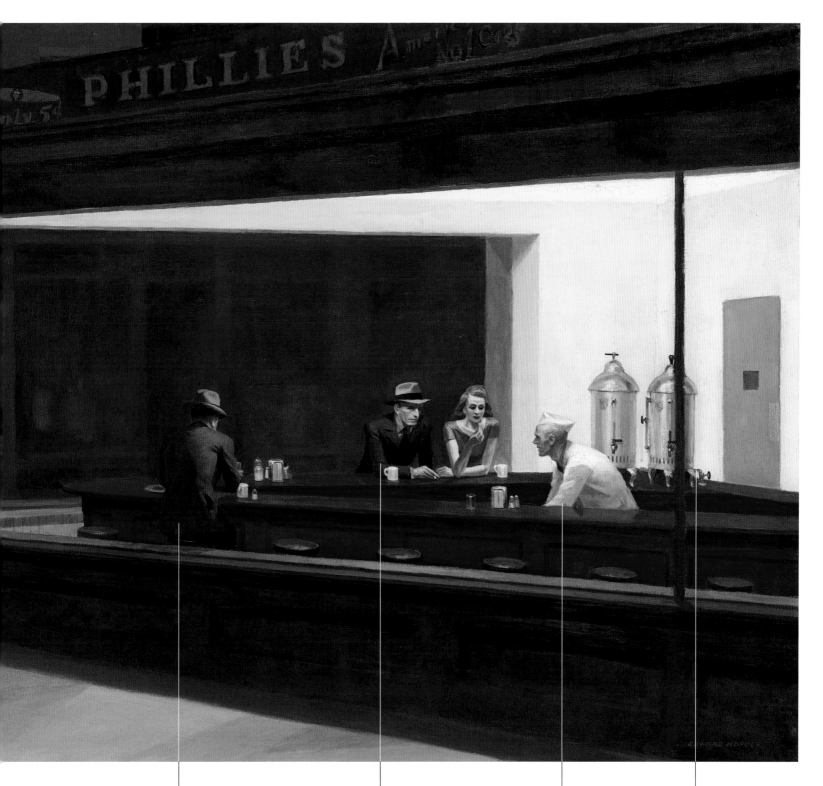

BACK VIEW
In her notes to the painting, Hopper's wife, Jo, referred to the "dark sinister back" of the man at left – but, like the other figures, he remains essentially enigmatic.

◁ **MAN AND WOMAN**
Hopper used himself and his wife, Jo, as models for the two central figures; they are physically close, hands almost touching, but Hopper does not make the relationship between them explicit.

BARTENDER
The bartender appears to be speaking, but because his face, like those of his customers, is bleached by the harsh fluorescent lighting, it is hard to gauge his expression.

COFFEE URNS
The huge coffee urns are the most conspicuous of the "props" Hopper uses to accompany the figures, including cups, glasses, and salt and pepper shakers.

DIARY OF ANNE FRANK ▷
Anne's diary includes photographs and
clippings alongside entries detailing her
innermost thoughts. She later produced
an edited version intended to document
her war experience for others to see.
Dimensions: 17.3 x 14.7cm (6³/₄ x 5³/₄in).
Date: 1942–44; published 1947.

Diary of Anne Frank

*The handwritten journal of an adolescent girl that became
a universal symbol of the human cost of the Holocaust*

Amsterdam,
The Netherlands

△ **AUTOGRAPH BOOK**
Anne's original diary was actually
an autograph book. Once it was
full, she used school exercise
books as replacements.

In 1934, when the Frank family moved to Amsterdam,
the city seemed like a safe haven for German Jews.
That situation changed with the Nazi occupation of
the Netherlands. Forced into hiding in 1942, the family
lived in a "secret annex" at Otto Frank's business
address for 25 months, until their hideout was raided
and they fell into the hands of the German police.

From ordinary to extraordinary
Less than a month before her seclusion began, Anne
Frank had started writing entries in the diary that was
to win her enduring renown. Over the following two
years she maintained a detailed account, revealing
with startling honesty the thoughts and impressions
of a young girl of unusual intelligence and sensitivity
caught in an unimaginable situation. After the family's

arrest, Anne was transported to the Auschwitz
concentration camp, and then to Bergen-Belsen,
where she died of typhus in 1945, aged 15. Her father,
who survived internment, later retrieved the diary and
had it published. It has since been translated into more
than 70 languages.

What makes the diary unique as a cultural artefact
is the penetrating insight it gives into the mind of one
talented, impressionable individual in the face of a
global horror. In its artless simplicity, Anne's account
has come to symbolize in microcosm the profound
tragedy of the Holocaust, bringing home its impact
in the story of one of many millions of persecuted
families. Its handwritten pages exude the hope of
youth, but now in retrospect memorably convey
the brutality with which that hope was crushed.

THE SECRET ANNEX

The secret annex where Anne
wrote her diary was hidden on
the second and third floors of a
rear extension of the canalside
building in central Amsterdam
where her father ran his
business. The entrance was
concealed behind a movable
bookcase. Its three bedrooms
served to shelter not just Anne,
her parents, and her sister,
Margot, but also a second family,
the Van Pels, plus a dentist friend
of her father's. They relied on
non-Jewish helpers, including
former employees of her father's
firm, for food and other supplies,
as well as for news of the outside
world. The families had to be
especially quiet and careful
during the daytime, because
the warehouse and offices
below were still in use; they
walked around in socks.

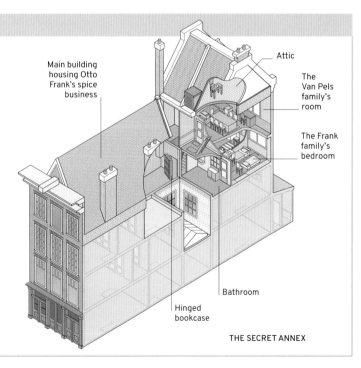

Main building
housing Otto
Frank's spice
business

Attic

The
Van Pels
family's
room

The Frank
family's
bedroom

Bathroom

Hinged
bookcase

THE SECRET ANNEX

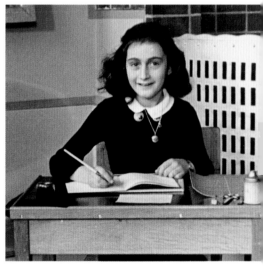

△ **AT THE 6TH MONTESSORI SCHOOL,
AMSTERDAM, 1940**
This photograph shows Anne during her final
year of primary school. In her class were several
other Jewish children who had fled Nazi Germany,
including her close friend Hanneli Goslar.

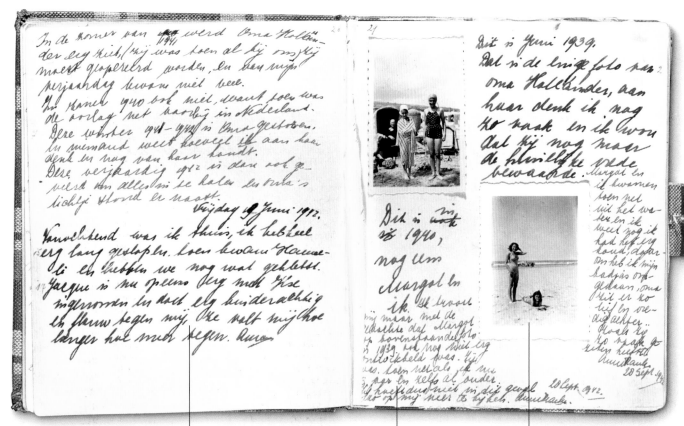

A FATHER'S TASK
After the war Anne's father transcribed the diary entries, initially to send to friends and relatives.

NATIVE TONGUE
Although born in Germany, Anne wrote in Dutch, having lived in Amsterdam from the age of four.

SEASIDE HOLIDAYS
The two photographs on this page show Anne on a beach with her elder sister, Margot.

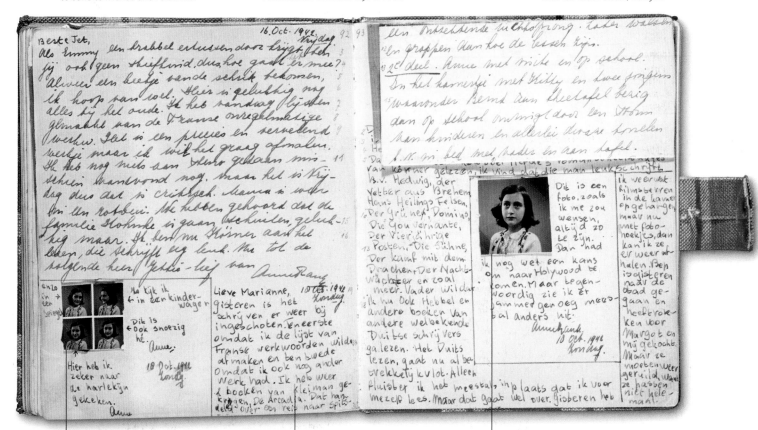

YOUNGER SELF
These photographs, with Anne's comments, come from a sheet of 48 passport-sized photos taken in 1939.

IMAGINARY FRIENDS
Early entries were addressed to up to eight imaginary friends; later she would settle on one, called Kitty.

IDEAL IMAGE
Anne comments on this portrait: "This is how I would wish to look all the time."

Scale

Pelagos

An elegant masterpiece by one of the leading pioneers and greatest exponents of abstract sculpture

St Ives, England

In 1939, just before the outbreak of World War II, Barbara Hepworth moved from London to St Ives in Cornwall, and lived there for the rest of her life. This fishing port had long been a magnet for artists, and became a flourishing centre for avant-garde art. Hepworth was often stimulated by the Cornish landscape, and *Pelagos* (Greek for "sea") was inspired by the curve of St Ives Bay, which she could see from her house and which gave her "a sense of containment and security". Hepworth was a key figure in enriching the language of sculpture by showing that it could deal with concavities and openings as well as solid forms. In *Pelagos*, the curving, hollowed-out wood, with its matt, cool-blue interior surface, brings to mind a shell or a wave, while its intimate scale adds to the sense of protection and shelter. Far beyond literal depiction, the sculpture is a superb example of her attempt to translate internal feeling into three-dimensional form.

HEPWORTH

Together with her lifelong friend Henry Moore and her second husband, the painter Ben Nicholson, Barbara Hepworth (1903–1975) was at the heart of the development of abstract art in Britain. Early in her career she was mainly a carver in stone and wood, but later she also worked in bronze. From the 1950s she was internationally renowned, earning numerous prestigious commissions and awards. She died tragically in a fire in her studio in St Ives, which is now a museum devoted to her.

▽ **PELAGOS**
The sculpture achieves a remarkable balance between stillness and movement, serenity and tension. **Height:** 43cm (17in). **Date:** 1946.

COILED SPRING
The coiled form creates a sense of sheltering but also of tension, suggesting a spring about to unfurl.

PAINTED INTERIOR
The interior surface is painted a very pale blue, evoking the sky or sea; its coolness contrasts with the warmth of the unpainted wood.

STRINGS
According to Hepworth, the strings represent "the tension I felt between myself and the sea, the wind or the hills".

BASE
The base is made of oak, subtly differentiated from the elm wood sculpture.

ELM WOOD
The sculpture is carved from elm wood. This is not suited to creating fine detail, but it has an attractive colour and texture.

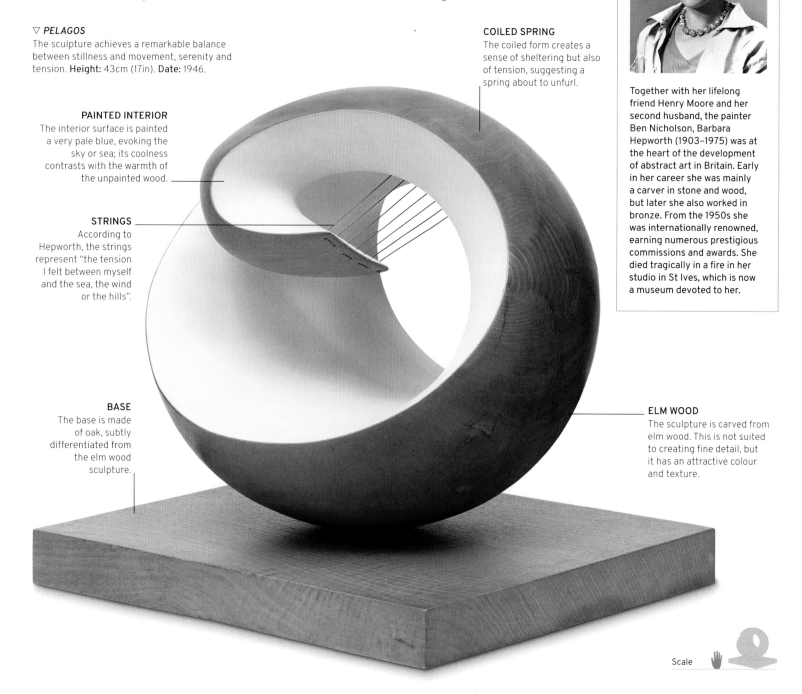

Scale

Paris, France

Scale

Man Pointing

One of the key works of art of the immediate postwar period, setting the agenda for a generation of sculptors

Man Pointing is one of several sculptures that Giacometti produced for an exhibition of his work at the Pierre Matisse Gallery, New York, in January to February 1948. He made the life-size figure in a single night of creative fervour in October 1947, working against a deadline: when workmen arrived to take it to the foundry to be cast in bronze, the clay was still wet.

Earlier in his career Giacometti had experimented with various styles, but in this New York exhibition he arrived at his distinctive mature idiom, characterized by extremely elongated, emaciated human figures. *Man Pointing* and his gaunt, nervous companions expressed a vision of the fragile and uncertain state of humanity after the horrors of World War II. Giacometti worked from live models, but scraped and pared away the clay until he seemed to be recording not flesh but the skeleton beneath; the skin appears tortured or scarred, the workings of the sculptor's fingers and knife in the clay still visible in the bronze. Rooted in its solid bronze base, and despite its painful attenuation, the figure dominates its surrounding space, somehow noble in its extreme isolation and abandonment.

Giacometti said he made the figure "between **midnight** and **nine** the next morning"

GIACOMETTI

Alberto Giacometti (1901–1966) came from a family of Swiss artists, but he spent most of his career in Paris. He painted a good deal (though intermittently) and was a prolific draughtsman and occasional printmaker, but is best known as a sculptor. His exhibition in 1948 in New York was a sensational success, establishing his international reputation, and he went on to win prestigious awards, including first prize for sculpture at the 1962 Venice Biennale. However, he continued to work in a tiny, shabby studio in Paris, and was admired for his integrity and indifference to the trappings of worldly success.

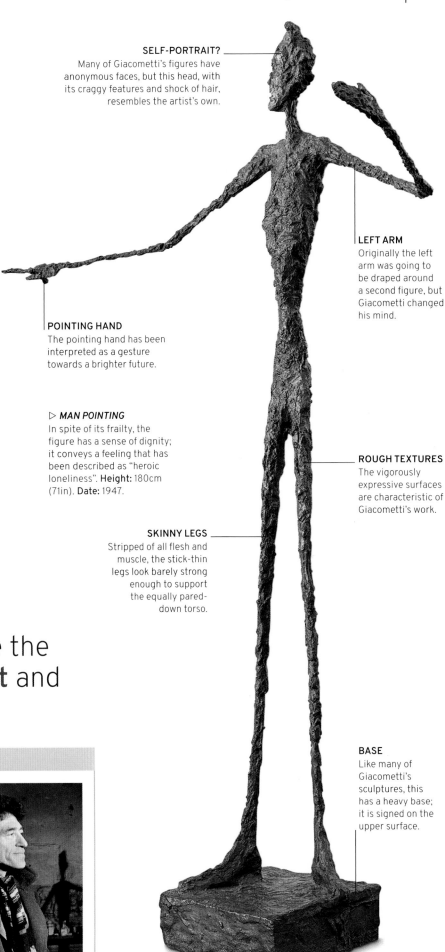

SELF-PORTRAIT?
Many of Giacometti's figures have anonymous faces, but this head, with its craggy features and shock of hair, resembles the artist's own.

POINTING HAND
The pointing hand has been interpreted as a gesture towards a brighter future.

▷ **MAN POINTING**
In spite of its frailty, the figure has a sense of dignity; it conveys a feeling that has been described as "heroic loneliness". **Height:** 180cm (71in). **Date:** 1947.

SKINNY LEGS
Stripped of all flesh and muscle, the stick-thin legs look barely strong enough to support the equally pared-down torso.

LEFT ARM
Originally the left arm was going to be draped around a second figure, but Giacometti changed his mind.

ROUGH TEXTURES
The vigorously expressive surfaces are characteristic of Giacometti's work.

BASE
Like many of Giacometti's sculptures, this has a heavy base; it is signed on the upper surface.

▷ **FLUID PAINT**
Pollock generally used commercial enamel paints (rather than more conventional oils or acrylics) because their fluidity suited his unusual technique.

New York, USA

One: Number 31, 1950

A masterwork of Abstract Expressionism by the movement's most famous artist

The Abstract Expressionists were a loose association of American painters working in the 1940s–50s, who brought a new energy and ambition to their country's art. They shared certain attitudes more than a common style, particularly a belief that abstract painting could be as meaningful as more traditional forms of art.

Jackson Pollock was the most radical of the Abstract Expressionists in his approach to painting. In the period 1947–52, which marked the summit of his career, he worked with the canvas laid on the floor of his large studio – a converted barn – and applied paint by dribbling and splashing it from a can, rather than through conventional brushwork. He walked around the canvas, pouring and flicking the paint from all sides. The photographer Hans Namuth, who took a series of pictures of Pollock at work, vividly described the "great drama" of the process, which balanced spontaneity with careful control, involving movements that he described as "dance-like". *One: Number 31, 1950* is one of the largest and most magnificent paintings that Pollock created in this way, combining dynamic energy with ravishingly delicate surface textures.

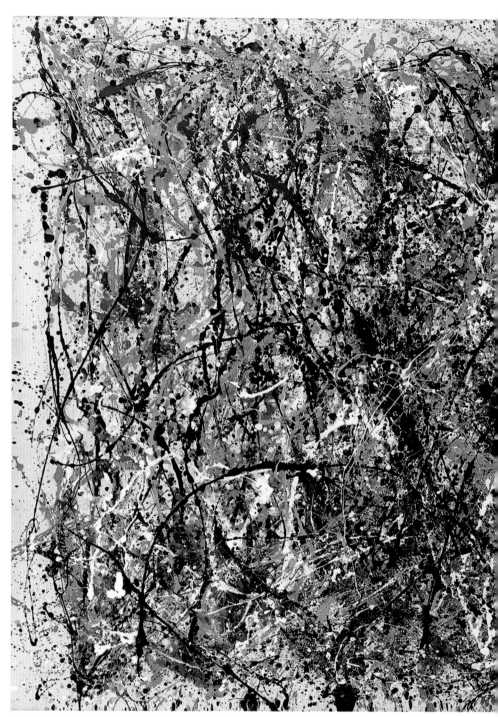

POLLOCK

Jackson Pollock (1912–1956) is famous for his troubled personal life as well as revered as one of the most original figures in the history of abstract art. Alcoholism and depression afflicted him for most of his career; he remained sober during his peak creative period but produced almost no work in his final year. By the time of his death in a car crash, at the age of 44, he was widely regarded as one of the most significant artists of his time, and the vitality and passion of his work inspired many other painters.

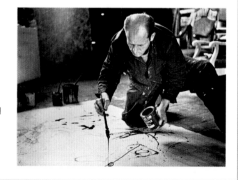

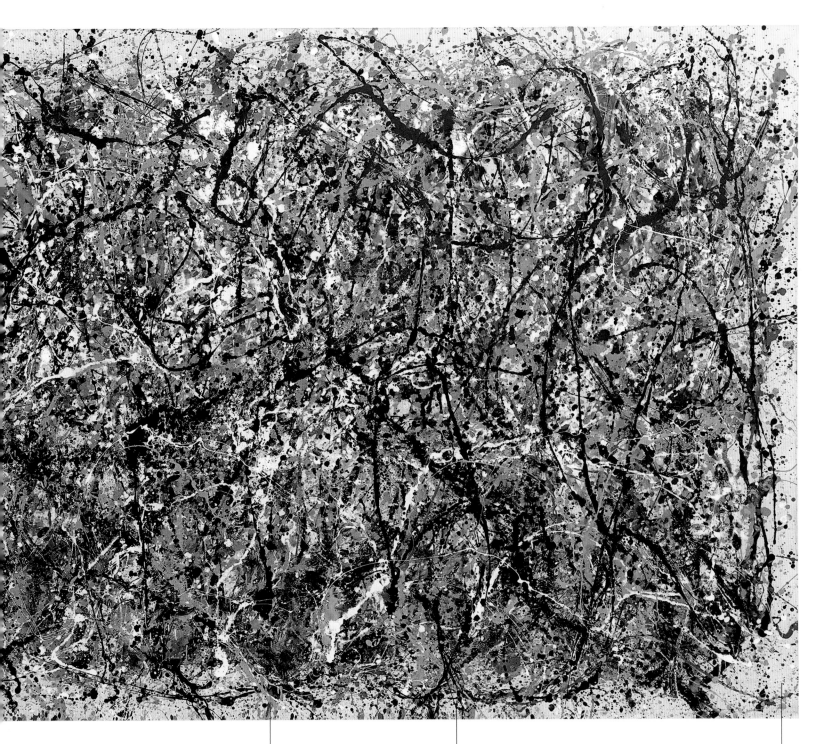

△ *ONE: NUMBER 31, 1950*
Pollock often assigned his paintings numbers, rather than conventional titles, which he thought tended to distract the viewer with extraneous associations. **Dimensions:** 270 x 530cm (106 x 209in). **Date:** 1950.

LIMITED COLOURS
Characteristically Pollock uses a limited range of colours; here they are predominantly neutral (black, grey, brown, and white on a pale background), but there is also a delicate blue.

ALL-OVER COMPOSITION
Pollock created his paintings in such a way that every part is of equal value, with no sense of a centre or other focal points; this idea of "all-over" composition was highly influential.

EXPOSED CANVAS
Pollock did not cover the entire surface with paint, but left parts of the canvas bare (particularly around the edges), forming part of the colour scheme and texture of the work.

Pollock **manipulated paint** with a variety of tools – **brushes, knives, sticks**, and even a syringe-like **turkey baster**

Scale

In **1962**, Campbell's sold **32 varieties** of soup; Warhol included **all of them**

New York, USA

Campbell's Soup Cans

Warhol's regular array of red-and-white cans is a landmark of US Pop art

From around 1960, US artist Andy Warhol (1928–1987) began exploring Pop art, using familiar imagery – adverts, packaging, comic books – as his subject matter. He transformed the mass-market graphics, the antithesis of fine art, by altering their context and displaying them as great works. Campbell's soup, which Warhol ate every day, provided an ideal source of inspiration. He painted a single can of soup in 1960 but the subject really came to the fore in 1962. Now portrayed in stacks, the cans formed the core of major shows in New York and Los Angeles, turning Warhol into an overnight celebrity.

THE FACTORY

Warhol's celebrated studio in an industrial loft in New York was dubbed "The Factory" to match the assembly-line nature of his work. The interior was decorated entirely with tinfoil and silver paint. It was the creative hub of his work, but also a meeting place for his bohemian friends.

ANDY WARHOL, NEW YORK, 1966

▽ **CAMPBELL'S SOUP CANS**
It may seem incongruous to describe a collection of mundane objects as "treasure", but Warhol's cans marked an important milestone in the development of modern US art. **Dimensions (overall installation):** 246.4 x 414cm (97 x 163in). **Date:** 1962.

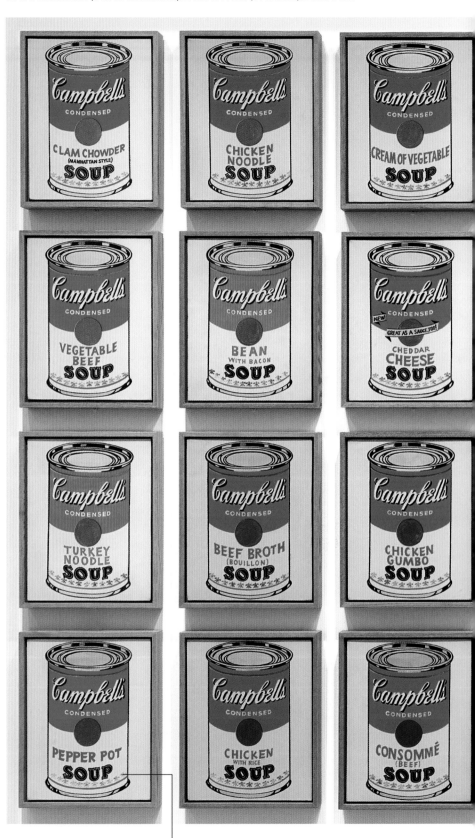

Scale

FLEUR-DE-LIS
Warhol painted some parts of his cans very meticulously, but he also cut a few corners – for example, he created a rubber stamp for the fleur-de-lis and simply printed them on.

GOLD CIRCLE
At first glance, the paintings look like faithful copies of the original cans, but in most versions of the subject Warhol replaced Campbell's medallion with a simple gold circle.

SOUP NAMES
Warhol arranged his simple cans to look like random stacks in a grocery store, but there is nothing accidental about it. Every can has a different title.

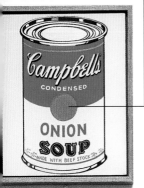 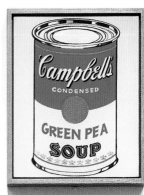 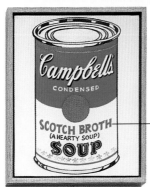 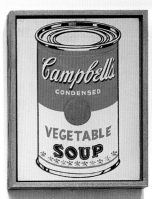 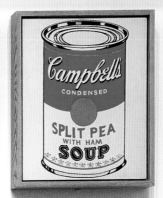

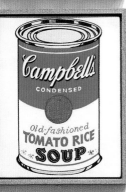 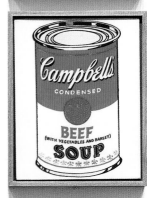 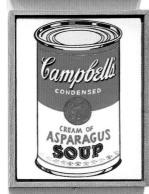 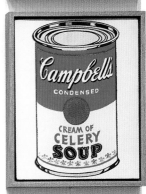 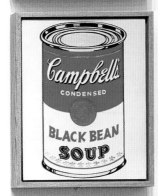

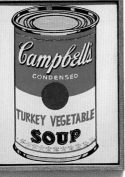 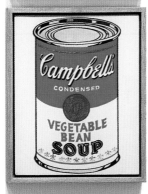 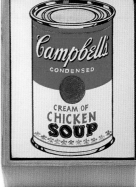 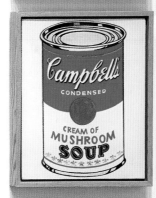

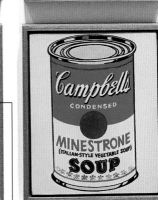 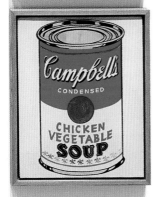 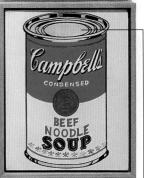 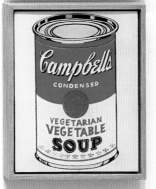

MINUTE VARIATIONS
By painting each panel separately, Warhol could not avoid introducing some tiny variations in his pictures. There are, for example, very slight differences in the calligraphy and the shade of red used on some of the labels.

METALLIC PAINT
Warhol used shiny, metallic paint to make the cans appear as realistic as possible.

Earthrise

The celebrated photograph of the Earth that profoundly changed our understanding of our world

On 21 December 1968, the Apollo 8 spacecraft carrying three astronauts – Frank Borman, James Lovell, and William Anders – was launched from the Kennedy Space Center, Florida. Its mission was to become the first manned spacecraft to leave low Earth orbit; it would also be the first human spaceflight to reach another astronomical object – the moon.

Distant beauty

After 68 hours, or nearly three days, Apollo 8 reached the moon, and entered lunar orbit. On 24 December, during the fourth orbit, as they emerged from the far side of the moon, Borman began to roll the spacecraft. As he did so, Earth slid into view behind the moon's surface. Looking out of the right side window, Anders quickly snapped a black-and-white photograph of the sight, the first picture of Earth taken by a human from another planetary body. While he rushed to put a roll of colour film into his camera, Earth disappeared from view. It reappeared in a different window, and Anders started shooting colour photographs. The result was the now iconic image of Earth emerging beyond the moon's barren horizon, capturing – as Anders later put it – "the only colour in the universe".

Taken with a specially modified Hasselblad camera with a 250mm (telephoto) lens and using 70mm film, the *Earthrise* photograph provided one of the first views of Earth as it appears from deep space. The perspective it offered of a beautiful, blue oasis, in stark contrast with the moon's surface – described by Anders as "like dirty beach sand" – had a profound influence on our perception of our place in the universe. The photograph remains a powerful reminder of the uniqueness and fragility of Earth.

EARTH DAY

The *Earthrise* photograph has been called "the most influential environmental photograph ever taken". With Rachel Carson's 1962 bestseller *Silent Spring*, it is credited with inspiring the environmental movement. In 1970, the first Earth Day was declared, rallying 20 million Americans to protest against the effects of industrial pollution on the environment. *Earthrise* had powerfully focused humanity's attention on the vulnerability of "Spaceship Earth".

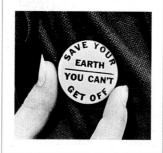

> "**Wow**, is that **pretty**!" William Anders, **seeing Earth** coming up

△ **APOLLO 8 CREW**
Left to right, James Lovell, William Anders, and Commander Frank Borman pose in their space suits at the Kennedy Space Center.

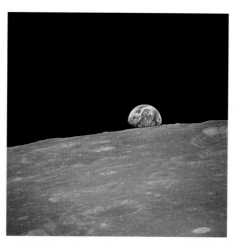

△ **FIRST EARTHRISE PHOTOGRAPH**
Anders had been using a telephoto lens to take high-resolution black-and-white photographs of the surface of the moon when he noticed Earth "rising" as the spacecraft began to rotate.

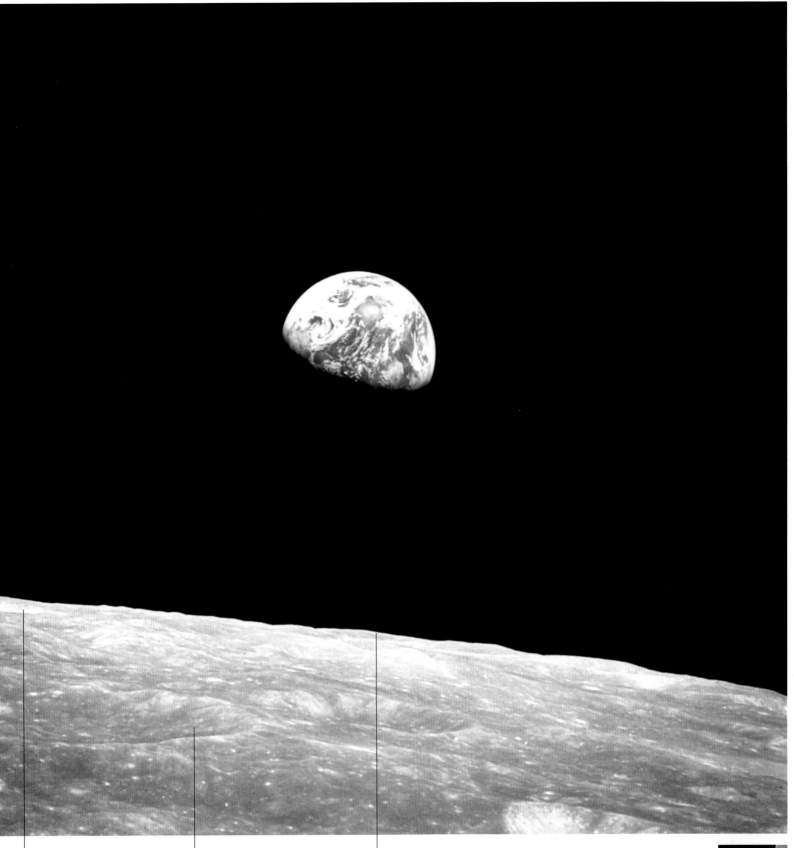

8 HOMEWARD
This crater was named to commemorate the fiftieth anniversary of the Apollo 8 mission in October 2018.

ANDERS' EARTHRISE
This crater was named after the Apollo 8 astronaut William Anders in October 2018.

DISTANT HORIZON
The lunar horizon is about 780km (480 miles) from the spacecraft.

▷ TILTED EARTH
The original photograph showed Earth to the left of the moon; it was rotated 95 degrees clockwise to give the image of Earth rising above the moon's surface.

▽ *PUMPKIN*
Pictured here in situ on a jetty jutting out from the island of Naoshima into the Seto Inland Sea, Japan, the bright yellow plastic of Kusama's *Pumpkin* stands out dramatically against the natural landscape. **Height:** 2m (6ft 6in). **Date:** 1994.

STALK
The colours on the pumpkin stalk have been reversed out.

SURFACE
Kusama's sculpture has an extremely smooth and glossy vinyl surface.

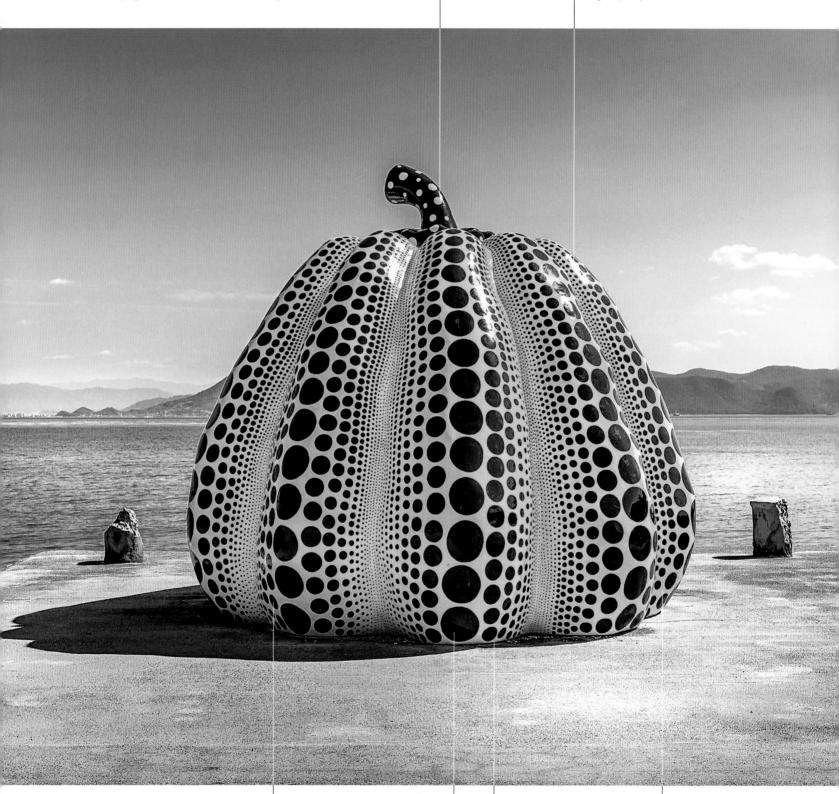

POLKA DOTS
For Kusama, the dot is a symbol of the sun, the moon, and the self, with each of us an individual dot among billons that make up the infinity of the universe.

SHAPE AND CONTOUR
Lines of dots follow the contours of the pumpkin, emphasizing the column-like shape of its ridges.

BASE
The bottom-heavy rounded shape suggests both sensuality and stability.

COLOUR
Black polka dots stand out in stark contrast with the yellow.

Pumpkin

*A giant avant-garde pumpkin sculpture covered in polka dots
from one of Japan's most influential artists*

Naoshima,
Japan

Although trained in the classical Japanese nihonga, a style of painting based on traditional Japanese techniques, Yayoi Kusama was attracted to US abstract art, and became involved in the New York Pop art scene in the 1950s. Her avant-garde approach earned her world recognition, and from the 1970s she was seen as one of the most influential and popular artists to emerge from Japan in the 20th century.

Obsession and repetition

Pumpkins and polka dots have been signature motifs in Kusama's works since 1948, expressed in a variety of colours and media, including prints, sculpture, and paintings – and ranging from the size of a keyring to the monumental presence of *Pumpkin*, shown here.

She regards the pumpkin as a symbol of comfort and stability, and a form of self-portraiture: "What appealed to me most," she says, is its "generous unpretentiousness. That and its solid spiritual base."

Installed on a pier at the Benesse Art Site on Naoshima Island in 1994, the first outdoor work to be unveiled there, *Pumpkin* is one of Kusama's most renowned works. It was among the largest pumpkins she had so far made, and also the first to be constructed not just with the intention of open-air exhibition but at a specific location. The yellow sculpture is 2m (6ft 6in) high, 2.5m (8ft 3in) wide, and covered in black polka dots. Made from fibreglass-reinforced plastic, it stands as a dramatic and incongruous form against the backdrop of the sea and mountains.

Kusama's **fascination with dots** arose from **hallucinations** she had in childhood

KUSAMA

Yayoi Kusama (1929–), inspired by her family's plant seed nursery, began drawing pumpkins as a young girl in the 1940s. She studied at the Arts and Crafts School in Kyoto before moving to New York, where her initiatives included making "orgy garments" to be worn by several people at once; a more conventional engagement with clothing came in 2012, in a collaboration with fashion house Louis Vuitton. Kusama devised the first of her famous infinity rooms (which create repetitive forms using mirrors and lights) in the early 1960s and in 1993 designed a mirror room that related to pumpkins for the Venice Biennale. Soon after returning to Japan in 1973, she voluntarily entered a psychiatric hospital in Tokyo, which has remained her home ever since.

Scale

Scale

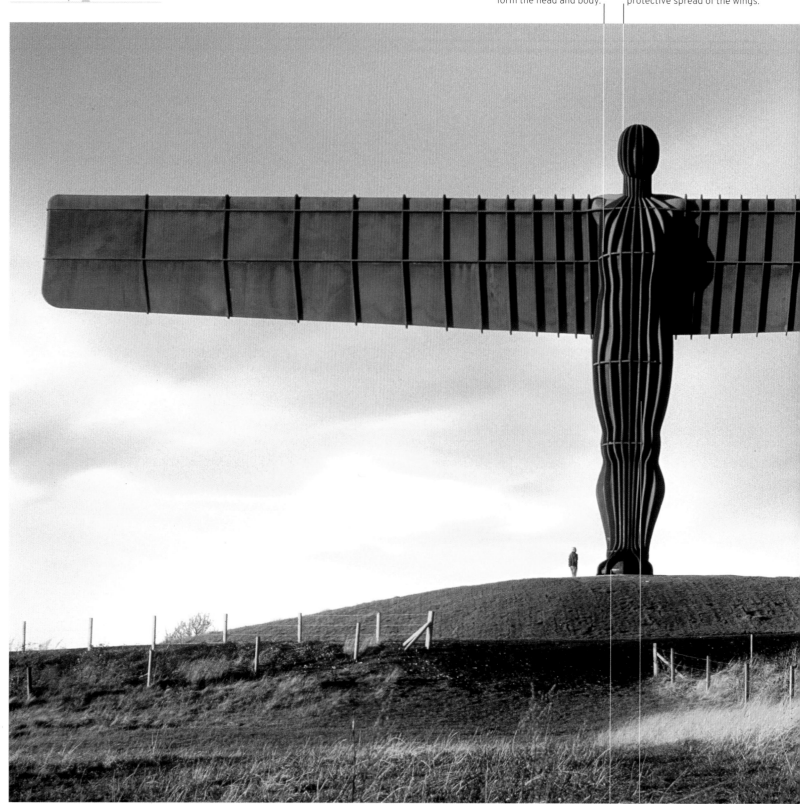

RIBS OF STEEL
The external skeleton is made of 50mm (2in) thick steel ribbing. A 6mm (¼in) "skin" of sheet steel was welded to it to form the head and body.

HEAD WITHOUT A FACE
Gormley left the face featureless to stress the work's universality, expressing its message in the protective spread of the wings.

FEET ON THE GROUND
The small feet and narrow ankles caused an engineering challenge (*see box*). Aesthetically, the statue's tapering shape sets off the monumentality of the outstretched wings.

HIDDEN CORE
Inside the angel's body, a hollow steel tube provides extra support from the feet to the chest.

WEIGHTY WINGS
Weighing 50 tonnes each, the wings were secured to the body with 136 bolts before being welded in place.

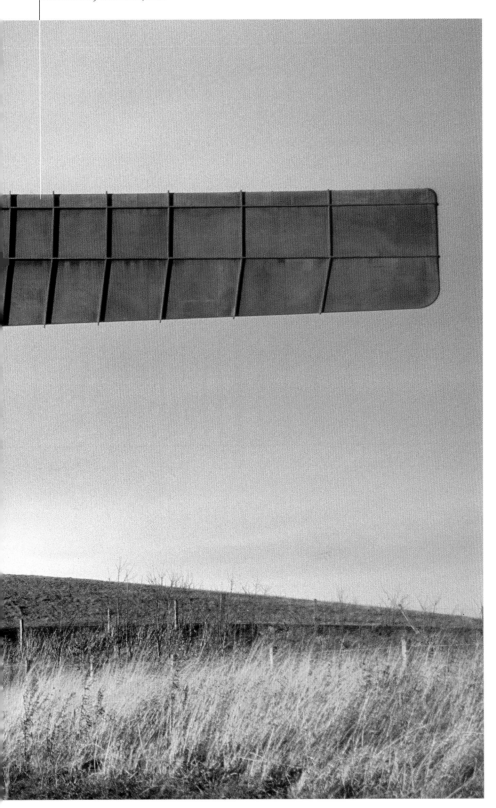

△ *ANGEL OF THE NORTH*
The statue has come to be seen as a protective figure watching over a region that once flourished through coal-mining and manufacturing but is now coping with deindustrialization. **Height:** 20m (65ft 6in) **Date:** 1998.

Sculptor **Antony Gormley** used a plaster cast of his **own body** as a **model** for the statue

Gateshead, England

Angel of the North

A dramatic five-storey-high statue that is an icon of England's North East

Commissioned as part of a regeneration scheme for a depressed industrial region, Antony Gormley's giant statue is an unmissable landmark, seen by at least 30 million people every year. Gormley's aim was not just to celebrate the area's industrial history and reference the future but also to provide a focus for people's hopes and fears. The huge steel angel fulfils that function, its outspread wings, slanted 3.5 degrees forward, reaching out to embrace all who come within sight of it.

CONSTRUCTION

During construction, there were fears that the slender base might not be strong enough to support the sculpture in strong winds. To counter this, 20m (65ft 6in) deep concrete and steel foundations moor it to the rock beneath.

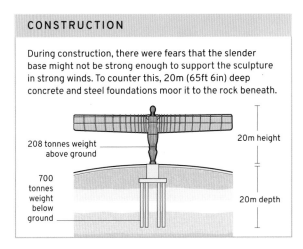

208 tonnes weight above ground

20m height

700 tonnes weight below ground

20m depth

OBJECT LOCATIONS

Most of the objects in this book are held in curated collections or dedicated buildings. Listed here are their current locations; note that objects may be on loan to other institutions.

p.14 Venus of Hohle Fels: Museum of Prehistory Blaubeuren, Germany

p.15 The Lion-Man of Hohlenstein-Stadel: Museum Ulm, Germany

pp.16–17 Altamira Bison: Santillana del Mar, Cantabria, Spain

p.18 Kakadu Rock Art: Kakadu National Park, Northern Territory, Australia

p.19 Judaean Stone Masks: Israel Antiquities Authority, Israel

pp.20–21 Palette of Narmer: Egyptian Museum, Cairo, Egypt

p.22 Ram in the Thicket: British Museum, London, UK

p.23 Cycladic Figure: (complete figure) National Archaeological Museum, Athens, Greece; (head) Louvre, Paris, France

p.24 Tell Asmar Hoard: (standing male worshipper) Metropolitan Museum of Art, New York, US

p.25 Great Sphinx of Giza: Giza, Egypt

pp.26–7 Standard of Ur: British Museum, London, UK

pp.28–29 Head of an Akkadian King: Iraq Museum, Baghdad, Iraq

p.30 Mohenjo-daro Dancing Girl: National Museum, New Delhi, India

p.31 Babylonian Jewellery: Metropolitan Museum of Art, New York, US

pp.32–33 Meketre Tomb Figures: (Cattle parade) Egyptian Museum, Cairo; (Offering bearers) Metropolitan Museum of Art, New York; (Stable) Metropolitan Museum of Art, New York, US

p.34 Minoan Snake Goddess: Heraklion Archaeological Museum, Crete, Greece

p.35 Nebra Sky Disc: State Museum of Prehistory, Halle, Saxony-Anhalt, Germany

p.36 Erlitou Plaque: Harvard Art Museums/Arthur M. Sackler Museum, Cambridge, Massachusetts, US

p.37 Minoan Octopus Vase: Heraklion Archaeological Museum, Crete

pp.38–39 Mask of Agamemnon: National Archaeological Museum, Athens, Greece

pp.40–41 Trundholm Sun Chariot: National Museum of Denmark, Copenhagen, Denmark

pp.42–43 Oracle Bones: Academia Sinica, Taipei, Taiwan

pp.44–45 Bust of Nefertiti: Neues Museum, Berlin, Germany

pp.46–47 Mask of Tutankhamun: Grand Egyptian Museum, Giza, Egypt

p.48 Mummy of Katebet: British Museum, London, UK

p.49 Hittite Stag Bibru: Metropolitan Museum of Art, New York, US

pp.50–51 Kang Hou Gui: British Museum, London, UK

p.52 Phoenician Ivory Plaque: British Museum, London, UK

p.53 Olmec Mask: Metropolitan Museum of Art, New York, US

pp.54–55 Regolini-Galassi Fibula: Vatican Museums/Gregorian Etruscan Museum, Rome, Italy

p.56 Strettweg Cult Wagon: Universalmuseum Joanneum/Archaeology Museum, Schloss Eggenberg, Graz, Austria

p.57 The Cyrus Cylinder: British Museum, London, UK

pp.58–59 Attic Dinos: British Museum, London, UK

pp.62–63 Persepolis Bas-Relief: National Museum of Iran, Tehran, Iran

p.64 Nok Sculptural Pottery: Musée du quai Branly – Jacques Chirac, Paris, France

p.65 Chavín Stone Heads: Museo Nacional de Chavín, Peru

pp.66–67 Riace Bronzes: National Museum of Magna Graecia, Reggio Calabria, Italy

pp.68–69 The Oxus Treasure: British Museum, London, UK

pp.70–71 Parthenon Frieze: British Museum, London, UK

p.72 Golden Lion Rhyton: National Museum of Iran, Tehran, Iran

p.73 Chimera of Arezzo: National Archaeological Museum, Florence, Italy

pp.74–75 The Agris Helmet: Musée d'Angoulême, France

pp.76–77 The Terracotta Army: Xi'an, Shaanxi, China

pp.78–79 The Rosetta Stone: British Museum, London, UK

pp.80–81 The Gundestrop Cauldron: National Museum of Denmark, Copenhagen, Denmark

pp.82–83 Laocoön: Vatican Museums/Pio Clementino Museum, Rome, Italy

pp.84–85 Bimaran Reliquary Casket: British Museum, London, UK

pp.86–87 Augustus of Prima Porta: Vatican Museums/Braccio Nuovo, Rome, Italy

pp.88–89 Tillya Tepe Hoard: National Museum of Afghanistan, Kabul, Afghanistan

pp.90–91 Newspaper Rock: San Juan County, Utah, US

p.92 Amaravati Pillar: British Museum, London, UK

p.93 Artemis of Ephesus: Ephesus Archaeological Museum, Selçuk, Turkey

pp.94–95 Trajan's Column: Rome, Italy

pp.96–97 Fayum Mummy Portraits: (man) Art Institute of Chicago, Illinois; (woman) Metropolitan Museum of Art, New York, US

p.98 Gansu Flying Horse: Gansu Provincial Museum, Lanzhou, China

p.99 Paracas Textile: Brooklyn Museum, New York, US

p.100 Teotihuacán Sculpture: Metropolitan Museum of Art, New York, US

p.101 Moche Portrait Heads: Metropolitan Museum of Art, New York, US

p.102 Nazca Figure Vessels: Art Institute of Chicago, Illinois; Metropolitan Museum of Art, New York, US

p.103 Lycurgus Cup: British Museum, London, UK

pp.104–05 Ajanta Cave Paintings: Aurangabad District, Maharashtra, India

pp.106–07 Admonitions of the Instructress: British Museum, London, UK

pp.110–11 Mosaics of San Vitale: Ravenna, Italy

pp.112–13 Sutton Hoo Helmet: British Museum, London, UK

pp.114–15 Zapotec Mural: Monte Albán, Oaxaca, Mexico

pp.116–17 The Lindisfarne Gospels: British Library, London, UK

pp.118–19 Death Mask of Pakal: National Museum of Anthropology, Mexico City, Mexico

pp.120–21 Bonampak Murals: Bonampak, Chiapas, Mexico

pp.122–23 Diamond Sutra: British Library, London, UK

pp.124–25 Lindau Gospels Treasure Binding: Morgan Library & Museum, New York, US

pp.126–27 Ramayana Bowl: National Museum of Indonesia, Jakarta, Indonesia

pp.128–29 Igbo-Ukwu Bronze Wares: National Museum, Lagos, Nigeria

pp.130–31 Córdoba Mosque Mihrab: Córdoba, Spain

pp.132–33 Banteay Srei: Angkor, Cambodia

p.134 Carolingian Astrolabe: Institute of the Arab World, Paris, France

p.135 Yixian Luohan Statue: Metropolitan Museum of Art, New York, US

pp.136–37 Bernward Bronze Doors: Hildesheim, Germany

pp.138–39 The Bayeux Tapestry: Bayeux Tapestry Museum, Bayeux, France

pp.140–41 Qingming Scroll: Palace Museum, Beijing, China

p.142 Dancing Celestial Deity: Metropolitan Museum of Art, New York, US

p.143 Toltec Warrior Head: National Museum of Anthropology, Mexico City, Mexico

pp.144–45 Attendants of Fudō Myō'ō: Koyasan Reihōkan Museum, Wakayam Prefecture, Japan

p.148 Lewis Chessmen: British Museum, London, UK

p.149 Golden Rhinoceros of Mapungubwe: Mapungubwe Collection, University of Pretoria, South Africa

pp.150–51 Chartres Cathedral Stained Glass: Chartres, France

pp.152–53 Konark Sun Temple Sculptures: Konark, Odisha, India

pp.154–55 Mosaics of Hagia Sophia: Hagia Sophia, Istanbul, Turkey

pp.156–57 Illustrated Legends of the Kitano Tenjin Shrine: Metropolitan Museum of Art, New York, US

p.158 Coronation Chair: Westminster Abbey, London, UK

p.159 Chimú Collar: Metropolitan Museum of Art, New York, US

p.160–61 Easter Island Moai: Easter Island, Polynesia

pp.162–63 Mamluk Enamelled Glass Bottle: Metropolitan Museum of Art, New York, US

pp.164–65 Ife Head: British Museum, London, UK

GLOSSARY

ABSTRACT EXPRESSIONISM A type of painting that emerged in New York in the late 1940s. Its exponents sought to use abstraction to convey emotion, often working on large canvases with unusual materials, such as house paint.

AFRICAN PROPORTION The proportions of the human body as they appear in much African art. Parts of the body are sized according to significance, so, for example, the head, as the seat of destiny, may take up one third of a human figure, and the most important individual in a group may be depicted as the largest.

ANTHROPOMORPHISM The use of human characteristics to describe non-human attributes, for example ascribing thoughts to animals.

ART DECO A style of design, decoration, and architecture popular in the 1920s and 1930s and characterized by the use of geometric forms and bright colours. It takes its name from the International Exhibition of Modern Decorative and Industrial Arts held in Paris in 1925.

ART NOUVEAU A style of design, decoration, and architecture that emerged in Europe and the US in the 1890s in reaction to the imitation of historical forms that had dominated design in the 19th century. It is characterized by flowing lines often based on vegetal forms.

BAS-RELIEF A type of sculpture in which forms are carved into a flat surface, such as a wall, panel, or tile so that the features stand just proud of the background.

BODHISATTVA Someone on the path to becoming a Buddha (enlightened being) who defers final enlightenment to help others reach the same state.

BOKASHI An advanced Japanese technique of woodblock printing that relies on the selective application of ink to the printing block and is capable of rendering subtle transitions in tone.

CAROLINGIAN EMPIRE The territories in western and central Europe ruled by Frankish king Charlemagne and his successors, from Charlemagne's coronation by Pope Leo II in 800 until the death of Charles III in 888.

CINNABAR A red ore of mercury used in pigments, such as the scarlet pigment vermilion.

COLOPHON A section of text in a book, usually at the end, that gives information about the date and place of publication and identifies the publisher.

CONTÉ CRAYON Drawing tool made from compressed graphite or charcoal mixed with wax and pigment.

CONTRAPPOSTO A term used to describe poses in which one part of a figure twists or turns away from another part.

DIPTYCH A picture consisting of two equal-sized panels, often hinged.

DISTEMPER A water-based paint that uses glue as a binder.

ÉCORCHÉ A term used to describe a figure that is drawn or sculpted to display the structure of underlying muscles and bones.

ENCAUSTIC A painting technique, originating in ancient times, in which pigments are mixed with hot wax.

ETRUSCAN Coming from the ancient culture that occupied the central region of Italy from around the 7th century BCE to the 2nd century BCE.

EXPRESSIONISM Art in which the artist's subjective reactions and emotions take precedence over reality. Colour and form are often exaggerated or distorted.

FAUVISM An early 20th-century movement in French painting characterized by fierce, expressive use of colour. The name comes from the French word *fauve*, meaning "wild beast".

FRESCO A painting on a wall or ceiling created by applying pigments mixed with water to wet lime or gypsum plaster. The term is also used to describe the technique for producing such paintings

FILIGREE Open and delicate jewellery metalwork consisting of fine threads of gold or silver fused together to produce a texture similar to that of lace.

FRIT A ceramic glass made from pre-mixed powdered materials. It is melted and water added to it to cool the liquefied mixture.

GESSO A coating made from paint pigment, chalk, and a binder, such as animal glue, that is applied to boards or canvases before painting in order

to make oil paint adhere better to the substrate.

GUM ARABIC A thick, water-soluble binder made from the sap of acacia trees. It can be mixed with paint to make it viscous, allowing for more precise or textured brushwork.

IMPRESSIONISM An influential movement in painting that began in France in the 1860s. The Impressionists rebelled against the formal conventions of the art academies, employing broken brushwork and working in the open air to give their painting freshness and spontaneity.

LOW RELIEF see **bas-relief**

NORTHERN RENAISSANCE A period from the mid-15th century in which artists in the Low Countries, Germany, France, and England borrowed from the Italian Renaissance, incorporating ideas such as linear perspective and naturalism into their work.

PEDIMENT The triangular structure over a door or window; it is often highly decorated.

PHOENICIAN Relating to the culture of the seafaring people who lived in cities on the eastern Mediterranean coast, such as Tyre, Byblos, Arwad, and Sidon, from c.1500–300 BCE.

PIETÀ A term derived from the Italian word for "pity" that is applied to a painting or sculpture depicting the Virgin Mary supporting the figure of the dead Christ.

POLYPTYCH A painting or carving that is made up of four or more, sometimes hinged, panels. Often used for altarpieces.

POP ART Modern art that makes use of imagery derived from popular culture, such as that used in advertisements and comic books.

POST-IMPRESSIONISM A movement in art developed from the 1890s that was rooted in the exploration of the artist's mind and inner life rather than representations of external reality. It encompassed a wide range of artistic styles.

RENAISSANCE A rebirth of the arts and learning of Ancient Greece and Rome that began in Italy at the end of the 14th century and spread through much of Europe over the next two centuries.

ROCOCO A style of art, design, and architecture characterized by the use of ornate and sensuous curved and scrolled forms, gilding, and pastel colours. It originated in France in the 1730s and spread through Europe.

SILVER GILT Also known as vermeil, silver that has been coated with a thin layer of gold using one of a number of techniques, such as hammering on gold foil, fire gilding using mercury, or electroplating.

SLIPWARE A type of earthernware decorated with a coloured slip made of water, loose clay, and minerals such as mica or feldspar.

STELE A standing stone slab, often inscribed as a memorial or grave marker.

STUPA In Buddhist and Jain architecture, a dome-shaped monument containing sacred relics.

SURREALISM An artistic and literary movement that flourished in Paris in the 1920s and 1930s. Believing that rational thought served to suppress the imagination, Surrealists sought to channel the unconscious mind into their works.

SYMBOLISM An artistic and literary movement that emerged in late 19th-century France. It rejected realism and instead employed dreamlike imagery derived from the imagination and based on myth and mysticism.

TEMPERA A painting medium containing egg yolk, milk, or glues and gums, that is used to bind and carry pigment.

TRIPTYCH A painting or carving that is made up of three, sometimes hinged, panels.

VITREOUS ENAMEL A thin layer of glass that is fused at high temperature onto the surface of a metal to decorate the metal item.

ZOOMORPHISM The use of animal characteristics to describe the attributes of a person or deity, for example the Christian depiction of the Holy Spirit as a dove.

INDEX

ACKNOWLEDGMENTS

Dorling Kindersley would like to thank: Aliki Brane, Dr Fozia Bora, Dr Vivian Delgado, Anirban Saha, Robin Walker, and Shelley Ware.

Thanks to Senior Jackets Designer Suhita Dharamjit, the DK Product and Content Working Group, and Aasha in DK Delhi for their input and guidance on this title.

The publisher would like to thank the following for their kind permission to reproduce their photographs:

(Key: a-above; b-below/bottom; c-centre; f-far; l-left; r-right; t-top)

African Art, Smithsonian Institution. 246-247 Getty Images: Mondadori Portfolio (cl). 247 © The Metropolitan Museum of Art: H. O. Havemeyer Collection, Bequest of Mrs. H. O. Havemeyer, 1929 (ca, r). 248 © The Metropolitan Museum of Art: Gift of Florence and Herbert Irving, 2015 (r). 249 Getty Images: DEA / C. Sappa (bl). V&A Images / Victoria and Albert Museum, London. 250 Alamy Stock Photo: The Natural History Museum (cra). Getty Images: Heritage Images (c). 251 Bridgeman Images. Getty Images: Heritage Images (bl, br). 252 Bridgeman Images. 253 Bridgeman Images: Wallace Collection, London, UK. 254 Alamy Stock Photo: John Astor / The Brooklyn Museum / Museum Expedition 1922, Robert B. Woodward Memorial Fund (bl). Brooklyn Museum: Purchased with funds given by Mr. and Mrs. Alastair B. Martin, Mrs. Donald M. Oenslager, Mr. and Mrs. Robert E. Blum, and the Mrs. Florence A. Blum Fund (r). 255 © The Metropolitan Museum of Art: Purchase, Clara Mertens Bequest, in memory of André Mertens, 2002 (bl). Sotheby's, London: Private Collection (r). 256-257 Alamy Stock Photo: Historic Images (cr). 256 Alamy Stock Photo: Universal Art Archive (bc). Bridgeman Images: Museum of New Zealand te Papa Tongarewa / Gift of Lord St Oswald, 1912 (br). 258 © The Trustees of the British Museum. All rights reserved. Getty Images / iStock: AlinaMD (bc). 259 Fondation Dapper: (r). Yale University Art Gallery: Charles B. Benenson, B.A. 1933, Collection 2006.51.139 (bl). 260 Alamy Stock Photo: Album (bl); Fine Art Images / Heritage Images (cl). Getty Images: Leemage / Photo Josse (bc). 261 Getty Images: Leemage / Photo Josse. 262 National Museum of American History / Smithsonian Institution. 263 Getty Images: AFP / Joyce Naltchayan (br); DigitalVision Vectors / Keith Lance (cl); Universal Images Group / HUM Images (bl). 264-265 Photo Scala, Florence: Image Copyright Museo Nacional del Prado © Photo MNP. 264 Bridgeman Images. 265 Alamy Stock Photo: Vintage Archives. 266 Alamy Stock Photo: imageBROKER (bl); Uber Bilder (cl, br). 267 Getty Images: Heritage Images (c, cra, crb). 268-269 © The Metropolitan Museum of Art: Rogers Fund, 1914 (cl). 269 © The Metropolitan Museum of Art: The Howard Mansfield Collection, Purchase, Rogers Fund, 1936 (bc). 270-271 Bridgeman Images: National Gallery, London, UK (cl). 270 Bridgeman Images: National Gallery, London, UK (br). 271 Getty Images: Universal Images Group (br). 272 Dorling Kindersley: Maidstone Museum and Bentliff Art Gallery / Richard Leeney (bl). 273 Dorling Kindersley: Maidstone Museum and Bentliff Art Gallery / Richard Leeney (tl, tr, bl, br); Maidstone Museum and Bentliff Art Gallery / Richard Leeney (c). 274 Bridgeman Images: Brooklyn Museum of Art / Gift of Mr. and Mrs. Franklin H. Williams (c); Heini Schneebeli (br). © The Metropolitan Museum of

Art: Gift of Ernst Anspach, 1994 (bl). 275 The Art Institute of Chicago: Ada Turnbull Hertle Endowment (r). Bridgeman Images: Heini Schneebeli (bc). 276 Alamy Stock Photo: CPA Media Pte Ltd (bc). © The Metropolitan Museum of Art: Rogers Fund, 1930 (br). 277 University Of Pennsylvania Museum: Bequest of Maxwell Sommerville, 1904 (c, cr). 278 Alamy Stock Photo: photosublime (tc, bc). ©Tate, London 2018: (c). 279 Alamy Stock Photo: photosublime (tl). Getty Images: Corbis / Arte & Immagini srl (br); Heritage Images (bl). 280 © The Metropolitan Museum of Art: Purchase, Joseph Pulitzer Bequest, 1918. 281 Getty Images: Fine Art Images / Heritage Images (br). © The Metropolitan Museum of Art: Henry L. Phillips Collection, Bequest of Henry L. Phillips, 1939 (bl). 282 Getty Images: Corbis / Library of Congress / D.F. Barry (bl). Royal Ontario Museum: © ROM (bc). 283 Royal Ontario Museum: © ROM (c). 284 Getty Images: Fine Art Images / Heritage Images (br); Universal Images Group / Sepia Times (cl); Hulton Archive / Herbert Felton (bl). 285 Getty Images: Mondadori Portfolio (c, tl, tr). 286 Courtesy National Gallery of Art, Washington: Collection of Mr. and Mrs. Paul Mellon (l, r). 287 © The Metropolitan Museum of Art: H. O. Havemeyer Collection, Bequest of Mrs. H. O. Havemeyer, 1929 (cl). Photo Scala, Florence: Art Resource, NY / The Morgan Library & Museum (bl). 288-289 Getty Images: Leemage (c). 288 Bridgeman Images: National Gallery, London, UK (tr). 289 Alamy Stock Photo: Universal Art Archive (br); Visual Arts Resource (bl). 290 Bridgeman Images: National Gallery, London, UK (c). 291 Bridgeman Images: Neue Pinakothek, Munich, Germany (cl); Van Gogh Museum, Amsterdam, The Netherlands (bl, br). 292 The Art Institute of Chicago: Robert A. Waller Fund (br). Getty Images: Corbis / Geoffrey Clements (cl); Corbis / Francis G. Mayer (bc). 293 The Art Institute of Chicago. 294-295 Bridgeman Images: Photograph © 2022 Museum of Fine Arts, Boston. All rights reserved. / Bequest of Maxim Karolik (c). 294 Bridgeman Images: Photograph © 2022 Museum of Fine Arts, Boston. All rights reserved. / Bequest of Maxim Karolik (tr). 295 Bridgeman Images: Granger (br). 296 Alamy Stock Photo: Universal Art Archive (bc). Bridgeman Images: Mark and Carolyn Blackburn Collection of Polynesian Art (cl). 297 National Museum of New Zealand Te Papa Tongarewa: Ihaia Kereopa Whanau Trust. 298 Alamy Stock Photo: Penrodas Collection (bl). Getty Images: Universal Images Group / Picturenow (br). 299 Photo Scala, Florence: National Gallery, London. 300 Belvedere, Vienna. 301 © Cartier: (ca). 302 Alamy Stock Photo: Heritage Image Partnership Ltd (clb). Getty Images: Fine Art Images / Heritage Images (bc). 303 Alamy Stock Photo: Penrodas Collection (cl); Visual Arts Resource (bl). Getty Images: Fine Art Images / Heritage Images (r); Gamma-Rapho / David Lefranc (tl).

304 Alamy Stock Photo: AF Fotografie (bl). Getty Images: Chesnot (br). 305 Getty Images: Fine Art Images / Heritage Images. 306 Getty Images: Art Images (br); Imagno (cl); Moment / Smartshots International (bc). 307 Belvedere, Vienna. 308 Alamy Stock Photo: Album (bc). Getty Images: Bettmann (br). 309 © The Metropolitan Museum of Art. 310-311 Bridgeman Images: State Hermitage Museum, St. Petersburg, Russia (c). 311 Bridgeman Images: Kunstmuseum, Basel, Switzerland. 312 Alamy Stock Photo: Uber Bilder (clb). Bridgeman Images: Lebrecht Music Arts (br). Getty Images: Fine Art Images / Heritage Images (bc). 313 V&A Images / Victoria and Albert Museum, London. 314 Alamy Stock Photo: Wolfgang Kaehler (bl). Photo Scala, Florence: Art Resource / The Metropolitan Museum of Art (r). 315 Alamy Stock Photo: Artokoloro (bl). 316 Alamy Stock Photo: Stephen Lloyd Brazil (cl). AWL Images: Architecture / Art Deco (r). 317 AWL Images: Alex Robinson (bl). 318-319 Bridgeman Images: Museum of Modern Art, New York, USA. 319 Alamy Stock Photo: Prisma by Dukas Presseagentur GmbH (bl). Getty Images: AFP (br). 320-321 Photo Scala, Florence: Art Resource / John Bigelow Taylor / © Succession Picasso / © DACS, London 2022. 320 Photo Scala, Florence: Art Resource / John Bigelow Taylor (cla). 321 Bridgeman Images: Archives Charmet / © Succession Picasso / © DACS, London 2022 (br). Photo Scala, Florence: Art Resource / John Bigelow Taylor / © Succession Picasso / © DACS, London 2022 (cra). 322 Alamy Stock Photo: FLHC9 (br); ILN (crb). The Royal Collection Trust © Her Majesty Queen Elizabeth II: (bl). 323 The Royal Collection Trust © Her Majesty Queen Elizabeth II. 324 Alamy Stock Photo: Active Museum / Active Art / Collection / Active Museum / Le Pictorium (br). Getty Images: Bettmann / © Banco de México Diego Rivera Frida Kahlo Museums Trust, Mexico, D.F. / © DACS, London 2022 (bc). 325 Photo Scala, Florence: Art Resource / Photo Schalkwijk / © Banco de México Diego Rivera Frida Kahlo Museums Trust, Mexico, D.F. / © DACS, London 2022. 326-327 Photo Scala, Florence: Art Resource / The Art Institute of Chicago (cr). 326 Getty Images: Corbis / Oscar White (br). 327 Photo Scala, Florence: Art Resource / The Art Institute of Chicago (bc). 328 Alamy Stock Photo: Album (cl). Getty Images: Anne Frank Fonds Basel (br). 329 Getty Images: Anne Frank Fonds Basel (t); Anne Frank Fonds Basel (b). 330 Getty Images: Fox Photos (cra). ©Tate, London 2018: Barbara Hepworth © Bowness (bl). 331 Getty Images: Archive Photos / © Succession Alberto Giacometti / © DACS, London 2022 (bc). Photo Scala, Florence: The Museum of Modern Art, New York / Gift of Mrs. John D. Rockefeller 3rd. 678.1954 / © Succession Alberto Giacometti / © DACS, London 2022 (r). 332-333 Photo Scala, Florence: The Museum of Modern Art, New York / Sidney and Harriet Janis

Collection Fund (by exchange). Acc. n.: 7.1968 / © The Pollock-Krasner Foundation ARS, NY and DACS, London 2022 / © DACS, London 2022 (tr). 332 Getty Images: Susan Wood / © The Pollock-Krasner Foundation ARS, NY and DACS, London 2022 / © DACS, London 2022 (tc). Shutterstock.com: The LIFE Picture Collection / Martha Holmes / © The Pollock-Krasner Foundation ARS, NY and DACS, London 2022 / © DACS, London 2022 (br). 334-335 Photo Scala, Florence: The Museum of Modern Art, New York / Gift of Irving Blum; Nelson A. Rockefeller Bequest, gift of Mr. and Mrs. William A.M. Burden, Abby Aldrich Rockefeller Fund, gift of Nina and Gordon Bunshaft in honour of Henry Moore, Lillie P. Bliss Bequest, Philip Johnson Fund, Frances Keech Bequest. / © 2022 The Andy Warhol Foundation for the Visual Arts, Inc. / Licensed by DACS, London 2022 / © DACS, London 2022. 334 Bridgeman Images: Zumapress / © 2022 The Andy Warhol Foundation for the Visual Arts, Inc. / Licensed by DACS, London 2022 / © DACS, London 2022 (bc). 336-337 NASA: (cr). 336 Alamy Stock Photo: Futuras Fotos (bc). Getty Images: Lambert (bl). NASA. 338-339 Alamy Stock Photo: Anthony Shaw © the artist / Courtesy Yayoi Kusama Studio / Victoria Miro Gallery, London. 339 Shutterstock.com: AP / Itsuo Inouye (br). 340-341 Getty Images: Universal Images Group / View Pictures / Antony Gormley, Angel of the North, 1998, Steel, 2000 x 5400 x 220 cm, Commissioned by the Gateshead Metropolitan Borough Council, Gateshead, England / Permission courtesy of Antony Gormley Studio © the artist

All other images © Dorling Kindersley